▶▶| **Image and Territory**

Nature and Territory

▶▶❙ **Image and Territory**

Essays on Atom Egoyan

Monique Tschofen and
Jennifer Burwell, editors

Wilfrid Laurier University Press
[WLU]

This book has been published with the help of a grant from the Canadian Federation for the Humanities and Social Sciences, through the Aid to Scholarly Publications Programme, using funds provided by the Social Sciences and Humanities Research Council of Canada. We acknowledge the support of the Canada Council for the Arts for our publishing program. We acknowledge the financial support of the Government of Canada through the Book Publishing Industry Development Program for our publishing activities.

Library and Archives Canada Cataloguing in Publication

 Image and territory : essays on Atom Egoyan / Monique Tschofen and Jennifer Burwell, editors.

Includes bibliographical references, filmography, and index.
ISBN-13: 978-0-88920-487-4
ISBN-10: 0-88920-487-X

 1. Egoyan, Atom—Criticism and interpretation. I. Tschofen, Monique, 1969– II. Burwell, Jennifer Lise

PN1998.3.E334I43 2006 791.4302'33092 C2006-904391-4

Cover design by P.J. Woodland. Cover photograph by Martin Slivka. Text design by Catharine Bonas-Taylor.

This book is printed on Ancient Forest Friendly paper (100% post-consumer recycled).

Printed in Canada

▶▶ Contents

▶▶| Acknowledgments

We must begin by thanking Atom Egoyan and Marcy Gerstein at Ego Film Arts for their thoughtful engagement with and gracious support of this project. They have been consistently generous with their time and resources at every stage in the writing of this book, allowing the editors and writers access to their film archive and library, granting permission for the reproduction of film stills, putting us in contact with Egoyan researchers in North America and abroad, and providing meticulous and valuable feedback on the bibliography and filmography.

Theresa Rowat at the Toronto Film Reference Library and the interlibrary loans staff at Ryerson University Library greatly facilitated our research. Ian Balfour, John Knechtel, and Gilbert Li allowed us to preview their Alphabet City *Subtitles* volume. Martin Slivka was most generous in allowing us to use his image for the cover, as were Michael Cooper, with his photographs of the Canadian Opera Company's *Salome*, and Jennifer Pugsley, who helped us track down all the actors in the photographs. Michael Helmsworth and Michael McDonald provided invaluable technical support.

We thank all of the contributors for their fine work. As well, we would like to thank Peter Harcourt, Imre Szeman, Hamid Naficy, Christine St. Peter, Mary Alemany-Galway, and Sourayan Mookerjea for their participation in earlier versions of the book. Our team of anonymous reviewers, who vetted

the contributions, offered valuable feedback to the authors, as did Christopher Gibbins, Étoile Stewart, and Curtis Maloley, who read and commented on early drafts of essays.

Our research assistants—Julie Williamson, Christine Johns, Katherine Bruce, Jeremy Singer, Erin MacKeen, Marisa Bregman, Angela Joosse, Alexandra Oliver, and Cheryl Ramage—deserve every praise for their hard work and dedication. We are most indebted to the people who have been the longest involved in the project with us: to Angela Joosse, for her phenomenal organizational skills and calm brilliance, and to Kathleen McLean and Matthew Kronby, for their keen eyes, incisive feedback, and constant support.

This book was possible due to the generous support of Ryerson University, especially Carla Cassidy, John Cook, and Lorraine Janzen. We are likewise grateful for the assistance of the Office of Research Services at Ryerson University through its Publications Fund.

Finally, we wish to warmly thank Jacqueline Larson, Brian Henderson, Leslie Macredie, Heather Blain-Yanke, Catharine Bonas-Taylor, Pam Woodland, Rob Kohlmeier, and everyone at Wilfrid Laurier University Press for their enthusiasm, support, and commitment.

▶▶▌ Introduction

In Media Res
Atom Egoyan's Utopian Praxis

Monique Tschofen and Jennifer Burwell

Atom Egoyan has written, directed, produced, and exhibited one of the most intriguing bodies of work. In dense, multi-layered projects in a remarkably wide range of media, he has focused on everything, as he says, from "the stories of survivors passed on to children and grandchildren, to the industrial needs of commercial entertainment, to the private and sacred mythologies of art," showing "the collective human linkage of experience [that] is both the wonder and tragedy of our condition" (Egoyan 2004b, 903). It is in between these two poles—between tragedy and wonder—that his work is best understood. He relentlessly puts on display, spectacularizes, and even reproduces in his viewers all of the unhealthy symptoms of modernity. He documents the global flows of persons, culture, and commodities caught up, like every other aspect of capital, in transnational movements and exchanges, and shows how these flows radically transform the touchstones of place, home, self, and family. Yet at the same time, he depicts the forging of new communities that develop beyond consanguinal relations, by chance and by choice, across the diaspora. Egoyan displays our cultish and fetishistic reliance on images and screens, and reveals how they render human experience hallucinatory or solipsistic. At the same time, he constructs the screen as a meeting place where new, profound, and consciousness-altering forms of exchange takes place. Against official history's erasures and amnesias, he

shows how in intimate moments, lovers, parents, children, and perfect strangers can express what has been repressed, using words, images, and gestures. In so doing, they connect to each other and to their shared pasts and futures.

This volume aims to examine the central arguments, tensions, and paradoxes of Egoyan's work and to trace their evolution. It also aims to locate his work within larger intellectual and artistic currents in order to consider the ways he takes up and answers critical debates in politics, philosophy, and aesthetics. But perhaps most important, it aims to address the ways in which his work strives to be both intellectually engaging and emotionally moving. Within a culture that often understands formal experimentation or theoretical argument to be antithetical to pleasure, Egoyan has consistently managed to appeal to popular audiences. For all their artifice and provocation, his films, work in television, stagings, and installations are, at some fundamental level, striving to speak plainly and openly about profound human experiences.

The essays in this collection by some of the leading Egoyan scholars from Canada, the United States, and Europe—themselves experts in music, visual arts, literature, film, and television studies—cover Egoyan's central works using a variety of critical approaches. We have grouped the essays into sections that together illuminate some of the chief patterns in his oeuvre as well as the larger issues we believe Egoyan's work raises for popular audiences, scholars, and critics.

The first sequence of essays, titled "Media Technologies, Aura and Redemption," addresses the importance of technology in Egoyan's work. Where early scholarship on Egoyan frequently sought to understand his highly self-reflexive practice through the lens of postmodernism, the writers in this section draw from a wide range of resources to reconsider the myriad of relationships his films articulate between technological media, forms of knowing, and modes of being. Linking Egoyan's use of technological artifacts and "image narratives" to existential structures of being, and showing how his approach to technology is grounded in far more than postmodern thinking about technology, these essays uncover in Egoyan's work an alternative relationship to technology, one that shows characters using technology in ways that enable rather than disable, drawing on technology's evocative rather than deadening potentials.

The second sequence of essays, titled "Diasporic Histories and the Exile of Meaning," considers the ways in which Egoyan's and his family's experiences of the Armenian diaspora have been a central preoccupation in his work. The authors argue that Egoyan's work both overtly and covertly takes up the question of what it means to be Armenian and to bear the heritage of the "legacies of denial and forgetting" surrounding the Armenian genocide.

At the same time, they also consider broader and more universal issues, such as the social, political, and historical tensions, contradictions, and paradoxes characterizing the global historical experiences of displacement and deterritorialization.

In the third sequence of essays, titled "Pathologies/Ontologies of the Visual," the authors continue to focus on the social dimensions of Egoyan's work; but where the previous sections turned to media studies and post-colonial history to provide frameworks of understanding, the essays in this section draw from the insights that psychoanalytic discourse, feminism, and film theory have brought to many disciplines about desire, voyeurism, and scopophilia. These papers focus on Egoyan's recurring creation of narratives around deeply personal attempts to resolve a feeling of lack or absence by constructing a relationship to someone or something more tangible and vis-ible. The authors connect these substitutive gestures to complex ethical and epistemological questions of culpability versus innocence—questions that, in Egoyan's work, frequently implicate the viewer's own fetishistic desires along with those of the characters. As in the previous sections, these authors take up questions of agency, power, and guilt, showing the innovative man-ner in which Egoyan's work engages the aural, visual, and tactile aspects of our experience and expression.

The fourth section, "Conversations," features two interviews. The first interview, with Gariné Torossian, a Toronto-based Armenian-Canadian film-maker whose works draw raw materials from Egoyan's, stands in counter-point to the academic voices in the collection and reveals how artists, and not only scholars, generate fascinating critical engagements with Egoyan's work. In the second interview, the director himself talks about his work. Finally, to round out these contributions, the volume offers a comprehensive filmography and bibliography.

In the essays that introduce each section, we frame the critical issues and speak more specifically about the arguments of our volume's contributors. In this general introduction, we seek to set the stage for the volume as a whole by exploring the relationship Egoyan's work sets up with the viewer. Our purpose is to articulate what is at stake for the spectator of Egoyan's work in all these arts—in short, to show what his formal preoccupation with interstices between media and genres does to us as viewers. Beginning with a discussion of Egoyan's fluency in a wide range of media and leading into a close reading of Egoyan's 2002 installation *Hors d'usage*, this introduction argues that Egoyan's work as a whole has sought to transmute his represen-tations of trauma, loss, and uncertainty into a larger order characterized by instability and mobility. We discuss how Egoyan exiles his audiences from their comfort zones with the intention of prompting them to explore new imaginative territories. In so doing, he generates again and again, out of the

margins of shattered histories and ruptured forms, new kinds of commu-
nity. At its core, we argue, his is a utopian project that is not the "elsewhere"
of its historical moment, but rather is firmly grounded in it.

Throughout his career, Atom Egoyan has shown himself to possess the
rarest kind of singularity. As Jonathan Romney puts it, Egoyan's "preoccu-
pations and tropes have been so consistent that he's practically created his
own genre" (1995, 8). Hrag Vartanian adds, "Egoyanesque has become a
word to film aficionados, commonly understood to mean a cinematic moment
that examines sexuality, technology and alienation in the modern world"
(2004). For this singularity, Egoyan is widely hailed as a true auteur—some-
one carrying on the legacy of the European art-house traditions of Bergman,
Godard, and Truffaut. Certainly, his work bears a most recognizable signa-
ture—there is no confusing an Egoyan work with anyone else's. Like his art-
house predecessors, Egoyan clearly intends that his work be, as Dudley
Andrew puts it, "read rather than consumed," that is, viewed meditatively,
reflected upon, and discussed (2000, 24). And indeed, in this world in which
filmmaking has become commonplace—where, as Egoyan has said, "what
used to be a rarified activity is now available to anyone with a digital cam-
era and a computer" (2001b, 18)—he intends through much of his work to
recall an earlier image culture in which artists had an ability to produce
something that gained its power precisely through its rarity.[1]

Egoyan has revealed that he is very aware, however, of the dangers inher-
ent in his wish to capture the magic and rarity of the moving image. He does
not mean to promote a naïve nostalgia for more innocent times when film-
makers were blindly worshiped. Rather, he seeks to remember a time that,
if not more cynical, was at least more conscious of the powers of image-
makers. Egoyan has always understood that the cinema has the power to
make people believe that what they are seeing is real, and that this makes it
an ideal instrument for propaganda (Egoyan 2004b, 888).[2] He has also
observed that in different ways, when other storytelling and representational
arts strive to construct the real, they too carry the potential to distort and
manipulate, to lie and deny. Seeking to draw attention to the conundrum
that the very tools we use to represent ourselves to the world and to trans-
late the world back to ourselves might be deceitful and dangerous, he has con-
sistently tried to lay bare the mechanisms of representational practices,
showing, as he puts it, "the frame as well as the picture" (Romney 1999, 6).
The central "Egoyanesque" themes revolving around trauma such as incest,
violation, erasure, and forgetting—all of which are elaborated upon by the
essays in this volume—thus emerge directly from the place where the logic
of representational systems and the agency of individual subjects collide.

A few examples from Egoyan's works will show what we mean here. In
The Sweet Hereafter (1997), a father pictures his daughter as a beautiful rock

star. Seduced by this image of herself, the daughter complies with her own violation until she realizes that she never resembled this image. Having once been a victim of the art of misrepresentation, she appropriates its tactics in order to rupture other deceptions and fictions. In *The Adjuster* (1991), a film censor is molested by her colleague while violent pornography plays on the screen before them and another colleague watches on voyeuristically. She frightens them both by seizing her aggressor's hand as if about to act out the kinds of scenarios they are beholding, and thus exposes the scene's sadistic logic, rendering her assailants impotent. In yet another film, *Ararat* (2002), an art historian lectures about the many ways destruction is part of a painting by artist Arshile Gorky, in its genesis as well as in its execution. Her exegesis, which sets this one work on a pedestal above all others, suggests that the image serves as a "mirror" to history, offering what she calls a "sacred code" that translates the traumatic history of the destruction of her own and the artist's people. Traumatized by the loss of her father, and seeking to mirror a more private history of destruction, the historian's stepdaughter constructs an alternative code to articulate her personal pain by seeking to destroy the "sacred" painting. All of Egoyan's human traumas are similarly inextricably bound by and caught up in the logic of the media that represent them. As in Escher's famous drawing of the hand drawing the hand, in Egoyan's works there are only pictures and frames—nothing is outside of the realm of representation. And yet, as in the examples above, if sometimes this means that his subjects become victims of histories scripted for them, other times this means that his subjects transform the logic of these scripts and are, themselves, transformed for the better.

Egoyan's output in a wide range of media has shaped the way he conceives the relationships different media can provoke between producers and consumers of cultural products. As a precocious young man living in Victoria, Canada, Egoyan was, by the age of thirteen, not only familiar with but thoughtfully experimenting with the premises of the theatre of the absurd—Ionesco, Genet, Beckett, Pinter, and Adamov—as well as with the British absurdist humour of Monty Python (Egoyan 2004a, 68).[3] In the dozens of plays he has written and that are available in the archive—at least ten of which were mounted on stage, often under his own direction—Egoyan clearly announces the core issues his later work pursues: immigration, dispossession, and placelessness; history, memory, and forgetting; and that highly charged and aestheticized tension between intimacy and violation. In these early plays, many of the character types that recur in his work make their first appearances, where they are outlined in their starkest forms; we are introduced to ferocious patriarchs, sullied yet complicit young women, and, above all, "aliens" confused by their new surroundings and trying to adapt. The topics and scenarios he later redevelops and refines are also visible in nas-

cent form in the plays. It is possible, for instance, to see the genesis of *Ararat* in his play about Armenia, *Open Arms* (1984), just as it is possible to see the roots of *Exotica*'s treatment of male violence in plays like *Convention* (1982) and *After Grad with Dad* (1980), the roots of *The Adjuster*'s treatment of forgetting in the 1973 play *A Fool's Dream*, or the treatment of linguistic alterity and the problems of forgetting of the mother tongue that he revisits in *Calendar* (1993) in the handwritten manuscript of a play titled *The School* (1975).

After becoming deeply involved in the world of theatre, Egoyan left Victoria to study international relations at the University of Toronto. It was in Toronto in the late 1970s that he connected for the first time to an Armenian community, and then became involved in filmmaking, when the Tarragon Theatre turned down his play. Egoyan's contributions to moving pictures—at the time of writing, twelve short films, eleven features, and ten pieces for television—have earned him accolades and critical recognition around the world. The list of awards is most impressive. In addition to innumerable Genies, Geminis, and jury and critics' prizes from some of the most venerable institutions of the film and television industry, Egoyan has received recognitions ranging from the nomination of *Exotica* (1994) for an Adult Video Award for Best Alternative Video to the National Board of Review of Motion Pictures award for "Special Recognition of Films that Reflect the Freedom of Expression" and the Political Film Society of Hollywood's award for Best Film on Human Rights for *Ararat* in 2002.

Egoyan's first installation, *Return to the Flock*, mounted at the Irish Museum of Modern Art, Dublin, in 1996, prepared the way for two more installations at the prestigious Venice Biennale, as well as for installations in England, France, Belgium, Portugal, Spain, Denmark, the Netherlands, Japan, Canada, and the United States. Moreover, since 1996, Egoyan has been working in opera, directing both classic operas, such as Strauss's *Salome* (1996, 2002) and Wagner's *Die Walküre* (2004), and contemporary ones, such as Gavin Bryars's *Dr. Ox's Experiment* (1998) and *Elsewhereless* (1998), for which he also wrote the libretto. In addition to collaborations with Steve Reich and Philip Glass, for which he provided images for musical performances, Egoyan has always worked closely with composers such as Mychael Danna on the soundtracks to his own films.

While Egoyan has migrated between media, he has made himself at home in many. But how has he conceived of the media he works with? As Egoyan has translated and adapted his own concerns from one medium to another and woven them together as a whole, he has made it clear that he in no way believes the media he works with to be interchangeable technological systems that offer neutral vehicles for narrative and thematic content. Rather, like scholars ranging from Marshall McLuhan to Paul Virilio to Friedrich Kittler, Egoyan understands each medium to possess its own econ-

omy that permits and constrains the patterns of thought it seeks to represent. Since his earliest films, all of his work has sought to exploit the contrasts in tones and textures between photography, film, video, and, eventually, digital imagery, often inserting one medium within another so that it is impossible to tell which contains the other. Through these self-reflexive framing strategies, his work seeks to bring dimensions of depth, both emotional and spatial, to the experiences of televisual, video, and cinematic images. But he has also set up these contrasts between media in order to exploit their different epistemological and ontological grounds. His deliberate negotiations of the intersections of and boundaries between media demonstrate how, in their form and very operation, hybrid media can induce different kinds of social relations and different modes of being for the subject who observes and manipulates them.

Although there is much to say about the ways in which Egoyan's work is highly conscious of how media technologies provoke changes in our very sensory perceptions, in this introduction we will restrict ourselves to a discussion of his use of the media ecologies of theatre, opera, and installation to construct a particular kind of role for the spectator. Following closely upon his already promising career in the theatre proper, Egoyan's early films were very much indebted to the theatre. They feature convoluted and highly wrought narrative structures, and stilted and stylized acting styles that many have described as Pinteresque and Brechtian (Harcourt 1995, 5). From the dramatic use of scrims and screens in the short film *Open House* (1982) to the miniaturized stage sets in the television short *Looking for Nothing* (1988) to the claustrophobic artificial hotel interiors of *Speaking Parts* (1989) to the *trompe l'oeil* effects in *The Adjuster*'s show home (1991), his early films rely on highly "staged" settings. On these various artificial stages, Egoyan draws special attention to "props" that range from books to photographs to billboards to television screens to audio recorders and telephones to cameras—all serving relentlessly to remind us *en abyme* that we are witnessing a representation. Egoyan has remarked that at the moment generally understood to be the midpoint in his career, when he ceased making absurdist films on absurdist sets and turned his attentions to more classically narrative and character-focused films, the theatre continued to inform his filmmaking. In particular, he explains that he intended his film *Exotica* (1994) to translate the themes of technological mediation of his earlier work "through more theatrical means, through costumes and things like that" (Egoyan 1995). Even in his later films, which are less overtly theatrical, it is possible to see his indebtedness to the theatre of the absurd, to *Kammerspiel*, and to Brechtian epic theatre in the ways he seeks to produce powerful effects of distanciation and estrangement. These effects, such as the dispassionate way he represents the bus accident in *The Sweet Hereafter* (1997) and the heightened

artifice of the film within the film in *Ararat* (2002), are perhaps most explicit in his home movie-styled film about the image's powers to seduce and repel, *Citadel* (2004).

Responding to critics' accusations that because of these artifices and distancing effects, his films evidence a kind of coldness, Egoyan stresses that "you cannot get warm and cuddly with the films. That's maybe what people are talking about: they can't simply sit back and have a story told to them and identify and lose themselves. They have to be always aware of their position and their relationship to these images" (Egoyan 2002 b, 154). This notion of the viewer's position in relation to film images is resolvedly spatial. In other discussions of the terms of the viewer's engagement, Egoyan, whose own life story is very much informed by the experiences of the Armenian diaspora, brilliantly condenses the theatre's spatiality with the idea of migration or travel. Explaining that he wishes viewers to be active and exploratory, he states, "the work you have to do with live theatre as an audience member is something that has really informed my film work. A theatre audience has to be very exploratory, and they have to be willing to suspend disbelief and trust and make a huge effort. And a lot of films are just too easy. You don't have to make those leaps; you don't have to travel to find those places and put them together in your own subconscious" (Egoyan 1999). In a way, what he is arguing for here is a kind of exchange between viewer and text; in order to be *moved*, the viewer must *travel* into the image. His own spatial metaphors point to a kinetic, embodied model of seeing that much resembles the phenomenological models of the cinema articulated by Vivian Sobchack (1992) and Laura Marks (2000).

Underneath these "cold" films, which nevertheless demand a certain engagement from the viewer, are structures of feeling and perception that Egoyan has borrowed from other arts. While Egoyan has made reference to the theatrical tactics of estrangement to explain audiences' perception of a kind of "coldness" in his films, he has also made use of references to opera. Again and again, Egoyan describes the traumatic experiences his characters have endured and are trying to cope with as "operatic," explaining that they have simply "arrived at a point where they cannot afford to express those feelings" (*Formulas* 1999). Egoyan alludes here to the emotional excesses we associate with the kinds of narratives staged within opera. His suggestion that operatic tropes are present in his works through their very repression, bracketing, or even absence is intriguing insofar as he seems to be demanding a very subtle interpretive strategy that is as attentive to silences and elisions as it is to what is heard and seen. On the one hand, it might be possible to conceive of his strategy of entombing passion and heat beneath his films' cool surfaces as an example of what postcolonial and feminist theorists, drawing from Mikhail Bakhtin's notion of dialogism to describe a kind of politics

that disrupts the repressive cultural logic in which they are embedded, have termed "double-voiced discourse." But on the other hand, when Egoyan suggests that his films are "operatic" precisely at the moments when his characters cannot find their voices, he is also recalling a musical strategy associated with postmodern composers such as John Cage, Steve Reich, and Philip Glass of using silence to rethink the art of listening.

With his allusion to an operatic element at work in the early films, Egoyan also introduces an important element of opera's performativity. As Linda and Michael Hutcheon argue in *Bodily Charm* (2000), opera is a highly physical medium—"a ritual in which the representation of bodily sensation on stage meets with intense physical engagement of the audience to create a truly communal theatrical experience" (Smart 2002). Egoyan's early work is therefore "operatic" insofar as it develops in the midst of a struggle between Dionysian excess and Apollonian repression to summon forth the multisensory and affective engagement of his viewers.

Egoyan has also likened his early work in film to installation. In an interview with him, Jacinto Lageira and Stephen Wright observe, "Your approach to the image is less that of a filmmaker than that of a visual artist taking the image's plasticity into account." Egoyan's response is explicit: "I've always viewed the screen as a sort of installation site" (Egoyan 2001a). He elaborates on this comparison between film and installation in an interview with Janet Cardiff when he refers to his early film *Family Viewing* "as a dramatic installation that uses a screen and 16-millimeter projector" (Cardiff 2002, 63). Confessing his fascination with "the whole question of reflexive or self-reflexive responses to a space, how gallery space operates on a viewer, the ritual of going into a space, of seeing art presented within a space," he notes that with film, we too often are "not aware of the process of having to traverse the space in order to enter into the state that the artist is wishing to express" (Egoyan 1993b, 105). Installation, Egoyan elaborates, offers "the opportunity to see other people enter the space, to look at whether or not they have engaged themselves in the activity of interpreting—which itself becomes part of our appraisal of our own need. That is impossible to do with film, where there is a tacit assumption—no matter what language the film uses— that we are all in this space and will not move; and if someone does leave or respond, it is the result of some physical urgency. We are simply not aware how the viewer moves through the room, so we are not as self-conscious" (Egoyan 2001a). With the theatrical, operatic, and installation frameworks he uses to locate and explicate his own practice, Egoyan seems to be expressing an interest in an experiential poetics that reintroduces to representational spaces the full dimensions of the body (character, performer, and spectators) and makes the very acts of perception and interpretation visible and thus communal.

In an oft-quoted essay prefacing the screenplay to *Speaking Parts*, "Surface Tension," Egoyan articulates his mission to understand the nature of images in relation to a dialectics of surfaces and depths. Mass media typically offers up images as *conveyors*; we viewers are encouraged to be passive consumers waiting for the media to deliver their meanings and pleasures to us. In place of this model, Egoyan seeks to offer the notion of the image as a *container*, which sets up a different kind of relationship between the viewer and the image. "We treat the idea that a projected image can be a *container*, rather than a *conveyer* of emotion," he notes, "with uncertainty and confusion. We don't want to consider the implications of the projected image's status as a *container*, since that involves a greater responsibility on our part. A *conveyed* image is brought to us, the viewers. A *contained* image has to be sought out, beyond the glimpse of its surface that a screen affords" (Egoyan 1993a, 26). The activity of seeking out things *beyond* the glimpse of surfaces—something he has argued theatre, opera, and installation by very definition make us do—takes us well beyond the "primitive responsibility of any watcher: to stare and forget" (Egoyan 1993a, 28). Indeed, he argues, it produces the possibility of an exchange. In a gesture that itself exchanges one set of meanings for another, Egoyan recalls Paul Virilio's notion of the surface—a figure of depth, not shallowness, conceived of as an interface rather than as a border—observing that "when the screen image *contains* something more immediate to the viewer ... a true surface can be developed if the viewer breaks the impassive nature of the screen identification process with a degree of involvement" (Egoyan 1993a, 28). Insofar as his notion of surface seems to be very much indebted to modern art's equation of painting's "physicality" with its "possession of a surface," he further complicates our understanding of not only how images are perceived but how they are produced (Wollheim 1992, 787–88).

Egoyan's formal preoccupations with the interstices between media and genres, then, is motivated by a desire to show the frame. But even more is at stake in this self-reflexivity that mobilizes viewing subjects and forces them to seek out new forms of involvement with representations. Drawing on the etymological connection in French between the material of film and human skin (*peau* and *pellicule*), Daniele Rivière has discussed how Egoyan's self-conscious use of the camera is in effect an *emotional* approach, which "invests the image with affective intensities that bring the spectator into a tissue of relations, where he can give the image body again" (1993, 98). Rivière continues to discuss how Egoyan's conception of the film image, in its material contingency, *touches* us: "The gesture/movement of the camera lingers on the film/skin, in order to cut through, to re-establish contact and exchange, thus giving rise to a theatre of materials, no longer the site of an evocation of images in a representational space but a condensation of images

and imagination in a *co-belonging*" (1993, 100). Attentive to a medium's materiality and plasticity, as well as to the way it positions viewers intellectually, emotionally, and spatially, Egoyan, like McLuhan, understands that "the moment of the meeting of media is a moment of freedom and release from the ordinary trance and numbness imposed by them on our senses" (McLuhan [1965] 1995, 55). What we find in Egoyan's work is ultimately a utopian praxis that seeks, in the crossing of boundaries between genres and media technologies, to generate new forms of sociality and new forms of belonging.

Egoyan's installation *Hors d'usage*, which appeared at the Musée d'Art Contemporain de Montréal in 2002, exemplifies the way Egoyan uses his own migration between media to reposition the viewer and thus produce the possibilities of co-belonging. Orchestrating elements of theatricality and film, *Hors d'usage* emerged from his call to the Montreal community to locate and donate old reel-to-reel recorders and the tapes community members had made, and then tell a story about it.

The installation itself is organized into three "acts." Before entering the primary installation space, viewers must pass through two unconventional screening spaces. The first, where the video *Le récit d'Eric Shoup* loops on a mid-size television screen, is halfway down a set of stairs. In order to watch the video, in which Eric Shoup speaks about memories of his mother prompted by his retrieval of a reel-to-reel recorder in the basement, it is necessary to pause in the middle of things. Standing or perhaps sitting on the stairs, we become aware of our bodies in space, experiencing a sort of discomfort, an awareness of blocking the view of others or of disrupting their entrance into and exit from the show. This first screening space is entirely transitional; we feel impelled forward because it is neither here nor there. In order to observe the video, however, we have to resist the urge to keep moving by claiming both the space and the time to listen and see.

In the second screening space at the bottom of the stairs, a nondescript bench of the sort often found in gallery spaces suggests that pausing is permissible. And yet something still seems wrong. In order to watch this second video (or rather videos, since the narrative of Marie-France Marcil speaking about her mother is projected on one television screen next to another television screen showing an image of a pair of hands threading tape through a reel-to-reel recorder), we have to turn our backs to the darkened room that seems to be the goal of the visit. Again, giving the sense that the real action must lie in the theatre of that darkened room now behind and out of sight and that these two preliminary screenings merely foreshadow a spectacle that has not yet begun, Egoyan generates a pressure to resist the *telos* of the space. As with all of Egoyan's work in film and television, in galleries, and on stage, the main show is offered up only after the viewer has travelled a strange

journey through interstitial and liminal spaces in which the landmarks—screens and their flickering images—serially repeat, here doubling before proliferating wildly.

In the third act in the main room, the eyes must adjust to the darkness before observing dozens of screens appearing to hover in mid-air at unsettling angles. Set in neither the vertical nor the horizontal plane, the screens are suspended—in space, obviously, but also in time, for, hanging at impossible angles, they appear to be temporarily frozen in the midst of falling. On each screen are ethereal images of hands, each doing the same task of setting up the tape on a reel-to-reel player. The task involves some manual dexterity: the insertion of the tape in the take-up reel, the threading of the tape through the player, and the manual winding of the reel to the start of the tape. Egoyan's work has often focused on hands. *The Adjuster* opens with a close-up of an image Egoyan intends to invoke Fatima's hand of fate, while in films like *Exotica* and *Ararat* many key narrative moments are punctuated with images of hands reaching, touching, and making things. In his interview in this volume, Egoyan speaks at length about his fascination with hands and handiwork. In addition to engaging with larger debates about the analogue and artistry, the ethereal projections of these manual labours in this installation suggest that some kind of paradox is at work.

The images are ghostly, for the screen is merely a piece of translucent acrylic that captures the light from a cathode-ray television mostly hidden from view. Images of images, then, these hands—busy in their fully tactile activies of making—serve as compelling indices of transience, absence, and distance. Neither producing nor stopping the light in its trajectory, the floating images from recordings made earlier draw attention to the mechanisms of representation that detach images from the *nowness* of their action. Shot in a single take in close-up, the hands become decontextualized as the camera refuses to pan up or zoom out to show us the bodies or faces they belong to. Their framing thus further detaches them from any idea we might have about embodied presence.

Below each screen sits a reel-to-reel tape machine, or rather *the* reel-to-reel tape machine that appears in the image above it. This uncanny echoing draws attention to the disjunctions between the "real" and the reel, for brought together in this one space are layers and layers of mediations of pastness, revealing, as Annie E. Coombes also notes about Egoyan's installation *Steenbeckett* (2002), the "desire to recover the intangible sensation of time, unreclaimable and unduplicable" (2003, 162). Within the room, we wind our way through recorded soundscapes of everyday life in all its richness and glory: songs sung, stories narrated, performances captured, and special occasions preserved. But we also journey through everyday life in its tenuousness, as a particularly wrenching audio suicide note recalls endings

and loss. In this installation, we as viewers are thus called to become witnesses to both lost and found histories, rendered, at the moment of their preservation, fragile as tape, ephemeral as light refracted through glass, and yet with more longevity than an individual human life.

One of the central metaphors of the installation is the loop, and here, Egoyan, who has become the veritable master of the arts of repetition, conjures its physical dimensions. At each station, the imaged sequence of setting up the tape and the audio recording from that tape repeat themselves ad infinitum, showing, if not how life repeats itself, then how the prosthetics we use to extend our memories make it seem this way. Between the stations, the tape running through the recorders is diverted over several metres upward to an elaborate system of pulleys that lead back down and into other machines, showing how all of the stories, all of the histories, brought into that room are interwoven. Describing *Hors d'usage* as a "monument to the most vulnerable aspects of analogic recording," Egoyan has remarked that the installation is also a monument "to the ways a technology that is no longer in use can express concepts that pertain to the changing nature of communities." In a perfect synchronicity of medium and message, then, the tape loops, as Egoyan explains, "expose the fragile side that connects [communities] to show how their links are precious and vulnerable" (Delgado 2002, translation eds).

Within the context of his oeuvre, however, the looping of the tape in this installation has other connotations. In *Speaking Parts* (1989), for example, the video mausoleum that Clara visits features dozens upon dozens of taped loops that replay fragments, severed from the flow of time, in an awkward simulation of life itself. When Egoyan observed of the film that nothing can be shared in that room (Burnett 1993, 19), his comments reveal just what is at stake in this practice made possible by modern media technologies. Looping, in other words, can be a metaphor for the things that bind us together and to our pasts, but it can also be a metaphor for the things that keep us apart and that cause traumatic pasts to replay endlessly in the lives of generations to follow. In their staging of a fantasy of control and community, the looped tapes in *Hors d'usage* conceal larger anxieties about repetition and fragmentation.

If *Hors d'usage* aptly conjures the paradoxical solidity and fragility of human connections over and within time, it also offers, like so many of Egoyan's works—from the short film *Peep Show* (1981) to the feature *Exotica* (1984) to the direction of the opera *Salome* (1996/2002) and the recent film *Citadel* (2004)—a meditation on the tease. Egoyan has long been fascinated with the injunction "you can look but don't touch," which he suggests is at the heart of the transactions not only of pornography but of all audiovisual culture. In the installation *Hors d'usage*, each reel-to-reel player

has a black band of tape across it, with the imperative *"ne touchez pas s.v.p."*—do not touch please. This routine injunction to discourage gallery visitors from wrecking the equipment here serves as a witty spin on Magritte's *Ceci n'est pas une pipe*, because at one level, in this installation where the images of persons consist only of the light of cathode ray tubes refracted through glass, and where their voices consist only of magnetic traces preserved on tape, there is no body there for us to touch. (In fact, even the magnetic traces on the audiotape are not really there; due to the technical constraints of the looping effect, the recorders each have within them a digital system replaying a secondary recording of the primary recording.) As we viewers behold the projected and refracted images of someone's hands and their handiwork setting up the players and manipulating the tape, we become acutely aware of the absence of these bodies from the time and space they are occupying. At the same time, however, we are to understand that, as extensions of the body, the media technologies that recorded and that display these images of absent bodies also stand in for them, provoking in us as viewers similar kinds of feelings and desires (a topic to which the essays in the first section of this volume turn). Indeed, as if underlining the fact that this displacement of technology's body for fleshly bodies needn't disturb the economy of desire, in an interview with Louise Ismert in the catalogue for *Hors d'usage*, Egoyan remarks that "there is something that I found very moving about the physical properties of the instrument": "These machines have a sense of proportion, there is an irregularity in their design which suggests something corporeal; they are an extension of our own body and they have personality. Look at the small Sony that came on that morning; remember how cute it was. Look at some of the Philips, very round and very friendly; there is something inviting about the idea of touching them" (Egoyan 2002a, 38). In other words, the injunction to not touch the machinery is at some level no different from a strip club's injunction to not touch the dancers' bodies in *Exotica*, and is charged with the same powerful dynamic of desire and interdiction, presence and absence.

In this hypermediated audiovisual space, the "do not touch, please" sign, poised right below images of hands touching, makes viewers aware of the disruptiveness of their own bodies. We cannot touch because we might break the fragile loop of tape linking machine to machine, memory to performance, past to present, individual to community. We cannot touch because to do so would violate the body of the text—the private realms perhaps already being violated by the public's voyeuristic observing and listening. Our desire to engage with and, more important, to connect to the community woven in that space is thus thwarted. This injunction *not* to touch asserts our non-belonging in the same way as the positioning of the screens in the middle of things outside the room does: our wanting notwithstand-

ing, we seem to know at some visceral level that we are not supposed to feel settled, nor are we supposed to reach out. Like so many of his films and work in television, Egoyan's installation thus reproduces the feelings (*ek-stasis*) of the foreigner or exile moving through a landscape, imbued with other people's memories, to which he or she will never fully belong and that will never fully belong to him or her (a topic the essays in the second section of this volume explore). Likewise, the installation reproduces the feelings (*ecstasy*) of the voyeur, yearning for but never attaining the object of his or her desire (a topic the essays in the third section of this volume pursue).

In the *Hors d'usage* installation, Egoyan sets our experiences as obedient, unanchored, mobile observers who "do not touch" against the experiences of many of the people represented in the installation, who through their manipulation of tape and machine discover and share their own voices. Outside of the darkened room of the primary installation space, the video of Marie-France Marcil in particular reveals how a kind of "authority is granted to people when they have the ability to turn themselves into producers" (Egoyan 2002b, 154). Marcil uses a highly tactile vocabulary that underscores an intimate, interactive relationship with the tape machines to describe what it was like for her to find the audio machine that her now-deceased mother used to use: "When I see it, I want to touch it. What makes an impression on me is touching it.... Something about telling and touching brings back memories.... It is a privilege to touch it, my mother's machine. I wanted to penetrate the mystery of the machine. There was a memory; there was a kind of spiritual heritage. It's touching, because in confiding a memory one becomes aware of emotions" (translation eds). Connected here through the work of the eye and the hand that activates the body of a machine are the physical and the spiritual, the present and the past, the living and the dead. There is a fullness to this experience that is entirely antithetical to the eros of the tease and the mixed feelings of *ek-stasis* and ecstasy it arouses. It has to do with what Elizabeth Harvey describes as "the figurative sense of 'touching' as kindling affect ... evok[ing] at once agency and receptivity, authority and reciprocity, pleasure and pain, sensual indulgence and epistemological certainty" (2002, 2). It is thus with Marcil's description of a relay—seeing, touching, remembering, telling, feeling, and *being touched*—that we become aware of these other, redemptive and utopian dimensions of the installation and of Egoyan's work as a whole.

Marcil's narrative serves in the installation to delineate between the two classes Egoyan has always been interested in: those who turn themselves into producers and those who do not. An ordinary member of the public just like us, Marcil responded to the museum's call for artifacts; she delved into dusty basements to pull out materials from her family's recorded archives. As she caressed and manipulated these objects and explored her

own memories of the stories they contained and of the person who told them, she narrated her own stories. Transcending the personal, Marcil's narrative reaches out to connect with universal issues; as Egoyan himself notes, "She delivered this 10-minute monologue which encapsulates everything I feel about memory, emotion and technology. It's something I could have written if I were that good of a writer. She spills out this story about her relationship to her mother and how it was reflected through this machine.... We felt very privileged to include that in the piece" (Egoyan 2002c).

We could have located our own archives, manipulated machines, and touched tape to wander through the territories of our personal and shared memories, but at this moment in the exhibition, we remain outside, our own stories disconnected from the vast circuit of tape looping through the room, simply because we did not respond to the call. With this realization that we might have had similarly profound experiences, weaving our personal stories into collective public realms, the *"ne touchez pas s.v.p."* sign is transformed from tease into a challenge to seize whenever possible the opportunities to become producers and not merely consumers. We can do this, as the title of the installation implies, simply by using the representational technologies that might otherwise remain out of use.

One of the most consistent elements in Egoyan's work has been this kind of subtle but persuasive exhortation to the viewer to unpack the baggage that they carry around with them about the nature and purpose of representations. Again and again, his work tells us to become explorers, actively mapping the terrain of the image on the boundaries between media, to claim its territory rather than be exiled from the realm of representation altogether. By moving into the space of representation and listening to its voices and its silences, his work suggests that it is possible to re-establish contact and exchange even in a world of screens and simulations. In his films, television programs, installations, and theatrical and operatic stagings, it is when his represented subjects and viewers take up the means of production—an act forcing them to view the frame and the picture—that their conditions of uncertainty and trauma are transmuted into mobility and flexibility. Although Egoyan's work emerges from and speaks to tragedy—personal and collective histories marred by tragedy and circumscribed by the logic of technologies of representation—the wonder of his work has to do with the way his work seeks to induce new modes of being and new kinds of community.

Notes

1 The experimental digital feature *Citadel* (2004), which Egoyan made with Arsinée Khanjian, might appear as an exception; where in most of his work Egoyan has prided himself on working with the properties of analogue media, in this film, shot with a consumer rather than a professional camera and edited on a home computer, he plays with the conventions of the home movie to inquire whether the digital image, thus domesticated, retains any power and sway.

2 In *Ararat* (2002), as well as *Citadel* (2004)—although the former film has been accused of being propagandistic—Egoyan explicitly constructs his narrative to reveal the seductiveness of propaganda.

3 In what appears to be one of his earliest reviews, the lukewarm notes from an adjudicator of his play *Manx* (1975) signal the play's self-reflexivity, lack of naturalism, and attention to the incongruous—all elements one finds in Egoyan's later work as well: "Heavy absurdist influences, chiefly Ionesco, I'd guess. Awkwardly written, but has a certain capricious imagination in the invention of the stage business. Now if there were a good *reason* for it all, other than the sheer incongruous, this might be a more worthwhile play" (Toronto Film Reference Library File 1999-001-05.9)

Works Cited

Andrew, Dudley. 2000. "The Unauthorized Auteur Today." In *Film and Theory: An Anthology*, ed. Robert Stam and Toby Miller, 20–30. Malden, UK: Blackwell.

Burnett, Ron. 1993. "Speaking of Parts." In *Speaking Parts*, by Atom Egoyan, 9–24. Toronto: Coach House.

Cardiff, Janet. 2002. "Janet Cardiff by Atom Egoyan." Interview by Atom Egoyan. *Bomb Magazine*, Spring, 60–67. http://www.bombmagazine.com/cardiff/cardiff2 .html.

Coombes, Annie E. 2003. "Atom Egoyan's *Steenbeckett*: An Installation." *American Anthropologist* 105, no. 1: 161–63.

Delgado, Jérôme. 2002. "*Hors d'usage*, la nouvelle oeuvre d'Atom Egoyan, suscite de l'émotion. Des souvenirs en bobines." *Cyberpresse.ca*, August 31. http://www .cyberpresse.ca/reseau/arts/0208/art_102080131983.html.

Egoyan, Atom. 1993a. "Surface Tensions." In *Speaking Parts*, by Atom Egoyan, 25–40. Toronto: Coach House.

———. 1993b. "Video Letters." Interview by Paul Virilio. In *Atom Egoyan*, by Carole Desbarats, Jacinto Lageira, Daniele Rivière, and Paul Virilio, trans. Brian Holmes, 105–17. Paris: Dis Voir.

———. 1995. "Look but Don't Touch." Interview by Liza Bear. *Filmmaker: The Magazine of Independent Film*, Spring. http://www.filmmakermagazine.com/ spring1995/dont_touch.php.

———. 1999. "Egoyan's Journey." Interview by Michael Dwyer. *Irish Times*, October 11. http://www.asbarez.com/archives/1999/991011md.htm.

———. 2001a. "Relocating the Viewer: An Interview with Atom Egoyan/Reloger le spectateur: une interview avec Atom Egoyan." Interview by Jacinto Lageira and Stephen White. *Parachute: Contemporary Arts Magazine*, July–September, 51–71.

———. 2001b. *"Turbulent."* Review of *Turbulent*, by Shirin Neshat. *Filmmaker: The Magazine of Independent Film*, Fall: 18–20. http://filmmakermagazine.com/fall2001/reports/turbulent.html.

———. 2002a. "Atom Egoyan: Out of Use." Interview by Louise Ismert. In *Atom Egoyan: hors d'usage*, by Ismert, 34–42. Montreal: Musée d'Art Contemporain de Montréal.

———. 2002b. "Family Romances: An Interview with Atom Egoyan." Interview by Richard Porton. In "Atom Egoyan 1960– " *Contemporary Literary Criticism* 151: 121–77. First published in *Cineaste*, Spring 1997, 8–16.

———. 2002c. "Fusing Art and Memory: Canada's Most Prominent Filmmaker, Atom Egoyan, on His New Art Installation." Interview by Matthew Hayes. *Montreal Mirror*, August 29. http://www.montrealmirror.com/ARCHIVES/2002/082902/cover.html.

———. 2004a. "Atom Egoyan: Face the Strange." Interview by Wyndham Wise. *Take One*, September–November, 63–94.

———. 2004b. "In Other Words: Poetic License and the Incarnation of History." *University of Toronto Quarterly* 73, no. 3: 886–905.

Formulas for Seduction: The Cinema of Atom Egoyan. 1999. Dir. Eileen Anipare and Jason Wood (IV). Documentary. 52 min. UK.

Harcourt, Peter. 1995. "Imaginary Images: An Examination of Atom Egoyan's Films." *Film Quarterly* 48, no. 3: 2–14.

Harvey, Elizabeth D. 2002. "Introduction: The 'Sense of All Senses.'" In *Sensible Flesh: On Touch in Early Modern Culture*, ed. Elizabeth D. Harvey, 1–21. Philadelphia: University of Pennsylvania Press.

Hutcheon, Linda, and Michael Hutcheon. 2000. *Bodily Charm: Living Opera*. Lincoln: University of Nebraska Press.

McLuhan, Marshall. [1965] 1995. *Understanding Media: The Extensions of Man*. Cambridge, MA: MIT Press.

Marks, Laura U. 2000. *The Skin of the Film: Intercultural Cinema, Embodiment, and the Senses*. Durham, NC: Duke University Press.

Rivière, Daniele. 1993. "The Place of the Spectator." In *Atom Egoyan*, ed. Carole Desbarats, Jacinto Lageira, Daniele Rivière, and Paul Virilio, trans. Brian Holmes, 83–103. Paris: Dis Voir.

Romney, Jonathan. 1995. "Exploitations." *Sight and Sound*, May, 7–8.

———. 1999. "Return of the Mighty Atom: Atom Egoyan Talks to Jonathan Romney about His Latest Film, Which Rediscovers Bob Hoskins and Makes Birmingham Almost Poetic." *The Guardian*, September 24. http://film.guardian.co.uk/Feature_Story/interview/0,5365,85039,00.html.

Smart, Mary Ann. 2002. Review of *Bodily Charm: Living Opera*, by Linda Hutcheon and Michael Hutcheon. *University of Toronto Quarterly* 71, no. 1: 297–98. http://www.utpjournals.com/product/utq/711/hutcheon135.html.

Sobchack, Vivian. 1992. *The Address of the Eye: A Phenomenology of Film Experience*. Princeton, NJ: Princeton University Press.

Vartanian, Hrag. 2004. "The Armenian Stars of the Canadian Cultural Universe: Atom Egoyan and Arsinée Khanjian: Canada's Premier Couple of the Arts." *AGBU News*, November 27. http://www.agbu.org/agbunews/display.asp?A_ID=39.

Wollheim, Richard. 1992. "The Work of Art as Object." In *Art in Theory 1900–1990*, ed. Charles Harrison and Paul Wood, 787–93. Oxford: Blackwell.

▶▶| section 1

Media Technologies, Aura, and Redemption

 1

Artifice and Artifact
Technology and the Performance of Identity

Jennifer Burwell and Monique Tschofen

Atom Egoyan has said that the "containers we use to store experience" express as much meaning as the experiences themselves (Egoyan 2002). Indeed, in his highly self-reflexive work, audio and visual media technologies—tape recorders and complex musical structures, along with screens, cameras, mirrors, and other devices—drive both the plot and the characters within it, serving as arenas through which the characters can perform and act out their identities. In all his films and in his work in television, opera, and installation, we can see Egoyan establishing, directing, and recalling to us our relations to the act of viewing, even as he provides a commentary on his own use of these media technologies. What emerges from his particular attentiveness both to the formal qualities of media and to the manner in which this materiality acts on and is acted upon by subjective perceptions is a sustained exploration of a unique interplay of human desires, pathologies, compensations, and even redemptions in and through representational media. Egoyan's ability to capture and engage the overdetermined ways in which technology "means" has made his work an important part of contemporary debates about the ways technological possibilities are intertwined with historically specific "structures of feeling" (Williams 1974). If his work ignited the attention of scholars like Paul Virilio and others interested in the relationship between media, forms of knowing, and modes of being, this might

be because, as Jonathan Romney puts it, Egoyan is a leading contender for being the "most alluringly postmodern" filmmaker (2003, back cover).

The authors in this section draw from a wide range of sources to reconsider Egoyan's approach to technology, showing how his use of technological artifacts reflects and refracts his interest in existential and phenomenological questions as well as his understanding of the epistemological dimensions inherent in a myriad of different media environments. While they delve into Egoyan's treatment of the alienating, detached qualities of the image, these essays uncover in Egoyan's work an alternative relationship to media technologies that his characters and audiences are able to forge, a relationship that enables rather than disables, drawing on technology's evocative rather than its deadening potentials.

In "Fetish and Aura: Modes of Technological Engagement in *Family Viewing*," Elena del Río argues that in Egoyan's work, technological artifacts serve as extensions of embodied subjectivity. This reference to technologies as extensions of the body recalls McLuhan. But in her nuanced analysis of what she calls the "complex interaction between human desire and the production and circulation of electronic images," del Río avoids falling into technological determinism by arguing for a highly interactive relationship in which technological artifacts function not as objects one manipulates at will, but rather as open-ended "scenarios" through which subjectivity both acts and is acted upon. According to del Río, by supplementing a fixed, instrumental practice of technology with the notion of a mobile, ungrounded technological "environment" that is always open to reinvention according to characters' psychic conditions, Egoyan shows how the results of the interaction between psyche and medium are never predetermined, just as the modes of engagement between user and technology are always diverse in their aims and effects. Egoyan's characters' relationship to technology, says del Río, thus does not emerge solely from the internal characteristics of the technology itself. Rather, it reflects an epistemological choice on the part of the characters.

While the problematic of fetishistic behaviour is central to her analysis, del Río skilfully enlists Walter Benjamin's notion of aura (1982) in order to advance beyond a simple psychoanalytic analysis of the relations between characters, complexes, and images. Focusing on a more fundamental problematic of "loss" as the driving structure behind *Family Viewing* provides a structure for del Río to talk about images as more than "fetishistic tokens," and allows her to analyze them as potentially evocative of auratic moments in characters' histories. Through this framework, del Río explores how the arrangement of images and image narratives can facilitate rather than hinder the characters' and the viewers' management of existential realities such as mortality and the passage of time.

While del Río emphasizes subjective engagement with image technologies, she also points out how Egoyan uses the screen to eliminate the rules of spatial and temporal continuity for the viewer. Egoyan's deployment of the screen, says del Río, heightens viewers' consciousness of the film's artifice, inviting them to "restage" their own relation to the film and give up the comfortable illusion of a straightforward relation to reality. Del Río refers to Benjamin's observation that the auratic never claims for itself full apprehension of reality but insists instead on the impossibility of turning reality into the static and manageable picture. This impossibility suggests that an auratic relationship to technology requires the viewer or character to accept a certain psychic dis-ease; at the same time, however, the subject's discomfort provides the necessary cathartic force to enable a "restaging" of the existential conditions of temporality and death.

In "*The Adjuster*: Playing House," William Beard similarly focuses on the choices that Egoyan's characters make around how they deploy technologies to construct those "image-narratives" through which they manage—or, more often, mismanage—their emotional lives. Beard shows how characters shore up their "feeble sense of self" by excluding and containing feelings and by transferring a complex sets of attitudes into images that "fix" in a reassuring but distorting manner their perceptions and feelings about their world. In his analysis of *The Adjuster*, Beard concentrates on how the characters literally perform their identities, leading lives predicated on theatrical artifices and a kind of play-acting that casts them as characters in their own drama. These performances are characterized by fakery and inauthenticity; through them, the characters replace the material reality of their lives with a virtual reality maintained through the endless production of images. Beard's close analysis of the theatricality of this film aligns with del Río's discussion of the manner in which the characters instrumentalize technology in order to remove themselves from temporality and contingency. He argues that in this, his fourth feature film, Egoyan suggests that the price to be paid for extracting things from the time and mutability is their extraction also from reality, rootedness, and history.

On the other hand, Beard, like del Río, also argues that Egoyan offers an alternative to this instrumentalizing relation to the world. Beard draws a connection between the characters' inauthenticity and a kind of "cultural impoverishment" or historical rootlessness characteristic of contemporary Western culture. He argues that in *The Adjuster* the distinction between authentic and inauthentic falls along the lines of gender and ethnicity, and that Egoyan offers a feminine, non-Western relationship to the interaction of image and experience as an alternative to an alienating, masculine, "WASP" relation to images. According to Beard, the differing uses to which characters put images form a powerful strand that connects Hera, Seta, and the

ethnic old country with a somehow more authentic life, while simultaneously associating video-besotted North America with a more false and shallow one.

Instead of fetishizing the image, as Bubba and Mimi do, or instrumentalizing it, as Noah does, Seta burns the black and white photographs sent to her from her homeland by her brother. In this process of destruction, Seta actually refutes the kind of alienated relationship to images into which the masculine WASP characters continuously fall. Through her insistence on temporality and contingency, Seta refuses the illusion that images allow one to manage and control human experience; instead, she releases the auratic potential of the photographs that can only be realized, paradoxically, in the act of their destruction. In destroying these visual records, Seta asserts the primacy of lived experience over its representation, and bears testimony to the uniqueness and unreproducibility of personal history, which by its very nature cannot be "captured" and "fixed."

In "The Thirteenth Church: Musical Structures in Atom Egoyan's *Calendar*," Katrin Kegel offers an analysis of *Calendar*'s complex and prismatic narrative structures. Rather than simply understand these highly self-reflexive tactics as part of Egoyan's postmodern sensibility, Kegel's innovation is to uncover the film's oppositions and counterpoints using the formal qualities of musical composition as her interpretive framework. Kegel argues that, in *Calendar*, his most "musical" work, Egoyan models his tightly structured, symmetrical, and cyclic organization of repeated rituals arranged in time on the musical forms of the exercise, the theme with variations, and the sonata. Uniting an understanding of the thematic complexes of Egoyan's work as a whole with an understanding of the history of ideas behind these intricate musical forms, Kegel uncovers concealed patterns in the film that recall dimensions of both baroque and classical music.

Like Beard, Kegel takes up the way that Egoyan's characters represent certain archetypes as they seek to mediate their relationships with each other and their worlds, but Kegel locates these archetypes on a continuum of Armenian consciousness—nationality, diaspora, and assimilation. Throughout the first half of the film, the photographer struggles with the same kinds of alienation that disable the characters in *The Adjuster*, using image technologies as prostheses designed to preserve his distance from his culture of origin. In the process, the photographer stays true to the kinds of stereotypes about WASP culture that Egoyan sets up in his early films.

However, arguing that *Calendar* represents the climax and turning point of certain patterns in Egoyan's work, Kegel tracks how the photographer goes through a process of simultaneously reconfiguring his psyche and repositioning himself culturally. The photographer's greatest insight in the film is reflected in the phrase "We're both from here, but being here has made me

from somewhere else." Kegel views the placement of this statement at the absolute centre of the narrative as a reflection not only of a new beginning within *Calendar*, but of a turning point within Egoyan's entire cinematic oeuvre.

To evolve beyond the literally alienated position within which he is suspended, the photographer must put down his camera and use his own senses to encounter the Armenian and Toronto landscapes directly—unmediated by the safe distance of technology—and embrace an improvisory relationship with his environment and the people who inhabit it. Paradoxically, he gets to the place where he able to do so precisely through his rituals of control. The photographer, here searching "for the right composition" is, of course, also the composer—the "single reflecting mind" rationally arranging the events and representations that structure the narrative elements into meaningful patterns that liberate emotions and conjure cosmic harmonies.

According to Kegel, the photographer's transformation illustrates the fact that certain ritualized and mediated patterns of behaviour, so prevalent in Egoyan's films, can function under the right conditions like a therapeutic cure, resulting in healing rather than stasis or death. In making this point, Kegel returns to the analogy of music, noting that Bach considered the repetitive character of his *Goldberg Variations* to have recuperative and even cathartic powers. Within the sublime harmonies of form and theme that Kegel unfolds for the reader, she shows that the truly transformative and redemptive powers of this film thus emerge indirectly and invisibly but most powerfully from the characters' and the director's engagement with the logic of visual and musical systems.

In "The Passing of Celluloid, the Endurance of the Image: Egoyan, *Steenbeckett*, and *Krapp's Last Tape*," David Pike explores how personal historical testimony is manifested through the dialectic between the subject and the medium within which the subject's memories are stored and preserved. Pike focuses his analysis on *Steenbeckett*, an installation that displays a "cat's-cradle" suspension of 35mm celluloid film on which is recorded the final twenty minutes of John Hurt's famed stage performance of *Krapp's Last Tape*, alongside a large-scale version of the same performance, projected in its entirety from a DVD player situated behind the wall of a long, narrow corridor. Pike's is a study of oppositions: on one hand, of the seamlessness of digital technology and Egoyan's formal appreciation of it, and, on the other hand, of the "tenuous materiality" of pre-digital technology. Pike views as the real agenda underlying Egoyan's use of media technology the exploration of identity and of those existential structures of being that organize a character's relation to his or her world. He reveals how in this installation, Egoyan opposes the virtuality of digital technology to the materiality of celluloid, with its time-bound uniqueness and connection to personal memory and loss.

The very obsolescence and the inevitable decomposition of celluloid lend it a sense of contingency and ephemerality, says Pike, at once invoking nostalgia and vulnerability. In fact, it seems that the very materiality and vulnerability of this obsolete technology anoint it with what Egoyan, in a phrase that contains echoes of Benjamin's aura, calls a kind of "tenderness." Digital technology, while it offers the potential for manipulation and transportability that Benjamin associated with mechanical reproducibility, suffers the same loss of authenticity and presence that Benjamin observed.

Pike's essay explores the dialectic of novelty and obsolescence in Egoyan's work, where each technological innovation inevitably passes from the former to the latter. In fact, the changes in Egoyan's artistic production testify to the ever-shifting status of technologies in our culture. As Pike points out, Egoyan's relation to digital and pre-digital technologies reflects both a tension within his individual films and an evolution in his filmmaking. Pike proposes that this tension is expressed within Egoyan the filmmaker as a conflict between practical and emotional approaches to technology. Egoyan has said that, in practical terms, he recognizes the strategic value of digital technology and what it enables him to do as a filmmaker— particularly as a filmmaker who, in his practice, is highly self-reflexive. Pike also points out, however, that as Egoyan's relationship to technology in the present has become ever more practical, his attitude toward its history seems to have become ever more emotional. The real melancholy at the heart of Egoyan's installation, Pike offers, "may be the slow realization that filmmaking itself, in whatever mode of production, is no longer guaranteed the cultural centrality it enjoyed throughout the past century." Celluloid in this sense not only represents a singular increasingly obsolete technology; it is also the screen that confronts Egoyan—and us—with the inevitable passage of time.

The authors in this section show that technology in Egoyan's work is both virtual and material, aloof and immediate, reifying and liberating—always in relation to how his characters enact their desires and make their lives meaningful. In the process, they suggest that however much he explores the alienating properties of technology and its mediations, Egoyan always offers the viewer a vision of another kind of relation that is both auratic and redemptive.

Works Cited

Benjamin, Walter. 1982. "The Work of Art in the Age of Mechanical Reproduction." In *Modern Art and Modernism: A Critical Anthology*, ed. Francis Franscina and Charles Harrison, 217–21. New York: Harper and Row.

Egoyan, Atom. 2002. "Memories Are Made of Hiss: Remember the Good Old Pre-digital Days." *The Guardian*, February 7.

Romney, Jonathan. 2003. *Atom Egoyan*. World Director Series. London: British Film
 Institute.
Williams, Raymond. 1974. *Television: Technology and Cultural Form*. London:
 Fontana.

 2

Fetish and Aura
Modes of Technological Engagement in *Family Viewing*

Elena del Río

> Blaming media and technology for our cowardice and for our fear of
> being unable to live artificially with grace is self-defeating.
> — Wolfgang Schirmacher

> The brain is the screen. — Gilles Deleuze

In three of his films, Atom Egoyan deals explicitly and extensively with the
impact of audiovisual technologies on daily living. *Next of Kin* (1984), *Family Viewing* (1987), and *Speaking Parts* (1989) all thematize the complex inter-
action between human desire and the production and circulation of electronic
images. Much to his credit, Egoyan manages to avoid technomaniac and
technophobic positions alike, and confronts the viewer with the challenge
of thinking the technological without reference to predetermined notions
of stable ground or essence. Unlike the humanist discourse of Western cap-
italist culture, which objectifies technology alternately as the scapegoat for
human failures and as the guarantor of human achievement, Egoyan's films
represent the technological artifact as a continuation or extension of embod-
ied subjectivity. Technology is thus conceived not as an object that one
manipulates at will, but as a scenario where subjectivity both acts and is
acted upon in a reversible and inconclusive way.

Sustaining a dialogic encounter between the media of cinema, television, video, the telephone, and the surveillance camera, *Family Viewing* invites a reconsideration of many of the assumptions that we have come to hold regarding the massive commodification of each of these media. Instead of emulating this commodification by staging a flashy show of technological gadgets, Egoyan's film underscores the potential of desire and memory to interfere not only with technology's obvious and transparent performance, but also with its regimenting and disciplinary action upon the user. Thus, *Family Viewing* supplements a fixed, instrumental practice of technology with the notion of a mobile, ungrounded technological environment capable of reinventing itself according to the psychic conditions informing each performance. To facilitate a theoretical understanding of the two major representational modes featured in the film, I will analyze them with reference to the concepts of the fetish and the aura. These will serve as the two paradigmatic forms of address and response defining each technological environment or practice in the film.

As a metaphor for a form of representation and technological practice, my use of the term *fetish* follows Sigmund Freud's idea that a fetish object attempts to substitute for that which has been lost or is absent. For Freud, the fetish is a "penis substitute," "a substitute for the woman's (mother's) phallus which the little boy once believed in and does not wish to forego" (1963, 215). Threatened by the female lack of a penis (castration), the male adult continues to engage in fetishistic practices by transferring to an object (a female body part or clothing item) the value represented by the penis. Although Freud's theory of fetishism is limited to the area of sexuality, my use of it in this essay follows a tendency in feminist film theory to expand the Freudian notion of sexual/biological castration to include the Lacanian notion of symbolic castration, which accounts for the subject's loss of being through the entry into language and the advent of desire. From this standpoint, the idea of castration is centred not so much on a physical organ as it is on a psychic history that involves a whole array of psychological/affective renunciations of mastery and self-sufficiency. In this sense, a fetishistic technological practice aims at denying the losses and limitations that threaten to diminish a person's sense of power over his or her reality. As fetish, the image behaves as if it encompasses the whole of reality, as if nothing exists outside its frame—indeed, as if it has no frame to limit and contain its field of action and vision.

Walter Benjamin's notion of the aura informs the second mode of representation I discuss in my analysis of *Family Viewing*. Benjamin attaches an auratic quality to forms of vision or works of art that allow us to dwell in the memory of things and events that cannot be fully recovered. For Benjamin, the aura entails the "unique appearance of a distance... a strange web of

time and space" (1980, 209). Although the aura is often related to past forms of representation that we tend to idealize from the standpoint of today's technological frenzy, its emergence is not contingent upon a specific form of representation or technology. Aura involves less the object or medium as such than a subjective mnemonic event that is only accidentally triggered by a particular object or medium. In its auratic guise, the image opens up a space of distance despite its physical proximity to us. In contrast with the fetish, the auratic experience never claims full apprehension of reality, but insists instead on the impossibility of turning reality into a static and manageable picture.

Family Viewing introduces a slight, yet significant, shift of focus from prevailing ways of conceptualizing the image in conventional narrative films. While these films tend to treat the image in a univocal, invariably fetishistic manner, *Family Viewing* considers the image first and foremost within a problematic of loss. This shift from the problem of fetishism to the more fundamental problem of loss is important because it displaces the privileging of fetishism in psychoanalytic film theory as the obvious and only strategy for dealing with loss. Instead, Egoyan's film raises a double possibility in the way viewers consume and receive photographic and electronic images: the image as fetishistic token covering up for the subject's anxieties and insufficiencies, and the image as potentially evocative of an auratic moment in the subject's history. Moreover, the film is unabashed in its articulation of these two modes: while it infuses fetishistic kinds of subjectivity or image-making machines with irony and derisive distanciation, it shows a particular bias toward those moments that affirm and build from the discovery of loss. *Family Viewing*, therefore, privileges the kind of image that, rather than filling out the psychic void experienced through the recognition of temporality or death, works to enable a restaging of those existential conditions. To put it in another way, the image facilitates rather than hinders the viewer's awareness of time and mortality.

Family Viewing posits the affinity between technological and bodily or psychic configurations as anterior to substitutive or fetishistic strategies. That is, the ability of a certain technology or machine to substitute for formerly unmediated actions—the fetishistic mode—seems to rest upon two interrelated facts: an implicit continuity between human and technological performances (substitution between two elements can take place only where these elements share at least some of their features) and the epistemological possibility of forgetting this inherent continuity or affinity. Fetishism thus appears to be a matter of epistemological choice, rather than a consequence of the ontological status of technology itself. However unconsciously generated, fetishism operates as a structure of subjective intentionality,[1] stemming from the desire to contain and forget the corporeality and mortal-

ity that both limit and enable human existence. Simply stated, technology is not inherently fetishistic, but, in order to ignore existential hurdles and anxieties, the user can deploy it as a fetish.

Picking up some of the themes and concerns already explored in Egoyan's first feature film, *Next of Kin*, *Family Viewing* recounts the dissolution of a family and the emergence of another, non-traditional familial configuration. Television and videotape figure as the central representational modes providing the members of this family with a sense of identity and history. Van (Aidan Tierney), an apparently conventional young man in his late teens, lives with his father, Stan (David Hemblen), and his stepmother, Sandra (Gabrielle Rose). As Stan videotapes his own and Sandra's sexual performances, he simultaneously erases the records of the family's past. These video recordings feature two women whom Stan has banned from the family's present: Van's maternal grandmother, Armen (Selma Keklikian), confined against her will to a nursing home, and Van's mother (Rose Sarkisyan), who presumably abandoned Stan a few years before the time of the film's events. Van becomes increasingly critical of his father's obsessive attempts to elide the family's past not only by de facto getting rid of mother and grandmother, but also by suppressing the video images that testify to their existence. In the meantime, Van meets Aline (Arsinée Khanjian), a phone-sex operator whose mother (Jeanne Sabourin) also lives at the nursing home where Armen has been abandoned. After Aline's mother takes her own life, Van decides to fool Stan into believing that it is Armen who has died. By means of this exchange of identities, Van manages to take Armen out of the nursing home and into Aline's apartment, where he joins them. After a series of failed attempts by Stan to interfere with his son's plans, Van and Aline reunite with Armen and Van's mother.

From a narrative standpoint, one of *Family Viewing*'s most radical strategies consists of the structuring role that old age and death play in a techno-environment whose relentless circuitry of production, marketing, and consumption is frantically engaged in the abolition of all things past, wasted, or old. The idolization of technological novelty implicit in the characters' use of the latest gadgets of communication and representation sharply contrasts with a regressive narrative movement impelling the storyline to revisit its past. Ironically, the new family emerging at the film's end can take shape only by recycling or recomposing elements from the past in the context of the present: as fragments of the past, Van's mother and grandmother realign themselves with Van and Aline, the derelict fragments of the present.

The narrative destabilization of past and present—repetition/recycling versus linear teleology—finds its formal counterpart in the film's consistent use of montage. Much like the film's narrative line, the juxtaposition of the cinematic screen with the video and televisual screens upsets the supposed

transparency and intelligibility of the technological image. While at times these screens retain their specificity, there are moments when the tendency toward montage makes it virtually impossible to distinguish one kind of screen from another. Different technologies then merge in hybrid configurations that disregard the idea of fixed boundaries circumscribing in advance the conditions and effects of each medium. Traversing the borders between film, television, and video, this kind of technological montage redefines the relation between technologically manufactured images and Benjamin's concept of the aura. For Benjamin, the production of the aura in art or representation is simultaneous with a spatio-temporal disarray that disconnects time and space from their physical/empirical determinants and reconfigures them according to affective/subjective needs and desires. Montage's affinity with the auratic experience lies in its elimination of the rules of spatial and temporal continuity that are prevalent in the majority of realistic narrative films. Thus, Egoyan's use of montage (both as a discontinuous form of editing and as a way of conceiving the intersections of different technologies) enables the production of auratic moments of complex spatio-temporal constellations. Relying on montage, *Family Viewing* shows that, notwithstanding the massive political and ideological appropriations of technological media in our culture, the modes of engagement between user and technology may be diverse in their aims and effects—hardly reducible to either the instrumental agenda of commodity fetishism or the so-called objective conditions of a specific technological ensemble.

Television and Video: Neutrality and Bias of the Technological

Television viewing may be regarded as a "family affair." Whereas cinema construes its spectator as an isolated individual, the viewing subject of television is primarily the family. Appropriately, the film's title—*Family Viewing*—signifies the routine activity of a family gathered around the TV set. The title connotes, moreover, that the TV set is the family's modus operandi, as it serves to define their identities as members of a group sharing a common "world picture." TV functions within the story as the seemingly innocuous mode of communal viewing—in fact, as the least challenging method of communication among family members, hence the atrophy of communication altogether. Smoothing out differences and tensions with its characteristic blend of obviousness and security, TV offers forgetfulness and amnesia for the most pressing issues and concerns. Thus, for example, at one point in the film, Stan diffuses his son Van's accusations of having placed Armen in a nursing home by simply inviting him along to watch TV. The pretext of TV viewing momentarily absolves Stan from having to address Van's incisive remarks.

The viewing practices of this family, however, are not restricted to the medium of television. While the television may function in the film as the permissible, non-confrontational framework of "communication," video operates as the catalyst for the hottest, most contentious issues within the family. Like a repository of repressed desires and socially unacceptable practices, the video image in this film seems to speak that which the televisual image, monitored by anonymous voices from afar, cannot accommodate.[2] In contrast to the univocal effects *Family Viewing* assigns to TV, video functions as a more malleable and ambivalent medium, perhaps in part because it incorporates a higher degree of private initiative and therefore stems from a wider range of psychic dispositions and intentions. *Family Viewing* gives ample evidence that, as Egoyan himself has remarked, video "is something flexible, transitory, as ephemeral as memory"; video, he adds, can function as "a metaphor for the workings of thought or consciousness."[3]

The interaction of TV and video in *Family Viewing* can be compared with respect to the viewing modes and effects of each medium in order to address not only the institutional biases and boundaries that delimit each medium, but also the potential neutrality or flexibility of these boundaries. In fact, the issues of neutrality and contextuality may be seen as two sides of the same coin. Although socio-economic and political interests always condition the historical appearance and actual uses of a material artifact, this artifact retains the potential for reinventing itself through successive and differently conditioned performances.[4] Precisely because of this mobility, this lack of definitive fixation, we need to examine the context that accompanies the use of a certain technology.

The distinction between apparatus and context I advocate here may be held only at a theoretical level, yet it seems a useful one to maintain, since it allows us to envision a more heterogeneous and contingent view of technology. It is in this light that Robert Kubey and Mihaly Csikszentmihalyi contest the idea that TV is inherently unsuitable to the exercise of thought or imagination: "[We should] debunk the much-repeated idea that television is a medium best suited to transmitting emotions, and that it either 'cannot' or is not 'good' at transmitting ideas. The answer to why we see what we see on television lies in a combination of how audiences have come to conceive of the medium, what audiences want to watch (or have grown accustomed to watching), and what the people who control and sponsor television believe needs to be created and broadcast in order to maximize profit" (1990, 189). Like these commentators, I insist on the non-definitive and non-essential status of any particular medium. While a technology, as deployed in particular cultural practices, political institutions, and so on, may never be neutral, the equipment per se does retain a degree of neutrality, if only because it lacks the ability to signify prior to its insertion into those very practices, institutions, or intentionalities.

The theoretical distinction between apparatus and context enables us to contemplate a variety of uses and results within a single technological medium. *Family Viewing* is illuminating in this respect insofar as its handling of TV does not succumb to the idea of an alleged inherent technological imperative; instead, the film maintains the gap between the audiovisual apparatus and the social and cultural determinants that construct its context of production and reception. In the section that follows, I examine the specific instances of televisual representation in the film. Although, in contrast to its more benevolent look at the flexibility of video, TV will appear comparatively essentialized here, *Family Viewing* does not posit the numbing character of TV viewing in a vacuum, but rather sees the colonizing effects of the TV image in conjunction with cultural and social trends that far exceed and even antedate the specificity of the televisual.

The Filmic Look at Television: Defamiliarizing the Familiar

In *Family Viewing*, the televisual image unfolds primarily in two different settings: the family's living room and the bedroom at the nursing home. The film treats each of these televisual environments in a different fashion. In the living room, the camera places itself behind the television set and films only the bodies and gestures of the viewers seated on the proverbial couch in front of the monitor. Although we do not actually see the TV image, the sounds coming from the set together with the characters' body language and vocalized responses tell us all we need to know about the kinds of formulaic movies Stan, Sandra, and Van are watching. Egoyan uses the cliché-like *mise en scène* of the family gathered around the TV monitor as a metonymic displacement for the overfamiliar relation of the film's spectator to the stereotypical patterns of TV movies. Since we are all so well versed on this kind of storytelling, the film's explorative and argumentative emphases avoid the redundancy of showing us the televisual image, focusing instead on the impact of this image as it becomes immediately imprinted on the viewer's face. Reading the viewer thus becomes synonymous with reading the TV image, since no distance separates one from the other.

In contrast to the economical rendition of TV viewing unfolding in the space of the living room, the *mise en scène* at the nursing home weaves a densely metaphorical discourse on the enframing capacities of the televisual.[5] Relative to the self-contained space of the living room, the *mise en scène* on this occasion relies rather heavily on a montage of technological interfaces and existential themes. This is not, however, a traditional montage: it does not rely so much on the shock effect produced by a succession of highly disparate images or sounds, but rather on the clash between elements coexisting within one single frame or series of frames.[6] This montage-like tech-

nique juxtaposes the cinematic and the televisual, the human and the animal, the reality of death and the illusion that one can contain and marginalize death by means of technological regimentation. It is through the adoption of montage at thematic and formal levels that the family and its mythical televisual identity are seen to disintegrate in *Family Viewing*. Montage becomes a powerful tool of estrangement and distanciation, dislodging the institutions of the family and of television from the safety of their customary boundaries.

The discursive aspects of these scenes engage directly with the age-old relation between technology and the drive to avert difference and death in the name of human sovereignty and life. Such anthropocentric bias in the modern uses of technological images is explored through the recurrent presentation of TV nature shows, which work as a kind of contrapuntal commentary on the actions and emotions of human characters. The appropriateness of this particular *mise en scène* seems to lie in the close ties that the environment of the nursing home maintains with the natural world. In a sense, these affinities are grounded in biology: both the nursing home and the natural world are the repositories of the elemental forces of decrepitude and death. In a more crucial way, however, the affinities respond to cultural or ideological imperatives; like the natural ecosystems, the communal spaces for the elderly are increasingly pushed away from the centres of exchange and activity, "forced into little ghettos in the middle of nowhere for protection."[7]

In the first of these scenes, the televisual frame pays its dues to the ideological assumption that the animal world and the world of humans are fundamentally continuous. Aline is paying a visit to her mother at the nursing home. The nature show displayed on the TV monitor revolves around the life of some primate species. Taking on a pseudo-scientific tone, the disembodied and authoritative voice-over (John Pellatt) explains, "Man occupies a unique position in the primate world; he alone can analyze his past and contemplate his future. This gives man a tremendous advantage, yet we still have much to learn from our primate cousins. Studies of monkeys and apes in the past few decades have helped us come to a clearer understanding of ourselves." This highly prized understanding is later related specifically to the activity of mothering: "Lab experiments on monkeys, for example, have given us a number of conclusions about motherhood." At this moment, the film camera closes in on Aline's mother, lying on the bed and most likely oblivious to the enthusiasm infusing the humanist rhetoric of the TV show. As an old woman denied the warmth and the comfort of a home, the figure of Aline's mother provides a reality check on the humanist glorification of motherhood as the sacrosanct institution of the civilized world. Here, in ironic contrast with the pervasive idealization of motherhood, the mother, as an actual person, is devalued or ignored. In a later

scene, Stan, who has been watching the same nature show, takes evolutionary theory to its logical consequence as he subsumes the animal species into the overarching category of the human. "There was a time," he says, "when we [humans] needed [our nails] for scratching the ground or attacking our enemies. Makes you wonder if there isn't some use we're missing out on."

These two moments in the film address the televisual complicity with the rationalizing claims of a techno-scientific discourse on nature. The nature shows, as presented in *Family Viewing*, merely echo the objectifying tactics of this discourse. Implicit in these tactics is the assumption of a common biological and even affective bond between humans and animals—a bond that the focus on the primate species only serves to render more irrefutable. In our perceptual and cognitive stance toward the animal world, these scenes imply, we humans become the measure and value that we use in appraising everything that is. As instantiated by the characteristic approach in countless scientific studies of animal behaviour, while we adamantly assert our superior talents and capacities over the animal species, we at the same time require the latter to mirror and even act as a kind of causal determination for our own behaviour.

The televisual act of enframing the world fits rather smoothly with the objectifying economy of Western representation. Televisual representation is characterized by the construction of a sense of immediacy and instantaneity tying the viewer with the images and sounds emitted. These qualities give the illusion that the televisual frame is capable of capturing with fidelity and transparency the remotest times and places. Inherently positing the world as an apprehensible and self-evident object, television constructs a subjectivity that depends on its objects for the confirmation of its uniqueness and mastery. Television in fact designs our "world picture"[8]—one that we unquestioningly establish as necessary and "natural." The televisual picture enforces a utilitarian and commodifying view of nature that tends to subjugate and exploit that which is indeed natural in all its irreducible difference from the human. This means that, at least in the West, television behaves as if it could reduce every form of life or culture, no matter its complexity or difference, to a set of fully intelligible and uniform cultural and ideological patterns.

Egoyan uses a type of drum beat that commonly calls up images of the "jungle" not to connote "primitive" cultures but rather to further undercut the anthropocentric claims of the televisual representation. Supported by the wildlife context of the nature shows seen on the television screen, the overwhelming effect of the sound mocks the human claim to dominion over the natural world by underscoring its inherent intractability. This non-diegetic use of sound is particularly effective in the scene in which Stan comes to the nursing home to pay a visit to Armen, his mother-in-law. The drums play at

a frenetic pitch and rhythm as Stan proceeds to hand some flowers to the wrong woman in the wrong room; this faux pas indicates a total lack of affective involvement with Armen. When Stan approaches the real Armen, the old woman thrusts her clawlike fingers deep into his face. Stan's screams rapidly cut to televisual images of a nature show in which birds are seen to attack members of their own species. At one point, the voice-over of this documentary casually remarks, "Although this attack occurs at daylight…, the light is ten to a hundred times dimmer than that needed by the human eye." Again, the mode of perception constructed by the televisual frame cannot spare the comparison between the animal and the human. Yet, through a calculated synchronization of the televisual and the cinematic, the animal and the human, Egoyan's montage serves to ironize the human-animal hierarchy, equating, if not reversing, the terms involved. The film in fact suggests that human relations may be predatory, and that we therefore cannot deploy the alleged continuity between animals and humans to further the ethical or moral superiority of humans; instead, the film implies that this continuity should reflect a levelling off of the difference that humans conveniently tend to construe as privilege.

The last and most dramatic example of this series addresses the uprooted status of subjectivity brought about by televisual fascination; it signifies, in other words, a dwelling inside the televisual image that is concurrent with the viewer's despatialization or disconnection from his or her immediate environment. At the nursing home, Aline's mother takes her own life, gulping a vast quantity of pills she has been methodically hoarding for the purpose. Van, whom Aline has asked to spend some time with her mother as she attends to some business out of town, is physically present in the same room, yet, allured by a nature show on polar bears, he is not aware of the incident. The televisual voice-over of the nature show now decrees, "While the animal appears to be dead, it is only actually fast asleep," and it continues, "Scientists can pinpoint the animal's exact location several times a day… if necessary."

The multi-layered irony is again too caustic to be missed: in a culture that places high stakes on the acquisition of scientific knowledge, monitoring animal life and death is an obsessive pursuit, not only for the community of scientists but also for the TV viewers who are made privy to the latest and most exclusive findings of the science world. Yet the homage paid to accuracy and control in the science world—and by extension adopted by televisual representation—is documented here as a failure of perception regarding decisive events unfolding in our very midst. The implication is that the televisual/scientific mode of seeing, as effective and productive as it might claim to be ("Scientists can pinpoint the animal's exact location several times a day"), is in fact utterly useless and even obstructive when it

comes to enabling a perception of what remains nearest to us—in this case, death. The juxtaposition between animal nature and human nature reaches its greatest degree of irony when Aline's mother's suicide—clearly unleashed by the social stigma on old age and death—is later diagnosed by the medical community as a "natural death."

Van's immersion into the televisual interface at this point renders him immune to the suicide taking place in the room. As Avital Ronell has noted, the fascination exerted by the televisual goes hand in hand with a willed blindness that holds televisual representation and its viewer in one undifferentiated unit. According to Ronell, television has taught us that "what fascinates us also robs us of our power to give sense; drawing back from the world at the moment of contact, it draws us along, fascinated, blinded, exploded" (1994, 291). Television's power of fascination thus begs the question of the viewer's despatialization—his or her transportation into an environment that, contiguous with that of the physical body, is nevertheless discontinuous from it at both epistemological and affective levels. Whatever the empirical location of our bodies might be, the TV set manufactures a dwelling space for us. In order to effect its reduction of wonder and difference down to uniform and manageable criteria, this space requires our commitment to numbness and complacent uninvolvement.

Within the televisual frame, one rarely finds a dividing line separating the thing from its representation: the assumption is that it is all there, and that all that is there is all that *is*. Whereas television collapses world and representation in one indivisible unit, the montage of film and television in *Family Viewing* opens up a distance between what is represented in and by television and the ideologies intervening in the fashioning of those representations. The film thus seems to enact television's montage potential, which commentator Paul Adams sees as one of two coexistent modalities of representation: as a particular form of enframing (*Gestell*), television orders and appropriates, closes off and reduces, yet, as a field of inscription, television necessarily articulates its representations across temporal and discursive lines and thus opens vision into new configurations and concerns. Even though this latter feature of television remains for the most part a potentiality that is tenuously reflected in actual practice, Adams does not give up the idea that it might be explored and brought to light: "Television is always both and between the 'real' as (re)presented in a monitoring and the fashioning of (re)presentations. Perhaps here we could … re-animate a dream (a dream not too distant from that of Benjamin and some of his contemporaries): the dream of montage. We could speculate that television would produce articulatory movements which estrange things in their uncovering and reveal things in their strangeness, which is to say, (re)present and distance things in a nearing" (1993, 61–62).

Egoyan's practice of montage no doubt offers forth the possibility of diminishing the degree of narcissistic fascination exerted by the televisual apparatus on the viewer. In the interface between its ideological reading of television and its representation of televisual images, *Family Viewing* uncovers television in its internal alterity. I use *alterity* to mean that television can be something other than a representation of the immediately obvious, as is usually the case—that instead of claiming to mirror the real as self-evident truth, it can expose its radically ambiguous and multiple nature. Alterity surfaces here in terms of the double and contrapuntal inscription that characterizes these TV scenes: on one hand, the "compulsive discourse of effacement... to which TV is seriously committed" (Ronell 1994, 285); on the other, the cinematic interruption of this discourse, which Ronell in the same text refers to as an "ethical scream." Weaving the scientific discourse, with its tendency to appropriate nature, with a discourse on death and aggression that reminds us of the impossibility of taming nature, *Family Viewing* extricates television from its rigid mode of enframing and effacing the world.

Filming the Videotape: The Coexistence of Fetish and Aura

As I suggested in my introductory comments, *Family Viewing* seems to privilege those images that resist the fetishistic characteristics of certainty, totality, and closure. And yet the film could not live up to its inclusive and non-moralizing standpoint if it did not account for the way fetishistic attitudes in visual practices can be potential strategies for containing or appeasing a sense of loss. In this sense, the film shows that video, no less than television, is available for appropriation by the enframing and objectifying interests of a particular user. In what follows, I will read one of the most representative instances of video fetishism in this film: Stan and Sandra's use of video images as a means to enhance their dreary sexual relations.

As part of their technically elaborate sexual practices, Stan and Sandra combine the image track supplied by the video images of their own bodies with the soundtrack provided by Aline's distant voice as a phone-sex operator. This technological split between video and telephone—bodily image and aural image—is crucial in advancing Stan's orchestration of video images along fetishistic lines. The scene opens with a shot from each end of the phone line: Stan and Sandra sitting on the bed (the video monitor merely recording their silent immobility), and Aline sitting on her couch. Both Sandra and Aline are shown doing their hair as if preparing for the "mating" rituals that will follow. The phone rings. Attempting to perform her job without much conviction or enthusiasm, Aline responds to Stan's formulaic cues, uttered in the hope of producing the magic of sexual arousal:

Stan: What does a girl like you do when she's lonely?
Aline: She dreams of being with a man like you.
Stan: You like my type, don't you?
Aline: Oh, yes…
Stan: What do you dream of doing to a man like me?
Aline: I'd run my tongue over your chest…

In the meantime, Stan has been surveying Sandra's reaction, and eventually asks her to embody the fantasies that Aline speaks through the phone. Prompted by Aline's suggestions, Sandra begins to play with her right breast, as uninvolved and stiff as if she were touching an inanimate object. Suddenly, Aline hangs up. The next shot shows Aline sobbing in her apartment, and immediately the film cuts to some video images of her mother's funeral.

Crucial to the particular fetishistic economy of video in this scene is the fact that Stan acts as the sole arbiter of all parties involved. Although, as a couple, Stan and Sandra may figure jointly as the consumers of the sexual commodity fabricated by the ensemble of phone and video, it is Stan who masterminds the conditions of this technological scenario and who calculates its effects with uncanny precision. By orchestrating the split between image and sound along technological lines, Stan effects a split upon the female subject as well. In depriving Sandra of a synchronized action between body and voice, Stan suppresses her possibility of agency—her capacity to desire without coercion. Aiming at securing control over his female sexual partner, he substitutes a fetishistic fantasy for the embodied Sandra sitting in front of him. Thus, what film theorists usually construe as a progressive strategy in some experimental forms of filmmaking—the asynchronization of visual and aural registers—results here in a regressive tactic based upon the unequal distribution of power between man and woman.

In an important sense, however, one may say that Stan's manipulative efforts are directed at neither Sandra nor Aline as individual women. Rather, these efforts are symptomatic of a fear of castration and death that sees in female subjectivity as a whole the signs of a latent but sure threat. Stan splits this symbolic archetype of the feminine between a disembodied voice (Aline's voice over the phone) and a voiceless body (Sandra's body acting out the specifications of the fantasmatic body as delineated by Aline). Thus, while Stan's fantasy depends upon an aggressive fragmentation of the female subject, its gesture of disavowal requires the equally aggressive fantasmatic reassembling of the fragments—a reassembling that will signal the successful control over the threat. What the scene emphasizes is this reordering or recreating of the terms—the aspect of the fetish that provides closure and reassurance.

It is important, moreover, to determine the specific role that the technological devices play in this fetishistic staging of sexuality. Here, I think, one would have to distinguish between objectification and fetishism as inter-

related yet not always equivalent structures. Both the sound delivered through the phone and the image delivered by the video play upon the relations of distance and proximity between oneself and one's own body as well as between the latter and the body of the other. The technological artifacts generally reproduce—yet perhaps magnify—the oscillation between presence and absence that is always already at the basis of human desire. The tendency to objectify—in the sense of positing at a distance—oneself or the other is part of the usual functioning of subjectivity, and is therefore not what constitutes fetishistic behaviour as such. It is when objectification is attended by a fierce denial of distance and absence that it may be said to turn into fetishism, hence the easy slippage between the two structures. In this regard, I would not attribute the failure of sexuality to become embodied in this scene to the externalization and projection that necessarily obtain from technological interactions. Rather, the failure lies in Stan's particular coercive intervention—a psychic disposition that can hardly be assigned to an inert piece of equipment.

Despite the distinctive character of the fetishistic underpinnings of this and other scenes in the film, what is truly insightful and provocative about Egoyan's treatment of video is the fact that it hardly allows one to find the definitive dividing line separating fetishistic from auratic modalities of viewing. The characters' various interactions with video have radically different effects; yet, at the same time, fetishistic and auratic uses often take place side by side and occur almost simultaneously. The film's narrative organizes the uses of video along generational lines: whereas Stan and Sandra, father and stepmother, use video primarily to establish the power dynamics in their relationship, Van and Armen, son and grandmother, rely on the recording and reproducing capacities of video as a means to re-establish contact with their lost mother and daughter respectively. These two modes of interfacing with the video screen, however, coexist within the same domestic space; what is more, they are inscribed on the same videotape, where the recording of Stan and Sandra's sado-masochistic games progressively, but never completely, erases the images of the family's past.

Through Van's eyes, the spectator is introduced to the existence of this hybrid videotape. In a kind of technological version of the primal scene, Van walks into his father and stepmother's bedroom and plays a videotape featuring their performance as robotic, wholly uninspired, sexual partners. Following an extreme close-up of Stan looking straight into the camera, both Van as diegetic spectator within the film and we as the film's spectators are suddenly transported to a set of images that resonate on a completely different frequency. In images that present all the signs of a potentially auratic event, past and lost moments of childhood unfold before Van's eyes. It is a sunny day. A young Van is playing football with his father, then sitting on

his mother's lap as he claps and sings along with his mother and Armen. The aura of these images resides not merely in their reference to the past, but primarily in the way they affect the viewer's memory with the recognition of a distance that the images themselves refuse to bridge or deny. If the aura consists of an unresolved oscillation between proximity and distance, this series of family records certainly partakes of the auratic impulse: in their privileging of a kind of lighting that is paradoxically intense and hazy and in their playing down of the analytic aspects of language, the childhood images do not attempt to anchor the meaning of family relations in some institutional or socialized manner. Both the lighting and the virtual silence that envelops the scene speak to a psychic sense of reality, as they enhance the feeling of temporal distance and at the same time underscore the poignant proximity through which Van sees these past moments.

Sandra's sudden irruption into the room brings Van back to the present. Van informs Sandra about his father's "erasing mania," that is, his obsession with erasing memories by substituting the images of their staged and stereotypical sexual performance. The childhood images then fade again, to be replaced by Sandra and Stan's lovemaking. As in the television scenes at the nursing home, the film relies once again on its idiosyncratic practice of technological montage to comment on and ironize the fetishistic enclosure manufactured by Stan's use of video. The scene creates effects of montage by playing upon the distance between the cinematic look and the video look, alternately opening up or closing this distance. By merging its camera vision with the video's own camera vision at one point, the film seems to interfere with and contaminate these apparently transparent and goal-oriented video images. This fusion of one kind of visual technology into the other works paradoxically to articulate the psychic split that Stan and Sandra attempt to shun with their self-recordings. The filmic camera visualizes this split by showing Stan and Sandra as capable of two radically different looks: the gaze as lack and the gaze as narcissistic plenitude. As the film's camera closes in on the video's close-up of Sandra, her solitary and questioning or obscure look into the camera is undoubtedly a sign of lack. By contrast, the reciprocal exchange of looks between Sandra and Stan as framed by the video and kept at a distance by the film builds again upon their sense of self-deception. One kind of look thus impinges upon the other, and the split is articulated by the sense of incongruity arising between the two.

The exposure of video fetishism in this scene, I argue, is a matter of looking at video through a differential play of distances—the distances that separate video from film and the subject from him- or herself. If fetishism collapses the distance between image and reality—the fetish and the emptiness that it is designed to fill—its exposure must aim at redrawing that distance. In the literal movement traced by the filmic camera to cross the space

that separates it from the video image is also inscribed, in a metaphorical way, the ontological distance that opens each subject to the uncertainties and provisionalities of its own existence. Hence the significance of the double look that the film manufactures for Stan and Sandra in the above sequence, for the splitting of the look is bound to invoke precisely that distance.

Video as Memorializing Event

In *Family Viewing*, the video image functions at times as a memorializing event, not only with respect to the subject's past, but also in the context of death. Aline's mother's death serves as the narrative component whereby the film interrogates the videotape's ability to provide the subject with an experiential link with death. The question the film explicitly poses is whether a video recording may substitute for Aline in her absence from her mother's funeral; what is at stake, then, is the potential of the video image to become a kind of original site of experience capable of fuelling the chain of memories that might otherwise be fuelled by live events. As in the scenes unfolding at the nursing home, Aline is physically absent at the moment when her mother commits suicide. Van, however, has recorded the burial ceremony on a videotape, which he then shows to Aline at the video store. While Aline watches the tape, with a mixture of rejection and incredulous absorption, Van attempts to convince her of the invaluable service performed by these video images:

> *Van*: It was a good funeral, Aline. Believe me, you wouldn't have done it any differently.
> *Aline*: I would have been there.
> *Van*: But you weren't. You were out of town. And now you're watching it.
> *Aline*: On television.
> *Van*: Sure. You're just not in the right mood. But when you are you can play it… any time you want.

Van's casual proposition infuriates Aline. As though her most intimate feelings had been desecrated, she hurls the tape back at Van with anger and contempt.

In taking these two opposing views—technology as unmitigated possibility versus technology as ominous intruder and violator of human values—Van and Aline unwittingly align themselves with the two humanist discourses conventionally mobilized to gauge and judge the effects of the technological. Thus, Van's position exhibits a naïve and uncritical belief in the full correspondence between technologically lived events and those other events where the physical body may be directly involved—be, that is, temporally and spatially co-present with the event. Aline, for her part, represents the humanist perspective predicated upon the suspicion that, if given

free rein, technological advances would make human action and emotion obsolete and wholly dispensable.

Van's positing of technology as an unproblematic substitute for the realm of immediate perception entails at the outset a simplistic reduction of technology to its instrumental aspects. Yet, as I argued earlier, built into the principle of substitution itself is an intrinsic affinity or continuity between the two settings—between the immediate and the technologically mediated. Thus, despite the crudeness of Van's remarks to Aline, his vision of video technology intuitively announces what is at stake in the technical reconfiguration of subjectivity: the structural affinities between the banks of memory available through video and those stored in the equally virtual space of the psyche. While the film may not share the naïve commitment to technological progress implicit in Van's position, its narrative and discursive movements seem to be more in tune with his fearless incorporation of technology than with Aline's technophobic stance.

Family Viewing's investment in technological representation seeks to foreground technology's capacity to deconstruct the authority of metaphysical presence—to achieve the dissolution of boundaries between the real and the image. If Aline's initial reaction is to defend herself against the intrusion of video into her private life, she eventually cannot help but submit to the virtual continuity between the video image and the memory image. After spending a few minutes trying to perform her role as a phone-sex operator for Stan, Aline hangs up and gives in to her emotions. Bluish and grainy video images of her mother's funeral then appear on the screen. This point-of-view shot corresponds not to Aline's live memories, but to the memories of a video lens. Despite her initial protestations, Aline appears to have had no trouble in making these memories her own.

The meager images of the recorded funeral—involving an inept Van and an unknown priest, who join in a meaningless ritual—are clearly incapable of supplanting Aline's desired reunion with the absent mother. These images, moreover, signal metonymically back to Aline's absence from her mother's deathbed and, even more painfully, back to Aline's absence from her mother's life—the fact that ultimately seems to trigger the old woman's suicide. This implicit chain of metonymic displacements into the past indicates the impossibility of recovering origins and presence, inscribing instead an ongoing process of erasure within which the technological image seems to figure merely as an accidental, albeit definitive, confirmation of absence. As the scene suggests, however, the erasure of origins and presence hardly entails the erasure of subjectivity. Aline does eventually visit her mother's grave with full bodily presence, yet it is important to remember that, as scant and uneventful as these video records might be, they prove crucial in supplying Aline with an indelible relation to the "original" event itself.

Some commentators tend to regard the reproductive and repetitive properties of video solely in the context of a growing commodification of vision. Anne Friedberg, for example, sees the videocassette as a commodity-experience whose modes of production and consumption blatantly eliminate all traces of the aura:

> The market of commodified video-movies available to the home viewer has meant that the "aura" of the original moment of cinema exhibition also disappears. The VCR... becomes a privatized museum of past moments, of different genres, different times all reduced to uniform, interchangeable, equally accessible units.... As a "commodity-experience," the video-cassette proffers an exponent of the spatial loss (the loss of aura that, as Benjamin describes, is incurred by mechanical reproduction) and offers a loss of aura of the second order, a temporal loss (which the opportunities for repetition-replay produce). (1993, 139–40)

Friedberg's allusion to the repetitive nature of video does not pertain only to the context of film distribution. Her comments on the loss of aura clearly address the viewing experience as well, as evident in her reference to the VCR as a "privatized museum of past moments" and in her allusions to the spatial and temporal losses incurred through the use of video. As a marketable commodity, the videotape is no doubt designed to provide the viewer with his or her daily or weekly dose of leisure and forgetfulness—the institutionalized counterparts of labour as well as of depression, sickness, or even death. But while it is true that, within the capitalist circuitry of production and consumption, the video properties of repetition and accessibility function largely to reduce the discursive effects of difference, distance, and absence, *Family Viewing* makes clear that repetition and accessibility may also promote a reactivation or revalorization of the subversive dimensions of the image.

In this sense, Aline's remembrance of her mother through video images comes to demonstrate that repetition, far from being inimical to aura in some intrinsic way, may under certain conditions further an auratic mode of vision. Even though, as Van tells Aline, the video-memories of the funeral are available for replay at any time, Aline is not allowed to subject this replay to a conscious or controlled programming. Aline's video-recollections reverse the paradigm of closeness and distance that characterizes the situation of the TV viewer sitting in the comfortable enclosure of his or her living room. Aline is not the safe viewer who watches a fictional show from a convenient position of distance and uninvolvement. Instead, she is literally invaded by the video-memories at the point when she is most vulnerable and confused— the moment when her degradation as an unwilling sexual fantasy-maker calls for some other kind of self-confirmation or support. The appearance of the video-memories is therefore far from random: the loss Aline incurs by

performing a role for which she feels ill equipped triggers her mourning for her mother. Through her recently gained knowledge of loss, Aline can now face and mourn this loss.[9] As present and past converge in this moment, it is not merely nostalgia that overwhelms Aline, but the acute sense of a self-recognition that forestalls mastery.

For Egoyan, as for other filmmakers, such as Jean-Luc Godard, repetition does not function monolithically as a mechanical and numbing recuperation of sameness. Rather, repetition may inscribe a sense of poetic difference that discloses in its accumulative wake the least apparent yet most determining drives of the subject. *Family Viewing*'s enactment of repetition puts into practice one of Godard's most famous phrases: "*Répète un peu pour voir*" (repeat a little to see). It is this power of disclosure in repetition that Egoyan's film attributes to video images; through repetition, Aline comes to terms with the guilt felt at her absence from her mother's death. First rejected as a mechanical and intrusive reminder of this guilt, the video-memories later become inextricable from Aline's own subjectivity. Thus, the film seems to suggest that we should evaluate the spatio-temporal disjunctions brought about by the video machine not as a set of objective or static determinants, but rather in relation to the ways in which these disjunctions impinge on the viewer's corporeal, temporal, and affective experience. From this it follows that no technological apparatus is inherently suited or unsuited to stage a fetishistic or auratic program. Rather, it is in the intersection between the apparatus and the discursive and affective modalities through which users engage with it that we may be able to sketch a certain course of viewing effects.

Part of the appeal and success of Egoyan's cinematic aesthetics lies in its singular ability to have identified the double facet of the image as a vehicle for both the fetishistic and the auratic dimensions of seeing. Egoyan, however, avoids the pitfall of looking at fetish and aura in simplistic binary and moralistic terms. Instead, his films open the photographic and electronic images alike to a field of perceptual and psychic indeterminacy where fetish and aura are situated in the closest possible proximity. The unstable movement of the characters between the fetishistic and the auratic positions prevents the film from falling back onto a rigid assignation of stereotypical moral roles. This oscillation or passage is also crucial because it undercuts the attempt at reifying either fetish or aura as static or mythical ideals. (Even the aura escapes this mythical status, the film suggests, for it cannot be located in a far-off mythical space of absolute redemption; rather, the auratic experience arises in the intransferable space of difference carved out within the psyche itself.)

Egoyan's demystifying tactics overturn our expectations concerning the status of all visual technologies: if *Family Viewing* is bent on defamiliarizing

the televisual environment with powerful ironizing strategies, the film just as effectively deconstructs the demonic connotations of the surveillance camera. This proverbial instrument of coercion is most successfully demystified or dephallicized in the film's closing scene, which features Van and Aline's reunion with Van's mother and grandmother at a centre for the homeless. As Van and Aline enter the room where the mother and grandmother quietly, perhaps unwittingly, await their arrival, shots of a surveillance camera operating in the room are juxtaposed with former video images of Van as a young boy. The use of discontinuous editing allows Egoyan to dodge two major humanist stereotypes that the scene might have potentially invoked: the cliché of the surveillance camera as an alienating institutional force having taken over the lives of these individuals and, conversely, the sentimental depiction of the family reunion as a form of melodramatic closure.

Several elements work jointly in this scene to mitigate, and even to cancel out, the conventional status of the surveillance camera as a controlling agent of vision.[10] As it slowly pans the room, presumably scanning for its occupants in an objectifying fashion, the point of view of the camera is conveyed to us not by means of shots of the room and its occupants, but rather through video shots of young Van appearing to look directly into the camera's eye. The idyllic overtones of the music reinforce the impression that the surveillance camera has taken full account of the auratic charge of the moment, becoming a benevolent witness that presides over the encounter of grandmother, mother, and son.[11]

Notwithstanding the strong potential for closure implicit in this kind of narrative resolution, the moment radically departs from a traditional family encounter and seems instead to flow directly out of the longing inaugurated by the video images of the family's past. Here, Egoyan resists the conventional melodramatic desire of a family long separated to end their separation by resorting to physical contact and speech. Consistent with the upholding of distance in the midst of proximity that characterizes the film's overall representation of aura, distance and silence are no longer feared at this moment, hence, no embraces, greetings, or questions need be exchanged to avert their potential threat. Not even the physical presence of mother and grandmother proves strong enough to delete or supersede former memories and desires constructed by the video images. Rather, these are the filter through which Van looks at his family anew.[12] The eye of the surveillance camera and the eye of the cinematic camera join now in the memorializing function of the video camera, as they too suggest that only through distance can these people hope to see each other.

Notes

1 In accounting for fetishism as a form of subjective intentionality or even episte-
mological choice, I am not adhering to the orthodox psychoanalytic distinction
between consciousness and the unconscious. Instead, I follow the phenomeno-
logical model, which argues for the continuity (rather than the opposition or
split) between conscious and unconscious. All Being involves intentionality, but
the latter need not be fully conscious or fully unconscious. From a phenomeno-
logical perspective, intentionality is by no means synonymous with the Cartesian
notion of consciousness as self-presence based on epistemological certainty.
Instead, it may be described as an implicit mood or comportment, rather than a
cognitively grounded decision.

2 In an article on television and the media events surrounding the Rodney King beat-
ing, Avital Ronell discusses the relationship between television and video in ways
that resemble Egoyan's representation of these two technologies in *Family View-
ing*. Ronell argues that "where nomadic or testimonial video practices a strategy
of silence, concealment, and unrehearsed semantics, installed as it is in televi-
sion as bug or parasite, watching (out for) television, it at times produces the eth-
ical scream that television has interrupted" (1994, 285). Transposing Ronell's
notion of an "ethical scream" into a psychoanalytic discourse, one may say per-
haps that certain uses of video seem better equipped to speak the "truth" of the
subject. In *Family Viewing*, for example, this "truth" of desire and mortality does
surface primarily through the use of video.

3 Excerpt from an interview with Atom Egoyan published by the Canadian journal
Ciné-Bulles and cited by François Ramasse in "Atom Egoyan: la video mode d'em-
ploi" (my translation).

4 There is little doubt that the apparatus already presupposes certain things about
its prospective user. As Langdon Winner notes, however, this inherent determi-
nation of effects can be countered or at least rearranged in some way if the user
remains an active participant. "As a person encounters a device or system," Win-
ner argues, "it is crucial that he or she ask what the form of this thing presupposes
about the people who will use it. Having asked that question, one can move on
to make explicit what artifact/idea or ideas the object embodies ... to give voice to
the presuppositions in human-made things.... Having begun such a dialogue
with and about material things, we can go on to ask what technical devices and
systems should presuppose about human beings. What forms and features should
be present in the technologies our society adopts?" (1994, 196–97).

In his *Virtual Geography*, McKenzie Wark makes a similar distinction between
the presuppositions embedded in the apparatus and the possibility of deviance
from those presuppositions during the actual user-apparatus interaction; again the
factors of use and context are given primacy over static theorizations of technol-
ogy: "It is in the everyday that a life can be made which uses these tools with other
ends in view than the institutionally delimited ones.... A TV or a library is an appa-
ratus through which flows along particular vectors can be channeled, fashioned,
edited, styled, and passed along. Nothing ever guarantees this process in advance"
(1994, 160).

5 Consistently in this discussion, I use the term *enframing* instead of *framing*.
Whereas *framing* simply means the physical or objective act of circumscribing an
object or representation within certain limits, *enframing* implies a blindness to
the reductive operations involved in any act of representation. It denies the fact

that representation achieves only a partial disclosure of reality, not a total one. I draw the term *enframing* from Heidegger's elaborations on the essence of modern technology in *The Question Concerning Technology*. Here, Heidegger considers *enframing* as the utilitarian act of ordering and exploiting natural resources through technological means. For Heidegger, *enframing* blocks the poetic and creative potential that lies in technology's capacity to reveal the world to us: "Where enframing holds sway, regulating and securing of the standing-reserve mark all revealing" (1977b, 309).

6 As a cinematic term, *montage* originated in the Soviet cinema of Sergei Eisenstein. For Eisenstein, the meaning of the film image lies in the collision between successive images of opposing graphic, emotional, and intellectual qualities. *Montage* has gradually come to mean discontinuous or disjunctive editing, to be distinguished from the system of continuity editing of classical Hollywood cinema.

7 Egoyan's representation of old age as an endangered species connects in truly remarkable ways with the concerns of environmentalists such as Birute Galdikas (1995). By interlacing its discourse on old age with a rationalized, hence violent, discourse on nature, *Family Viewing* places itself on the very side of environmental activists, carrying out a similar critique of the instrumentalization of nature.

8 I am borrowing the notion of the "world picture" from Martin Heidegger's seminal essay "The Age of the World Picture" (1977a).

9 Significantly, both Van and Aline are seen to derive a strong auratic experience from certain video images that evoke the absence of the mother: Van's mother, who supposedly deserted her sadistic husband, Stan, a few years earlier, and whose whereabouts are unknown until the film's closing shots, and Aline's mother, who has passed away at the nursing home. This centrality of the figure of the mother in the context of the auratic image derives strong support from Roland Barthes's reading of a picture of his own mother as a young child in his *Camera Lucida*. There, too, the subject finds in the photographic image of the mother a "radiant, irreducible core"—a core that, having been "lost forever," renders the subject acutely aware of its own mortality. Having found the long-sought photograph of his mother as a little girl, Barthes writes of its uniqueness and incommunicability to others: "I cannot reproduce the Winter Garden Photograph. It exists only for me. For you, it would be nothing but an indifferent picture, one of the thousand manifestations of the ordinary.... In it, for you, no wound.... What I have lost is not a Figure (the Mother), but a being; and not a being, but a quality (a soul): not the indispensable, but the irreplaceable" (1981, 73–75).

10 The use of the surveillance camera in this final scene exemplifies Egoyan's desire to turn the camera into a character. As Carole Desbarats suggests, this autonomy of the camera implies its "intervention in the story, and a treatment of viewpoint that is far more specific to fictional than to experimental cinema" (1993, 14). In an interview with Virilio published in the same volume, Egoyan explains that he very often "choose[s] the camera... as being the spirit or the embodiment of [the] missing person," and he continues: "The lens with which you are regarding these people might hold the secrets of the very thing that they feel is lacking in their own lives.... Maybe the lens becomes a redefinition of the classical Greek chorus. Maybe... it is the thing which comments on the actions of the principal actors, but contextualizes them and invites our own sense of what it is we expect from these people, from these mere mortals. It is the closest we come to finding the voice of the Gods... the notion of the chorus. It becomes our oracle" (1993, 114–15).

11 In *Family Viewing*, Egoyan uses two major extra-diegetic musical scores, which suggest two radically different subjective modes: the mode of appropriation, aggressivity, and anxiety, represented by what one may call the "jungle" or drum music, and the auratic mode of longing, loss, and release, represented by a kind of music that seems to be a blend of electronic and melodic strains.

12 In *Next of Kin*, Bedros/Peter delivers a speech at his birthday party that is most relevant to the emphasis on distance in the final scene of *Family Viewing*. There, too, distance is valued as the only position enabling an authentic perspective on those who are closest to us. Surrounded by his "new family," Bedros can see his old family for the first time: "I've learned something very important in the last few days, and that's that in a way it's a pity that you're born into a family. If you're raised with a group, you're obliged to love them and that really denies you the possibility of getting to know them as people outside of that group. In a way that means that you could never really love your family, and that's because you're denied the freedom that's required to make that sort of commitment.... I guess what you call the freedom of choice."

Works Cited

Adams, Paul. 1993. "In TV: On 'Nearness,' on Heidegger and on Television." In *RUA/TV? Heidegger and the Televisual*, ed. Tony Fry, 45–66. Sydney, Australia: Power Publications.

Barthes, Roland. 1981. *Camera Lucida: Reflections on Photography*. Translated by Richard Howard. New York: Noonday Press.

Benjamin, Walter. 1980. "A Short History of Photography." In *Classic Essays on Photography*, ed. Alan Trachtenberg, 199–216. New Haven, CT: Leete's Island Books.

Desbarats, Carole. 1993. "Conquering What They Tell Us Is 'Natural.'" In *Atom Egoyan*, ed. Daniele Rivière, 9–29. Paris: Dis Voir.

Egoyan, Atom. 1993. "Video Letters: An Interview between Atom Egoyan and Paul Virilio." In *Atom Egoyan*, ed. Daniele Rivière, 105–15. Paris: Dis Voir.

Freud, Sigmund. 1963. "Fetishism." Translated by Joan Rivière. In *Sexuality and the Psychology of Love*, ed. Philip Rieff, 214–19. New York: Macmillan.

Friedberg, Anne. 1993. *Window Shopping: Cinema and the Postmodern*. Berkeley: University of California Press.

Galdikas, Birute. 1995. "All in the Family." Interview by Chrissie Hynde. *Interview*, March, 100–102.

Heidegger, Martin. 1977a. "The Age of the World Picture." In *The Question Concerning Technology and Other Essays*, trans. William Lovitt, 115–54. New York: Harper and Row.

———. 1977b. "The Question Concerning Technology." In *Basic Writings: from Being and Time (1927) to the Task of Thinking (1964)*, ed. David Farrell Krell, 283–317. New York: Harper and Row.

Kubey, Robert, and Mihaly Csikszentmihalyi. 1990. *Television and the Quality of Life: How Viewing Shapes Everyday Experience*. Hillsdale, NJ: Lawrence Erlbaum.

Ramasse, François. 1989. "La vidéo mode d'emploi." *Positif*, no. 343.

Ronell, Avital. 1994. "Video/Television/Rodney King: Twelve Steps beyond the Pleasure Principle." In *Culture on the Brink: Ideologies of Technology*, ed. Gretchen Bender and Timothy Druckrey, 277–303. Seattle, WA: Bay Press.

Wark, McKenzie. 1994. *Virtual Geography: Living with Global Media Events*. Bloomington: Indiana University Press.

Winner, Langdon. 1994. "Three Paradoxes of the Information Age." In *Culture on the Brink: Ideologies of Technology*, ed. Gretchen Bender and Timothy Druckrey, 191–97. Seattle, WA: Bay Press.

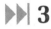 3

The Adjuster
Playing House

William Beard

The Adjuster (1992) takes a solid and important place in the succession of Atom Egoyan's films between *Next of Kin* (1984) and *Exotica* (1994)—a series in which all the members have a strong family resemblance, in which the themes, character types, narrative construction, and filmic style are intensely similar and interrelated throughout and the resulting amalgam is as consistently strong in the flavour of an individual creative personality as the work of any other filmmaker in the world. During this period (and I emphasize the limitations of a time frame only because the director is so young and in his most recent projects has given indication that he is going off in new directions), there is absolutely what may be described as an "Atom Egoyan film." And though the Atom Egoyan film has its influences and proximities and affinities, essentially it is like nothing else in cinema. *The Adjuster* is defined by a modular or schematic plot and characters, elaborate thematic explicitness, and severe neurosis in the people and events of the story combined with extreme detachment in their presentation. It is a film about family and social dysfunction; about displacement and substitution as (bad) life strategies; about the structures of alienation, social dislocation, and (mostly male) social power and their use or rejection by males and females; about the irrational and messy results of mixing altruistic and appetite-driven feelings. It is a film about the instrumentalizing gaze of the camera and, reflexively, the power

of image-narratives to capture, interpret, and very often distort the human world. This is a list that might apply, more or less, to any Egoyan feature film of the 1984–94 decade (with the possible exception of his television movie *Gross Misconduct*, about the life and death of hockey player Brian Spencer). But *The Adjuster* also has, as every one of these films does, its own angle and focus, its own stylistic signature, and altogether its own aura. It is a film with a complex and wide-ranging set of narrative and thematic elements, and my procedure here will be to address these systematically, one at a time, with linkages and overlaps mentioned as they arise and with a final section devoted to some considerations of purely visual style.

The Two Noahs

Noah Render (Elias Koteas) is the insurance adjuster of the title, and his job is to contact people whose homes have been destroyed, set them up in temporary accommodations, and undertake the process of estimating the value of what was lost, piloting the claim through to settlement. He takes his responsibilities with great—indeed, consuming—seriousness. He directs all his clients to the same motel (which he provides with enough business to keep open year-round), visits them constantly, and gives them aid and advice and heartfelt sympathy. He can't show his face at the motel without getting several cheery greetings from passersby; many of his clients are overflowing with tearful gratitude, while the spectacle of his unstinting devotion and humility has earned the deep admiration of the motel staff and management. Noah is an extraordinary person, clearly. And he hardly seems less extraordinary when it is revealed, somewhat later, that he is conducting affairs with two of his women clients, including a married one, Lorraine (Patricia Collins); he shuttles between making love with Lorraine and comforting her husband, Tim (Gerard Parkes), who ends up actually kissing his hand. He utters the same formulas of consolation and sympathy to each new client ("You may not feel it, but you're in a state of shock"; "Your whole life has been uprooted"), in a fashion that is clearly rote but never insincere, and he doggedly pursues the mammoth and intricate task of cataloguing every lost item and converting it to a cash value. This is, in fact, the "adjustment" of his job title, but it comes more and more to resemble a metaphysical activity—the activity of translating not really the material but rather the emotional loss suffered by victims into something solidly quantifiable, first as a list of physical items and then as their monetary approximate value. Noah's appetite for this particular endeavour, his need to feel the vulnerability and gratitude of his clients, and the way his benevolence is tainted by sexual desire are increasingly understood as being his own neurotic symptoms.

But as complex as this situation is, it is only one side of Noah's circumstance. He has what we assume is a wife, Hera (Arsinée Khanjian), and she has a sister, Seta (Rose Sarkisyan), who is also living with them. Hera and Seta seem to be of Middle Eastern origin: Khanjian speaks with her usual slight accent and Sarkisyan speaks no English at all. (In the context of Egoyan's history and other work, one imagines they are Armenian, but the film itself gives no specific information.) There is also a child of kindergarten or early school age, Simon (Armen Kokorian), but it is not entirely clear who he is: he seems not to speak English and may be Seta's son, or possibly Hera's (although in a family as close as the sisters show themselves to be, he may be a nephew or some other relative instead). There are pictures of him evidently taken in the old country, where Hera and Seta also have a brother, though no mention is made of a husband of Seta. Noah tumbles Simon about playfully and tousles his hair in a parental fashion, though again this doesn't say anything about their exact relationship.

The family grouping Hera/Seta/Simon is extremely strong. These three are constantly framed together: Hera and Seta hug and hold and comfort each other; they seem to communicate telepathically, and when they do talk to each other, it is in their native tongue (not understood by Noah). In general they give off emanations of self-sufficiency and impenetrability.[1] The fact that the film doesn't tell us who Simon actually is nor why Seta is living with Noah and Hera in North America means that, although there are doubtless straightforward answers to these questions, viewers tend to feel excluded from this threesome in just the way that Noah does. In any case, what we are presented with is a dichotomy, a schizophrenia, in Noah's life. On the one hand is the strange substitute family and relationships represented by his clients, uprooted and living in a motel, getting their lost homes and personal effects translated into cash, and being lavished with the protective care of a kind of substitute father, Noah, who works for a remote institution and who constantly recasts his fatherly ministrations into formulas of compassion and then into money (when he isn't sleeping with his clients, that is). On the other hand is this close family of women and children with its inward, blood-tied, ethnic, and somehow authentic bonds. This is an odd and striking juxtaposition.

A House Is Not a Home

At least as strange are the house Noah and his family live in and the environment surrounding it. This is a truly spectacular, cinematically rich and suggestive location, and every time it appears, right to the end of the film, its appearance causes new astonishment. This setting simply cannot be normalized by the viewer. Noah's house is one of only three actually standing units in an unfinished, bankrupt suburban housing development, set in a vast

Noah with bow in front of the billboard in front of his house. Note the arrows, shot by Noah, sticking out of the billboard. (© Ego Film Arts)

expanse of open land without trees or grass or any kind of vegetation, with the city distant on the horizon. Noah's is the middle one, and there is no indication that the houses on either side of it have been completed. The trio of houses perch in the middle of this desolation as if sitting bizarrely on a Somme battlefield, accompanied only by an equally bizarre range of large full-colour billboards depicting all the different available models of house, each with its own grandiose name ("The Baron," "The Marquis," "The Nottingham") and a giant idealized painting of a happy white family in capitalist-realist wholesome-advertising style. All the homes, both the three solid ones and the many billboard-image ones, are in a familiar upmarket suburban mode—large, brick, two-storied, with gabled roofs, multi-car garages, porches, and decks. Compared with many of the arriviste pocket Taj Mahals that spring up at the edges of any prosperous North American city, they are tasteful and elegant, but the kind of aristocracy they promise is without any kind of history or authenticity. As a set of contextless labels and floating signifiers suggesting wealth, ease, culture, and taste in the complete absence of substructure, continuity, causality, or rootedness of any kind, houses and districts of this kind are a symbol of the cultural impoverishment of their society and of the virtuality of the social positions they offer their purchasers. Such houses always seem unreal at some level, but the housing development in *The Adjuster* carries this quality to extremes. Standing on and surrounded by nothingness, most of the houses existing only as flat, painted representations, complete only in their substanceless grand mythology of commercial self-presentation, the Sherwood Forest Estates (as they are called, standing on a spot that no doubt once *was* forest but is now human-made desolation) are compellingly absurd and poignant. Noah ironically—if not necessarily consciously—acknowledges their fake appropriation of history and legend as he stands repeatedly in the upstairs bedroom of his house ("The Nottingham") with bow and arrow like Robin Hood, loosing shafts

through the open window at the billboard house and family opposite. It is a surreal spectacle, perfectly fitted to the surreal spectacle of its environment. His own "completed" house, it turns out, isn't even a real one: when, later, one of its bookshelves of well-worn old volumes comes right off and is revealed to be facade only, we discover that it is a show home, its already fake status now moved one level farther into virtuality.

Hera, Matron Deity

Hera has a job as well—one that, in keeping with the film's general mode, is also an unusual and symbolic one. She is a film censor sitting on a screening committee of five or six people, under the direction of a middle-aged man named Bert (David Hemblen). We see her over and over again in the front row of a darkened screening room where pornographic films are being projected, the images never visible but the soundtrack always giving a vivid impression of the extreme, explicit, and usually sado-masochistic events taking place on the screen. The connection of serious, reserved, family-oriented Hera, still carrying ties to her socially conservative homeland, with some of the ugliest detritus of "sexually liberated" Western culture creates a disturbing and even scandalous juxtaposition.[2] The point is not so much the offence such material causes her (though we do see her flinching during one particularly excessive male-sadistic film) as our sense of how this material *must* offend a woman of her background, circumstances, and appearance. Surely she will be a severe judge, we feel, even when there is no evidence that this is particularly the case, because she stereotypically seems to represent a conservative and proper set of values and is so closely tied to home and family (as also implied rather overtly by her name, that of the Greek goddess of marriage, childbirth, and married women). When we see her furtively videotaping the porn films she is watching, we don't necessarily jump to the same conclusion that Bert and her young fellow censor Tyler (Don McKellar)do—that she is copying this stuff for private enjoyment.

Hera and Noah's marriage seems to be in many ways a tissue of noncommunication and strange contradictions. He is always leaving the house in the middle of the night to tend to some new client disaster, or else pacing sleeplessly around his bedroom while his wife tosses and turns and mutters (they sleep in twin beds, like the married couples of Hays Code—that is, censor-bound—Hollywood movies). Whenever he wakes her to relieve her of what he thinks must be a nightmare, she seems anything but grateful; and this little situation seems to replicate the general condition wherein he can never tell what's going on in her head and can't seem to break into her world, while she thinks of him as somebody who isn't as concerned with her and her family as he ought to be. She criticizes him for taking no interest in her job, and he responds with a sarcasm that underlines

his self-absorption. The following dialogue is typical of the way they keep
going past each other:

> *Noah*: You were having a nightmare.
> *Hera*: How do you know?
> *Noah*: You were moving around.
> *Hera*: I don't scare you when you move around.
> *Noah*: I move around?
> *Hera*: [*she nods*] Yes.
> *Noah*: [*urgently*] When?
> *Hera*: All the time.
> *Noah*: When I'm asleep?
> *Hera*: [*looks at him, pauses*] Then too. [*he breathes out, it sounds affection-
> ate; she reaches out to touch his shoulder*] What's the matter?
> *Noah*: Not sure.
> *Hera*: Work?
> *Noah*: I suppose. It becomes so…
> *Hera*: What?
> *Noah*: Weird.
> *Hera*: In what way?
> *Noah*: Sorting things out. Deciding what has value and what doesn't. You
> know.
> *Hera*: I know what you mean. It's the same thing I do.
> *Noah*: [*doubting this*] You're a censor.
> *Hera*: So?
> *Noah*: You've got nothing to do with my job.
> *Hera*: [*she holds up flashlight, points it at him, turns it on*] Do I make you
> feel stupid?
> *Noah*: [*long pause*] What do you mean?
> *Hera*: [*speaking carefully but with emphasis*] When I say something which
> deserves consideration and you respond without thinking, how do you
> feel?
> *Noah*: I feel fine.
> *Hera*: I thought you might feel stupid. [*long silence*]

The sharing Hera apparently can't achieve with Noah, though, is taken
to extraordinary extremes with her sister. In one of the strongest example of
the many ways in which the film misleads the viewer, the explanation for
Hera's covert videotaping of pornography turns out to be the desire that she
and her sister have to share her workday activities. As she explains to the
astonished and disgusted Bert and Tyler, "She likes to know what I do. She
always has. She's my sister. When I was at school she always wanted to
know what I learned. I'd tell her. That way we'd learn it together. She didn't
go to school, she's older than me. She had to stay home. That's how things
are, where I'm from….You see, it's very strange, what we do here. Very dif-

ficult to explain. Since I started taping she can actually see what we cut, what we don't allow other people to watch. So when I take these tapes home, and she watches the decisions *I* am making, she's—she's very *proud*."

The terrain here is complicated, because if at first it seems that there is a fairly simple moral dichotomy between Hera and Seta's mutual sympathy (good) and the alienation and instrumentalization that's going on in the Western society around them (bad), Hera's extraordinary sharing activities apparently have their downside as Seta's attitude toward the porn videos moves from frightened distaste to compulsive addiction. Eventually a long-haired man in a dishevelled white suit who has been seen furtively haunting the housing development, identified in the credits as "the wild man of the billboards," parks himself outside the large glass patio door and masturbates while Seta watches porn videos inside the house.[3]

A similar complication may be seen in the respective attitudes of Noah and Hera/Seta to their house. Noah seems not to like it, and to prefer the very ordinary motel where he places and visits all his clients; he expresses his dissatisfaction by regretting that the development was never finished and by shooting arrows at its symbolic representations. The two women, meanwhile, seem quite content in its cool, tasteful, palatial comforts, apparently unconcerned with its fakery and isolation (perhaps because those just seem like simple extensions of the condition of new-world society in general). The battle of authenticity, which these women can easily win when compared with the shallow human products of a shallow North American culture, strangely turns itself around here as the women align themselves with a strikingly artificial emanation of that culture.

Perhaps I should take a moment to spell out what I mean here and throughout this essay by *authenticity* in the film's North American milieu. I do not mean that things are innately or naturally authentic or inauthentic—merely that they are perceived or experienced as such by majoritarian white culture in Canada and the United States. For the members of this culture, everything that is truly theirs in their society is new-made, without history or tradition. In breaking away from European culture and (theoretically) leaving behind the old-world class system and oppressive restrictions, American culture gains freedom and self-reinvention but loses rootedness and the time-weathered substantiality that goes with it. When American culture wants to reassure itself that there are roots and substance, or when it wants in its material wealth to take on the grandeur (and roots and substance) of European aristocracy, it apes European forms—for example, architectural ones. These forms are, however, only available virtually, as copies: they cannot *be* European. Awareness, however subliminal, of their status as copies always carries an undertone of pathos, since the values that are sought through association must also be virtual. In the realm of architecture

as it is seen in *The Adjuster*, then, the status of the Sherwood Forest Estates is doubly inauthentic and doubly pathetic—first, as fake-European aristocratic substance; second, as incomplete and in some cases only painted-on-billboard dwellings. Bubba and Mimi's mansion is one level more "authentic," since it is more massive and less obviously a copy. Meanwhile, the motel achieves real authenticity; that is, it is authentically un-European in intention and inspiration, unselfconsciously tacky, new, spiritually substanceless and history-less, authentically inauthentic. The same system rules the realm of ethnicity. Mainstream middle-class WASP North Americans, whatever their actual ethnic makeup and history, feel themselves to be without ethnic identity, without historical rootedness and tradition, "new" men and women. In English Canada, without even the "New City of God" mythology of our American cousins, this syndrome underlies an identity crisis whereby authentic identity is what other people have—people from Europe, or people from Asia or Africa. This is the context in which I can say that Hera and Seta will easily win a battle of "authenticity" with white North Americans, and it is in this context that Egoyan can place Bubba and Mimi as white North Americans who dramatize and act out their own inauthenticity with deliberately exaggerated vividness.

In another of the schematic pairings of opposites that is so characteristic of Egoyan's cinema at this point, Noah's motel is in every way an antithetical environment to his home. Stuck in the middle of busy city streets, its asphalt-covered parking lot usually well stocked with cars, it is a hive of population utterly contrasted to the isolation of Noah's house. Its decoration, too, is as different as can be imagined. Its colour scheme is aquamarine, red, and cream on the outside, a combination that says cheap, tacky, and downclass as surely as the stippled earth-toned brick of the Sherwood Forest Estates says expensive, tasteful, and aristocratic. The place is clean and in good repair—it is not its physical condition that is the problem; it is its cultural position. As mentioned, however, it is as authentic as North American culture can get. The room interiors are invariably painted in a richly vibrant shade of orange-red that is probably a bit too strong but that seems very warm and alive and certainly in contrast to the elegant cool blues and whites of the rooms in Noah's house.

The relationships that Noah conducts with his clients in the motel are not entirely sound or healthy (to put it mildly), but they do involve a lot of overt emotion and also sex—which again differs strongly from the silence and the twin beds that seem to separate Noah from his wife and from the wordlessly bonded trio of Hera, Seta, and Simon. Noah's clients are not self-contained and self-sufficient, like these three, but instead desperate and needy, and that desperation and need allow Noah in some way to contact and act out his own, in however distorted or inappropriate a form. It is hard to

tell exactly what is going on in Noah's head as he sleeps in turn with a married woman, a single woman, and a partnered gay man—whether it's an extension of his compassionate services, a series of lustful lapses, or some strange combination of the two—but his dalliances at the motel are more fervid and channelled than anything going on in his life at home.

The Bubba and Mimi Show

I turn now to the film's second—and again schematically contrasting—married couple, Bubba (Maury Chaykin) and Mimi (Gabrielle Rose). Episodes from their lives are intercut with scenes centring on the other characters, and eventually they intersect forcefully with Noah and his family. The names of both pairs function practically as labels. Noah Render (whose ark-like motel saves people from fire and flood, and who renders the remains of their lives after fiery loss, and then renders them Caesar's recompense) and his wife, Hera (goddess of home and family), have been given names whose all-too-visible solemnity seems to bestow ancient mythic resonance upon them with one gravely serious hand while taking it back with the ironically exaggerating other. Bubba and Mimi, though, could hardly have more trashy, casual names. The unrootedness of their names reflects the inauthenticity of their lives and of the empty culture they seem to represent. They are wealthy, though the source of their wealth is not clear. Bubba may be a retired football player, and may also be the film producer he represents himself to Noah and his family as being, but then again, who knows? Not just the essence but the whole body of Bubba's and Mimi's lives seems to be made of artifice, theatre, and extraordinary play-acting. Bubba may or may not be a businessman, but he doesn't seem to actually have anything to do other than partake in the extensive and elaborate charades that he and his wife construct in search of some essential pleasure or satisfaction, something that would foster meaning or at least desire in their lives.

We see them for the first time on the subway, as they are watched by Hera riding to work. Bubba is a filthy, fat wino dressed in rags, scarcely able to sit on his seat, snorting and muttering to himself—an object of distaste to Hera as he would be to so many other people. Mimi, wearing a short-skirted "arrest-me" red business suit, sits in the seat next to Bubba, then takes his hand and places it between her thighs, looking up with a brilliant shark's smile at Hera to register her shocked reaction. As with so many scenes in *The Adjuster*, what we see here looks pretty strange, but when we find out what is really going on it is even stranger. This is the case with Noah and his house, with Noah and his clients, with Hera and her porn-taping. And so it is with the startling introduction of Bubba and Mimi, because the next time we see them they are being ushered out of a big black Lincoln limousine by the chauffeur and making their way into their gigantic stone pile of a man-

Bubba not looking at what Mimi is getting up to with her squad of football hunks (out of focus, back of shot). (© Ego Film Arts)

sion. This house is a big brother to the one that Noah and Hera live in, but with much more solidity, and probably as much sub-colonial historical authenticity as you can find in North America—but this authenticity has been bought rather than inherited and is being tried on for size like every other aspect of this couple's lives. The episode in the subway, we now see, has been merely the little *jeu* of a wealthy couple with too much time and money and with an obviously jaded decadence in their sex lives.

Their next game takes place in a deserted football stadium by night. The stadium has obviously been rented for their purposes, along with the nine-man football team in full gear that pours onto the floodlit Astroturf and lines up to watch Mimi, in cheerleader outfit, dance for them to the raunchy strains of Rough Trade's "High School Confidential." The lyrics mention Anita Ekberg, Mamie Van Doren, and Dagmar, and Mimi in her huge fright wig and spangles seems to be trying to emulate something of the surreal heroic kitsch of those 1950s icons of overblown sexuality. Although Mimi has prefaced the scene with expressions of love and gratitude to her husband ("You're so good to me"), Bubba does not look especially pleased, and turns away so as not to see the spectacle of Mimi picking out a particularly succulent football player, beckoning him over, and commanding him to kneel, then swinging her leg over his shoulder and pressing her crotch to his face. Egoyan's camera presents this spectacle with a typical combination of wit and pathos, as Bubba's sensitive and melancholy face fills the foreground of one side of the anamorphic frame while Mimi and the football player are visible in the background of the other side—but out of focus, in a way that is both comically detached and representative of a painful scene that Bubba knows about but is perhaps trying not to visualize.

Now Bubba stumbles onto the unfinished housing development where Noah lives, and his practised eye at once registers its poignancy and power, its perfect, dramatic, unselfconscious fakeness. One of the most striking

images of the film depicts giant Bubba in his tiny red Suzuki Sidekick (a toy car, really, and self-consciously adopted as such by Bubba and by Egoyan in their play-actings) speeding in telephoto longshot across the endless grey wasteland of the dirt patch that surrounds the Sherwood Forest Estates. He emerges from the car wearing sneakers and an enormous sky-blue Hermann Göring-style greatcoat with jumbo collar flaps (yet another of the film's innumerable design triumphs), notes the billboards and the small stand of three houses, and immediately starts snapping pictures. These photos then emerge as part of a slide show going on at some kind of strange dinner party at Bubba and Mimi's mansion, where the guests are all males in tuxedos and Mimi walks around on the table dressed as a flapper, conducting a discussion with Bubba about why people sing in the shower (she opines that it is because they are touching themselves all over). Mimi is particularly struck by the images of Noah's house, including one of little Simon peeking out a window, and demands to know who lives there. This leads to the next— and last—of Bubba and Mimi's real-life enactments. Bubba visits Noah and Hera, explains that he's a film producer, and asks to rent their home for use in a movie. They are flattered and agree (Hera does not recognize the bum from the subway), and Noah turns out to be eager to move his actual family to the motel together with his adopted one. If this is Noah's attempt to integrate the two halves of his life, it is a typical—that is, strange and inappropriate—strategy.

A Fiction Film

Bubba arrives early on the morning of the house transfer, which has not even been finalized yet, and, while Noah isn't looking, creeps up the stairs and into the master bedroom, where he finds Hera, Seta, and Simon all sleeping in the same bed and starts taking pictures of them. The invasiveness of the action is very clear, but Bubba's only reaction to everyone's incredulity is to remark to Noah, "You have a very beautiful family." It is evident here, and in other places, that Bubba means this sentiment sincerely, and that he looks with envy on a family that is the exact opposite of his own. To Mimi, the family may be a turn-on simply by virtue of its innocence—a quality so scarce it can be exotic, and there to be mocked or corrupted. In any event, Bubba decides to also rent Seta and Simon for the shoot, or play-shoot, because (as he says to the irritated Mimi) "they make a nice background." When Bubba and Mimi move into the house, with lighting stands, cameras, and eventually a crowd of child extras, the sense that Noah's house has always been an artificial location—a set—is made explicit. Shots of the house at night illuminated by movie lights present this idea with overt self-consciousness. So that the currents will go both ways, Bubba gives everyone in Noah's family a ghastly electric-blue satin athletic jacket

with his logo on the back. It is a horrible sight to see Seta wearing one as she and Simon are escorted from the Lincoln while Bubba awkwardly tries to incorporate them further by carrying Simon and reaching his arm around the shoulder of Seta, who wriggles away. Bubba's "movie"—we see rehearsals for one tracking shot—evidently centres on a children's birthday party (all boys), and his flustered direction shows annoyance at the slippage between reality and pretence: "Please! don't eat those! those are props. Okay, so only eat them when the camera is moving. Basically, so far, I think you guys have been—It's a party! and you guys look kinda pissed off. So enjoy yourselves. Otherwise this doesn't really make any sense. You look like you're being paid. I mean, I know that you *are* being paid, but you just can't *look* like you're being paid." Mimi, surrounded as in the two preceding scenarios entirely by a cast of young males, now plays Mom with her tea tray and apron presiding over a children's game, then coos "Hey, Bubba, do *you* want to play?" while removing her halter top amid the snickers of the boys. Bubba just looks tired.

Two Strange Families

Juxtaposing the two family units—Noah/Hera/Seta/Simon and Bubba/Mimi— the complex game of oppositions and counterpoints that Egoyan is carrying out becomes visible in a particularly juicy way. Primary is the aforementioned opposition of old and new, ethnic and white-Anglo, rootedness and shallowness, and it is centred in the women. The stereotypes here are ones of sexuality versus fertility, sexuality versus motherhood. Mimi is not just oversexed, converting everything into sexual desire; she also needs to act it out flamboyantly. Her insolent, licentious dress-up and make-believe scenarios are lurid and deliberately over the top, a provocation and a defiant expression of shameless transgressive desire. Her mission is casual sex, sensationally inventive and unattached sex—one might almost say porn-sketch sex. Such a mission does not need and does not want conjugal or familial relations, except as ironic signifiers of that which is to be transgressed. Insofar as Bubba is a husband in this situation, he is either the roué who can be roused to desire only by the unholy spectacle of his wife in another man's arms or the indulgent proprietor of a marriage so "advanced" that it is actually made up of the very things that are total anathema to a "conventional" marriage (in Mimi's construction, that is; there is every indication that Bubba doesn't share this interpretation).

With Hera and Seta, the situation is exactly the opposite. There is no sex, and within the marriage, it would seem, no sexual desire, but a very strong atmosphere of family ties. Hera and Noah never caress each other or sleep together, but Hera and Seta, Seta and Simon, even Simon and Noah often do. In this family we find mother and child (Seta and Simon) but no father, and

at the same time a father and mother (Noah and Hera) but no children. It seems like a painstaking effort to depict an extraordinary situation: a powerful familial togetherness alongside a dysfunctional leading married couple. To a degree here, *The Adjuster* repeats the configuration of *Family Viewing*, with its image-wielding patriarch and his sexual activity that exists outside of the ethnic woman-centred family—except in this case Noah is clearly motivated by strong, if strangely distorted and misplaced, impulses of compassion rather than the kind of cold domination that the David Hemblen character represents in *Family Viewing* (as in almost all his appearances in Egoyan's cinema, including the one in *The Adjuster*). Noah has the status of the excluded one in this configuration, and takes his place with the other WASPish males in Egoyan's cinema—in *Family Viewing*, *Calendar*, and *Exotica*—watching their wives' female/ethnic "authenticity" from the outside, somehow excluded by something that includes sexual infidelity. It is a theme that Egoyan circles around almost as obsessively, if not quite so overtly, as that of the moving image and its uses. So, like Bubba and Mimi, Noah's family is oversupplied with some family or marital characteristics while completely lacking others, and these either too-large or absent qualities seem to complement each other. It is worth noting that there isn't one word of love exchanged in either of the marriages (although there's a certain sympathy at one or two points). And, of course, the contrast between the two families mirrors the larger cultural polarity between sexually free female (Mimi) and matron (Hera)—again inscribed in their names.

A Picture Is Forever

The thematic cluster of image-making, photographs, video and film, mechanical reproduction of visual representation, and the uses people make of these images to manage or mismanage their emotional lives is on view in *The Adjuster*; and if it is not as completely central and inextricably interwoven into the constitution of the story and the characters as it is in *Family Viewing*, *Speaking Parts*, or *Calendar*, it is still an important presence. Photographs are one thread of this theme, tied to three of the characters. Noah's work as an adjuster draws him constantly to photographs, as concrete, indexical evidence of the material destroyed in the fires that have devastated the homes of his clients. The photographs become an important part of Noah's strategy not just of restoring something to his clients, but of obsessively translating emotional loss into material terms. He inspects the snapshots his clients show him, and instead of interpreting them in the ordinary way—as documents of human presence and activity—filters all that out to concentrate on the material objects of the background. In every example of this innately perverse operation, the photograph is dehumanized and even deorganicized, as when Noah "reads" some real butterflies mounted for display

as pictures of butterflies. The employment of photographs in the process of converting human feelings of attachment and loss into money emphasizes the instrumental, quantifying, reifying aspect of these (and all) photographs, and is in keeping with one facet of Egoyan's ongoing view of photographic representation.

A related facet is visible in Bubba's photographic activities. Bubba uses photographs to "fix" his own perceptions of and feelings about the world he travels through. His photos of Noah's house and family transfer a complex set of attitudes toward family and social stereotypes into images that both capture the conventional idealism of these stereotypes and indirectly express their exoticism to Bubba's alienated view, as well as his sense of exclusion from them. Capturing the image of something, dramatizing it in a theatrical but narcissistically incorporating way, is an activity that seems to be essential for Bubba (and also for Mimi) and is a feature of both his photography and his movie-making—and it is never plainer than in his invasion of the bedroom of Noah's house and the tender, excited, vampiric capture of the image of the sleeping women and child.

Seta's photographs, like the character herself, represent a refusal and cancellation of all this (male) reifying, fixing, capturing activity. They are black and white photographs, sent to her from her brother in her native country ("photos of our old neighbourhood," says Hera—though they include a picture of Simon, which only increases the uncertainty about the exact history and movements of this family). Seta is seen on more than one occasion carefully burning these photos, so ritualistically that they look like votive offerings. One scene juxtaposes Seta burning pictures with Bubba prowling around the house snapping his own pictures. When he asks Hera why Seta is doing this, she replies, "She doesn't like to keep things." Bubba is completely floored by this answer, and can only repeat her words in astonishment. This is a wonderfully characteristic Egoyan moment. Hera's explanation, simple and seemingly baffling in itself, causes a furious cerebration in the viewer, who starts to connect it with all the other elements the film has presented in this sphere of visual recording and with the different attitudes of the characters toward them. Seta's action denies exactly those aspects of the process that are most cherished and fetishized by the males on the other side of the question, emphasized through juxtaposition with Bubba and his camera. The way that photography can "fix" people and things so that they can be kept and managed and controlled is just what Seta avoids through her imposition of temporality and contingency upon the photographs. She doesn't like to keep things. Seta's action bestows an aura (Walter Benjamin's term signifying the object-qualities of uniqueness and authenticity that are dispersed by mechanical reproduction) on her photographs. By destroying these visual records, she makes them more real—whereas, of course, what Bubba and Noah and the cultural forces they embody want photographs to

do is to remove events in time from temporality and contingency. The price that has to be paid for extracting things from the ceaseless flow of time and mutability is their extraction also from reality, from rootedness and history and authenticity. Pictures of families instead of families (as in Bubba's project), pictures of objects instead of the meaning of those objects to the people they surround (as in Noah's adjuster-photos), pictures of homes instead of homes (as in the billboard paintings at the Nottingham Forest Estates)—that is the pattern. The price for abstracting in this way is invisible to those who pay it without thinking; but it is not invisible to Seta.

These different attitudes toward and uses of the image form one more powerful strand in the film that connects Hera, Seta, and the ethnic old country with a somehow more authentic life, while simultaneously connecting photography—and video-besotted North America—with a falser and shallower one. We may recall how in *Family Viewing* the video images of a female-centred ethnic family do not persist, and also seem more authentic because of their absence, when they have been replaced by a form of home pornography. This juxtaposition is continued in *The Adjuster*, with its dual presentation of Seta's family photographs (and to an extent those of Noah's clients) and the porn films Hera encounters at the office. The fact that even one as representative of female ethnic "authenticity" as Seta is starting to become somehow addicted to sadistic pornography is a testament to the corrosive power of photography-as-debasement. When this nexus is combined with the scenes depicting Bubba as a real or pretend filmmaker, it continues Egoyan's project of reflexivity. The activities of photography, video-making, and filmmaking are the object of severe criticism—or at the very least of severely unflattering depiction—in all of Egoyan's films of this period. And the criticism is directed inward, for who is Egoyan but the master photographer and video/filmmaker, the master abstracter and manipulator? There is also a rueful sense of humour about filmmaking to go with this implied critique. Bubba as director presents an amusing portrait of the undignified and frustrating activity of herding people around on a set, and all his and Mimi's kitschy and extravagant theatricals are pastiches of the process of dramatic staging. As well, the first question out of Hera's mouth when she hears about the movie Bubba is supposedly making is "Who's in it?"; and Noah's constant appraisal of every material aspect of settings and backgrounds makes him seem in this context like a producer looking over scene layouts with an eye to the budget.

Quis custodiet ipsos custodes?

The Adjuster's image-critique appears at its most concentrated, in a way at its purest, in the events taking place at the institution of the Censor Board. Here it seems almost all the films that are shown are sado-masochistic

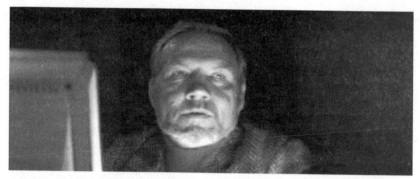

Bert, the censor board chief. (© Ego Film Arts)

pornography, and once more the viewer is forced to weigh the possible rea-
sons for such an unpleasant restriction. The first film whose soundtrack we
encounter seems almost comical in its dominatrix scenario, but after that all
but one of the films are truly horrifying examples of brutal, male-sadistic, non-
consensual sex, where traumatized females are heard begging to no avail
for something awful to stop. As these scenes unfold, the members of the
committee sit impassively pressing buttons on little keypads, with Bert
perched regally at the control board at the back of the room, his face bathed
in cold white light from his instruments. They are tabulating infringements
of the censorship code, identified by letter—as we discover when Bert inter-
views Tyler for a job on the board and asks him to describe the various cat-
egories of unacceptable content:

Bert: A.
Tyler: A graphic or prolonged scene of violence, torture, crime, cruelty, hor-
ror, or human degradation.
Bert: B.
Tyler: The depiction of physical abuse or humiliation of human beings for
the purposes of sexual gratification or as pleasing to the victim.
Bert: [*curt nod*] C.
Tyler: A person who is or is intended to represent a person under the age
of sixteen appears...
Bert: [*raises finger*] One—
Tyler: nude or partially nude in a sexually suggestive content, or text,
or...
Bert: Two—
Tyler: in a scene of sexually explicit activity. [...]
Bert: D.
Tyler: D, uh, D. Explicit and gratuitous depiction of urination, defecation,
or vomiting.
Bert: H.
Tyler: A scene where an animal has been abused in the making of a film.

This dialogue is funny, particularly in view of Bert's schoolmasterly manner and the smirking Tyler's goatee, pompadour, and affected costume, which resembles that of a young artist in a Chekhov play—and also in the little exchange (omitted from the quotation above) about both of them living at home with their mothers until their late twenties or thirties. But the scene is also disturbing in its machine-like codification of transgressive human behaviour, which translates shocking deeds into abstract symbols with far too much ease. After one distressing screening, Bert's tabulation of marks is utterly businesslike and unaffected: "All right, we seem pretty much in accord. twenty-five A's, thirteen B's, thirteen C-1's, forty-three E's, thirty-nine F's. Huh, no G's, surprising. And three H's. Any comments, questions? [*short pause*] Good. Jerry, what have we got next?"

This anaesthetized surgical extraction of all feeling from material that arguably should cause a whole variety of inflamed emotional reactions is in fact only the most blatant example of a process of abstraction and reification that is taking place in many contexts in *The Adjuster* and elsewhere in Egoyan's cinema. It is typical of Egoyan that the classification method should be so starkly codified and the contrast with the sensationalism of the material censored so marked, that the result is overvisible and borders on surreality in its schematizing activity. Again, it is funny, and the film's amusement is doubly underlined when we see some of the other activities of the Censor Board, especially the even more surreal spectacle of people at desks ripping photographs out of magazines, wadding them up, and tossing them into big bins (these bins all seem full to the top, and the mostly young male employees are seen idly examining samples from other people's bins as they stroll past).

Illegal Substitution

The process of abstraction and reification here is in turn part of a larger, and equally pervasive, tendency in the film, and in Egoyan's cinema altogether: the tendency for characters to substitute one set of symbolic, formulized, and more controllable activities for another, more authentic set that is, however, much harder to understand and manage. This is the strategy of so many of the central characters in Egoyan's films, especially in *Speaking Parts* (Clara and Lisa), *Calendar* (the photographer), and *Exotica* (Francis)—and, of course, in *The Adjuster*, where the protagonist, Noah, has made it literally into a profession. The situation of loss in Noah's home life—his inability to understand or communicate with his wife, his total inability to communicate with her sister, the fundamental dislocation of the family habitation as signalled by the surrounding wasteland and show-home construction, the general sense of isolation and helplessness—is addressed by Noah, but it is not addressed in the appropriate place with the appropriate people. Rather, it is

transported to his job as adjuster. When he says to his clients, "You may not feel it, but you're in a state of shock" and "Your whole life has been uprooted," he is describing his own condition as well as theirs. His condition isn't so visible and the catastrophe that has occasioned it is more diffuse, but what he feels all the time is something *like* shock and homelessness.

Noah's technique of dealing with his own loss is to appropriate the mechanism of his profession that pays out money for damage. On the one hand, he brings an excess of feeling, really too much compassion and care, to his treatment of his clients. This is what makes him extraordinary as an insurance adjuster, and an object of almost hagiographic admiration and love. He seems to be trying to redeem the cold cash-for-loss, cash-for-life's-blood equation of the insurance business and of the whole fabric of capitalist life. (This gesture is answered by the prayer cards the motel management leaves on every pillow, whose endless flowery litany of "heartfelt" good wishes is also excessive—solemn, absurd, and embarrassing in itself, but especially so from a business that will be presenting you with a bill when you leave.) On the other hand, even as he is conducting the operation of making capitalism compassionate, Noah is also conducting the diametrically opposite operation of making compassion capitalistic. As he expresses profound sympathy with his clients, he not only applies the same verbal formulas of consolation to each one in turn, but with a relentless probing persistence seeks to turn every item of loss into "approximate value," in dollars and cents. Like so many aspects of the film, this one at first seems normal or harmless but as time goes on emerges as quietly pathological. Eventually—as for example when we see Noah asking Larry (Stephen Ouimette), the shell-shocked more sensitive half of a gay couple who have been burned out—how much it cost to have his diploma framed and whether his dead pet dog was a valuable purebred, it is obvious that there is something very wrong here. In fact, he is engaged in the same procedure as is taking place at the Censor Board: your burned-up diploma is A, your burned-up butterfly collection is B, your burned-up dog is C-1, and so on. Indeed, this is what "adjusting" is; this is what "the adjuster" does.

This attempt to exclude or contain feeling is, of course, doomed. Its impossibility is amply demonstrated on both sides of Noah's life. On the substitutive, professional side, the instrumental project of providing prepackaged compassion to victims is invaded by sexual desire. Noah beds Lorraine, the movie actress Arianne (Jennifer Dale), and the other half of the gay couple, Matthew (Raoul Trujillo). None of these three falls nicely into the "destroyed victim" category, as for example their partners, Tim and Larry, do. Each of them seems, instead, more detached and self-possessed, more aware of other perspectives, other appetites. Patricia Collins's mere presence in the role of Lorraine ensures a cool, skeptical intelligence; Arianne is revealed

to have deliberately refused to stop the fire that broke out in her house ("Something had to change"); and Matthew sits in the background sardonically appraising Noah while he is leading Larry through the "approximate value" process, and eventually inserts a beefcake nude photo of himself into the stack of family snaps Noah is trying to use for assessment. None of these people truly derails Noah, but their sexual encounters with him all emphasize the nature of *his* neurosis—most satirically in the scene that depicts Noah and Arianne gasping out, while in the throes of intercourse, various detailed strategies for itemizing her valuables. This perverse behaviour is always evident, and seems even to be an additional turn-on for Noah's partners, though it is never anything but ill advised and pathologically symptomatic for Noah himself.

Meanwhile, on the other side of his life, Noah engineers his own expulsion from home (which in Bubba's hands eventually becomes more real and complete than he intended), shepherding another family—his own—to the motel. The picture of Hera, Seta, and Simon in the orange-walled motel environment is a jarring sight, the wrong picture. In this new environment Noah's midnight excursions from their room to his other clients for extracurricular sex leads immediately to the dissolution of the family unit: Hera ushers Seta and Simon into a taxi, and they leave. Simultaneously, Bubba is preparing to immolate Noah's house with himself and Mimi inside it. These occurrences precipitate the final collapse of Noah's system, an event signalled by what seem to be the hallucinatory unrealities of the final scene. Here, as Noah stands disbelieving before the conflagration that is (at last) devouring his own house, the film flashes back to a previous fire, in which a younger Noah comforted Hera and Seta, with what is presumably Simon as a babe in Hera's arms. This indicates that Noah's own family has been constituted through the same process of loss, comforting, and re-housing that we have seen his other clients experiencing. It tempts us to look retrospectively at Noah's family life as in some ways just as artificial as the house they are living in—as much an adoption himself as any of his clients—and to feel that the dualism of family versus customers has been, if not an illusion, then at least a deliberate construct. Or it *would* tempt us to feel this if it were apparent to viewers what was supposed to be happening in this scene. For it is not at all clear that what we are looking at is a flashback and not some kind of fantastic mental projection or hallucination, of the kind we see toward the end of *Speaking Parts*. Most viewers simply don't get this, and I confess the latter was my first impression. On the other hand a hallucination interpretation works rather well: what we are seeing is a breakdown of Noah's strange and substitutive modus vivendi, signalled by the breakdown of his (and the movie's) experience of reality into phantasmagoria. The idea that another adjuster, looking identical to Noah, is now consol-

ing his own family is just as appropriate and thought-provoking as the idea that this has actually all happened in the past.[4]

Substitution is, of course, also central to the lives of Bubba and Mimi—perhaps even more central than to Noah's, given that the only thing we ever see Bubba and Mimi doing is enacting their baroque theatricals, which are highly self-conscious forms of substitution. The artificiality of their enterprise is essential to it, and essentially marked upon it: of all the film's characters, they are at the farthest remove from anything "natural," and their exile from everything natural is constitutive of their existence. When this project too comes crashing down, it does so even more drastically than Noah's does, though given the dead-end character of their attitudes and mode of life, it is perhaps more fitting. Something this sick has to come to an end, and Bubba, certainly the more tormented of the pair, finally arrives at the mindset necessary for a Götterdämmerung. Noah, returning to his house after the flight of his family from the motel, finds Bubba in a gas mask and surrounded by personal effects from his own house, dousing everything in gasoline while Mimi sings in the shower. Perhaps she is singing because she is touching herself all over, but Bubba's own interpretation of why people sing in the shower—"the joy of washing things away"—is also being enacted. Bubba would like to wash away his whole life—or, as he is actually engaged in doing, burn it away. Throughout his discussions with Noah and his family about renting their house, Bubba has been forced into improvising a movie narrative to describe what kind of character will be living in this house: "The person who is supposed to live here is going through a *very strange* time in their lives. They have everything they want, or they have means to have everything they want, but they don't know what they need. So they—*try* different things, and this house is one of them." This explanation, as we understand immediately, describes not any movie Bubba might be making, but rather the actual circumstances of his life. (Indeed, it makes very little sense as a movie narrative, unless of course it is describing something happening in an Egoyan movie, which it—reflexively—is.) Now, pouring liquid fuel all over Noah's living room and enveloped in gasoline fumes, Bubba adopts the same discourse as a prelude to murder-suicide: "Now you've come in just at the moment that the character in the film, the person who was supposed to live here, decides that he's gonna stop playing house [*takes a big box of matches out of his pocket*]. So [*about to ignite the match*], are you in? or are you out?" Noah backs out of Bubba's movie a moment before it explodes, just as he is forced to back out of his own movie by *its* comprehensive collapse. As ever in Egoyan, these substitutions don't work. These adjustments are really maladjustments.

Pornography is another form of substitution, and another use of images to service emotional needs. Having Bert and Tyler, on one hand, and Hera,

on the other, as custodians of the institution that regulates pornography makes for an interesting and typically bizarre configuration. The men behave toward these images that are largely byproducts of patriarchy in sex relations—that is, heterosexual male fantasies, and depictions of power relations in sex as abstracted into sado-masochism—in ways that are patriarchally complicit. Just as the young men working in the magazine section scan the offending images with casual but desiring interest, so too, hiding behind the impassive face of cold institutional power, are Bert and Tyler revealed as guiltily desirous males disavowing their own desire. Bluntly, they are both white males turned on by the filth they are supposed to be suppressing. Putting David Hemblen into the role of the chief censor accomplishes everything at a stroke, particularly for those who have seen *Family Viewing* and *Speaking Parts*, since Hemblen's pallid stone face and commanding blank voice make him a marvellous iteration of authority so impersonal that its no doubt sinister purposes are completely unreadable. In *The Adjuster*, Hemblen's character is less frightening and unreachable than he is in Egoyan's other films—more vulnerable and even ridiculous—even as he once more occupies the seat of patriarchal institutional authority. His job interview with Tyler reveals him, in a comic moment, as socially stunted in some ways (a charge the film lays by extension against all these institutionally invested furtive porn consumers):

> *Bert*: How old are you, Tyler?
> *Tyler*: Twenty-eight.
> *Bert*: You still live at home.
> *Tyler*: [*little embarrassed smile*] How did you know?
> *Bert*: I called your number yesterday. An older woman answered. Your mother? [*Tyler nods, looks away*]. There's nothing to be embarrassed about—I lived with my mother till I was thirty-five. It's very common in some parts of the world. Italy, for example.
> *Tyler*: Are you Italian?
> *Bert*: Do I *look* Italian?
> *Tyler*: N-no.

And when Bert and Tyler later confront Seta with her illicit videotaping of porn screenings, Bert's confession of desire, while creepy, has a tinge of vulnerability and even pathos:

> *Bert*: You seem to be getting the wrong idea. I'm not upset. Not at all. In fact, I'm thanking you.
> *Hera*: For what?
> *Bert*: For bringing this into the open [*Hera is silent*]. You see, when I was first appointed to this job I used to think I was alone.
> *Hera*: Alone? In what?
> *Bert*: In feeling, on occasion, *aroused* by some of the material I was

> expected to classify. It used to disturb me. Then when Tyler told me about
> what he saw you doing, I suddenly felt—liberated. What you acknowl-
> edged was healthy. *Of course* it's exciting material.

Hera's explanation—that she is allowing her sister to share in her work-
day—is a dumbfoundingly innocent reproach to this confession, and leaves
Bert even more acutely with his pants down, so to speak.

This is also the moment that stages most clearly the dichotomy within
the board, and Hera's place as a radically different representative. Not only
does she feel no sexual excitement at the spectacle of the materials she views
at work, but she has converted even this into a branch of her agenda of sis-
terly sharing. If there is something definitely unhealthy about watching
sado-masochistic pornography for sexual pleasure, there is also something
unhealthy (and objectively a lot stranger) about watching hours and hours
of the stuff as a method of appreciating the work your sibling does, or covertly
copying it in order to make this possible.[5] Again, Hera, especially in conjunc-
tion with Seta, is an asexual, almost anti-sexual agent. She doesn't seem to
be feeling any sexual desire at home, any more than she does at her job (she
does have a couple of odd quasi-erotic encounters with her podiatrist, but
they are quite sublimated). At home in her single bed, she seems to have been
censored herself. Bert's last word to her in the conversation just quoted,
after he has heard her explanation, is, "We all have impulses, just admit
that." But Hera apparently *doesn't* have impulses, certainly not ones that
would be recognized as such by Bert. She doesn't even seem offended by what
she is watching, just detached. She looks at this material with eyes that are
as disengaged as the men's are complicit—again, something at least as pecu-
liar as the men's disavowal and covert misogyny. Of course, *The Adjuster*, with
its rather explicit Noah-Arianne sex scene and its masturbated erect penis
(the "wild man's"), can also provoke *its* audience in parallel ways, perhaps
even making itself a candidate for censorship.

Mise-en-scène and Performance

The Adjuster stages its drama and its theses with a visual articulateness that
comes as no surprise in a film that is so self-conscious and meticulously elab-
orated. Among all its dichotomous juxtapositions, there is another, parallel
one on the level of setting—a literally elemental one. *The Adjuster* is repeat-
edly marked by fire and by water, antithetical elements that seem always to
be linked here. The impression is that every single home-destruction that
Noah attends to (including his own) comes through fire. But the fires that
we see are always accompanied by thunder and rain, and the aftermaths in
which, say, Noah and Arianne tour the burned-out hulk of her house are
always of the particular mess that comes from a fire that has been doused.

Noah, hand up, standing in front of his burning house. Note the movie-lighting fixtures. (© Ego Film Arts)

It rains constantly. Seta ritually burns her photographs while Bubba and Mimi discuss singing in the shower; and Bubba finally burns down the "toy" house in which his wife is singing in the shower. The fire destroys people's homes—always traumatic, if sometimes necessary ("Something had to change"; you have to "stop playing house")—and also, in a redemptive way, Seta's photographs. Noah not only saves people in his ark (the motel where it always seems to be raining), but rains on their fire. The fire-and-water motif extends also, most fittingly, into the decor of Noah's two basic locations: the walls of the motel rooms are of a fiery dark orange (quite a startling shade in Egoyan's cinema, which has heretofore been very sober in appearance), while the rooms of Noah's house are painted in watery pale blues, mauves, greys, and whites. In this way the film's pervasive interwoven dichotomies of authenticity and artifice, home and false home, actuality and image, family and society, and all the rest are powerfully if inchoately augmented, and made to seem somehow elemental.

In a more general sense, the film is Egoyan's most richly colourful so far. His palette has always tended toward the sober and dampened. This is especially the case in his preceding film, *Speaking Parts*, which, though in colour, is almost a study in hueless monochrome. By contrast, *The Adjuster* revels in the vibrant opulence of orange motel walls and orange flames in the black darkness, in the vibrant tackiness of the motel's red and aquamarine exterior panels and of Bubba's red car and light blue greatcoat, in the vibrant glare of floodlights illuminating the football stadium and Noah's movie-set home at night, and in the rich shadows of various bedrooms at night. The film's first image is of Noah's hand turned translucent fleshy orange by being held contemplatively over a flashlight, and its last is a repetition—Noah's hand held wonderingly up against the roaring flames of his own house burning down. As we have seen, this is only one side of a dichotomy of colour and tone schemes, with the other one (typified by the greys and pale blues of

Noah's house and of Bubba and Mimi's house) much closer to the regime of *Speaking Parts*. But *The Adjuster* has, for example, none of the extensive video footage, with its washed-out contrasts, desaturated colours, and poor definition, that is such a strong feature of Egoyan's earlier films. Video still keeps a place, in Hera's covert tapings, but we don't see it; instead, the primary medium now is film, whether still photography or Bubba's movie-making apparatus, complete with dollying tracks and huge auxiliary lights. It is appropriate, therefore, that *The Adjuster* should have more film-like visual qualities—greater photographic richness and definition, a more three-dimensional sensuality. Egoyan's fondness for slow, measured tracking shots is amplified here also, while the visual field is epic anamorphic widescreen, so that the end product is bigger, more solid, more movie-like.

It is an impression that arises also from the presentation of the characters. Egoyan's casting is always excellent, and even otherwise relatively undistinguished actors inevitably end up giving fine performances in his films. But *The Adjuster* marks a movement onto a somewhat larger stage. The characters themselves, perhaps, are quite typical in their interiority, blankness, and thematic functionalism. The presence of faces familiar from other Egoyan films, behaving in familiar ways, maintains a continuity with the feel of the earlier work, too—Arsinée Khanjian and Gabrielle Rose most importantly, but also David Hemblen, Patricia Collins, Gerard Parkes, Tony Nardi (the motel manager), and Jacqueline Samuda (the motel maid Louise). And all of these performers do sterling work, especially the glistening-eyed, pumped-up-to-explosion-point Rose. But there is definitely an increase in bore-size with the arrival of Elias Koteas, Maury Chaykin, and even Jennifer Dale (perhaps not the most refined actor technically, but a striking presence nevertheless). Certainly Noah is a typical sleepwalking Egoyan protagonist, and certainly Koteas acts him with appropriate somnambulism, but Koteas also possesses a screen presence that suggests depth without even trying. The biggest presence of all, however, is Chaykin. Reading Bubba's dialogue on the page would, I imagine, make a much more typically Egoyanesque effect than Chaykin actually creates in the movie. With his sad eyes and bright little-boy's voice in a mountainous frame, and with his wonderfully hesitant delivery, Chaykin makes Bubba a philosophically curious person, a man who is always sending out existential feelers, and at the same time someone who is cut off and personally doomed, trapped on an ice floe drifting farther out to sea and just watching everything get more and more remote. It's a great performance, and it enlarges the movie.

Envoi

The Adjuster presents the thematic counterpoint and schematically placed characters, the narrative balanced between realist action and abstract pat-

tern, the characters quiet on the outside and indescribably strange within, the scrupulous art-film craft, the splendidly unique sensibility of Egoyan's earlier work. But it adds a level of cinematic richness and more rounded character, a certain sense of freedom and expansion from the very closed worlds of *Family Viewing* or *Speaking Parts*. Simply the inspired use of locations such as the Sherwood Forest Estates and the motel, along with the accumulation of striking, reverberant set-piece images (Noah shooting arrows through his bedroom window, Bubba and Mimi's theatrical sketches, Tim and his lamps, and on and on), moves *The Adjuster* to an exhilarating cinematic plane. The result is a beautifully balanced and confident film, perhaps Egoyan's best before *Exotica*, and still one of his most accomplished achievements.

Notes

1 The casting of Rose Sarkisyan as Seta also means that the repeated images of Seta and Simon visually replicate the video images of *Family Viewing*'s male protagonist, Van, and his vanished ethnic mother—also played by Rose Sarkisyan—and further reconfigure a recurring motif in Egoyan's cinema.

2 This juxtaposition recalls the similar configuration in *Family Viewing*, where the Arsinée Khanjian character also has dual ties to authentic Armenian family feeling and to the sex industry (she is a phone-sex worker who dabbles in prostitution to support her aged mother).

3 Here again is an echo of *Family Viewing*, in which the Rose Sarkisyan character also moves into the space of sadistic video porn, in her case as a participant in Stan's home movies.

4 Egoyan himself spelled out his intentions regarding this scene in an interview with Hamid Naficy (1997), who himself confesses he did not make this interpretation.

5 In this respect, the action of the masturbating "wild man of the billboards" in taking not only what Seta is viewing but the fact that she is viewing it as an erotic activity is quite understandable.

Works Cited

Naficy, Hamid. 1997. "The Accented Style of the Independent Transnational Cinema: A Conversation with Atom Egoyan." In *Cultural Producers in Perilous States*, ed. George E. Marcus, 179–231. Chicago: University of Chicago Press.

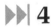 **4**

The Thirteenth Church
Musical Structures in Atom Egoyan's *Calendar*

Katrin Kegel

To Gudrun Oswald and Karl Rathgeber

Musica est exercitium arithmeticae occultum nescientis se numerare animi.[1]
 — Gottfried Wilhelm Leibniz, in *Epistolae ad diversos* (1712)

Calendar (1993), Atom Egoyan's fifth feature, is a small film. Originally produced for TV, it was shot without Egoyan's usually scrupulous preparations, partially without a script, and it has a running time of only seventy-two minutes. Yet this improvisory but highly structured work, which achieves its kaleidoscopic complexity through elaborate editing, seems to have transformed, even revolutionized, Egoyan's entire cinematic oeuvre. Striking a tone between melancholy and sarcasm, this tale of the transformations of a character, whom Egoyan describes as corresponding to "the worst nightmare of myself" (Bohr 1995), occupies a place of transition and of transformation in his oeuvre leading from the highly coded style of Egoyan's early period to the matured epic narratives of *Exotica* (1994) and *The Sweet Hereafter* (1997). The first time Egoyan represents Armenia, the country of his ancestors, onscreen, *Calendar* also represents an important step toward *Ararat*'s (2002) explicit negotiations of Armenian history. Looking at the films in his corpus on either side of *Calendar*, one cannot help but wonder what happened to lead him from the absurdist obscurity and wilful inaccessibility of *The*

Adjuster (1991) to the psychological realism and more straightforward narratives of his later features.

Calendar has been described in reviews and articles as fascinating and lapidary, poetic and ironic, sad and optimistic, transparent and mysterious, gracefully unfolding and repetitive, complex and simple, a breakthrough film and a masterpiece. The prominence of Armenian churches has also lead some critics to wonder about the film's spiritual dimensions. Keeping these paradoxical and often contradictory responses to the film in mind, in this essay I will take a closer look at *Calendar*'s multi-layered formal structures. A film's structure, as Egoyan remarks, offers "direct access to the way the filmmaker thinks" and, at the same time, is "the key to the viewer's subconscious" (Bohr 1995). Through this examination of structure, I am seeking to account for the film's fragile but intrinsically positive quality which lies beneath the surface of its focus on separation and loss and, at the same time, I am seeking to explore the transformative role of this particular film in Egoyan's overall oeuvre.

In his essay "Imaginary Images: An Examination of Atom Egoyan's Films," Peter Harcourt points out a musical quality within Egoyan's films (1995b, 6). That Egoyan would have a familiarity with musical forms is not surprising. He studied classical guitar seriously until his university years and must have been surrounded by musical activity within his family, too, since his sister, Eve Egoyan, is a concert pianist. Not only can aspects reminiscent of a musical composition be found in *Calendar*, but, of all his feature-length films, *Calendar* appears to be the most musical. Instead of following a narrative logic—that is, instead of allowing the storyline to organize the piece— Egoyan places narrative elements into the frame of a composition that follows a musical logic, which yields its meanings only within the view of the whole of the form.

Indeed, when the Armenian guide in *Calendar*, apparently anxious to get one positive interaction with his employer, comments on the photographer's efforts in installing the camera, the photographer dryly replies, "Well, I'm trying to find the right composition." This statement appears as an ironic comment not only on the photographer's general frame of mind, who, after the experience of the trip to his homeland, finds himself back in Toronto without his wife, but it also comments on Egoyan's own efforts as director in giving the film an appropriate visual as well as musical structure.

A serious exploration of *Calendar*'s musical structures offers intriguing insights, especially in those levels of the film that are otherwise concealed from immediate and conscious comprehension. At first sight, the film appears to contain an eclectic variety of musical elements, brought together to form a distinctly individual composition. A closer look, though, reveals specific formal fragments from different periods, which overlap, coexist, and figure

simultaneously. Three main musical forms stand out in Egoyan's composition. The rigorous scaling down and reworking of his earlier thematic material in *Calendar* is reminiscent of the form of the musical exercise. The film's specific situational arrangements and the repetitive elements within its narrative recall baroque contexts, specifically the musical form of theme with variations. And finally, the personal transformation of the photographer, which is accompanied by a heightening and resolution of the narrative toward the end of the film, conjures the nascent early classical sonata form.

The Exercise and Egoyan's Thematic Inventory

The intention of the form of the musical exercise lies in establishing a technical problem relevant to the structure of a composition within a highly restricted frame. Since the exercise does not have to follow any specific formal pattern, impressions of complex virtuosity as well as of improvised lightness often coincide. Yet, ideally, the composer remains focused on the structural process taking place between himself, his material, and his mental concept for the composition. Despite all appearances of virtuosity, this self-restraint lends the exercise a certain sincere simplicity.[2]

How does the structuring of Egoyan's thematic material in *Calendar* recall this musical form? Throughout his four earlier feature films, Egoyan created an impressively coherent inventory of themes, motifs, and narrative structures that together formed a unique stylistic signature. This inventory is marked by three main thematic complexes: the experience of belonging to an Armenian diasporic culture, the experience of the process of assimilation to Anglo-Canadian culture, and the contemplation of the effects of a collectively remembered historical disaster—the Armenian genocide—on Egoyan's own generation.[3] Characteristic of Egoyan's early period is an ambivalence that relates to his desire to deal with these emotionally delicate issues at the same time as to conceal them, a strategy that reaches its extreme in *The Adjuster*, where disguised references to Armenian history push toward the surface like snatches of an unconsciously remembered traumatic experience in a nightmare.

With *Calendar*, Egoyan withdraws to the restricted form of an exercise, as if he felt the need to revisit and sort out the complexity of the working material that had been created so far. He limits the film's narrative to three main characters, to two different settings, and to repetitive arrangements, all without limiting the scope of his thematic material. In this genuinely revolutionary creative process, reflected in a restricted form and breaking itself against its borders, this thematic material becomes clearly arranged and appears more transparent, ready to be reworked to new ends. As though a catalyst were accelerating its transformation, Egoyan's working material is fractionalized into its smallest components, reflected, refracted, and inten-

sified, and finally appears in the highly wrought formal structure, which lends to the film its characteristic prismatic complexity. Within this revisionist structural process, Egoyan also places his own process of cultural assimilation, which he retrospectively describes as a painful experience yet as a vital necessity, through a pitiless examination, and for the first time openly reveals as Armenian his own cultural background and the culture to which his films have been referring. The photographer's quintessential insight gleaned from this first trip to the homeland is "Being here has made me from somewhere else"; in an unexpected turn, his confession of belonging to his culture of origin causes the acceptance of the culture he now lives in. As will become clearer, this sentence, placed at the very centre of *Calendar*, represents the climax and turning point of the revisionist process and the beginning of the transformation and restructuring of Egoyan's oeuvre.

These structural transformations inaugurated through the exercise of *Calendar* are perceptible on many levels within Egoyan's work. Narrative structures that before contributed to the depiction of loss of identity and displacement now become elements of a very personal, psychologically comprehensible narrative of self-definition and cultural repositioning. The interrelated thematics—absence, loss, memory, belonging, marginalization—which before *Calendar* appeared in the imminent context of Armenian culture, enter a much wider, generally human context.[4] Egoyan's intense use of video and photographic material is reduced to a minimum. His sparse and pessimistic depictions of Canadian landscapes and claustrophobic urban deserts, familiar from his early films, make room for bright, open and harmonic aspects of landscape after *Calendar*. But the most dramatic and most visible transformation initiated by the formal exercise of *Calendar* occurs within Egoyan's depictions of identity and of homeland.

Egoyan's early films revolve around the theme of the wilfully constructed identity. Hamid Naficy notes that through the experience of diaspora or exile, "one is forced to face, perhaps more than at any other time, the essential constructedness of one's own structures of belonging. Distanced from familial and familiar structures, the exiles are in an enviable position of being able to remake themselves. If it can be constructed, identity can also be reconstructed, deconstructed—even performed" (2001, 269). Referring to *Next of Kin* (1984), Matthias Kraus goes so far as to diagnose a "calculated schizophrenia" in Egoyan's protagonist's strategy of finding an authentic identity within either of Anglo-Canadian or Armenian worlds (2000, 112). Yet at the same time as Egoyan argues for wilful and performed identities in his early films, one of their essential features is his pointed criticism of Anglo-Canadian culture and his rejection of Canadian multiculturalism as a model of cultural integration. In the social relations among Egoyan's characters before *Calendar*, multiculturalism is depicted as an artificial con-

struct of a culturally dominant group, serving mainly to protect its own privileges while keeping immigrants on a socially lower level and under control. In these early films, the performative range of identities is thus expressed along a continuum that ranges from the stereotypical extremes of the male, sadistic, Anglo-Canadian oppressor at one end[5] to the idealized, tortured, female Armenian victim at the other.[6] Egoyan's ability to play on every possible shade and nuance between these two extremes, which in the early films yields ambivalent depictions of *both* Anglo-Canadian and Armenian characters, after *Calendar* leads him to more psychologically complex and less culturally and historically anchored constructions of performed identities.

The three characters in *Calendar*—the native Armenian guide, the bilingual wife, and the assimilated photographer—not only represent three levels of Armenian consciousness, that is, nationality, diaspora, and assimilation (Egoyan [1992] 1993, 41); they also cover the entire performative range of identities Egoyan had developed within the characters of the early films. With the character of the guide, played by Ashot Adamian—the first native (as opposed to diasporic) Armenian character in his films—Egoyan constructs a positive cultural archetype that condenses many of the characteristics of Armenianness he features in his early films and then deconstructs any idealization of this identity by playing with the cultural prejudices attached to this character. The guide initially shows a certain bohemian ease and a friendly curiosity. Unlike the assimilated photographer, he appears to be able to intuitively and sensually comprehend his native culture and environment. Yet the photographer's sarcastic comments about the guide's meandering explanations reveal some of the limits of his knowledge of his homeland. When the photographer tactlessly questions his financial motives, the guide reacts—understandably—by becoming deeply hurt. Retrospectively, this display of hurt feelings turns out to be a farce when, much later on in the film, it becomes clear that in this very moment of hurt the guide was already busy seducing his employer's wife behind the scenes. When toward the end of their trip he is asked by the photographer to explain himself, his evasive and trivial answers, going as far as to refer to the "evil and the divine," also completely disappoint any expectations one might have had regarding his genuine understanding of the spiritual implications of his culture.

The guide's negative and inauthentic performances of a "pure" national identity, unmarred by the experiences of exile and assimilation, are balanced against the "authenticity" and "naturalness" of the photographer's diasporic wife. Reminiscent of her performances in Egoyan's previous films, the character of Arsinée,[7] played by Arsinée Khanjian, represents idealized aspects of the Armenian diaspora: she preserves her native language and culture even though her life takes place away from the homeland. Her bilin-

gualism allows her access to both cultures, but in neither of them is she completely at home, and she speaks both languages with perceptible accents. Although the Armenian language is for the first time overtly identified as such in *Calendar*, it is not subtitled; the audience, like the photographer, depends entirely on Arsinée's translations of the guide's explanations into English. As she gradually develops a relationship with the Armenian guide and drifts away from her husband during the trip, she translates less and less and increasingly deviates from what is really being said within her translations. Through her, the Armenian language is thus raised to the level of a meta-language, representing an increasingly inaccessible cultural otherness to which Arsinée more and more belongs and from which the photographer and the audience are gradually excluded.

In three overlapping scenes toward the last third of the film, we witness an extraordinary development of this character as archetype. In the first, Arsinée and the guide (videotaped by the photographer) sit at a kitchen table, singing an Armenian song, which is familiar from the end credits in *Next of Kin*, as well as from *The Adjuster*, in which it is heard while Seta burns photographs from a neighbourhood in her home country. The next scene shows the image of a church and a decaying fortress, which slowly dissolves into bright white and is accompanied by the photographer's indirect, critical contemplation of the repercussions of the nineteenth-century arousal of nationalism. In the third scene, Arsinée appears to move toward and away from the camera within this landscape, an effect of the fast-forwarding and rewinding of the videotape by the photographer, until her movements finally end in a close-up. The Armenian song from the first scene is taken up again by a single female voice and intriguingly reinforced by an echo. The song lyrics tell the story of a man who compares the beauty of his lost lover to the flowers of the pomegranate tree. Within Egoyan's films, this recurring song (alluded to more obliquely once again in *Ararat* by the metaphor of the pomegranate seed) represents the complex emotional aspects of life for those in the Armenian diaspora. With this image of Arsinée set in the deeply melancholic Armenian landscape, with the church and the destroyed castle in the background, and resonating with the many associations of the song that accompanies it, Egoyan stylizes this character into a positive allegory of diasporic Armenian identity. Within the process of cultural repositioning, he seems to strive to transcend an entire thematic complex through her, before being able to leave it behind. Accordingly, what in the narrative of this film looks like the fateful event of an unwanted separation must rather be interpreted as a metaphor for a difficult but conscious farewell to an idealized identity, rather than to a spouse.

If the Armenian guide represents ambivalent qualities of the identity of the native Armenian, Egoyan assigns a variety of negative qualities to the

photographer that are familiar from Anglo-Canadian characters in his early films. First of all, the photographer annoys and disconcerts his travel companions with his urge to control. Instead of living up to an agreement whereby he and Arsinée could both have access to the video camera, he insists on keeping full control over every image produced in Armenia. Because he is constantly behind the camera, his own appearance is excluded from these images, with the exception of an image of his shadow and his oversized finger, which he points into the video frame in order to mark certain objects and which appears as an irritating gesture of patriarchal control and authority. He repeatedly interrupts the natural flow of events, cutting off Arsinée's translations, the guide's instructions, or his dinner conversations whenever his guests reach a touchy subject. Even the viewer is interrupted by his sudden fast-forwarding or rewinding of the video material.

The most intriguing transformation of a thematic complex in *Calendar* has to do with the photographer's ritualized dinners. Keeping in mind that the separation from his wife in *Calendar* represents a poetic metaphor for the loss of the original Armenian culture through the process of assimilation, Egoyan reverses the logic of his recurring motif of ritualized patterns of dealing with loss. Where in films like *Family Viewing* and *The Adjuster* these patterns lead to hatred, to death, or literally to nowhere, in this film the regularly scheduled ritualized dinners with escorts-for-hire appear to function rather like a therapeutic cure, resulting in wholesomeness and healing. Within this ritualized arrangement, the photographer stages the basic constellation of the loss of his wife: a bilingual woman of ethnic origins leaves him behind to turn to a (fictitious) lover of the same cultural origin, to whom she speaks on the telephone in her native tongue. In an act of displacement, the photographer attempts to overcome his own helplessness by confronting himself with the situation that had gone out of control, but this time within a controlled setting. Oddly enough, in *Calendar* the ritual actually works, and the photographer comes closer to authentic identity and a state of salvation than any of his predecessors have. Unlike these earlier characters, he does not remain attached to pathological, repetitive patterns and shifts the level of communication from a context where authentic connection is compromised by the transactional nature of the exchange to that of a personal conversation.

Throughout the film, the initially taciturn photographer gradually opens up and realizes that his rigidly scripted scenario is beginning to turn against his awakening desire to communicate. On a spontaneous impulse, he brings the ritual to an end and asks his last guest, who like him comes from the Armenian community of Cairo, to return to the table in order to continue the lively and playful conversation they had begun on their common cultural origins and their childhood memories of their assimilation to the Anglo-

Canadian environment. Thus, in a conciliatory gesture elegantly swaying between release and surrender, the process of assimilation is laid open and, in all its aspects, finally accepted.

After *Calendar*'s formal exercise, Egoyan's narratives' nodal points of idealized, criticized, or camouflaged ethnic identity, as well as their critical juxtaposition with Anglo-Canadian identity, are transformed into less judgmental, less self-reflexive, and more psychological explorations of characters and their experiences of loss, survival, and belonging.

Baroque Fragments: The Photographer's Variations on a Theme

If the way Egoyan draws together, condenses, and works through the thematic complexes visible in his early body of work in *Calendar* in order to be able to transform and finally transcend them generally evokes the musical exercise, his work also refers more explicitly at the level of theme and structure to the musical practice of theme with variations, which established itself in the baroque era. One particular example from this genre that is a most important intertext and a structural model for *Calendar* is Bach's *Goldberg Variations*. As taken up by Egoyan, these two musical forms—the exercise and the baroque theme with variations—are, however, loosely connected, since Bach's *Variations*, laconically subtitled *Clavier Übung bestehend in einer Aria mit verschiedenen Veränderungen vors Clavicimbal mit 2 Manualen* ("Keyboard Practice Consisting in an Aria with Several Modifications for Harpsichord with Two Manuals"), through the notion of practice and modifications, are themselves variations of the form of the exercise.

Like the exercise, the form of theme and variations also manifests itself at the level of the film's theme and structure but is intriguingly focused through the character of the photographer and his repeated rituals arranged in time. As elaborated above, during the course of a full year—which is structured by takes of the calendar on the wall next to the telephone, as well as by the photographer's dated announcements on his answering machine—the photographer relives his loss through a ritualized series of dinners with escorts. His lonely process of mourning within a varying but ritualized setting, the evocation of the trip to Armenia, and his reflection of this trip and the separation in a letter form the narrative frame of *Calendar* and create a musical dynamic that invites thematic as well as structural comparisons with Bach's *Goldberg Variations*.

Bach's first biographer, Johann Nikolaus Forkel, explains how the idea of the *Goldberg Variations* was born. A friend and admirer of Bach, Baron Keyserlingk, who as a result of a painful stone disease suffered from sleeplessness, mentioned to the composer how much he would appreciate some piano pieces of "gentle and lively character," which his protégé Johann Gottlieb

Goldberg could play for him at night. Bach considered the repetitive char-
acter of variations, a form he had neglected so far, to be the appropriate
musical remedy for his friend. When he handed over the completed
Clavierübung, Keyserlingk allegedly was so fond of the composition that he
rewarded Bach most generously. From then on it was apparently Goldberg
who had sleepless nights, since the baron demanded "his" variations again
and again (Forkel [1802] 2000, 102).

Another nocturnal sufferer hoping to find relief in the *Variations* is
described in the first chapter of E.T.A. Hoffmann's *Kreisleriana* (1814–15),
titled "Johannes Kreisler, the Director of Music's, Musical Sufferings." Com-
paring himself to a "recovering patient," the unrecognized musician Kreisler
outlines the "torments of hell" he had to endure during a social gathering,
a somewhat illustrious yet thoroughly bourgeois tea party that turns to mak-
ing music—a procedure Kreisler describes as a merciless massacre of art.
When the musician is urged to "fantasize a little" on the piano, he accepts
the *Goldberg Variations* someone hands to him, fully aware of the crowd's
ignorance and their expectation of coquettish variations popular at the time,
and so he plays on with grim determination. In his report of the evening, he
notes with satisfaction that already by Variation no. 15, not one single guest
remained in sight, except for the courteous host, who, quietly getting drunk
by the piano, endured until Variation no. 30. Carried away by the music,
Kreisler finally finds himself left in the sole company of "his Sebastian
Bach," a bottle of burgundy, and the servant, whom he describes as "spiritu
familiari." Shattered by the torturous gathering, he starts to write down the
events of the evening until the bottle of wine is emptied (Hoffmann [1814–15]
1983, 10–13).

Loneliness, isolation, illness, suffering, the sublimation of such suffer-
ing, and the therapeutic effects of repetitive settings and vespertine recitals
on melancholics in distress are themes Egoyan brings forth in *Calendar*.
The photographer's affinity to Bach and Kreisler is clear: he, too, is a recov-
ering patient and a *spiritu familiari* with this group of masculine sufferers.
Too wounded to accept the company of anyone close, singled out through
his pain, he withdraws and intuitively turns to a repetitive yet varied noc-
turnal arrangement, in hope for relief and healing. Just like poor Kreisler, he
feels isolated and misunderstood by his fellow human beings, and, staying
near the bottle of red wine, he opens his heart to a piece of paper, on which
he writes his sufferings. Where Kreisler counts the number of variations it
takes to chase away his audience, the photographer counts the number of
seconds it takes his wife to notice him.

Beyond these thematic connections are more formal, structural ones.
Both *Calendar* and the *Goldberg Variations* are characterized by a constant
change of tension, tempo, and rhythm, which play the full scale of techni-

cal, stylistic, and affective possibilities and result in an exciting interplay of contrasting forces.[8] As will become clear, beyond the complex surfaces of *Calendar* appears a rationally designed formal plan of construction that forms a stabilizing foundation for the artfully developed variations.

Bach's *Goldberg Variations* consist of thirty-two pieces altogether: one aria defining the theme, thirty variations on this theme, and the recapitulation of the aria at the end. In its serene tranquility, the aria frames the exuberant middle part. Every third of the thirty variations is composed as a canon, starting with a *canon all'unisono*, followed by a *canon alla seconda*, *alla terza*, and so on, up to *alla nona*. The variations culminate in the *quodlibet* of Variation no. 30, which instead of a canon is a canonical composition made of several independent melodies, the humorous exuberance of which seems to compete with its underlying melancholy.[9] The thirty variations are thus subdivided into ten segments consisting of three pieces each: two free variations (one study of composition, one of virtuosity) plus one canon *quodlibet* in Variation no. 30.

Calendar's narrative is similarly structured. The sequences consisting of the Armenian titles, the static views of two Armenian churches, and the video of the flock of sheep, which together open and close the film, refer to the question of cultural belonging. Like the aria, they reflect a melancholy, thoughtful mood, which forms a contrast to the dynamics of the film's lively middle part. This middle part can also be subdivided into ten narrative segments, which each consists of three different "variations" of the theme of belonging. One would think that the number of the photographer's dinners matches the number of the churches in the Armenian sequences, which, since they appear in the wall calendar, is logically twelve. But in fact it doesn't: only ten dinners are shown throughout the film. These churches and dinners subdivide the extensive middle part into ten Canadian and twelve Armenian narrative episodes, respectively—an inequality that seems to underline once more the incompatibility of the two cultural worlds presented. To simultaneously follow both narrative lines of this double-tracked construction, the viewer of *Calendar* basically has to split him or herself in two—and is thus forced to imitate the photographer's torn condition.

Throughout the entire middle part, the narrative seems to vacillate between these two worlds, yet, in the end, the photographer asserts himself as the single reflecting mind and *arrangeur* of the overall formal setting—of the dinners, as well as of the images of Armenia, which are filtered either through his perception or through his memory. He thus turns out to be the centre toward which the narration gravitates, and his dinners with the escorts prevail in subdividing *Calendar*'s middle part into ten narrative segments. Within each of these segments, the theme of loss is varied within three narrative levels—a two-plus-one construction that subtly echoes the

composition of the *Goldberg Variations*. The first level is the present; it consists of the photographer's ritualized dinners in his apartment. The second is the past, consisting of the sequences taking place at the church sites in Armenia. And finally, a superior narrative level of memory and reflection, within which the occurring events of the film are contemplated, consists of the video material viewed by the photographer after the trip together with his letter to Arsinée, which accompanies the narrative in the form of a voice-over spoken by Egoyan. The representation of each narrative level through a different instrument (film, photography, video/letter) adds to the musical, polyphonic impression.

Even traces of a cinematic *quodlibet* can be perceived in *Calendar*, although positioned at the beginning of the "dinner variations" rather than at their end. The dinner sequence in which the photographer pours the first glass of wine is followed by a church motif within which Arsinée translates the guide's explanations. After roughly one minute, Egoyan visually interlaces and acoustically adds another sequence: the nostalgic "video-memory" of Arsinée, which is accompanied by the warped sound of a stringed instrument. This music now runs at the same time as the dialogue taking place at the church site. Forty seconds later, the sequence of the photographer's dinner joins in, with his guest now talking at the telephone, accompanied by his choice of music, Vivaldi's *Four Seasons*. For the following two minutes, all three acoustic tracks, one out of each narrative level—past, present, and memory/reflection—run simultaneously. Only the satisfying click of the camera's shutter release brings the sequence to a sudden, but still musical, conclusion. This *quodlibet per definitionem*, very confusing to the viewer, gives a perceptible idea of the overwhelming multitude of impressions, memories, and emotions the photographer has to deal with at the beginning of the film.

A series of other, generally baroque structural elements can be discovered in this comparison, as, for example, the positioning of the photographer's crucial recapitulation of the trip to Armenia, which marks the beginning of his new understanding of cultural belonging: "We're both from here, but being here has made me from somewhere else." Without being titled as such, Variation no. 16 of Bach's keyboard cycle is composed as an overture, thus dividing the cycle symmetrically into 16:16 (1 aria + 15 variations : 15 variations + 1 aria) and placing a hidden new beginning within the exact centre of the cycle. In *Calendar*, chronologically as well as formally, the photographer's insight is positioned at the very centre of the film—between the fifth and the sixth dinners, between the sixth and the seventh churches and at exactly thirty-six minutes of the seventy-two-minute running time. Within *Calendar*'s symmetrical structure, the central placement of this statement allows one to literally identify this very sentence as the "hidden" new begin-

ning and revolutionary turning point within the film, as well as within Egoyan's cinematic oeuvre.

Another baroque device—quoting the art of the musical affects—appears at the moment of definite loss: at the twelfth church (recalling the twelfth Station of the Cross), where the photographer videotapes Arsinée and the guide disappearing together into the cave of a ruin. In Bach's *Matthäus-Passion*, for example, the moment of loss—the death of Christ—is expressed in a general rest (a considerable and complete silence). Similarly, in *Calendar*, after Arsinée and the guide have disappeared, the film has a complete halt: the image turns to black, and the silence is marked only by a treacherous noise from Arsinée, indicating the ongoing betrayal.

According to musicologist Rolf Dammann, within baroque music, numbers and the numeric structure of a composition represent the "keys to the treasury houses of an esoteric symbolism" (1984, 470, my translation). Not surprisingly, the interpretations of the intended mystical implications of the artful and enigmatic numeric arrangements of the *Goldberg Variations* have filled volumes. In *Calendar*, the noticeable numeric arrangement likewise leaves room for various interpretations: twelve churches, twelve months; ten dinners, ten women (ten different conversations, atmospheres, languages, types of music); three protagonists, three Armenian sensibilities, three levels of narration, three media; two countries, languages, and cultures; and finally, one remaining human being and—tracing an essential feature of the *Goldberg Variations*—one reflecting and structuring human mind—the *individual*: a Latin derivation equivalent to the Greek word from which Egoyan is named, *atomos*—the indivisible. Symmetry, rational proportions as a solid fundament to the abundant and manifold elaborations of a theme, numeric arrangements, the perceptible presence of an individual, artistic and structuring mind in the creative process of contemplation of worldly events— together these elements confirm the impression that Egoyan has sought to frame his composition within a baroque musical structure to house his own esoteric symbolism.

In his *Musicalische Paradoxal-Discourse* (1702), Andreas Werckmeister (1645–1706) laid out a structural understanding of baroque music.[10] Departing from the biblical quotation "Though you have ordered everything in terms of measure, number, and weight" (Lib.Sap. 11.21), so essential to the universalistic philosophy of the baroque era, Werckmeister perceived music as belonging to the quadrivial, that is "superior," natural sciences, which included arithmetic, geometry, and astronomy.[11] These four sciences were regarded as interrelated worldly manifestations of a cosmic principal of order. The divine will was perceived as the source of harmony, rational proportions, and genuine beauty. Corresponding to this universalistic outlook, Werckmeister describes the harmonic arrangement of celestial bodies as

being reflected within the harmonic proportions of music, a *"donum dei,"* which brings a notion of the divine into the worldly microcosm. This perception is enthusiastically shared and confirmed by the baroque philosopher Gottfried Wilhelm Leibniz, who wrote, "L'ordre, les proportions, l'harmonie nous enchantent, la peinture et la musique en sont les échantillons; Dieu est tout ordre, il garde toujours la justesse des proportions, il fait l'harmonie universelle: toute la beauté est un épanchement de ses rayons" ["Order, proportions, harmony delight us, painting and music are thereof the proof; God is all order, he always keeps the rightness of proportions, he creates universal harmony: all beauty is an effusion of his light"] ([1710] 1875–90, 27, my translation). In structuring a composition with regard to harmony and proportion, the baroque musician not only acts in accordance with divine principals; based on the observation that between music and the movements of the human soul exists a wondrous, almost mechanical correlation, he inevitably communicates these principles to the listener on a subconscious level, through the structure of his music. Three hundred years later, this understanding of harmony, proportion, and structure is echoed in Egoyan's conviction that the structure of a film gives access to the viewer's subconscious.

According to Werckmeister, the closer music remains to the divine principles—to unity, equality, and measured proportions—the more it causes pleasure, clarity, and the crucial enjoyment of the soul[12] within the listener. With increasing distance, on the other hand, these effects diminish until unequal proportions and multitude finally cause irrationality, sadness, and confusion. The theory of musical affects,[13] so essential to Bach's *Goldberg Variations*, relies precisely on such approaching and distancing from the divine principles of harmonious structure.[14] One could say that, within a cathartic process, musical affects were intended to cause the experience of a performed sensation within the listener—even by using disharmonies in order to emphasize unethical sensations and confusion, as, for example, in the dissonant chords accompanying the word "crucify" within the passion music of Heinrich Schütz or J.S. Bach. In *Calendar*, as the photographer goes through a repetitive and emotionally upsetting process, such dissonant sensations for the viewer are caused by structural inequalities, the dissociation of narrative levels, and rhythmic interruptions, such as when the photographer suddenly rewinds or fast-forwards the video material. The baroque listeners expected from music the experience of being emotionally overwhelmed and of living through heightened alternating emotional states. Their cathartic transformation was achieved when passions, after being aroused and experienced, were improved and finally quietened—on the condition that a rationally structured foundation guaranteed participation in the divine principles and thus the indispensable "enjoyment." A rational structure

therefore appeared as one of the fundamental requirements of a baroque composition. With a similar intention, Egoyan arranges the "variations" of the photographer's dinners in such a way that the viewer might initially find overwhelming. Through the self-tormenting evocation of his wife's betrayal within the ritual, the photographer consciously and repeatedly puts himself into situations that challenge his emotional capacity to the extreme, until finally the situation is transformed, resolved, and quietened. The audience, exposed to the film's formal structure, unconsciously participates in that process.

By modelling *Calendar*'s formal composition upon the baroque structure of theme and variations, and, in particular, upon Bach's *Goldberg Variations*, Egoyan satisfies several intentions. First of all, he is able to situate his protagonist, the photographer, within a genealogy of suffering males who seek solace and comfort and ultimately catharsis in repetitive structures. Second, the baroque elements offer a solid foundation that is able to manage the impact of the revisionist process of the entire thematic material; they stabilize the film's structure, allowing the abundant variations to unfold on top. Finally, and perhaps most important, through the distinctly spiritual implications Egoyan evokes through his baroque intertext and model, he establishes for himself a thematic constant, reminiscent of an organ point (another baroque device), which refers to a dimension that remains untouched by concerns of national identities, borders, and political events. Representing what remains eternally unchanged and what stands the test of time and history, this constant forms an intense contrast to the notions of nationalism and garrison evoked in the scene in which the photographer comments on the video image of a destroyed fortress: "All that's meant to protect us is bound to fall apart." Surprisingly, this hidden spiritual dimension stands apart from the most prominent and obvious motif of Christian spirituality in *Calendar*—the Armenian churches. If the presence of churches has led to the perception of a spiritual quality of the film, this perception may not be entirely accurate, for Egoyan considers their historical, aesthetic, and emotional value as icons of the Armenian history and culture yet carefully avoids getting any closer than that. Preferring to remain at a safe distance, he refuses to enter or touch the churches. Their relevance limited to a certain cultural context, the churches lend an iconically religious dimension to the Armenian landscape, but not a spiritual one to the entire film. It is the film's overall formal architecture rather than its iconography, then, that through unmistakable references reveals a much more subtle sacred space just beyond the film's visible surface—a hidden "thirteenth church" that we enter almost without our noticing.

Transforming the Ritual and
Classical Fragments

In a way much less dramatic than Egoyan's use of the baroque characteristics, but no less fascinating, *Calendar* delicately reflects fragments of the classical form. The late baroque era of composers such as J.S. Bach (1685–1750) or Handel (1685–1759), who were about to complete their oeuvres with sublime masterpieces, overlapped with a period of transition characterized by the search of a younger generation of composers—such as Bach's sons Carl Phillip Emanuel (1714–88) and Johann Christian (1735–82), or the early Haydn (1732–1809)—for a new style, which could not yet clearly be attained. The universalistic teachings of Werckmeister or of Athanasius Kircher (1602–80) disappeared into oblivion. Instead, the literary movements of *Empfindsamkeit* and Sturm und Drang prepared the ground for the musical writings of Ludwig Tieck (1773–1853), Wilhelm Heinrich Wackenroder (1773–98), and the before-mentioned E.T.A. Hoffmann (1776–1822), which laid out an entirely new, metaphysical approach to instrumental music. Within this transition, the notion that music offers a reflection of a divinely structured universe was replaced by the notion that it should offer an exploration of the human psyche; notions of exterior and universalistic were replaced by notions of inherent and individual, and music was more and more understood as the reflection of the human soul and spirit. Wackenroder, for example, writes,

> Nachdem aber die unaufhaltsam wirkende Natur die ursprünglich in eins verwachsenen Kräfte der Menschlichen Seele durch viele Säkula hindurch in ein ausgebreitetes Gewebe von immer feineren Zweigen auseinandergetrieben hat, so ist in den neueren Jahrhunderten auch aus Tönen ein kunstreiches System aufgebaut und also auch in diesem Stoff, so wie in den Künsten der Formen und Farben, ein sinnliches Abbild und Zeugnis von der schönen Verfeinerung und harmonischen Vervollkommnung des heutigen menschlichen Geistes niedergelegt worden. [Like the continuous effects of nature, which through many centuries have forced the initially unified forces of the human soul into an expansive tissue of increasingly refined branches, another, equally artful system of tones has been built in more recent centuries, which, like the arts of form and colour, results in a sensuous image and proof of the beautiful refinement and harmonious improvement of the present human spirit.] ([1799] 1973, 77–78; my translation)

The composers of this period strove to develop a form through which individual sensibilities, heightened to an ideal, could be adequately expressed. This development from baroque to classical style was perceived not as a natural evolution, but as a dramatic shift in paradigms. The notion of a historical moment that offers a passage from one style to another also

sheds a light on the position of *Calendar* within Egoyan's oeuvre. The protagonist, on the point of performing a crucial transition, shifts his focus from one cultural identity to another, a shift that itself is in preparation of a change of a stylistic paradigm. The film's presentation of the nascent possibilities of a not yet fully articulated or even perceived new style, its experimental approach permitting occasional stylistic eccentricities, and a certain appealing simplicity and coarseness in the thematic material together suggest parallels to elements of this pre-classical period.

By the last quarter of the eighteenth century, the stylistic uncertainty of the pre-classical period ended with the development of what is now called the classical form in music. Formally, this period is defined by the structure of the first movement of a sonata or symphony, the so-called *Sonatenhauptsatzform* (sonata form).[15] Breaking down the formal arrangement of *Calendar* according to the sonata form reveals partial overlaps with the comparison to baroque structures. The sonata form consists of three different segments—exposition, development, and recapitulation—which can be preceded by an introduction and concluded with a coda. Unlike the contrapuntal baroque structure, which does not really bring about an autonomous second theme, in the sonata two contrasting themes are introduced within the exposition—the first one in the tonic key, the second in a closely related key, most often the dominant. Characteristically, the contrasting natures of the two themes were described by notions of the masculine and energetic on one side and of the feminine and lyrical on the other. In the middle part, the development, the thematic material is combined, transposed, opposed, changed in harmony, rhythm, and tempo, and finally brought to a dramatic conflict in its last quarter, which then leads to the reprise. This last formal segment is characterized by a lower level of tension, a conflict resolution, and the resumption of both themes in the tonic key.

In *Calendar*, fragments of a three-part arrangement reminiscent of the sonata form can be perceived. The opening sequence is followed by an impressive exposition of almost ten minutes. It starts with the photographer's video shot, taken from the moving car, of Mount Ararat and of a flock of sheep and lasts until the first time he sends his dinner guests to the telephone by emptying the bottle of wine. Within these first ten minutes, the film's entire thematic and structural material is on display: Armenia and Canada; homeland and diaspora; nature and urbanity; masculinity and femininity; churches and dinners; the characters and their cultural and social positions; separation, loss, and ritualized patterns of dealing with these; the fight over the control over image production; the narrative use of three different visual media plus the answering machine; multilingualism; the simultaneity and dissociation of acoustic, visual, and narrative levels throughout the entire film.

Although the middle part can be related rather to the variations of baroque structures, it also implies elements of a classical development. The narration meanders through the intricately interlaced sequences of the ritualized dinners and the developing conflict between the three protagonists. The thematic material is being juxtaposed, compared, combined, separated, and put through modifications in tempo, rhythm, and harmony. Playing with the notion of contrasting themes, Egoyan assigns notions of defeat and melancholy to the masculine theme, which is supposed to be strong and energetic, represented by the assimilated photographer—while the feminine, lyrical theme, represented by Arsinée, is full of vital energy. The closely related "key" between the separate couple—their common cultural background—as well as their incompatibility and the painful deviation from this key on the photographer's side, are constantly played in the foreground. The notion of a dramatic climax of the middle part, however, is distinctly underplayed; it ends laconically in the sequence in which Arsinée and the guide, videotaped by the photographer, disappear into the ruins.

Accompanied by a complete change of tone, a recapitulation of about twelve minutes sets in. As opposed to the middle part, this last part of the film—especially its notions of resolution and of transformation—are meaningfully supported by classical elements again. It begins with the last dinner of the photographer and ends with Arsinée's last message on the answering machine, in which she reveals the beginning of her betrayal. The conversation by which the photographer brings the series of ritualized encounters to an end is characterized by a bright tone; the initially troubling theme of social and cultural belonging underlying the entire narrative is resumed and brought to a resolution. Arsinée's message indicates that a full year has passed by—a natural cycle is completed. Basically, the narration ends here. It is framed by the atmospheric static views of the churches that, in imitation of introduction and coda, respectively, open and close the film.

According to American pianist and musicologist Charles Rosen, the sonata is characterized less by a prescriptive formal scheme than by a specific way of "musical thinking," which implies a certain sense of direction, a complex understanding of tonality and of formal, inner coherency ([1971] 1983, 22–29). The introduction of a hierarchically structured tonal system that emphasizes the significance of parallel and related keys offers a frame of reference within which contrasting thematic material can be developed dynamically and brought to a resolution. Noticeably, toward the end of the film, *Calendar*'s indebtedness to the sonata thus extends beyond its formal structure into the film's thematic dynamics. The vital importance of the photographer's need to transform himself in order to be able to deal with his history on a different mental and emotional level is made perceptible within

the recurring juxtaposition of the two contrasting themes—Armenia/ Canada—by their treatment within various moods, settings, narrative levels and media, as well as within the protagonist's contemplative reflection of the events that are crucial in initiating the transformative process. Within his reflections, the classical aspect of transcending the human psyche onto the level of the ideal is underlined in the nostalgic transfiguration of Arsinée. By the end of the film, the rigid setting of the ritual is resolved, and a new state of mind, a new personal identity, a new level of development is reached—a fact acknowledged almost with an air of surprise, a trace of melancholic regret, and, finally, serene acceptance. Whereas the baroque fragments seem to refer to universalistic transcendence and the position of the individual within this structured universe, classical elements seem to prevent the film's narrative from weighing too heavily on the themes of loss and separation; instead they add to the film's lightness by emphasizing a certain upward movement that results from their emphasis on the possibilities of contemplation, sublimation, and the transformation of life's events.

A Brief Note on Serial Music

The repetitive elements in the series of dinners and of church sites in *Calendar* may lead to the notion that a comparison to serial music might be relevant, yet the understanding of the term *serial* as referring to repetitive elements is misleading. As a method of composition, serial music developed after the Second World War among European composers such as Karlheinz Stockhausen, György Ligeti, and Pierre Boulez. Almost obsessively, they strove for a "purification" of the process of composing from any possible link to Romanticism and other European musical traditions, which in their opinion had served the fascistic ideology. This purification was achieved through a rigid, complex, arithmetical, and highly prescriptive methodology, based on the ideas of Anton Webern, Arnold Schönberg, and Claude Debussy, that gave the composer utmost control over every possible, digitally measurable element of the composition. Within this theoretical system, *serial* referred to a series of notes (in which repetitive elements were even strictly prohibited in the beginning) that related to each other within specific numeric proportions. In a hierarchically organized process of composing, these numeric proportions of the initial series—which did not imply immediate metaphysical references, as did the baroque elements—were abstracted to become binding as an overruling principle for every aspect of the entire composition, including rhythm, harmony, and tonal qualities. Even though this method initiated groundbreaking developments within contemporary music, the main problem of serial music remained its limited possibilities of reception. The audience was not able to perceive, let alone comprehend, either on a conscious or an unconscious level of perception, the theoretical

intentions of a complex process of musical abstraction—another reason why the comparison to *Calendar* does not appear as relevant, since the film's structure as well as its implications are perceptible, at least on "some level" as Egoyan has mentioned (Harcourt 1995b, 6).[16]

Conclusion

Egoyan probably did not consciously intend to introduce metaphysical or spiritual dimensions by quoting elements from baroque, pre-classical, and classical music within the structure of his film. His trip to Armenia might well have had emotional effects on him that were difficult to capture on a conscious level at the time, thus provoking their artistic treatment through forms available to the trained musician on another level. Also, while baroque audiences expected and demanded a spiritual dimension within music, the viewer of Egoyan's films is not necessarily oriented in that way. But keeping Egoyan's understanding of structure in mind, it is possible to imagine that within a contemporary audience, a certain sensorium had survived, allowing us to perceive and to accurately interpret such structural implications. In an environment oscillating between the rise of religious fundamentalism on one hand and the desacralization and commercialization of life, skepticism toward official religious institutions, and the search for spirituality within commercialized esoterics or undifferentiated "designer religions" on the other, it is a delicate venture for a contemporary artist to refer to spirituality in any way. It seems all the more remarkable to me that Egoyan, consciously or unconsciously, through the musical structure of his film, retraces and subtly re-establishes the link between the artist, the work of art, and the spiritual. This subtlety is understandable, but considering the fact that the Armenian people were the first to adopt Christianity as a state religion (in the third century), so that it represents an essential aspect of the Armenian culture, Egoyan's overt and more extensive treatment of the religious question should be extremely interesting to watch.

The last words of the film are Arsinée's haunting and echoing questions left on the answering machine: "Were you there? Are you there?" Besides representing a cultural confession and an artistic turning point that revolutionizes and transforms an entire oeuvre, thematically and structurally *Calendar* appears to articulate a certain understanding of life as an artist. Whether here or there—that is, whether at home or abroad, native, in diaspora, or assimilated, separate or united—a reflecting, structuring, and creative individual remains in the end. This border-crossing comprehension and appreciation of the possibility of an individualistic perception of life and life's events and of their reflection and transformation through a genuinely artistic process seem to reveal the film's innermost statement—comforting and inspiring to the receptive viewer as well as to the maker.

Acknowledgments

I would like to express my sincere gratitude for their support to Peter Ackermann, Stuart Cockburn, Markus Hinterhäuser, Roman Hurko, Philipp Hoffman, Christa Kegel, and the editors of this volume, Jennifer Burwell and Monique Tschofen.

Notes

1 "Music is an arithmetic exercise, during which an unconsciously performed counting occurs within the soul" (my translation).

2 A literary example modeled on a musical exercise is Raymond Queneau's *Exercices de style*, which he wrote after having listened to a performance Bach's *Art of the Fugue* (1750).

3 See Kegel 2003.

4 In *Ararat*, of course, this entire complex is revived and made transparent through historical parallels.

5 See, for example, Stan in *Family Viewing*, the Producer in *Speaking Parts*, and the director of the censorship board in *The Adjuster*, all performed by David Hemblen.

6 See, for example, Van's mother in *Family Viewing* and Seta in *The Adjuster*, both played by Rose Sarkisyan.

7 In this chapter, I use Arsinée Khanjian's first name for this character, since she is explicitly called so in the film; Egoyan's character is never called "Atom," however, so I use "the photographer" for this character. The frequently evoked parallels between these two characters and the actual couple Egoyan/Khanjian are wilfully deceiving to the viewer. Because of this, it is important to keep in mind the fictional nature of the character.

8 Compare Dammann's formal characterization of the *Goldberg Variations* (1986, 74–78).

9 Forkel reports that after the obligatory singing of chorals during their annual gatherings, the Bach family, mainly consisting of musicians, would arrange ordinary folk songs in an improvisory way into *quodlibets*, in which occasional obscenities evoked much laughter in singers as well as in listeners ([1802] 2000, 20). As if in a nostalgic evocation of these joyful gatherings, Variation no. 30 playfully picks up the tunes of two different folk songs. *Kraut und Rüben haben mich vertrieben* (approximately, "A higgledy-piggledy mess has swept me away") alludes to the confusing "mess" of variations left behind, and the longing melody of the folk song titled *Ich bin so lang nicht bey dir gewesen, rück her, rück her* ("I have not been with you for such a long time, come close, come close") refers to the imminent return of the aria that opens and completes the cycle.

10 One of Bach's cousins had studied with Werckmeister, and it is known that he was given a copy of this text upon his leaving. Considering Bach's profound interest in musicology, theology, and pietistic mysticism—his library contained about one hundred books referring to these issues—it is assumed that he was familiar with the *Paradoxal-Discourse*. In any case, Bach's compositions intimately reflect Werckmeister's writings. In his film *Werckmeister Harmonies* (2000), Hungarian filmmaker Bela Tarr also refers to the musicologist and to the influence he had on the temperature of the musical scale.

11 The (trivial) "inferior" sciences were grammar, rhetoric, and dialectics.

12 "Ergötzung des Gemüths" in the German baroque language (Damann 1986, 77).

13 Composers of the seventeenth and the first half of the eighteenth century had created an immense variety of technical devices to perform distinctly musical imitations of events—natural events, human activities, emotions. In his film *Tous les matins du monde* (1991), Alain Corneau contemplates the significance of the theory of musical affects through the musician Sainte Colombe (Jean-Pierre Marielle), who stands for an almost esoteric interpretation of the theory, covering aspects of natural philosophy as well as of baroque mysticism. In the film Sainte Colombe is praised as having the ability "to imitate every possible nuance of the human voice; from the sigh of a young woman to the sobs of an old man, from the battle cry of Henri de Navarre to the gentle breaths of a sleeping child."

14 It appears as a peculiar coincidence that one of the most affecting documents of the affectations and their transcendence is given by Egoyan's famous countryman Glenn Gould. In the legendary recording of the *Goldberg Variations* from 1981 documented for TV by Bruno Monsaingeon, Gould plays the second aria, which completes the worldly microcosm of the thirty variations so tenderly, serenely, and otherworldly that the receptive listener literally risks being carried away. Monsaingeon's visual documentation gives deeply moving evidence of an act of wilfully chosen, contemplative solitude, the striving for transcendence and its apparent fulfilment in the second aria.

15 It should be mentioned here that the *Sonatenhauptsatzform* was defined only *retrospectively*, by the Austrian composer Carl Czerny around 1840. Czerny's concept is not unproblematic since it retrospectively suggests the existence of a consciously perceived, prescriptive formal scheme that had to be followed in order to be composed in the officially "right" way (Rosen [1971] 1983, 32). Considerable and frequent deviations from this scheme, especially in most refined manifestations of the classical form, seem to emphasize the insufficiency of such a prescriptive model.

16 "I think that there is something there that you must be able to feel, that there is an energy at work that I trust my audience will be able to pick up at some level" (Harcourt 1995a, 44).

Works Cited

Bohr, Alexander, dir. 1995. *Atomstrukturen: Die Filmwelt des Atom Egoyan*. TV documentary. Germany: ZDF.

Dammann, Rolf. 1984. *Der Musikbegriff im deutschen Barock*. Laaber: Laaber-Verlag.

———. 1986. *Johann Sebastian Bach's "Goldberg Variationen."* Mainz: Schott.

Egoyan, Atom. [1992] 1993. "Gespräch mit Atom Egoyan über *Calendar*." Interview by Tim Shary. In *Internationales Forum des Jungen Films*. [Festival Catalogue], 41. Translated by the editor. Berlin: Freunde der Deutschen Kinemathek.

Forkel, Johann Nikolaus. [1802] 2000. *Ueber Johann Sebastian Bachs Leben, Kunst und Kunstwerke*. Berlin: Henschel.

Harcourt, Peter. 1995a. "Atom Egoyan: An Interview," *CineAction* 16 (Spring 1989): 40–44.

———. 1995b. "Imaginary Images: An Examination of Atom Egoyan's Films." *Film Quarterly* 48, no. 3: 2–14.

Hoffmann, E.T.A. [1814–15] 1983. *Kreisleriana*. Stuttgart: Reclam.

Kegel, Katrin. 2003. *Auf der Suche nach dem authentischen Stil: Ethnizität in den frühen Filmen Atom Egoyans*. Master's thesis, Johann Wolfgang Goethe-Universität.

Kraus, Matthias. 2000. *Bild–Erinnerung–Identität: Die Filme des Kanadiers Atom Egoyan*. Marburg: Schüren Verlag.

Leibniz, Gottfried Wilhelm. [1710] 1875–90. "Essais de Theodicee." In *Die philosophischen Schriften von G.W. Leibniz*, vol. 6, ed. C.I. Gerhardt, 21–471. Berlin: Akademischer Verlag.

Leibniz, Gottfried Wilhelm. [1712] 1738–42. Letter to Christian Goldbach. Hannover, April 17, 1712. In *Epistolae ad diversos*, 242–43. Leipzig: Breitkopf.

Naficy, Hamid. 2001. *An Accented Cinema: Exilic and Diasporic Filmmaking*. Princeton, NJ: Princeton University Press.

Rosen, Charles. [1971] 1983. *Der Klassische Stil*. Translated by Traute M. Marshall. München: Deutscher Taschenbuch Verlag.

Wackenroder, W.H. [1799] 1973. "Das eigentümliche Wesen der Tonkunst und die Seelenlehre der heutigen Instrumentalmusik." In *Phantasien über die Kunst für Freunde der Kunst*, by Ludwig Tieck and W. H. Wackenroder, 77–78. Stuttgart: Reclam.

Werckmeister, Andreas. [1702] 2003. *Musicalische Paradoxal-Discourse*. Laaber: Laaber-Verlag.

▶▶▌ 5

The Passing of Celluloid, the Endurance of the Image
Egoyan, *Steenbeckett*, and *Krapp's Last Tape*

David L. Pike

The Chill of the New, The Glow of the Old

I find cinema is a great medium to explore ideas of loss, because of the nature of how an image affects us and how we relate to our own memory and especially how memory has changed with the advent of motion pictures with their ability to record experience. Our relationship as filmmakers to those issues has changed radically over the past fifteen or twenty years. And people in our society have the instruments available to document and archive their own history.
— Atom Egoyan, in interview with Richard Porton, 1997

Here I end this reel. Box—*(pause)*—three, spool—*(pause)*—five. *(Pause.)* Perhaps my best years are gone. When there was a chance of happiness. But I wouldn't want them back. Not with the fire in me now. No, I wouldn't want them back.
— Krapp, recorded at age thirty-nine, in Samuel Beckett,
Krapp's Last Tape, 1958

Introducing a post-screening discussion of his new adaptation of Samuel Beckett's dramatic monologue *Krapp's Last Tape* (1958), at the 2001 New York Film Festival, Atom Egoyan told the audience that he had first read the

play as a teenager, and that it had changed his life, inspiring the node of ideas that had generated his first six feature films.[1] It was, of course, a quintessentially Egoyan moment, framing the new film in a cyclical image perfectly formulated to duplicate Beckett's themes of memory, loss, alienation, and the technological reproduction of the past. "The things that I've been drawing on for the past 10 years are basically the literature and theatre and film I saw in my late adolescence and early twenties," Egoyan said in an interview at the time of the release of his breakthrough film, *Exotica* (1994). "That continues to be very inspiring to me, but it's time to make myself more aware of other influences" (Egoyan 1995b, 67). For Egoyan, as a feature filmmaker, this awareness has meant working for the first time with other people's stories (something he had been doing since the mid-1980s in television commissions); however, it has also meant a lateral movement, not so much away from those earlier influences as into other means of expressing their thematics and concerns: through opera productions, omnibus commissions like *Sarabande*, a dramatization of Bach's *Cello Suite No. 4*, *Krapp's Last Tape*, and art installations at the Oxford Museum of Modern Art, the Irish Museum of Modern Art in Dublin, the Venice Biennale, Le Fresnoy in France, in Montreal, and at the former Museum of Mankind in London, where *Steenbeckett*—a stunning meeting between an editing table and *Krapp's Last Tape*—was on show for a month in early 2002. *Steenbeckett* demonstrated once again that Egoyan is his own best exegete, but it also demonstrated perhaps more pointedly than ever his ongoing desire to make a critical tool out of the fabled hermeticism of his works. In this essay, I begin with *Steenbeckett*'s confrontation of analogue and digital technology to hypothesize an analogy between, on the one hand, the seamlessness of digital technology, Egoyan's understated but evident mastery of it, and the formal perfection of his works and, on the other hand, the tenuous materiality of celluloid and of magnetic tape and the rips, tears, and gaps that have, intentionally or not, insinuated themselves into the Egoyan oeuvre just as they do into the physical world.

The centrepiece of *Steenbeckett* as shown at the former Museum of Mankind was a large, darkened room, through which threaded two thousand feet of 35mm celluloid in what one reviewer aptly termed a "cat's cradle" of film stock, powered by a mammoth Steenbeck editing table in the back of the room (Hirst 2002, 4). The film is an unspooled reel double the standard length, specially ordered from Kodak to match the Steenbeck's capacity. Printed on it were the final twenty-one minutes of *Krapp's Last Tape*, a single take of John Hurt's bravura performance as the sixty-nine-year-old title character with a reel-to-reel, playing over a tape he made thirty years before while listening to a tape he made some ten years before that. Like the collection of tape spools on which Krapp annually recorded his birthday ruminations, the celluloid preserved a specific performance. As Egoyan

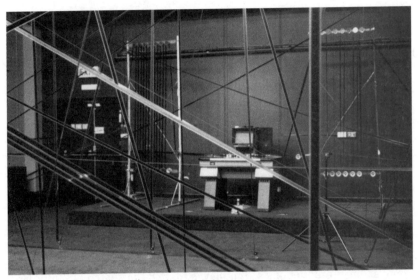

Steenbeckett: An Installation: The main room. (© Artangel)

remarked, "there's physical effort involved in holding the gaze; the camera-man was sweating and his efforts corresponded with John Hurt's endurance and stamina" (Egoyan 2002b, 49). But the celluloid also was projected here in a demonstration of the instability and time-bound quality, not only of memory, but of the material technology on which it was recorded: "As scratches and dust gather, the sound and image will deteriorate more and more, while the digital projection next door remains perfect" (Egoyan 2002b, 49). Just before entering the room of spooling film, the visitor would pass through a narrow corridor on one full wall of which the same film was projected in its entirety on a sublimely large scale from a DVD player behind it. At one corner of the makeshift screen, a square had been cut out to allow the visitor to glimpse, at the far end of an otherwise empty room, the new-fangled machine capable of repeating the same sequence of images, over and over, without ever changing or deteriorating (or, at least, so they say). In one room, then, with barely enough space to stop, look, and listen, there was the extraordinary sight of Hurt's expressive features blown up to the size of a wall, caressingly laying his face atop Krapp's reel-to-reel. In the room next door was the material stuff of so many dreams, being unmade on a table just like the one on which it had previously been assembled—for, to edit *Krapp's Last Tape*, "unable," Egoyan wrote, "to resist the possible confluence of form, content and process," he had returned to the machine he had not used for nearly ten years (Egoyan 2002a, 12).[2]

Obsolete technology, especially when associated with distant memories, tends to accumulate a patina of nostalgia; no longer called on to sym-

bolize the progressive ideology of modern technology, it can revert to some-
thing natural, become in retrospect warm rather than cold.[3] It thereby reminds
us of our irrational need to separate technology from nature, to define moder-
nity by relegating to the past whatever is by contrast no longer modern.
When Beckett wrote his play in 1958, the tape recorder would have had a
very different resonance, as a cutting-edge technological innovation newly
arrived on the recently created home recording market.[4] Conceived by Beck-
ett originally as a technical solution to the desire to reproduce in stage terms
the different temporal layers of an aging man's memories and, more contin-
gently, to take advantage of the "ruined" quality of Patrick Magee's voice
(the play was conceived for Magee), the tape recorder, if anything, would have
been a novelty rather than a machine as old as the man operating it, as it
appears in Egoyan's film (Knowlson 1992, xiii).[5] Indeed, Beckett's chronol-
ogy is an impossibility: there are nine boxes with five spools each, one for
each birthday, meaning that logically the first would have been recorded
when Krapp was twenty-four, in 1913.[6] While Egoyan's film took the same
route as most productions of the play, stressing the shared antiquity and
obsolescence of man and machine, *Steenbeckett* proposed both interpreta-
tions in contiguous rooms.

The major distinction between *Steenbeckett* and *Krapp's Last Tape* com-
pared with Egoyan's other cinematic depictions of the relationship between
human beings and media technology is the way the former stress oral and
tactile qualities while the latter are primarily visual. Egoyan heightened this
effect at the installation by causing the visitors to enter by ascending a steep,
narrow, and claustrophobic black velvet–lined stairway and corridor. You
could hear the whirring and rustling of the rapidly moving film but could
not yet see it. The first view of the main room, which had been a small cin-
ema used for screening ethnographic films, came from above, through the
double glass wall of the projection booth, but it was so brightly lit and so dis-
tant from the small viewing screen of the Steenbeck that it was difficult to
take in much detail beyond the shadowy whirring of strips of film, like a for-
est of symbols sheltering a rare beast. Later on, you could hear the sound-
track from the digital screening of the film before turning a corner and find-
ing yourself in the corridor, this time dwarfed by the image rather than
squinting to see it. Rather than the accustomed position(s) in the idealized
centre of the movie-theatre seats or the living-room sofa, you experienced
Krapp's Last Tape from a series of perspectives familiar perhaps to film tech-
nicians and projectionists but not to audiences and consumers. Moreover,
few if any of the visitors to the installation would yet have seen the film
itself, although they might have caught the Hurt performance live, so the
experience was doubly unfamiliar, not to mention uncomfortable, if you
actually wanted to watch the film, as most visitors did.[7]

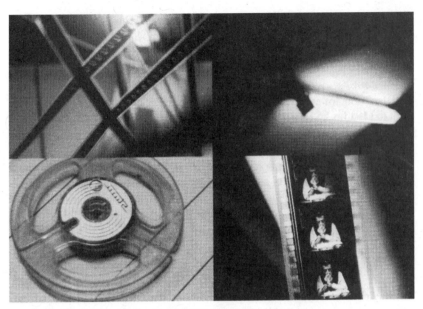

Steenbeckett: An Installation: Four details of the installation. (© Artangel)

Between the screening window and the projection corridor, Egoyan installed a series of rooms with tableaux especially suited to the Department of Ethnography of the defunct Museum of Mankind: another editing table, with gloves and strips of film; a dismantled reel-to-reel; metal filing cabinets full of film spools and other antiquated recording media; a landing with scattered ethnographic films out of the museum collection piled on both sides of a stairway cut through its centre, spilling out of their canisters, and including titles of both Canadian and international origin; on the wall behind, yellowing mimeographs encased in peeling plastic, of typewritten instructions for operating the Steenbeck machine. Downstairs, where you could already hear Krapp's voice somewhere offstage, were metal shelving with tape strips and more equipment. In sum, the typical paraphernalia of a decrepit institution—a decrepitude made all the more poignant by the knowledge that the very discipline it had been intended to monumentalize has itself been made obsolete, its "objective" mode of anthropological observation and recording discredited. There's a moment in Claude Massot and Sebastien Regnier's documentary *Nanook Revisited* (1994) when an Inuit filmmaker runs Robert Flaherty's landmark ethnographic feature of Eskimo culture, *Nanook of the North* (1920), through a viewing machine, and amuses himself by telling his audience how the director and the actors staged each supposedly authentic scene. But then the film cuts to an Inuit audience watching the footage, talking about memories of the departed friends and family preserved onscreen, and enjoying the fictionalization.[8] From where was

the global audience for these home movies gathered to the Museum of Mankind? What could be more melancholy than these endless spools that had lost their currency as science, that would never be reunited with those who could remember them, that were rapidly disintegrating from the chemical instability of their nitrate or acetate base, and that could provoke from the disconnected urban souls who passed them by nothing more than a generalized feeling of loss?[9]

This is the enigma of the solitary Krapp as well, whose treasured collection of tapes will have no meaning for anyone once he is gone; no one will even come to sift them through, and they will slowly decompose in their shelves in his basement closet. Before we generalize from Krapp's plight to the fate of world culture, however, let us recall that Beckett in fact resisted the standard interpretation of his day, which would have resolved this enigma by making of Krapp an Everyman figure, asserting instead that "Krapp is not a way of looking at the world.... No, this is just Krapp, not a world-view" (Knowlson 1980, 70).[10] The installation's title, although not as scatologically irreverent as Beckett's wordplay, surely indicates Egoyan's appreciation of the tragic absurdity inherent in the melancholy conjured up by the passing of so much celluloid, the loss of cultural memory represented by these scattered canisters, evidence of so much misplaced collecting, documentation, and archival fervour.[11] After all, at the installation, we only even consider this material because we must pass through it to get to the Beckett room glimpsed at the beginning; spliced into our memories on the editing table, these relics of the Museum of Mankind have nothing of the idiosyncratically affective connection of Krapp to his tapes, of the individual to her or his memories. "The sour cud and the iron stool" is how the aging Krapp describes the passage of his days (Beckett [1958] 1992, 9)—rumination and constipation, as Beckett explained to Magee when the latter asked him what the devil it meant.[12] Egoyan has taken an industry workhorse, a machine intended to cut up and excrete as efficiently as possible, and transformed it into a Steenbeckett, passing the same reel of film over and over through its stomach, the iron stool stuck defiantly in its innards until the show closes down, the machine is dismantled, and the film reverts to its "proper" purpose of preserving Beckett as a classic in the archives of Channel Four.

As in his other installations, in *Steenbeckett* Egoyan returned to his own roots in the theatre and art world to stage his films, to betray their essential nature as endlessly repeatable screenings by rendering them into unique performances. *Steenbeckett* is certainly the most vertiginous of these performances, since it staged a filmed version of a play itself built around the issue of the mechanical reproduction of a theatrical performance. One of the peculiarities of staging *Krapp's Last Tape* is that the performance is neatly split between the near silence of the present-day Krapp and the crucial mod-

ulations of voice on the pre-recorded tape; one varies from night to night, the other does not.[13] Moreover, the central action of the play, the primary physical movement, involves a perfect mastery of the timing and mechanism of the tape player. The actor Donald Davis is famous for having operated the tape himself in the American premiere at the Provincetown Playhouse in New York in 1960, causing great difficulties for his less technically adept successors in the role (Knowlson 1980, 58–64).[14] Of course, Egoyan's installation did avoid the contingency of live actors, but it compensated with a comparable analogy between our sense of the tactile, personal, and transient nature of celluloid, Steenbeck, and theatre, and the mediated, impersonal, and permanent nature of the digital image. "It is difficult to view the new technology with the necessary tenderness," Egoyan confessed, just as five years earlier while editing *Sarabande* he had registered his "shock" that "all this technology really does, despite the fact that it allows us to do something so much faster than it was ever possible to do with a Steenbeck, is make us more anxious" (Egoyan 2002a, 12; Egoyan 1997, 12).

There is a deep-seated suspicion of new technology that emerges even as Egoyan asserts a sincere belief in the need to approach its ambiguities with a level head and avoid "demonizing" it. Many critics of Egoyan's films have tended to pick up on the emotional resonance of the former rather than the intellectual issues of the latter. Likewise, quite a few reviewers of the installation saw its primary theme as some manner of "lament" for "specificity, individuality, the here and now" or "on the passing of film's unparalleled ability to burrow into your imagination in the dark" (Jones 2002, 25; Januszczak 2002). I address the ramifications of this tension in Egoyan's oeuvre in more detail below. For the moment, I want to focus on his consistent effort to not unduly privilege the past over the present mode of visual reproduction or to consider one to be in any way separable from the other. Something is lost, but there is no going back, and to force the issue would only lead to empty misunderstanding. "I am not nostalgic about the ancient technologies of mechanical film splicers, bins of dusty celluloid, and the behemoth that was the editing machine—the mighty Steenbeck," Egoyan wrote in hyperbolic defiance of the explicit message of his own installation. "I am a practical person. Digital technology has saved me time, and given me the comfort that my work will last, if not forever, then certainly for longer than it would have. I am writing this essay on a computer, much as I edited my last few films on a digital system" (Egoyan 2002a, 12). By going rhetorically so far out of his way to disclaim the Luddite reading he knew most visitors would take away from the installation, Egoyan underlined a split in his own work between what we could term a practical and an emotional attitude toward technology. Thematized in his early films as the difficult negotiations of updating the world of human emotions and desires to a dig-

ital age, these conflicting attitudes were represented visually as the contrast between film and video that in fact also characterized Egoyan's own means of production. As means of production became more and more dominated by digital from the mid-1990s on, the split no longer found a recognizable form of representation onscreen. Egoyan's works have always had the capacity to resolve themselves into facile postmodernist conclusions about the loss of immediacy, about alienation and the danger of the image. What becomes especially clear with the more extreme and less easily reconcilable form taken by the dialectic of technology in *Krapp's Last Tape* and *Steenbeckett* is that Egoyan's works have also always demonstrated ways in which the polarization of outmoded and novel technology works to constitute the meaning of each, blocking analysis of the repetition of an identical relationship with a new object of time-saving innovation. Celluloid and analogue haven't actually disappeared any more than manuscripts, books, or LPs have, but they have ceased to typify the contemporary as they did back not so long ago when their deleterious effects on society vis-à-vis theatre and print culture were all the rage of cultural criticism. Digital has now become both the container for all the fears about the future elicited by new technology and the means with which to represent those fears, primarily through contrast with the now sanitized, detoxified, and nostalgia-infused mode of analogue.

The Absurd Object of Desire

What happened, starting with *Family Viewing*, was that I pulled back and said, "Okay, if I have to make the formal plan really obvious in order to stake my terms, so be it." Then I started this investigation of the film texture in a much more controlled way. That reached its peak with *The Adjuster*, which I now look at and kind of gasp at because it has reduced emotions to *such* a degree. I mean, these people are so gone, so beyond the point of return, it becomes absurd. A lot of the humour of the film is the result of how far gone these people are. They're all on the verge of suicide. If they can even muster *that* amount of emotional response.

— Egoyan, in interview with Geoff Pevere, 1995

He stoops, opens drawer, feels about inside it, takes out a banana and bangs drawer shut. He advances to edge of stage, halts, peels it, drops skin at his feet, puts end of banana in his mouth and remains motionless, staring vacuously before him. Finally he turns aside and begins pacing to and fro at edge of stage, in the light, i.e. not more than four or five paces either way, meditatively eating banana. He treads on skin, slips, nearly falls, recovers himself, stoops and peers at skin and finally picks it up and throws it away backstage left. He resumes his pacing, finishes banana, broods, returns to drawer, takes out second banana, bangs drawer shut. He advances to edge of stage, halts, peels it, makes to drop skin, thinks better of it, tosses

skin backstage left, puts end of banana in his mouth and remains motion-
less, staring vacuously before him.
— Beckett, *Krapp's Last Tape*

Just as Beckett was made the standard-bearer of modernist anomie by a crit-
ical establishment not always willing to recognize the absurdist humour
intertwined with and tempering the metatextual ponderousness, so have
Egoyan's exegetes often ignored the double-edged tone of the latter's cul-
tural critique, also signalled by an undercurrent of humour.[15] Coming early
on in the film of *Krapp's Last Tape*, the banana scene registers a double shock
of pleasure, the colour of the peel breaking the monotone steel grey of the
subterranean set as the slapstick breaks the tension of the silent, portentous
Krapp. Far from being a throwaway gag, the banana skin is at the heart of the
play's imagery. Eating bananas is, along with listening to the tapes of his
past, Krapp's sole pleasure, a pleasure both gustatory and tinged with eroti-
cism. Like his rumination, however, the bananas lead to constipation; nearly
the first words out of box three, spool five—the birthday tape of the thirty-
nine-year-old Krapp—are "Have just eaten I regret to say three bananas and
only with difficulty refrained from a fourth. (*He grunts.*) Fatal things for a man
with my condition" (Beckett [1958] 1992, 5). Along with the operation of
the tape recorder, the banana scene offered the greatest difficulty of per-
formance: "Well, personally," commented Magee, "I find the pantomimic
side incredibly difficult; slipping on a banana skin, for example" (Knowlson
1980, 44). Asked why he had directed that the unwanted spools be littered
around the floor of the stage, causing an additional hazard for the actor,
Beckett said simply that Krapp was treading on his own memories (Knowl-
son 1980, 44).

The most Beckett-like of Egoyan's films, and the one that in retrospect
looks very much like an updated version of *Krapp's Last Tape*, is *Calendar*
(1993); perhaps not coincidentally, it was also the first of his films to origi-
nate from an external source prompted solely by his reputation as an auteur.
It was also the first outside commission—a commission inspired by his rep-
utation as an auteur.[16] In the precision and repetition of its temporal scheme—
the monthly ritual of the interrupted dinner date, the sequence of months
in the calendar of Armenian churches—in the virtuoso texturing of differ-
ent soundtracks in space and time; in the combination of the gustatory, the
erotic, and the sense of loss; in the obsessive playback of the answering
machine and the VCR; in the juxtaposition of the ever-growing absurdity of
the present 16mm situation in Toronto with the deadly serious tone of the
video scenes in Armenia—in all these, Egoyan found a cinematic equivalent
of *Krapp*'s theatrical combination of past and present. Moreover, just as
Krapp's crucial insight emerged from the gradual realization that the moments

and thoughts he had singled out as most worthy of remembering—the great pronouncements of ambition and renounced love—were as nothing to the incidental, inexplicable and apparently digressive instances that snuck in unawares, so too in *Calendar* the key scene of the past turns out to have been the endless and absurdly beautiful tracking shot of a herd of sheep, which has been screened early in the film nearly unnoticed beyond its duration only to return at the end as the strongest memory of the filmmaker's character—the moment, in retrospect, where he had lost his wife: "Did you know? Were you there?"

In his films before *Calendar*, Egoyan appears to have aimed for a different synthesis of the mediation of emotional loss and alienation through media technology. In his discussion of his films, if not in the works themselves, there is a large measure of ambivalence, a desire to have it both ways. On the one hand, there is a thoroughgoing critique of the loss of immediacy, of physical contact, of the deleterious effect of the media and image-making on the human psyche—a critique wholly in keeping with the tradition of Canadian cultural theory and filmmaking, and a mainstay of Egoyan criticism. On the other hand, there is an inescapable fascination with the potential of new technology, with the ways in which desires and behaviour have been adapted to and transformed by that technology, and a recognition that neither alienation nor experience mediated through technology is a novel experience. Egoyan explains: "In *Family Viewing*, there's a real ambiguity about the role of technology. It's the means by which the father controls the family, but it's also ultimately the way in which the boy recovers his past. It's very easy to take a moralistic position and condemn these technologies, but the fact is that they are with us. It's a question of educating people how to use the technology, instead of demonizing technology or allowing it to become casual" (Egoyan 1997, 12).

Similarly, writing about the concluding sequence in *Speaking Parts* (1989), Egoyan argues that the structuring of the film within the film as a talk show by the Producer (David Hemblen) was actually an innovative, self-conscious approach to the issues drama of organ transplantation (Egoyan 1993c, 34–35). It is difficult, however, fully to reconcile this assertion with the dramatic structure of *Speaking Parts* itself, which so strongly demonizes the Producer as the worst kind of manipulator of people and images. Likewise, the schematic dialectic Egoyan employed for *Family Viewing* (1987) emphasizes rather than mitigates the facile sentimentality of the boy's escape from his neurotic family and his attempt to establish an alternative community.

Put another way, in order for these films to realize the sort of ambiguity attributed to them by Egoyan's different remarks, there would have to be a total lack of identification with the characters as characters, an "elim-

ination of subjectivity" that many critics and reviewers indeed saw in the films, either for good or for ill (Burnett 1993, 18). At the same time, for the films to be more than cold and unfeeling dissections of postmodern anomie, there would need also to be a deep emotional investment in the characters, as Egoyan recognized quite well: "To me, the films are almost operatic. They're almost embarrassingly emotional. To me, there's nothing more vulnerable than showing people who are obviously trying to hold back an emotional agenda.... I thought the other films are pretty obvious in their representation of people incapable of dealing with what's on their emotional plate. But I guess not" (Egoyan 1995, 60).[17]

The diegetic relationship to technology was the desired vehicle for expressing the fraught tension between the desire for distanced critique and the need for emotional identification with alien emotional practices, and was also the cinematographic means whereby Egoyan attempted to produce that tension. Of the handheld camera in *Next of Kin* (1984), for example, Egoyan confessed that he was intending "to pull the audience back but in fact sucked the audience right in.... What I didn't understand was, the moment you have a shaky camera you say, 'Hey this is really happening! Get right in there!'" (Egoyan 1995, 60). A mode of representation inseparably identified with documentary tilted what had been intended as an interplay between a formal scheme and an emotional identification into a rejection of the film as a realistic portrayal of damaged goods; the effect was heightened by the stereotypically ethnic qualities of the Armenian family, probably meant to be as exaggeratedly animated and emotive as the WASP family was cold and distant, but rendered by the same representational codes as a faithful depiction. The film's evident humour was taken as reflective of ethnic joie de vivre rather than the token of an absurdist fable. When the film was seen on video, where it found its largest audience, Egoyan realized that the visual tension between film stock and videotape on which the formal scheme of the film depended was lost (Egoyan 1993a, 42).

The marketing of *Exotica* raised a different but analogous dilemma between the tensions within the film and those surrounding it. For the first time, visual media—the briefly glimpsed video Bruce Greenwood's character watches of his wife and daughter, which provides key narrative information even more than formal argument; the two-way mirror at airport customs that introduces the film—were pushed to the background, replaced by the ostensibly alienated rituals of interpersonal interaction, loss, and desire. Satisfied that he had resolved the problem of identification—"*Exotica*'s the first film where people are able to apprehend the structure at an intellectual level and engage in the emotional world of the film at the same time" (Egoyan 1995, 59)—Egoyan was now faced with the dilemma of his film's participation in a different level of video culture: its being mistaken for "soft-core

titillation" that "seemed to pander to an art-house audience," as the left-wing film journal *Cineaste* put it (Egoyan 1997, 8). By contrast with the candid acknowledgment of earlier audience misreadings of his intentions, here Egoyan perhaps understandably seems caught in the traps of his own multiple interests, unable quite to reconcile the plausible charge of exploitation with the undeniable power derived from the way the film plays with the audience's generic expectations in order to simultaneously pull it into the film and distance it from its structure. Says Egoyan, "The real breakthrough was when the French distributor came up with this visual concept for the poster which broke through a lot of things I wasn't prepared to admit. *You mean the design with the woman's torso framing Mia Kirshner's face?* Yeah. There are expectations this film provides which—even if they're not the ones met in the screening room—if properly engineered could bring people to the theatre.... Without pandering to the most prurient aspects of the film, there's a way of generating a level of excitement about what you're going to see" (Egoyan 1995, 59).

The formal and stylistic breakthrough—to manipulate audience expectations of visual pleasure and generic satisfaction in order to raise questions of loss, memory, ritual, and alienation rather than symbolizing those questions diegetically through the preponderance of technologically mediated experience—shifted critical scrutiny of Egoyan's oeuvre away from hermeneutics and into reception and auteur theory. Rather than being praised or damned for the coldness of his gaze and the deadness of his characters, he was praised or damned for betraying his earlier work. He had achieved formal perfection at the cost of a break in the seamlessness of his authorial vision and persona.

Curiously, Egoyan identified the dynamic of this tradeoff, albeit in an uncharacteristically one-sided fashion, in response to an interviewer's question about the influence of Cronenberg's *Videodrome* (1982) on his work: "I think the difference between David's work and mine probably is that he gave up a certain formalism, much to his commercial success. His early films, *Crimes of the Future* and *Stereo*, are very esoteric, and he just turned away from that very early in his career. He realized that, if he was to continue making films at that time, he had to work within the horror genre" (Egoyan 1997, 13). There is a certain irony in Egoyan's discussion of Cronenberg's decision at the time of the release in 1997 of *The Sweet Hereafter*, the film that undeniably renounced "a certain formalism, much to his commercial success." To be sure, Egoyan did not follow up on the art-house soft-core genre-bending of *Exotica* but settled instead into the character and issues-driven psychological realism of quasi-indie cinema of the late 1990s, "absorbed by the system" as he somewhat nervously put it (Egoyan 1995, 63).

The move came much to the dismay of his academic and critical fan base, invested as it is in the harsh visions of image alienation it has distilled

from the earliest films, as in the recent monograph by German media studies scholar Matthias Kraus, who regards the video cooking shows of the serial killer's mother as merely a "citation" of the "modernist self-reflexivity of Egoyan's early works" and concludes by accusing the filmmaker of betraying his own identity as auteur by drawing ever nearer to "illusionistic narrative cinema" (2000, 80n74, 245; my translation). To be sure, no long-time follower of Egoyan's career—or the man himself—can have failed to note the strong shift toward mainstream themes, genres, and production values. Kraus's disappointment in the failure of *Felicia's Journey* to live up to the framework established by the earlier films, while perfectly justifiable, fails to account for Egoyan's shifting framework. Egoyan's most recent features require different critical paradigms; the degree to which they live up to those paradigms is a question beyond the scope of this essay.

Collections, Archives, and Containers

> It was a great privilege for me to create a set.... For instance, when you make a set like that and want to populate it in England, there are prop houses where they've kept everything from every film that's ever been made....When you're making a period film [*Felicia's Journey*], it's a real treat to be making it in a culture that enshrines the notion of collection.
> — Egoyan, in interview with Porton, 1999

> *He draws curtain of cubby-hole half open, disappears inside, reappears with ledger, lays it on table, returns to cubby-hole, disappears inside, reappears with tin boxes containing reels of recorded tape, lays them on table, returns to cubby-hole, disappears inside, reappears with tape-recorder, lays it on table....*
> Krapp: [*Briskly.*] Ah! [*He bends over ledger, turns the page, finds the entry he wants, reads:*] Box ... three ... spool ... five. [*He raises head and stares front. With relish.*] Spool! [*Pause.*] Spooool! [*Happy smile. Pause. He bends over table, starts peering and poking at the boxes.*] Box ... thrree ... thrree ... four ... two ... [*with surprise*] nine! good God!... seven ... ah! the little rascal! [*He takes up box, peers at it.*] Box thrree. [*He lays it on table, opens it and peers at spool inside.*] Spool ... [*he peers at ledger*] ... five ... [*he peers at spools*] ... five ... five ... ah! the little scoundrel! [*He takes out a spool, peers at it.*] Spool five.... Box thrree, spool five. [*He places spool on machine, looks up. With relish.*] Spooool! [*Happy smile.*]
> — Beckett, *Krapp's Last Tape*

Rather than simply mourning the passing of celluloid, Egoyan seems to have been far more preoccupied in *Steenbeckett* with the specific issue that he terms "digital archiving." As early as the release of *Family Viewing* in 1988, he was speaking of the difference between the built-in editing required by

the time constraint of the home movie reel and the promise of video tech-
nology that you can record everything (Burnett 1989, 44). But since he began
shooting in digital, what had been a diegetic theme has become an intrin-
sic part of the production process. He explains: "I was speaking to an editor
friend who is working on a directorial debut (shot on digital) and he is over-
whelmed by the sheer volume of material. The editor has always been cru-
cial, but now they do most of the jobs that the directors should have been
doing months before. Digital is great because it is very spontaneous but it also
takes away the power of the gaze. There was a real focus with analogue"
(O'Connell 2002). What the site chosen for the *Steenbeckett* installation so
effectively demonstrated, however, was that a similar archiving impulse and
lack of focus had already been well and truly out of control at the Museum
of Mankind. What keeps Krapp just the other side of the video generation is
the ascetic control he has exerted over his archiving impulse: a constipated
one spool per annum rather than the flood of reels with which Egoyan sur-
rounded him in *Steenbeckett*. And even so, Krapp requires a ledger to keep
them all straight; and even so, he ends by finding what he wasn't looking for
and didn't even remember he had recorded.

Although Egoyan generally seems to elide the distinction between *archive*
and *collection*, sticking to the former, there is quite a difference between the
two terms. Archives are by definition public records or documents (kept in
the *arche*, or government house), and usually under the care of an archivist.
Collections are primarily private; if public, they are generally of private ori-
gin and held to be unified by some less abstract or more idiosyncratic prin-
ciple than those of the archive; they may have a curator, but they are not
expected to be organized rationally. What offended a critic such as Januszczak
about the formation of the Museum of Mankind was the thoughtless heap-
ing of everything under the sun into "the same crowded showcase," the ran-
dom collecting of relics that ought to have remained living archives.[18] Both
collecting and archiving have their nightmare images: treating living things
as objects by collecting skins, scalps, specimens, people; treating living
things as social documents by compiling them in meticulous archives like
those at the concentration camps, at Stasi headquarters in East Berlin, or in
the more anodyne corridors of heedless government bureaucracies.

The tension between archiving and collecting is at the heart of such
recent art projects as Mark Dion's *Thames Tunnel Dig*, an archaeological
excavation along Bankside that was exhibited in the Tate Britain in two enor-
mous mahogany *Wunderkammer*, in an attempt to reclaim a "tenderness" out
of the garbage buried on the river's edge, and also of earlier influential oeu-
vres such as Kurt Schwitters's *Merz* series or Joseph Cornell's boxes. Rather
than being intrinsically related to the ease of assemblage and limitless stor-
age capacity of digital technology, as Egoyan argues,[19] the same disregard for

origins and cultural specificity is characteristic of the great museum-building of the nineteenth century; of the syncretic fantasies created by Hollywood out of bits and pieces of the real world; of the all-inclusive libraries that continue to this day indiscriminately to collect everything that has ever been published all over the world, even as the volume has begun to overwhelm; and of both the utopian promise and the dark spectre of the World Wide Web. Egoyan's oeuvre is packed with images of archives and collections, and there is often an unresolved tension between them—the father who tapes over the video archive of his family with his own pornography in *Family Viewing*, only to have the tapes erased by his son; the video mausoleum in *Speaking Parts;* the photographer's "collecting" of images of Armenian churches rather than making an archive of their history and meaning in *Calendar;* the customs agent who collects luggage tags and then draws the faces of their possessors from memory in charcoal, which she hangs all over her apartment in *En passant*, Egoyan's contribution to *Montréal vu par…* (1992); the "collection of things" assembled by the dying Dr. Kassovitz and his deceased wife all over the world, which he insists on giving with the house he is selling on condition they are left exactly as they are, in *Sarabande* (1997); and Hilditch's collection of his mother's cooking-show videos and of young women's bodies in *Felicia's Journey*. Most striking perhaps is *The Adjuster* (1992), which is centrally concerned with the loss of things. Photographs that once held sentimental and personal value are transformed by Noah's probing into records of the value of lost possessions. But Egoyan also shows the need of individuals to be freed from the impulsion to collect or archive. Consider Arianne, the first victim introduced in *The Adjuster*, who allowed an electrical fire to grow from a spark in her kitchen to consume her house and who is wholly uninterested in reclaiming anything from it, apparently relieved to be rid of it all; or the play-acting Bubba, whose last action is to move all his possessions into Noah and Hera's house before setting it on fire. Obsession with archiving may lead to depression in Egoyan's films, but failure to cathect one's things and one's memories leads instead to suicide. As Egoyan has remarked of Bubba, the character's pathology is closely linked to "the fact that he comes to associate the archival evidence as providing access to a control of intimacy" (Egoyan 1999, 40). In *Felicia's Journey*, when this system, which had given a cohesion to his own life at the cost of those outside it, threatens to collapse, Hilditch hangs himself.

In its focus on the destruction of material goods, its almost cruel mockery of lives emptied by the inability either to find emotional satisfaction in things or to live without them, Egoyan seems in *The Adjuster* to have bid farewell to the representation of the video technology with which he had so effectively captured the contradictions of this experience. The acknowledged looseness of *Calendar* seems to have released Egoyan simultaneously

from an aversion "to hav[ing] scenes where people are speaking very naturally" and from the "overworked ... video image [that] was allowing people to reduce the ideas I was working with to a cliché" (Egoyan 1995, 51, 52). It is also the case that, faced with the new world of the internet, the cellphone, the DV camera, and the laptop, the clunky monitors and video cameras of the 1980s and early 1990s films seem already as antique as Krapp's tape recorder. Built on a stark opposition between analogue and digital, between celluloid and video, these films allowed Egoyan to exploit what he has called his own preference for the "hallucinatory" distancing of video within film: "To me seeing a video image on film is a very seductive and compelling texture, but to a lot of people it's really removed" (Egoyan 2000). The transferral of video from within the frame to outside it, as part the production process, has paralleled the movement of Egoyan himself outside of the tiny world of Anglo-Canadian cinema and into the global market of multinational co-production, Oscar nominations, foreign studios, and even the high-profile controversy of his epic about the Armenian holocaust, *Ararat* (2002). In his recent work, Egoyan appears to have been seeking a way to make the supposedly distinctly Canadian ambivalence about images speak to audiences that either, in the case of the mainstream, tend to embrace them unproblematically or, in the non-Canadian intellectual community, tend to treat them with absolute suspicion.[20]

Writing about *Speaking Parts*, Egoyan developed the concept of the "screen"—the possibility that a projected image could be a container as well as a conveyor: "When the screen image *contains* something more immediate to the viewer (a loved one, for example) a true surface can be developed if the viewer breaks the impassive nature of the screen identification process with a degree of involvement" (Egoyan 1993c, 25, 28). Rather than compile a collection of the brief clips in which her co-worker Lance appears on video into a single tape, Lisa continues to seek them out one by one; rather than becoming absorbed in the mausoleum as a whole, Clara remains fixed on the single image of her brother. In Elena del Río's reading of this concept, screens "supply the image with enough spatial density so that the viewer may retrace the path of affective and symbolic signification that subtends its construction" (1996, 106–107); that is, they can work to bind the viewer to the corporeal world rather than distancing her or him further from it within a fantasy replacement. Although overreliant on a modernist conception of the subject's forgoing pleasure for truth, this conception of the screen is analogous to the role of the archivist and the collector, the former gaining meaning out of giving order and structure to a chaotic mass of documents or images, the latter by removing obsolescent objects from circulation and restoring to them an innate value—a materiality, so to speak—the opposite of Noah's occupation in *The Adjuster*. In both cases, the concept of the archive

or the collection has the potential to provide a container for the emotions and memories that can be elicited by and through the objects, to transform what might appear to be neurotic repetition into a meaningful form of personal ritual.[21]

Instead of directly confronting his earlier film/video dialectic with the question of virtual reality, Egoyan has embraced an aesthetics of realism. Responding to a question on the "different kind of screens" he had used in *Exotica*, he responded, "That's a good question because for me, all the films have been inspired by a need to tell an emotional story. But I think that because the filters were so visceral [in the previous films], like seeing a video image, or seeing something within a frame which removed you, that the audience was not even able to attach itself to the emotional issues.... In a way [*Exotica*] is more traditional, but it also allows the people to access the emotional lives of the characters more directly. They're not as threatened" (Egoyan 2000). The current vogue for site-specific installations of the type in which Artangel, the sponsors of *Steenbeckett*, specializes is another way of reacting to a changing attitude toward materiality and technology. As Egoyan noted in an essay on the installation, the "containers we use to store... experience" are as essential to its meaning as the experience itself (Egoyan 2002a, 12). Krapp's spool containers thus function as a screen in the same way that video did in the earlier films: "Some of the most emotional moments in *Krapp's Last Tape* show the physical effort the old man puts into taking the tapes out of the box, putting the spools on to the machine, and then, so tenderly, placing the magnetic tape into the slot of the playback head" (Egoyan 2002a, 12). Krapp's rituals with the containers and with the ledger demonstrate the value of these tapes as a collection, technology endowed by the passage of time and ritual repetition with emotional content. The Museum of Mankind, too, functions as a container, but one that has failed in or at best outlived its purpose. By the very act of using it to bestow added emotional heft to the film at its beginning and end, the space is even further emptied of its own meaning, its containers now signifying only their own abandonment.

It is in this unenunciated dialectic that we can begin to take seriously Egoyan's not always convincing assertion that rather than film versus video, his real subject had always been "to what extent [one can] trust one's identity to someone else feeling what that identity is about" (Egoyan 1993a, 56). Rather than being suspicious about technology, media, and images as such, Egoyan's films are suspicious about identity and subjectivity; at heart they are closer to ethnography than to cultural critique. The difference between characters who use technology to gain some form of autonomy and those whose experiences are trivialized or erased by technology is only a difference between barely tolerable misery and utter misery—between Peter/Bedros

in *Next of Kin* or Van in *Family Viewing* and their respective parents; between the damaged souls in *Exotica* and *The Adjuster* and the dead ones; between shrivelled-up Krapp with his one rediscovered happy memory and the thousands of cultural memories surrounding him in *Steenbeckett*. While his treatment of technology has changed, Egoyan has stubbornly clung to the "elegiac" mode whereby Cameron Bailey characterized his attitude toward it back in 1989 in contradistinction to Cronenberg's more speculative "anatomies" (1989, 51). But while celluloid may pass, the image endures. The changes in Egoyan's artistic production testify to a change in the role of technology in culture, but the problematic dialectic of novelty and obsolescence is as old as capitalism, and the desacralization of experience simply migrates from one new medium to the next without ever being fully realized. For every lonely old man or woman glued to the television, there may be a youngster whose entire experience has been formed by video games; for every old man clinging tenderly to his reel-to-reel, there is also a youngster whose laptop has become the container of everything meaningful in his or her world—music, friends, collections, archives. The real melancholy at the heart of Egoyan's installations, and one motivation of his manic activity in so many fields beyond that of the cinema proper, may be the slow realization that filmmaking itself, in whatever mode of production, is no longer guaranteed the cultural centrality it enjoyed throughout the past century. As Egoyan's relationship to technology in the present has become ever more practical, his attitude toward it has become ever more emotional. Celluloid in this sense is not only the physicality of the traditional craft of filmmaking—the massive cameras, the painstaking editing, the heat and the dust and the scratches—but a screen, a container of the memories associated with the nostalgia-tinged days when he was a struggling filmmaker in a marginal national cinema, toiling and quarrelling with his ill-paid and tiny but loyal crew, writing, directing, editing, and everything else himself, controlling everything, and even sitting through screening after screening in a Toronto cinema undergoing the glorious "pain of watching the film with an audience."[22] The little square cut out of the screen into the room of the future in *Steenbeckett* gives us a hint that Egoyan knows the container may not be so airtight as his exquisite control of meaning would otherwise lead us to believe. As Franz Kafka, another great comic melancholist, once said, "There is hope, but not for us." While Egoyan's directorial persona moves more and more toward a negotiated truce with mainstream moviemaking and its high-tech armature, in his smaller-scale and more marginal projects such as *Krapp's Last Tape* and *Steenbeckett*, Egoyan has clung tenaciously to the modernist mantle of tragic absurdism that he inherited from Beckett and spliced unforgettably into the two decades of the video era. Whether a digital modernism will be able to emerge out of this split between globalized filmmaking and localized meaning-making remains to be seen.

Notes

1 The anecdote appears as well in various interviews about the film. See, for example, the web page for the Channel 4 series (http://www.channel4.com/culture/microsites/B/beckett/plays/krappslasttape/), and Kirkland (2000).

2 The last film on which Egoyan used a Steenbeck was 1994's *Exotica* (O'Connell 2002).

3 On ways in which the ideology of humanism tends to polarize and objectify both the technological object and the human body, see del Río (1996, 96–98). Where del Río bases her analysis in the ahistorically phenomenological philosophy of Merleau-Ponty, however, I would stress how different technologies and different conceptions of corporeality assume these iconographic roles in history.

4 Tape recorders were invented by the Germans during World War II, and first marketed for the home at the very end of the 1940s (Schoenherr 2002).

5 On the play's origins and the stages of its composition, see Gontarski (1980).

6 The play sidesteps the issue in the simplest way possible, by beginning with a note: "*A late evening in the future*" (*Krapp's Last Tape: A Play in One Act*, revised text approved by Beckett, qtd. in Knowlson 1992, 3). This was also the text used in the John Hurt production.

7 A leitmotif of the minority contingent of negative reviews harped on the "crowded" single row available for viewing (by standing or sitting on the floor, that is, in the middle of the main throughway of the exhibit) and on the "ageism" that assumes the audience "to comprise no one but sprightly students" (Hirst 2002; McEwen 2002, 11). By contrast, a more enthusiastic (and either younger or more dedicated) reviewer considered it "far better to see it here, surrounded by these salient cutting-room darknesses, than on Channel 4, late at night, framed by Bacardi Breezer ads" (Januszczak 2002). In the event, the first scheduled broadcast, for March 30, 2002, two weeks after the show had closed, was cancelled due to the death of the Queen Mother.

8 And indeed the fictional re-creation of oral history and tradition has become a staple of Inuit filmmaking. As Zacharias Kunuk has commented, on the "documentary-like short films which were mostly fictions" that he and his collective made before their first "fiction" feature, *Atanarjuat*, "for all those 4,000 years of oral history every story was fiction and non-fiction" (Said 2002, 24).

9 Disused for several years, its contents left simply to collect dust, the building that housed the Museum of Mankind will be reopened in 2007 as an extension of the Royal Academy, onto the back end of which it abuts; no one mentions what will happen to the current contents when it is renovated.

10 Martin Held in interview with Ronald Hayman on the Schiller Theater Berlin production of 1969.

11 As Bernard F. Dukore has observed, every word of the title is a pun: *last* can mean either most recent or final; *tape* can also refer to an alcoholic beverage; *play* can refer either to tape or to theatre; *act* can also be read scatologically (1980, 146). See also Ruby Cohn, *Samuel Beckett: The Comic Gamut* (1962).

12 Magee, interviewed, world premiere, Royal Court Theatre, London, October 1958 (Knowlson 1980, 44).

13 John Hurt first performed the play at the Barbican Theatre in London in 1999; set to play it at the Gate Theatre in Dublin two years later with the same tape, he commented, "It's the same process as playing with somebody else, except that the tape recorder is a constant. I find it even more exciting this time, because as that tape recording goes further and further into time, it's getting nearer and nearer

to the basis of the play. If I'm still using that same recording when I'm doing the play at the right age, which is when I'm sixty-nine, that should be fascinating" ("So Good It's Hurt" 2001, 64).

14 Interview with Donald Davis. Most performers have preferred to rely on the synchronized reflexes of a sound technician offstage, merely miming the pressing of buttons and flicking of switches.

15 There are many variations to this rule; Marianne Mays, for example, takes Egoyan to task for directing an unfaithfully "bleak" rather than a comically dour Krapp (2001). Generally, however, Canadians have been more attuned to Egoyan's humour, Europeans less so, and American academics somewhere in between. As Egoyan commented on an analysis of *The Adjuster* in the multi-author French monograph *Atom Egoyan* (1993), "It's funny... the French take it very seriously" (Egoyan 1995a, 71).

16 As Monique Tschofen has observed, Egoyan's short student film, *Howard in Particular* (1979), "offered an unabashed homage to Beckett," including the banana scene (2002, 167–68). Conversely, Egoyan's early professional work was as a freelance director for television shows such as *Alfred Hitchcock Presents* and *Twilight Zone*, being shot in and around Toronto (Burnett 1989, 42). In 1988, Egoyan described this work in "mainstream production" as one half of a "schizophrenic" career (ibid.), just as the ice hockey biopic he made for Canadian television in 1992, *Gross Misconduct*, is usually regarded as distinct from his properly "auterish" production. *Calendar* began life as a prize from the Moscow Film Festival that had the single requirement of being shot on location in Armenia; it was eventually funded instead by German television.

17 The need for emotional involvement is much less clear in a 1988 interview made after the release of *Family Viewing*. While it is evident that Egoyan was deeply invested in the film ("the film is very personal"), he seems more concerned with the audience responding to the challenge of the film's aesthetics (Burnett 1989, 41–44).

18 The Museum of Mankind was opened in 1970 as, in Januszczak's words, a "grim, grey, unloved and unlovable tribal-art dump" annex to the British Museum (2002).

19 See, for example, Egoyan's comments on video technology in an interview with Cynthia Fuchs on *Exotica*: "I think that's one of the more interesting things that's evolved, our new found desire to make archives of our experiences, and to document them" (Egoyan 2000).

20 On the "specifically Canadian dilemma to sort out the differences between images imagined for us by ourselves and images imagined for us by other people" and the concomitant theoretical discourse on the "the meaning of the technological experience" from Marshall McLuhan to Arthur Kroker, see Harcourt (1995, 6), Bailey (1989, 45–51), and Kraus (2000, "Introduction").

21 On the importance of repetition as a formal component in the structure of Egoyan's films, see Tschofen (2002).

22 Pevere recounts Egoyan's eager interest in others' opinions of his work and his propensity to sit in (incognito) on his own public screenings (1995, 14–16).

Works Cited

Bailey, Cameron. 1989. "Scanning Egoyan." *CineAction*, Spring, 45–51.

Beckett, Samuel. [1958] 1992. *Krapp's Last Tape: A Play in One Act*. Rev. ed. Edited by James Knowlson. London: Faber and Faber.

Burnett, Ron. 1989. "Atom Egoyan: An Interview." *CineAction* (Spring): 41–44; originally published in *Film Views*, Spring 1988.

———. 1993. Introduction to *Speaking Parts*, by Atom Egoyan, 9–22. Edited by Marc Glassman. Toronto: Coach House.

Cohn, Ruby. 1962. *Samuel Beckett: The Comic Gamut*. New Brunswick, NJ: Rutgers University Press.

del Río, Elena. 1996. "The Body as Foundation of the Screen: Allegories of Technology in Atom Egoyan's *Speaking Parts*." *Camera Obscura*, May, 92–115.

Dukore, Bernard F. 1980. "*Krapp's Last Tape* as Tragicomedy." In *Theatre Workbook I: Samuel Beckett's "Krapp's Last Tape,"* ed. James Knowlson, 146–50. London: Brutus Books. First published in *Modern Drama* 15, no. 4 (1973): 351–54.

Egoyan, Atom. 1993a. "Emotional Logic: Marc Glassman Interviews Atom Egoyan." In *Speaking Parts*, by Atom Egoyan, 41–57. Ed. Marc Glassman. Toronto: Coach House.

———. 1993b. *Speaking Parts*. Edited by Marc Glassman. Toronto: Coach House.

———. 1993c. "Surface Tension." In *Speaking Parts*, by Atom Egoyan, 25–38. Toronto: Coach House.

———. 1995a. "Difficult to Say: An Interview with Atom Egoyan." Interview by Geoff Pevere. In *Exotica: The Screenplay* by Atom Egoyan, 43–67. Toronto: Coach House.

———. 1997. "Family Romances: An Interview with Atom Egoyan." Interview by Richard Porton. *Cineaste*, December, 8–15.

———. 1999. "The Politics of Denial: An Interview with Atom Egoyan." Interview by Richard Porton. *Cineaste*, December, 39–41.

———. 2000. "Interview with Atom Egoyan." Interview by Cynthia Fuchs. *Pop Matters*. http://popmatters.com/film/interviews/egoyan-atom.html.

———. 2002a. "Memories Are Made of Hiss: Remember the Good Old Pre-digital Days." *The Guardian*, February 7.

———. 2002b. "The Splice of Life: Sarah Kent Talks to Atom Egoyan about Editing, Memory, and *Krapp's Last Tape*." *Time Out* (London), February 27–March 6.

Gontarski, S.E. 1980. "The Making of *Krapp's Last Tape*." In *Theatre Workbook I: Samuel Beckett's "Krapp's Last Tape,"* ed. James Knowlson, 14–23. London: Brutus Books.

Harcourt, Peter. 1995. "Imaginary Images: An Examination of Atom Egoyan's Films." *Film Quarterly* 48, no. 3: 2–14.

Hirst, Christopher. 2002. "The Weasel: Outside, Plato and Pals—Inside, I Was Up an Artistic Trouser Leg." *The Independent*, March 2.

Januszczak, Waldemar. 2002. "The Best Canadian Art Stays with You for Ever. The Worst ..." *Sunday Times*, March 10.

Jones, Jonathan. 2002. "Review: Art: *Steenbeckett*: Former Museum of Mankind, London." *The Guardian* February 16.

Kirkland, Bruce. 2000. "Egoyan's 'Dream Project': Director Thrilled to Make Beckett Film with John Hurt." *Toronto Sun*, August 24.

Knowlson, James, ed. 1992. *Krapp's Last Tape*. Vol. 3 of *The Theatrical Notebooks of Samuel Beckett*. London: Faber and Faber.

———, ed. 1980. *Theatre Workbook I: Samuel Beckett, "Krapp's Last Tape."* London: Brutus Books.

Kraus, Matthias. 2000. *Bild-Erinnerung-Identität: Die Filme des kanadiers Atom Egoyan*. Marburg: Schüren Verlag.

Mays, Marianne. 2001. "Space Matters; BeckettFest: *Krapp's Last Tape* on Film; *Act without Words I*." *The Manitoban*. http://www.umanitoba.ca/manitoban/archives/jan25_2001/arts5.html.

McEwen, John. 2002. "Mixed Bag of Killjoys and Jokers." *Sunday Telegraph*, March 10.

O'Connell, Alex. 2002. "Geek Bares His Gifts." *The Times*, February 4.

Pevere, Geoff. 1995. "No Place Like Home: The Films of Atom Egoyan." In *Exotica: The Screenplay* by Atom Egoyan, 9–42. Toronto: Coach House.

Said, S.F. 2002. "Northern Exposure." *Sight and Sound*, February, 22–25.

Schoenherr, Steven. 2002. "Video Recording Technology." http://history.acusd.edu/gen/recording/notes.html#tape (accessed March 23, 2002; revised March 23, 2003).

"So Good It's Hurt." 2001. *Irish Times*, September 1.

Tschofen, Monique. 2002. "Repetition, Compulsion, and Representation in Atom Egoyan's Films." In *North of Everything: English-Canadian Cinema: 1980 to 2000*, ed. William Beard and Jerry White, 166–83. Edmonton: University of Alberta Press.

▶▶▎section 2

Diasporic Histories and the Exile of Meaning

▶▶▶ 6

Mobile Subjectivity and Micro-territories
Placing the Diaspora

Jennifer Burwell and Monique Tschofen

The authors in the previous section examined some of the ways in which Egoyan has made representational technologies the central focus of much of his work, analyzing how his characters actively use, adapt, or transform media technology to manage their needs and desires, and considered some of the auratic and redemptive possibilities embedded in these mediations. The authors in this section explore the ways in which Egoyan's and his family's experiences of the Armenian diaspora have likewise been a central preoccupation. They argue that Egoyan's works both overtly and covertly take up the question of what it means to be Armenian and to bear the heritage of what Marie-Aude Baronian calls the "legacies of denial and forgetting" surrounding the Armenian genocide. At the same time, they also consider how working through the complexities of his cultural origins has lead Egoyan to inquire into broader and more universal issues such as the social, political, and historical tensions, contradictions, and paradoxes characterizing the global historical experiences of displacement and deterritorialization.

In his settings, characterizations, and thematic preoccupations, and even in his structural approaches to filmmaking, suggest the authors, Egoyan reveals himself to be grappling with two core issues: the severity of the trauma produced by the events of the genocide themselves followed by their erasure from "official" history, and the absence of a "place"—a home or

homeland—from which one could manage this trauma and anchor one's culture, language, and identity. Egoyan has said that "one of the advantages of working with the Armenian language or the Armenian culture is that it is, for most people, not something that can be easily identified, and that allows me the luxury of being able to treat it almost on a metaphorical level" (1987, 17). But his work shows how, like other traumatic events—but possibly more so because of the practices of denial that still surround it—often, the history of the Armenian genocide can be talked about, by Armenians and others alike, only obliquely, mediated through more generalized and metaphorical experiences of mourning and loss, and usually in the absence of any specific cultural or historical referent. The fundamental allusiveness and indirections that characterize Egoyan's films are thus attributable, on one hand, to his own mining of the metaphoric possibilities in the more universal elements of global diasporas in general and, on the other, to the rigid epistemological and ontological limitations imposed by the public erasure of the Armenian genocide in particular—the fact that it has not been possible to represent the "thing in itself."

As they explore the tensions, contradictions, and paradoxes characterizing themes of ethnicity, exile, and diaspora, the authors in this section uncover some of Egoyan's recurring tropes: substitution (of a present for an absent individual, or of family and home for homeland), displacement (of an image space for a geographical place), and translation or transference (between "native" and immigrant experiences). All of these tropes suggest movement, and refer to the ungroundedness of diasporic experience and to the deterritorialization that defines exilic and post-exilic existence. Through them, historical events become relocated to the imaginary, which in turn attests to the fact that the space of memory is without ground, subject to erasure and forgetting, and that the space of geography remains depthless and out of place.

In her essay "Telling a Horror Story, Conscientiously: Representing the Armenian Genocide in Atom Egoyan's *Ararat*," Lisa Siraganian shows how exilic and diasporic experiences are structurally embedded in every level of Egoyan's films in the forms of displacements, substitutions, repetitions, and translations. In *Ararat*, Egoyan's most overt treatment of the genocide to date, this logic of displacement is demonstrated in the way he seems less interested in the original genocide testimony itself and more in how the genocide is mediated by the various reactions to and interpretations of this testimony by later generations. Through a careful consideration of the historical and political allusions in a number of his short and feature-length films, Siraganian shows how Egoyan, always conscious of his directorial role, seeks not to transmit a trauma to the viewer, but rather to represent "catastrophe's aftermath." And so, the "truth" of the disaster—denied—is

viewable only through reactions to it, and the imaginary space of the disaster, like a black hole, is viewable only via the displacement of that which surrounds it. Genocide is an absence implied rather than revealed.

Siraganian is particularly interested in how the process of genocide memoralization takes place across generations. First, says Siraganian, a fundamental problem is posed by the basic unrepresentability of the events. Added to this is the radical skepticism of genocide deniers, which has distorted and undermined the truth-value of survivor testimony by suggesting that because a lie *could* be told, no truth *can ever* be told. In a very real sense, then, it is less the case that historical facts have not been represented than that these fact have been *un*-represented, erased from official history. Siraganian points out that the inexpressibility of the horrors and the denial by Turkish governments have often paralyzed Armenian artists and writers attempting to obtain a perspective from which to represent the genocide. This dilemma is summed up by Egoyan when he asks the question, "How does an artist speak the unspeakable?"

Like Siraganian, Marie-Aude Baronian, in her article "History and Memory, Repetition and Epistolarity," makes the socio-political issue of genocide and its denial the subject of her work. Baronian addresses the groundlessness of the exilic and diasporic experience by exploring the longing that haunts the disjunctures between image spaces and geographical spaces in Egoyan's short films *Open House, Diaspora*, and *Portrait of Arshile*. She points out, for example, that Saroyan's fictional placement of Mount Ararat in *Ararat* establishes it as a portable signifier, detached from any territory and thus representative of the ungrounded identity of the exile. Baronian suggests that a parallel "displacement-effect" is sometimes manifested formally in, for example, the non-linear structure of Egoyan's experimental short film *Diaspora*, which "exiles" the viewer from any stable referent. This, says Baronian, forces the viewer to experience time, space, and movement in a manner similar to the emotional and cognitive experience of spatial and historical disorientation felt by diasporic and exilic subjects. Expanding her focus, Baronian adds that the formal qualities of memory and experience in Egoyan's work are expressed through the migration of the same preoccupations from one work to another in a kind of structural repetition compulsion—manifested, for example, through repetitions of colour, music, and shots. For Baronian, this constant reprise parallels the relentless resurfacing and recapitulation of traumatic memories and histories. Even the kind of auto-citations to which Baronian refers are themselves always metaphoric displacements that never refer to the thing itself, again reflecting the impossibility of directly conjuring up a history that has been officially effaced.

Attending to both thematic and formal aspects of Egoyan's filmmaking, Baronian's analysis devotes a central part of her essay to what she calls the

"epistolary technologies" in Egoyan's films—using and extending Hamid Naficy's concept of epistolarity (2001) to refer to modes of intra- and extra-diegetic communication that reflect attempts to resolve the experience of distance, absence, and loss. Unable to rely on their own or others' personal experience, says Baronian, Egoyan's characters engage in a process of mediation through which they depend on recording technologies to function as "prostheses for memory." Instead of arguing that these prostheses are crutches through which characters attempt to achieve emotional detachment (as do some of the authors in the first section of this volume), Baronian argues that their presence comments on the impossibility of dealing directly with the past in general, and with the Armenian genocide in particular. Even when Egoyan refers specifically to historical events, Baronian adds, the conscious epistolarity of his films casts them as enunciatory acts that engage the viewers and encourage them to feel a "memorializing" responsibility to recollect and condense historical fragments and repetitions in an attempt to establish some kind of "comprehensible" representation of the events.

In her essay "The Immigrant Experience in Atom Egoyan's *Next of Kin*: The Double's Choice," Batia Stolar turns from the actual experience of genocide to the legacy of diaspora, examining Egoyan's treatment of experiences of immigration and assimilation in light of how Canadian and Armenian cultures operate in relation to each other. Like the other authors in this section, Stolar focuses on the destabilization of the traditional family institution through displacement, again emphasizing the constructedness of diasporic identity and indeed of identity in general. Stolar's primary focus is Egoyan's first feature film, *Next of Kin*, in which, she says, mediated experience and substitution confound the distinction between the original and its copy, in the process reflecting the relational position of the immigrant. Stolar argues that in "becoming" the absent son of the immigrant Deryan family, the WASP Peter takes on the status of a double—the "foster child" of a family already living in an "adopted country." Thus, says Stolar, the process of imitation is turned on its head: the "native" is imitating the immigrant, and the privileged white upper-middle-class male becomes the assimilated other. In this process, Stolar argues, Peter *becomes* the "immigrant"—a tabula rasa who arrives at the Deryan household "ready to be inscribed." Stolar's analysis thus conjures up another one of Egoyan's tropes of inversion, which reverses the stereotypical association of "self" with mind and "other" with body. If Peter is the body ready to be inscribed, the absent son, Bedros, is "a disembodied spiritual presence that needs fleshing out"—"a blank space that is inhabited by the ghost, memory, or idea of a missing son."

In externalizing what also remains very much an internal struggle within *Next of Kin*'s various characters, Egoyan connects private and individual conflicts with questions of identity and conflict surrounding intra- and extra-

cultural relations. As a double, Stolar says, it is up to Peter to inscribe, mediate, translate, articulate, and understand both cultures. Stolar goes on to claim that, in combining Peter's inherited agency with his chosen status as an immigrant double, Egoyan implicitly confers onto the immigrant both agency and power. Peter's conscious choice to become an other is not merely an appropriation, then. It also opens up the possibility that identity per se can be manipulated and re-created—that its adoption is a matter of choice. The theatricality of the double calls attention to how cultural identities are mediated, translated, and articulated—as well as appropriated—suggesting that ethnicity is a cultural construct or a performance.

Metaphorically, Stolar says, the double points to a double consciousness made up of two cultural memories, so that Peter/Bedros comes not only to signify both Canadian WASP and Armenian cultures, but to signify, in his split consciousness, relation itself. For Stolar, split subjects in Egoyan's films never resolve themselves into a fixed unity—either through the dominance of one side over the other or through the perfect integration of parts into a whole. Stolar thus signals Egoyan's interest in the mobility of identity, the transference of desires, hopes, and directions that takes place when identities conjoin in a relation that nevertheless remains full of ruptures and asymmetries. This mobility makes possible the birth of new types of relationships, but, as Stolar points out, it also requires us to consider the conditions under which one part of an individual either asserts dominance over or becomes subject to another part.

In her article "Atom Egoyan's Post-exilic Imaginary: Representing Homeland, Imagining Family," Nellie Hogikyan invites us to consider another lens through which the ungroundedness of the Armenian experience is refracted in Egoyan's films by returning to the two that are most explicitly about Armenia: *Calendar* and *Ararat*. Focusing on the generations after the diaspora, Hogikyan begins by establishing an important distinction between the exilic and the post-exilic, a difference that corresponds to the degree of each generation's remove from the homeland. While the exile typically yearns openly and straightforwardly for a return to the homeland, the consciousness and memory of the post-exile is structured more abstractly according to the logic of displacement and generalized anxiety about separation and loss. For Hogikyan, the post-exilic transcends territorial inscription and expresses a form of identity politics no longer based on identification with an ancestral homeland. In creating a post-exilic cinema, says Hogikyan, Egoyan challenges idealistic representations of homeland and deconstructs exilic myths of authenticity.

In *Accented Cinema: Diasporic and Exilic Filmmaking*, Hamid Naficy has argued that in films whose topic is the experience of living in diaspora, "every story is both a private story of an individual and a social and public

story of exile and diaspora" (2001, 31). Hogikyan points out that, in Egoyan's films, every collective story becomes a private story within which even the most abstract substitutions are humanized and personalized. Commenting on the deep sense of distance the post-exile must acknowledge, Hogikyan notes that distance in Egoyan's films becomes "a main character personified by technologies creating simultaneously and paradoxically virtual closeness that never materializes in reality." In fact, Egoyan has stated that in his films, the camera often stands in as a "substitute" for a missing person—representing the gaze of this absent person, and thus "inventing" them as memory (Egoyan 1993, 63). This insight provides a link that unites first two sections of this volume, for it suggests that in Egoyan's work, media technologies are involved in the "production" of absent individuals who themselves stand in for an absent collective history.

Hogikyan argues that in Egoyan's work, another order of substitution takes place within families, where non-biological but present "relatives" stand in for absent family members. Because of the collective disruption caused by mass migration, immediate family becomes the only possible imagined community, and family photos and portraits become memorial sites for national signifiers. But even the locations of family and home that promise to ground a displaced identity are deprived of any essentializing stability. By opting for imaginary rather than biological filiations, says Hogikyan, Egoyan highlights the fragility and instability of identity and suggests more fluid representations of communities and networks of kinship. Substituting reunions with lost people for reunions with a lost place, the post-exilic replaces traditional territorial belonging with inscription in the "micro-territories" of house, home, and family ties.

All of the following essays explore the ways in which the dispersion, migration, and displacement on a global scale caused by the Armenian genocide have already produced an intensely mediated historical event. When a historical event has virtually been erased from time and space, mediation not only becomes an outcome—it becomes a necessity. Since there is no location to which one can turn, it is only in the examination of dislocation that a story can be told. Since there remains no single body of collective of people bound by time and space by and through which that story can be told, it can be told only by alternative sites of subjectivity, which themselves become allusive and elusive. In Egoyan's work, collective legacy is translated to personal past, psychic displacement stands in for geographic exile, and homeland—in all its conditional formations—becomes house or home. More broadly, his work converts the negative experiences of migration into the positive conditions of mobile and performative subjectivity—the notion that identity is something an individual can try on, try out, and ultimately travel through.

Works Cited

Egoyan, Atom. 1987. "The Alienated Affections of Atom Egoyan." Interview by José Arroyo. *Cinema Canada*, October, 14–19.

———. 1993. "Entretien avec Atom Egoyan." Interview by Julia Reschop. *24 Images*, no. 67: 62–66.

Naficy, Hamid. 2001. *An Accented Cinema: Exilic and Diasporic Filmmaking*. Princeton, NJ: Princeton University Press.

 7

Telling a Horror Story, Conscientiously
Representing the Armenian Genocide
from *Open House* to *Ararat*

Lisa Siraganian

Between 1915 and 1922, the Ottoman Turkish state committed the first modern genocide of the twentieth century, against the Armenian population in eastern Anatolia (now Turkey). It was an event Adolf Hitler cited, on August 22, 1939, to justify his strategies for the ethnic cleansing of Poland: "Who, after all, speaks today of the annihilation of the Armenians?"[1] Atom Egoyan's *Ararat* (2002) is the first widely released cinematic representation of the Armenian genocide. However, the film seeks not simply to document the genocide, but to reveal how a ninety-year-old event continues to have disruptive and even traumatic effects on a scattered Armenian population, now known as the Armenian diaspora.[2] In large part, these traumatic effects are exacerbated by the Turkish state's continuous denial of the genocide.[3]

In this essay I will analyze *Ararat* with an eye toward the concerns that Egoyan's films have grappled with for years, such as "the psychology and politics of denial" (Egoyan 1999, 39–41). After introducing his earlier explorations of ethnicity, violence, and trauma in films ranging from *Open House* (1982) to *Felicia's Journey* (1999), I will show how *Ararat* expands on Egoyan's previous themes by developing and exploring the Armenian diaspora's dilemma of genocide memorialization.

It is notoriously difficult to find a frame in which to discuss the Armenian genocide; one approach has been to describe it as an atrocious,

foreboding model for the Jewish holocaust.[4] Armenia, situated in eastern Turkey, had for centuries been one of the conquered nations that made up the subject peoples of the Ottoman empire. In the late nineteenth century, as the Ottoman empire began to collapse (and lost control over its Christian territories of Greece, Bulgaria, and Serbia), Ottoman anxiety transformed into Turkish nationalism. The Turkish state began a systematic persecution of its last major group of Christian subjects, the Armenians. Tens of thousands of Armenians were massacred in the 1890s, and then, between 1915 and 1922, "over a million Armenians were killed by mass shootings, massacres, deportations, and induced starvation" (Melson 1992, 145). The Armenian community in Anatolia was destroyed, and by 1923 between one-third and one-half of the world's Armenian population had been annihilated. Survivors crowded refugee camps around the Middle East and in the rest of the world. For nearly seventy years this Armenian diaspora was viewed as "the inheritor of the potential of the Armenian nation..., the repository of that consciousness" (Shirinian 1992, 23).

In contrast to Germany after the Holocaust, Turkey does not admit the existence of—let alone its culpability for—the Armenian genocide. "There was no redemption, no compensation, no contrition," writes historian Richard Hovannisian. "Instead, the world seemed to succumb to prolonged amnesia, compounding the agony of the dispersed survivors" (1992, xvi–xvii). In fact, since the 1920s, the Turkish state has spent huge sums of money revising histories to omit accounts of the Armenian genocide, using all types of media in the process (newspapers, books, magazines, films, Internet bulletin boards).[5] This repetition of denial within the very media that could and should have recorded the genocide, combined with the more generic dilemma of acculturation, makes "forgetting" the genocide deeply disturbing for Armenians. As Roger Smith writes, "to forget the Genocide would be to repudiate one's people and one's self" (Smith 1992, 5). Furthermore, remembering the Armenian genocide has an urgency for Armenian survivors and their descendants that actually *increases* as the original generation of survivors steadily diminishes in number.[6] Turkish denial has meant that survivors are under an inordinate amount of pressure to bear witness to the genocide, often as the only remaining members of large families.

Egoyan's particular diasporic experience can be usefully situated in this context. As he explains in an essay on *Ararat*, "My grandparents from my father's side were victims of the horrors that befell the Armenian population of Turkey in the years around 1915. My grandfather, whose entire family save his sister was wiped out in the massacres, married my grandmother who was the sole survivor of her family" (2002, vii). Egoyan himself was born in Cairo in 1960 to Armenian parents. The Yeghoyans (later the Egoy-

ans) emigrated to Canada when Atom was three, in part because of the antagonism toward Armenians in Egypt (Naficy 1997, 222). In British Columbia, Egoyan experienced cultural isolation because the members of his immediate family were the only Armenian-speakers: "We had no church, no school, no community centre, and yet I was still Armenian. I was aware of the genocide, but only in the vaguest way. I knew that something had befallen my people. But it remained something shadowy that I heard about" (Ouzounian 2002, A1). When he arrived at the University of Toronto at the age of eighteen, Egoyan was exposed for the first time to a larger diasporic Armenian community, in which he could observe contemporary responses to Turkish denial. He became involved with the "more political, almost militant Armenian nationalist activities through the student association" (Naficy 1997, 191).

In the 1970s and 1980s, there was a burst of Armenian terrorist activity against Turkish civilians and diplomats. Two diasporic "terrorist" organizations were primarily responsible: the Beirut-based JCAG (Justice Commandos for the Armenian Genocide) and ASALA (the Armenian Secret Army for the Liberation of Armenia). Many of their members were young men born in North America, carrying out their plans close to home. As Richard Ouzounian explains, "On March 12, 1985, three armed Armenians stormed the Turkish Embassy in Ottawa. A Canadian security guard was killed, the ambassador was badly wounded, and his wife and daughter were taken hostage" (2002). Much debate in the diasporic community focused on the effectiveness, morality, and rationality of these acts, which the perpetrators justified by transferring past crimes onto the current Turkish government. ASALA presented a five-step rationale for terrorism based in part upon a series of metonymic exchanges and conflations compatible with the principles of trauma "logic"; these included, for example, the compression of historical time. Paraphrased, the rationale suggests that genocide is an incontrovertible crime (without a statute of limitations) that has never been resolved; since the Republic of Turkey is now the "logical" extension of the Ottoman empire, ASALA concluded that contemporary representatives of the present-day government are culpable for the genocide of 1915 (Miller and Miller 1991, 24–25). Egoyan himself admits that watching these terrorist acts (albeit on television) was overwhelming: "I was completely torn.... While one side of me could understand the rage that informed these acts, I was also appalled by the cold-blooded nature of these killings" (2002, viii). Around the mid-1980s, he wrote a script about these violent responses to Turkish denial, but he "wasn't ready to deal with the 'Armenian issue'" and never made that film (Egoyan 2002, viii). Allusions to the 1985 event appear in *Ararat* in the guise of Raffi's father, who was "killed trying to assassinate a Turkish diplomat. Almost fifteen years ago," which would place the event in the mid-1980s (Egoyan 2002, 53). In the next section, I trace how Egoyan's

films over the past two decades deal with the "Armenian issue" and pave the way for *Ararat.*

Egoyan's *Hai* Films

Egoyan's fourteen-minute first film, *Howard in Particular* (1979), is a darkly comedic homage to Samuel Beckett's *Krapp's Last Tape* (a play Egoyan filmed twenty years later for the Beckett on Film project). Egoyan imagines Howard as a Krapp transformed into a dismal retiree, mechanically dismissed by a large corporation. This topic is not particularly Armenian, but Egoyan does include one revealing detail: the title screen displaying his film production company, "An Ego Film Arts Production," also has an emblem that looks somewhat like the stylized, elongated, and cursive word *hi*. Egoyan uses this symbol to this day as his film company's emblem. In English, *hi* is obviously a term of greeting, but in Armenian, *Hai* or *Hye* is in fact the transliterated word for an Armenian person. *Haiastan* is the name of Armenia, and *hai* is also the root for the words meaning "father," "fatherland," and "countryman" (*hairen, hairenik,* and *hairenagitz*). Egoyan's emblem also looks vaguely like a mountain; as *Ararat* underscores, the iconic symbol of Armenia is Mount Ararat, even though this mountain is in what is now Turkey.[7] Thus this emblem of Armenianness, hidden in full view for all audience members to see (but not necessarily to interpret correctly), is characteristic of Egoyan's portrayal of ethnic identity from 1979 to the present.[8]

In some of Egoyan's earliest films, Armenian ethnicity is a source of cultural contrast: WASPish figures encounter displaced and often traumatized Armenians living in Canada. This theme permits Egoyan to explore the differences between Anglo-Canadian and diasporic Armenian culture and to depict diasporic Armenians struggling with past losses. In the short film *Open House* (1982), what at first appears to be a customary encounter between a real estate agent trying to sell a decrepit house to a young Anglo couple is eventually revealed to be a ritualistic drama staged and recorded for the agent's catatonic and possibly paralyzed father, Mr. Odahrian (Housep Yeghoyan).[9] We learn that Mr. Odahrian "hand-built" the house "like a castle," suggesting that while he now sits silently in a dark room hidden away from the potential buyers and watching slides of his family's home, he once was a strong and engaged member of his family. Although it is never explicitly stated, it is suggested that a debilitating catastrophe has occurred between the time the house was built and the present, a trauma that may be related to the father's viewing of old slides, like an internal viewing of memories.

Near the end of the film we are shown the front of the house, where the glass of a broken picture window has been replaced by a large piece of cardboard with painted Armenian letters. These letters spell out *patz doon—*

Howard in Particular: The "Ego Film Arts" logo. (© Ego Film Arts)

"open house" in Armenian. Egoyan's pointed use of the Armenian language effectively sets this house and family apart from the outside, Anglo world. The family name—Odahrian—is particularly revealing. *Odahr* means "foreigner" in Armenian, and *-ian* or *-yan* is the patronymic label of an Armenian name. Thus this family of Odahrians is literally a family of "foreign Armenians"—immigrants whose relationship to their "open home" (and, perhaps, to their homeland) is complicated and ambivalent. Their home is a source of pride and identity, a place that is open for outsiders to visit, but it is also a place that isolates them. They cannot keep it up and they pretend they want to sell it.[10]

Next of Kin (1984) explores similar ambivalences toward home, also by focusing on an encounter between a curious WASP—in this case, the adolescent Peter (Patrick Tiernay), dissatisfied with his Anglo family—and a diasporic Armenian family. After Peter sneaks a look at a video-therapy session of an Armenian family—Mr. and Mrs. Deryan (Berge Fazilian and Sirvart Fazlian) and their daughter Azah (Arsinée Khanjian), Peter decides to pose as their son, Bedros, who was given up for adoption as a baby. The family enthusiastically accepts Peter's explanation that he is their lost son by celebrating his arrival and welcoming him into the family home and business. The film imagines what it might mean to think that you could rediscover a family and a home you never actually had—just as a member of the

diaspora might imagine returning to the homeland he or she never actually lived in. As in *Open House*, a traumatic event motivates the rest of the action: the agonizing decision years earlier, when the family was indigent, to give up Bedros. The event has additional symbolic connotations for an Armenian family, as Donald and Lorna Miller describe: during the genocide deportations, mothers were often faced with the moral dilemma of either abandoning their children (to passing Turks or Kurds who might protect them) or struggling on together without food and water.[11]

Family Viewing (1987) is the first of Egoyan's films to deal explicitly with the Armenian genocide in some detail, although those details remain almost entirely allegorical.[12] Armenian history is alluded to through veiled reference: there is a grandmother named Armen, symbolic of Armenia and the traumatic history of survivors, and a grandson named Van. Van (Aidan Tierney) liberates Armen (Selma Keklikian) from the nursing home to which his Anglo, and presumably non-Armenian, father, Stan (David Hemblen), has had her committed. Van (also the name of the only Armenian town to stage a successful uprising during the genocide) thus finds a way to save Armen, this symbol of Armenian history.[13] Meanwhile, Stan records homemade porn over old family videotapes of Van's Armenian mother and Armen. Thus, while Van represents Armenianness defended—as do, more explicitly, the various representations of the town of Van in *Ararat*—Stan represents the principle of violently deliberate attempted forgetting. Stan—or, as it might be pronounced, St*ah*n—is a version of modern-day eastern Turkey, a *Haiastan* without the *Hais*. This allegorical representation of Armenian nationalism in the face of genocidal violence is literalized as the film that Saroyan is making in *Ararat*. But *Family Viewing*'s reliance on allegory and on veiled historical reference makes the issue of the Armenian genocide largely inaccessible to most viewers.

As the Soviet Union was collapsing in the early 1990s, the Soviet State of Armenia gained its independence and became, in September 1991, the Republic of Armenia. Suddenly there was a much more accessible notion of homeland for Armenians of the diaspora.[14] *Calendar*, Egoyan's 1993 film, explores the fantasy of returning to the Armenian homeland. It is Egoyan's most explicitly Armenian film prior to *Ararat*, but the genocide is only implicitly its focus. Instead, in this film each member of a diasporic couple (played by Egoyan and his wife, Arsinée Khanjian) represents polar positions on diasporic identity because each decides to return to a separate homeland at the end of their trip to Armenia. For the husband—a photographer on assignment in Armenia—home is Canada; for the wife, home gradually becomes Armenia. Thus, while the husband feels assimilated to Canada and returns there, the photographer's wife leaves her Armenian Canadian husband and remains in Armenia with their native Armenian tour guide. This split in the

notion of "home" alludes to the genocide, when Armenians had to leave their homes unwillingly in order to survive and assimilate in a new place. When the photographer's wife betrays her husband by holding hands with the guide while the husband is mesmerized by videotaping a large herd of sheep, the image of the herd of sheep suggests the rounding up of Armenians on death marches through the desert during the genocide (and, allegorically, the slaughtering of God's innocents). But the film ends with a critical question: is it more important to live in the present—and thus notice your wife holding another man's hand—or to live in the diaspora, shackled to symbolic images of the genocide and Armenian ruins?

As if to answer this question, after *Calendar* the obviously Armenian characters drop out of Egoyan's films. *Exotica*, *The Sweet Hereafter*, and *Felicia's Journey* take on contemporary themes and a more universal scope and reference, while the focus on survivor guilt is developed and the consideration of sadism intensifies. *The Sweet Hereafter* (1997), Egoyan's most well received film, complicates the issue of traumatic remembering introduced in *Open House* and *Next of Kin*. Like *Exotica* (1994), *The Sweet Hereafter* engages with issues of survivor guilt on a broader level, focusing on how we report and represent horrific events to others and ourselves. The film depicts a disastrous school bus accident, which might have happened anywhere, and its psychological and legal after-effects on the people in a small town. Yet this film also invokes issues that resonate in Armenian diaspora communities, such as the effect of violent catastrophes on individuals and communities, the motivation of survivor testimony, and the impact of a regularly evaded or denied issue within the different generations of a family.

Nicole (Sarah Polley), the lone adolescent survivor of the crash, is in a position similar to that of the genocide survivor: she is haunted by guilt for having survived, while paradoxically she finds her singularity empowering. Crippled in the accident, Nicole's new status as victim entitles her to a large settlement from an insurance company and thus suggests a way she can provide for her family. However, Egoyan is not interested simply in heroizing Nicole, but rather in representing her difficult struggle to integrate conflicting roles, both as a martyred witness to a catastrophe and as an adolescent girl with conflicts unrelated to that catastrophe. We gradually learn that Nicole was trapped in an inappropriately sexual relationship with her father (Tom McManus) before the crash. Her decision at the end of the film to lie about the bus accident—and thus forgo the settlement money that would have assisted her family—becomes a way to punish her father for his past abuse. Instead of representing a catastrophe as "fact," Egoyan represents the event rippling through a family: he shows how different generations within a single family manipulate one another, with the accident as pretence. Egoyan provides Nicole, the surviving witness, with an intelligible

motivation for lying about an event she witnessed and survived. She punishes her father by matching his own lie about their father–daughter love with a lie about the bus's speed during the accident.

Finally, *Felicia's Journey* (1999), the last major feature Egoyan produced before *Ararat*, is perhaps the ideal film to prepare him "to tell a story of horror" (Egoyan 2002, viii). The film takes one of the more common horror genres (the serial-killer movie) and turns it into a meditation on the complicated interaction of cruelty, denial, and self-knowledge. The teenager Felicia (Elaine Cassidy), forced to leave Ireland in order to have an abortion, is preyed upon by serial killer Hilditch (Bob Hoskins) in England. Like *The Sweet Hereafter*, *Felicia's Journey* represents violence reverberating in families. Thus, Felicia's father (Gerald McSorley), invoking Ireland's bloody history with England, curses her after learning that she's "carrying the enemy within" (Johnny, the father of her baby, has secretly left Ireland to join the British army). Felicia, manipulated by Hilditch, aborts Johnny's child. Hilditch's mother (Arsinée Khanjian) encouraged him to watch an opera dramatization of a severed head from *Salome* at an early age, and, perhaps in imitation, he murders his "lost girls" after acting for them in the role of surrogate parent.

More indicative of Egoyan's plans for *Ararat* are his methods of representing violence. Egoyan is extremely careful with his visual depictions of violence; he often uses indirect allusion and montages instead of graphic imagery. Felicia's abortion is represented in an ethereal, if tragic, light, with the bloody spot on her nightgown its only material manifestation. This is a serial-killer movie without a single representation of a killing. The closest we come to seeing one of Hilditch's murders is seeing his horrified reaction to a fictional murder on a hospital television set—a hackneyed, cinematic representation of a murder—again, the beheading of John the Baptist in *Salome*, although in this case, in a Rita Hayworth Hollywood version. Appropriately, a hospital sign next to the television underscores the source of his horror: "Blood Blood Blood." This entire scene is clearly meant to refer to the murders Hilditch commits—which presumably we are not shown because Hilditch himself denies his murderous acts. But in avoiding visual representation of the murders, Egoyan also avoids the crimes Hilditch's mother commits when she exposes her son to graphic violence. By subverting the serial-killer genre, *Felicia's Journey* explores what it means—for both the creator *and* the receiver—to represent violence, and the film considers why we represent what we do, and to whom.

Ararat explores these same issues by focusing on the horrors of the Armenian genocide. The film portrays survivors haunted by the memory of catastrophic events, while specifically focusing on the characters' attempts to represent the private, cultural, and national catastrophe of the Armenian

genocide both to themselves and to the world. The film consists of several intertwined plots. A contemporary, fictional Armenian director, Edward Saroyan (Charles Aznavour), is making a film about the Armenian genocide by focusing on the Van uprising that Armenian American painter Arshile Gorky (Garen Boyanjian and Simon Abkarian) witnessed and participated in. Much of Edward's film is based on his own mother's survivor testimony and on the autobiography of an American missionary who witnessed the genocide, Dr. Clarence Ussher (Ussher 1917). Edward also consults Ani (Arsinée Khanjian), an art historian and Gorky expert, who helps her son Raffi (David Alpay) get a job as an assistant on the set. Raffi, whose late father was an Armenian "terrorist," struggles with his own relationship to his Armenian past. He goes to Turkey, ostensibly to shoot background footage for Edward's film. Attempting to clear customs back in Canada, Raffi is interrogated at length by a custom's agent (David, played by Christopher Plummer), who has his own reasons to listen carefully for the truth (it is his last day on the job before retiring, and Raffi is the last traveller he interrogates).

Just as *Family Viewing* emphasizes the crucial role that the genocide survivor (Armen) plays in the contemporary Armenian diaspora (represented by young Van), so *Ararat* focuses on a genocide survivor, Arshile Gorky, who is vital to nearly everyone in the film. He is the film's most direct survivor of the genocide, and Egoyan represents him at various points in his life. As a young man, he takes part in the Van uprising that Nouritza Matossian describes in her recent biography *Black Angel* (which also serves as Ani's book in the film), although Edward fictionalizes Gorky's early life freely (Matossian 1998). As one of the members of the avant-garde art scene in New York in the 1930s, Gorky is portrayed struggling with his painting *The Artist and His Mother*. As Ani describes it, echoing Matossian, the painting is a "homage to his mother," Shushan Adoian, who died of starvation and illness after the family was forced from their home during the genocide (Matossian 1998, 93–99). Gorky—and more specifically, Gorky's direct relation to the tragedy of the genocide—is the focus of the film literally from the first scene to the last.

Most of the Armenian characters in the film's framing narrative are at least a generation distant from the event itself. Edward Saroyan, the director of the film within the film, creates his version of *Ararat* "based on what my mother told me." Other characters—Ani, Rouben, the ghost of Raffi's dead father—are most likely members of second and third generations, Armenians of the diaspora who would have heard about the genocide from parents or grandparents. Each represents the genocide to different audiences. As an art historian, Ani addresses the academic and art communities who have overlooked or ignored Gorky's Armenianness, while Rouben (Eric Bogosian), as the screenwriter of Edward's film, addresses a wide popular

audience. Ani's first husband, Raffi's dead father, had the most treacherous and controversial mission of "representing" the genocide for the Turkish government. Raffi's father was presumably a member of a diasporic "terrorist" organization such as ASALA, and we gradually learn that he was shot years earlier while attempting to assassinate a Turkish diplomat, a symbol of the Turkish government and thus a representative of its national policy of denial.

His son, Raffi, is a member of one of the youngest generations of diasporic Armenians; he is not only the Armenian in the film most temporally distant from the genocide, but is also grappling with the trauma of his father's death and reacting to the powerful feelings and ideas that led his father to become, alternately, a "terrorist" or a "freedom fighter." Raffi's distance from the experience of the genocide seems to link him to danger and violence in ways of which he himself is not entirely aware. Under the influence of his tormented stepsister, Celia (Marie-Josée Croze)—who not only offers the chilling suggestion that Raffi seek to be possessed by his father's ghost in order to keep the memory of his father alive, but also transfers her anger at Ani into a knife attack on Gorky's painting—Raffi goes to Turkey and, perhaps unintentionally, becomes a heroin smuggler.

As these brief descriptions illustrate, Egoyan not only portrays the genocide, but also investigates *how* and *why* various people choose to understand and represent the genocide to themselves and others. Previous Egoyan films have also focused on the way people "use history like a weapon" (as Raffi says of Ani). *Calendar* and *Felicia's Journey*, for example, both focus on how the ruins of buildings can be manipulated as a kind of rhetorical, testimonial device. In *Calendar*, many of the arguments between the photographer and his wife are sparked by the photographer's unwillingness to leave his camera and touch the ruins of churches and fortresses such as Noravank or Ampert. And in *Felicia's Journey*, Felicia's father repeatedly takes her to walk among Irish ruins while inculcating her with Irish nationalism: "Think of your great-grandmother. Her husband, your blood, was executed by the Brits, May 1916. Sacrifices have been made and they will be honoured. We have a duty to remember these things. Time will not allow us to forget." In each case, a building with national historic significance becomes a dramatic prop for a heated domestic argument.

From the very beginning of *Ararat*, the key historic object is not a ruined building, but Gorky's painting *The Artist and His Mother*. The painting becomes a device to consider how experiences not only are perceived by a person but are then transformed into a representation that can be perceived by someone else. Consider the title sequence, which begins with a simple brown button hanging from a thread in Arshile Gorky's New York studio— a sign of the reality of Gorky's mother, as well as of her attention to and care for her son. The camera glides onto the photograph of Gorky and his mother,

Ararat: Button hanging from thread, in the title sequence. (© Serendipity Point Films/Ego Film Arts)

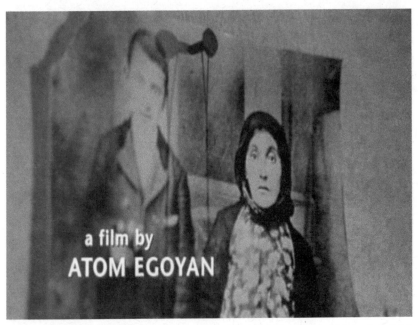

Ararat: Photograph of Gorky and his mother on the wall, in the title sequence. (© Serendipity Point Films/Ego Film Arts)

Ararat: Grid of Gorky's painting, in the title sequence. (© Serendipity Point Films/Ego Film Arts)

Ararat: *Khachkar* and flowers, in the title sequence. (© Serendipity Point Films/Ego Film Arts)

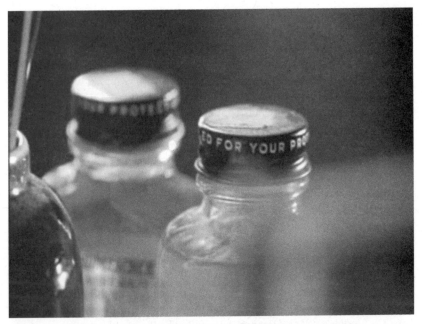

Ararat: Varnish jars, in the title sequence. (© Serendipity Point Films/Ego Film Arts)

which, we learn at the film's end, connects the button to the moment the picture was taken and to the painting he is working on. Next we see one of Gorky's many drawings of the photograph, this one with a grid that will allow the small drawing to be transformed, that is, blocked onto a large canvas while maintaining its proportions. Superimposed is the film's title, first in Armenian, which then transforms into English. As the camera continues to glide through the studio, picking out objects, moving in and out of focus, we see some of the iconic symbols of Armenian culture and landscape— bright, fresh flowers indigenous to the Van region; a small *khachkar* in the form of an ornamental stone crucifix. Both objects represent the homeland for a member of the diaspora. Finally, the tools and media used to produce a representation come into view: the pencils, paintbrushes, palette knives, and tubes of paint. Egoyan presents a representation in the middle of its production. Looking closely, one can read "for your protection" on the sides of the lids of varnish jars, warning us that closed jars of varnish pose the least danger. And yet Egoyan is also suggesting that the danger of art is one that needs to be opened up and exposed. Right from the start, the film foregrounds the working through of a representation, in all senses of working through: artistically, linguistically, interpretively, and psychoanalytically. In this title sequence (perhaps more correctly labelled a tableau sequence), we are not only deliberately moving through Gorky's studio to see his attempt

to grapple with a moment in history and memory; we are also following a particular path and process of symbolization.

By framing the film with Gorky's painting and, at various later points, with Ani's and Celia's interpretations of it, Egoyan is confronting a particular problem that Armenian artists and writers have grappled with for years as they searched desperately for an appropriate form and medium to give voice to at least the initial catastrophe. Certainly, confronting the genocide in art—as we see Gorky do in his painting—presented a task particularly formidable in unsympathetic or unknowing host cultures. The inexpressibility of the horrors, added to the denial of Turkish governments, often paralyzed Armenian artists and writers attempting to obtain a perspective from which to represent the genocide.[15] As Egoyan himself asks, speaking of the making of this film, "How does an artist speak the unspeakable?" (2002, viii). In other words, how can a violent, nation-shattering genocide be understood within the more or less conventional realm of aesthetic representation?

One might argue that the way to convince anyone of the magnitude and evil of this historical event would be simply to let the testimony speak for itself, that is, to depict an eyewitness account visually. Although there have been widely viewed representations of the Holocaust, such as Steven Spielberg's *Schindler's List* and Roman Polanski's *The Pianist*, the Armenian genocide has gone virtually unrepresented in popular visual consciousness. Thus, a straightforward, documentary representation of the genocide is likely to have a powerful effect on its audience. Egoyan portrays this type of representation—that is, a feature film as historical documentary—via the movie within the movie, Edward Saroyan's *Ararat*. Saroyan is largely effective at producing a horrified reaction in his audience. Near the end of Egoyan's *Ararat*, we see people watching the opening-night screening of Saroyan's *Ararat*; the audience is perceptibly disturbed by the images portrayed on their screen and, at moments, on our screen. Some cover their mouths in abhorrence; others shake their heads in disbelief. Some of the early reviews of Egoyan's *Ararat* expressed a yearning for this more familiar, cathartic movie experience. Anthony Lane of *The New Yorker* writes that Egoyan "should have made an exemplary documentary on the subject of the slaughter, and asked Aznavour ... to talk us through it" (2002, 104–105). Lane seems to want more of Saroyan's *Ararat* and less of the contemporary story of young Raffi, Ani, and Rouben. In fact, one of the initial questions about Egoyan's film was, considering the lack of a widely released dramatic movie on the genocide, why didn't Egoyan simply film Saroyan's *Ararat* as his *Ararat*?

Let me suggest some possible answers to this question. First of all, Egoyan underscores the idea that even a straightforward representation based on an eyewitness account—Ussher's autobiography, for example—is at least once removed from the event itself, exposing a documentary to the

charge of manipulation or falsification. One point of the lengthy interrogation of Raffi by the customs agent is to underscore the difficulty of establishing truth based on a single person's narrative. The goal of a customs agent is to ask questions that will expose a simple set of facts: Who are you? Where are or were you travelling to, and why? What are you bringing into our country? But Egoyan reveals that these seemingly straightforward questions are, in fact, existential questions for a member of the Armenian diaspora such as Raffi. Raffi interprets these questions differently than David intends them, hearing instead, Who am I as an Armenian in Canada? Why does a diasporic Armenian travel back to Turkey? What images, ideas, and dangers, such as the symbolic heroin, do I bring back from where I've been? Whatever questions David asks and whatever questions Raffi answers, the film suggests that to determine the truth by listening to someone speak is a difficult task. No wonder that before opening the cans of film, David voices his frustration: "What are we going to do? There's no one I can contact. There's no way of confirming that a single word of what you've told me tonight is true." Raffi's response—"Everything I've told you is exactly what happened"—is more or less true of the genocide, but not quite so true of what he's brought back with him inside the cans of film. The point here is that all representations—including the representation Raffi narrates to David about who he is and where he's been and why—are mediated by some person or thing doing the witnessing or recording. Had David chosen not to listen to all of Raffi's story and merely employed a drug-sniffing dog, the complicated truth that Raffi told—both the history of the genocide and the history of the film cans—would have been lost to David. By framing *Ararat* with this customs interrogation, Egoyan foregrounds the act of telling and hearing a personal narrative.

Many of Egoyan's previous films also contend with the way that media devices, such as Raffi's video camera, facilitate not just memory but also fantasies of forgetting or altering history. Photographs can be destroyed (*The Adjuster*) and video can be recorded over (*Family Viewing*) or used to make false claims (*Next of Kin*). In addition, witnesses might have substantial personal reasons to testify falsely, as does Nicole in *The Sweet Hereafter*. Genocide-deniers have distorted these intrinsic qualities of representation in order to reject the truth value of survivor testimony, employing a kind of radical skepticism to argue that because a lie *could* be told, no truth *can ever* be told. One of the most infuriating methods of Turkey's eighty-five years of denial has been to cast suspicion on eyewitness accounts of the genocide by claiming that these testimonies are so detailed, they must be made up.[16] Ignoring all evidence to the contrary, Turkish organizations claim that Armenian nationalist interviewers coached survivors in order to conclude that the testimony must be false propaganda.

Already at the opening night gala of Saroyan's *Ararat*, we see the character Martin Harcourt (Bruce Greenwood), the actor who plays Clarence Ussher in Saroyan's film, having to respond to a reporter's provocation that the genocide might be "all an exaggeration." Harcourt explains that Saroyan's film is taken from Ussher's published eyewitness testimony; but he might also have added that as an American missionary, Ussher conferred on his eyewitness account the tint of "Western objectivity" in the eyes of the world. Egoyan's film is not Saroyan's film because the distinction enables Egoyan to create a strategy to answer and dismiss within the film itself the charge of falsification. An Armenian making a film about the genocide is going to be accused of propaganda and falsification (as Saroyan is). By having those arguments within the film, particularly with the exchanges between the half-Turkish actor Ali (Elias Koteas), Saroyan, and Raffi (when Ali trots out some of the familiar arguments—for example, that "lots of people died…. It was World War I"), Egoyan effectively responds to Turkish denial on his own terms, undermining the Turkish government's facade of presenting a "balanced" argument.

Another crucial issue Egoyan is contending with is the fact that violent, graphic representations on the film screen are not only subject to manipulation; they are also potentially manipulative themselves, exploiting the audience's feelings. Egoyan's previous work has been deeply suspicious of the potentially manipulative quality of film to absorb us in an event we did not witness at first hand—whether that experience is pleasurable, painful or some combination of the two. A film such as *Schindler's List* induces cathartic identification in order to draw us into the action and maintain our absorption, but in both *Ararat* and his previous films, Egoyan portrays this type of audience absorption as dangerous passivity. In *The Sweet Hereafter*, sleepiness is associated with an almost hypnotic state of vulnerability: Nicole often looks sleepy in flashback sequences with her father.[17] In *Felicia's Journey*, Felicia is in most danger from serial killer Hilditch after he drugs her with sleeping pills. In her stupor, she is unable to resist him, but by willing herself to wake up, she manages to escape from his house. In a key discussion in *Ararat*, Raffi and Ali discuss Ali's portrayal of Jevdet Bey: "I was raised to feel a lot of hatred to the person you're playing," says Raffi. "You really pulled it off." When Ali points out that Raffi was "kind of prepared to hate" any portrayal of Jevdet Bey, Raffi responds with a reaction that speaks to an essential quality of Egoyan's filmmaking: "I'm also kind of suspicious of stuff that's supposed to make me feel anything, you know?… Even though I know you were supposed to make me feel like hating you, I resisted it." This resistance that Raffi describes marks a crucial distance between Saroyan's film and Egoyan's.

Egoyan's resistance to manipulating his audience might also be a protective gesture here, since one crucial audience for this film is the Armenian diaspora. Egoyan doesn't need to make a graphic film because Armenians already fill in graphic details for themselves with stories told by their parents and grandparents. Many genocide survivors described their memories of the past in distinctly visual, often specifically cinematic terms, and their stories tend to be brutal. One survivor said, "I think about my past all the time. It comes in front of my eyes like a dream. You don't want to think of those incidents, but they come to your eyes" (Miller and Miller 1991, 157). A child of a survivor illustrates the hardship of listening to violent narratives of the genocide: "My mother talks about a rape and it's a disgusting story that her mother told her. When she used to tell me some of these things she had such a vengeance in her voice that I didn't want her to talk about it. It was frightening" (Phillips 1989, 249). Egoyan, therefore, doesn't overload the viewer by adding more frightening graphic images, but alludes to scenes that more or less exist in the Armenian diaspora's collective memory.

Probably the crucial reason why Saroyan's film is not and should not be Egoyan's film, however, is that representing the horrors of the historical genocide captures only part of what the horror has become. Egoyan explains in an introductory essay to *Ararat: The Shooting Script* that "from the moment I began to write this script, I was drawn to the idea of what it means to tell a story of horror" (2002, viii). The horror, he explains, is not only the genocide, but also the ramifications of the world's *not* being told this specific story of horror. This is the horror of denial as it continues to reverberate. By focusing on "what it means to tell a story of horror," Egoyan shows how everyone can be drawn into the drama of telling, listening, and denying—not only the most direct victims of the horror but the survivors' children and grandchildren, perpetrators' children and grandchildren, and anyone who comes into contact with these descendants. Egoyan continues: "The grammar of the screenplay uses every possible tense available, from the past, present and future, to the subjective and the conditional" (2002, viii). Because all of these horrors are part of the current Armenian diaspora experience, all grammars must be used to tell the story of the ongoing horror of the Armenian genocide, reverberating and possibly creating new horrors.[18]

The most striking example of the full range of characters absorbed into this horror-drama is the juxtaposition of two sequences in *Ararat*.[19] First, an enraged Celia attacks Gorky's painting; then Ani, distraught at learning of Celia's knife attack on Gorky's painting, strides into the live set of Saroyan's film. Saroyan is filming a crucial genocide scene of the defence of Van, and Ani's presence (dressed in contemporary clothing) ruins the mood and the shot, drawing the wrath of Harcourt, who is still caught up in his portrayal

of Dr. Clarence Ussher: "What is this, God damn it?! We are surrounded by Turks. We've run out of supplies, most of us will die. The crowd needs a miracle. This child is bleeding to death. If I can save his life it may give us the spirit to continue. This is his brother. His pregnant sister was raped in front of his eyes, before her stomach was slashed open to stab her unborn child. His father's eyes were gauged out of his head and stuffed into his mouth and his mother's breasts were ripped off. She was left to bleed to death. Who the fuck are you?"

As he describes the gruesome abominations the Armenians around him have suffered—abominations historically corroborated by eyewitness testimony but that Egoyan is clearly reluctant to represent visually—it becomes clear that even *narrated* descriptions of these depraved acts have the power to horrify the narrator. The tirade leaves everyone, including Ani, speechless. Presumably, her concerns cannot compete with those of someone who has witnessed such acts. Egoyan suggests that these narrations are so horrible that they always shatter their representational boundaries. Thus, he also juxtaposes Celia's rupture of Gorky's painting with Ani's rupture of Edward's shot.

Harcourt/Ussher's attack on Ani challenges her sense of self-importance and her decision to waste everyone's time by ruining the take. And yet his final demand—"Who the fuck are you?"—is a question that Egoyan is endeavouring to answer for descendents of Armenian genocide survivors. As with David's interrogation of Raffi at customs, a seemingly simple query becomes a challenge to one's identity and motivations.[20] The question demands that Ani, as an Armenian genocide descendant, defend her sense of belonging to her historical people: who are *you*, Ani, in relation to *us*, victims of the genocide? Ironically, the "us" here includes the self-righteous non-Armenian actor Harcourt, absorbed in his role of Ussher. At this moment, he becomes— or, more accurately, ventriloquizes—the historical voice of Armenian genocide victims demanding precedence over all other concerns, such as Ani's anxieties about Gorky's painting.[21]

In these scenes, Egoyan is not just presenting an imagined dialogue between Armenian generations (a genocide survivor confronting his second- or third-generation descendent); he is also illustrating the implied challenge of "authentic" first-generation genocide testimony to all future representations of the trauma (such as Gorky's painterly depictions or Ani's biography of Gorky's life).[22] Earlier films such as *Family Viewing* and *Felicia's Journey* depict generational transmission of traumatic representations ambivalently veiled, but in *Ararat*, this face-off between different generational representations is starkly pared down to its most basic elements. Ani's speechlessness illustrates the power of first-generation testimony, for even a non-Armenian (Harcourt/Ussher) can employ testimony to suppress any

other concern. But Egoyan's decision to show us this scene *instead* of the graphic scenes Harcourt/Ussher describes reveals Egoyan's representation overcoming the second generation's speechlessness.

In other words, throughout the film Egoyan is most interested not in the original genocide testimony itself, but in the various reactions to and interpretations of this testimony by later generations. He shows, for example, how stories of genocide horror become a kind of fetish object for the Armenian diaspora community, just as genocide paraphernalia becomes a type of fetish object.[23] Armenian characters in the film clutch particular symbols of the genocide and of Armenianness. For Gorky, it is the photo of his mother and that coat button. For Saroyan, it is the spiritual image of Mount Ararat and the pomegranate his mother used to sustain her on the death marches, which represented "luck and the power to imagine." For Ani, it is Gorky's mournful painting, "a repository of our history." Raffi is clearly searching for such a symbol during his travels to Turkey, since part of the genocide's damage has been to leave younger generations without a meaningful symbol of memorialization. He records his despair while in the ruined town of Ani: "When I see these places I realize how much we've lost. Not just the land and the lives, but the loss of any way to remember it."

Egoyan's *Ararat*, unlike Raffi's or Edward's, is an attempt to make a crucial intervention in this proliferation of horror and loss, but *not* by adding another symbol or fetish to the proliferation of symbols of Armenianness or the Armenian genocide. Instead, Egoyan is considering how these symbols (such as the button, the pomegranate seeds, the Gorky painting) work—and don't work—in the Armenian diaspora. Thus, in Egoyan's *Ararat*, it is the interpretation of and engagement with these symbols that constitutes Egoyan's representation. Gorky's private and public trauma, for instance, is manifested at the moment in the middle of the film when he "finishes" his painting of himself and his mother by dropping his tools—the paintbrush and palette—and scoops up flesh-coloured paint with which to massage (or cover up, or blur) the representation of his mother's hands. He momentarily forgoes mediating the representation from that critical distance of the length of a paintbrush, desiring instead to touch the painting directly. This is a gesture Ani will echo at the end of the film: after giving a lecture on Gorky's paintings, she reaches up to the projection screen in order to touch the slide image of Gorky's mother's hands. Ani is another generation removed from the genocide survivor and the survivor's image (revealed by the way she "touches" the projected light instead of the actual painting), but her need to grapple with the survivor as a cultural symbol remains powerful.

Through the interplay of various stories of *Ararat*—both Saroyan's film *Ararat* and Raffi's digital video images of the mountain itself—and by animating characters whose motivations stem from a complex set of circum-

stances, Egoyan's *Ararat* conscientiously finds a way to represent the geno-
cide that will lead neither to the generation of more horror nor to the gen-
eration of more denial. Egoyan is not exactly representing the Armenian
genocide throughout his film career, but rather providing thoughtful accounts
of the genocide's complicated role in diasporic life. Moreover, he rejects the
view of the survivor as a martyred witness. Always considering his directo-
rial role, Egoyan seeks not to transmit a trauma to the viewer, but to repre-
sent catastrophe's aftermath—one with a particular, Armenian context. By
meditating on the way Armenians handle their symbols, Egoyan suggests
another way to interrupt—or at the very least delay—the progressive losses
to Armenians and Armenian culture.

Notes

1 For a succinct contextual analysis of this quotation see Dadrian (1995, 401–409).
2 Although the term *diaspora* originally referred to "Jews living dispersed among
the Gentiles after the Captivity (John vii. 35)" (*Oxford English Dictionary*), the
word has evolved to mean any group of people that has emigrated from their
homeland and that retains some sense of cultural (and not necessarily religious)
identity. Thus, there are an African diaspora, an Irish diaspora, an Indian dias-
pora, and an Armenian diaspora, among others. Over the past twenty-five years,
more and more people have come to understand themselves as members of a
diaspora. For additional discussions of this concept, see Tölölyan (1991) and
Safran (1991).
3 As Ronald Grigor Suny writes, "Allied with the [United States], present-day Turkey
refuses to acknowledge the historical experience on which its own territorial
hegemony is based. Armenians must be purged from memory, not only in Turkey
but internationally as well, and Kurds must be forcibly transformed into 'Moun-
tain Turks'" (1993, 115). For an analysis of some of the ways the Turkish govern-
ment continues to deny the genocide by threatening, impeding, and attempting
to manipulate historians, see Smith, Markusen, and Lifton (1995).
4 Robert Melson's comprehensive *Revolution and Genocide: On the Origins of the
Armenian Genocide and the Holocaust* (1992) explores this relationship fully. See
also Safran (1991, note 2) and Richard Hovannisian, ed., *The Armenian Geno-
cide in Perspective* (1986).
5 The Turkish state spends exorbitant sums "on public relations firms to improve
its image, lobby public officials, place advertisements in prominent newspapers,
and subsidize publications favorable to its point-of-view" (Smith 1992, 5). Between
1985 and 1990, there were extensive U.S. congressional debates on the commem-
oration of April 24 as a day of remembrance of "man's inhumanity to man with
particular reference to the Armenian genocide" (Hovannisian 1992, xix). The
Turkish government successfully deployed its strategic military leverage in order
to keep this day of institutionalized remembrance from being placed on the cal-
endar. Crucially, few media have been spared in this revision of history. In the
1930s, the U.S. State Department, "at the insistence of the Turkish government,"
impeded Metro-Goldwyn-Mayer from producing a film about a group of resist-
ance fighters who survived the genocide, *The Forty Days of Musa Dagh* (Smith
1992, 11).

6 In *Survivors: An Oral History of the Armenian Genocide* (1993), Donald E. Miller and Lorna Touryan Miller observe that "after approximately fifty years of relatively low-level political demands for recognition of the genocide, the pursuit of justice by survivors" in the 1970s and 1980s suddenly became increasingly violent; a number of grandchildren of Armenian genocide survivors took retribution into their own hands, assassinating diplomats and political officials (167). For a comprehensive examination of the cultural factors working here, see Tölölyan (1987) and Miller and Miller (1991).

7 As Egoyan himself points out, Mount Ararat is "the most fetishized symbol" of Armenia (Egoyan 1997, 219).

8 Of course, a similar self-consciousness about his Armenianness is suggested in Egoyan's play on his name: Ego Film Arts's films are, in various ways, films about his own ego.

9 The film is also playing on the stereotype of Armenians as greedy businessmen, trying to sell anything to anyone. In this case, the Armenians are creating a ruse so as *not* to sell.

10 A similar ambivalence on the part of Armenians toward home is seen in *The Adjuster* (1991). The film's contemporary narrative involves an insurance adjuster and his family, but the family clearly originates from another place. Seta's, Simone's, and Hera's Armenianness is never explicitly stated or remarked upon in this film, but they speak Armenian to each other as a hushed backdrop to the action. Along with the samplings of the *duduk*, an Armenian wind instrument, one can glimpse an Armenian shop sign from a photograph of Seta's old Beirut neighborhood—before she burns the photo. When one of the non-Armenian characters in the film asks why Seta persists in destroying these photographs, Hera replies casually, "She doesn't like to keep things." This is a darkly comedic portrayal of reactions to a series of traumatic events—the catastrophic elimination and displacement of Armenians from their homeland. In *The Adjuster*, Seta, Hera, and Simone move from their home in Beirut to the shell of a home in Canada, from one part of the diaspora to another.

11 Miller and Miller discuss this issue using numerous eyewitness accounts from survivors (Miller and Miller 1991, 97–102).

12 For a more complete analysis of this film, see Siraganian (1997).

13 The history of Van has taken on legendary status in Armenian history; it resembles the Jewish Warsaw ghetto, but its uprising succeeded. In mid-April 1915, the Turkish governor of Van, Jevdet Bey (portrayed in *Ararat*), ordered four-thousand Armenians to report to be drafted into the Ottoman army; following the pattern of genocide extermination since 1914, these men were certain to be massacred. Armenian draftees declined to report as ordered, and by April 19, Jevdet issued a general order that "the Armenians must be exterminated. If any Muslim protect a Christian, first, his house shall be burnt; then the Christian killed before his eyes, then his [the Muslim's] family and himself" (Walker 1980, 206–207). However, during that week the Van Armenians prepared for a Turkish onslaught, building extra walls to protect the old city of Van and the new suburb of Aikesdan. From April 20 to May 16, 1915, Van held up under siege by the Turkish army until the Turks retreated in defeat and "the advance guard of the Russian army, consisting of Armenian volunteers, arrived" (Walker 1980, 205–209). In keeping with this historical account of Van, in *Family Viewing* the door of Van's room is covered with a vintage movie poster displaying the prominent (and apropos) title "THE TANKS ARE COMING."

14 However, the issue is complicated because many of the descendents of genocide survivors came from western Armenia (eastern Turkey); there is considerable regional division between eastern and western Armenia, including substantial differences in dialect.

15 The scholar-poet Leonardo Alishan details the conundrum as follows: "Without art there was madness. But with this madness what art could there be? What genre could comprehend this catastrophe? What genre could possibly hope to give formal shape to this atavistic insanity?" (1992, 349). Many writers never found a suitable medium and consequently avoided the subject of "this atavistic insanity." The only possible response imaginable was Zapel Esayan's almost solipsistic sublimation: "I feel that I should let out the scream of the nation suffering for centuries under the yoke of oppression and slavery. I ought to let out the scream of liberation with my personal talent and my intrinsic power" (qtd. in Peroomian 1992, 240). As Esayan's conditional rhetoric portrays ("I should," "I ought to"), the inexpressibility of the horrors, added to the denial of Turkish governments, paralyzed Armenian artists and writers from obtaining the necessary distance with which they "should have" approached the genocide.

16 Miller and Miller provide a thoughtful analysis of the issues involving the authenticity of survivor testimony in *Survivors* (1991, 9–31).

17 Egoyan is suggesting that any type of art—film, painting, music—that is not being actively, consciously grappled with is potentially harmful. Consider the frame-story in *The Sweet Hereafter*: the Pied Piper who leads Hamelin's children away from their families and to their dubious future (perhaps death, perhaps displacement to Transylvania) does so by mesmerizing the children with the "sweet / Soft notes" of his music. Nicole narrates precisely this part of Browning's *Pied Piper* poem as we watch her surrender to her father's incestuous advances, with seductively placed candles and a guitar in the background.

18 The creation of terrorist organizations (such as the one that Raffi's father belonged to and gave his life for), as well as Raffi's unwitting smuggling of heroin from Turkey, are two examples of new horrors that emerge from old ones.

19 There is actually one additional scene between the two mentioned: David and Raffi discuss Celia's knifing of the painting.

20 Similar inquisitions occur in various other Egoyan films, such as the inquisition of the exotic animal smuggler in *Exotica*, and that of Felicia entering England in *Felicia's Journey*. In both cases, the person being questioned is, in fact, smuggling in another, developing being (the smuggler's eggs, Felicia's fetus). Although Raffi is not exactly smuggling in another being, he is smuggling in the heroin, and he is also "smuggling in" his newly developed consciousness of who he is as an Armenian.

21 In a certain sense, Harcourt, as Ussher, is serving a very similar role as Peter in *Next of Kin*. Peter, disgusted by his WASP family, "pretends" to be a historical figure (the family's long-lost son, Bedros) in order to align himself with a family of distraught, displaced Armenians.

22 The original screenplay has Gorky and Ani speaking to one another directly (Egoyan 2002, 75).

23 Jenny Phillips observes that there is a fetishism of Armenian genocide paraphernalia: "At a recent annual gathering to commemorate the Armenian genocide, an Armenian priest held up an old torn pair of trousers which had been removed from the body of a child, killed during the genocide. The priest said that when he handles the child's trousers he feels as though he is touching the robe of the Lord" (1989, 2–3).

Works Cited

Alishan, Leonardo. 1992. "An Exercise on a Genre for Genocide and Exorcism." In *The Armenian Genocide: History, Politics, Ethics*, ed. Richard Hovannisian, 340–54. New York: St. Martin's Press.

Beckett, Samuel. *Krapp's Last Tape*. 2000. Directed by Atom Egoyan. London: Clarence Pictures.

Egoyan, Atom. 1997. "The Accented Style of the Independent Transnational Cinema: A Conversation with Atom Egoyan." Interview by Hamid Naficy. In *Cultural Producers in Perilous States: Editing Events, Documenting Change*, ed. George E. Marcus, 179–231. Chicago: University of Chicago Press.

———. 1999. "The Politics of Denial: An Interview with Atom Egoyan." Interview by Richard Porton, *Cineaste*, December, 1999, 39–41.

———. 2002. *Ararat: The Shooting Script*. New York: Newmarket Press.

Hovannisian, Richard, ed. 1986. *The Armenian Genocide in Perspective*. New Brunswick, NJ: Transaction Books.

Lane, Anthony. 2002. "Worlds Apart: *Far from Heaven* and *Ararat*." *The New Yorker*, November 18, 104–105.

Matossian, Nouritza. 1998. *Black Angel: A Life of Arshile Gorky*. London: Chatto and Windus.

Melson, Robert. 1992. *Revolution and Genocide: On the Origins of the Armenian Genocide and the Holocaust*. New Brunswick, NJ: Transaction Books.

Miller, Donald E., and Lorna Touryan Miller. 1991. "Memory and Identity across the Generations: A Case Study of Armenian Survivors and Their Progeny." *Qualitative Sociology* 14, no. 1: 13–38.

———. 1993. *Survivors: An Oral History of the Armenian Genocide*. Berkeley: University of California Press.

Naficy, Hamid. 1997. "The Accented Style of the Independent Transnational Cinema: A Conversation with Atom Egoyan." In *Cultural Producers in Perilous States: Editing Events, Documenting Change*, 179–231. Chicago: University of Chicago Press.

Ouzounian, Richard. 2002. "Dealing with the Ghosts of Genocide: Egoyan and Khanjian Tell of Their Passion for Armenia." *Toronto Star*, September 5.

Peroomian, Rubina. 1992. "Armenian Literary Responses to Genocide: The Artistic Struggle to Comprehend and Survive." In *The Armenian Genocide: History, Politics, Ethics*, ed. Richard Hovannisian, 222–49. New York: St. Martin's Press.

Phillips, Jenny. 1989. *Symbol, Myth, and Rhetoric: The Politics of Culture in an Armenian-American Population*. Immigrant Communities and Ethnic Minorities in the United States and Canada Series 23. New York: AMS Press.

Safran, William. 1991. "Diasporas in Modern Societies: Myths of Homeland and Return." *Diaspora: A Journal of Transnational Studies* 1, no. 1: 83–99.

Shirinian, Lorne. 1992. *The Republic of Armenia and the Rethinking of the North-American Diaspora in Literature*. Lewiston, NY: Edwin Mellen.

Siraganian, Lisa. 1997. "'Is This My Mother's Grave?': Genocide and Diaspora in Atom Egoyan's *Family Viewing*." *Diaspora: A Journal of Transnational Studies* 6, no. 2: 127–54.

Smith, Roger. 1992. "The Armenian Genocide: Memory, Politics, and the Future." In *The Armenian Genocide: History, Politics, Ethics*, ed. Richard Hovannisian, 1–20. New York: St. Martin's Press.

Smith, Roger, Eric Markusen, and Robert Jay Lifton. 1995. "Professional Ethics and the Denial of the Armenian Genocide." *Holocaust and Genocide Studies* 9, no. 1: 1–22.

Suny, Ronald Grigor. 1993. *Looking toward Ararat: Armenia in Modern History*. Bloomington: Indiana University Press.

Tölölyan, Khachig. 1987. "Cultural Narrative and the Motivation of the Terrorist." *Journal of Strategic Studies* 10, no. 4: 217–33.

———. 1991. "The Nation-State and Its Others: In Lieu of a Preface." *Diaspora: A Journal of Transnational Studies* 1, no. 1: 3–7.

Ussher, Clarence D. 1917. *An American Physician in Turkey: A Narrative of Adventures in Peace and in War*. Boston: Houghton Mifflin.

Walker, Christopher J. 1980. *Armenia: The Survival of a Nation*. London: Croom Helm.

 8

History and Memory, Repetition and Epistolarity

Marie-Aude Baronian

Atom Egoyan's intensely rich, broad, and coherent oeuvre discloses the film-maker's ongoing fascination with the simultaneously possible and impossible filmic representation of collective history and memory. Egoyan, an assimilated Canadian from the western Armenian diaspora, believes that shared memories and history are what hold a community together, and yet he observes that for many communities, "certain histories have been deprived or denied" (1997b, 42).[1] While Egoyan's concerns with deprived or denied histories are frequently enacted at the level of the family, I will argue that his focus on the legacies of denial and forgetting is best understood as a refraction of a larger socio-political issue: the collective history of Armenians, specifically the problems posed for this community because of the official denial of their genocide. From his very first feature to his latest, and in other creations, including his films for television, video, installations, theatre, and short films, Egoyan has always in one way or another "talked" about Armenian history, though often obliquely, through narrative, structure, and visual style.[2] These oblique Armenian references often take the form of proper names, overt cultural or political references, symbolic images, musical motifs, and physical appearances, but also of themes that relate to this particular history. While *Calendar* (1993) is his most direct contemplation of what it means to be Armenian and *Ararat* (2002) most explicitly addresses

the tragic Armenian past, Egoyan's inquiry into Armenianness can be detected in other projects as well. The three short films discussed in this paper, *Open House* (1982), *A Portrait of Arshile* (1995), and *Diaspora* (2001), reveal Egoyan's personal and artistic preoccupation with Armenia's tragic history of genocide, a legacy that implies both a complex personal and political responsibility and the endless desire to fulfill that responsibility. The three short films continuously raise, in different terms and forms, questions such as, how can the Armenian past be (or not be) remembered? what imprints or scars has this history left? The films also express a fascination with memory in a broader sense by addressing the following question: what is the link between memory and technology? These three shorts are characteristic of the way his work as a whole questions the link between the possibility of remembering and our access to what must be or what cannot be remembered.

Before discussing the short films, it is worthwhile recalling the underrepresented history the filmmaker is confronting. In 1915, the Turkish government's Committee of Union and Progress (a revolutionary organization within the Ottoman government), better known as the Young Turks, entered into a systematic and organized plan to eradicate the Armenian people in an effort to homogenize the population and to forge a new nationalism behind the front of a world war. Between 1915 and 1922, approximately 1.5 million Armenians perished as a result of the Turkish government's policy of genocide. More than eighty-five years later, the present-day Turkish government has still not admitted that this genocide took place. This politics of denial inherent to this policy of genocide and its quiet acceptance by the rest of the world have perpetuated and reinforced the original violence and trauma. As a consequence of Armenians' being expelled, silenced, and excluded from official shared history and of having the genocide designated a "fictional" event, the heritage of the catastrophe has become localized in the imaginary. The work of mourning has never really taken place, and Armenians feel that they have to provide evidence to legitimate their past. The overwhelming power of this highly contested and neglected event, together with the contradictory possibility and impossibility of forgetting, has pushed Egoyan to create and re-create as many images as possible. For the filmmaker, the act of making images (even if those are not always specifically Armenian in content) constitutes an artistic response to the lack of specific images depicting the tragic Armenian past.

In the three short films I consider here—*Open House, A Portrait of Arshile,* and *Diaspora*—history and memory are modulated by two multi-faceted and subtle tropes: repetition and epistolarity. Commonly understood as the act of reiteration, I argue that in Egoyan's oeuvre, repetition is used predominantly in two of the senses proposed in Étienne Souriau's *Vocabulaire d'esthétique:* first, at the level of the structure of the work, where "the same

element or the same motif is found multiple times," but also at the level of his entire oeuvre, in which we find "the return of the same elements, of the same preoccupations, from one work to another" (Souriau 1991, 1220). Egoyan uses repetition both intra-diegetically (that is to say, within the narrative) and extra-diegetically (outside of the narrative) to generate a much richer, more complex repertoire of meanings.

While the term *repetition* is readily recognizable, *epistolarity* may be a less familiar concept. Hamid Naficy's definition of epistolarity, as developed in *An Accented Cinema: Diasporic and Exilic Filmmaking*, links the term to history and memory. For Naficy, epistolarity contributes to accented cinema by challenging classical narrative structures. Exile and the stylistic strategy of epistolarity require one another: they "are constitutively linked because both are driven by distance, separation, absence and loss and by the desire to bridge the multiple gaps" (Naficy 2001, 101). Egoyan uses all three of the main types of epistolarity Naficy outlines. First, there are the "film-letters": letters and acts of reading and writing letters by diegetic characters. Second, there are "telephonic epistles," distinguished from printed letters and including other media such as telephones and answering machines that diegetic characters use to address each other. And third, there are "letter-films," films that take the form of epistles addressed to someone inside or outside the diegesis and that do not necessarily include epistolary media (Naficy 2001, 101). Extending this third notion of letter-films a bit further, I would like to suggest that the trope of the epistle can serve as a way of modelling certain practices of spectatorship. Since epistolarity refers to a repeated and repeatable practice of addressing an other in a relation of some intimacy, the relationship between the filmmaker as the one who addresses and the spectator as the addressee could be described as an epistolary relationship. Egoyan is well known for being highly attentive to the involvement of the spectator in interpreting his work. His films presuppose an active spectator who must participate in meaning-making consciously and intentionally, working to reconstruct the plot from segments and sequences, looking for hidden meanings in the image, and questioning his or her own position as viewer.[3] Egoyan's "ideal" viewer is not an anaesthetized or passive subject, but one who is eager and who desires to elucidate, interrogate, and challenge what he or she is watching. The trope of epistolarity thus stands in for Egoyan's desire to communicate closely with the spectator.

With these concepts in mind, I will move on to the films themselves and examine the ways in which these three short films use repetition and epistolarity to deal overtly and obliquely with issues pertaining to the problems of Armenian history and memory. While the three short films are somehow comparable, they nevertheless represent different filmic genres and use different mises en scène: *Open House* is a half-hour narrative (though

absurdist) film, *A Portrait of Arshile* is a "video-document" film, and *Diaspora* is an experimental film. The films each deal with aspects of the inheritance of Armenian history and memory, but they do so in different manners. Each film offers a specific use of the tactics of repetition and epistolarity, but not in equal terms. The three shorts are thus characterized by different modalities and their differences are conducted by the different possible filmic approaches the films represent. A close reading of each of these shorts—which were made over a period of two decades—provides insight into what ultimately stimulated Egoyan to address later, in a more confrontational and "accessible" way, the inheritance of the Armenian genocide in his feature *Ararat*.

Open House

Immediately preceding his first feature film, *Open House* (1982) occupies a highly significant place in Egoyan's oeuvre. We already find some of the thematic components the filmmaker would continue to explore: family ritual, the idealized and fetishized past, memory through technologically reproduced images, the intrusion of the public sphere into the private sphere, the difficulty of communication, and a certain narrative experimentalism. We also find Egoyan characteristically revealing "hidden" Armenianness in small details. The names of the characters are clearly of Armenian origin; there is also a quick close-up of a book written in the Armenian alphabet, placed next to the father. In this film, therefore, the Armenian signs are disguised and allusive. Since the word *Armenia* does not appear, these hidden signs presuppose a certain basic knowledge about Armenian culture (Egoyan 1987, 17).[4] What is more, in this short Egoyan models a very open kind of spectatorship, deliberately leaving a great deal of room for interpretation and speculation. As he remarks, "I've always loved the silence and pause where there would be extended moments where the viewer or the reader would have to imagine what was unsaid. And it made you aware of how frail the process of communication is" (Katz 1998, 29).

Open House tells the rather strange and absurd story of an incompetent real estate agent (Ross Fraser) who tries to sell a dilapidated house in downtown Toronto to a young married couple (Sharon Cavanaugh and Michael Marshall). It quickly becomes clear that this real estate agent, really the son of the house's owners, has no intention of actually selling the house; he uses the pretence of selling as a way of bringing respect to the house—filled with its histories, memories, and nostalgia—and so to please his father (Housep Yeghoyan). By systematically recording the prospective buyers' praise of the house for his depressed father, who never speaks in the film, the son uses epistolary rituals to try to establish contact with him.

Opening and closing with the sound of a telephone ringing, *Open House* sets out to demonstrate the significance of epistolary technologies such as tape recorders, answering machines, telephones, and slide projectors, by linking them to the characters' obsessive and repetitive rituals. These epistolary technologies perform a function akin to translation—mediating, as it were, wherever characters are unable to communicate directly with each other. In the opening scene, the camera concentrates very closely on a telephone answering machine. The close-up on the machine is a typical Egoyan device; it reappears, for example, in *Krapp's Last Tape* (2000). A similar insistence on recording technology is found in the recent installations *Steenbeckett* (2002) and *Hors d'usage* (2002). In *Open House*, we hear the recorded message from the answering machine. The message is then repeated in the form of a voice-over representing the thoughts in the main character's head. This scene establishes a link between epistolary technology and repetition, and allows Egoyan to raise one of his favourite topics: the dependence on and visceral need for such recording media, explored in his most recent installations and in his next three features.

Many of Egoyan's plots present characters driven by repetitive behaviour. Monique Tschofen has, for example, insisted on the link between remembering and repeating the experience of loss in Egoyan's films, pointing out that "the characters' compulsion to return and to repeat scenes is shown to be the particular consequence of loving and losing in an age dominated by the image" (2002, 175). In psychoanalysis, the repetition compulsion is associated with a manifest repetitive behaviour (such as, for example, obsessive rituals), which usually reproduces (under the disguised form of the symptom) elements of a past conflict. As is clear from Egoyan's films, many of which deal with dysfunctional psychological patterns, Atom Egoyan is very much aware of such pathologies. His *Krapp's Last Tape* deals with a character's repetitive need (or compulsion) to listen to his tapes in order to keep in touch with his past, with his memories. Krapp's obsession with his machine substantiates his compulsive and mechanical engagement with and dependence on the process of repetition as rehearsal. *Exotica* (1995) depicts a character's compulsive need to return to a strip club to watch his murdered daughter's former babysitter's innocent-schoolgirl routine, which seems to connect him to a time in his life before the trauma at the same time as it re-enacts the terms of that trauma, namely the corruption of an innocent girl.

In *Open House*, both Mr. Odahrian and his son are involved in repetitive behaviours that convey the characters' obsessions and trauma, relying on telephonic epistles as a sort of prosthesis for memory to connect them to the past, even if this past is invasive and wounding. The invalid father, Mr. Odahrian, sits hidden in a room, looking with a nostalgic gaze at slides—

a medium that lies between photography and video. Through these disembodied images projected onto hanging sheets, we realize the house is haunted by memories the father longs for but cannot hold onto. The pictures of his and his family's past, when the house was beautiful and in good shape, provide a measure of the degree of his alienation. And when we see a slide depicting the entire family and it becomes clear that the real estate agent is in fact Mr. Odahrian's son, we have an even greater measure of the ways this man has become estranged.

The speechless character of Mr. Odahrian is portrayed as the silent witness, another figure who appears frequently in Egoyan's feature films. Think, for example, of the "victimized" grandmother in *Family Viewing* (1987), or to a lesser degree, the character of Nicole in *The Sweet Hereafter*.[5] Egoyan has commented on his use of silent witnesses, characters who have "information, a key, that would give the viewers some access to what is going on, into what was the nature of the relationship between [the characters]. These are all people who have secrets but cannot actually express them because they've been traumatized into silence. I think that the whole notion of persecution, of speech being a potential weapon, and of being silenced are obviously things that are part of my history. Either a part of my collective history as an Armenian, or personal history" (1997a, 222). As a silent witness, Mr. Odahrian can be understood in two ways then. On one hand, he serves as an index of the epistolary relationship, as I called it earlier, that Egoyan creates with his audience; since he cannot speak directly, we are forced to attend carefully to whatever it is he is trying to communicate. On the other hand, he is an emblem of the traumatic silencing of Armenia's history. As we observe his silent, flickering image on a screen, as he observes silent flickering images on a screen, we become aware of how difficult it is to animate or bring to life history and memory through representations.

But Mrs. Odahrian (Alberta Davidson) evidences repetitive behaviour as well, expressing a most sentimental and rather insistent longing to re-experience the past. About the bad state of the garden, Mrs. Odahrian remarks, "It used to be quite a lovely spot," and she will use this expression—"it used to be"—several times throughout the film. It becomes evident, however, that her nostalgia is itself a form of repetition compulsion taken on by those around her. Mrs. Odahrian tells the prospective buyers, "The house was built by my husband's father just after the First World War.... My husband worked very hard on this house, especially after his father died.... He was very proud of this house." Toward the end of the film, when the real estate agent asks the young woman what she thought of the house, her reply echoes Mrs. Odahrian's words. When she answers, "I thought it was very nice.... Mrs. Odahrian told me that her husband worked so hard on it. I was very impressed. He must be so proud of it. He built quite a castle for him-

self," the viewer receives this as a kind of repetition. The play-acting "real estate agent" son also takes on this nostalgic rhetoric, echoing this now-familiar discourse about the home yet one more time: "This house is like nothing you've ever seen, hand-built by the owner's father.... It is built like a castle." Nostalgia thus haunts and inhabits the entire film.

If the house is a "castle," however, it is so only in the minds of those caught up in this nostalgia for the past. Such complex structures of pretending are one of Egoyan's favourite motifs. In *Open House*, the motif of pretending is displayed through a *mise en abyme* of lying and role-playing; the son's elaborate ruse—pretending to be a real estate agent, pretending that the house is a castle—is mirrored in the character of the young male visitor, who lies about having a very important job.[6] The way the house is set up is also part of the rituals of deceitfulness and concealing. Some rooms are empty, and some of the furniture is covered by white sheets, as if certain things are masked and kept secret, not only for the characters in the film but also for us as viewers. Such tactics of concealment manifest Egoyan's tendency to disorient the viewer, just as they reflect his hermetic style. It is, at first sight, difficult to provide rational explanations concerning the characters' intentions. "The audience is never told what is real and what is imagined reality" (Churchill 1983, 31). Indeed, without recourse to extra-textual informative elements, it is quite difficult to differentiate properly between what is constructed and invented and what it is real and true. Why does the son become involved in this ritual pretence of selling? We might think it is designed to make the visitors witnesses to the house—to what it has been, to its memory—and, by this, to comfort the father. The son's repetitive rituals also function as a therapeutic device allowing him gradually to throw away the memories by having strangers violate them.

This house, built by Mr. Odahrian's father and worked on arduously by Mr. and Mrs. Odahrian, thus constitutes a core symbol that Egoyan will return to in later works. The possession of a house is often felt by immigrants to be a symbolic restoration of what they lost, and as such it embodies an inviolable micro-territory. The structure thus reflects the Odahrians' pride in reconstructing an identity in a new land and their gratification at "successfully" assimilating. But if the house in this film is depicted as something rewarding, as a place where the retention of memories is possible, it is also portrayed as being claustrophobic to its occupants and invaded by outsiders. A place of intimacy meant to protect memories and family stories, the home turns the private into public when strangers are invited in to buy it. The house is thus pictured as a site of memory indelibly impregnated with the dualities of possession and dispossession, of recovery and loss. This theme is echoed in the characters' names. The name Odharian contains the word *odar*, which in Armenian means "foreign" or "non-Armenian." This is

Open House. (© Ego Film Arts)

meaningful for two reasons. It reminds us of their assimilation in view of their immigrant origin. It also reverses the public/private dichotomy: the WASP "strangers" are perhaps not really violating the intimacy of an Armenian house that is already inscribed as non-Armenian—in other words, as theirs.

Egoyan elaborates on *Open House*'s exploration of the ambivalences in the categories of "house," "home," and "homeland" in later works, such as his fourth feature, *The Adjuster* (1991). In *The Adjuster*, the home stands for the micro-land that is supposed to protect, comfort, and preserve. Noah (Elias Koteas), an insurance adjuster, witnesses his clients' houses being destroyed by fire. For the clients, to lose their house is to lose a part of themselves, a part of their past, and a new house will provide a space within which to build new memories. But like the homeland, home is a constructed and enclosed space and can mean suffocation, threat, or claustrophobia to its inhabitants. Noah invades the privacy of his clients, needing to know what their life was like before the damage and even becoming sexually involved with some of them. Similarly, the son in *Open House* appears indiscreet when he questions the male visitor about his private life. It appears as though the false agent needs to enter the visitors' personal life before they can, in turn, enter the privacy and intimacy of the Odahrians' home. By entering each other's personal terrains and territories, what is private is transformed into something public and open—a literal open house.

Open House highlights the duality between remembering and forgetting, between possession and loss, but also between connection and displacement (displaced and alienated histories and memories). Near the end of the film, we see a full-screen image of a black and white slide of the house

as it used to be, an image that confirms the haunting imprint left by the past on the present. This picture imposes on the viewer—again in a repetitive and nostalgic mode—the idea that certain past histories, be they personal or collective, are invasive and cannot be fully forgotten.

Diaspora

Egoyan once said, "There is... a nostalgia for a world which exists as image, and which has itself as referent. You can always go back to an image. But you can't just go back to a land" (1997a, 215). Taking up the questions of longing that haunt the disjunctures between image spaces and geographical spaces, *Diaspora* (2001) treats this impossibility of returning. The title of this eight-minute short film draws attention to the film's visual, cultural, and historical framework and anchors its symbols in the history of the Armenian diaspora; but instead of explicitly tackling the question of diaspora through plot or other classic narrative devices, the film strives to reproduce the emotional and cognitive aspects of the experience—the feelings of spatial and historical disorientation. At the same time as the film exiles the spectator from any stable referent or narrative meaning, it produces a state of being familiar with this feeling of exile, as a small core of images and musical motifs return in various permutations and combinations. *Diaspora*, even more than *Open House*, relies on repetition. First, on the intra-diegetic level, repetition structures the short film: the image track consists of a restricted number of images constantly repeated, just as the soundtrack consists of repeating sounds and sequences. Second, on the extra-diegetic level, Egoyan repeatedly inserts his own visual memories and other filmic inspirations that vividly cultivate the filmmaker's vision. Thus, this experimental film crystallizes Egoyan's own diasporic condition in a significatory aesthetic language based mainly on elements of repetition.

 Diaspora engages with one of Egoyan's signature interests, music. Music has always been an important part of Egoyan's work, figuring prominently as well in his own background. Egoyan studied classical guitar at the University of Toronto. He has also directed operas and a filmic homage to Bach, and has always paid attention to the original soundtracks of his films, most of them composed by Mychael Danna. The well-known American minimalist composer Philip Glass, whose structural technique is repetition, composed the original soundtrack for *Diaspora*.[7] In Glass's work, every musical element (such as harmony, rhythm, or instrumentation) is created out of periodical repetitions and cyclical structures. The music gives us an impression of intense, almost epic movement but turns quickly into an experience of relentless circularity, without quiet or stasis. In the film, Egoyan uses Glass's reliance on repetitive structures as a way of expressing the complex questions diaspora involves, such as its link to painful history and mem-

ory, but also to time, origin, and nostalgia. The music thus conjures the way traumatic experiences relentlessly resurface in memories, as well as the way the way histories of those scattered from their homeland appear to repeat rather than move forward.

Like the soundtrack, *Diaspora*'s image track is highly repetitive. Images from within Egoyan's own corpus as well as from films that have informed his imaginary and nourished his artistic universe, are cited and re-presented in parallel and serial iterations in order to produce another degree of cyclical structuring. *Diaspora* starts with the video image of a huge, almost endless flock of sheep, an image taken from Egoyan's 1993 film *Calendar* that was later reused in a video installation entitled *Return to the Flock* (1996). *Diaspora* is thus the third time Egoyan works with this specific image. Such repetitive auto-citation is not uncommon in his work. The closing image of *Diaspora*, originally from the closing scene in *The Adjuster*, where Noah, witnessing his own house on fire, holds out his hand as if trying to touch and feel it, is another auto-repetition. This tendency to refer again and again to images in his own corpus expresses Egoyan's ongoing and overwhelming obsession with representing the history and memory of Armenian people in diaspora. Auto-citation relates to the denial of Armenian history, because by constantly reappearing in his various artistic creations, the citations manifest how deeply this history affects and concerns Egoyan in the manner of a transgenerational trauma, in which the denied violent past keeps returning.[8] Auto-citation, then, deftly discloses how repetition (thematically but also stylistically) has everything to do with Atom Egoyan's historical legacy.

The image of the flock of sheep invokes similar images used by the Armenian filmmaker Artavazd Pelechian's *Seasons* (1972). According to François Nizey, "Repetition is the major figure of Pelechian's cinema" (1993, 87–89).[9] Believing that music is movement itself and is therefore inevitably connected to image, Pelechian relies on a repetitive editing strategy comparable to musical composition in order to explore both infinite circularity and the tragic nature of movement that, for him, characterize life and existence. Egoyan borrows from Pelechian not only his Armenian ode to atemporal natural symbols, but also the fundamentally musical structural and editing techniques that convey the idea that everything in the world is moving, repeating, and reiterating. The image of the endless fast-moving flock of sheep is thus simultaneously a metaphoric impression of the diasporic condition, a symbolically condensed figure of the idyllic, timeless, agricultural image of the lost homeland—an allusive visual depiction of an actual geographical place—and a reference to the history of the Armenian people, representing the thousands of Armenians who were forced on death marches into the Syrian desert or drowned in the Black Sea.

To this image of sheep, Egoyan adds footage by the Turkish-born Greek exile director Elia Kazan, from *America, America* (1963), a film that inspired Egoyan when he made *Calendar*. *America, America* depicts the epic and exilic adventure of a young Anatolian Greek immigrant pursuing his dream of going to America. In *Diaspora*, Egoyan selects the scene from *America, America* in which an Armenian church, sheltering an Armenian community, is burning. The parallel between this scene and the image of the burning house in *The Adjuster* is significant. The contiguity is not only structural or symbolically linked to the imagery; the two fire scenes both show how certain places (churches, houses), supposedly protective and impregnated with histories and memories, are subject to a violent vanishing. Egoyan reused the same scene from Kazan's film in a video installation also entitled *America, America* (1997), at the Venice Biennale's, Armenian Pavilion, combining his own familial pictures with footage from Kazan's *America, America* to addresses the relation between personal, intimate memory and collective memory. Kazan's burning church scene in *Diaspora* juxtaposes the circular and endless movement of the fire with impression of intense back and forth movement of the image of people running all over trying to save themselves. This emphasis on circularity within otherwise linear movements reminds us that what characterizes history in this case can no longer be a matter of seamless, intact, and transparent linearity and continuity; rather, because of its prohibited, never self-evident, and traumatic nature, it can be represented only in an insistent, obsessively repetitive manner.

Egoyan again uses repetitive devices in the colouring and arrangement of the screen. At different points in *Diaspora*, Egoyan colours the sheep blue, black and white, and red. Egoyan also decomposes the screen, first into four and then into sixteen symmetrical squares that look like small TV screens. Gradually, some of these screens are replaced by red-coloured sheep, others by the *America, America* footage. This decomposition and fragmentation imposes on the viewer an impression of a shifting patchwork of images, some new, some drawn from elsewhere, all repeating. In *Diaspora*, the red-coloured image of Noah's hand from *The Adjuster* is juxtaposed with the fire in the *America, America* image, which is red as well. The image is also superimposed with small screens of blue sheep. The sheep are red just after the fire scene from *America, America*, giving an impression of glowing embers. The red colour contrasts with the blue previously used, as if to stress the opposition between life (blue) and death (red). By thus juxtaposing images from different sources, in different sizes and arrangements, and their iterations in different colours, Egoyan deftly evokes the universal condition of diaspora's endless movements, as well as the specific history of the Armenian diaspora. Indeed, the combination of multiple visual and stylistic techniques and strategies that Egoyan proposes translates the incessant desire to

Diaspora. (© Ego Film Arts)

capture this history—to approach its multiple layers and to reach its most profound meaning. Egoyan searches for any means to give a sense of the impossible past that is felt in diaspora.

While it would be tempting to think of this short film as a depiction of open and endless space, because of the pastoral footage of the flock of sheep, Egoyan's filmic style produces a very tight and closed image space, emphasizing the delimitation of the screen and the multiplication of repetitive images. In so doing, the film expresses the very experience of being in diaspora—the tension between the open, infinite, timeless, and boundless aspect of the homeland and its inheritance through closed constructed images of repressed memories. The deconstructive and reconstructive structure of the film's images, which Egoyan reshapes and reshoots in different formats and which he decomposes and multiplies, underlines, in a way, the myth of the possible unproblematic, transparent reconstitution of history. The form of the film is also a reminder of its status as a construct. The fact that we see different editing and colouring techniques as well as pixels renders the perception of the image neither transparent nor obvious, so that the very act of watching this film does not allow the viewer to escape into a pure depiction of reality.

Ultimately, *Diaspora* reveals Egoyan's tribute to and influence by experimental filmmaking. In his foreword to a book on Canadian experimental cinema, he explains how he has been deeply influenced by visual artists such as Michael Snow, Peter Mettler, and Bruce Elder,

> not simply because of the extraordinary quality of their work, but also, and perhaps more profoundly, because of the ceaselessly curious and

completely trusting nature of the audience they've had to imagine for
their creative efforts. These filmmakers taught me there is nothing more
exhilarating than to feel self-conscious in front of a screen. The viewers
did not have to lose themselves into an image, but could actually observe
it, and create a dialogue about that process. The dialogue could be med-
itative, amusing and provocative. By watching these films, I learned how
to respect and indulge the intelligence of my audience. (Hoolboom 2001, 1)

Egoyan evokes here what I mean by "epistolarity" in relation to spectator-
ship; *Diaspora*, for instance, requires from the viewer a certain type of engage-
ment and intimacy with Egoyan's work in order to distinguish the images and
to get a sense of what he tries to communicate to us. It forces the viewer to
experience time, space, and movement in a non-linear fashion that only the
experimental genre seems to be able to grasp and that replicates the diasporic
condition, with its structure of longing and belonging, its repetitive ongoing
(traumatic) motif. The film "exiles" us from certain worn trajectories and
lets us find ourselves in a different kind of representational space. Even
though there is a certain message in the film—for example, allusive references
to "real" historical elements of a specific diasporic history—Egoyan's language
and imagery are not thematically radical or unilateral. The epistolarity he pro-
poses encourages the spectator to feel committed to and responsible for rec-
ollecting the fragments, condensing the various repetitions, and establish-
ing a comprehensible representation, even if some parts will remain open
and ungraspable in the same way that the diasporic experience itself remains
disorienting.

A Portrait of Arshile

A Portrait of Arshile (1995) was part of a BBC program for which different
international filmmakers were asked to make a four-minute film inspired
by a work of art. Meant as a dual homage to Egoyan's young son and to the
American painter of Armenian origin Arshile Gorky, after whom his son was
named, the short film returns to the chief tropes of Egoyan's work, such as
filiation, memory, family rituals, the private–public relation, the medium
of image as an experimental process, and the filmmaker's attachment to his
origins. However, for the first time in the course of his work, the filmmaker
is quite explicit about the scars caused by the inherited genocide.

The film consists exclusively of two types of images. First, we see a
"home video" recording of Egoyan's son. This image is characteristic of what
Roger Odin calls the familial film, "made by a family member about char-
acters, events or objects that are, in one way or another, linked to this fam-
ily's history and to the privileged use of those family members" (1995, 27).
According to Odin, this type of home video presents recurrent stylistic fig-
ures such as an absence of closure, narrative crumbling, undetermined tem-

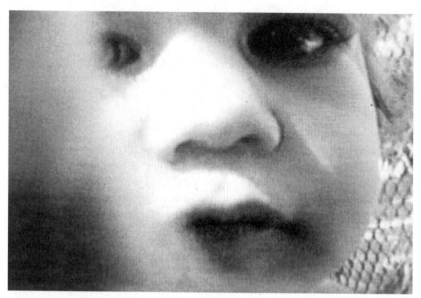

A Portrait of Arshile. (© Ego Film Arts)

porality, a paradoxical relation to space, animated photography, a direct address to the camera, a rather incoherent juxtaposition of shots, and interference of perception (1995, 28–31). The shot in *Portrait of Arshile* is shaky, grainy, and extremely close to the subject (with extreme close-ups of a huge eyeball, a cheek), so that Arshile's body is nearly caressed, nearly embraced by the camera. Then we see a self-portrait of Gorky and his mother, painted from 1929 to 1936. This second image contrasts with the first one: it is presented statically, in medium shot, its texture is clear and smooth, and its appearance is more informative and descriptive, since we also see the black and white photograph on which the portrait is based.

Passing between these two images, the image track enacts two desires, both of them reflecting the construction of memory. One is linked to the act of recording as an almost obsessive act born from the fear of forgetting the joy of one's progeny having been born, while the other is linked to the urge to make images as proof or trace of his having been born Armenian. To put this another way, the film reflects the wish of the parents to grasp the precious moment of Arshile's childhood, as well as the profound wish to transmit his ethnic origins in defence against oblivion, denial, and familial and ethnic amnesia.

A Portrait of Arshile takes the form of a letter from the parents to their son. Epistolarity is, in this regard, an essential component of the film. The short employs Naficy's three types of epistolarity: the film-letter, through the act of reading inscribed in the voice-over text; telephonic epistles, through

the home video itself as a mediating technology; and, finally, letter-films, which, according to Naficy, "sometimes address diegetic characters, sometimes real or imagined people outside the text. Their mode of address is usually direct, with the filmmaker the speaking subject primarily by means of voice-over narration" (2001, 141).

The film's voice-over is read first by Arsinée Khanjian (the filmmaker's wife, and mother of Arshile Egoyan) in Armenian, and subsequently translated by Atom Egoyan into English. The text connects their son to his namesake and to his tragic cultural heritage:

> You are named after a man who painted a portrait of himself and his mother.
>
> You are named after a man who based his portrait on a photograph that was taken in Van, Armenia 1912. The boy in the photograph was eight. His mother, a devoutly religious woman, was named Shushanik der Marderosian Adoian. Her son, the person you're named after, was called Vosdanik. Your name is Arshile.
>
> You are named after a man who adored his mother and was inspired by her love of nature and her pride of Armenian culture and language.
>
> You are named after a man who seven years after the photograph was taken would hold his mother in his arms as she died of starvation. The year was 1919. The city was Yerevan. The boy was fifteen.
>
> You are named after a man who would look at his mother's face staring back at him from a photograph in 1912 and would be afraid of disappointing her, of bringing shame to his name. So, Vosdanik Adoian changed his name to Arshile Gorky.
>
> You are named after a man who changed his name because of what he felt when he would remember his mother's face. His mother's face which now stares from a gallery wall into a land she never dreamed of.

A Portrait of Arshile thus supplements the image of the painting with an epistolary narrative in the language of origin that is then translated into the language of arrival, of assimilation. Here, translation can also be seen as a form of repetition. By telling the story in two languages, Egoyan makes it clear that Arshile belongs to two cultures in diaspora, marked by the public language of the host country and the private language spoken within the intimacy of the familial structure. In particular, the Armenian language spoken by the mother marks the word of origin; the maternal language is the guarantor of the native land, of the missing ground. Without the voice-over (and the reproduction of Gorky's painting), the film might be merely a sort of amateur home video. The epistolarity of the voice-over text in this film transforms its meanings, functioning as a supplemental narrative historical "document" that aims to break the amnesia of the long-standing denial of the Armenian genocide. On one level, these few words—referring to a place: Yerevan; to a time: 1919; to a condition: starvation—all forbidden in the

decades-long campaign of denial, bring forth the evidence of the tragedy. That this "proof" is not found in the mimetic depiction of the tragedy itself significantly reminds us that there were no images of the genocide that could circulate. On another level, this insistence on naming takes up the dialectics of genocidal experience. Naming is supposed to be the act of distinguishing individuals and establishing identity, but it also reminds us of the logic of naming enacted by the perpetrators who named the Armenians *as* Armenians and, in so doing, sought to destroy them.

So what is in this name? The name Arshile carries a wealth of associations with Armenian and art history that shed light on Egoyan's sense of his own personal and collective past as well as of the future promised by filiation and by aesthetic affiliation. Arshile Gorky is known primarily as an abstract expressionist painter, and although Gorky's Armenianness is often considered irrelevant and exotic biographical detail, Egoyan understands it to be an essential part of his work. The painting to which Egoyan's *A Portrait of Arshile* refers—Gorky's self-portrait *The Artist and His Mother*—is based on a photograph of the painter and his mother taken in Armenia before the genocide, "the only image of his childhood and his mother before Van had burned and their world had fallen apart" (Matossian 1998, 213). Gorky guarded it as a precious possession for his entire life. Traumatized by his experience of the genocide and haunted by the memories of his beloved mother, Gorky made different versions of the self-portrait. As Matossian has written, "it became Gorky's unfinished symphony" (1998, 216): "Gorky drew from that photograph like a man possessed, using different media to analyze different parts of the image: pencil, pen and ink, crayon and pastel. He did fine single line drawings and bold ink sketches with shading with every stroke of pen and pencil he brought her to life" (Matossian 1998, 213–14), Arshile Gorky is without a doubt the ideal reference for Egoyan's Armenian ethnic filiation and artistic affiliation. Indeed, Gorky is perceived by many Armenians as an iconic figure of Armenian tragic history and is probably the best-known artist to have survived the genocide. Parallels with Egoyan are self-evident and meaningful. Atom Egoyan has inherited the history of the genocide and a desire (an aesthetic desire) to evoke that past. Gorky experienced the trauma of genocide and displacement at first hand, and Egoyan wishes to discuss the legacy of this experience in his own work. In that sense, the inclusion of Gorky's painting in his filmic creations can be seen as a type of auto-citation. What is more, this type of repetition is confirmed by the filmmaker's *Ararat*, which places Gorky at the heart of the storyline.[10]

According to Naficy, in diasporic and exilic filmmaking, "every story is both a private story of an individual and a social and public story of exile and diaspora" (2001, 31). Because of its focus on the two Arshiles—Egoyan's

son and Gorky—Egoyan's short film can thus be seen as this kind of testimony. The filmmaker publicly exposes Gorky's experience, which has often been hidden or kept private. Moreover, the film itself combines private and public images. The private, intimate home video for the family becomes public because Egoyan includes it in a film showing Gorky's famous painting and its reference to the genocide. Furthermore, the film combines innocence and responsibility, juxtaposing the innocence of young Arshile, who does not understand a word of the Armenian testimony of his father and mother, and the parents' deeply felt responsibility to transmit the tragedy of their Armenian roots to their progeny. This heavy, uneasy, and uncomfortable responsibility is insistently expressed through repetition. Indeed, the phrase "you are named after a man" is reiterated to emphasize the urgency but also the burden of remembering and the overwhelming obligation it implies.

Egoyan's sense of the obligations of memory extends to the film's image track. Egoyan is aware that the genocide has not been represented—indeed, that it has been *un*-represented, erased from official history. A visual memory of the experience of genocide is therefore oxymoronic; the closest we can come to seeing what this history has meant happens when we learn to see past the surfaces of images like Gorky's into the displacements, condensations, and iterations—into all that isn't shown and can't be shown. Yet the film is characteristically hypervisual. Within four minutes, Egoyan uses four different visual media: video, photography, painting, and, of course, film. Though each medium undoubtedly has its own pictorial specificity and demands its own ways of seeing, what matters here is the fact that each of them originates in an act of memory, a desire to communicate, to transmit, to resist forgetting and conquer the "loneliness" to which Hannah Arendt refers in *The Origins of Totalitarianism* ([1951] 1979, 477).[11]

Although in many of Egoyan's films, the medium of video is shown to be problematic—either perverse and manipulative or a simulacrum of real experience—in films such as *Family Viewing* (1987) Egoyan has used the medium of video to stand metaphorically not only for the erasure and subsequent reconstruction of personal history, but also for the collective history of being Armenian. *A Portrait of Arshile* focuses on the video medium's revealing dimensions, suggesting that the video medium can become a familial and socio-historical document, another type of archive that brings together history and memory and that nevertheless remains fragile and ephemeral. Video is thus imbricated not only in the preservation but also in the precarious nature of memory. As in his other films, Egoyan here questions the private and public dimensions of home video: what do we record, when, why and for whom? But most of all he questions the issue of transmission and cultural memory: what should parents tell or not tell their children?

Epistolarity is a major motif in this short, appearing in relation to all four of its visual media. *A Portrait of Arshile* animates an epistolary relationship with the viewer, because the spectator is invited to become part of the intimate and private home video that, to establish this relationship, has to become in a way public and transmittable. The short film mirrors, reinforces, and substantiates the home video; the short and the video are both letter films, meant as personal and collective visual documents.[12] The two other media—painting and photography—also involve aspects of epistolarity, since both reflect a desire to inscribe the past, to represent and transmit it.[13] While film and video express Egoyan's epistolary style, painting and photography refer to Arshile Gorky's way of expressing his tragic Armenian experience. The different visual media repetitively underline the idea of epistolarity and, in doing so, invoke history and memory.

Conclusion

Egoyan's short films explore the overwhelming power of the Armenian heritage and its inevitable link to mediation and mnemonic technologies. Egoyan's films in general strongly reveal the inescapable burden of the past that inhabits the present and envelops these films as a sort of second skin. The shorts thus convey the filmmaker's interest in the relation between the heritage of the past and its representation and re-enactment in the present. Each film concentrates on the fetishized, idealized, nostalgic image of the remembered (or forgotten) past and/or the home(land). *Open House* explicitly focuses on the home but, in doing so, marks the absence of a homeland. *Diaspora* focuses on the homeland, but allusively it searches for a home, a point of homecoming that seems to be repetitively unreachable. *A Portrait of Arshile* elaborates on both. Whether explicitly or implicitly addressing the stunning legacy of denied history, *Open House*, *Diaspora*, and *A Portrait of Arshile* all, in different ways, touch on aspects connected to the filmmaker's ethnic origin and to the complex heritage of his past.

Notes

1 The same idea of community was also part of setting up his recent installation *Hors d'usage* (Musée d'Art Contemporain, Montreal, 2002). See the interview conducted by Louise Ismert in the catalogue for the exhibition (Egoyan 2002, 35–36).

2 Egoyan touches on Armenian topics in the play *Open Arms* (1984) and the TV film *Looking for Nothing* (1988).

3 This self-awareness on the part of the viewer seems to be even stronger when watching and experiencing installations. According to Egoyan, the relation to physical space is brought into question in a different way with the viewing of an installation than with the viewing of a film: "When you go into a cinema or when you are reading a book, the nature of the physical space is almost predetermined.

And I think what is exciting to me about installation is that you are not quite sure what the parameters might be. It is my frustration, sometimes, with cinema, that no matter how exploratory the film may be, we are always looking at it in terms of a very conservative means of physical projection" (Egoyan 2002, 39).

4 Commenting on *Open House*, *Next of Kin*, and *Family Viewing*, Egoyan says, "One of the advantages of working with the Armenian language or the Armenian culture is that it is, for most people, not something that can be easily identified, and that allows me the luxury of being able to treat it almost on a metaphoric level" (Egoyan 1987, 17).

5 On the questions of genocide and diaspora in *Family Viewing*, see Siraginian (1997).

6 *Next of Kin* (1984), which directly followed this short film, engages more deeply with the construction and manipulation of identities.

7 It may be worth noting that Glass is the grandson of Jewish immigrants from Lithuania and Russia. We could, therefore, speculate that the composer is addressing his own diasporic experience in this film.

8 On the specific question of the transmission of trauma from one generation to the next, see Altounian (2000).

9 See the interview François Nizey conducted with Pelechian in *Cahiers du cinéma* (Pelechian 1992, 35–37), and Jean-François Pigoullié (1992, 34).

10 In *Ararat*, for example, the character Ani (Arsinée Khanjian), who is an art historian, says of Arshile Gorky's famous self-portrait that it is the "depository of our history."

11 Hannah Arendt defines the concept of loneliness as follows: "What makes loneliness so unbearable is the loss of one's own self which can be realized in solitude, but confirmed in its identity only by the trusting and trustworthy company of my equals" ([1951] 1979, 477).

12 This strong parallelism is probably the reason for Paul Virilio's qualification of Egoyan as a "cine-videast" (Egoyan 1993, 105).

13 It is sufficient to point to the highly significant and precious meaning of photographs in the context of genocide. Photographs taken around the period of the catastrophe (as in Gorky's case) are quite rare and are preserved and perceived as iconic relics or talismans.

Works Cited

Altounian, Janine. 2000. *La survivance: traduire le trauma collectif*. Paris: Dunod.

Arendt, Hannah. [1951] 1979. *The Origins of Totalitarianism*. New York: HBJ Press.

Churchill, David. 1983. Review of Open House. *Cinema Canada* 98, July–August, 31.

Egoyan, Atom. 1987. "The Alienated Affections of Atom Egoyan." Interview by José Arroyo, *Cinema Canada*, October, 14–19.

———. 1993. "Video Letters: An Interview between Atom Egoyan and Paul Virilio." In *Atom Egoyan*, by Carole Desbarats, Daniele Rivière, Jacinto Lageira, and Paul Virilio, 105–15. Paris: Dis Voir.

———. 1997a. "The Accented Style of the Independent Transnational Cinema: A Conversation with Atom Egoyan." Interview by Hamid Naficy. In *Cultural Producers in Perilous States: Editing Events, Documenting Change*, ed. George E. Marcus, 179–231. Chicago: University of Chicago Press.

————. 1997b. "Writing and Directing *The Sweet Hereafter*: A Talk with Atom Egoyan." Interview by David Johnson, *Scenario*, Winter, 38–43, 197.

————. 2002. "Atom Egoyan: *Out of Use*." Interview by Louise Ismert. In *Atom Egoyan: Hors d'usage*, by Louise Ismert and Michael Tarantino, 34–42. Montreal: Musée d'Art Contemporain de Montréal.

Hoolboom, Michael. 2001. *Inside the Pleasure Dome: Fringe Film in Canada*. Toronto: Coach House.

Katz, Susan Bullington. 1998. "A Conversation with … Atom Egoyan." *Written By* 2, no. 2: 25–30.

Matossian, Nouritza. 1998. *Black Angel: A Life of Arshile Gorky*. London: Chatto and Windus.

Naficy, Hamid. 2001. *An Accented Cinema: Exilic and Diasporic Filmmaking*. Princeton, NJ: Princeton University Press.

Nizey, François. 1993. "Artavazd Pelechian ou la réalité démontée." In *Le cinéma arménien*, ed. J. Radvanyi, 87–89. Paris: Centre Pompidou.

Odin, Roger. 1995. *Le film de famille*. Paris: Méridiens Klincksieck.

Pelechian, Artavazd. 1992. Interview by François Nizey. *Cahiers du cinéma*, no. 454: 35–37.

Pigoullié, Jean-François. 1992. "Pelechian: le montage-mouvement." *Cahiers du cinéma*, no. 454: 30–34.

Siraganian, Lisa. 1997. "'Is This My Mother's Grave?': Genocide and Diaspora in Atom Egoyan's *Family Viewing*." *Diaspora* 6, no. 2: 127–53.

Souriau, Étienne. 1991. *Vocabulaire d'esthétique*. Paris: Presses Universitaires de France.

Tschofen, Monique. 2002. "Repetition, Compulsion, and Representation in Atom Egoyan's Films." In *North of Everything: English-Canadian Cinema since 1980*, ed. William Beard and Jerry White, 166–83. Edmonton: University of Alberta Press.

 9

The Double's Choice
The Immigrant Experience in Atom Egoyan's *Next of Kin*

Batia Boe Stolar

Immigrant experiences are most often characterized by the negotiation between two cultures: the one the emigrant leaves behind but still holds on to, and the one into which the immigrant enters. This new culture is oppressive or alluring, but in either case, it is always a threat to the autonomy of the old culture. Telling the story of Peter Foster (Patrick Tierney), a WASP Canadian only child who enjoys role-playing, who in the context of video-therapy sessions with his own family orchestrates a series of events that allow him to become Bedros, the missing son of an Armenian immigrant family, Atom Egoyan's first feature film, *Next of Kin* (1984), is the first of many sustained inquiries into this relationship between ethnicity and the experiences of immigration and assimilation. How WASP Canadian and Armenian-immigrant cultures operate in relation to each other, how they intertwine, and how they are polarized are all important questions raised in *Next of Kin* that continue to inform Egoyan's subsequent work, especially those films that deal explicitly with the question of ethnicity—*Family Viewing* (1987), *Calendar* (1993), and *Ararat* (2002).

Doubles, as Donald Masterson notes, are a staple of Egoyan's films, most often functioning as mirrors (2002, 883). In *Next of Kin*, mirror-like doubles are evident from the beginning—two families, two therapists, two sons, two cultures. But the film offers up another practice of mirroring and doubling

in its use of video "recording experience, mediating experience, 'surveilling' experience, reducing reality to replica" (Harcourt 1995, 6). An analogy is implied between this technology of reproduction, which mediates between the real and its replica, and the experience of the immigrant, who must mediate between two distinct cultures, ultimately choosing which culture to emulate, that is, which part of the double becomes real and which becomes its copy or mirror image. Deceptively simple, the double's choice draws attention to the constructions of identity and ethnicity from the perspective of an authoritative subject who is, as John Orr aptly terms it, a "split subject" (1998, 119). The split subject remains, because of its inherent doubleness, simultaneously inside and outside both cultural constructs. Out of all of the doubles in *Next of Kin*, the Peter/Bedros double speaks most directly to the difficulty of mediating between two distinct cultures, a difficulty that culminates in the need to choose one over its other. By having Peter enter the Deryans' world as an immigrant enters a new country, associated closely with his immigrant double, Bedros, Egoyan underscores the immigrant perspective, and, in so doing, privileges the other. Contrary to the normative narrative of assimilation, here it is the WASP Canadian subject who copies, or mimics, the immigrant other. The immigrant other is thus invested with the autonomy of the real, whereas the normative WASP Canadian is reduced to the level of mimic or copy.

Peter Foster appears to have no familial or cultural connection to Armenia. But his performance as the Armenian missing son allows him to become, in a sense, "ethnic." "Passing" strategies are most often employed by those racially or sexually marginalized people who seek to enter the mainstream. Writing about passing strategies in which "an individual culturally or legally defined as 'Negro'" would assume "a fraudulent 'white' identity," Elaine K. Ginsberg explains, "As the term [*passing*] metaphorically implies, such an individual crossed or passed through a racial line or boundary—indeed *trespassed*—to assume a new identity, escaping the subordination and oppression accompanying one identity and accessing the privileges and status of the other" (1996, 2–3). *Next of Kin* thus suggests that ethnicity is a cultural construct, a performance, much like gender. Judith Butler argues that sex, "no longer believable as an interior 'truth' of dispositions and identity," "will be shown to be a performatively enacted signification (and hence not 'to be'), one that, released from its naturalized interiority and surface, can occasion the parodic proliferation and subversive play of gendered meanings" (1990, 33). The construction of ethnicity can be shown to occur along a similar axis. Ethnicity, Werner Sollors reminds us, "refers not to a thing-in-itself but to a relationship: ethnicity is typically based on a *contrast*" (1990, 288).

In *Next of Kin*, the Deryans' ethnicity is defined in relation to the WASPy Fosters and vice versa. Paradoxically, what results from this contrast is an

essentializing gesture that naturalizes the Deryans' ethnicity as "a quality which cumulatively achieves the status of a somewhat mystical, ahistorical, and even quasi-eternal essence" (Sollors 1990, 290). What ensues is a tension between a denaturalizing process that casts ethnicity as a performance and a naturalizing process that fortifies the illusion of ethnicity as a natural essence. In the film, Peter's performance of ethnicity works to undermine the appearance of an essentialized ethnicity that is naturalized by the portrayal of the Deryans' ethnicity as being authentic. Conversely, the authenticity of the Deryans' ethnicity allows Peter's performance of ethnicity insofar as it provides him with an authoritative model to emulate and mimic. This tension in the representation of ethnicity further informs the relationship between the real and its copy, as well as the inversions that seek to undermine any authoritative notions of both the real and the copy.

Peter's performance of ethnicity when he assumes the role of Bedros is in keeping with the tradition of the dramaturgical double. On the theatrical stage, doubling is sometimes used as a strategy in which an actor performs two different roles, thereby calling attention to the very act of doubling while reminding the audience of the unspoken dialogue that exists between the two characters. For instance, in Tony Kushner's *Angels in America: A Gay Fantasia on National Themes*, three roles are assigned to the same actor: the roles of Hannah Porter Pitt (a Mormon mother), Rabbi Isidor Chemelwitz (an orthodox Jewish rabbi), and Ethel Rosenberg (a historical figure who, with her husband, was convicted of and subsequently executed for being a spy). In Kushner's theatrical extravaganza, the audience is meant to recognize the actor's doubling of these characters and to consider the juxtaposition of the two maternal figures (Hannah and Ethel) and the two religions (Mormonism and Judaism), as well as the play between them (a female actor playing the role of an orthodox rabbi). In *Next of Kin*, the Peter/Bedros double is also a metaphor that points to a double consciousness made up of two cultural memories. Peter/Bedros thus comes to signify not only both WASP Canadian and Armenian-immigrant cultures, but how these two diametrical opposites operate in relation to each other. Following Freud, Homi K. Bhabha argues that the "uncanny lesson of the double lies precisely in its double-inscription. The authority of culture, in the modern *epistémé*, requires at once imitation and identification. Culture is *heimlich*, with its disciplinary generalizations, its mimetic narratives, its homologous empty time, its seriality, its progress, its customs and coherence. But cultural authority is also un*heimlich*, for to be distinctive, significatory, influential and identifiable, it has to be translated, disseminated, differentiated, interdisciplinary, intertextual, international, inter-racial" (1994, 136–37).

As a double, it is up to Peter to inscribe, mediate, translate, articulate, and understand both cultures. The double can therefore be defined as an

insider-outsider. As insider, Peter/Bedros is a participant who is privy to each world's cultural nuances and beliefs. As outsider, Peter/Bedros is an observer who exhibits feelings of isolation and dislocation in each of his worlds. In spite of his split subjectivity—or, rather, because of it (as Bhabha would argue)—Peter/Bedros re-signifies both cultures. Peter/Bedros is, after all, the only one who has knowledge of, access to, and entry into both the Foster and the Deryan domains. He is the only one who can cross the dividing boundaries that separate the Fosters and the Deryans.

Because Peter is *pretending* to be Bedros, the strategies of doubling suggest a blurring of the line "between doubling and duplicity" (Naficy 2001, 274). Arguing against such duplicity, Peter defines his act of doubling as follows: "I figured out a long time ago that being alone was easier if you became...two people. One part of you would always be the same, like an audience, and the other part would take on different roles, kind of like an actor." According to Peter's model, one part of the double is active while the other remains passive; one acts as the other watches. This relationship becomes classic Egoyan in his subsequent films. But doubles in Egoyan's films are also inversions, metaphors of film. A photographic negative conjures a positive image, suggesting that the double is constructed by binary (positive/negative) images of itself. For this reason, the binary here eschews the categorical good/evil dichotomy that most often defines it. On the surface, the Peter/Bedros double suggests a fusion of the Foster (WASP Canada) and Deryan (Armenian-immigrant) binary opposites. But Peter's doubling act takes on larger proportions when he assumes another role and mirrors the therapist. He states, "It must be really exciting getting involved with another family, trying to solve their problems. What could be more satisfying than giving direction to other people's lives? It must give one a real sense of purpose." What indeed? As Timothy Shary rightly notes, Peter becomes "the behind-the-scenes director of [the Deryan] family," and in this role he emerges "as director, not as a participant" (1995, 8). As therapist, Peter/Bedros mirrors Egoyan himself, both as immigrant subject and as director.

In examining the relationship between ethnicity and the immigrant experience as it is articulated through and by the acts of doubling, we must also consider how Egoyan's own cultural doubleness and experience of immigration is refracted in the Peter/Bedros double. The parallels between Egoyan and the Peter/Bedros double are manifold. First and foremost is their shared Armenian Canadian identity. Also telling is their age; Egoyan was twenty-three years old when he made *Next of Kin*, and Peter celebrates his twenty-third birthday at the beginning of the film. Thematically, both Egoyan and Peter/Bedros fit the profile of the missing son who is lost and recovered; Egoyan left his parental home to pursue his education and career in Toronto, but it is his reconnecting with his Armenian heritage while away from his

parental home that resonates extra-textually. *Next of Kin* is, in many ways, a film about the Armenian "missing son" who finally comes "home." Hence, as Peter discovers the Armenian immigrant world of the Deryans when he travels to Toronto, he parallels Egoyan's rediscovering of his own relationship to his Armenian roots.

For many of Egoyan's later characters, however, homecoming is relative. Peter, in *Next of Kin*, has direct access into the Deryans' Armenian world, but a part of him is always outside looking in. Similarly, Van (Aidan Tierney), in *Family Viewing*, reclaims his entry into the silent world of his Armenian grandmother, Armen (Selma Keklikian). Even though he is reunited with Armen and his estranged Armenian mother (Rose Sarkisyan), he is also kept outside of the world of the Armenian women, characterized by silence or by the Armenian language, which Van does not speak or understand. For Egoyan's later characters, entry into the Armenian world is even more difficult. The photographer in *Calendar* (played by Egoyan) and Raffi (David Alpay) in *Ararat* return to their ancestral Armenia to find a connection to their historical and cultural roots. Yet, despite their experiences there, their fetishizing of Armenia in film and their return to Toronto mark their own cultural estrangement. As is evident in Egoyan's earlier films, the immigrant has access to both the old and the new worlds in a way that an assimilated ethnic subject of his later films cannot.

If his first film speaks to the difficulty of mediating between two cultures, this and his subsequent films speak to the difficulty of reconnecting with a cultural heritage, a history and its legacy, because of assimilation, another central theme for Egoyan (Taubin 1989, 27; see also Jones 1998, 35). In *Next of Kin*, as Azah Deryan (Arsinée Khanjian) seeks to assimilate into the dominant white, Anglo-Canadian culture, Peter Foster assimilates into the Armenian-immigrant culture in Toronto. Erasure of cultural difference is often a result of assimilation that threatens to erase the immigrant's native culture. Alternatively, anti-assimilationist discourses draw on the fear of erasure of the dominant culture to caution against miscegenation. In Egoyan's films, assimilation and cultural erasure are most often articulated through the loss of a family member. For the Deryans, cultural erasure coincides with the loss of their son, Bedros, and is reiterated by the possibility of losing their daughter, Azah, while Peter's assimilation into Bedros results in the Fosters' loss of their son. Similarly, Van's maternal loss in *Family Viewing* coincides with his father's erasure of the family videos that showcase Van's bicultural childhood. Yet the trauma of loss that is so pervasive in Egoyan's oeuvre is countered by a constant familial presence, be it in actuality, on video, or in memory. His films thus respond to the threat of erasure by ensuring that there is a consistent cultural presence that mediates the familial absence: the missing son in *Next of Kin* and the missing mother in *Family Viewing*. Sim-

Calendar: Arsinée in front of church. (© Ego Film Arts)

ilarly, the video sequences of the photographer's estranged wife in *Calendar* ensure that the familial loss evokes a cultural memory of Armenia. Hence, in Egoyan's films, two cultures (most often represented as two families or two characters) continuously veer between presence and absence, existence and erasure, centrality and marginalization. They are often pitted as irreconcilable binary opposites between which the central character must choose, precisely because that central character is a composite of both cultures.

Although Egoyan's films comment on the act of assimilation, they do not necessarily condemn or dismiss it altogether. Egoyan explains: "When you come into a culture from outside,... you're very aware of the things you need to do to become normal, to fit in" (2003, 65). Egoyan uses the elusive figure of the "WASP young man" (Egoyan 1987, 18) as a focal point from which to explore the effects of assimilation. In an interview, he tells José Arroyo, "there's an element in me which is a WASP young man. I would be misleading anyone if I was to try and tell them I was ethnic.... The WASP young man is the blank canvas in my films. That's the character that for me is easiest to paint, who I can also feel very close to" (1987, 18). For these reasons, critics question how to read Egoyan's representation of ethnicity, or how to interpret what political message, if any, his films offer. Egoyan may belong, as Tony Rayns suggests he does, to that category of "writer-directors who base their work on deeply personal preoccupations and use it to confront issues they want to resolve for themselves or to exorcise personal demons" (1997, 60). If so, it is understandable why Jonathan Romney asserts that "ethnic identity has been a constant enigma in Egoyan's films—the jigsaw piece that always refuses to fit" (1995, 8).

For Hamid Naficy, who locates Egoyan in the global context of diasporic and exilic filmmakers beyond Canadian multiculturalism, the answer is not that puzzling. Naficy explains that subtle ethnic and racial resonances permeate Egoyan's films (2001, 37). Although the Deryans in *Next of Kin* are Armenian immigrants, there are no explicit references made about where they came from or what language they speak. They are simply immigrant, foreign, ethnic, other—much like the Armenian women in *Family Viewing*. *Next of Kin* may explicitly explore the world of an immigrant family in Toronto, but Egoyan shies away from labelling the Deryans "Armenian." This may seem odd, especially since the film is filled with veiled Armenian signs. Egoyan even identifies the Deryans as Armenian immigrants by adopting "the derogatory stereotype in Canada of Armenians as 'rug merchants'" and flaunts it as George's proud occupation and legacy (Naficy 2001, 284). But, as Egoyan tells Arroyo, "one of the advantages of working with the Armenian language or the Armenian culture is that it is, for most people, not something that can be easily identified, and that allows me the luxury of being able to treat it almost on a metaphorical level" (1987, 17). Claiming not to be particu-

larly invested in a specific state of "national alienation," Egoyan neverthe-less draws on the experiences of cultural and national dislocation to inform his characters' ethno-existential crises (1987, 17). It appears that the miss-ing piece of the jigsaw puzzle has finally been offered, especially if we read Egoyan's films in the context of what Naficy terms "an accented cinema": "simultaneously local and global," the best of accented films signify the con-ditions of exile and diaspora "by expressing, allegorizing, commenting upon, and critiquing the home and host societies and cultures and the deterrito-rialized conditions of the filmmakers" (2001, 4).

In *Next of Kin*, cultural negotiation is expressed in various familial ten-sions. In the Deryans' father-daughter conflict, George (Berge Fazlian) is more closely associated with the old world (Armenia) and its values, whereas Azah (Arsinée Khanjian) is more closely associated with the new world (English Canada) and its values. As such, the film appears to cast the old-world-versus-new-world conflict in sexual and generational terms. Most explicitly, George equates Azah's independence and defiance of his patriar-chal order with her sexuality, when he calls her a whore. The film identi-fies the immigrant other more closely with the emasculated patriarch whose dominance over the presumed feminine other is needed to reestablish his authority. In his subsequent films, however, Egoyan identifies the immi-grant and the native Armenian culture more closely with the feminine other. In *Family Viewing*, for instance, the immigrant is a more subtle presence. The Armenian women in the film are clearly immigrants who hardly speak English. In fact, aside from their conversations in Armenian in the homemade family videos Van watches, they do not speak at all. Symbolically, the Armen-ian women's stories and experiences of immigration are left untold, effectively silencing the immigrant and raising questions about their immigration and lack of assimilation. We can only imagine what social conditions drive these women to Canada, to endure the sexual and cultural abuse at the hands of the Anglo-Canadian patriarchal tyrant Stan (David Hemblen).

In *Next of Kin*, the sexual/cultural conflict is more murky. Just as George is emasculated by the experiences of immigration and assimilation, Peter's father (Thomas Tierney) is emasculated by Peter's domineering mother (Mar-garet Loveys). Peter's familiarity with his father's subjugation enables him to understand George's anxiety as he watches the Deryans' video therapy session, in which the therapist skilfully redirects George's anger at Azah into anger at the feminized English Canadian culture that has assimilated (or devoured) his lost son. The therapist assumes the role of an assimilated Bedros, voicing what he perceives to be George's biggest fear—that his miss-ing son, having assimilated into English Canadian culture, has rejected his native culture and family. He says, "Hi, George. Aren't you gonna hug me? Are you afraid that I won't listen to you either? Do you think that I'll find you ignorant? That I'll be embarrassed by your accent? Well, I am. You're just a

Next of Kin: Peter and George with the exotic dancer. (© Ego Film Arts)

foreigner, a lousy peasant! No wonder people don't trust you... you smell!"
Here the film calls attention to the negative stereotyping of unassimilated
immigrants as uneducated, poor, ignorant, lying, cheating, and unaccus-
tomed to modern standards of hygiene. George's physical reaction, attack-
ing the therapist while shouting "no," discloses his fear of rejection and of
assimilation, as well his primal passion. The social order that his presumed
assimilated son is now a part of undermines and emasculates the immigrant
who strives to retain control and authority over his home and kin.

Another instance in which the immigrant is more closely associated
with patriarchy is in the importance of family lineage. Upon picking up
Peter-as-Bedros from the airport, one of the first things that George and Sonya
fuss over is the fact that their new-found son has kept his given name:

> *George*: So you keep your name, hey, Bedros?
> *Peter/Bedros*: Yep.
> *George*: You're proud of it.
> *Sonya*: Of course he's proud.
> *George*: Yeah, but some changes their names.
> *Sonya*: Not our son.

For the Deryans, names are symbolic of their native culture. Being proud of
one's name means being proud of one's heritage and symbolizes an attempt
at resisting assimilation. Traditionally, in patriarchal societies, the family
name is passed on through the male members. The absence of a son, like the
changing of given and family names, points to an interruption in the Deryan

family's lineage. Without Bedros to carry on and pass on the family name, the Deryans will die out or cease to exist. Hence, the Deryans may be overjoyed and relieved at being reunited with a son who is proud of his ethnic heritage, but their focus on naming tells a different story, of names and identities that disappear into a vacuous or blank space and of cultural memories that are forgotten, unknown. Implicit in the threat of erasure, of becoming extinct, is the knowledge of social conditions that lead to cultural effacement—assimilation into a dominant culture and genocide. This passage also nods at Egoyan's own family history; his parents changed their surname "from Yeghoyan to the more pronounceable Egoyan" when they immigrated to Canada (Johnson 1994, 46).

The immigrant's anxious desire to survive in the adopted or host nation is expressed both materially and metaphorically. The film may celebrate the spirit of the immigrant, but the use of irony undermines such a celebration. George's assertion "I love this country" is juxtaposed with the negative stereotypes of the immigrant as a dirty foreigner. The immigrant's spirit is doomed if he loves that which rejects and despises him. The immigrant's survival and success is therefore dependent on his ability to exist in a hostile world that threatens to consume him. Passing on the family name and family history are two ways in which cultural survival can be guaranteed. In *Next of Kin*, this is most important to George, who passes on his story, his experiences of immigration, to Peter/Bedros: "At home, I had two stores. Two. I inherit from my father. I had so much money I don't know what to do…. One day, I wake up and I saw everything taken from me. My house, my money, my stores… everything. The bastards make me wait three years to get out of that hell. Three years! I come here with nothing. No money, no house… nothing. So I work. I work like a dishwasher, taxi driver… you name it. Finally, I make small money and I buy this store." Although George provides the details about why he immigrated to Canada, there is a lot of information missing from his account—the location of home, who the bastards were, what the political situation was that left him suspended (imprisoned?) for three years, and why he was stripped of all his material goods. Implicit in this account is also a narrative about the immigrant experience upon arrival, as well as of the immigrant's dream of re-creating his identity and home in the new land. The immigrant's dream is parallel to that expressed by Peter at the beginning of the film: to leave the oppressiveness of home and enter a new, foreign country as an autonomous free subject. The imagined new country is filled with possibilities and promise, as well as the freedom to pursue emotional, intellectual, and material ambitions. The immigrant, like Peter, is hopeful yet naïve, unaware of the cultural negotiation that is necessary in order to survive and succeed in the new, foreign land that he (in this case) seeks to make into his adopted home. Neither Peter's nor George's

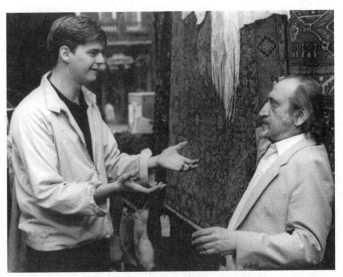

Next of Kin: Peter and George in front of rugs. (© Ego Film Arts)

dream calls for a re-creation of their previous lives, or a mirror image of their respective pasts. Instead, Peter's and George's dreams are to forge and reconstruct a new life. For George, the social conditions (namely corruption) that made the homeland "a nightmare" have to be replaced by those offered in the new land: "No bribes. No lies. No fear." George is thus able to rebuild a store that is in keeping with his paternal inheritance and that forms part of his legacy to be passed on to Peter/Bedros. What Peter internalizes from George's immigrant experience and accepts as his inheritance and familial lineage, then, is a morality tale of the self-made man—an identity he can easily relate to.

Peter's receptiveness to George's legacy and his willingness to accept George's cultural and material inheritance stem, in part, from his uncanny perception of Bedros and of the familial space that he occupies, even in his physical absence. When Peter comes across the tape of the Deryans' therapy session, he sees Bedros as a spiritual presence in need of fleshing out. Bedros's familial space is rife with ethnic specificity and parental expectations. When Peter enters the Deryan home, he enters into their idealized image of Bedros— the son who takes pride in his parents and cultural heritage, the very things Peter does not feel about his own family. Yet, as much as Peter can know Bedros by understanding the Deryan's idealized image of their son, Bedros remains a blank space that is inhabited by the ghost, memory, or idea of a missing son. Bedros, unlike the corporeal Peter, remains a disembodied presence throughout the film, as the missing son whose absence haunts the Deryans, particularly George. Sonya even tells Peter-as-Bedros that George

cannot sleep because he is thinking of his missing son: "Sometimes he thinks you're in his house. Watching him." A constant presence that is defined by its physical absence, like a ghost, is a familiar trope in Egoyan's films. This type of ghost is, as Bhabha suggests, part of the double's makeup: "The performance of the doubleness or splitting of the subject is … evident in the play on the metonymic figures of 'missing' and 'invisibleness' around which [the] questioning of identity turns. It is articulated in those iterative instances that simultaneously mark the possibility and impossibility of identity, presence through absence" (1994, 52). Unlike Bedros's physical absence and ghostlike presence, Peter is spiritually absent but embodied in his family's portraits or tableaus: rather than being a ghostlike presence in need of fleshing out, he is a physical presence in need of spirit. By fulfilling parental expectations and accepting cultural specificity, Peter is able to inscribe his self into being. He is able to infuse Bedros's spirit into his own shell-like body; the self that is ultimately inscribed is that of the double.

Whereas the film celebrates the naturalness of the ethnic household, it also emphasizes that there is nothing "natural" about the Foster household. During the video therapy scenes, for example, static shots zoom in and out, highlighting the oppressiveness of the Foster parents to underscore the artificiality of the family structure. This is also accomplished by filming the Foster family "in tableau style" (Egoyan 2001). Father, mother, and son most often sit without moving, without speaking, statically completing their respective familial roles simply by being within the frame of the "happy" family picture. In the pool scene, for instance, Peter's mother bids him emerge from the water to take his appropriate place by the pool's side. As Peter assumes a statue-like stance, within her sight, the family still-life portrait is complete—even if the camera zooms in to focus only on Peter. In each family portrait, Peter looks directly at the camera, acknowledging its presence. Exactly at whom he is gazing is brought into question. Is it the camera? The audience? Egoyan? Bedros's disembodied spirit? Does the camera represent a kind of mirror that allows Peter, Narcissus-like, to gaze at himself? Peter's gaze indicates his seeing something or someone who is and is not there. Regardless of whom or what Peter is looking at, his gaze defies the purpose of the tableau; it breaks the illusion of the still photograph or portrait to reveal his awareness of the artificial structure of which he forms a part. Peter's gesture at the end of the film, when he sends his parents his taped diary of his experiences (or experiment) with the Deryans, reinforces his statement about the Foster family's condition. He gives his parents a tape recorder that replaces his body in the Fosters' therapy session, giving his parents physical control over him insofar as they can play, rewind, fast-forward, or even erase his voice at will. Peter's mechanical reproduction of himself thus assumes his place in the family tableau.

The formal style of the tableau also works to undermine Peter's parents as "natural" parents. Moreover, the strained relationship between Foster parents and an alienated son naturalizes Peter as a "foster child." In contrast to Peter's metaphorical or symbolic characterization as a foster child, Bedros Deryan was actually given to foster care as a result of the Deryans' immigration to Canada. When Peter, pretending to be Bedros, asks George if they also gave up his sister, George replies, "We don't give you up. We have no choice. No money, no doctor... no friends, no house. What you want us to do? Let you starve?... It was [the] only thing to do." When Peter chooses to remain as Bedros with the Deryans, he appears to be choosing the warmth of Armenianness over the coldness of WASP family culture, thereby suggesting that the Deryans are his "natural" kind—or kin. The foster child is also a double of the immigrant, who is regarded as a "foster child" of his or her "adopted" or "host" country. Thus, when the foster child is reunited with his natural parents, the film is not suggesting that the immigrant return to his native homeland. Rather, it is calling attention to the consequences that the ever-present parental gaze, as a mechanism of surveillance that regulates the child's behaviour within the foster home, has on the child. In other words, the film calls attention to the oppressive surveillance of the governmental, institutional gaze that regulates the immigrant's behaviour within the nation, demanding that the immigrant assimilate into the nation's expectations of normalcy, which inevitably results in the effacement of the immigrant's native culture, language, and ethnicity.

Symbolically, the film begins with a disembodied gaze that evokes a feeling of cultural, social, linguistic, and geographical dislocation. The opening scene, which forms part of the airport sequence at the beginning of the film, defamiliarizes the camera's gaze because of its position on a moving conveyor belt. As the camera continues on its journey, from the perspective of the baggage, the conveyor belt's movement is as disorienting as the white noise made up of unintelligible fragments of conversation. The defamiliarized space of the airport underscores the theme of foreignness. It is unclear at first whose gaze the camera represents—tourist? immigrant? Noreen Golfman's comments on *Exotica*'s opening scene are equally appropriate here: "Egoyan's movies convey that oddly alienating experience we are all so familiar with of hanging around an airport terminal," leaving us in "that uncertain space between Departures and Arrivals" (1998, 27, 28). In this space of in-betweenness, in which Peter is simultaneously departing and arriving, his arrival is juxtaposed with that of a presumed foreigner, an immigrant. At the same time, it is also juxtaposed with the disembodied gaze that suggests Bedros's presence. Peter's dislocation at the beginning of the film and his feelings of alienation can be construed as a manifestation of the immigrant condition.

The airport sequence begins from the perspective of the baggage, but as the camera dislocates its gaze from the conveyor belt, the red baggage is brought into focus. Symbolically, Western culture invests in the colour red those volatile emotions associated with passion, especially anger and sexual desire—the very feelings that the Foster family represses and the Deryan family overtly displays. The red carpets in George's store associate the Deryans—and the Armenians by extension—with the colour red (passion and heat). In contrast to the Deryans, the Fosters—and WASP Canadians by extension—are more closely associated with the colour blue (and thus with depression and coldness), especially in the videotapes of the Foster family, which are filmed in black and white and appear with a bluish hue on the television screen.

Initially, the camera focuses on a single red valise. Peter, however, picks up two red suitcases. Symbolically, one suitcase is larger than the other, but their pairing on the conveyor belt is as unmistakable as is their abstract symmetry. Naficy's comments on the symbolism of the suitcase are relevant here. According to him, the suitcase is a symbol of the exilic subject that can represent the freedom to wander as well as the oppression that forces a subject into exile. The suitcase may contain mementos and memories, and as such is associated with nostalgia for home and the homeland (Naficy 2001, 261–62). Specifically, Naficy argues that "*Next of Kin* forcefully proposes the suitcase as a metaphor for both the constructedness and the mobility of identity" (263). The emphasis on two suitcases, rather than one, thus reiterates Peter's double identity, but in doing so raises questions about the relationship between his two seemingly separate parts. One is, after all, larger than the other. But which? Sitting on the bed in his hotel room, Peter extracts the folder containing the personal information on the Deryan family from the larger suitcase that is opened. The smaller suitcase remains closed, its contents undisclosed. Metaphorically, the closed smaller suitcase suggests the past that is repressed, or Peter's experiences with his Foster parents. Suggestively, the emphasis on Peter's suitcases replays (like Peter's memory) the conversations of the therapy sessions.

Like the set of two red suitcases, the Peter/Bedros double is a composite of two asymmetrical parts. Peter's choice does not reflect a choice of one self over the other, one identity over the other. Instead, his choice simply allows that which has become most dominant (or that which has always been most dominant but repressed) to fully emerge and take over. By the end of the film, the moment of recognition of the synthesis between Peter and Bedros occurs, when Peter, sitting by his hotel-room window, hums the Armenian lullaby Sonya hummed to him when he pretended to be her baby. As he hums, the camera pans across the urban landscape, eventually fixing its gaze on the Canadian flag. The juxtaposition of the Canadian icon and the

Armenian lullaby make clear the integration of the Peter/Bedros double. Flesh (Peter/the Canadian flag) and spirit (Bedros/the maternal Armenian lullaby) are inextricably integrated.

The Peter/Bedros double in *Next of Kin* is instrumental in understanding the cultural doubleness that informs Egoyan's films. Often characterized as two distinct cultures that are polarized, the double calls attention to the ongoing dialogue between the two parts that leads to their inevitable intertwining. Using inversion as metaphor and strategy of and for the double, Egoyan casts the privileged mainstream, upper-middle-class, white, Anglo-Canadian male as the assimilating immigrant other. Peter/Bedros is identified as an immigrant insofar as he is a blank who arrives, ready to be inscribed, in a foreign host land where he works toward forging a new identity. Egoyan thus reinforces the notion that ethnicity is a performance that can be learned, mimed, articulated, and, somewhat disconcertingly, appropriated. Yet the performance of ethnicity is a necessary tool when confronting illusions of ethnicity as being in any way authentic or natural, as well as when destabilizing negative cultural and racial stereotypes. Such a performance also brings into question issues of cultural assimilation. In investing the characteristics of the immigrant in his double, Egoyan grants the immigrant the double's agency and power. The double, after all, has the power to choose which part to showcase and which to repress, and as such gains control over his (in this case) fluid identity. Similarly, the power of choice grants the immigrant the possibility of reconstructing a new identity as well as the possibility of taking control of his life (and the lives of his kin). The double's choice speaks to the ability to control and recreate identity—of which ethnicity is a part. Symbolically, however, the power of Egoyan's central characters remains in their doubleness, in their being split subjects. Understanding the dichotomy of Egoyan's split subjects demands resisting the desire to make one part real and the other a copy, or else to make both parts fit neatly together to produce a desirable whole. The dichotomy of these characters emphasizes instead that within the ruptures and asymmetry of the split subject lie the possibilities for new relationships to develop between the two unequal parts. Each of Egoyan's split subjects demand we consider which part becomes more dominant and what conditions allow for that part to take over. Understanding the doubling strategies in *Next of Kin* allows us to understand the ongoing dialogue in Egoyan's works: each film differently represents the relationship between two cultural parts, correlating a narrative of the split self that begins, in *Next of Kin*, as a self-consciously created double seeking, as Peter does, to give direction to his and other people's lives. But whose?

Works Cited

Bhabha, Homi K. 1994. *The Location of Culture*. New York: Routledge.

Butler, Judith. 1990. *Gender Trouble: Feminism and the Subversion of Identity*. New York: Routledge.

Egoyan, Atom. 1987. "The Alienated Affections of Atom Egoyan." Interview by José Arroyo. *Cinema Canada*, October, 14–19.

———. 2001. "Director's Commentary." *Next of Kin. Family Viewing/Next of Kin: The Early Films of Atom Egoyan*, DVD. Ego Film Arts and Asset Digital.

———. 2003. "Face to Face with Atom Egoyan: Through the Eyes of a Director." Interview by Line Abrahamian. *Reader's Digest*, August, 58–65.

Ginsberg, Elaine K. 1996. "Introduction: The Politics of Passing," 1–18. In *Passing and the Fictions of Identity*, ed. Elaine K. Ginsberg. Durham, NC: Duke University Press.

Golfman, Noreen. 1998. "Surviving Ourselves: *The Sweet Hereafter*." Review of *The Sweet Hereafter*. *Canadian Forum*, January/February, 31–32.

Harcourt, Peter. 1995. "Imaginary Images: An Examination of Atom Egoyan's Films." *Film Quarterly* 48, no. 3: 2–14.

Johnson, Brian D. 1994. "Exotic Atom." *Maclean's*, October 3, 44–47.

Jones, Kent. 1998. "Body and Soul: The Cinema of Atom Egoyan." *Film Comment*, January/February, 32–37, 39.

Masterson, Donald. 2002. "Family Romances: Memory, Obsession, Loss, and Redemption in the Films of Atom Egoyan." *University of Toronto Quarterly* 71, no. 4: 881–91.

Naficy, Hamid. 2001. *An Accented Cinema: Exilic and Diasporic Filmmaking*. Princeton, NJ: Princeton University Press.

Orr, John. 1998. *Contemporary Cinema*. Edinburgh: Edinburgh University Press.

Rayns, Tony. 1997. Review of *The Sweet Hereafter*. *Sight and Sound*, October, 60–61.

Romney, Jonathan. 1995. "Exploitations." *Sight and Sound*, May, 6–8.

Shary, Timothy. 1995. "Video as Accessible Artifact and Artificial Access: The Early Films of Atom Egoyan." *Film Criticism*, Spring, 2–29.

Sollors, Werner. 1990. "Ethnicity." In *Critical Terms for Literary Study*, ed. Frank Lentricchia and Thomas McLaughlin, 288–305. Chicago: University of Chicago Press.

Taubin, Amy. 1989. "Up and Atom." *Film Comment*, November–December, 27–29.

▶▶ 10

Atom Egoyan's Post-exilic Imaginary
Representing Homeland, Imagining Family

Nellie Hogikyan

In the age of globalization and displacement, the imbrication of nations and ethnicities as well as the fluidity of transnational communications render the theorization of exile and diaspora more and more complex. Diasporas comprise multiple layers and waves of migrants, and the cultural production of diasporic artists is characterized above all by plurality, heterogeneity, and paradox. Contemporary film critics and theorists have justly associated Canadian filmmaker Atom Egoyan with these postmodernist features, yet his most studied film, *Calendar* (1993), has been discussed primarily in the context of an "exilic" cinematic genre and of the loosely defined "diasporic" genre (Burnett 1993; Naficy 2001; Rollet 1997). In the first part of this chapter, I propose the notion of post-exile as a theoretical space through which to examine Egoyan's work, in particular the two films in which the filmmaker deals with questions of homeland and origin: *Calendar* and his more recent *Ararat* (2002). The framework of post-exile acknowledges a deep sense of distance and brings into focus a specific structure of feeling, one that moves beyond exile, beyond nostalgia, beyond ethnicity. In order to analyze Egoyan's (re)presentation of the nation and his relationship to his ethnicity in a post-exilic context, I address the recent postcolonial visions of post-nationalism and post-ethnicity discussed by Leela Gandhi (1998) and Rey Chow (2002). In the second part of the chapter, I argue that Egoyan's work,

especially his earlier feature films, portrays allegiance to absent or lost family members rather than to a lost homeland.

Identity: Exile, Diaspora, Post-exile

> The "past-present" becomes part of the necessity, not the nostalgia, of
> living. — Homi Bhabha, *The Location of Culture*

> Just as his father had grown distant from India; just as he himself had grown even further from the life that, in memory, his father had represented and then, later in life, from that which he himself had known on the island, so too had his eldest son gone beyond.
> — Neil Bissoondath, "Insecurity"

In *An Accented Cinema*, Hamid Naficy theorizes diasporic films and differentiates them from exilic ones (2001, 11–15).[1] In my opinion, however, this distinction between exilic and diasporic genres is not satisfactory, especially for theorizing the highly complex work of Egoyan. Exile is a constituent of diaspora. Every diasporic instance begins with exile, and exile, be it individual or collective, is the foundational heritage of diasporas. Diasporic cultural productions are part of transnational, globalized cultures and stand in opposition to national or local productions. In this age of extensive and incessant migrations, distinctions within the diasporic culture itself need to be articulated, just as the categorization of diasporic and migratory genres needs to be constantly redefined. Specifically, the issues of generational differences merit closer examination, since the experiences of the generations after exile announce new histories of migration and diaspora. The problematics in the contexts of diasporization, on one hand, and technologization, on the other, raise questions such as these: When does an artist stop being an exile? What if exile is not a first-hand experience for the diasporic artist? How does one's integration in the country of residence—other than the place where previous generations were born and raised—influence one's relation to the origin? And how do family ties figure within globalized and technologized structures of society and culture?[2]

While the first generations living in diaspora experience exile with the destabilizing effects of accompanying material and spiritual losses, the second, third, or fourth generations—the post-exiles—integrate themselves into essentially unstable transnational and postmodern cultural identities. Although the latter do not experience exile directly, loss and absence haunt their lives, such as we see in the artistic productions of diasporic cultures. The situation further complicates itself when members of the diaspora of the same generation, born and raised in different countries, belong to different waves of migration.

The prefix *post* in *post-exilic* does not designate a rupture with or indifference to the condition of exile. The term *post-exile* leads inevitably back to exile; it can reject the condition of exile, re-evaluate it, replace it, or revitalize it. Far from effacing the exilic past, this history becomes a crucial dimension in the reconstruction and representation of one's identity. Thus *Ararat*, for instance, opens with the exilic figure of Arshile Gorky and alternates between fragments of the historical context of that exile and stories from the present.

Both exilic and post-exilic sensibilities shape diasporic forms of art. The exile, typically, yearns for home and aspires to return to the homeland. He or she is torn between the place left behind and the place where he or she now "survives." In contrast to this exilic condition characterized by the search for home, the post-exile makes no claim to an ancestral homeland as the sole space of belonging. Instead, what defines the identity of the post-exilic subject is the set of aesthetics associated with postcolonial and diasporic realities such as hybridity, postnationalism, and post-ethnicity. The experience of post-exile—especially within diasporas that are marked by a tradition of migration, as in the case of the Armenian, Caribbean, and Jewish diasporas—places the subject in a complex relationship with a displaced memory and with migratory identities. Canadian Caribbean writer Neil Bissoondath said it best: "My roots travel with me, in my pocket" (1994, 26).

The post-exile, then, deals with an unconscious of displacement and separation; his or her consciousness is one that is rooted in the memory and anxiety of loss and absence. This brings us to the major distinction between the exilic and post-exilic experiences: while the exile feels alienated and estranged from the other—the new culture, the host country—the post-exile is estranged from the same: from his or her own origin. In his film *Ellis Island*, Georges Perec expresses this alienation from within thus: "Quelque part je suis étranger par rapport à quelque chose de moi-même; quelque part je suis 'différent' mais non pas différent des autres, différent des miens" [Somehow I am a stranger with respect to something within/of myself; somehow I am 'different' but not from others—different from my own folk] (1980, 44). This example addresses a dissociation from one's own origin as well as a dissociation from one's kin. Similarly, American blacks no longer share common roots with Africans or with Blacks in the Caribbean such as Aimé Césaire, and Caribbean Indians such as Neil Bissoondath identify with an Indianness based on a displaced memory and displaced family.

Beyond roots, beyond land, beyond borders, post-exile is a condition of that which is beyond the exilic preoccupation with national boundaries. Using an analogy to Derrida's logical contradiction, with which he opens his essay, "Le monolinguisme de l'autre,"—"Je n'ai qu'une langue, ce n'est pas la mienne" [I have but one language, it is not mine] (1996, 13)—the post-exilic

subject can say, "I have many countries, they are not mine,"as he or she transcends inscription in territory, accepting an identity politics that is no longer based on identification with a homeland—and especially not with an ancestral homeland. One of the ways in which the post-exile compensates for this irremediable loss of the place of origin is the substitution of family for the homeland. In other words, the post-exilic surpassing of territorial belonging seems to give way to an inscription of family ties. Arjun Appadurai illustrates this phenomenon through the dedication of his book on the cultural dimensions of globalization to his son, to whom he refers as "home": "For my son Alok, My home in the world" (2000). In the absence of the permanence of connections, as distances grow larger between individuals and peoples, and in the absence of continuity of filiation due to migration, immediate family becomes the only possible imagined community.

Current Paradigms: Postnationalism, Post-ethnicity

The exilic condition of yearning and nostalgia is not the only alternative to the loss of the homeland or of the origin. Complex, enriching, and new pluralistic identity strategies are being presented by diasporic artists every day, as the postcolonial critic Edward Said noted already in 1984: "But if true exile is a condition of terminal loss, why has it been transformed so easily into a potent, even enriching, motif of modern culture?" (159). Drawing on Said's subsequent works, Leela Gandhi offers the vision of an "enlightened 'postnationalism'" that is analogous to the post-exilic positionality in the sense that it accounts for one's detachment from the country of origin. The prefix *post* here suggests "cognitive mastery—a detached perspective or vantage point from which it is possible to discern and to name the completed and clear shape of the past" (Gandhi 1998, 173). Such detachment allows for a lucid national consciousness that is not nationalism (Gandhi 1998, 124); it also clears a space for postnational and post-ethnic voices. And so the post-exile who stands at a distance from the experience of exile, and therefore at a distance from the loss of the homeland and from the dissociation from the nation, is capable of envisaging active non-resistance to new cultures. This position naturalizes plurality and heterogeneity and renders the future of one's identity unpredictable. As the post-exile moves from the national to the postnational, ethnicity ceases to be the fundamental organizing category of his or her identity. The voices that have been so far unaccounted for in exilic and sometimes diasporic discourses (depending on the generation of the diaspora) can now be heard. From the hitherto neglected silence, new ways of telling identities are born.

In "Melancholic Memories and Manic Politics," Anahid Kassabian and David Kazanjian offer a clear illustration of the way postnational diasporic voices are suppressed by nationalistic perspectives on exile—perspectives

that perpetuate the nation from the outside. The authors identify a particular genre in Armenian diasporic cultural production, namely *Hai Tahd* ("Armenian Case"), which represents diaspora as a *"problem* to be solved with the securing of reparations for and recognition of the genocide, and the stabilisation of culture, history, language and territory" (1999, 202). Kassabian and Kazanjian analyze mourning the lost homeland and genocidal loss in Theodore Bogosian's documentary *An Armenian Journey* from Freudian perspectives on mourning and melancholia.[3] The nationalistic discourse that runs throughout *An Armenian Journey*, the authors affirm, generalizes and idealizes the lost past and aims to ensure a just and stable future in diaspora. In fact, Theodore Bogosian's essentialist discourse perpetuates the nation from the outside: "The search I undertook for a truth no one could deny remains unfulfilled. But I did find in my search something greater. I did find the strength, *the immortality of an Armenian Spirit* that has endured despite all challenge and denial. In my search I found another truth that could not be denied. *In a living people scattered across the globe, I found a Nation"* (qtd. in Kassabian and Kazanjian 1999, 211, my emphasis). By thus idealizing the past and by constructing a nationalistic future, the film neglects the complex and rich plurality of diasporic experiences; it silences individual voices that do not share the nationalistic "Spirit." The voice that is most silenced in *An Armenian Journey* belongs to a second-generation diasporan, Joan, who is successfully marginalized by the director. As a matter of fact, Joan is completely excluded from the dominating past-oriented discourse of the film. Nor does she ever appear at the centre of the frame; she is but the shadow of her mother. By reading what has been pushed to the edges of the frames in Bogosian's documentary, Kassabian and Kazanjian draw attention to the disruption that the "shadowy figure" of Joan causes within the film's project of constructing a homogeneous Armenian diaspora whose "Spirit" would be primarily that of a survivor's—the exile's. In this context, the paradigm of post-exile, which accounts for diasporic voices that speak beyond national and exilic narratives, allows for an identification with the liminal figure of Joan, whose experience of diaspora is different from her mother's and whose identity, as her first name suggests, is, in the least, cross-ethnic.

Leela Gandhi proposes three conditions that prepare for the shift toward postnationalism in postcolonial perspectives. I will be concerned with the first two, as they apply directly to the study of post-exilic cultural productions. The first condition is globalization, or "an unprecedented movement of peoples, technologies and informations across previously impermeable borders—from one location to another" (1998, 125). In fact, transnationalists show that their identities are increasingly diaspora-based rather than land-based (Ong and Nonini 1997, 326). Moreover, in a world where electronic

images and simulacra travel instantly across the globe, the borderlines between nations are blurred. Globalization, however, as contemporary theorists maintain, does not necessitate the erasure or homogenization of cultural or ethnic identity, nor is diaspora intrinsically liberating of nationalistic fervour (Appadurai 2000; Ong and Nonini 1997). And so, although globalization is associated with the transcendence of national boundaries, a consolidation of local, national, and religious identities, whether in more or less subtle ways, is sometimes maintained by post-exilic artists with a postnational awareness that examines the stakes of such identifications (Hanif Kureishi's *My Son the Fanatic* is a case in point). On another level, the extensive displacement of peoples, on the one hand, and the ever-growing dependence on technologies in communications accompanying globalization, on the other, bring forth fundamental changes in human relations. In a world of long-distance communications, where the movement from immediacy to "mediacy" alters the once stable family dynamics, how does distance figure within "intimate" family ties? I elaborate on this in the second part of this chapter.

The second condition within Leela Gandhi's postcolonial perspective that favours the move toward postnationalism is the growing suspicion of a certain identity politics, namely, "the preservation and perpetuation of essentialized racial/ethnic identities" (1998, 126). Gandhi bases her argument on Rey Chow's criticism of a neo-Orientalist view of nativeness as "endangered," a view that renders the neo-Orientalist anxious to "retrieve and preserve the pure, authentic native" (1998, 126). In the Canadian context, cultural critics have argued that the politics of multiculturalism encourages a definition of identity based on one's ethnicity and ex-national belonging. In *Selling Illusions* (1994), Neil Bissoondath, for example, contends that the Canadian policy of multiculturalism, which seeks to preserve diversity, creates unease on many levels; it stereotypes, highlights ethnicity, and favours emphasis on the former or ancestral homeland alone. In my view, however, the association of multiculturalism with ethnic enthusiasm can be true of first-generation immigrants only (although a few extreme cases figure in successive generations). A certain period of nostalgic preoccupation with one's background seems to be inevitable in the life of exiles—nostalgia that dissipates starting with second-generation immigrants who integrate fluid Canadian identities. As these children of immigrants mix with other Canadians, they find themselves in spaces where they can explore other ways of identifying and address their origins from new perspectives. The flourishing transnational or intercultural cinemas, literatures, and other forms of art attest to the hybridity that defines the main characters in contemporary Canadian productions. This is not to say that there are no "typically ethnic" main characters in intercultural cinema; these are usually represented by first-

generation immigrants like Bedros/Peter's parents in Egoyan's *Next of Kin*, who are exiles, speak with an accent, and have "different" or "particular" values and customs. As a matter of fact, the very existence of "ethnic" characters contributes to the heterogeneity and hybridity that define intercultural arts.

Hybrid identities are characterized by uncertainty and fragility, and hybridity draws attention to and emanates from the malleability of ethnic identity. In fact, ethnicity is a conceptually vague and ambivalent notion, and there is no absolute consensus on its representation. In her recent deconstructive discussion of the ethnic, Rey Chow writes, "ethnicity appears to be a category with mythic potential (since it is a kind of narrative of belonging) and is therefore manipulable" (2002, 25). Chow further affirms that "even the most long-held and cherished assumptions about the ethnic culture are contestable and potentially dismantleable" (2002, 190). The question of the representation of ethnic and national belonging[4] occupies an important place in the work of Atom Egoyan. In what follows, I offer a close reading of *Calendar* and *Ararat* from post-exilic perspectives, while also situating his work within the cultural tradition of the Armenian diaspora.

Representing Homeland and Nation: *Calendar* and *Ararat*

> I was only slightly curious about my Armenian background—or so I thought, although, if I had understood how to acknowledge such matters, I might have known that I was haunted by it...distant and repellent events that I had vaguely heard about and that obviously had little or nothing to do with us [today, in the United States].
> — Michael J. Arlen, *Passage to Ararat*

Armenian Post-exile The migrant character of the Armenian people has established a globalized diasporic cultural identity that distances itself further and further from "homeland." For the Armenian diaspora, the process of globalization started toward the end of the nineteenth century. By the beginning of the twentieth century, especially after the catastrophe of 1915, Armenian refugees were scattered across continents, mostly in the Middle East, Europe, Canada, and the United States. Famous artists such as New York painter Arshile Gorky (born Vosdanig Adoian in 1904) and Cairo photographer Van-Leo (born Levon Alexander Boyadjian in 1921) quickly became associated with transnationality, multi-ethnicity, and invented identities. Furthermore, Gorky and Van-Leo (and, later on, filmmaker Parajanov, born Sarkis Parajanian in the USSR) introduced aesthetic expressions that lay out some of the terms for an avant-garde tradition characterized by plurality and abstractness but most consistently by disrupted genealogical representations. Gorky, for instance, falsely introduced himself as a Tiflis-born Georgian prince who had fled the Bolshevik persecutions. He pretended to

have studied in Paris and assumed the pseudonym of Russian playwright
Maxim Gorky, saying he was his cousin (Tchilingirian 2000, 42). Arshile
Gorky's new identities were accompanied by innovation in his artistic work.
His biographer, Nouritza Matossian, writes, "He was always questioning and
criticizing. In the thirties when people were producing paintings by formula
or assigned by the government, Gorky did not follow the norm. He went on
to produce some of the most interesting abstract murals of the period"
(Matossian, quoted in Tchilingirian 2000, 43). On another continent, the
eccentric photographer Van-Leo, having also completely changed his name,
was revolutionizing photography in Egypt by declaring himself an art pho-
tographer (Iverson 1998). In the 1940s, Van-Leo took more than four hundred
self-portraits, disguised as four hundred different characters representing
various nationalities, ethnicities, and religions. Akram Zaatari from the Arab
Image Foundation comments on Van-Leo's perspectives within the then-
blooming nationalistic discourses in Egypt: "He used photography to dis-
play multiple images of himself, assuming different identities. At a time
when nationalism was close to rising in Egypt, Van-Leo was plotting, encour-
aging, and promoting that multiplicity in the look (people's façades, peo-
ple's landscape), as well as in people's ethnic and religious backgrounds.
He is the antithesis of nationalism, even in a period when such slogans were
prominent at every occasion" (Zaatari, n.d.). Egoyan belongs to this counter-
national innovating artistic tradition. As with Gorky and Van-Leo, any crit-
ical understanding of the filmmaker's work goes beyond national bound-
aries and beyond genealogical belonging.

Representing "Armenia" If Egoyan draws from Armenian artists associ-
ated with transnationality, multi-ethnicity, invented identities, and an
avant-garde artistic tradition, his own experience as an immigrant, as well
as his family history of migration, also contributes to his awareness of the
unstable nature of national identity within the diasporic experience. Three
worlds and three generations stand between Egoyan and his place of ori-
gin. His grandparents moved from western Armenia (parts of eastern Turkey
today) to Egypt, where his parents lived for nearly three decades before
immigrating to Canada when he was three years of age.[5] This physical and
temporal distance from the origin—from community and from homeland—
receives its primary representation in *Ararat*, a film that is not directly
about the genocide and the ultimate separation from the homeland but
rather about the mediatization of this historical event, that is, about the
communication and the representation of its repercussions on the post-
genocide generations. In *Ararat*, Egoyan is dealing with exilic and nation-
alistic discourses from a post-exilic, distanced position. For example, the
fact that the whole film turns around the making of second-generation dias-
poran Edward Saroyan's film *Ararat* tells of the impossibility for Egoyan—

Ararat: Atom, Bruce, and Elias. Atom Egoyan directing the film within the film. (© Lousnak)

a third-generation diasporan—to deal directly with the issues of genocide and homeland. Egoyan's main concern is the Turkish denial that follows the genocide and that persists three generations later. The memory and anxiety of the brutal separation from loved ones due to the genocide and the deportations, a trauma that constitutes the roots of the Armenian post-exilic identity, is dealt with through the grieving character of a first-generation exile, the painter Arshile Gorky. Certainly, this distance from an unfathomable past from which Egoyan is situated is responsible for "muffling the impact" (Wilmington 2002)—as we are constantly interrupted by the process of the making of the film within the film—and deferring much of the grief that some of *Ararat*'s critics expected. Four generations after the genocide, complexity and convolution impose themselves on the process of working through these historical and political issues. This complexity of the story (played out in five time periods: the customs interview, the making of Saroyan's film, the events around the making of this film at the festival, the events from 1915 to 1918, and Gorky's exile), coupled with the filmmaker's dazzling style, inevitably postpones the post-exilic subject's direct dramatic involvement with those faraway emotions.

The spatial and temporal distance that separates Egoyan from his place of origin also makes the notions of home and homeland complicated for the third-generation diaspora artist, especially because, historically, Armenia has been divided into east (Soviet) and west (Ottoman/Turkish). In fact, in his films that are concerned with his place of origin, Egoyan deals with his

allegiance and with belonging to two different Armenian entities, and his rep-
resentations of it are multiple. Present-day former Soviet Armenia, where the
Eastern Armenian dialect is spoken,[6] is supposed to be the homeland of all
Armenians—natives and diasporans alike; however, the post-genocide and
post-exile diasporans are the descendants of Armenians who lived in west-
ern Armenia (speaking the Western Armenian dialect).[7] We see the 1915
western Armenia, where several massacres, genocide, and deportations took
place between the late nineteenth and the early twentieth centuries, through
two sets of representations in *Ararat*. The first representation of western
Armenia is through Edward Saroyan's film, which is also called *Ararat* (in
the film, Edward Saroyan is a second-generation Armenian diasporan, played
by Charles Aznavour). For Saroyan, representing the lost homeland for a
second-generation diasporan is a matter of consciously imagined reconstruc-
tion; the artist is fully aware of the impossibility of return to a ravaged land.
Unlike "authentic" representations of native land that one sees in exilic
films, in Saroyan's *Ararat* it is a question of shifting ground, as Saroyan re-
members and dis-places this powerful symbol of the Armenian nation in
nationalistic discourses. In the film within the film, Mount Ararat is pre-
sented along the lines of such dis-placement. In one of the film's scenes, a
painting of Mount Ararat has been installed in order to shoot a scene for
Saroyan's film; Ani, the art historian (played by Khanjian), comments on
the misplacement of the mountain: "You wouldn't be able to see Mount
Ararat from Van." Saroyan replies, "Well, yes! But I thought it would be
important." And Saroyan insists on preserving this misplacement; as Ani
reminds him that the mountain's existence in that specific place "is not
true," Saroyan maintains, "It's true in spirit!"

By displacing Mount Ararat through Saroyan's representation, Egoyan
transgresses national geographic representations of homeland and decon-
structs the exilic myth of "authenticity" expressed by exilic filmmakers.
Whereas a mountain may express "nostalgia for an authentic 'world before'
and the desire to return to that world" (Naficy 2001, 160), Mount Ararat
becomes a portable signifier that can be readily fixed and re-fixed to accom-
modate the situation, without any suggestion of return to a specific place.[8]
By displacing this ancient fetishized symbol of the Armenian nation in the
film within his film, Egoyan abandons the stable ground of homeland and
enters into the terrain of new reconstructions of more fluid and deterritori-
alized collective identities. And so, although the use of the word *spirit* at
the end of Saroyan's remark might echo the nationalistic discourse in
Bogosian's documentary, referred to above, Egoyan's presentation of multi-
ple individual narratives throughout the film speaks of the filmmaker's inten-
tion to move away from unitary discourses on belonging and identity. As a
matter of fact, Egoyan does not give a purely historical account of the Armen-

ian genocide. His depiction of characters spans over almost one century of diasporic past and present, representing ties not only with a collective past, but also an interconnectedness with the other. Egoyan's distanced position as a post-exile allows him to move beyond national and international histories. Without effacing collective memory, he concentrates on individual reflections on the consequences of exile, collective trauma, and witnessing, as well as on the denial that surrounds and perpetuates this trauma. Hence, fourth-generation diasporan Raffi searches for his father's identity, for the truth and proof of the genocide in a parallel to Celia's search for the truth about her own father's death, and Ani researches the life of Arshile Gorky and questions the consequences of the artist's separation from his father as well as the definitive loss of his mother on his art in New York. Finally, with the absence of the question of return to a homeland in *Ararat*, Egoyan moves away from a territorially based identity, and what remains in his representations of this collective experience of Armenianness is an ancestry massacred and deported, a mountain misplaced, a travelling pomegranate bringing "luck and the power to imagine," a painter gone mad.

The second representation of western Armenia in Egoyan's *Ararat* is through the digital images that the customs officer watches during his elaborate interview with Raffi (played by David Alpay), who is coming back home to Canada from a trip to Turkey. Here, we see and feel the utter remoteness of this place that once was homeland. The sense of rupture and dissociation is metaphorically conveyed not only through the distancing strategy of mediation, but also through Raffi's narrative accompanying these images. In this second film within the film, Raffi tells his mother of the total absence of connection to this deserted place and his uncertainty about what to feel in that context. For him, it is a "dream-world" in which nothing seems imaginable except for togetherness of family: "I'm here, Mom. Ani. In a dream-world, the three of us would be here together. Dad, you, and me." As he consciously integrates loss, ruin, and destruction in the construction of his memory, Raffi announces the absence of a real homeland in the representation of his post-exilic identity.

Representations of "Armenia" in Egoyan's work are based on survivor memories and forgettings of the devastating consequences of the genocide. Apart from the scenes portraying the historical events around the genocide and deportations—which, in Saroyan's film, depict in themselves a nation on the verge of annihilation and a homeland bordering on destruction—the representations of "Armenia" in Egoyan's work portray a historically lost entity, existing only in the form of ruins and accessible solely through an imaginary built and rebuilt over four diasporic generations. The images representing post-genocide Armenia in Egoyan's are of a deserted landscape in ruins, a no man's land that in reality is a part of eastern Turkey, which is inac-

cessible to Armenian diasporans today. This reflects Egoyan's own imagination of a country of origin that is no longer living in the reconstruction of his diasporic identity. An aesthetics of ruin and absence is then very much present in the filmmaker's imaginary and is, in actual fact, transferred to the representation of contemporary ex-Soviet Armenia as well.

In *Calendar*, Egoyan's representation of former Soviet Armenia is also one of ruin, not only depicting the actual loss of what once was, but also stressing the temporal distance that separates the two diasporic characters—the photographer and his wife—from their historical past. Here, the ancient ruins are distanced through multiple strategies of mediation: the narration/presentation by the guide, the translation/interpretation by Arsinée, and the photographs, video-clips, and Super 8 films being manipulated by the photographer-*vidéaste*-filmmaker. Egoyan, moreover, offers an atemporal representation of Armenia. By insisting on the rural landscape throughout the film, as well as on symbols of eternity and timelessness such as the herds of sheep, Egoyan again highlights the distance that separates the characters in the film from actual time-bound Armenia.

In both *Calendar* and *Ararat*, a true living Armenia is absent, stressing the absence of homeland in the reconstruction of the post-exilic characters' identity. The actual former Soviet Armenia in reconstruction, albeit in misery, does not figure in Egoyan's films. This contrasts in significant ways with other Armenian post-exilic films such as Nora Armani's *Last Station* (1994). In this autobiographical film, the main female character, a theatre actress, decides to stay in Armenia after her first tour in the capital, Yerevan. Separated from her husband in order to pursue her acting career, Nora faces profound despair as she witnesses the endless lineups to buy bread on her first morning in the Armenian capital. Unlike *Calendar*'s characters, who wander in ruined and rural landscapes, *Last Station*'s protagonist is fully there, experiencing the day-to-day activities of contemporary, impoverished, yet living Armenia (Hogikyan 2003).

Performing Absence, Abstraction, and Estrangement from the Origin

The distance that figures in Egoyan's representations of "homeland" and national identity reflects the filmmaker's abstract relationship to Armenian communities in diaspora as well as to his place of origin. In *Calendar*, Egoyan stresses the precarious nature of national identity and maintains that his experience of "Armenia," like that of his wife, Khanjian, is "very abstract" (Egoyan 1994, 94). Egoyan explains:

> [Arsinée] est née à Beyrouth, mais, contrairement à moi qui ai été élevé dans un environnement complètement étranger, elle a grandi au sein de la plus importante communauté arménienne de la diaspora. Elle avait

une idée précise de ce que peut signifier le fait d'être "arménien," idée fondée sur une expérience tangible et durable des valeurs et des traditions de la communauté.

En revanche, son rapport à l'actuel territoire de l'Arménie était moins net. Sa communauté exilée l'avait certainement élevée dans l'idée d'une patrie historique rêvée, et, même si son expérience de l'Arménie était moins "voyeuriste" que la mienne, elle restait quand même très abstraite.

[(Arsinée) was born in Beirut, but, unlike me, who was raised in a completely foreign environment, she grew up at the heart of the most important Armenian community of the diaspora. She had a precise idea about what being "Armenian" could signify, an idea founded on a tangible and lasting experience of the values and traditions of the community.

On the other hand, her relationship to the actual territory of Armenia was less clearly defined. Her exiled community certainly raised her with the idea of a dreamed historical homeland, and even if her experience was less "voyeuristic" than mine, her experience remained nevertheless very abstract.] (Egoyan 1994, 93)

Egoyan is observing how different diasporic migrating subjects experience their relationship to their country of origin in different ways. Through two diasporic characters in *Calendar*, Egoyan portrays two different ways of dealing with the distant origin. Like Atom Egoyan and Arsinée Khanjian themselves, the photographer and his wife (played by Egoyan and Khanjian) are third-generation diasporans who have different ideas about what it means to be Armenian. Whether the photographer's wife's choice to stay in Armenia is motivated by her more or less precise idea of the meaning of Armenianness or not, her direct involvement with the guide and her physical approach and attachment to the historic sites of Armenia contrast in obvious and significant ways with the photographer's detached and fleeting attitude.

The photographer's relationship to Armenia is "voyeuristic" (Egoyan 1994, 93). His stable position *behind* the camera in all the scenes that take place in Armenia suggests that he is a spectator who dissociates himself from his ancestral land through his work. Khanjian's character opts for placement in the "homeland." She "returns" to the origin and favours fusion with "home," an attitude common within the stereotypical dichotomy of exile/homeland. Egoyan's character remains detached from the place of origin, and upon his return to his Toronto studio, he reproduces the state of estrangement and alienation he felt in the "home" country. Hence, the filmmaker presents two different ways of dealing with the post-exilic condition of abstraction and absence of the "same."

Egoyan's character's absence in *Calendar* from the scenes of feeling and touching the ruins of his country of origin marks his detachment from national and territorial belonging. In fact, photography serves here as a

metaphor for the distanced positionality of the post-exilic subject—"a stance in which one stands at a distance from one's own emotions" (Gabriel 1999, 78). The photographer's trip to Armenia is motivated by a calendar project suggested to him by a cultural association. In response to the guide, who asks him if he would have come to Armenia had the project not been assigned to him, the photographer asserts, "Probably not, not if I didn't have a specific reason to come here." Nor does he feel concerned with the idea of moving "back" to Armenia. When the guide tells Arsinée that it would probably be better for the children, if she had any, to live on their ancestors' land, the photographer asks blandly, "He thinks if we had children we'd come and establish ourselves in Armenia?" The photographer thus confirms a definitive and ongoing separation from his ancestral homeland. His dissociation from Armenia is emphasized by his refusal to be intimate with the monuments and ruins of the country.

Khanjian's approach is physical and fusional; her direct contact with these figures of Armenian national heritage speak of a desire to renew her bond with the origin. Here, while Khanjian is attracted to the national history of Armenia as it is being related by the guide, her husband is seeking another sense of belonging—a personal, individual history. The photographer would like to present himself, rather than be represented by history. As he watches his wife drift away from their own story, he feels excluded and alienated and demands her artistic complicity. He wonders, in distress, "Has this place made you forget *our* history? Has this place that you've dreamed of made you forget *our* dreams?... Why can't you refer to *our* history of each other? You make me feel like a stranger.... We're both from here, yet *being here has made me be from somewhere else*."

Estranged from the origin, the photographer performs absence by not appearing physically in the scenes that take place in Armenia. The spectator listens to his voice, dissociated from the body, from behind the camera, but never sees him enter the frame he is photographing or filming. Through his absence from the visual representations of Armenia, the photographer maintains a positionality that differs significantly from the one presented in the main discourses of exile in general, and from the national discourses of the Armenian diaspora in particular. His constant interrogation of the place and its language tells of the absence of an integral Armenianness in his identity; it is forever impossible to unite the separated parts into a whole. As philosopher and psychoanalyst Daniel Sibony, commenting on the impossibility of healing the ruptures with the origin, remarks, "Les deux parties, liées du fait de la coupure qui les sépare, ne forment pas un tout (encore moins sont-elles le tout) quand elles sont réunies" [The two parts, bound due to the rupture which separates them, do not form a whole (even less do they comprise the whole) when they are reunited] (Sibony 1991, 17). Further-

Calendar: The photographer and the Egyptian actress. (© Ego Film Arts)

more, by insisting on the photographer's "artist" identity at his Toronto stu-
dio—the only place where we see him—Egoyan saves his character from
adopting a received and pre-determined "Armenian" identity.[9] Nevertheless,
despite the photographer's construction of himself as "artist" in the scenes
in Toronto, his Toronto studio is the only place where we see him connect
to his ethnic identity. There, at the end of the film, we see and hear him dis-
cuss ethnicity and belonging from a very personal, unmediated point of
view, having at this point stopped the act by calling the Egyptian actress to
his side in his longing to converse:

> *Photographer:* When you said before that your father was Armenian, I
> mean he's not really Armenian....
> *Actress:* Well he *considers* himself to be Armenian.
> *Photographer:* That's ridiculous, it's like saying I *consider* myself from
> Yugoslavia or from anywhere else; I mean just because his grandfather was
> Armenian. I mean my...
> *Actress:* I *consider* myself to be *Egyptian* and I grew up in *Canada.*

This first-person discourse of "I *consider* myself..." comes to emphasize the
personal aspects of the representations of ethnic identity. But this process
of identification is complicated when, at the end of the scene, both actress
and photographer recognize a certain "look" in each other. When the pho-
tographer tells the actress, "You *look* Egyptian," she answers, "I can *see* it in
you too.... I wouldn't say you were Canadian." What do these final com-
ments tell us about the construction of personal and ethnic identities? The

issue here is not merely whether the photographer "looks" Egyptian, Armenian, or Canadian. Here, the personal and collective perspectives on identity are fused. No analytical distinctions are made between the different ways of looking at identity, and we are left with questions rather than answers. Egoyan is insisting on the malleability and multi-dimensionality of identity, making room for contradictions and paradoxes.

The photographer's refusal in *Calendar* to get close to the ruins of his country of origin, as well as the excessive use of technology in the film (at once symbolizing and creating distance), represents the gap existing between himself and his material—in this case, Armenia—as well as between himself and his art. Here, the photographer's identity blends with that of the spectator, who is inherently an other, intensifying the already important distance that the artist is working with. This reflects Egoyan's own dissociation from his origins; and as Sylvie Rollet affirms, Egoyan's decision to name his film production company Ego, deleting the Armenian signifier *-yan*, accentuates the "lack" of an Armenian signified in his affiliation—"la perte du suffixe arménien dit clairement la rupture des attaches" [the loss of the Armenian suffix clearly tells of a break-up in ties] (Rollet 1997, 104). This dissociation from his genealogical filiation can be read as a metaphor for the impossibility of identifying with his own Armenianness, his own originary culture.[10]

The Aesthetics of Distance: Media, Substitution, and Incest

> Distance is the opposite of closeness. The essentially distant object is the unapproachable one…. True to its nature, it remains "distant, however close it may be." The closeness which one may gain from its subject matter does not impair the distance which it retains in its appearance.
> — Walter Benjamin, *Illuminations*

The collapse of the originary bond—the national onomastic umbilical cord—can be seen as a reproduction of the primal scene of trauma of the Armenian people, that is to say, their violent separation from their homeland and their families at the beginning of the twentieth century. As Egoyan reproduces the separation from his original genealogy by deleting the Armenian suffix *-yan*, he not only acknowledges the fragility of national symbols, but also problematizes questions of genealogy and kinship.[11] In this context, the filmmaker deals with issues of loss and absence through the strategies of mediation and substitution, which act in contradictory ways: mediation is at once a symbol and condition of distance; substitution is a strategy that fills the void brought about by the distancing techniques of mediation as well as by other social conditions of loss and absence. In a world where technique

mediates and modifies all human activity (Hedley 2002, 166), extremely mediated relationships promise virtual intimacy and virtual immediacy, leaving one desiring close, stable ties. And so the consequences of globalization—the "tragedies of displacement"—touch on something, perhaps most dear in the context of family dynamics: direct physical contact.[12] The seemingly unrestricted human interaction, guaranteed by the constant advancements in technology, is coupled with another kind of loss—the physical proximity that allows direct, organic contact through which warmth, affection, and sensuality can be nurtured. As family relationships become more and more volatile in the context of large-scale migrations, the process of imagining family deserves particular attention. Egoyan's use of the substitution strategy within the family context and his use of the metaphor of incest in association with substitution, especially in his first three feature films—*Next of Kin, Family Viewing*, and *Speaking Parts*—constitute new ways of representing present-day family relations and familial dramas and fantasies.

Visual Media

In the context of the Armenian post-exile, the breakdown of such structures as family and nation due to the original dispersion of the Armenian people, on one hand, and to perpetual migration and displacement on a global scale, on the other, give rise to an intense dependence on media, especially within the family context and in the home. As in the case of most displaced populations, Armenian homes in diaspora become memorial sites for both national signifiers (photographs of churches and monuments) and family photographs and portraits. The photograph of Arshile Gorky and his mother taken in western Armenia circa 1915 and destined for Gorky's father in New York is but one example of the crucial role of media in maintaining or constructing identity and family relations after exile. In *Ararat*, the art historian Ani's comments about Gorky's painting based on this photograph underline the way media come to stand in as anchors of identity and memory for members of the Armenian diaspora: "That painting is the repository of our history; it is a sacred code that explains who we are and how and why we got here." As a matter of fact, this famous photograph is also what enabled Gorky to survive spiritually (though not for very long, as he took his own life at the age of forty-four) by recreating his intimacy with his mother through the numerous reproductions (paintings) of *The Artist and His Mother* in New York.[13] In other words, Gorky's obsession with the memory of his mother transforms itself into a passion for representation, for the medium of painting. His mother can never again be anything but a chimeric representation—an image. Egoyan extends this tradition of relating to others through images and meshes it with the postmodern trend of hyperdependence on images and mechanical reproductions and, in fact, on (audio)visual media in general.

Ararat: Shoushan and Arshile: Photograph of Arshile Gorky and his mother. (© Lousnak)

Lisa Siraganian identifies media as one of the major operating principles of Egoyan's work and holds that media come to replace the missing characters in the film's world (1997, 128). According to Egoyan himself, the camera can replace the missing person. In an interview with Julia Reschop, the filmmaker relates, "Dans tous mes films, je suis fasciné par l'idée d'une personne disparue, d'un personnage central qui serait absent du drame.... Quand un personnage est absent, la caméra, très discrètement, peut se substituer à celui-ci. Elle pourrait représenter le regard de cette personne absente, qui est témoin de son propre drame." [In all my films, I am fascinated by the idea of a person who has disappeared, of a central character who would be absent from the drama.... When a character is absent, the camera can provide a very subtle substitute, representing the gaze of this absent person who is a witness of her/his own drama.] (Egoyan 1993, 63). Analyzing Egoyan's representations of homeland, language, and love in *Calendar*, André Roy remarks that the story of the film "favorisera une autre triade et dont les composantes sont le cinéma, la vidéo et la photo" [favours another triad and whose constituents are cinema, video, and photography] (1993, 67).

The obsession with visual media in Egoyan's films establishes distance as a main character personified by technologies such as the video camera, the tape recorder, the telephone, the answering machine, the photograph, and other mediating devices, creating simultaneously and paradoxically a virtual closeness that never materializes in reality. Ron Burnett affirms that in *Speaking Parts* (1989), Egoyan's "mediatic" characters are dependent on their relationships to images, such as Lisa's love for Lance, which, in reality, is a love

for the image she has created of him (1991, 134). Within this framework—inside the home—sounds and images abound while flesh and warmth disappear from the diegetic world. The resulting effacement of the organic causes depersonalization and dehumanization. Egoyan is critical of the technology narrative as a dominant pattern for living and communicating. While his depiction of the mechanical within human relations is impressive and portrays extreme aloofness and coldness, the filmmaker always hints at another mode of communicating that is achieved through organic family reunions. In *Family Viewing* (1987), for instance, young Van feels disconnected when he is at home with his father and stepmother alone, while "accompanied" by television sitcoms and private home videotapes. The only time he feels "connected," as he tells his father, is when he is with his grandmother, who is in a nursing home. Van's ultimate desire is to bring her in to live with the family—against the will of his father and stepmother—in order to reproduce the warm and loving atmosphere recorded on videotapes in his childhood.

Re-membering Family: Substitution and Incest

> In the beginning there was separation.
> Fearful of losing his childhood and his identity, he placed himself next to his mother and he painted her back to life. Vartoosh [his sister, with whom he emigrated] described to me how Gorky warned her before letting her see [the painting] for the first time. Then he sat down, facing the portrait... and said, "Vartoosh dear, here is Mother. I am going to leave you alone with her." He shut the door.
> "Oh, I was so shocked! Mother was alive in the room with me. I told her everything and I wept and wept."
> — Nouritza Matossian, *Black Angel: A Life of Arshile Gorky*

Most of the time, the distance between family members that is reproduced or created in Egoyan's films is redeemed by substitution and, in extreme cases, through fusional, incestuous desires. Re-membering and reconstructing family is a practice that preoccupies a great number of post-exilic artists. The obsession with connecting to relatives and the substitution of family members by others is revealed in the work of one of Egoyan's Canadian contemporaries, the poet, writer, and scholar Lorne Shirinian.[14] In Shirinian's fiction, characters, whether Greek, Jewish, or Armenian, are often portrayed as "orphans of memory" who may discover "distant relatives in Toronto," who "wonder about grandparents," and who desire an impossible relationship with a "murdered brother" (2002, 52–56). In Shirinian's short story "Hotel Diaspora," the narrator sits in the Café des Âmes Perdues imagining the following scenario about a newcomer he meets at the hotel (the newcomer could be from Albania or Rwanda, or any other place where human catastrophes

have taken place in the recent past): "One afternoon, he runs through the lobby, excited, incoherent. 'My family. They're alive. My family survived.' After the attack on their column, they had become separated. Each thought the others dead. Through some miracle, some perverted fiction, he finds his family intact in another hotel in the city. They see each other on Jacob Street and run to each other. 'Papa,' his daughter yells, 'Papa.' They hug each other tightly and kiss, tears flowing" (2002, 51). In a chapter dealing with questions of linkage, post-memory, and disconnections, Shirinian comments on his own poem "Evolution (On Looking at a Photograph Taken in Western Armenia in 1915 and One Taken of Me in 1997)"[15] that as he looked at the photograph from 1915, aware that the person was not a relative of his, he "accepted him as a surrogate to fill in for my murdered grandparents, aunts, uncles, and cousins in an attempt to create a connection and some form of continuity, knowing full well that such forms of intimacy were impossible" (2004, 40).

In Armenian post-exile, and especially in the aftermath of the extreme separation, there is a profound desire for connection with lost people rather than with a lost place. In *Calendar*, for instance, although the photographer expresses no particular interest in the place of origin (he is there on an assignment), he nevertheless engages in nostalgic correspondence with Lucinée, the young girl he has sponsored in Armenia. By sponsoring this girl from Armenia, the photographer is trying to regain metaphorically blood ties with the people of his origin. The sponsored Armenian girl is therefore a substitute for lost extended family, or a "should-have-existed" member of family had the genocide not occurred. At another level, the twelve actresses who visit the photographer's studio in *Calendar* are also substitutes for his recently separated wife. Egoyan's act of breaking ties with his Armenianness through the deletion of the inherited suffix -*yan* is compensated for through the establishment, in his art, of ties with Armenian individuals in Armenia and with Armenian artists in the diaspora.

But the "ineffable melancholia for close ones" (Altounian 1990, 30) does not always translate into a desire for the same. In *Next of Kin* (1984), for example, the substitution of the Armenian son, Bedros, by the Canadian Peter allows both "mother" and "son" to regain the physical contact that has been disconnected for both of them, albeit in different circumstances. The mother has lost contact with her son, whom she has given away for adoption in order to facilitate the emigration of the rest of the family. Peter has been unhappy with his own bland parents; he quits video therapy and opts for organic family therapy by pretending he is the Armenian family's biological son.

Egoyan transposes this desire to relocate and remember family members—a common theme in the Armenian post-exilic cultural production—

onto the postmodern characters of his films. With the strategy of substituting one member of family for an other, Egoyan not only pays homage to lost or absent family members, but also destabilizes the traditional family institution, displacing biological filiation as the ultimate foundation of familial unity. By opting for such imaginary filiation, Egoyan highlights the fragility and instability of identity and moves to more fluid representations of communities and networks of kinship.

The strategy of substitution in Egoyan's films is always correlated with the idea of incestuous inclination. In fact, the theme of incest pervades much of Egoyan's work and emerges early in his filmmaking. Except for *The Sweet Hereafter* (1997) and *Exotica* (1993), in all the films where incest is present, the taboo relationship is between consenting adults and does not seem to violate the code of ethics of the film's diegetic society, particularly because one of the partners is always a substitute. In *Family Viewing*, Van has a sexual relationship with his stepmother; in *Speaking Parts*, Clara has a sexual relationship with the young actor, Lance, who resembles her dead brother; in *Exotica*, a risk of incest exists between the father and the daughter-substitute (the dancer); and finally, in *Ararat*, the step-siblings Raffi and Celia engage in an incestuous relationship. Egoyan has even expressed regret for not actualizing the possibility of an incestuous relationship between the sister and the substitute brother in his first feature film, *Next of Kin*. In an interview with Mario Falsetto, Egoyan said, "One of the ideas I'd take further, if I were to do it now, is the notion of an incestuous relationship between Khanjian's character and the boy she obviously knows is not her brother. There's an attraction between the two of them, but I made a decision not to develop that. More could have been made of it, but it was something murky at the time. I think it was a real opportunity lost. It could've been very interesting" (Egoyan 2000, 129). The persistence of the incest theme attests certainly to its inevitability in an oeuvre for which the major guiding metaphors are displacement, separation, and alienation. If these notions constitute the predicament associated with globalization and high technology, they are also metaphors for the originary separation of Egoyan's ancestors from their homeland and from family members. The repercussions of this violent rupture on the Armenian diasporic culture, the roots of which, in most cases, are orphanhood and adoption, constitute a major component of the imaginary of Armenian artists. Here, fusional relationships evoke an anxiety of annihilation—this haunting existential menace and the attached fear of discontinuity, of being perpetually exterminated. Incest, in this context, metaphorically insinuates reproducing or becoming the same/other.

Egoyan's attraction to "the more extreme sides of human behaviour" (Egoyan 2000, 122) along with a compulsive preoccupation with separation and communion, results in pushing the metaphor of reconnection to its lim-

Next of Kin: Sister and brother. (© Ego Film Arts)

its. The filmmaker is working with an aethetics of the extreme: separation on the one hand, fusion on the other. His depiction of incest serves as a metaphor for reunion in fusion—fusion that annuls distance, fusion with the same who is also other, always in keeping with the complex and paradoxical diasporic identity.

Conclusion

In the first part of this chapter, I laid out some of the terms for the identity paradigm of post-exile, a theoretical frame that addresses Atom Egoyan's complex cinematic discourse from new perspectives. A close look at Egoyan's material makes it possible to focus on the acute and unique consciousness of distance with which the filmmaker operates. The detachment that defines some of his main subjects is a characteristic that serves to deconstruct and transcend the paradigm of exile, and that tends toward a post-national, post-nostalgic, and post-ethnic positionality. Situating Egoyan in the Armenian post-exilic artistic tradition, I maintain that Egoyan's cinematic techniques of distancing through mediation, along with his decision to delete the Armenian signifier from his last name for his production company—Ego Films—emphasizes the critical distance he has established between his material and the notions of homeland and nation, as well as his estrangement from his own culture. In the second part of this chapter, I showed how Egoyan's work concerns itself with a special consciousness of family ties. In this con-

text, the filmmaker uses technology, simultaneously and paradoxically, to (re)create virtual intimacies that never materialize in reality. Post-exilic kin relations are contaminated by disproportionate distances; such dispersion constitutes a perfect, irresistible condition for imagining absolute reunions.

Acknowledgments

I wish to extend my appreciation to Livia Monnet, my thesis supervisor, for her guidance during the writing of the first draft of this chapter. My hearty thanks go to Samuel Torello who both mothered and fathered our two-year-old many weekends and many long evenings. Finally, I thank the editors of this book, Monique Tschofen and Jennifer Burwell, for their invaluable comments and suggestions.

Notes

1 Naficy also proposes a postcolonial cinema but limits it to the hyphenated ethnic identity. Leela Gandhi's vision of a new postcolonial theory is more helpful for the analysis of Egoyan's work, as I will elaborate in the next section.
2 In his discussion on global culture, Arjun Appadurai mentions the threat that the large movement of people brings to the stability of communities and networks of kinship: "The warp of these stabilities is everywhere shot through with the woof of human motion, as more persons and groups deal with the realities of having to move or the fantasies of wanting to move" (2000, 33–34).
3 The documentary relates the search by diasporic filmmaker Theodore Bogosian of "irrefutable historical proof of the genocide" and the trip of an American Armenian survivor, Mariam (and her daughter Joan), to her childhood village in Eastern Anatolia (Kassabian and Kazanjian 1999, 210–11).
4 The distinction between national and ethnic identities has been discussed by many postcolonial and diaspora theorists. See, for example, Aihwa Ong's *Flexible Citizenship: The Cultural Logics of Transnationality* (1999). The definition of *national* is problematized especially by the expansion of cosmopolitan centres such as Montreal, New York, and Toronto and their suburbs; the definition of a nation based on ethnicity is thus no longer possible. So Canadian national identity, for example, is really transnational, multi-ethnic, and intercultural.
5 Egoyan's mother's family settled first in Alexandria before she moved to Cairo (Hogikyan 2003).
6 In *Calendar*, we see eastern Armenia, where the guide speaks this dialect.
7 The Western Armenian dialect is Egoyan's, as well as the Khanjian family's, dialect.
8 Certainly Egoyan's films do not lead us to believe that his main characters are nostalgic exiles waiting to return to their homeland.
9 This might reflect the filmmaker's exhaustion with Canada's policies of multiculturalism, a political strategy that aims at a convenient "Othering and exoticisation of ethnicity," a phrase I borrow from Stuart Hall, who uses it in the context of Thatcherite Britain (Gandhi 1998, 126).
10 In an interview with Hamid Naficy, Egoyan talks about this culture that is unavailable as a collective identitarian aspect to associate with:

> *Egoyan*: The most autobiographical element in the films for me is
> the notion of the submerged culture. The notion of a culture that has
> somehow been hidden, either for political or for personal reasons.
> And the notion of the dramatic motor of the film [*Calendar*] being the
> escaping from or the redefinition of that culture.
> *Naficy*: Are you referring to the Armenian culture?
> *Egoyan*: Yes. But also to the notion of culture as something which is
> a very strong, identifying feature that has somehow been denied to
> the characters who are most in need of it. (Egoyan 1997, 221)

11 Charles Aznavour, a second-generation diasporan, has also opted for this type of
rupture with the origin, namely the suppression of the Armenian suffix–*y/ian*.

12 The "tragedies of displacement" that Appadurai discusses in the context of the
sex trade and the pornographic film industry (2000, 39) are also present—though
in different ways—for hundreds of thousands of migrating families whose mem-
bers are most of the time in transition or in waiting, whether in Central and Latin
America, in Eastern Europe and the Balkans, or in China and the former Soviet
Union. One such example is the case of Filipino and Sri Lankan men and women
who slave to rich and not-so-rich homes all over the world, leaving newborns,
small children, or young fiancé(e)s behind. In this case, though, the waiting fam-
ilies do not have the "luxury" of high technologies.

13 For more, see Matossian 2001.

14 Shirinian is a second-generation Armenian diasporan, the son of one of the George-
town Boys—a group of Armenian young orphans who were adopted by Ontario
families in the 1930s. Many Armenian diasporans are children or grandchildren
of orphans. Egoyan's grandmother on his father's side was an orphan; so were
three of my own grandparents.

15 This poem appears in a collection entitled *Rough Landing*.

Works Cited

Altounian, Janine. 1990. *Ouvrez-moi seulement les chemins d'Arménie: un génocide
aux déserts de l'inconscient*. Paris: Belles Lettres.

Appadurai, Arjun. 2000. *Modernity at Large: Cultural Dimensions of Globalization*.
Minneapolis: University of Minnesota Press.

Bissoondath, Neil. 1986. *Digging Up the Mountains*. Toronto: Macmillan.

———. 1994. *Selling Illusions: The Cult of Multiculturalism in Canada*. Toronto:
Penguin.

Burnett, Ron. 1991. "Parlant de rôles." In *À la recherche d'une identité: renaissance
du cinéma d'auteur canadien-anglais*, ed. Pierre Véronneau, 133–42. Montreal:
Cinémathèque Québécoise/Musée du cinéma.

———. 1993. "Between the Borders of Cultural Identity: Atom Egoyan's *Calendar*."
CineAction, Autumn, 30–34.

Chow, Rey. 2002. *The Protestant Ethnic and the Spirit of Capitalism*. New York:
Columbia University Press.

Egoyan, Atom. 1993. "Entretien avec Atom Egoyan." Interview by Julia Reschop.
24 Images, no. 67: 62–66.

———. 1994. "*Calendar*." Trans. Michel Sineux. *Positif*, no. 406: 93–94.

———. 1997. "The Accented Style of the Independent Transnational Cinema: A Con-
versation with Atom Egoyan." In *Cultural Producers in Perilous States: Editing*

Events, Documenting Change, ed. George E. Marcus, 179–231. Chicago: University of Chicago Press.

———. 2000. "Atom Egoyan." In *Personal Visions: Conversations with Contemporary Film Directors*, by Mario Falsetto, 119–52. Los Angeles: Silman-James.

Gabriel, Teshome H. 1999. "The Intolerable Gift: Residues and Traces of a Journey." In *Home, Exile, Homeland: Film, Media, and the Politics of Place*, ed. Hamid Naficy, 75–83. New York: Routledge.

Gandhi, Leela. 1998. *Postcolonial Theory: A Critical Introduction*. New York: Columbia University Press.

Hedley, Alan R. 2002. *Running Out of Control: Dilemmas of Globalization*. Bloomfield, CT: Kumarian.

Hogikyan, Nellie. 2003. "De la mythation à la mutation: structures ouvertes de l'identité." In *Poésie, terre d'exil*, ed. Alexis Nouss, 51–60. Montreal: Trait d'Union.

Iverson, Barry. 1998. "Van-Leo: Master Cairo Portrait Photographer." *Van-Leo: A Moveable Feast*. http://www.adhamonline.com/Sony%20Gallery/Van%20Leo/iverson.htm. (accessed October 28, 2004).

Kassabian, Anahid, and David Kazanjian. 1999. "Melancholic Memories and Manic Politics: Feminism, Documentary, and the Armenian Diaspora." In *Feminism and Documentary*, ed. Diane Waldman and Janet Walker, 202–23. Minneapolis: University of Minnesota Press.

Matossian, Nouritza. 2001. *Black Angel: A Life of Arshile Gorky*. London: Pimlico.

Naficy, Hamid, 2001. *An Accented Cinema: Exilic and Diasporic Filmmaking*. Princeton, NJ: Princeton University Press.

Ong, Aihwa. 1999. *Flexible Citizenship: The Cultural Logics of Transnationality*. Durham, NC: Duke University Press.

Ong, Aihwa, and Donald Nonini, eds. 1997. *Ungrounded Empires: The Cultural Politics of Modern Chinese Transnationalism*. New York: Routledge.

Perec, Georges. 1980. *Récits d'Ellis Island: histoires d'errance et d'espoir*. Paris: du Sorbier.

Rollet, Sylvie. 1997. "Le lien imaginaire: une poétique cinématographique de l'exil." *Positif*, no. 435: 100–106.

Roy, André. 1993. "Une machine célibataire." *24 Images*, no. 67: 65.

Said, Edward. 1984. "Reflections on Exile." *Granta*, Autumn, 157–72.

Shirinian, Lorne. 2000. *Rough Landing*. Kingston, ON: Blue Heron Press.

———. 2002. *Memory's Orphans*. Kingston, ON: Blue Heron Press.

———. 2004. *The Landscape of Memory: Perspectives on the Armenian Diaspora*. Kingston, ON: Blue Heron Press.

Sibony, Daniel. 1991. *Entre-deux: l'origine en partage*. Paris: Points.

Siraganian, Lisa. 1997. "'Is This My Mother's Grave?': Genocide and Diaspora in Atom Egoyan's *Family Viewing*." *Diaspora* 6, no. 2: 127–54.

Tchilingirian, Hratch. 2000. "Reinventing Life." *Armenian International Magazine*, April, 42–47.

Wilmington, Michael. 2002. "At the Movies: *Ararat*." *Chicago Tribune*, November 27.

Zaatari, Akram. n.d. "Van-Leo, The Discipline of a Rebel." *The Arab Image Foundation*. http://www.adhamonline.com/Sony%20Gallery/Van%20Leo/virt_vanleo.html.

▶▶| section 3

Pathologies/Ontologies of the Visual

▶▶ 11

Modes of Perception
Visuality, Culpability, and Innocence

Jennifer Burwell and Monique Tschofen

The essays in the previous section address the ways Egoyan's work has spoken to his own cultural heritage and in particular to the enduring legacies of the Armenian genocide on later generations spread throughout the diaspora. Through this lens, the authors uncover the political and historical dynamics informing Egoyan's recurring negotiations of identity, his explorations of experiences of dislocation and alienation, and his representations of missing persons. The essays in this section consider more universal qualities of Egoyan's work, showing how, even as they are deeply rooted in a specific history and politics, Egoyan's films and installations speak to fundamental human issues. Set in what he describes as "operatic" scenarios, Egoyan's characters are always driven by powerful needs. The manner in which they strive to bridge the distance between what they have and what they desire constantly interferes with the attainment of whatever or whomever they covet. Egoyan's characters thus take us to the fine line between power and perversion, innocence and culpability, where thwarted desires turn voyeuristic, fetishistic, and even incestuous. Drawing on the intersections of psychoanalysis, feminism, and film theory, the authors consider typically Egoyanesque tropes such as the substitution of one person for another or for one's past self, of image for reality, or of the part for the whole,

connecting these substitutive gestures to complex ethical and epistemological questions that often implicate the viewer's own desires.

These authors view questions of agency, power, and guilt in Egoyan's work as being inextricably linked to visuality—that is, to the idea that the human sense of vision is not natural but rather is something that is socially constructed, historically contingent, and deeply imbricated in power relations. They show how in Egoyan's work, images construct barriers between the self and others and, conversely, draw characters and/or viewers into an uncomfortable proximity to the screen. The authors also show how images in his work are offered to stand in for the real and how, through complex mediations, they invoke new relationships to that real. The authors then extend their analysis to consider how Egoyan's work also engages other senses—in particular how the aural, spoken, and tactile act in counterpoint to the visual. Thus we come to understand that while sensory overload—particularly of the visual—can excite feelings of overstimulation, Egoyan's films often engage *multiple* senses as a means of offering protection from the pathological visuality to which he subjects us. As we have already seen, Egoyan's interest in exposing pathologies also extends both to the characters and the viewers the possibility of transcendence and redemption.

In his essay "*Speaking Parts*: The Geometry of Desire," William Beard returns to the question that he addressed in his essay in section one: how do characters use the mechanical reproduction of images in misguided attempts to manage their emotional lives? This time, Beard focuses on the characters' use of images as "object-substitutes" and on the inevitable distance that this strategy creates between what they are and what they desire to be or to possess. Beard argues that, in the process, the very means that these characters employ to bring others into their lives become the cause and measure of their separation, isolation, and self-absorption. The characters in *Speaking Parts* are all fundamentally possessed by their own obsessive, narrowly focused concerns—Clara with her incestuous desire for her dead brother, Lisa with her desire for the inaccessible Lance, and Lance with his narcissistic obsession with his own image. In each case, the object of desire is fetishized through its articulation as image. The fact that much of the action in *Speaking Parts* is abstracted and consigned to the realm of video images reflects the disassociation between characters' inner and outer lives, where everyone is trapped in his or her own "self-generating, self-referential, and disconnected" desire. For Beard, the "melancholy" in Egoyan's films, and in *Speaking Parts* in particular, derives partly from the hollowness of these substitutions and fetishizations.

Beard highlights how Egoyan repeatedly blurs the borders between what is happening and what appears to be happening, both for the characters and for the viewer. Toward the end of *Speaking Parts*, events that seem

to be occurring on tape or video move into the "phantasmagoric realm," where everything the viewer sees has an unknown status. The confusion between reality and representation that overcomes the central characters eventually overcomes the viewer and even the film itself. This final destruction of "any possible realist basis for the phenomena that we see," as Beard puts it, is the result of another circuit of substitution—not just of people for images, but of reality for the imaginary. Things that seem to be photographed and watched turn out to exist only in the characters' imaginations, or even to be hallucinatory products of the narration itself. The central characters' image-projects end in immersion and dissolution in hallucinatory confusions of image and reality, but these immersions also function productively by forcing them into what turn out to be transformative crises of subjectivity. Similarly, the production of a narrative that challenges the viewer's comprehension using traditional modes of interpretation, while unnerving, opens up a space for the viewer to rearticulate his or her received modes of perception.

In "Look but Don't Touch: Sensation and Self-Censorship in *Exotica*, *The Sweet Hereafter*, and *Felicia's Journey*," Patricia Gruben takes up the question of innocence and culpability by examining characters' ambiguous or unsuccessful attempts to achieve or recover their agency. Gruben draws on Laura Mulvey's distinction in "Visual Pleasure and Narrative Cinema" between voyeurism (gaining a sense of control through separation from and domination over the object) and fetishistic scopophilia (a narcissistic identification with the spectacularized and fetishized object). Gruben then offers up a parallel set of relations that she calls *seeing-to-control* and *seeing-to-touch*. In seeing-to-control, visual screens separate the characters from inaccessible loved ones through an unstable voyeurism that frequently descends into fetishistic fictional constructs that stand in for the unreachable object of desire. Fetishistic scopophilia exists outside linear time in the form of a preserved, suspended past; characters cannot resolve their relation to this externalized or past self, and become either trapped within a past trauma or paralyzed by a ritualistic "faulty mourning" (Rayns 1995, 9). According to Gruben, when an object of mourning or desire is preserved or abstracted through photography or video, it becomes doubly fetishized, and the character's grief is "fixed" onto a fetishized image that further impedes the character's recovery from the original trauma.

According to Laura Marks, images are always both multi-sensory and embodied (2000, 73). With her concept of seeing-to-touch, Gruben suggests a relation to the screen that draws from Marks's notion of "haptic visuality": "the way vision itself can be tactile, as though one were touching a film with one's eyes" (2000, xi). While Gruben, like Marks, argues that the thwarting of multi-sensory fulfilment is instrumental in the characters' fetishiz-

ing scopophilia, her analysis also suggests that this very act of denial makes the viewer aware of his or her own and the characters' relationship to the screen. From this perspective, this very denial of sensory fulfilment functions as a deliberate narrative device that increases the viewer's awareness and that generates in the viewer a more sophisticated understanding of his or her relationship to the screen. Characteristically, then, Egoyan chooses indirection as his form of address and situates meaning within an act of negation; viewers develop an awareness of something not through its presence, but through the manner in which it affects and displaces that which surrounds it. Citing Deleuze's distinction between a "movement-image cinema" that has the coherent, conventional narrative logic of dominant film and a "time-image cinema" in which the juxtaposition of images does not serve a causal storytelling function (1992, ix), Gruben observes that Egoyan's radical manipulation of time, space, and causality confounds our illusion of being in control of the narrative. By denying us a sense of coherence and closure, Egoyan in a sense "cures" us of what Gruben calls "our illusory sadistic voyeurism." A healthy relation to narrative, Gruben suggests, is one that acknowledges and accepts the impossibility of achieving full mastery over what we see on the screen.

Part commentary on and part response to the conventions informing feminist work on representations of incest, Melanie Boyd's essay "To Blame Her Sadness: Representing Incest in Atom Egoyan's *The Sweet Hereafter*" argues that, in *The Sweet Hereafter*, Egoyan represents a nuanced and ambiguous agency that is both contradictory and dialectical—alternating and sometimes suspended between a "victim-blaming" portrayal of quasi-consensual incest and a "victim-empowering" portrayal of a protagonist who claims control over her own story. Boyd argues that while the protagonist, Nicole, achieves some measure of agency, it is a qualified and negotiated agency, bound by the tension between innocence and culpability. Nicole achieves the greatest measure of agency, says Boyd, when she assumes narrative control by deliberately thwarting her father's attempt to capitalize on the bus wreck that has disabled her and left most of the town's children dead. In a metonymic relay between trauma and blame, Egoyan shows Nicole reintroducing the question of culpability by asserting that the bus wreck was not a tragic accident—that it in fact did have both "a cause and a culprit." Nicole's sudden reversal of her story, along with the gaze she directs at her father, functions in the film as a "signal" that reactivates the notion of culpability and then implicitly transfers the suggestion of culpability back onto her father and his incestuous actions. Thus, says Boyd, does Nicole—and the film— capitalize on the accident in order to make the incest suddenly visible *as* incest, as exploitation rather than simple romance. The incest subplot then emerges as the frame through which the viewer sees both trauma and jus-

tice, and Nicole shifts from fetishized object of mourning to active subject. Boyd concludes that this inversion—or conversion—of guilt ultimately offers a feminist intervention that surpasses the "clichéd" conventions of representations of incest while still assigning agency and blame their proper place.

In "*Close*: Voyeurism and the Idea of the Baroque," William Van Wert analyzes Egoyan and Julião Sarmento's installation for the Venice Biennale, comprised of two wide cinema screens separated by a corridor or aisle too narrow for people to pass comfortably by one another. Van Wert focuses on the viewer's indirect relationship to the images on the screen and considers in particular the interaction between the viewer's disturbingly close physical proximity to the screen and the placement of the visual focal point at the very edges of the screen, so that the focal point appears only in the periphery of the viewer's sight. In his examination of proximity and distance, caution and risk, Van Wert argues that the arrangement of the relation between viewer and screen initially appears to deny viewers access to the anonymous, distant, and protected position of the voyeur, instead throwing them into a too-close and potentially fetishistic position. At first, then, Van Wert seems to be describing a straightforward tactile or fetishistic relationship between viewer and image. Like the other authors, however, he complicates this interpretation by pointing out that, although we do have the option of reaching out and touching the screen in front of us, the nature of perception ensures that we are drawn away from this too-immediate relation to the screen and pulled toward the focused images at the edges of the screen— images that we can see but cannot touch. Like Gruben, Van Wert shows how Egoyan suspends viewers between a fetishistic and voyeuristic position, intensifying their self-consciousness about the manipulations to which they are being subjected.

Van Wert argues that the logic of metonymy, not metaphor, impels the construction of meaning in *Close*. Metonymy suggests the impossibility of achieving a self-contained meaning and offers in its place the generation of meaning through a chain of associations. Again we see how Egoyan uses indirection to generate meaning; in fact, Van Wert's analysis demonstrates that the indirection of metonymy not only provides an alternative mode of signification, but may also provide a form of protection from a threatening proximity. In connecting trauma narratives and indirection, Van Wert's analysis both echoes the other authors in this section and refers us back to the authors in the previous section, who connected modes of substitution and displacement with necessary compensations for a story that could not be told. In those cases, the indirection was revealed to be a product of historical erasure and of the limits of the speakable; in this case, that indirection is deployed simultaneously to heighten the viewer's awareness and to protect the viewer from an overstimulation threatened by oppressive closeness.

Metonymy, which Van Wert identifies as being based on a lack or absence, is finally what establishes the underlying and more foundational tension between pleasure and pain, discipline and eroticism.

In "Seeing and Hearing *Salome*," film theorist Kay Armatage and musicologist Caryl Clarke collaborate to explore the relationship between the visual and the aural in Egoyan's opera production of *Salome*. Like the other authors in this section, Armatage and Clarke take up the questions of empowerment and constraint. Like Gruben, they argue that the protagonist expresses an ambiguous agency that opens up questions of innocence and duplicity, chastity and seduction, victimization and power. Like Van Wert, they focus on the ways in which both the viewers and characters are at once implicated in and protected by and through their relationship—carefully staged by Egoyan—to the screen.

In *Salome*, Armatage and Clarke argue, the gaze is associated with power, but also with danger; the aural is associated with safety and innocence, but also with blindness and denial. Clarke points out that, through the innovative use of screens in the staging of this opera, Egoyan presents us with a "sadistic ocular presentation of *loss of innocence*"—a loss that is incurred not primarily by the characters but rather by the audience, which, via the screen, is deprived of its sense of innocence. Armatage argues, for example, that the rape scene defiles all who participate in the watching—and that the scene is projected in such a way that it is obviously directed at the audience alone. She further suggests that the audience again is in danger of being overwhelmed and of adopting a fetishistic relation to the image when it is subjected to the extreme closeup of Joachanaan's lips. Finally, the audience must suffer alone the image of Salome's cannibalism—an image from which even Salome is protected, by the blindfold that shields her eyes. Armatage's and Clarke's analysis suggests that here it is in fact Egoyan who plays the sadistic composer, victimizing his audience through his staging of images and screens.

As a contrast to the sadistic images that Armatage uncovers, Clarke offers an interpretation of the music in *Salome* that associates the aural with power, privilege, and redemption. As an example, she cites Salome's own privileged relation to the aural, as the only one to hear the holy and prophetic harmonies expressed by Joachanaan's voice. Furthermore, says Clarke, one of the opera's most intense vocal moments occurs during Salome's final monologue, when the power of the operatic diva is released through the sheer strength, prowess, and presence of her voice. Composed last, says Clarke, the "Dance of the Seven Veils"—the longest stretch of solely orchestral music in the entire opera—is a prelude to a new dynamic wherein the balance of power and sympathy shifts toward the victimized Salome. If representations of fragmented and fetishized images alienate and even disgust

us, the force and harmony of the aural offers redemption and transcendence—not only for the character but also for the audience.

It is not difficult to see how the same preoccupations revealed in the first two sections emerge again here: trauma, absence, substitution, displacement, denial, inversion, negation, the disruption of space and time. If Egoyan toys with trauma and narrative in his work, he also protects the viewers from being overcome or immersed in the trauma that they are viewing or experiencing. Even as Egoyan lures in and plays with his audience, he sets up structures of image and sound that prevent them from falling into a static, fetishized relationships to the screen. Through these structures, Egoyan intervenes both to protect the audience from being overwhelmed and to release the audience from the impossible desire to achieve narrative mastery. The viewers are never allowed to become totally comfortable, but they are never abandoned either. Egoyan has said that it is not possible to view the new digital technologies with "tenderness," yet we see here an artist who is able to use these technologies not just to represent or cause alienation but also to express a sympathy that embraces both his characters and all those who are drawn into and moved by his work.

Works Cited

Deleuze, Gilles. 1992. *Cinema 1: The Movement-Image.* Translated by Hugh Tomlinson and Barbara Habberjam. London: Athlone Press.

Marks, Laura U. 2000. *The Skin of the Film: Intercultural Cinema, Embodiment, and the Senses.* Durham, NC: Duke University Press.

Rayns, Tony. 1995. "Everybody Knows." Review of *Exotica. Sight and Sound*, May, 9.

▶▶ 12

Speaking Parts
The Geometry of Desire

William Beard

Characteristics of Egoyan's Cinema

Speaking Parts is typical of Atom Egoyan's extended first phase of feature film-making—a model example, in fact. It is impossible to find a work that more fully embodies the characteristics of his cinema during the decade between *Next of Kin* (1984) and *Exotica* (1994). Indeed, the films of this period are almost parodic in the way they repeat motifs and strategies of storytelling and filmmaking. Slotted between *Next of Kin* and *Family Viewing*, which precede it, and *The Adjuster* and *Calendar*, which follow, *Speaking Parts* restages many of its creator's insistent themes and patterns. In the interests of setting the stage for a detailed reading of this film, it will be useful to enumerate some of the most important aspects of Egoyan's cinematic practice in this period.

The films usually present a set of characters whose behaviours and aims mirror or complement each other so meticulously that you feel their configuration could be expressed in a map or diagram. This already inter-woven situation is then worked out with repetitions and parallels, varia-tions, and juxtapositions, which occur so insistently and so flowingly that musical metaphors spring repeatedly to mind: counterpoint, recapitulation, theme and variations. The films repeatedly assert that life in a contempo-rary Western environment is constantly being mediated and distorted by

technologies of representation. Egoyan's characters routinely adopt these technologies as a means to distance themselves, or conceal themselves, or live out their emotional lives in a voodooist or substitutive fashion. Dominating this landscape is the massive presence of video, with its ability to record, fix, replay, and rephrase people and situations. An astonishing number of the characters in these films are found obsessively making tapes or watching them or both, fixated on using video as a magical tool that will somehow enable them to process and manipulate their own lives and the world around them. The intensity of their involvement with the virtual realities of videotaped material sometimes grows so strong that they fall into a hallucinatory or synaesthetic relationship with it, where fact and video image, objective outer and emotional inner realities are confused. This in turn allows Egoyan to engage in similar cinematic games with the viewer on a supra-diegetic level—games that blur the borders between what is happening and what appears to be happening. This development is particularly extensive in *Speaking Parts*.

The world in and to which all this is happening is one that very often features strong polarities of power. Cold, institutionally invested figures dominate and control the lives of individuals who are outside or on the margins of the institutions of power, and the resulting spectacle is sometimes almost dystopic in its social dimension. One expression of power is control of the means of representation, and there thus seems to be a relation between the hypermediation and alienation of everything through video and other technologies, on the one hand, and the icy control of the powerful over the powerless, on the other. Certainly, the emotional condition of the principal human participants is a condition of suffering and loss, a spectacle of sad people with bizarre coping mechanisms. Finally, the films manifest a distinctive visual stylization as well: locations are restricted, the *mise en scène* has a cool detachment, and the purposeful repetitions and intertwinings of places, people and actions are accomplished with a fastidious formal elegance. Altogether, these are the characteristics of Egoyan's other work, and they certainly encompass the essential qualities of *Speaking Parts*.

Events of the Film

The film has three central characters, a small handful of other important but more peripheral characters, and a few other personages yet further out toward the margins. The three at the centre are Lisa (Arsinée Khanjian) and Lance (Michael McManus), two menial employees at a large hotel, and Clara (Gabrielle Rose), a film scriptwriter who is also a guest at the hotel. Lance's career—as opposed to his job—is film acting, so far restricted to a few roles as a non-speaking extra. He is also a beautiful, slightly androgynous young gigolo of sorts, pimped to clients in the hotel by the management. Lisa is a

quiet, recessive, solitary young woman completely besotted with Lance; she follows him around and leaves gifts for him, and she repeatedly checks his movies out from the video store in order to watch his little silent background appearances over and over again (he has never earned a "speaking part"). Lance is indifferent to her, bored and somewhat annoyed by her attentions. Clara is the writer of a film script in production for television screening—an autobiographical retelling of how her beloved brother donated a lung to save her life and died himself as a result. As Lisa is engulfed by her obsession with Lance, so is Clara with her dead brother: she visits the techno-mausoleum where his remains (presumably) rest and where she is able to watch—also over and over again—a home video of her brother. Because of Lance's slight physical resemblance and some other "chemical" reaction that seems to connect him to her brother, Clara shows immediate interest when he tells her he's an actor who is looking for work, and auditions him for the part of her brother in the film. In a development with obviously incestuous overtones on Clara's part, they start an affair.

Clara's video of Lance's audition meets with the approval of the coldly powerful Producer of the project (David Hemblen), who casts Lance in this role. But Clara then discovers that the Producer is taking greater and greater liberties with her story, and she employs Lance's help to restore the original script. Meanwhile, Lisa becomes fascinated not just with watching Lance's movies on video, but with making videos herself. Eddy (Tony Nardi), a worker in the video store she rents from, has taken an interest in her, and also does videos of weddings and parties. When Lisa sees the emotion he has captured in a father whose daughter has just been married, she insists on trying it herself. Her effort is a catastrophe, as she asks an air-headed bride a series of incomprehensible and upsetting questions about love and loss and provokes the groom into an angry assault. Death itself enters the scene when a guest to whom Lance has been given as a special hotel sexual service by the imperious Housekeeper (Patricia Collins) is heard crying by Lisa, and later commits suicide. It is an event that seems to have little emotional impact on Lance, still less on the Housekeeper, though Lisa is guilt-stricken because she feels she could have intervened.

From here the film produces an intermeshing set of reflective and reflexive developments that eventually arrive at a giddy *mise en abyme* and the disappearance of any possible realist basis for the phenomena that we see. Things that seem to be occurring on a tape or video feed photographed somewhere and watched somewhere turn out to be imagined by a character or to be emanations of the narration itself. This situation finally becomes so extreme that the video-events couldn't actually be happening anywhere, and we find ourselves in a phantasmagoric realm where everything we see has an unknowable status. It is difficult, consequently, to give a plot sum-

mary of the film's later scenes. Lisa's guilt over the suicide of the hotel guest seems to be the impetus that finally pushes her over the brink into video-hallucinations, just as Clara's increasingly desperate emotional appeals to Lance to save her true story of herself and her brother push *him* over. The video of her brother that Clara watches repeatedly at the mausoleum now contains Clara herself, wielding a video camera. Lisa watches a tape of Lance and the Housekeeper plotting the cover-up of the hotel guest's suicide—a tape in which Lance begins to talk directly to Lisa. The final scenes feature the shooting of Clara's script in its surreally revised form as a talk show about organ transplants, with the Producer acting the part of emcee. Here we discover that the character representing Clara is now male rather than female, and is played by Lance. The show cuts between the dying brother in the hospital and the studio, with the emcee and a studio audience that includes Lance. Clara also makes an appearance there *in propria persona*, pointing a pistol to her own head—but whether she is really there or only in Lance's imagination is impossible to say. All of this is then intercut with Lisa's anguished encounter with the video that talks to her. The denouement, now set firmly back into quiet realist territory, shows Lance finally visiting Lisa's apartment and reaching out to her. Their final embrace and kiss are the last events of the film.

Style: Replication, Abstraction, Austerity

The stylized look of *Speaking Parts* helps to realize Egoyan's wish to crystallize everything in the film, visual and narrative, into an abstract schema where meanings can be made visible in the form of geometrical patterns and relations. The basic visual set of the film is simple—simplified to the point of stylization. Much of the action takes place in the hotel where Lance and Lisa work as maids, where Clara stays, where later the Producer stays, and where the wedding reception that Lisa attempts to film takes place. The suites are elegant enough, though dominated by dark wood furniture and cream carpets and walls. But the "backstage" area, where the workers spend much of their time, is industrial and ugly, pervaded by the big distant sounds of fans and electric motors. The working areas are not especially bad, but there is a strong contrast between the aspect of the hotel that is for public consumption and the aspect whose operation enables this front to exist. This contrast both presents the artifice of a theatrical world (a living environment not really lived in by anybody), by showing the behind-the-scenes realm that produces it, and functions as a microcosm of the base/superstructure class system with its lifestyle consumption and managerial power sustained by quasi-invisible and dehumanizing labour. Both environments are inhuman—or are made to seem so by Egoyan's camera. The maids are dressed in black pantsuits that make them look uniformly

Lisa working "backstage" at the hotel. Note the black ninja uniform and the TV-like washing-machine windows. (© Ego Film Arts)

industrial, cogs in the machine of an institution, but with slightly sinister, ninja-like overtones.

This literal uniform of the hotel employees is only part of a more extensive uniform, in which the three central characters all manifest a strong degree of iconic resemblance. Even when off-duty or working in other jobs, the main characters dress consistently in black. Lisa wears black in every scene, Lance is rarely seen in any other colour, Clara has a strong propensity toward it, and Eddy the video guy is in black most of the time as well. Even more strikingly, Lisa, Lance, and Clara all have long, jet-black hair hanging from their heads in profuse curls or done up in ponytails. This hair is also to be seen on Clara's dead brother. One might point as well to the androgynous nature of this style. The long hair and dark pantsuits sported by so many of the characters, male or female, blur the division between the sexes, and this rhymes with the other barrier-breachings and confusions of opposites going on in the film (even the sex of the guest who commits suicide is left scrupulously unspecified). By contrast, the two figures of institutional power—the Housekeeper and the Producer—wear lighter hues and have lighter-toned hair.

The absence of colour in the decor is striking as well. The hotel is dark wood and cream or white; the video store is decorated in black and white tiles; Clara's cyber-crypt is made up of dazzling white walls divided into tile-like squares concealing mortal remains or video monitors playing tapes of the deceased (pretty much the same thing). It is scarcely an exaggeration

to say that there are no primary colours in the film (Egoyan's next film, *The Adjuster*, with its insistence on loud reds and blues and its many swatches of strong colour, seems almost like a deliberate reversal of this approach). The photographic style is a match to this. Cool and elegant, beautifully composed and lit, with a profusion of sensual, slow dolly-shots, it pursues these ends without any kind of overt display, and seems to echo the film's detached, scrupulously careful view of the action. The mood evoked by this style is strongly underlined by Mychael Danna's hypnotic synthesizer ostinatos on the soundtrack. We might describe these characteristics *in toto* as expressing a regime of austerity and stylization. The film engages in a paring down of the range of character and event, of locations, of the palette of tones, of the visual environment in general: a few characters, physically resembling each other, encounter one another in a restricted set of locations (mostly interior), fixated on one another in different ways but all fundamentally possessed by their own obsessive, narrowly focused concerns.

In terms of the narrative, the very means these characters employ to bring the others into their lives become the measure of their separation, isolation, and self-absorption. The abstraction of so much of the action into the realm of video images reflects and embodies the disassociation of inner and outer lives, of individuals and the world. And the echoing and paralleling and counterpointing of the events of the story add another powerful abstracting force to the mix. Even from the beginning, the film subordinates realist conventions of character exposition and story-building to an imperative of patterned relations and a kind of thematic Rubik's cube (by the end, of course, realist conventions are dissolved completely). The film is poised, as Egoyan's films so often are, between this kind of chess-piece or aerial-view detachment and the fervid, even hysterical, emotional lives of the characters, which are anything but detached. It is this vertiginous contrast between the melodrama of longing and loss and the analytical control and distance of its presentation that defines the careful, small-scale, art-cinema style of *Speaking Parts* and its companions in Egoyan's work.

Hierarchies of Power and Longing

Among the elements that tend to render things schematic or abstract are the lines of power that run through the narrative. The starkness of the film's representation of power becomes particularly visible when we meet those two almost allegorical figures, the Producer and the Housekeeper. These personages are defined only by their positions within institutions (the film industry, the hotel management), and those positions are defined only in terms of the power they confer. The Producer has power over Clara because he can make life-and-death decisions about her screenplay, and over Lance because he can make life-and-death decisions about his casting and by exten-

sion his whole career. And since for Clara and Lance these are exactly the things of most consuming and obsessive importance while for the Producer they are matters of relatively marginal interest and no emotional involvement whatever, the Producer's power begins to seem absolute. With his stone face and uninflected voice, he soon takes on an aspect of monstrous impassivity and unscrupulous control. The fact that he is present for so many of his scenes only as a video image ported in from somewhere else further emphasizes the impression of remoteness and the length of his reach. His style is patriarchal (as the Housekeeper's is matriarchal), full of expressions of concern for the members of his professional family—for example, reassuring Clara that her views are respected—but turning to steel when decisions are made and when underlings try to exert any power of their own. His apparent lack of affect is in the greatest contrast to the *need* of Clara and Lance, and his power and deafness to emotional appeal seem practically synonymous.

The Housekeeper has a smaller role, but her place in the "internal" world of the hotel is almost identical to that of the Producer in the "external" world of filmmaking. They are like the monstrous mother and father of correlative domestic and worldly realms. The Housekeeper's faintly smiling, ice-cold manner is always disturbing but becomes truly creepy when we learn that she runs a pimping service for selected hotel guests and that Lance is a star rent boy in this sleazy little world. (The fact that this is the only context in which Lance actually *is* the star he wants to be carries a nasty irony.) She dispenses advice to him on how to handle these encounters, specifically on how to exclude any emotional entanglements that might seep in: "Cool head, cool heart, *very* playful body." After the suicide of the guest—and this is the only example of the sexual-services arrangement we see in the film— the pathology of this philosophy is underlined. The Housekeeper (and Lance too) passes over the human scandal of this death with a certain amount of apprehension but with no remorse whatever (only Lisa, a mere casual witness to one moment of the process, feels that). The Producer and the Housekeeper behave in cold, instrumentalizing ways, and this style of behaviour is both the sign of their power and the means of its implementation.

The Producer and the Housekeeper represent a pole of frigid detachment and impassive power in the film. Together they stand as one end of the film's bipolar representation of power and desire, or power against desire. The opposing end is a pole of desire—a particular kind of desire that most often takes the form of an abject longing and vulnerability—and this pole is most importantly exemplified in the characters of Lisa and Clara. These two poles complement each other in perfect opposition, and this complementarity is another manifestation of the film's abstracting approach. The pole of "emotional need" is certainly the more dominant and insistent of the two in

Visual parallels: two women with black curly hair, their backs turned to us, watch video images of their unattainable male fetish objects. Top, Clara in the techno-crypt (on the screen, her dead brother). (© Ego Film Arts). Above, Lisa watching one of Lance's bad movies (on the screen, Lance an indistinguishable blob in the back of the video). (© Ego Film Arts)

terms of screen time and character grounding, and is in fact the base upon which the film is built. The very first part of the film introduces us to this world of helpless yearning in striking fashion. The opening scenes cut between Clara sitting alone in the techno-crypt, devouring the video image of her dead brother, and Lisa sitting alone in her bare apartment, feasting upon the video image of Lance as an extra in some mediocre movie. Certainly, these scenes raise questions of the power of representation and the substitution of virtuality for actuality in our culture, but just as prominent is the intensity of affect that holds these women in its grip. Both of them are consumed with a desire for something they cannot have, for something that is not there—in other words, with a powerless desire. One might imagine the warmth of this emotional commitment, this desire, to be a counterpoint to the coldness that suffuses the figures of power in the film (and also the procedures of the film itself). But when the impossibility of its fulfilment is written directly into the very expression of the desire, all warmth is dissipated, and *Speaking Parts* is a cold film at both ends, so to speak.

Lisa's desire is directed toward a phantasmagoric being, the bad-movie extra whom she has promoted to a central role in her imagination, while Clara's is for someone who is dead. As the film proceeds, the one-way nature of these desires is inscribed more and more heavily. Lisa trails Lance around the halls and back rooms of the hotel, leaving flowers for him in the clothes dryer, making him solemn gifts of the last clean towels during his rounds, while he avoids her and refuses to acknowledge her at all. (One doesn't exactly blame him: Lance may be an insensitive narcissist, but there is definitely something odd and unhealthy about Lisa's fixation on and pursuit of him.) Her abjectness, her extreme naïveté, her complete openness and vulnerability, are traits that produce both our sympathy and our recognition that she is a hopeless social casualty who will always torpedo her own project through maladroitness and an ignorance of the basic facts. When, toward the end, she can't distinguish at all between reality and fantasy, when her videos talk directly to her and a world that is objective simply disappears, it is only an extension of the condition she has always inhabited. Dressed in black, tentative in speech if not almost wordless, her face a mask of noncommunicative private feeling, Lisa seems sealed into her own impossible world. She is a figure of pathos and exclusion.

Clara's case is both different and similar. She is socially adept, poised, and articulate, and, as a woman whose screenplay has been bought and is actually in production, something of a professional success. All of this is based, however, on a foundation even more impossible than Lisa's. Clara is completely consumed by the memory of her dead brother, a person who clearly held some kind of special attraction for her when he was alive and who compounded this attraction by donating a part of his body to save her

life before dying himself. Now he literally forms the perfect unattainable object of desire. Everything in this relationship, including whatever might have been always impossible in it, such as sex, has now been definitively frozen and idealized and projected into an emotional landscape of eternal and eternally unreachable desire. Clara's strategy for living out this unreal condition is to seek its concretization in the form of moving images. She sits endlessly in the video-mausoleum consuming the home movie of him that we later learn she took herself, and she has dedicated her active life to a project of encapsulating the boundless emotions of her brother's sacrifice and her own resulting situation in a movie script.

During the continuing negotiations over the filming of this script, Clara becomes more and more distraught as it is demonstrated to her that she doesn't really have power over the production. In the end, she is entirely written out of her own life story, her place derisively taken by Lance, the actor/fetish-object she has herself chosen to represent her brother. It is a development that drives her to suicidal despair. (The issue of creative autonomy seems to be strongly present in this situation, but it is a red herring: although Clara's script is obviously a profoundly heartfelt piece of work, there is no indication that it is a particularly good one. The reverse seems more likely— the scenario really does seem like a typical maudlin movie-of-the-week, and the Producer is very possibly right to ask for changes.) Although this would be a nightmare scenario for any writer and Clara's feelings are entirely understandable, the fact remains that hers is a terribly flawed strategy for dealing with personal trauma. To invest so much in a fictional construct, to fixate so completely on a virtual recreation of irrecoverable past events, reveals a psyche that has drifted dangerously free of reality and proportion. Something similar happens in her relationship with Lance. Almost arbitrarily (he has long curly black hair, she finds him physically attractive), she casts him as her brother, both for her movie project and in a subsequent sexual relationship in which she can act out incestuous desires she may or may not have recognized or done anything about with her actual brother. As with her script project, this investment in a substitute distorts things and is not very healthy. Clara is in the world and functional in a way that Lisa is not, but at bottom the two are equally engaged in pathological behaviour.

Lance sits between Lisa and Clara—in fact, he is precisely positioned there, in accordance with the map-like nature of the scenario—a fantasy object for both of them. He has a scenario of his own that he is pursuing, but it is not fixated on anybody but himself. He is understandably unenthused about cleaning rooms at the hotel and also about being the object of Lisa's desiring gaze. But being the object of *somebody's* desiring gaze is actually his life project. He wants to be a movie star, and to be consumed as an image. And he consumes his own image eagerly. He is forever looking in the mir-

ror and studying himself; he is well supplied with 8 x 10 glossies of himself for professional purposes. When we see one posted inside his own locker, we understand that he is in love with his own image, a true Narcissus. In this respect, Lance is diametrically opposed to both Lisa and Clara. These women fixate on images of their objects of desire, and this fixation is a sign of their powerlessness. Lance—who, so to speak, *is* the image—exerts power over them by this very fact. Clara, although she also has sex with him at least once, loses no time in converting him to a video format via the screen test she gives him, and then communicates with him exclusively by teleconference video (they even continue their sexual relation in this realm, in a scene of video-conferenced masturbation). In effect, she casts him into the realm her dead brother already occupies.

At the same time, the relationship between Lance and Clara is invaded—one might even say tainted—by power of a different kind, institutional power like that possessed by the Producer and the Housekeeper. If Lance has power over Clara because he occupies the imagined position of her dead brother, then Clara has power over Lance because she can cast him in a movie—and later, Lance assumes power over her when, after he *has* been cast, Clara appeals to him to try to reinstate her original script. When the institutional power in this relationship has shifted away from Clara (whose script is taken away from her) toward Lance (who is now cast as the lead actor), Clara moves from using institutional power as a lever to service her emotional needs to using emotional power (desperate entreaties for Lance's pity) as a lever to service her *institutional* needs (the undoing of script revisions). Everywhere in the film, power and desire are conducting an extended negotiation, interpenetration, and battle.

For Lisa, Lance's presence as a real object is nothing but frustrating; he can be consumed only as a video image. But this strategy, apart from its inherent disadvantages for somebody who wants something more substantial than the virtual necrophilia Clara is pursuing, relies too much on what the subject herself must supply, and the distortions Lisa introduces into Lance's movies on tape eventually get completely out of control and turn into madness. Meanwhile, Lance has moved into a new relationship—with the Producer—and in this relationship he alone desires something, is the one without power.

The lines of power and the lines of desire, then, run in directly opposite directions. Except for the strange balance of power in the early stage of the Clara–Lance convergence, there is no relation of equals in this film until the very last scene, when a chastened Lance goes to Lisa's apartment to finally acknowledge her presence and her love (and this scene presents itself as something entirely *new* in the film, a new order of being and relationship). Every human relationship before this exists, rather, between one more

powerful and one less powerful, one more desiring and one less desiring, a suppliant and one who grants or does not grant. And the affects attached to these two polarities are equally contrasted: the less powerful exude pathos; the more powerful inspire fear. This dimension is yet another facet of the schematization operating everywhere in the story: all the characters are polarized in this way in every individual instance. Egoyan seems to see the world as a place ruled by iron binaries where neither side is truly sympathetic, where there is a pathology on both sides even if one is worse than the other. It is a cold, unfriendly world, full of sickness.

The characters in *Speaking Parts* are cut off from each other. In fact, the film's whole world seems to exist in states of individual isolation. This is true of the powerful characters, who don't need others emotionally, only practically, for exploitation; but it is also true of the suffering, traduced, and desiring characters. Even when these characters are pursuing each other, they don't connect. Clara doesn't really see Lance, she sees only her brother, the brother in her head. She doesn't see the Producer or even the film they are making, she sees only her emotional project; she cannot see past her own desire. Lisa too interprets everything, including Lance himself, from the perspective of her self-subjugating internalized image of Lance. And Lance's own narcissism has already been noted: the people he encounters become simply useful or irrelevant to his self-realization project. Everyone is trapped in his or her own desire, and these desires are self-generating, self-referential, and disconnected from the world—hence their much more functional realignment with reified, reproducible, controllable *images*.

Instruments, Substitutions, Images

In interviews, and in the director's commentary in the DVD edition of *Speaking Parts*, Egoyan has stressed the social and individual importance of technological image-representations, their substitutive and instrumentalizing character, and also the power differential between producers of these images and mere consumers of them. Certainly even a cursory glance at his films will confirm the importance of these ideas to him. All of the desiring characters in *Speaking Parts* choose an instrument with which to pursue their desires, something to mediate the terrible distance between themselves and what they want. Now technology enters the picture, specifically the technology of representation; now photographic images can stand in for what they depict. One need not regard this situation suspiciously—as, for instance, a manipulation of technology by sinister forces (of capitalism, for example) to sap our authenticity and make us more controllable. What is assuredly the case is that our culture is suffused in image-representations, and the desires of individuals may therefore be drawn in a primary way to images of persons

Lance in the world of video. The shot features Lance, a video image of Lance (foreground left), and a video image of Clara (background centre, out of focus). The film often doubles and trebles images within the shot in this fashion. Note that he wears black even when not working at the hotel. (© Ego Film Arts)

rather than to persons themselves. Moreover, we reach eagerly for the means to objectify and control our "natural" and otherwise unfulfillable desires. Such a substitution of images for persons is a pervasive condition throughout the narrative of *Speaking Parts*. Lisa's substitute for Lance is the videos of his movies. Clara's substitute for her dead brother is a home video, then a screenplay, then an actor playing her brother in that screenplay, then a video image of that actor. Obviously, Lisa is caught in the throes of image consumption, while Lance seeks to be image content, and is infatuated with his own image.

The gulf between image consumption and image production is something that Egoyan also draws attention to in his DVD commentary, and the way this gulf embodies the polarities of power and desire is both a subject of the film and something that is instinctively perceived by its characters. Lisa tries to move into the production of video images—and thus to exercise some kind of power in the image-realm that dominates her—when she begs to conduct an interview at a wedding Eddy is taping. It is a disastrous move, as her overinvestment in her own emotional situation—her inability to get away from her own viewpoint—runs the interview right off the rails and creates a small scandal. The ugly conclusion of this scene brutally demonstrates to

Lisa the politics of image-production, the way that power resides on one side of the camera only, as the outraged groom pushes the camera and its powerful light into her face and shouts, "How do *you* like it?" Clara is a producer not only by virtue of writing a movie script and bringing it to market, but in an even more primary way, through the video she has made of her actual brother, an image-representation she now worships in the crypt in a way that suggests its power over her is more focused and absolute than her living brother's might have been, because it is fixed and quantified. Clara's fetishization through image-production works out very badly for her when her script is taken away from her and transformed unrecognizably. All of the central characters' image projects—Lisa's, Clara's, and Lance's—end by immersion and dissolution in hallucinatory confusions of image and reality that torture them and force them into some kind of ultimate crisis of subjectivity. Though it may provide a functioning modus operandi for a while, this mixture of images and reality—the emotional investment in images— turns out to be drastically unworkable for all of them. Everybody's instruments are wrong; everybody's substitutions are bad.

The Producer, seemingly empowered precisely by his *lack* of emotional investment, manipulates image production with a sovereign hand, and therefore also manipulates the consumers of those images and *their* emotional investments. He seems to rule his kingdom through the medium of the video relay, dominated by his presence as a self-produced self-image. In these many appearances, he clearly commands the means of representation in a way that mocks not only Lisa's fumbling efforts, but also Clara's attempts to enter the realm via autobiographical fiction. Clara's emotional investment in her project gets swept away in the Producer's purely impersonal rewriting of the project, while Lisa finally finds herself inside one of her own videos and unable to get out and Lance, at last the star of the show, finds in this environment not the realization of his narcissistic fantasies but a rack of pain wherein Clara's desperate appeals for compassion and committed action are rendered inescapable by the threat of suicide.

The moral of all this appears to be the following: the mixture—the conflation—of desire and images damages individuals, and attempting to use images in this emotional way is distorting and dangerous. Since the Producer's unemotional use of images is also chilling, it would seem that images themselves are simply bad, or at least are bad in the hands of those who seek them out and try to command them. This is a strange position for Egoyan, a filmmaker by trade, to be taking, but its logic seems clear enough in *Speaking Parts*. It is also a logic that seems to reappear in many of Egoyan's other films. For example, in *Family Viewing*, the David Hemblen character's home videos represent a horrifying inscription of the persecutory techno-patriarchal values he represents, overwriting and erasing the

more innocent-seeming videotaped traces of an earlier time (these preserve a kind of authentic, auratic record of ethnicity, family, and femaleness, even though they too were wielded by the instrumentalizing patriarch). In *The Adjuster*, the Maury Chaykin character is a filmmaker whose film project is a crazed paraphrase of his own neurosis that ends in murder and suicide. The insurance adjuster himself (Elias Koteas) seizes eagerly upon the photographs of clients as tools for converting their losses into cash settlements. These photographs foreground a human content that is then—perversely, from a human standpoint—ignored by the adjuster, who instead picks out background objects in his search for something stable and quantifiable. In the most explicit of all Egoyan's statements on this question, *Calendar*'s protagonist (played by Egoyan himself) carries the adjuster's misaligned gaze to ludicrous, pathetic, and finally almost comical extremes as he constantly pushes his camera into the place where an actual human relationship with his wife and an authentic ethnic history ought to be, and fixates on the coldly instrumentalizing nature of his film project even as he fails to notice that it is recording his wife's attraction to another man and the corollary crumbling of his marriage. In this context, contrapuntal commentary of *Speaking Parts* on the unhealthy uses of the video image is right at home.

Reflexivity

Egoyan's cinema is reflexive and self-analyzing. Films like *Family Viewing*, *Speaking Parts*, and *Calendar* are commentaries on, among other things, Egoyan's own manipulative, technologically fixated, detached, and reifying practices as a filmmaker. Technological image-production is centred upon the repetition, seriality, variation, and juxtaposition that are inherent both in the camera's activities and in the post-production stages of image-work creation and reception. These are both the most characteristic procedures of Egoyan's cinema and, taken together, one of its most characteristic subjects. *Speaking Parts* is typical Egoyan on the formal level because of its abstraction and symbolization, its highly structured positioning and patterning of characters and events, its contrapuntal repetitions, variations, inversions, and juxtapositions; and it is typical Egoyan on the thematic level in its foregrounding and problematizing of the whole activity of image production and manipulation, and of abstracting images from their pro-filmic realities and contexts for fetishistic use for other purposes. This reflexivity is not simply of the usual kind—a self-conscious realization of the constructedness of the whole narrative-making project and of the absurdity of ever regarding it as natural or self-sufficient. The melancholy of Egoyan's films comes partly from their sense of the hollowness not just of the characters' substitutions and fetishizations, but potentially of the films themselves. At some

moments—or, rather, at all moments, from one angle—*Speaking Parts* is cold in the same way as the Producer and the Housekeeper are: cold in its expression of control, cold in its representation and abstraction. True, the film both sympathizes with the suffering of its characters and anatomizes its own pathology, but the chilling perspective is never quite extinguished.

Speaking Parts is, especially toward the conclusion, also a quite dramatic example of pure formal reflexivity. The activity of filmmaking (video-making, actually) is staged and thematized throughout, with practically all of the characters (Clara, Lisa, Lance, the Producer, Eddy) either making or appearing in videos at one point or another. In addition to the way this activity always calls attention to *Speaking Parts* itself as a construct, baring the device, it also affords extra opportunities for commenting on the motives of filmmakers and especially on the conflicting creative criteria of emotional commitment and commercial viability. Both Lisa and Clara are emotionally overinvested in their filmmaking, and as a composite portrait of artistic integrity in a market situation they do not present a flattering picture of a film-making that is trying to balance personal commitment and commerce. Clara's personal project is likely to be a rather bad movie if made in its original form, while Lisa's wedding video drives the bride to tears and the groom to violence—and both filmmakers are left in a state of defeat and humiliation. On the other hand, we have the cynical, commercially driven detachment of both the Producer and Eddy. Eddy explains to Lisa that the profound emotions displayed by the father of the bride of an earlier wedding video—emotions that are fascinating to her and that spur her own desire to become a film-maker—are the result of "knowing which buttons to push" in his subjects, a mechanical manipulation that a filmmaker can acquire as straightforwardly as knowledge of the basics of camera and editing. (The alignment here of females with uncontrollable emotional involvement and males with instrumental detachment recalls notions, familiar from different areas of cinematic gender theory, of the overinvolvement of female viewers on the one hand and the patriarchal mastery of the male gaze on the other.) In any case, the gap between, for example, the almost deranged commitment of Clara to the "brother's lung" movie and the Producer's total detachment and power ("I'm shooting three of these suckers right now," he remarks to Lance) is pretty depressing as a picture of the art and business of filmmaking.

The Disappearing Diegesis

Speaking Parts takes reflexivity to extremes rarely seen even in the arena of reflexive filmmaking. Its most radical activity is a toying with the basic mechanisms of diegetic versus non-diegetic planes of filmic enunciation and reception, a systematic confusion of the viewer as to what is happening on the plane of the action and what is happening on the plane of the film's

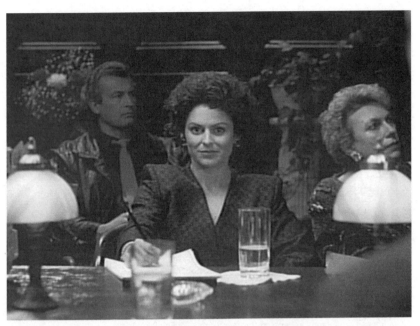

Baring the device: Clara looks directly at us while all others watch the Producer holding a video conference. Note the curly black hair and black costume. (© Ego Film Arts)

own narration. Early in the film, there are a couple of occasions in which soundtrack music starts out apparently diegetic, as source music, only to persist beyond the apparent source and into the next scene, thus becoming non-diegetic. In Lance's audition scene with Clara, the scene's own tracking shot comes to rest in exactly the point-of-view position of the video camera that is recording his audition; then Clara points her remote control directly at *us* to command the camera. At another point, during the Producer's video-script conference, Clara looks directly at the camera—that is, at us—while everyone else is looking at the Producer's image. During Lance's video-conference interview with the Producer, we watch the video image as the Producer tells his cameraman to adjust the framing. But later the scene shows a *different* framing of the Producer, one that seems outside the parameters of the shot whose exact nature has been called attention to at the beginning of the scene but that, since it remains in "video" form even after its change of frame, seems not to be part of the film's own omniscient narration either. Clara's "brother video," viewed so repetitively and identically by her in the crypt, eventually develops an extension in which Clara herself appears in the video, actually carrying a video camera, with which she shoots her brother. Who then is shooting the original brother-video? What seems to have happened is that the video has shifted from being a concrete object,

Clara impossibly appears in her own "brother-video." (© Ego Film Arts)

taken by Clara of her brother at a certain point in historical time and viewed by her objectively in the memorial crypt, to being purely an event in Clara's mind—one that she herself, and her camera, can now appear in, though still suggesting an impossible objective status because of its presence in "video" visual format, with scan lines, washed-out colour, and poor definition.

Or is it an event in the film's mind, instead of (or in addition to) Clara's? *Speaking Parts*, like most films that feature video footage at certain points, seems to reserve video for "sourced" occasions (transcriptions of video signals fed or taped in a concrete time and place, and viewed in a similar fashion) while its own omniscient narration occurs in the film format. But as the narrative progresses, this dichotomy begins to break down, and by the end of the film it has disappeared completely. What happens to Clara's brother-video is one example of this breakdown. An even more extensive and extreme one is provided by the video that Lisa is watching near the end of the film. At first it looks like the record of a security camera, showing an interview between Lance and the Housekeeper in which they conspire to cover up the suicide of the guest. How Lisa might have gotten hold of such a video is not even faintly addressed, but that question evaporates quite soon, as Lance begins to address the camera (that is, Lisa) directly, and to be able to hear her replies. Clearly this is not really happening; clearly it, like Clara's extended brother-video that also contains her, is a hallucination, a mental

event. Then the rewritten "brother's lung" movie, in the Producer's revision, which has not only replaced the sister with a brother but has also sprouted its own grotesque reflexive mechanism in the form of the TV talk show where the whole drama of organ donation and the brother's actual operation are being debated, begins to become more and more phantasmagoric, a hallucination of Lance's, of Clara's—ultimately of the movie's. All this builds up to a big climax as the movie cuts in grand, extended counterpoint between Clara's extended brother-video, Lisa's crazy security video that talks to her, and the set of the movie/TV talk show where Lance is appearing as Clara's character, everything on a plane—a series of planes—whose narrative ontological status is completely destabilized. Now what is part of the story and what is part of Egoyan's narration is impossible to know. The reality-versus-representation confusion that overcomes the central characters at last overcomes *Speaking Parts* as well. This is quite radical filmmaking practice for a movie that is always basically a story-film.

Morals and Conclusions

The film's coda, in which, after the unknowable but obviously very disturbing events of the talk show/movie, Lance creeps back to Lisa's apartment and sits meekly waiting for her, almost takes the form of a moral. Lance's narcissistic trajectory—his avoidance of the real Lisa and his pursuit of success as a movie star—is didactically reversed, as he now seeks something humble, something direct and physical—a hug, a caress—from a real person, to rescue him from the hell of ethical and psychological disorientation caused by irresponsible pursuit of the image. Somehow he has come to stand for all three of the central characters in this regard. He comes cap in hand to the woman whose desire he had so callously fled. He has learned his lesson: reality is good; virtuality is bad. And by its placement at the very end of the film, especially following the virtuoso psychic collapse of the central characters and of the movie itself, it seems to be the film's moral, too. My own feeling is that it is not really an adequate resolution of the issues raised by the film, that there is something rather pat and even sentimental about this reversion to a wholesome actuality that must replace all the whoring after images. But one sees Egoyan's difficulty. He wants to exit from the phantasmagoria; he wants to escape from technology; he wants to assert the primacy of a still-conceivable reality. And he is drawn, ethically and philosophically, to a denunciation of his own (filmmaker's) instrumentality and complicity with image-fascination and to a privileging instead of some eclipsed authenticity that he associates, often, with a certain kind of female principle and female personage. (It is a personage usually occupied in Egoyan's cinema, as it is here, by Arsinée Khanjian, and it also has family and ethnic-historical overtones. *Calendar* is again the clearest version of

this configuration, though it is also seen in *Family Viewing* and *The Adjuster*.) Really, however, there is no exit from the condition outlined so extensively in *Speaking Parts*—or at least not one that can be compressed into such a brief space. Rather than expressing the culmination of his extended critique of the social and individual effects of a culture of images, the film's coda functions as a deus ex machina, basically offering a way of getting out of the story.

Whatever dissatisfaction might attach to this ending, though, *Speaking Parts* remains a compelling examination of the issues it raises and a highly original and aesthetically successful little art film. It is what one might call a *Kammerfilm*, with a small group of characters and an obsessively narrowed focus, but it is also contrapuntally spread out and creates a unique impression of being both confessional and detached. Its investigation of image-mediation in contemporary Western culture and of the interplay between technology and psychology within individuals offers a penetrating, provocative interpretation of phenomena that all viewers can recognize. As a substantial episode in an ongoing filmic examination of this subject, *Speaking Parts* helps to construct an idiosyncratic world view we can recognize as belonging entirely to Egoyan.

▶▶ 13

Look but Don't Touch
Visual and Tactile Desire in *Exotica*, *The Sweet Hereafter*, and *Felicia's Journey*

Patricia Gruben

A hallmark of Atom Egoyan's work is the mediation of desire through technologies of representation. The longing of a young man to remember his childhood by replaying home movies, the obsession of a hotel chambermaid with a co-worker's film roles, the framing of a photographer's viewfinder to reveal the growing intimacy between his wife and their guide—all exemplify Egoyan's characteristic use of video and other media to portray the anguish of separation. The hunger of these characters may be for family ties, as in *Family Viewing;* for romantic love, as in *Speaking Parts;* or for the recuperation of an ancient culture, as in *Calendar*. Three Egoyan films from the 1990s—*Exotica* (1994), *The Sweet Hereafter* (1997), and *Felicia's Journey* (1999)—are driven by the longing of adults to penetrate the veil of childhood and return to a state of remembered or imagined innocence. In each film, an adult, tortured by the pain of a life isolated from human contact, reaches out to a child or child-substitute for emotional intimacy. In each case, however, the longing is unfulfilled because the child is a surrogate for an earlier, more primal relationship that has ended in estrangement or death. Connected to this death, sometimes even the cause of it, the adult is psychically paralyzed, unable to atone or grieve and move on. In *Exotica*, the bereaved father of a murdered young girl compulsively revisits the simulacrum of her innocence by obsessively watching an exotic dancer whose

plaid-skirted costume recalls the dead child's school uniform. In *The Sweet Hereafter*, an incestuous father and his crusading lawyer both exploit the teenaged survivor of a horrific school bus accident. In *Felicia's Journey*, a serial killer, himself abused as a child, preys on the young women from whom he seeks love; he is finally overcome by the inviolability of his last intended victim. In all three films, the adult's craving for a deep connection with a child stems from nostalgia or desire for an idealized happy family. Yet when adults use children for their own narcissistic fulfilment, they threaten the very innocence they are seeking. Trapped in their own emotional paralysis, they re-enact compulsions that reinforce their own isolation. All three films are fraught with incestuous desire—direct or metaphoric, imagined or realized. Even in rare cases when the craving is consummated, as between Nicole and her father, Sam, in *The Sweet Hereafter*, true intimacy is unattainable.

In this chapter I consider Egoyan's use of screens and other barriers as metaphors for his characters' isolation from the innocence of childhood. In the films' mix of nostalgia and eroticism, I identify a dialectic between what we might call *seeing-to-control* versus *seeing-to-touch*—a dialectic that parallels Laura Mulvey's identification of voyeurism and fetishistic scopophilia as the two contradictory formative structures of cinematic looking ([1975] 1988). I will relate these relationships to what Laura Marks calls "haptic visuality"—the tactile imagery that, as Marks (2000) notes, is prominent in the work of many non-Western film and video artists. Finally, I examine the impact of these two kinds of looking on the narrative structure of these three films. The exaggerated spectacle of Egoyan's objects of desire can fracture the flow of the narrative, not just for a moment, but as a reverberation throughout the film. These images not only punctuate the story structure—they ultimately subvert it.

Screens

In *Exotica*, Francis Brown (Bruce Greenwood), whose wife and daughter have both died tragically, replays a video fragment over and over in his head. Mother and child laugh together as the hand-held camera watches from outside their pleasure. Suddenly the mother acknowledges the intrusion, protecting the daughter from the camera's gaze with an upraised hand. This fragment is in some ways typical of Egoyan's use of home video in earlier work, to portray a survivor's mourning for a lost loved one. The video functions as a flashback from Francis's point of view, his unseen presence behind the camera signified by its hand-held subjectivity. Thus the image is doubly articulated: as both a metaphor for the separation of Francis from the object of his gaze and as a distanciating device for the film's audience. This shot is further coded by the spectre of incestuous longing that runs through the film. Lisa has been murdered; the killer has never been caught; Francis him-

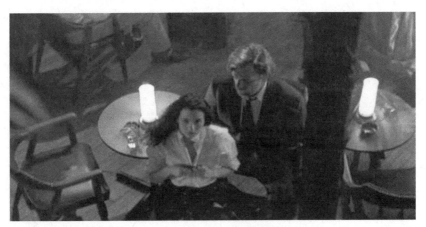

Exotica: Christina gazes knowingly into the camera. (© Ego Film Arts)

self was suspected in her death. The incest taboo here is made visible as a literal screen protecting the intimacy of the mother–daughter bond from the father's invasive desire. Francis, we learn later, is not guilty of the murder of his daughter; nor is he, apparently, an abuser. Here, however, Egoyan has proposed the question of what is allowed, and it is this question that gives the film its dark energy. The video screen is also a safety net that keeps Francis's attachment to Lisa unconsummated. Preserved in this way, she can never again be hurt by anyone.

Further, and more perversely, Francis re-enacts this attachment through a ritual in suspended animation. Every night he picks up his teenaged niece and takes her to his empty house as if to babysit while he visits the strip club Exotica. Here he pays another young woman, Christina (Mia Kirshner), to dance at his table in her schoolgirl's uniform, identical to the one that Lisa wore. Years earlier, Christina was Lisa's actual babysitter, and was in the search party that found her body. Now she writhes at Francis's private table, where physical contact is forbidden. The visible screen of the video image separating the dead Lisa from Francis's touch has its corollary in the invisible screen around the live body of Christina.

Like *Exotica*, The *Sweet Hereafter* is filled with material or metaphoric screens preventing the desiring subject from touching the object of desire. These screens leave the victims of a school bus accident inaccessible to those who have survived them. In the moments leading up to the crash, we see an extended sequence of two children in the back of the bus, waving at their father, Billy Ansel (Bruce Greenwood), as he drives behind them in a light-hearted daily ritual. Children and father see each other framed through a double screen: the rear window of the bus and the truck's windshield. It is through this frame that Billy watches the bus plunge off an embankment,

The Sweet Hereafter: The window of the school bus frames Billy Ansel's children, his last image of them before the bus crashes. (© Ego Film Arts)

skate out onto thin ice, and sink into a quarry pond, drowning everyone but Nicole (Sarah Polley) and Dolores (Gabrielle Rose), the bus driver. Afterward, Dolores and the surviving parents live in a fog, surrounded by yet more screens: photos and mementos that are constant reminders of children who have passed over to the other side.

In translating Russell Banks's novel into cinema, Egoyan suggests a metaphoric screen with Browning's poem *The Pied Piper of Hamelin*. In the novel, Banks's characters philosophize about the ways in which our children become lost to us; Egoyan used the Pied Piper to make the same point with a more narrative device. Nicole reads the poem to Billy's children on the night before the accident and recites it in voice-over at strategic points throughout the film. This is most poignant in a flashback to the night before the crash. Much earlier in the film (but just before this chronologically), we have seen Nicole trying on Billy's dead wife Lydia's clothes. Billy has offered her the clothes, saying that Lydia has "outgrown them." When Nicole questions this turn of phrase, Billy is embarrassed. We have already heard one bereaved mother worry that Nicole caused the accident by wearing Lydia's clothes. Trying on these garments symbolically transports her toward the world of the dead. Nicole stands in the upstairs hall of Billy's house, dazzled by the headlights of Billy's approaching car as they shine through the window. Though it is the night before the accident, it is the moment of her discovery of that world.

Felicia's Journey contains similar screen imagery, using video as in *Exotica* and Egoyan's earlier films to depict the alienation of its characters. Like *The Sweet Hereafter*, it is adapted from a book whose themes connect with Egoyan's leitmotifs of thwarted and perverse desire. Unlike the ensemble structure of much of Egoyan's his work, *Felicia's Journey* has only two major

Felicia's Journey: A picture window thwarts Felicia's urgency to communicate with Johnny's mother. (© Icon Productions)

characters: Joseph Hilditch (Bob Hoskins), a catering manager and serial killer, and Felicia (Elaine Cassidy), an innocent Irish Catholic searching for the lover who has left her pregnant. In adapting William Trevor's novel, Egoyan added his trademark video images, displaced memories, and dreams. Many of Hilditch's memories are attached to his dead mother Gala's TV cooking show, in which he appears as a plump, humiliated child. He watches old kinescopes of the show through opera glasses, following Gala's instructions to create elaborate party meals, which he eats alone. These video-memories are mixed with more recent surveillance tapes of young women he has befriended and then recorded on a camera hidden in his car.

In these three films, the screen creates a tension between looking and action that is played out in complex formations. While the screen acts as a barrier to emotional connection, at the same time it is a shield protecting these stunted characters from intimacy and thus from the full impact of their pain. Francis Brown, Joseph Hilditch, and Mitchell Stephens, the lawyer in *The Sweet Hereafter*, are watchers like us, vicariously engaging in a ritual of desire from a protective distance. Egoyan's screen metaphors are self-reflexive; as we watch characters watching other characters on video, in photographs, and through windows, we are caught up in their desire and at the same time forced to acknowledge our own complex relationship to the screen.

Seeing-to-Touch versus Seeing-to-Control

In her essay "Visual Pleasure and Narrative Cinema," Laura Mulvey distinguishes between two modes of film spectatorship: voyeurism and fetishistic scopophilia. Following Freud, Mulvey argues that voyeurism results from the desire of children to see and thus control the forbidden world of sexu-

ality. As voyeurs, we take pleasure in the illusion of control over the events onscreen, assigning guilt and punishment or forgiveness to the cinematic characters (Mulvey [1975] 1988, 56). For Mulvey, voyeuristic scopophilia derives from pleasure in obtaining sexual stimulation through sight, and the voyeur's pleasure derives from keeping himself separate from the object on screen (64). Christian Metz notes that to bridge the gap between voyeur and object would overwhelm the voyeur, leading to loss of control. Thus the object of our view is threatening to us; for us to maintain control as spectators, the object must never be able to look back at us (Metz 1977, 60). But pleasure in looking is not only about what I shall call *seeing-to-control*, which is based on separation from and dominance over the object of the gaze. The viewer also takes pleasure in *seeing-to-touch*, which develops through narcissistic identification with the object of desire. As children recognize their distinction from objects associated earlier with their own bodies (the maternal breast, a beloved blanket), they feel a symbolic castration; the resulting anxiety impels them to reconnect with these or similar objects through scopophilic fetishization. Mulvey argues that the film viewer substitutes a fetish object for the self in the mirror or turns the character onscreen into a fetish, making the object reassuring rather than threatening. Fetishizing endows the object with beauty, transforming it into something desirable in itself. Watching a film, the viewer constantly oscillates between voyeurism and fetishistic scopophilia. In Egoyan's films, the dialectic between these two modes of spectatorship is explicitly brought to our attention. As in the classic voyeuristic model, a character with nominal authority spies on the private or pseudo-private life of another in order to gain control. In *Exotica*, for example, Eric (Elias Koteas), the host of the strip club, watches customers through a two-way mirror while they in turn ogle the dancers; a customs officer peers through another two-way mirror at disembarking passengers; Francis searches the papers of a pet shop owner, looking for tax evasion. In *Felicia's Journey*, Hilditch stalks Felicia in his car, using his side mirror to spy on her.

The voyeur's sadistic illusion of control quickly disintegrates in Egoyan's films, however. Egoyan's characters are rarely able to exert their authority as unobserved observers. Instead they fetishize the object of desire from the need to complete the self through an emotional connection with another person, even a dead one. They identify not with the narrative but with the spectacle, as the facade of control gives way to reveal a compulsion for attachment. Their initial attempt to play the role of voyeur, hiding behind uniforms and two-way mirrors, makes exposure all the more unbearable. In *Exotica*, both the video clip of Lisa with her mother and the spectacle of Christina performing exemplify the tension between controlling voyeur and obsessive fan. This is obvious in the way that Eric watches Christina as she dances. He

Exotica: A body-shaped two-way mirror intensifies Eric's voyeurism. (© Ego Film Arts)

Felicia's Journey: Hilditch's side mirror frames a distorted view of his prey. (© Icon Productions)

introduces her with a beguiling voice-over extolling her attractions, seeming to speak personally to Francis though his amplified voice reverberates through the club. He lures Francis into touching Christina, then ejects him for violating the rules of the club. Yet, as he spies on others and manipulates their obsessions, Eric himself is clearly obsessed with Christina—or at least with his image of her and his idealization of their long-ago love, when she was a naïve schoolgirl "for real." As Christina dances before Francis, he is on display as much as she is, his need and longing, obvious to all and to Eric watching *him*, is equally revealed. The object of their desire violates the screen by looking back, which, as Metz notes, is frightening to the viewer.

In *The Sweet Hereafter*, Mitchell Stephens (Ian Holm) likewise attempts to maintain voyeuristic control but succumbs to fetishistic scopophilia.

Stephens has come to the town of Sam Dent to enlist the parents of the dead children in a class-action lawsuit against the bus manufacturer. As a clever, manipulative lawyer, he investigates the private lives of his potential clients, looking for model citizens whose cases will be strongest and coaching them on how to present themselves at the inquest. He gazes at photos and souvenirs of the dead children, evaluating their potential to evoke sympathy. He sneaks into the cordoned-off school bus with his video camera, looking for evidence to bolster his case. It soon becomes clear, though, that his underlying motive is not greed so much as displaced revenge: an attack on the unknown, evil forces that have turned his own daughter, Zoe (Caerthan Banks), into a drug addict. When Billy Ansel asks why he brings up Zoe while they're discussing the accident, Stephens answers, "Why am I telling you this, Mr. Ansel? Because we've all lost our children. They're dead to us. They're killing each other in the streets. They wander comatose in shopping malls. Something terrible has happened. It's taken our children away. It's too late. They're gone."

As Egoyan has acknowledged, Stephens himself is a sort of Pied Piper blindly propelling the townspeople into mass hysteria through the misguided lawsuit (Egoyan 1997a, 13). At the same time, Stephens was left behind when his own daughter entered another world. Although in his role as lawyer Stephens acts as a controlling voyeur, he is consumed by fetishes from his own remembered and idealized past. When he meets Zoe's childhood friend Alison on a plane, he describes a long-ago paradise in which Zoe was a child and the family was together, suggested in one of the most beautiful and compelling images in the film: a close shot of an archetypal young family drowsing in the morning sun. This image of contentment is undercut, however, by Mychael Danna's soundtrack in Rennaissance style, its flute suggesting the Piper poised to lure the child away. The film begins with this image and returns to it later as Stephens launches into the story of how his daughter's life in this paradise was corrupted by a nest of baby spiders. He recounts how, as they drove at top speed from their rural cottage to the hospital, he was painfully aware that Zoe's throat might swell shut, forcing him to perform a tracheotomy. Here, a close-up of the wary child's face with the penknife inches from her throat presents another image of both innocence and death. The child's tender flesh is a fragile barrier to the father's penetration, the moment of anticipation unnaturally prolonged. Although anchored by narration, this image transcends the specifics of that family, that crisis, in the sense that it contains no narrative details (other than the knife itself) that would tie it explicitly to Stephens's story.

In *Exotica*, the male figure struggling for control of his own desires is doubled into two characters, Francis and Eric, both fixated on the faux schoolgirl Christina. In *The Sweet Hereafter*, three men are in conflict over the faux

virgin Nicole. Her father, Sam (Tom McManus), uses her first as an object of romanticized sexual exploitation, later as a means to gain money from the lawsuit. Stephens sees her as a means to recover from the loss of his own daughter by punishing the faceless bastards responsible for hurting children. Both men see her as a "wheelchair girl"—a fetish no longer of erotic desire but of their own mourning. Billy Ansel, however, does not objectify or exploit Nicole; he appeals to her moral instinct, enlisting her as an ally to liberate the town from its grief by dropping the misguided lawsuit.

Like the lame boy left behind by the Pied Piper, Nicole is caught between the timeless innocence of the children who have died and passed into the "sweet hereafter" and the corruption, cynicism, and grief of the adults who have survived them. She seems confined, like Sleeping Beauty, Snow White, or Rapunzel, in the paralysis of the child before adolescence and the discovery of sexuality. But in fact it is her entrapment in premature sexuality, disguised as intimacy, that has put Nicole to sleep. Like Christina in *Exotica*, Nicole has been touched and defiled. She now lives in a protective bubble, unable to go backward into innocence or forward into adulthood. Like Stephens's drug-addicted, HIV-positive daughter, she lives in limbo between the worlds of the living and the dead.

Nicole's motive for sabotaging the lawsuit is not only to free herself from Sam's manipulation, but also to liberate the town from its hysteria. At that point, near the end of the film, Egoyan assigns her a final verse in the same iambic pentameter as Browning's poem, over a brief close-up of Sam's lips:

> And why I lied he only knew
> But from my lie this did come true
> Those lips from which he drew his tune
> Were frozen as the winter moon.

This disturbing, disruptive shot of Sam's lips creates a disjunction between what we see and what we hear—another screen of sorts. Between Nicole's voice-over and her father's silent lips there is no synchronicity. Instead, a new connection is made, articulating the link between Nicole's decision to ruin the lawsuit and her liberation from her father's oppression. She has seized the voice, effectively castrating her molester. This final action frees her to move forward.

As Kaja Silverman argues (following Lacan), the mastery of language removes us from undifferentiated experience of the world and thus creates a lack: "The entry into language is the juncture at which the object is definitively and irretrievably lost, and the subject is definitively and almost as irretrievably found.... Not one of those elements [in the field of signification]... is capable of reaching beyond itself to re-establish contact with the real. The

door thus closes as finally upon the subject's being as upon the object" (1988, 8). For Silverman, the lack is represented inevitably in cinema, particularly through its depiction of objects and characters that are clearly untouchable, unattainable—just as, for Nicole, resisting a symbolic order that has silenced her irrevocably ruptures her intimacy with her father. Silverman continues: "Cinema thus revives the primordial desire for the object only to disappoint that desire, and to reactivate the original trauma of its disappearance. Since the loss of the object always entails a loss of what was once part of the subject, it is—in the strictest sense of the word—a castration" (9). Thus the "castration" of the subject through loss of attachment to the world beyond itself is reproduced in the viewer's recognition that the objects on the screen are not real, only photographic reproductions. The attempt to recuperate these images leads us once again to fetishism. Egoyan's self-conscious choice to photograph Sam's lips in extreme close-up forces us to recognize them as yet another screen. Yet here the disembodied lips become a negative fetish, representing not an object of desire, but an icon of linguistic control that Nicole has seized from her father.

Felicia's Journey further develops the tension between seeing-to-control and seeing-to-touch. Hilditch's memories in particular operate as fetishes that shift the gaze once again from voyeurism to fetishizing scopophilia (as we shall see, Felicia's memories function in another way). As noted earlier, Egoyan gives Hilditch two primary video screens to represent his memories. The first is a series of videos of his mother's cooking show; the second is a set of tapes from a hidden camera that has recorded his encounters with the young women he is about to murder.

Carrie Zlotnick-Woldenberg, a psychoanalyst, examines Hilditch's psychopathology in relation to his mother. She cites a cooking-show episode in which Gala (Arsinée Khanjian) playfully stuffs raw liver into Joey's mouth, describing her force-feeding as a perversion of the archetypal nurturing role. Watching this episode again forty years later, Hilditch chokes at his own supper table just as he choked as a boy. Zlotnick-Woldenberg argues that Hilditch, prevented from differentiating properly from his mother, reacts by "splitting" into a schizoid state, pitting the good mother of his ideal against the bad, rejecting mother; this splitting forces him into a "constant creation and recreation of reality" (2001, 43). Hilditch sees Felicia not only as an innocent child, but also as a mother figure. Her very supposed goodness as an "incipient" mother inspires his pathological rage; he is driven to eliminate the good mother before she becomes the bad mother by rejecting him.

In her book *The Skin of the Film: Intercultural Film, Embodiment and the Senses*, Laura Marks comments on the power of cinematic images to evoke a sense of time past that spreads beyond individual memories. According to Marks, cinema creates an aura around the image by recording it as an

artifact, transforming it into a fetish in its apparently disturbing ability to re-create its object in the present. She relates this charge to Deleuze's concept of time as always splitting into two parts: "the time that moves smoothly forward, or the 'present that passes,' and the time that is seized and represented (if only mentally), or the 'past that is preserved'" (2000, 40). For Deleuze, following Bergson, the present that passes corresponds to the actual image; the past that is preserved creates a virtual image. Thus, in any remembered moment, the image splits into two disjunctive representations. Marks notes that for Bergson and Deleuze, *image* refers not only to the visual but to the complex of all sensory perceptions: "An example may be found in home videos of family gatherings. At the moment that the video is shot, the two aspects of time look the same; but the present-that-passes can never be recalled (I feel ill; I am angry at my mother), while the past-that-is-preserved (we were gathered around the table, smiling) becomes the institutionalized representation of the moment. Virtual images tend to compete with recollection-images—the memory I have of the gathering that is not captured in the video—and, as we know, their power is such that they often come to stand in for our memories" (Marks 2000, 40).

As in Deleuze's "past-that-is-preserved," Hilditch's memories of his mother are packaged for consumption in her TV cooking show, her kissing and squeezing of young Joey a mere theatrical performance. As he watches the scenes of his mother's emotional abuse, Hilditch seems to be re-enacting a perverse nostalgia for her false, manipulative simulacrum of mother-love. Even after her death, he continues to follow her TV instructions as he cooks a meal. He objectifies the young women he befriends by videotaping them; he replays the moment of trauma, the moment each attempts to withdraw from him, thus unleashing his unseen, murderous, schizoid rage. Whether he literally plays the tapes back or only relives them in his head is ambiguous and ultimately irrelevant; his traumatic memories intrude on his carefully constructed routine world, and he seems to have packed away these experiences, not fully conscious of what he has done. He remembers only the safe aspects of his meetings with these young women, until the video-memories rupture, exposing the moment of trauma.

Once again, what started out as sadistic voyeurism is transformed into pathos through fetishized images of unrequited desire. Hilditch's assumption of a fatherly role toward Felicia makes his plotting of murder both more insidious and more tragic. There is clearly a need to control in his videotaping of his victims, his emotional manipulation of Felicia through his self-serving lies and fantasies, and of course in the murders themselves. But Hilditch's need for love from these young women and from his mother is never far from the surface. As in the other two films, the urge to control through watching gives way to the fetish. For Hilditch, because the videos

of his mother remain fetishized, and he cannot balance them with a fantasy of dominance over her, his need for control erupts from the protective confines of voyeurism into the ultimate dominance of murder. Hilditch is the first of Egoyan's characters to penetrate the screen with actual homicide. The fracture of his carefully tended oppositions leads to disintegration and finally self-destruction.

Haptic Visuality

In *Exotica*, *The Sweet Hereafter*, and *Felicia's Journey*, we recognize the impulse to touch another human more often because of the thwarting of that touch than because of its realization. As we watch, the perverse desire of these characters draws our attention not only to the visual but also to the sense of touch, precisely because that is what is denied.

Egoyan's iconography of screens extends beyond video, windows, and two-way mirrors to the human body itself, as we see in *Exotica*. A brief example of the corporeal screen is contained in a flashback of a younger Eric and Christina as they join a search party looking for Lisa's body. When Eric finally discovers it, he covers Christina's innocent eyes with his hand in a classic gesture of protection. Two more complex corporeal screens are icons with signification beyond their attachment to specific characters in the film. The first is Christina's school uniform—plaid skirt, white shirt, and tie. This uniform explicitly connects her with Lisa, who wears an identical outfit in every photo and flashback. Paul Coates identifies the uniform as a classic fetish object, which Egoyan compares to the use of video in his other films: "In order to preserve the memory of someone, you go to this artificial means, which is not a video or a photographic reproduction, it is a theatrical one" (Coates 1997, 25). Christina's uniform, a conventional erotic fetish, becomes a displaced signifier that Coates says "renders [Egoyan's] habitual self-reflexivity implicit" (1997, 29).

Another universal icon is Zoe's pregnant body. Egoyan called this one of the most personally disturbing images he has created, because of his willingness to objectify his own pregnant wife (Arsineé Khanjian, playing Zoe) and unborn child (Coates 1997, 30). The maternal image, from prehistory to the present, signifies the eternal family, the continuity of life. Yet here, Zoe's pregnancy is detached from family and history. She has made a contract with Eric that he will provide her with a baby for reasons that are unarticulated—presumably to assuage her loneliness. This is suggested in her repeated invitation to others to touch her swollen belly. Eric touches it in a brief moment of intimacy but ultimately spurns her, saying, "I gotta watch my feelings. That's why we have a contract, isn't it?" Zoe seems to be using her pregnancy to try to insinuate herself between Eric and Christina. Christina rubs her belly like a good-luck charm, but without conviction, like her dis-

passionate acceptance of Zoe's kiss; this is the only time that touching Christina is permitted in the film.

We need only remember our gut reaction to any horror, action, or pornographic film to recognize that the desire for (or threat of) touch evoked through visual images can cause a visceral response in the spectator. In a subtler way, Egoyan's iconography of corporeal screens—the "schoolgirl's" nubile, uniformed, untouchable body; Zoe's pregnancy; the eyes covered by the hand—take us to the limits of phenomenal visuality. Adult characters in Egoyan's three films may cross the boundary from the desiring gaze into child abuse and even murder. But our discomfort in watching these films comes not from the tactile consummation of abuse but from the displacement of that desire into fetishes in which we the audience are also implicated. Most disturbing of all these fetishes is the excruciating close-up, in *The Sweet Hereafter*, of the child's throat beating with a tiny pulse as her father's knife hovers over her. What gives these images their energy is the suggestion that the body-screen could be penetrated. Eric, the father of Zoe's unborn baby, might make contact with it, or at least with its mother; the young Christina might have to face or even touch a murdered child; the toddler's constricting windpipe might be punctured.

Actual penetration of the screen in Egoyan's films is more often associated with violence than with intimacy, like the rape behind a screen in Egoyan's staging of the Strauss opera *Salome*, or the scene in *Felicia's Journey* in which Gala stuffs raw liver down young Joey's throat. But overt representations of physical violence and sexual encounters are uncommon in Egoyan's work. Though these three films contain many allusions to death (the killing of Lisa and the car accident that takes the life of her mother in *Exotica*; Hilditch's murders in *Felicia's Journey*; the school bus accident in *The Sweet Hereafter*), the actual events always take place off-screen. We see the bus plunge into the lake, but from a distance, through the windshield of a truck. We do not see the screaming children struggling to escape. Because of the stillness of the imagery portraying the extreme emotions of Egoyan's conflicted characters, this distant violence lacks closure, remaining disturbing and emotionally unresolved.

There are a few rare and powerful moments of tactile closeness in the films. In *Exotica*, both Eric and Christina touch Zoe's pregnant belly. Later, Francis goes to the club to punish Eric for ejecting him; when Eric tells him it was he who discovered Lisa's body, Francis's grief is finally unleashed and he falls weeping into Eric's arms. In *The Sweet Hereafter*, the recurring shot of mother, father, and child sleeping together in the sunlight is a universal icon of family intimacy. There is a tender candlelit love scene between Nicole and Sam, and a brief moment of illicit tenderness between the widowed Billy and the unhappily married Risa. In these images, the depiction of desire creates an almost tactile response in the viewer.

As Frederic Jameson argues, movies are recalled not only as visual and aural memories, but as a physical experience: "Memories are first and foremost memories of the senses.... It is the senses that remember, and not the 'person' or personal identity.... Film is an addiction that leaves its traces in the body itself" (1992, 1). We are grateful for these rare moments of physical intimacy but almost afraid to enjoy them, wondering what comes next. After touching Zoe's belly, Eric spurns her for the fetishized, unattainable Christina. The romance of Nicole and Sam is incestuous and exploitative; its beauty exists only in her childish imagination. The tender moment between Billy and Risa is marred by our knowledge that their children will die the next morning, destroying even this small happiness. Where another filmmaker might have ended *Exotica* with the reconciliation of Eric and Francis, Egoyan ends it instead with a flashback revealing Christina as an awkward teenaged babysitter, afraid to leave the safety of Francis's car to return to her own abusive household. Again, we are denied a traditional sense of closure with its reassuring return to a world in balance.

In *Felicia's Journey*, Hilditch's sensual connection with the world comes through food rather than human contact. Food is associated with Gala, a perversion of the maternal archetype. Yet for Hilditch, food remains a way to stay in touch. He manages a factory cafeteria with obsessive attention to detail, even delivering special desserts to people on the factory floor. He rejects an automat salesman, saying, "Food must be served by loving hands, not machines. It makes us feel ... loved." Most of his considerable time alone is spent in shopping, cooking, eating. He prepares an entire turkey dinner for himself and gorges on it. For Hilditch, food is a substitute for love and human touch. Other objects of his desire are framed by mirrors, video screens, opera glasses, effectively preventing him from touch. His mother's touch is smothering or punishing. There is no suggestion of tactile contact with his young women—except, of course, at the imagined point of murder. He raises his hand to touch Felicia while she sleeps on his couch but cannot complete the gesture.

In contrast, Felicia's memories and fantasies are direct and tactile: Johnny kissing her, Johnny carrying their young son on his shoulders. Unlike the memories of most of Egoyan's characters, Felicia's are characterized by emotional integration and not mediated through video or photography. They are indeed memories of desire, but of a desire that is direct and transparent rather than perverse. Felicia's innocence is pure; Egoyan adds no layers of artifice as he does with Christina's fetishized schoolgirl pose or Nicole's romantic fictions with her father. The 1950s theme song of the film, "Through the Eyes of a Child," reiterates the idea of innocence to be protected; though the song itself is maudlin, it is not used ironically. Felicia's naïveté has made her vulnerable to Hilditch's stratagems, but ultimately it saves her.

Felicia's memories evoke what Marks refers to as "embodied sensation." Marks's "haptic visuality… the way vision itself can be tactile, as though one were touching a film with one's eyes," recalls Bergson's theory that memory is embodied in the senses (2000, xi). For Bergson, the "image" is not only visual, but a complex of all sensory impressions that the perceived object conveys to the perceiver at any given moment. Elaborating on this, Marks argues that "images are always both multisensory and embodied. Pure memory does not exist in the body, but it is in the body that memory is activated, calling up sensations associated with the remembered event" (2000, 73). From Bergson and Deleuze, Marks develops a theory of representation that she defines as "auratic, embodied and mimetic": "When verbal and visual representation is saturated, meanings seep into bodily and other dense, seemingly silent registers…. Since memory functions multisensorially, a work of cinema, though it only directly engages two senses, activates a memory that necessarily involves all the senses" (2000, 5). Marks focuses on video and film from non-Western traditions, in which she sees a tendency for a more direct engagement in representing the non-visual. Yet she also refers to Egoyan's *Calendar* (1993) in her examination of this trend in intercultural film and video, pointing out that it is "structured around the losses that take place in acts of translation" (2000, 39) and citing examples of "inadequate" visual and auditory images throughout the film that we complete through our own perceptions.

Marks's notions of embodied sensation thus take us one step further than Mulvey's idea of the fetish as a dominantly visual formation into an awareness of how both the principal characters and the spectators of Egoyan's film translate visual/auditory perception into multi-sensory response. Marks cites numerous examples of synaesthesia expressing memory of or intimacy with a loved one—or its lack, as in *Calendar*. As we have seen, Egoyan characteristically represents the impulse toward synaesthesia as an absence rather than a presence. Instead of portraying direct images of touch, he more typically shows us its negation, the inability of his characters to find that sensory comfort; the thwarting of multi-sensory fulfilment, particularly the sense of touch, is instrumental in generating fetishizing scopophilia.

Iconography and Narrative

In conventional narrative cinema, the filmmaking team facilitates the spectator's identification with the protagonist by depicting the story from that character's point of view, perhaps briefly shifting to the perspective of other characters, who are the protagonists of their own subplots. As Mulvey explains, this seamless unfolding narrative allows the character to maintain a sense of control over the events onscreen, in part because they are predictable within a familiar range of possibilities. Contrasting it to fetishistic

scopophilia, she equates this voyeuristic subjugation with sadism: "Pleasure lies in ascertaining guilt (immediately associated with castration), asserting control, and subjecting the guilty person through punishment or forgiveness. This sadistic side fits well with narrative. Sadism demands a story, depends on making something happen, forcing a change in another person, a battle of will and strength, victory/defeat, all occurring in linear time with a beginning and an end. Fetishistic scopophilia, on the other hand, can exist outside linear time as the erotic instinct is focused on the look alone" ([1975] 1988, 64). This dominant narrative style gives the spectator a sense of control over events onscreen, in part because they are predictable within a familiar range of possibilities. Either the hero will reach the ticking bomb in time, or he will not. In Hollywood films, broad generic indicators and star-recognition factors further reassure us that he will. Egoyan's films, however, feature apparent disruptions in the linear narrative that rend our comfortable suturing into the story with its illusion of control. For Egoyan, video serves as a marker that shifts us from photographic reality to a more internalized state of mind. The video icons serve a dual function, oscillating between a character's point of view and a collective symbology that transcends the character's subjectivity. By turning images into spectacle, Egoyan undercuts the thrust of the narrative. His radical manipulation of time, space, and causality make us work to interpret the logic of these images. In these three films, narrative continuity, fractured into a mosaic of temporal and spatial perspectives, generates a tension between our fixation on these images and our awareness of Egoyan's distanciating strategies. To see how he plays off our attraction to these images against his disruptive use of narrative requires a closer look at exemplary sequences in the three films.

In *Exotica*, it may seem that we are following the point of view of one or more characters and that any events outside of linear time-space continuity are flashbacks controlled by one character's memory and imagination. For example, at one point Eric lures Francis into touching Christina, saying, "Trust me, my friend. Just a little touch. Then you will get the full experience, my friend." Francis asks, "And what happens when I touch her?" We cut to the home movie of Lisa and her mother playing together; as her mother becomes aware of the inquiring camera, she puts her hand against the lens in laughing protest. The quick cut to a memory-video from Francis's point of view is not radically different from what we might see in a more conventional film.

Elsewhere in this film, however, Egoyan's montage and multiple narratives juxtapose images whose relationship is unclear. The visual narrative is assembled in a complex, sometimes deceptive manner. Point of view is a visual conundrum. Consider an early scene in the club: Francis watches Christina dance for him, then suddenly gets up and heads for the bathroom.

We assume he is going to masturbate as he locks himself into a stall. But while Eric croons over the PA system, "What is it about a schoolgirl that gives you that special innocence?" we cut to a high angle of Christina gazing into the camera. Because we are looking down on her from an apparently omniscient point of view, she seems positioned as a universal object of desire, though at the same time tied to Francis in particular. Cut then to an ultra-wide shot of a line of searchers covering a field. They look like primitive gleaners, the figures too small to recognize.

Whose point of view is this, if anyone's? Although conventionally, point of view is attached to the person seen just before the flashback, the seductive nature of Christina's pose in the previous shot suggests that she is the object rather than the subject of the gaze. Immediately after the field shot, we cut to Francis in the bathroom stall, but there is nothing other than proximity to tie him to the flashback. Much later we discover that Eric and Christina were in the search party; on second viewing, the grain of Eric's imagining, remembering voice ties him aurally (though not visually) to this memory. But at this point the image floats free of character subjectivity. Instead of a reliable point of view, we are forced to acknowledge that the filmmaker himself controls our surrogate memories and, as Paul Coates argues, implicates us in the fetishizing process: in opening the image to a collective point of view, the filmmaker includes the spectator in its signification (Coates 1997, 26). This four-shot sequence becomes a fetish object even as Egoyan's disruptive flashback to the search for Lisa pulls us out of our desire into awareness of the filmmaker's radical manipulation. This disorientation is exacerbated by our uncertainty concerning who might be the protagonist of the film, whose point of view might be identified as dominant. In *Exotica*, as in much of Egoyan's work, there is no one character anchoring the story.

In these three films, characters are paralyzed by what one group of analysts have described as "faulty mourning," the construction of a ritual that fixes and spectacularizes grief rather than enabling recovery; when the object of mourning is preserved through photography or video, the moment of grief is encapsulated and thus extended long beyond its natural life (Rayns 1995, 9). *Exotica*'s *syuzhet*, or narrative structure, as well as its fabula, or story, is paralyzed by the characters' inability to move on. Its off-balance ending, revealing new and disturbing information about Christina's past, leaves the plot ultimately unresolved, reminding us that other characters are fixed in mourning for their own lost innocence. Francis and even Eric may have found emotional release, but for Christina, Zoe, Thomas, and the others, the story is unfinished.

The Sweet Hereafter goes considerably beyond *Exotica* to fracture narrative by displacing both space and time, trailing screened fetish objects as floating signifiers. In his novel, Russell Banks uses first-person monologues

to tell the story in overlapping narratives from four characters' points of view—those of Dolores, Billy, Stephens, and Nichole (the film's Nicole). In the film, Egoyan narrows this down to the latter two, shifting from Stephens's to Nicole's perspective about halfway through the story. However, *The Sweet Hereafter* is not contained even within the subjectivity of *two* protagonists. In this film, linear narrative is fractured across time and space—not only into numerous subplots, but into a metastructure clearly beyond any one character's point of view. Although in Egoyan's films narrative continuity can ultimately be reconstructed, in *The Sweet Hereafter* (as in *Exotica*) he weaves together so many intersecting subplots in such a discontinuity of time and space that we are continually struggling to follow.

Egoyan often manipulates our expectations regarding characters' perceptions, as previously described regarding *Exotica*. Yet the opening of *The Sweet Hereafter* is more disjunctive than anything in *Exotica*, beginning with the beautiful young family sleeping in the sunlight. We cut from this to Stephens on a chilly night at a small-town car wash, as his daughter, Zoe, calls from a phone booth in another city. While Stephens talks into his cellphone, his car jams in the car-wash machinery and he crawls out, getting drenched. Cut to the previous summer at the town's fairground, where Nicole practises a song and strolls with her adoring father. Cutting back and forth between winter car wash and summer fairground, we have no idea of how these stories are connected. Not only are we unaware of the relationship between these characters (which is not unusual in the opening scenes of mainstream films); here the second scene takes place at least four months *before* the first, a flashback with no identifying markers.

Stephens makes his way to a motel, where he questions two bereaved parents about the best families to recruit for a lawsuit against the bus manufacturer. Cut to Stephens meeting Alison, a childhood friend of his daughter, two years later on a plane. Then we are back in town on the morning of the accident, as an unseen narrator (Dolores, the bus driver) begins to recount the day's events. For the next fifty minutes, the film cuts back and forth over a two-year period before and after the accident before finally settling down into a more or less linear narrative to convey the complicated evolution of Nicole's decision to lie. At about the same time, we shift from Stephens's point of view to hers.

As in *Exotica*, Egoyan violates one of the primary premises of conventional screenplay structure, which is built around the struggles of a single protagonist to achieve his or her goal against obstacles presented by the antagonist. Here, Egoyan seems to set up Stephens as his protagonist—introduces his dilemma, goes to some lengths to develop sympathy for him—then switches to do the same thing for Nicole. Yet Nicole is not an active protagonist in the traditional sense. Just as the parents' lives are stalled, so is

the film's narrative. In the climax Nicole does make an active choice to lie on the stand, but there is no clear resolution of this action for her or anyone else. Furthermore, throughout the film (as in *Exotica*'s flashbacks) Egoyan shatters our willing suspension of disbelief, our identification with a particular character, by shifting to a memory or fantasy from another point of view.

To understand how Egoyan's screen fetishes function to disrupt the narrative in *The Sweet Hereafter*, I will look at the sequence of the actual accident. As Dolores tells her story to Stephens, we see her crying on her couch. The camera tilts up the wall of photos over her head and dissolves to the interior of the bus, tracking down the aisle to focus on Billy's children waving through the back window at their father, driving behind them. This is followed by a close shot of Billy through his windshield, waving back. A look of horror appears on his face. After a quick interior shot of Dolores wrestling with the steering wheel, we cut to Billy's long perspective as the bus goes over a cliff. Billy skids to a stop and dashes out of his truck. Seen from his point of view, the bus splays out onto the ice far below and sinks. He scrambles down the embankment; from a great distance we hear the children's screams.

Cut to the shot from the title sequence: the beautiful family drowsing together in the morning sun. Nude figures under a blanket on a wooden floor, they are anchored neither in time nor in space; like the music, they belong to the fable-world of the Pied Piper. Thus this image functions as a fetish beyond the narrational imperative. In *The Sweet Hereafter*, as in *Exotica*, fetishized images are detached from the narrative, interrupting and displacing the dramatic trajectory of the story. Over this shot, Stephens begins to tell Alison the tale of Zoe's childhood brush with death. This shocking story too is told with great economy. The primary image is the close-up of little Zoe's face, the knife poised over her throat for the tracheotomy. Cut to a close shot of Mitchell and Alison; he says, "I did not have to go as far as I was prepared to. But I was prepared to go all the way." After another timeless image of young Zoe's mother lifting her, the camera tilts past them to the sky and down again, now looking up at Billy from the imaginary perspective of his dead children as he identifies their bodies. Stephens's story of Zoe's crisis is so powerful that we have briefly forgotten the school bus accident. When we return to this scene, it is all over.

Of course, the stories of Zoe's emergency and the bus accident are connected. For Egoyan, cutting here to the image of the sleeping family should make us "suddenly think of it as heaven, so that we're suddenly transposed into this other world.... And yet it reinforces the idea that anything can happen at any moment" (Egoyan 1997b, 42). The connection between the two events links Mitchell's grief over his daughter to his passion for the lawsuit

and feeds the universal fear that all our children will pass through the curtain into the "sweet hereafter." This cut from accident to Mitchell's story back to accident scene glides past the crucial question for the investigation: What really happened? We never see the accident from Dolores's point of view: no ghostly dog, no patch of ice, too-high (or not) speedometer,[1] or any other factual or imaginary proof. Most important, cutting away from the accident screens us emotionally from the screaming children. The multiple perspectives and flashbacks are part of a network of alienating devices that hold us at arm's length from the passions of the event itself. The temporal juggling act consistently pulls us away from attachment to the characters in their grief.

In *Felicia's Journey*, the narrative becomes more linear and more psychologically developed. This film was also adapted from a novel that periodically switches point of view. Here, though, partly because of the reduced number of characters, the plot is more straightforward. Although the narrative is fractured by Egoyan's characteristic flashbacks and mediated imagery, in this film such interruptions are more clearly anchored to Hilditch's or Felicia's subjectivity than in the earlier films, where point of view may be ambiguous.

The narrative is most disrupted in one disturbing sequence that depicts Hilditch's increasingly schizoid crisis through a montage of disjointed images. This comes at a point where he is losing control of his ability to repress the horror of what has been done to him and what he has done to others. The hallucinatory quality of this sequence is explicitly seen from inside Hilditch's mind, and its mixture of biblical epic, home video, and childhood trauma is highly disorienting. It begins with Hilditch entering a suburban hospital, pretending to visit the invalid wife he has invented, while Felicia waits in the car outside. Incongruously, the 1953 film *Salome* plays on a TV in the waiting room. On a monitor over Hilditch's head, Herod offers Salome half of his kingdom. The film scene playing on the monitor cuts to a video close-up of another young woman, saying to an unseen companion (Hilditch himself), "I'll always remember you." Then another woman: "Why do you need me? Why do you read my stories?" And another: "I can't get attached to people in my profession." These are intercut with closer shots of Salome demanding the head of John the Baptist. Salome begins to dance. Cut to another of Hilditch's victims on video: "It's really scary. Please stop the car. Say something!" Back to Salome, screaming as the head is delivered to her on a platter. Hilditch's video-memory montage accelerates, with fragments of other women trying to escape. Cut to the young Hilditch in a theatre with his mother, Gala, as she hands him the opera glasses. He stares in shock at another Salome onstage, nuzzling the Baptist's severed head, as Gala smiles with glee. Cut to a video from the cooking show, with

young Hilditch and Gala in the garden as he sniffs a rosemary bush; she prances up and kisses him on the forehead. This sequence connects Hilditch's plot against Felicia to his memories of other women trying to leave him, to his love and fear of his mother, and to the violence of Salome; like Hilditch, Salome destroys what she desires most. This multi-sensory sequence clearly delivers us into Hilditch's psychopathic subjectivity. The video image first appears as part of a full shot of Hilditch in the lobby; presenting his nightmare in the space that contains Hilditch himself spectacularizes the fragmentation of his personality.

Conclusion

In *Exotica*, Christina in her schoolgirl's uniform becomes a collective fetish, and images from the past become collective memories. In *The Sweet Hereafter*, point of view switches unpredictably from one character to another, and characters seem to "own" events that are not really theirs. The film ends with Nicole speaking to Stephens in voice-over, describing an encounter he had with Dolores that Nicole could not possibly have witnessed. In these two films, Egoyan creates characters trapped in fetishizing desire, lures his own audience into this desire, and then undercuts it with ambiguous subjectivity. The illusion of getting inside his characters is thwarted by his nonlinear narrative techniques. Our inability to identify fully with these characters focuses us on their symbolic value rather than their illusionary role in the sadistic narrative as described by Mulvey. Motives remain opaque, plot points are unresolved. We never find out who killed Lisa, or whether Francis's brother was her real father, nor do we solve the mystery of her real parentage.

Egoyan denies to his own audience (or protects us from) the total immersion that victimizes so many of his characters. Although these screen images represent the unattainability of the object of desire and are thus on one level tragic, Egoyan never allows emotion to overcome his ironic authorial distance. His fragmentary fetishes are often shown out of context. Who are these people? Where does this image come from? What is going on? His eroticized icons are not so much tools for manipulating his audience as they are devices that draw our attention to the cinematic apparatus and to our own role as spectators. The video artifacts in particular are degraded, their exaggerated scan lines literally breaking the image into fragments, stressing the empty space between the lines. As the gap between subject and object of the gaze in his films is emphasized, so is the gap between film spectator and cinematic character.

Marks describes incompletely realized visual signifiers as lures that draw the viewer into closer intimacy with the image by requiring us to complete the missing elements. Following Deleuze, she argues that these images,

as the viewer fills them in, have the power to seep through the imagination beyond simple signification: "The optical image, because it cannot be explained and mobilized into action, requires the viewer to puzzle over it. The inability to recognize an image encourages us to confront the limits of our knowledge, while the film's refusal to extend into action constitutes a refusal to 'explain' and neutralize the virtual image. Because the viewer cannot confidently link the optical image with other images through causal relationships, she is forced to search her memory for other virtual images that might make sense of it" (2000, 46–47). This in itself is not inconsistent with Mulvey's notion of fetishizing such images. In fact it could be argued that we invest more psychic energy into unclear forms than into those whose signification is easily recognized. However, when the fetish object is contained within a fractured narrative over whose meaning we must puzzle, the power of the fetish is undercut just as the authority of the narrative is questioned.

Silverman, citing Oudart and Dayan, notes that as soon as the spectator recognizes the operation of the cinematic apparatus, "he or she becomes aware of visual constraint, and hence of an unseen agency of control. The spectacle is evacuated of its fullness, becoming an empty signifier for the invisible enunciator. Thus, rather than affecting the viewer 'like a phenomenon in nature,' the cinematic image attests to artifice and coercion" (1988, 11). Just as the absence of the actual object in cinema, when reproduced photographically, creates a sense of either lack (for the female spectator) or castration (for the male) that must be recuperated through the creation of fetishes, so the recognition of artifice in the cinematic narrative generates a threat to the viewer's pleasure that must be compensated by the shot/reverse shot dialectic, in which the second shot supplies the information missing from the first and creates a sense of completion (Silverman 1988, 11). When Egoyan denies us this illusion and instead offers us a whole new visual field with a shot that does not match subjectively, our loss of a sense of narrative control—our illusory sadistic voyeurism—fails, just as it does for Francis, Eric, Stephens, and Hilditch. These icons of desire—the children waving through the bus window, the beautiful sleeping family, Christina gazing seductively into the camera—undeniably act as fetishes for these characters, and to some degree for Egoyan's audience. Yet in *Exotica* and *The Sweet Hereafter*, the incorporation of these images into a non-linear puzzle is disruptive to the flow of the narrative and even to the spectacular form itself. Though it might be argued that the characters fetishize these images still more compulsively to compensate for their loss of a sense of narrative control, the audience is granted an emotional distance from the images.

The drive to investigate human desire has always been at the root of Egoyan's work, even if his formal strategies have undercut its representa-

tion. In these three films we see an evolution toward psychological realism, which Egoyan himself has noted. He has characterized his films before *The Sweet Hereafter* as having "a more figurative approach to the characters, because that's what these films needed" (Egoyan 1997a, 12). A change began with *Exotica*, however. Egoyan explains: "I think once you embark on the representation and depiction of human beings who are in a very problematic situation, you have to apply yourself to who these people are and what they need to tell. In that way, when it comes to my definition of dramatic characters, as untraditional as my techniques may seem, my motivations are quite classical in terms of what I want to reveal about the characters, my desire to find a catharsis or some sense of resolution. It's just that the means by which these things happen is unorthodox" (1995, 26). As for *The Sweet Hereafter*, he remarks, "I've always wanted to resist films which have the ability to make people think that what they're seeing is real. Maybe I've grown out of that at this point. And certainly the challenge in *The Sweet Hereafter* was to create a very vivid sense of what this community was about and who these people were within a very unorthodox structure. It's completely nonlinear, but because you have a strong sense of who the people are and what the community is about and what the central event is, you have tremendous freedom to play with that structure" (1997a, 11).

This move toward psychological narrative reaches its apex in *Felicia's Journey*. The fragmentation in the story is contained within the pathological subjectivity of one of the characters; this disintegration does not spread beyond it into the narrative itself. Correspondingly, these characters are drawn more conventionally in terms of psychological realism than the emblematic figures of *Exotica*, and even the more fully realized characters of *The Sweet Hereafter*. In *Felicia's Journey* we are granted more or less complete access to the characters' subjectivity, offered an explanation of Hilditch's psychopathology via his abusive mother. The very fact that Hilditch can be psychoanalyzed as if he were human points to a shift in Egoyan's work from emblematic to representational. This corresponds to the shift in his handling of fetishized images. In *Exotica* and *The Sweet Hereafter*, these images function somewhat as floating signifiers, disintegrating the narrative as we struggle to interpret them. In *Felicia's Journey*, they are recuperated into the subjectivity of his characters, allowing us to feel a corresponding sense of identification with them. Felicia is Egoyan's first character who seems fully integrated as a human being, and this is the first of his films that has what might be considered a truly hopeful ending.

Just as his characters crave plenitude with an imagined innocent childhood, Egoyan is tempted by the illusions of dramatic cinema. But although his films have gradually become more psychologically realist, he has not given up on formal self-consciousness, which returns more aggressively in

Ararat with its film within a film and its airport surveillance cameras. Recalling Mulvey's comment that "fetishistic scopophilia can exist outside linear time as the erotic instinct is focused on the look alone," we might expect Egoyan to maintain his fragmentary formalism as long as he continues to explore unfulfilled desire. He recognizes our characteristic patterns of viewing and the drive to identify with certain characters, and moves this implicit understanding into self-reflexive focus. Theoretically sophisticated, balancing extreme dramatic circumstances with self-conscious formal strategies, he presents us as spectators with opportunities for the illusion of voyeuristic control and fetishizing scopophilia—then undercuts them with distanciating strategies, leaving us puzzling over our own complex responses to his films.

Acknowledgment

Thanks to Elena Feder for her comments on the manuscript.

Note

1 Egoyan shot a close-up of the speedometer within the speed limit but chose not to use it.

Works Cited

Coates, Paul. 1997. "Protecting the Exotic: Atom Egoyan and Fantasy." *Canadian Journal of Film Studies* 6, no. 2: 21–33.

Egoyan, Atom. 1995. "Atom's Id." Interview by Lawrence Chua. *Artforum*, March, 25–26.

———. 1997a. "Family Romances: An Interview with Atom Egoyan." Interview by Richard Porton. *Cineaste*, December, 8–15.

———. 1997b. "Writing and Directing *The Sweet Hereafter*: A Talk with Atom Egoyan." Interview by David Johnson. *Scenario: The Magazine of Screenwriting Art* 3, no. 4: 42–46.

Foucault, Michel. 1979. *Discipline and Punish: The Birth of the Prison*. Translated by Alan Sheridan. New York: Vintage.

Jameson, Frederick. 1992. *Signatures of the Visible*. New York: Routledge.

Marks, Laura U. 2000. *The Skin of the Film: Intercultural Cinema, Embodiment, and the Senses*. Durham, NC: Duke University Press.

Metz, Christian. 1977. *The Imaginary Signifier: Psychoanalysis and Cinema*. Translated by Celia Britton, Annwyl Williams, Ben Brewster, and Alfred Guzzetti. Bloomington: Indiana University Press.

Mulvey, Laura. [1975] 1988. "Visual Pleasure and Narrative Cinema." In *Feminism and Film Theory*, ed. Constance Penley, 56–71. New York: Routledge.

Pevere, Geoff. "No Place Like Home: The Films of Atom Egoyan." In *Exotica*, by Atom Egoyan, 9–41. Toronto: Coach House.

Rayns, Tony. 1995. "Everybody Knows." *Sight and Sound*, May, 9.

Silverman, Kaja. 1988. *The Acoustic Mirror: The Female Voice in Psychoanalysis and Cinema*. Bloomington: Indiana University Press.

Zlotnick-Woldenberg, Carrie. 2001. "Felicia's Journey: An Object-Relational Study of Psychopathy." *American Journal of Psychotherapy* 55, no. 1: 40–51.

▶▶▌ 14

To Blame Her Sadness
Representing Incest in Atom Egoyan's *The Sweet Hereafter*

Melanie Boyd

One of the most empowering things you can feel as a filmmaker is
that you are tapping into a current *Zeitgeist*.
— Atom Egoyan, discussing his hope that
The Sweet Hereafter would find a wide audience

[*The Sweet Hereafter*'s] sub-plot dealing with incest treats that diffi-
cult subject with extraordinary taste and tact.
— *The Christian Science Monitor*

The Politics of Representing
Father–Daughter Incest

The feminist analysis of sexualized violence extends outward from the recog-
nition that violence is, to paraphrase the second-wave feminist insight, as
political as it is personal; seen from this angle, seemingly discrete acts of
abuse cohere into a fundamental institution of sexism. As feminist researchers
of the 1980s established the astonishing frequency of such violence against
individual women and girls, feminist theorists moved beyond the grim sta-
tistics to explore the pervasive impact of violence on female experience and
subjectivity. Noting the innumerable ways in which sexualized violence and
the fear of it circumscribe women's everyday freedoms, these theorists have

argued that vulnerability becomes a, or even *the*, defining female experience. Within this analytic frame, the cultural discourse about sexualized violence is as crucial as the acts of violence themselves: the regulatory power of violence operates through expert and popular narratives that first stress female vulnerability and then—by blaming victims for their own victimization—go on to make women and girls responsible for the management of that vulnerability. Accordingly, the feminist anti-violence movement has worked over the past few decades to alter this discourse. Publicly identifying the misogyny of these victim-blaming narratives, activists have set out to supplant them with pro-victim accounts that adamantly contrast the victim's innocent suffering with the perpetrator's inexcusable guilt. Stories of father–daughter incest are especially well suited to this activist work. The openness with which traditional paradigms blame daughters and mothers for the fathers' actions provides a transparent case study in misogyny, while the clarity of the power imbalance between male parent and female child underscores both the injustice of abuse and the victim's helpless innocence. The autobiographical narratives of father–daughter incest that proliferated through the 1980s and 1990s are thus weighted with political aspiration and duty: they offer the victim's perspective to force a cultural paradigm shift that would produce at the least a recognition of incest as intolerable abuse, at the most a radical reorganization of gendered power relationships.[1]

The production of these new feminist narratives has not been easy, however. Authorial struggles with dominant victim-blaming paradigms are compounded by the need to negotiate the secrecy that so often structures the experience of incest itself, the historically entwined prohibition and promise of speech that lead to a testimonial "telling" overdetermined as both impossible and imperative. Piled atop that obstacle are the particular psychic and linguistic challenges of articulating any trauma, a phenomenon defined as the encounter with an event that is "experienced too soon, too unexpectedly, to be fully known," one that thus "overwhelm[s] the ordinary human adaptations to life" (Caruth 1995, 4; Herman 1992, 33). Among these overwhelmed adaptations is that self-narration by which individuals process events into experiences, telling stories to themselves as the prerequisite for telling stories to others. Some theorists go further, to argue that trauma takes shape when there is no referential language for an event, thus locating the unspeakability not just in the trauma survivor's ability to narrate, but in the limits of language itself.[2] Given these hurdles, it is no wonder that the feminist call to speak out has produced narratives both powerful and constrained. Drawing upon an increasingly codified set of conventions to emphasize the father's guilt, the child's helpless innocence, and the narrator's adult struggle for recovery, feminist incest narratives of 1980s and 1990s rhetorically shift the burden of action onto the reader. They draw upon the ethical imper-

atives inherent in any trauma narrative to demand of their audience, "Are you listening? What will you do?"[3] Interpellating readers into a sympathetic position, the narratives hold out a range of possible interventions—empowering children, fighting sexist power dynamics in all forms, telling one's own story—each shaped by the fundamental assertion that incest is not an individual or familial aberration but a widespread social manifestation of patriarchal oppression. The tremendous cultural impact of this feminist effort can be measured, ironically enough, in its production of new obstacles to narrating incest, which range from backlash accusations of false memories to the more subtle resistance of boredom in the face of these now-familiar tales.

I offer this political and cultural history—most specifically, the late 1990s endpoint of boredom—as the Zeitgeist into which Atom Egoyan's 1997 *The Sweet Hereafter* taps. My reading of the film focuses on one of the most striking changes Egoyan makes in his adaptation of Russell Banks's 1991 novel: the reimagining of the sexual relationship between a young teenaged girl and her father as not coercive but rather quasi-consensual. Explaining the shift to reviewers of the film, Egoyan frames it as an aesthetic revision: "There was no way I could depict the incest the way it was in the book," he says, "because it has become a cliché" (Egoyan 1997b).[4] Rebelling against the feminist conventions that Banks determinedly follows, Egoyan's film goes beyond novel exploration to construct what is arguably an anti-feminist portrayal of incest, abandoning the project of clearly documenting the atrocity of abuse in favor of mapping both father's and daughter's confusion. In this light, the "extraordinary taste and tact" that reviewers praise in this incest representation is a troubling measure of how easily the film sets aside uncomfortable political demands, of how its reinvigoration of victim-blaming models defers rather than provokes ethical response. And yet even a suspicious feminist viewer such as myself cannot escape the fact that Egoyan's *The Sweet Hereafter* constructs a startlingly agential victim; indeed, the bulk of the small body of *Sweet Hereafter* criticism concerns itself with the film's portrayal of the daughter's power. How, then, should politically concerned viewers judge the revision? Do we condemn its failure to represent an innocent victim, or celebrate its ability to represent an empowered one?

Complicating these questions is the resemblance Egoyan's film bears to other, more politically credentialed incest accounts, ones that self-identify as feminist projects even as they also deliberately abandon the conventional feminist insistence on the daughter's innocent helplessness. These provocative texts—recent autobiographies and autobiographical novels by authors such as Dorothy Allison, Kathryn Harrison, Carolivia Herron, Elizabeth Potvin, and Sapphire—have emerged alongside theoretical pieces that ques-

tion feminism's traditional focus on speaking out about female victimization. Discussing the sustained testimonial effort to "expose the reality of rape culture," for example, political theorist Renée Heberle notes that "this strategy is not without risks.... One of those risks is that as the ever-enlarged map of women's sexual suffering is pieced together, it becomes, in effect, the social insignia of male power," thus "further[ing] the reification of masculinist dominance" (1996, 63–64). Similarly, Sharon Marcus argues that the fight to make violence visible has prevented feminists from being able "to imagine women as neither already raped nor inherently rapable" (1992, 387). Representing a small but persuasive strand of 1990s feminism, Heberle and Marcus argue for the current need to tell different stories, ones that cast sexual violence as a mutable category for its participants and actively "subvert the images of women as [solely or utterly] vulnerable" (Heberle 1996, 67).

Is it too much of a stretch to identify Egoyan with these feminists in search of new representational possibilities? Perhaps. Certainly, the ongoing interest in incest Egoyan asserts in interviews about the film, and which is manifest in his other works, is not marked by the feminist concern with the relationship between incest's representation and its routine practice.[5] And yet the power that both he and Banks invest in their young incest victim is extraordinary: she makes use of her own abuse as a tool, ultimately using it to reshape not just her own but the entire town's experience of the traumatic bus wreck. Banks does this within many of the other confines of the conventional incest narrative, which typically emphasizes the girl's vulnerability to her father; his representation of her agency is powerful but also familiar. What happens, then, when Egoyan decides to avoid "cliché"? Is the filmic *Sweet Hereafter* a step toward the deconstructive narrative for which recent feminist theory calls? Or does Egoyan's problematic investment in quasi-consensuality sabotage any political utility this representation might otherwise have?

In the discussion that follows, I pursue two linked arguments: first, that the paradoxical combination of victim-blaming and victim empowerment plays out not only in *The Sweet Hereafter*'s story of incest but also in the film's use of the incest subplot as a narrative device within its broader story; second, that attention to the structural effects of incest within the film reveals that the key question is not "Is *The Sweet Hereafter*'s representation of incest feminist or reactionary, good or bad?" but rather, "How does the film build its 'good' representation out of the 'bad' one?"

Incest as Structure and Story in *The Sweet Hereafter*

The Sweet Hereafter presents itself as the story of a small town struggling in the aftermath of a tragic school bus accident. The story of the incestuous rela-

tionship between the teenaged Nicole and her father, Sam, begins as a subplot but ultimately breaks through its initial containment to wrest the primary plot off course: as the people of the town become increasingly defined by their embrace or rejection of the lawsuits that follow the bus wreck, Nicole renders their hopes and fears moot by lying in her deposition in order to punish her father, thus shaping a resolution that depends upon the incest rather than the accident. We could interpret this usurpation as a mark of the bus wreck's incompatibility with narrative, of the inherent structural weaknesses of a traumatic account. Such an explanation falls short, though, in failing to name the incest narrative as equally (albeit differently) traumatic; it also fails to explain the incest plot's ability to defeat *The Sweet Hereafter*'s sole non-traumatic plotline, the lawyer's litigious narrative that so persuasively revives the logic of cause and effect. Instead, I argue, we must recognize that the incest subplot acquires narrative control precisely because of its traumatic elements. The incestuous relationship offers an alternate entrance into the questions that swirl around the bus wreck: questions of innocence, guilt, and complicity; of victimization and agency; of the power (and powerlessness) of testimonial speech; of the possibility of pleasure in the face of crisis; of damage, healing, and irredeemability; of the ethics of vengeance. The story of Sam and Nicole offers unexpected elaborations upon the story of the children's deaths, clarifying that public trauma by offering a private one with very different structural relationships to time, knowledge, and intentionality.

Both Banks's novel and Egoyan's film use this doubled vision as a way to produce traumatic instability within the text. Such a manoeuvre is necessary given the complexities of representing trauma; after all, trauma is defined by its ability to resist representation. Trauma theorists of recent decades have accepted Freud's claim that trauma is not an event but a structure, one in which the inaccessibility of knowledge ruptures time. Cathy Caruth's definition stresses this structure of belatedness: "Trauma is not locatable in the simple violent or original event in an individual's past, but rather in the way that its very unassimilated nature—the way it was precisely *not known* in the first instance—returns to haunt the survivor later on. The truth, in its delayed appearance and belated address, cannot be linked only to what is known, but also to what remains unknown" (1995, 4).

Consisting of retrospective accounts from four of the main characters, Banks's novel reflects this structure of belated unknowability by offering a series of distinct perspectives, each of which offers its own focal points and interpretive axes. Rather than buttressing one another, these narratives construct an increasingly unstable account of the tragedy and thus highlight the vicissitudes of memory and affective response. Banks uses the superficial differences between the two traumas—the secret outrage of Nichole's inti-

mate abuse versus the public and collective grief of the town's tragedy;[6] the easily pinpointed fault of the father versus the ambiguous search for someone to blame for the accident; the control Sam exerts over the incest versus the absolute failure of control represented by the accident—to highlight the many ways in which these divisions failed to hold. Ending with the powerfully ambiguous impact of Nichole's false testimony, the novel ultimately abandons the search for truth altogether.

With its marketing campaign proclaiming "There is no such thing as the simple truth," Egoyan's *The Sweet Hereafter* promises to follow Banks's lead. And yet the transformation into filmic mode strips away almost all of the first-person narration and brings the action into a series of present timeframes, discarding Banks's techniques for introducing uncertainty. The visual immediacy of the film registers an implicit truth claim, yet Egoyan manages to undermine that effect by maintaining Banks's series of competing subplots, by offering images that contain multiple sites of action (May and Ferri 2002, 134), and, most importantly for my analysis of trauma in the film, by disrupting the narrative sequence—by making time (and thus plot) unreliable.[7] *The Sweet Hereafter* opens enigmatically, with the camera panning across wooden planks that viewers recognize as floorboards only when its gaze reaches the edge of a bed and pulls back to reveal a young family asleep. The who, where, and when of this scene remain undefined as the film moves on to focus in its first half on the people of Sam Dent (the ill-fated small town) in three primary timelines: the period before the accident, in which we see the characters' lives as they were; the morning of the accident, in which we watch the bus driver, Dolores, making her cheerful rounds; and the days immediately following the accident, in which big-city lawyer Mitch collects information and recruits clients. These intermingled timelines each occur in the diegetic present, sorting themselves into groups only implicitly.[8]

This jumbling of time keeps viewers off balance, prolonging the period in which the characters, their relationships, and the plot all remain unfixed. More important, the story's non-linear unfolding profoundly shapes the audience's relationship to the trauma of the bus accident. Although two of the three primary timelines take place in a present before the trauma, the audience is necessarily in alignment with the third—having seen the wrecked bus, we cannot be subsumed in a filmic present that does not share the knowledge of disaster. Yet we also cannot completely assimilate the perspective of the third timeline, for it presumes the experience of the accident that the film has not yet shown. The audience thus sees the unfolding scenes from the very perspective by which Caruth defines traumatic survival: we are haunted by the accident we have yet to experience. Egoyan has created a pre-traumatic period of normalcy for the characters, but this only underscores the audience's banishment to the post-traumatic "sweet hereafter."

From this location, viewers can do nothing but wait for the crash. Repeatedly cutting to and then away from Dolores's bus as it is boarded by more and more children, signalling and then deferring the looming disaster, the film creates an anxiety about what we will ultimately see, thus foregrounding our own role as voyeurs of this tragedy. Whether we wait with dread or with eagerness (to see? to get it over with?), we are fundamentally divided from the characters who do not wait, who will be caught unawares. Unable to be shocked by the skidding bus, unable to identify with the characters, *The Sweet Hereafter*'s audience is oddly buffered from the trauma of the accident even as it is steeped in it.

The power of the incest subplot inheres in its ability to reverse these dynamics: its revelation, by sending us unprepared into a trauma that Sam and Nicole enact with steady familiarity, inverts the distribution of knowledge between viewers and characters. This inversion necessarily refigures the audience's relationship to trauma, disrupting the marginal safety afforded by the post-traumatic perspective on the bus wreck by reminding viewers that knowledge is always incomplete, that one can never be fully braced or prepared for what may come. It offers precisely the view into trauma that the fractured timeline has blocked, producing a moment of stunned incomprehension that allows us at last to identify with the people of Sam Dent.[9] The audience's new identification with the characters unlocks the rest of the film: the camera pans up from Sam and Nicole's sexual contact and then back down onto the bus, which it now follows almost seamlessly to the disaster that the film has finally prepared us to see. The very structure of the film itself seems reconfigured by this pair of traumas, its second half maintaining this new alignment between audience and character. The film persists in some of its temporal juggling but no longer allows our knowledge to lag behind or jump ahead of the diegesis; indeed, the scene that follows the bus accident immediately ties up the one remaining loose end by revealing the sleeping family to be Mitch's, years earlier. Assuming increasing narrative control as the film progresses, the incest subplot takes on an equally increasing epistemological importance as the frame through which viewers can see both trauma and justice.

Given incest's cultural history as a secret to be denied, its role in *The Sweet Hereafter* as that which makes trauma visible is striking, a praiseworthy use of an incest narrative. And yet the entwining of the incest and the crash depends upon the film's structural inversion of intentionality as well as of knowledge. Displacing the shock of the bus accident onto the incest denies incest's fundamentally deliberate nature—this representation casts incest as an accident, as unpredictable and circumstantial. It is instructive, here, to turn to Egoyan's own efforts to describe the non-coercive incest he is trying to represent. His descriptions persistently rely upon the passive

voice: "It's a love that becomes confused"; "something where distinctions are blurred"; "a love between parent and child that becomes blurred" (Egoyan 1997b; Egoyan 1999, 10; Hartl 1997). This incest has no clear cause, no subject who acts to make it happen—the paternal culpability that feminist representations emphasize is entirely absent here. When Egoyan does invoke paternal responsibility, moreover, he imagines the father's error as inaction, not action. "It is the parent's responsibility to see that the lines don't become blurred, but sometimes the blurring is irresistible," he comments, as if the parent were warding off an entirely external phenomenon rather than an abuse he will perpetrate himself (Egoyan 1998). To the extent that there is an agent of this accidental incest, it is romance. Cast by Egoyan as more than a mitigating circumstance, romance becomes the force that blurs familial boundaries and confuses love, eliding the sexual element of incest and conveniently absorbing culpability into an abstraction.[10]

These directorial theories about the "confused" origins of Sam and Nicole's incestuous relationship are not explicitly voiced in the film, which neither shows nor discusses their past. Instead, the film interpellates its audience into the confusion, misleading us with its initial representation of Sam and Nicole as a "regular" romantic couple. Like Egoyan's hypothesized father and daughter, viewers are caught off guard by the blurring lines: by the time we understand that we are seeing an incestuous couple, it is too late to invoke the straightforward ethical judgment upon which conventional feminist reactions to (and representations of) incest ground their political indictment. *The Sweet Hereafter* opens with a sequence of four scenes: the silent image of the sleeping family; Mitch trapped inside a noisy carwash and arguing, via cellphone, with his drug-addicted daughter, Zoe; Nicole and Sam on the county fairgrounds; and Mitch abandoning his stuck car in the car wash, following the noise of an equally abandoned guitar, and finding the wrecked shell of the school bus. In this episodic alternation of peace and destruction, the time and space of the fairground are coded as the world of simple safety. The character we will come to know as Nicole rehearses onstage with her band, the gentle harmonies of her song providing a welcome respite from the harsh noises of Mitch's post-accident world (the car horn, the sirens of Zoe's city, the guitar's reverberations). Her hair falls in her eyes as she stands in front of an artfully doubled photograph of herself. Its poised lines and hint of nudity both age and sexualize her, while its surreal abstraction cues us to think of image and object, of performance as spectacle. And she is watched—one of the men setting up the fair has paused to stare admiringly. Older than her but still young, his face framed by hipster curls, this man and his gaze are decidedly not paternal. But neither are they threatening, for the man undercuts any power of his stare by smiling and shyly ducking his head as Nicole sings to him. Sam appears to be an older boyfriend,

a possibility the film convincingly develops as Nicole leaves the stage to join him. Side by side, their age difference is more apparent, yet his infatuated grins, her escalating demands for evaluative reassurance, and his nervousness as he casts about for convincing words of praise all register exactly the awkward intimacy one might expect in such a pairing. By the time "Daddy" appears as a term of address, it is a confusing one, requiring repetition and the proposal of an ice-cream outing before viewers can see a father and daughter rather than a romantic couple.

The unease of this perceptual reorientation lingers for the first half of the film, amplified but also at times hidden by the complex anxieties of waiting for the accident. Voyeurism and dread simmer together as we return to Nicole via a playful and tender babysitting scene—the film need offer no explicit hints for us to know that these children are surely among those whose deaths we await. Reading at bedtime from a lavishly illustrated edition of Robert Browning's *The Pied Piper of Hamelin*, Nicole pauses to answer the children's curiosity:

> *Mason* [*the child*]: Did the Pied Piper take the children away because he was mad the town didn't pay him?
> *Nicole*: That's right.
> *Mason*: Well, if he knew magic... why didn't he use his magic pipe to make the people pay him?
> *Nicole*: Because [*pause*] he wanted them to be punished.
> *Mason*: So he was mean?
> *Nicole*: No, not mean. Just very [*longer pause*] very angry.

Introducing *The Pied Piper* (another of Egoyan's innovations) at this fraught intersection of childhood innocence and doom, the film lays out the Piper's ethics of vengeance as an argument for the righteousness of punishment—an argument the film ultimately uses to cast Nicole's angry revenge as a just act. In the moment, however, the children fall asleep well before Nicole reaches the Piper's retribution, leaving the unfinished poem and the tragic anticipation it prompts to linger as the leitmotif of the film's second half.

The anxieties of the unresolved fairy tale appear initially to cathect around the sleeping children, thus catching us off guard when they follow Nicole home. The foreboding is unmistakable, however, even if startlingly displaced from the fate of the bus. Nicole's father has come to take her home, but they drive in silence past their lit-up house to park mysteriously outside a dark barn. As they wordlessly get out of the car, Nicole's reading resumes in a voice-over accompaniment, picking up the poem at the point where the Piper enchants the children with his tune. The film sets the two narratives together: the visual account of the incestuous encounter between Nicole and Sam unfolds alongside the auditory account of the loss of Hamelin's children. While previous critics have stressed the contrast between these

two accounts, I argue that *The Sweet Hereafter* aligns the verse so tightly with the images that the two cannot stand in simple contrast.[11] At times even replacing the images of Nicole and Sam with storybook illustrations, the film imbricates the visual and auditory narratives. Given that the images of incest here are unexpected ones, viewers are especially likely to take the poetic narrative as an interpretive frame for the incest, to read the disorienting visual account of incest through Browning's relatively direct account of childhood loss. In considering the poem's gloss on the incest, I will focus on a key narratorial shift within the poem: the emergent voice of the lame boy, who speaks "to blame his sadness."

At the start of the episode, as I suggest above, the mere presence of *The Pied Piper* is a signal for danger, functioning as would a more familiarly ominous musical soundtrack. The relationship between verse and image quickly becomes more specific, however, as the two narratives link up. As Nicole's voice describes Hamelin's enchanted children happily "tripping and skipping" behind the vengeful Piper and his tune, we see Nicole onscreen evincing resistance, trailing her guitar-laden father more and more slowly along the path and surprising him by ultimately coming to a thoughtful halt. They exchange a long stony look before he eventually turns away, resuming his path to the barn with the full confidence that she will follow, as she indeed hastens to do. "And the Piper advanced and the children followed," she reads. Having previously withheld its judgment of Sam, the film now maps him with astonishing speed onto the dangerous Piper. At the same time, the film sets Nicole into a more complex relationship to the children of Hamelin. Entering the barn just as the children pass through the "wondrous portal," barely visible behind Sam with his dim flashlight, Nicole is both like and unlike the children: headed toward their different fates, she and the children are equally lost, yet she possesses an awareness of impending doom that sets her apart from their blissful ignorance. In this conjunction of sound and image, Nicole knows too much to be child, let alone one so beguiled.

This is exactly what the film gives us next, however: Nicole enthralled and seduced by her Piper-father in the candlelit barn. How can we, as viewers, make sense of this shift? How do we understand her sudden compliance? In his commentary on the film, Egoyan describes the scene in the barn as a glimpse into the "mythology" Nicole has created "to justify the [confused] abuse" (1997b). "If she had a camera that could float," he says, this would be the "very unrealistic" footage it produced; in this interpretation, Nicole's reluctance presumably evaporates as she abandons reality. Citing the candle flames among the straw as a clear marker of impossibility, Egoyan seems confident that viewers will understand this scene as the distortion of Nicole's fantasy (Egoyan and Banks 1998). But will we? I suggest instead that viewers, having already engaged with *The Pied Piper* as the interpretive mecha-

nism for what they are seeing, continue to follow its narrative. And while we might expect the verse only to sharpen the confusion—surely, even the children of Hamelin's blithe complicity will end once "the door in the mountain-side shut[s] fast"—the poem does indeed offer an explanation for Nicole's sudden enchantment.

Just as the visual representation of incest shifts from resistance to romance, the verse sets aside its story of tragic enchantment to tell an unexpected one of loss, narrating suddenly from a radically different perspective that rewrites the implications of being under the Piper's spell. Having hesitated as the onscreen Nicole passed into the initial darkness, Nicole's voice resumes with the first glimmer of distant candlelight:

Did I say all? No! One was lame
and could not dance the whole of the way.
And in afteryears, if you would blame
his sadness, he was used to say:
"It's dull in our town since my playmates left.
I can't forget that I'm bereft
of all the pleasant sights they see
which the piper also promised me.
For he led us, he said, to a promised land
adjoining the town and close at hand
where waters gushed and fruit trees grew
and flowers put forth a fairer hue
and everything was strange and new." (Browning 1888, 43–45)

As she begins this stanza, the film cuts away from Nicole and Sam's slow progress through the shadowy barn to a storybook image: the lame boy looking longingly after his playmates who follow the Piper's call. As the narrative asserts, his faith in the Piper's wonders is untroubled by the children's disappearance into the mountain, his vision of delights still clear even as adults of the town mourn.[12] And what of Nicole, now beyond the portal with her Piper-father? With tight control, the film offers a vision of its own. As we hear of "the pleasant sights they see" the camera returns to the barn to pan with excruciating slowness upward along softly flickering bales of hay; only with the "promised land" stanza does it reveal the provocatively beautiful image of Nicole and Sam laying among the hay, softly lit by dozens of candles. As they come fully into view, the camera briefly halts its ascent, shifting its angle and moving slightly in to better show Sam stroking Nicole's hair for a moment before he pulls her down into a kiss that jolts the camera back into its upward sweep, its now-familiar deliberate pace ever more intolerable as their embrace continues. When a beam in the foreground suddenly moves in to cut short the scene, the audience shares the thwarted perspective of the lame boy—like him, we have been promised visual pleasures that

we are then denied. Ambivalent though viewers may be about these pleasures, *The Sweet Hereafter* has already excused our voyeurism with the calculated romance of the scene, which, seen through the eyes of the lame boy, becomes a mysterious space of pleasure, one that appears dreadful only to those who cannot hear the Piper.[13]

When next we see Nicole, she is in the hospital, alive but crippled. "Don't even try to remember," her father ambiguously commands as she regains consciousness. In the scenes that follow, we learn he can barely bring himself to touch her—she has become the lame boy, expelled from the promised land, and she is indeed bereft. When Sam finally names the new gulf between them, Nicole responds with a mixture of provocation and accusation:

> *Sam*: You seem … I don't know … distant I guess. Hard to talk to.
> *Nicole*: We didn't use to have to talk a lot, did we Daddy?
> *Sam*: What do you mean?
> *Nicole*: I mean, I'm a wheelchair girl now, and it's hard to pretend that I'm a beautiful rock star. [*no response*] Remember Daddy, that beautiful stage you were going to build for me? You were going to light it with nothing but candles?

Damningly, Sam cannot muster a response. His failure, as registered in this scene, is not his use of Nicole as a romantic and sexual object, but rather the loss of this vision, of his desire. In this and other scenes, the film maps Nicole's depression and rising fury, leading us to her final determination to punish him. Accompanied by her own voice-over repeating the lame boy's explanation for his sadness, now her own rather than the viewer's, Nicole stares at her father while she lies in the deposition, causing the lawsuits to collapse around her and forcing the town into a less recuperative model of post-traumatic existence. By making her revenge its dramatic climax, *The Sweet Hereafter* centralizes Nicole's anger at Sam's abandonment, thus securing the lost joys of incest as the memorable pivot around which its plot finally turns.

Assessing the Implications

Considering the scene in the barn alongside the origins of Nicole's anger, viewers concerned that incest representations appropriately condemn the practice as exploitative abuse must judge the filmic *Sweet Hereafter* harshly: it does not merely evade a feminist representational cliché—it reinvigorates the very clichés that responsible politics insist we stamp out. The incest in this film is titillatingly romantic, a sign of confusion rather than exploitation, a problem only when it abruptly ends. And yet the film is surprisingly adept at uncoupling the representation of incest from its representation of incest's

participants. The feminist condemnation of perpetrators, for example, survives the revisionist *Sweet Hereafter* intact. Despite Egoyan's musings in interviews on the paternal passivity by which non-coercive incest begins, the film marks the father's active malevolence. Sam's eager pursuit of a monetary settlement shocks even the lawyer, and his willingness to taunt Billy (the recent widower who has lost both his children in the accident) over his inability to "get on with his life" seems designed to alienate Sam from even the most sympathetic viewer. Similarly, the film manages to represent Nicole as both sympathetic and powerful despite holding her responsible, at least in part, for the abuse.

Indeed, the two published critical readings of *The Sweet Hereafter* focus their analyses of the film upon its construction of Nicole's power. Vivian May and Beth Ferri's "'I'm a Wheelchair Girl Now': Abjection, Intersectionality, and Subjectivity in Atom Egoyan's *The Sweet Hereafter*," which is concerned with overlapping identity categories, praises Nicole's character as one that "simultaneously evokes and subverts ableist and gender stereotypes as a means of challenging their power to define and delimit" (2002, 142). Similarly, Katherine Weese's "Family Stories: Gender and Discourse in Atom Egoyan's *The Sweet Hereafter*" begins with the presumption that Nicole is a "character with feminist vision" and explores the ways in which "the film grants [her] narrative power" (2002, 70). Strikingly, both of these essays sidestep the political questions raised by the film's representation of "noncoercive" incest. Weese pushes the issue into a footnote, where she raises the possibility that the scene in the barn might appear consensual but argues that the episode is more accurately interpreted as a measure of Sam's power.[14] May and Ferri note that incest occurs but do not engage with the political implications of this specific representation of it, thus eliminating the issue from their analysis altogether. Reading *The Sweet Hereafter* as if it were a traditional feminist representation, each of these analyses takes for granted that the incestuous relationship marks Nicole's powerlessness; they thus set out to map the representational trajectory through which the film transforms Nicole from an abused child into a triumphant heroine, stressing the role of the bus accident that unexpectedly enables Nicole to see (and thus fight) her father's commodification of her body.[15]

Certainly, Nicole does gain power over the course of the film.[16] Yet ignoring *The Sweet Hereafter*'s representation of quasi-consensual incest masks the film's central paradox: the film tells a dangerously victim-blaming narrative and yet produces a tremendously powerful victim. The paradox is deepened by the fact that the troubling portrayal of incest runs throughout the film; there is no ideological transformation along the way, no simple move from irresponsible victim-blaming to laudable victim empowerment. Overlooking this apparent contradiction is a theoretical mistake, I argue, for

it is precisely this paradox that makes *The Sweet Hereafter* such a productive site for feminist analysis. Earlier in this essay, I invoked recent feminist critiques of the anti-violence movement's emphasis upon combating cultural tendencies to "blame the victim" by insistently representing victims' innocence and helplessness. Citing their calls for "a self-consciously performative and deconstructive" portrayal that "conceives of female sexuality not as a discrete object whose violation will always be painful and instantly apparent, but as an intelligible process whose individual instances can be reinterpreted and renamed over time," I asked if *The Sweet Hereafter* could possibly contribute to that effort despite its problematic investment in quasi-consensuality (Heberle 1996, 63; Marcus 1992, 400). At this point, I want not only to suggest that yes, the film does offer a usefully deconstructed incest narrative, but also to raise a disquieting possibility: that the film succeeds not *despite* but *because of* its most troubling elements—that it unexpectedly produces Nicole's agency out of its patently problematic blurring of incest and romance.

This assertion invites an interpretation of Nicole's singing, for example, that is very different from both Weese's and May and Ferri's. While I agree with them that the film links her music to Sam's abuse, I argue that the film does not contain the import of her music within that linkage. Instead, *The Sweet Hereafter* figures Nicole's singing simultaneously as a mark of subjugation and agency. Reading the scene of the fairground rehearsal, in which Egoyan undoubtedly presents Nicole as "the object of both her father's and the viewer's gaze," Weese suggests that "Nicole is playing out a role in her father's fantasy for her, and hence becomes the bearer of his meaning" (2002, 74). Yet in this scene Nicole is not simply a "vision" but someone *with* vision. That the film does not share this vision with us (that is, that the camera never films from her perspective) does not negate the many ways in which the scene registers Nicole's literal and metaphorical ability to see. First, she stands on stage, above her father—quite literally, she can see wider and farther than he. Second, the admittedly discomfiting portrait of Nicole's doubled head and shoulders grants her the symbolic vision of Janus—looking backward and forward in time, she is the auspice of new beginnings. Third, her song suggests a route to living wisely and well that relies upon the power of clear vision—its refrain struggles to create meaning out of all-encompassing limits (the inescapable bounds of place and time).[17] Yes, the film marks Sam's pleasure at this performance, but it marks with even greater emphasis Nicole's ability to demand that Sam reveal and articulate that pleasure, as well as his anxious struggle to do so.

Extending this argument to the scene in the barn is, I acknowledge, unsettling. While it seems possible that the film goes too far in disrupting our expectations, that it risks disrupting the still-new presumption of the

unacceptability of father–daughter incest, this portrayal unmistakably answers Heberle's call for stories of violence that foreground their own representational qualities. Whether we see the scene in the barn as a mysterious promised land to which we have been unduly denied access, as a fantasy that Nicole has spun to tolerate the abuse, or as some combination of the two, the image of daughter and father kissing among the candles does not produce a self-naturalizing story of incest. It emphasizes its own construction and thus the possibilities of interpretation. In going further to cast Nicole as one of the authors of this patently constructed (and thus deconstructable) incest narrative, in demonstrating how and why she might participate in its writing, *The Sweet Hereafter* makes Nicole vulnerable to being blamed for her own abuse. Like other recent representations that abandon the traditional feminist insistence on girlhood helplessness, however, the film seeks out limited instances of childhood power. Dangerous though this move may be, it carries its own rewards—it grants Nicole what May and Ferri describe as "agency within constraint," a quality they assume she acquires over the course of the film but that I insist is present in her from the first. The narrative authority Nicole displays in the deposition is not newly sprung from the bus accident; it is an extension of the broad perspective *The Sweet Hereafter* grants her in the initial fairground scene and in the troubling authorship it attributes to her in the barn.

Egoyan's representation of incest culminates with Nicole's false testimony, as does Banks's. A comparison of this scene in the two texts—the novel that enacts conventional feminist strategies and the film that transgresses their careful limits—thus offers a final assessment of the impact of those transgressions. In both novel and film, Sam makes a futile attempt to salvage the lawsuit by assuring Mitch that Nichole/Nicole has lied. Mitch knows that this is irrelevant. "Right now, Sam," he says, "the thing you've got to worry about is *why* she lied." Because she is angry and sad, the audience can reply—but about what, and with what hopes? Answering the first part of this question, it seems impossible to imagine a feminist defence of the filmic version: Banks's Nichole is angry and sad because her father had sex with her, while Egoyan's Nicole is angry and sad because he stopped.[18] The film's accomplishment—its ability to complicate what seems otherwise to be a reactionary patriarchal fantasy—lies in the answer it provides to the second half of the question, an answer inextricably linked to the first. In the novel, Nichole explains that the combination of the lawsuit and the incest have left her family fragmented, with too many secrets. Naïvely enough, she expects that scuttling the lawsuit will allow them to "become a regular family again ... all of us trusting one another"; she imagines the tacit acknowledgment of the incest will be amusing but beside the point, and is surprised but pleased to see how thoroughly it destroys her father (Banks 1991,

198–200). Relying on Nichole's helpless innocence to make her sympathetic, Banks cannot allow her to plan for revenge. Egoyan's Nicole, on the other hand, has enough agency to scheme. The film introduces and then interrupts her lie—her rewritten version of the accident that reshapes her family and her town—with two voice-over stanzas. The introductory recital of the lame boy's sorrow reminds us of her motivation, while the interruption makes clear her intent. Wresting authorial control from Browning, she fulfils the poem's early promise of just revenge by articulating a desire most clearly her own: "And why I lied, he only knew / But from my lie, this did come true / Those lips from which he drew his tune / were frozen as a winter moon."

Earlier, I argued that *The Sweet Hereafter* interweaves its two traumas, using the shock of the incest to register the horror of the bus wreck; in this alignment, the film uses incest as a powerful epistemological frame even as it troublingly casts incest as accidental, an unavoidable event for which no one is culpable. I want now to propose we read the deposition scene as a traumatic repetition of sorts, a return to and reversal of the film's earlier structural moves. Nicole's lie proposes that the bus wreck was no accident, that it had both a cause and a culprit. In its vehement denial of this possibility—no one who matters believes in Dolores's recklessness for an instant[19]—the film introduces the prospect of culpability only to translate it away from the bus wreck and onto the incest. It is only within that frame that the rhetoric of Nicole's testimony makes sense. Her story is ostensibly a lie about Dolores, ostensibly told to the deposing lawyer. But as she declares "I'm remembering," it is Sam who literally snaps into focus to hear the more fundamental truth she is telling. Freed from the constraints of their unequal collaboration by the very abandonment that motivates her speech, Nicole silences Sam's voice by narrating her own version of their past. "I was scared," she says, crying a bit and looking like a child for the first time in the film:

> *Nicole*: We were going too fast … and I was scared.
> *The deposing lawyer*: Did you say anything?
> *Nicole*: No.
> *Lawyer*: Why not?
> *Nicole*: Because I was scared, and there wasn't time.
> *Lawyer*: You remember this?
> *Nicole*: Yes, I do, now that I'm telling you.

Keeping the lawyer as a literal blur, the camera focuses itself and our attention on Sam, at whom Nicole stares sadly as she offers at last the story of his recklessness, of his undeniable guilt. And then she becomes the abandoner, ending their story and the film itself by describing her new life "in the sweet hereafter," the promised land of the Piper into which only those who were on the bus can pass. In this final inversion, the film uses the accident to

make the incest suddenly visible as *incest*, as exploitation rather than simple romance. Stripped to its core, Nicole's telling is almost a cliché: her father has taken advantage of her fear. And yet it is not—we grasp the terrible crime, finally, not through Nicole's vulnerability or her destruction, but through Sam's utter culpability. It is in this moment, I would argue, that Egoyan's problematic portrayal provides the representational intervention for which feminist theorists have recently called: it measures the horror of incest on a scale not calibrated with female devastation.

Acknowledgments

I am very grateful to the University of Michigan's Institute for the Humanities, where I was in residence while writing this article. I am also indebted to Anne Rodems, Christopher Matthews, and Susan Boyd for the insight and patience they each demonstrated in our many conversations about *The Sweet Hereafter*; to Douglas Rogers and Theresa Braunschneider for extending that patience into thoughtful readings of this work; and to the editors of this volume for offering their own valuable guidance.

Notes

1 For a concise overview of feminist theorizing about sexualized violence, see Ann Cahill's 2001 *Rethinking Rape*, especially her introduction, "The Problem of Rape," and her first chapter, "Feminist Theories of Rape: Sex or Violence?"

2 The extensive theoretical literature on trauma begins with late-nineteenth-century studies on hysteria, a history well documented in recent writings on trauma and its effects. The foundational texts of current theorizing are the 1991 special issues of *American Imago*, edited by Cathy Caruth and republished in book form as *Trauma* (1995), Judith Herman's *Trauma and Recovery* (1992), and Shoshana Felman and Dori Laub's *Testimony* (1992).

3 For one of the most nuanced analyses of the audience's role, see Dori Laub's "Bearing Witness, or the Vicissitudes of Listening" (1992).

4 Egoyan repeats variants of this statement in almost every interview about *The Sweet Hereafter*. Often he suggests that the "cliché" of incest is fairly new; it is unclear whether he is unaware of the pre-1990s wave of incest narratives or if he is simply offering an excuse for Banks's portrayal.

5 Incest is also a central theme of Egoyan's 1994 *Exotica* and his 2002 *Ararat*; suggestions of incest occur in other films, such as his 1999 *Felicia's Journey*.

6 "Nichole" of Banks's novel becomes "Nicole" on Egoyan's cast list. The change is minor, but I follow it here as a background reminder of the text under discussion.

7 In their article, "'I'm a Wheelchair Girl Now': Abjection, Intersectionality, and Subjectivity in Atom Egoyan's *The Sweet Hereafter*," Vivian May and Beth Ferri argue that the multiple sites of action within each shot disrupt the narrative by forcing viewers "to make choices about where to focus our attention... [making us also] aware of all that we are *not* seeing" (2002, 134).

8 There is also a fourth timeline, which functions less disruptively, since its location in the future (two years hence) is explicitly marked within the film. A long

episode broken into several scenes, this future plot concerns Mitch's chance encounter with a childhood friend of his now adult daughter; they discuss Zoe's addictions as well as a near-fatal spider bite in her childhood. Like the incest subplot, Mitch's relationship with Zoe interacts with the main story of *The Sweet Hereafter* by raising questions of causality and loss. Amplifying the impossibility of redemption, this subplot is appropriately unaffected by other events within the film; structurally, it remains outside the primary narrative.

9 The structural function of this shock sheds new light on Egoyan's desire to avoid cliché—he needs the audience to be utterly unprepared for what it will see.

10 Egoyan immediately qualifies his one allusion to the sexual aspect of incest, naming "the father's sexual desires but also a shared romance" as a motivation (Egoyan 1998).

11 May and Ferri, for example, see the two narratives as emphasizing a juxtaposition between "the idyllic safety and comfort of a nursery rhyme with stories of incest, loss, and vindication"; their quick reading of this scene thus takes it as a damning representation of "innocence lost" (2002, 138). Taking more time to attend to the dangers present in the fairy tale itself, Katherine Weese offers a highly nuanced reading, yet one that still positions the verse as offering a statically critical perspective on the incestuous scene (2002, 76–77). In so doing, each of these assessments echoes (and is perhaps shaped by) Egoyan's own explanation: "While the image we see onscreen suggests Nicole's acquiescence— even complicity—in the incest, the reading of the poem, with its intimations of manipulation and annihilation, reveals her feelings of surrender and confusion" (1997a, 20).

12 In Robert Browning's poem, the children do emerge safely with the Piper in a strange and wonderful new land. The lame boy is right.

13 Weese, in contrast, argues that the use of Nicole's voice in reading the "lame boy" stanzas aligns her with the "left-out child." In her interpretation, "the lines imply she is bereft not because she doesn't get to enter the cavern (barn) but precisely because she does follow her father, does engage in acts that strip her of her childhood" (2002, 77). While I find much of Weese's careful analysis persuasive, this reading points to the limits of setting aside, as she does, the role of the audience—it prevents her from considering the lame boy's specific role as the excluded watcher.

14 In her footnote, Weese uncharacteristically elides the fictional nature of the barn scene by referring readers to the work of Judith Herman for an explanation of why daughters might appear willing when they are not (2002, 87–88, fn. 16). Such a reading might well be helpful in understanding Egoyan's perspective. Still, a theory of why a girl might seem willing is not the same as an analysis of the film's portrayal of a girl's willingness.

15 Given their tendency to read the film through the lens of the incest "cliché," it is worth noting that this model of transformation is much more present in Banks's novel. There, the accident clarifies Nichole's relationship with Sam. "Before," Nichole narrates, "everything had been fluid and confused, with me not knowing for sure what had happened or who was to blame. But now I saw him as a thief, just a sneaky little thief in the night" (1991, 180). This realization begins her transformation.

16 Weese's explication of Nicole's evolution into the film's heterodiegetic narrator is an especially persuasive account of her growing authority.

17 Nicole is singing the Jane Siberry song "One More Colour."

18 Banks's novel, with its device of first-person narration, allows its Nichole a more direct articulation of her anger with Sam: "He had robbed me of my soul" (1991, 180). Her reaction to his post-accident withdraw, however, is one of relief.
19 Nicole's lie can derail the lawsuit only because the film has already cast the legal system as an obfuscator rather than a revealer of truth; she uses the system's weakness (the need for simple answers) against itself to seize the interpretation of the accident away from Mitch and place it back in the hands of the townsfolk.

Works Cited

Banks, Russell. 1991. *The Sweet Hereafter*. New York: Harper Collins.

Browning, Robert. 1888. *The Pied Piper of Hamelin*. New York: Frederick Warne.

Cahill, Ann. 2001. *Rethinking Rape*. Ithaca, NY: Cornell University Press.

Caruth, Cathy, ed. 1995. *Trauma: Explorations in Memory*. Baltimore, MD: Johns Hopkins University Press.

Egoyan, Atom. 1997a. "Recovery: Atom Egoyan on Incest, Fantasy and the Tragic Death of Children in *The Sweet Hereafter*." *Sight and Sound*, October, 20–21.

———. 1997b. "Staying Open." Interview by Cindy Fuchs. *Philadelphia City Paper*, December 25, 1997–January 1, 1998. http://citypaper.net/articles/122597/movies.interview.shtml. (accessed November 7, 2004).

———. 1998. "A Conversation with Atom Egoyan." Interview by Marcia Pally. http://www.marciapally.com/egoyan.html. (accessed March 1, 2003).

———. 1999. "Family Romances: An Interview with Atom Egoyan." Interview by Richard Porton. *Cineaste*, December, 8–15.

Felman, Shoshana, and Dori Laub, eds. 1992. *Testimony: Crises of Witnessing in Literature, Psychoanalysis, and History*. New York: Routledge.

Hartl, John. 1997. "Egoyan Changed Course for *Sweet Hereafter*." *Seattle Times*, December 26.

Heberle, Renée. 1996. "Deconstructive Strategies and the Movement against Sexual Violence." *Hypatia* 11, no. 4: 63–76.

Herman, Judith Lewis. 1992. *Trauma and Recovery*. New York: Basic Books.

Laub, Dori. 1992. "Bearing Witness, or the Vicissitudes of Listening." In *Testimony: Crises of Witnessing in Literature, Psychoanalysis, and History*, ed. Shoshana Felman and Dori Laub, 57–74. New York: Routledge.

Marcus, Sharon. 1992. "Fighting Bodies, Fighting Words: A Theory and Politics of Rape Prevention." In *Feminists Theorize the Political*, ed. Judith Butler and Joan W. Scott, 385–403. New York: Routledge.

May, Vivian M., and Beth A. Ferri. 2002. "'I'm a Wheelchair Girl Now': Abjection, Intersectionality, and Subjectivity in Atom Egoyan's *The Sweet Hereafter*." *Women's Studies Quarterly* 30, nos. 1–2: 131–50.

Weese, Katherine. 2002. "Family Stories: Gender and Discourse in Atom Egoyan's *The Sweet Hereafter*." *Narrative* 10, no. 1: 69–90.

▶▶ **15**

Close
Voyeurism and the Idea of the Baroque

William F. Van Wert

Deceptively simple in its execution, Atom Egoyan's installation with Julião Sarmento at the 2001 Biennale in Venice, *Close* is decidedly complex in its mechanisms and theoretical apparatus.[1] Two boards or screens (the size and shape of wide-screen cinema), arranged in sandwich fashion, form the simple body or "cineplex" of the installation. A walk-through aisle or corridor is situated between the two screens, but the walk is a tight fit: two people cannot pass each other side by side. Had someone already been "inside" the installation space, I would have had to wait for that person to leave in order to walk through. As it was, on that particular Saturday morning the third weekend in June, I had the installation all to myself for almost two hours. While the installation was praised critically, there was no indication of any "popular" success.

Standing inside the installation, I felt the viewing screen was closer than an arm's length away while the "backing" screen ran snugly along my body from head to toe, providing the first meaning of *close* as claustrophobic or too close. Actually, the physical space of the installation demonstrated at least three primary meanings of *close*: (1) the cinematic close-up, which both aggrandizes and cuts off; (2) close quarters and claustrophobia; and (3) close(d), that is, shut off or missing.[2] Looking straight ahead, I could see nothing in distinct focus, only undulating beige forms and shapes that looked

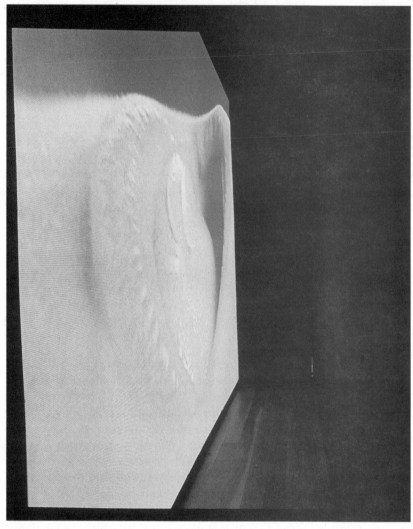

Close. (Rita Burmester © Museu de Arte Contemporânea de Serralves)

like skin. But from the left-most end of the installation, if I looked periph-
erally toward the right-most end, I could see various permutating images in
focus: a foot (or what appeared to be a foot) and the clippings of toenails; a
woman's mouth (lipstick denoting gender) around a big toe (or is it a thumb
in her mouth?); fingers (a dentist's?) at work inside a woman's mouth with
the aid of a silver metallic apparatus. Their status as extreme close-ups keeps
them provisional in terms of any absolute meaning. But these images (mouth,
fingers, arms, legs, toes) provide the primary arena of the pictorial. Further,

these are images of pleasure and pain, seemingly gendered female, although there is no absolute proof except for the lipstick on the mouth and some references in the spoken text.[3] Rather than offer a soundtrack straightforwardly synchronized with the image track or providing some kind of voice-over commentary that would help us situate these images, the spoken text accompanying these images meanders in a digressive and analogical way (using likenesses, similes, metaphors—tropes of resemblance), touching on a remembrance of childhood, a discussion of whether a rabbit's foot means luck or not, and a realization that it certainly isn't lucky for the rabbit and that something else like a starfish—a parthenogenetic creature, able to grow back lost parts—would be a more apt symbol for luck. What connects the image track to the soundtrack, then, is a structural strategy rather than direct links. The whole of the installation is repetitive and looping: the same images in acceptable focus on the right-most edge are also in focus on the left-most edge when viewed from the right-most end of the installation, and the spoken text repeats itself at regular intervals.

A few examples will show how the images and spoken text illustrate and play off of each other:

> *Soundtrack*: "What's weird is that its existence is based on the possible torture, well… or—at the very least—the complete lack of luck on the part of the animal."[4]
>
> *Image track*: Close-up of fingers with the silver metal apparatus in the female mouth, nostrils behind the fingers.

The rabbit's foot is never shown, but rather is exemplified in the close-up of the silver metal apparatus, which cuts off even as it aggrandizes. The "complete lack of luck" is exemplified in the connotations of pain most of us feel on visits to the dentist. The open mouth and open nostril are vulnerable to the probing, penetrating finger and apparatus. The rabbit's foot is divorced from the rabbit and from any sense of an amputation and torture of a live animal, and is felt as an anachronism, the way wisdom teeth are in a human mouth.

> *Soundtrack*: "It's like they become possessed with that moment…"
>
> *Image track*: Clamp holding mouth open wide.

The soundtrack emphasizes possession as a key process in the appropriation of the missing animal part (rabbit's foot, Cinderella's slipper, and so on), and I will later explain how possession ultimately plays a key role in voyeurism. But here what is important to note is what can be called the trauma of the image coinciding with the soundtrack. This strategy is not unlike the image of an empty eye socket in *Hiroshima mon amour* (Alain Resnais, 1959) that coincides with the statement that love cannot be forgotten. Resemblance makes it so. Although there is no proof that love cannot

be forgotten, this visual of an empty eye socket cannot be forgotten and thus, love cannot be forgotten.

> *Soundtrack*: "Of course, in the wild, they'd wear their nails down by running around and digging."
> *Image track*: Close-up of teeth in mouth.

There is no visual of nails being worn down by running around and digging. But by way of resemblance, the extreme close-up of the teeth functions as proof: teeth wear down by chewing, masticating, cutting, swallowing.

> *Soundtrack*: (Cinderella story): "... the stepmother uses a knife to cut her foot to make it fit... and that's how the prince realizes that the slipper isn't hers..."
> *Image track*: Close-up of finger in mouth.
> *Soundtrack*: "... because... he sees the blood through the glass dripping over the edge..."

This very detailed description, including the blood, is in the book of *Close* but not in the final installation. Yet the analogies or metaphor-cluster still work: from rabbit's foot to Cinderella story to "cat got your tongue," a series of amputations is illustrated on the pictorial plane by the extreme close-ups, by the finger penetrating the mouth, by the silver metal clamp, silver slipper, rabbit's foot holder. Throughout these image-looping and repetitive texts, the viewer/listener is treated to a play of resemblances.

Vicente Todoli, who curated the *Something Is Missing* exhibit—the first exhibit emanating from the *Close* collaboration of Egoyan and Sarmento—described the work this way: "We find identical concerns: the spectator's relationship with the image projected onto the screen; *voyeurism;* the vestiges of an action, whether mundane or significant; the paring away of the narrative, which is reduced to its bare essentials; an eroticism that is based on what we do not see" (Egoyan and Sarmento 2002b, 8). I am most struck by the last statement: "an eroticism that is based on what we do not see." Not only will this statement provide a basis for defining the baroque in this paper, but it also points to a relationship otherwise easily overlooked or missed: that between metaphor and metonymy. While metaphor connects the various amputations of the spoken text (rabbit's foot, Cinderella story feet, cat got your tongue), metonymy (the trope of lack or loss, what is missing, the underside of metaphor) is what finally explains the pleasure/pain, the eroticism of the piece. And this missingness is generative, as Michael Tarantino points out: "If something is always missing, there is always something for us to imagine in its place" (Egoyan and Sarmento 2002b, 8).

Obviously, the installation plays with voyeurism, but of a convoluted sort. Voyeurism transforms vision into cathected vision or eroticized vision. As Christian Metz has pointed out, voyeurism extends beyond arm's length.

If you can reach out and touch the object of your voyeurism, then it's not voyeurism. (This is why Michael Powell's 1960 film *Peeping Tom* is not really about voyeurism.) *Close* would seem to be a contradiction here, but it's really not. We can reach out and touch the screen in front of us, but there is nothing in acceptable focus there; what draws us is the focus of the other end of the screen, which we cannot reach out and touch. Voyeurism turns eyes into fingers, seems to transform the visual field into a tactile field, takes faraway distance (tele-distance) and turns it into something pleasurably myopic: extreme close-up. But, in so doing, it "amputates" the visual field: a body becomes a body part. An extreme close-up literally cuts what is seen off from what it logically attaches to. A body part is thus severed from its overall body through voyeurism. Metonymy, the use of a part for a whole, becomes, then, the trope of choice here. In *Close*, a mouth sucks a big toe or attaches to a finger. Notice how this voyeuristic formulation differs from a more holistic one, wherein the mouth belonging to a woman attaches to the finger belonging to the hand of a male, perhaps a dentist.

In addition to this amputation of the visual field, or perhaps because of it, voyeurism always involves a misrecognition, in the psychoanalytic Lacanian sense, or literally a missed recognition. When we are in love, for example, we trade accuracy of vision (we no longer see the loved one "correctly," as others see the loved one) for eroticized vision (so that the loved one, we think, has no flaws). If and when we fall out of love with that person, we are shocked that we ever felt such caring: accuracy of vision has been restored, and we no longer see voyeuristically. Voyeurism always involves this trade-off: the pleasure, often "guilty," of trading eroticized, close-up, amputated vision for accuracy. We think we see better, when in fact we merely see closer, and in that enlargement is a misrecognition, a missed recognition or connection, a blind spot. This is what Lacan calls the screen or snare or trap for the gaze (1979, 89), his *objet petit a* (*a* standing in for *autre*, or "other").

So while voyeurism exaggerates things, it does not clarify them. In fact, ambiguity is a condition of voyeurism. We describe what we see in the installation *Close* in a narrative way when in fact there is no narrative. I see a mouth with lipstick around a finger (whose?). The ambiguity is coloured or inflected by the metonymic linkage of metaphoric images suggested by the spoken text, however. The image on the screen is initially (provisionally) described in the spoken text: a woman's voice as she idly clips her toenails (linking the silver metallic apparatus to a toenail clipper?). But the soundtrack proceeds to talk about the amputated rabbit's foot, the bloody hacked-off toes in the original Cinderella story (all sanitized and disappeared in the Disney reincarnation), and the amputated tongue implicit in the last words of the text: "Cat got your tongue?" And so the image of the woman idly clipping her toenails is transformed (no longer so ambiguous) and made men-

acing, threatening. The apparently innocuous act of clipping toenails, when likened to the Cinderella story, in which women deliberately amputate their toes for the sake of beauty, now becomes grotesque, yet still voyeuristic, pleasurably painful.

Added to all that is going on in front of the eyes is the claustrophobia of the cramped body (mine) in the corridor, forced so close to the viewing screen by the backing screen. Ordinarily, we think of voyeuristic pleasure as an anonymous or invisible pleasure, but in this instance we are made aware of our own whole bodies by the back wall, which gives us no retreat, no anonymity, no invisibility. We would like to become lost in the amputation of the visual field, the tele-distance made close, the looked-at become suddenly and seductively tactile, but we're not allowed to escape the totality of our own very limited viewing space and the unfortunate totality of our cramped bodies—unfortunate, because the whole body seems useless, archaic like an appendix, since only our eyes are seemingly engaged in the viewing of the undulating and ambiguous images. So, then, we experience the many meanings of close: close-up, exaggerated, amputated, and misrecognized; close, at close quarters, claustrophobic; close, as in metonymy, proximity, meaning through contiguity, parts for wholes; and close(d), shut off, blinded, limited, missing.[5]

Egoyan's *Close* installation belongs to the illusionistic tradition of anamorphosis, *trompe l'oeil*, and foreshortening that includes both the curious and the exotic: Pozzo's ceiling in the church of St. Ignatius in Rome; the anamorphic "corridor" in the French nunnery atop the Spanish Steps in Rome; *The Ambassadors* (1533), the fascinating painting by Hans Holbein of a disklike shape containing a skull; the many foreshortenings of Caravaggio; the sculptures of Bernini. In fact, *Close* reminds me of the introduction of the baroque into Western art in the seventeenth century. Let me illustrate this point by way of a few close observations on the above examples.

Hans Holbein's *The Ambassadors* has benefited a great deal in recent years from various psychoanalytic readings of the skull, beginning with Lacan,[6] but its importance as a precursor of the baroque is what interests me here. On one level, the skull quite simply is a signature of the painter (*Holbein* means "hollow bone" or skull). But on another level, the skull reminds us that we are always repressing something in art—mortality, death, but also ambiguity and conflicting messages (lines of sight cut off, single explanations thwarted, and so on). On the pictorial plane, the skull is sandwiched between the foreshortened lute above and the circular forms on the rug below the feet of the two ambassadors, so that it is quite possible to miss the skull altogether on first viewing. What is most important about the painting is that it is necessary to see it from at least two vantage points to get its full import. Holbein's visual field marks a radical departure from Albertian per-

spective (variously called single-point perspective, monocular vision, Cartesian logic).[7] The anamorphic painting does not yield a skull when one looks at it head-on (similar to the screen of *Close* yielding nothing head-on). When one moves to the side of the painting and looks back, however, the skull suddenly becomes visible (just as the image comes into focus when one looks from both extreme corners at the opposite corners in *Close*) (Jay 1993, 48–49). Having glimpsed and grasped its hidden forms, the viewer then wants to return to the centre to review the overall painting. This necessity for multiple viewing points is what characterizes the baroque.

A colleague recently told me his definition of the baroque was "wanting to look around corners." A sense of looking, but not fully seeing, is what I keep from my colleague's definition, which reminds us of the passages I quoted earlier from Todoli and Tarantino regarding the erotics of the things we do not and cannot see.[8] Egoyan's *Close* fits here perfectly. Seen head-on, the undulating images yield nothing—no focus at all. Focus comes from viewing to the side, over the shoulder, askance, deflected vision; from making peripheral vision into frontal. This over-the-shoulder vision, it occurs to me, does not happen without a certain psychological risk—think of Lot's wife and of Orpheus. The experience of the viewer of *Close*, standing at the extreme left and looking to the extreme right then standing at the extreme right and looking to the extreme left, zigzagging the corridor, involves making an X of vision. The same images loop, repeat enigmatically, just as the spoken text does.

Bernini's *The Ecstasy of Saint Teresa* (1651) in the Cornaro Chapel of the Church of Santa Maria della Vittoria in Rome is another point of reference for the idea of the baroque (Avery 1997, 144–49). Perhaps more than any other artwork in the baroque period, it represents the need for multiple perspectives. The viewer wants to see the source of the light rays coming down on St. Teresa and the angel. To do so, the viewer must go as close to the altar as possible (now roped off), and the light source is still not visible from there. The tease is similar to that of Marcel Duchamp's *Tu m'as* peephole at the Philadelphia Art Museum (a voyeuristic look without full satisfaction of seeing, exemplifying the difficulties of looking, the thwarting of sightlines, the limits of voyeurism's pleasure). But this close to the Bernini altar, the viewer completely misses the gallery of cardinals on either side of the altar, most of whom were already dead by the completion of the piece by Bernini, and are certainly not paying attention to St. Teresa's ecstasy (except for one). Thus, the dilemma is that to stand back far enough to see the gallery on either side (completing the piece) is not to see the altar close enough to engage the light source; to stand close enough to St. Teresa and the angel is to miss the gallery of onlookers, thus misrecognizing the overall work. So, we see the need for the multiple viewing points of the baroque.

What in fact the viewer wants most of all to see is impossible to see: St. Teresa's point of view. Herein lies the paradox: extreme states like religious rapture or sexual ecstasy cannot be conveyed. They are visions, but they are not visual. St. Teresa's own verbal descriptions of the event betray her: they are full of similes and metaphors, tropes of resemblance, but they are thus substitutions, stand-ins, simulacra, and not the real thing.

This same paradox holds true for Caravaggio's *The Conversion of Saint Paul* (1600–1) in the Cerasi Chapel of Santa Maria del Populo in Rome. As viewers we squeeze and contort ourselves, trying to look up and see the foreshortened hoof of the horse from St. Paul's vantage point, only to realize that St. Paul's eyes are closed and that the whole ground or floor of the painting cannot be level and hold all of these appendages. His "vision" is not visual. And, while not concerned with visions of ecstasy or conversion, Egoyan's *Close* installation is also, I would contend, not strictly visual or at least ambiguous visual in a similar way to the baroque examples. We think we see toenail clippings, a mouth held open for some purpose, but without a context (narrative), we're not really sure what exactly we're looking at or in fact seeing, just that we are compelled to look obliquely or diagonally to see anything in focus, and that we want to be two places at once, to enfold and unfold the work.

One is tempted to find puns and double meanings at every juncture of the installation or in the various readings of the installation: the cut (film cut, rabbit's foot, Cinderella's various cut feet, the cut tongue of the cat in "Cat got your tongue?"); the clip (film clip, toenail clip, undulation competing with the clip of editing or insert); screening (a showing, but also a blocking or filtering). But the most fruitful double meanings come from Egoyan, himself, who wrote that the installation will be a meditation on projection.

Projection should be understood first as physical projection, the space of the installation: the source of the DVD projection is hidden from the viewer, not readily apparent at all. That its source is hidden from the viewer is in keeping with the "guilty pleasures" of voyeurism, the misrecognition of the scene, the eroticism of what is missing, but it also reminds me of David Hockney's conjectures on "tricks" of projection in *Secret Knowledge*, which gives us another way to look at Holbein, Caravaggio, the baroque (Hockney 2001). And we are unaware as well that we might be projected onto the back screen without our knowing it, in the way that spectators in the stands at sporting events ironically provide the studio audience for television and its packaging of those same events for still other spectators, voyeurs. This end of projection involves surveillance, another favourite theme of Egoyan, here repressed much more than in other works of his.

On an even more provocative level, projection should be understood in all of its psychological ramifications. In this regard, I have so far only

explained but half of the mechanism of voyeurism at work in the installa-
tion. The other half has to do with projection and possession. Through
voyeurism we bring tele-distance, what is far away, up very close. But at
some level we appreciate the misrecognition involved and wish for a "cor-
rected" vision (not unlike Chuck Close's portrait of himself as Van Gogh,
which becomes a blur of spots and dots as the viewer comes closer to the
actual work), so that we project ourselves psychologically across the dis-
tance and onto the voyeurized object: analogous to superimposed slides,
they remain separate while creating a third image in their superimposition.
If someone as "exhibited" is shown in a provocative pose (or what we mis-
take as a provocative pose), the voyeur projects herself or himself as the
would-be partner, possessor, superimposition, even intruder, invisible but
almost/always there. We are psychologically called, summoned, interpel-
lated into the visual field.

In *Close*, Egoyan voyeurizes time as well as space, which is the function
of the installation as story. In memory of childhood, that time of long ago is
aggrandized and misrecognized in the close-up of selective memory. The
spoken text of *Close* begins with such a memory and the ambiguity and con-
fusion of gender:

> *Soundtrack*: "You may not think it to look at me now but...I was a bit of
> a tomboy."
> *Image track*: Corresponding visual of adult arms and legs.

Across the repeated pauses (rhythmic, repetitive and active, much like pauses
function in Beckett's plays), the phenomenon of projection takes place:

> *Soundtrack*: "Does the rabbit's luck suddenly transfer to the person who
> gets its foot?"

The voyeur, through projection, empathizes with the rabbit and the loss of
the foot (visually, the loss of the toenails). After likening a rabbit's scream
to that of a human baby, the text makes clear the generative nature of pro-
jection: transformation, possession, a total standing-in for the original object
of one's gaze:

> *Soundtrack*: "It's like they become possessed with that moment, like
> they're almost about to transform into another being."

That metamorphosis is the fascination, then. The rabbit/child analogy gives
way to the Cinderella story (the metamorphosis there is from ash-girl to
princess), and through projection we are treated to a kaleidoscope of quickly
changing points of view: stepmother to prince to listener to reader of the
fairy tale. The following reason for cleaning up the fairy tale is offered: "You
can imagine why they changed it. It's because they thought it wasn't appro-
priate for children." "Appropriate" here means not fitting, not suitable, but also,

in fact, the total empathy of projection, the possession of the baby's scream by the rabbit. The second meaning, then, is as an act of appropriation. And "the cat got your tongue" has at least in one etymology the stealing or appropriation of a baby's breath by the cat. The move into childhood through memory is finally mirrored by a move back out of childhood and a reappropriation of adulthood: "I can't imagine what it would be like to scream like another animal, to so completely transform yourself that you'd become something else." In that possible transformation, there is both the potential pleasure of mimicry and also the devastating fear of losing oneself in the other. This latter fear is why we come close but then cut off and don't allow our voyeurism to become possession/appropriation. We would gladly take full possession of another if we weren't also afraid the other would first take full possession of us. Egoyan's *Close* is a narrow escape from that latter kind of possession.

Notes

1 The *Close* installation at the 2001 Biennale in Venice was the collaborative effort of Atom Egoyan and Julião Sarmento, but neither in the exhibition catalogue nor anywhere else have I found an explanation of how the work was divided. I do freely acknowledge that my attributions to Egoyan are perhaps a slight to the contributions of Sarmento, but such a slight is not intentional.

2 *Something Is Missing* was an exhibition that emerged from the *Close* project. It was held at the Serralves Museum of Contemporary Art from January 25 to March 17, 2002, and was curated by Vincente Todoli, some of whose remarks appear in the catalogue insert published by Serralves (Egoyan and Sarmento 2002b).

3 There is no musical soundtrack to the text of *Close*, and my references to the baroque apply only to painting and sculpture, not to music. However, there is a fruitful connection between Egoyan and the baroque in music, for which I refer the reader to Monique Tschofen, "Repetition, Compulsion and Representation in Atom Egoyan's Films" (2002). [See also Peter Harcourt's essay "Imaginary Images: An Examination of Atom Egoyan's Films" (1995) and Katrin Kegel's essay "The Thirteenth Church: Musical Structures in Atom Egoyan's *Calendar*" in this volume. Jean-Pierre Salgas's essay "Et in Canada Egoyan" (1993) compares Egoyan's early short film *Peep Show* to Holbein's *Ambassadors*. –Eds.]

4 [The soundtrack of the installation is reproduced in the *Something Is Missing* catalogue, which is unpaginated (Egoyan and Sarmento 2002a). –Eds.]

5 It is my personal belief that American films especially, but world cinema as well, have gotten more and more myopic, obsessed with extreme close-ups, in the last ten years. And myopia relates to blindness in this way: the blindness of the nearsighted not wearing their glasses, whereby we think we can't be seen because we can't see anything.

6 Lacan makes special reference to the Holbein in his exposition on the gaze in *The Four Fundamentals of Psychoanalysis* (1979, 85–90).

7 See Martin Jay's argument about how the baroque counters the model of the monocular and static viewing subject whose body was bracketed (1993, 97–106). The viewer's body, cramped in the physical corridor of *Close*, is anything but bracketed.

8 See also the use of the fold as a major metaphor in Deleuze (1993).

Works Cited

Avery, Charles. 1997. *Bernini: Genius of the Baroque*. Boston and New York: Little, Brown.

Deleuze, Gilles. 1993. *The Fold: Leibniz and the Baroque*. Translated by Tom Conley. Minneapolis: University of Minnesota Press.

Egoyan, Atom, and Julião Sarmento. 2002a. *Close*. [Catalogue]. Porto, Portugal: Fundação de Serralves, Edições ASA.

———. 2002b. *Close*. [Catalogue insert]. Porto, Portugal: Fundação de Serralves, Edições ASA.

Harcourt, Peter. 1995. "Imaginary Images: An Examination of Atom Egoyan's Films." *Film Quarterly* 48, no. 3: 2–14.

Hockney, David. 2001. *Secret Knowledge*. London: Penguin.

Jay, Martin. 1993. *Downcast Eyes: The Denigration of Vision in Twentieth-Century Thought*. Berkeley: University of California Press.

Lacan, Jacques. 1979. *The Four Fundamental Concepts of Psychoanalysis*. Edited by Jacques-Alain Miller. Translated by Alan Sheridan. London: Penguin.

Salgas, Jean-Pierre. 1993. "Et in Canada Egoyan." In *Café des images*, ed. Danièle Hibon, 9–18. Paris: Jeu de Paume.

Tschofen, Monique. 2002. "Repetition, Compulsion, and Representation in Atom Egoyan's Films." In *North of Everything: English-Canadian Cinema since 1980*, ed. William Beard and Jerry White, 166–83. Edmonton: University of Alberta Press.

▶▶| 16

Seeing and Hearing Atom Egoyan's *Salome*

Kay Armatage and Caryl Clark

The story of *Salome* is legendary. The brief biblical reference in the gospel of St. Matthew (chapter 14, verses 3–12) to a young Jewish princess and her bizarre request for the head of John the Baptist in payment for dancing for her stepfather, King Herod, became an obsession for late-nineteenth-century European culture. Salome was soon the subject of innumerable poems, stories, plays, sculptures, objects, ballets, films, and paintings. Sultry, orientalized, and lascivious, Salome became an icon of the nineteenth-century decadent aesthetic, "the symbolic incarnation of undying Lust, the Goddess of immortal Hysteria, the accursed Beauty exalted above all other beauties… the monstrous Beast, indifferent, irresponsible, insensible" (Hutcheon and Hutcheon 2000, 206–208). The iconoclastic Irish playwright Oscar Wilde wrote the first play on the subject, in French in 1892, staged in Paris in 1896. Emphasizing contradiction and ambivalence, Wilde portrays Salome as a young and chaste—though wilful—girl, who at the same time embodies sensuality (Hutcheon and Hutcheon 2000, 209). A failure in Paris and banned in England, Wilde's play was subsequently well received in a German translation by Hedwig Lachmann when presented in 1902 by Max Reinhardt in Berlin, where Richard Strauss saw the production the following year. Strauss's 1905 setting of a libretto based on Lachmann's translation of Wilde's text is a provocative modernist creation. Notable for establishing

the brash Bavarian as a major operatic composer (who carried his daring innovations to German opera even further in his 1909 *Elektra*), *Salome* makes extraordinary orchestral and vocal demands, demands that are often eclipsed by the work's sensational dramatic events.

The moral decadence, psychological turmoil, outrageous perversions, and shocking bodily depictions of Strauss's opera push the boundaries of musical theatre, offering perfect fodder for modern-day producers and directors who seek to capitalize on the raw dramatic intensity inherent in the work. More often than not, however, modern productions of the opera have tended to eliminate the central paradox of Wilde's play—the question of Salome's innocence or culpability—tending to emphasize instead one over the other. Most interpretations favour the whore, rather than the virgin, constructing Salome in the operatic tradition of the femme fatale, the demonic beauty who can lure men to damnation (Carmen, Delilah, Lulu), (Hutcheon and Hutcheon 2000, 210). That subsequent productions of *Salome* have broadly contemporary aims, meanings, and different ramifications of both an artistic and political nature is the beginning point of this article, for in the Canadian Opera Company's production of *Salome*, directed by Canadian filmmaker Atom Egoyan, we are offered an unusual rationale for the heroine's actions. The production, which premiered at the Hummingbird Centre in Toronto in September 1996, was revived in January 2002 with a new cast; the talented and nubile Welsh soprano Helen Field performed the leading role, with tenor Robert Tear and soprano Karen Armstrong rounding out the dysfunctional family as Herod, Salome's stepfather, and Herodias, her mother, while baritone Tom Fox completed the main cast as the alluring yet unfortunate Jochanaan. Although both productions were infused with the themes and seductive images prevalent in Egoyan's film *Exotica* (1994), this latest revival of the opera was greeted with more critical acclaim and public scorn than Egoyan's original production. It was clear that many in the Toronto audience already knew what to expect and were prepared for a visually powerful presentation described by one critic as "clarifying, visualizing, and realizing for the first time on stage the unsavory truth that the rest of us displace or evade" (Gerstel 1996). What follows is a polyphonic reading of Egoyan's *Salome* by a musicologist and a film theorist, both deeply invested in their home disciplines yet nevertheless dependent upon each other's skills in order to "read" a work of opera whose inherent visual properties, including sets, costumes, and lighting, are further subjected to the rich dynamics and metanarrative techniques of film.

Caryl When I first saw the provocative production of *Salome* by the Canadian Opera Company in 1996, I remember being dumbstruck by the imaginative and controversial filmic overlay applied to the dramatic audiovisual

text of the opera. My initial response was geared less to the overall artistic achievement of the radical new production, however, than to the representation of the conflicted young Judean princess and her motivations for the bizarre request and heinous crime. My expectations of a powerful, self-possessed diva portraying a seductive femme fatale were shattered by the sadistic ocular presentation of loss of innocence—the abuse of a young, mixed-up teenaged girl of privilege in her own home by those responsible for her care and well-being—and of her misguided search for love in the wrong place and projection of her desires for self-mutilation onto another. Her plight was rendered all the more powerful by the affective musical expression of Richard Strauss's brutally modernist score that, although less challenging to highly trained and supersensitized musical ears in the early twenty-first century than a century ago, still has the power to assault the listener with loud, discordant chords capable of producing an unsettling effect. My applause came only when the spectre of the ugly societal ill enacted in the dance slowly dissipated, vanquished by the reality of the noisy opera house.

Kay I came to the Canadian Opera Company's production of *Salome*, on the other hand, without any prior knowledge of the opera or the music of Richard Strauss and with only the vaguest memory of the Wilde play or the biblical story of Salome and John the Baptist. I came, however, with considerable acquaintance with the films of Atom Egoyan, particularly with the complex, conflicted, and contradictory representations of women characters that so deeply inform them. *Calendar* (1993), *Exotica* (1994), *The Sweet Hereafter* (1997), and *Felicia's Journey* (1999) all hinge on young women who can be variously read as innocent or duplicitous, chaste or seductive, victims of sexual misconduct or wilful perpetrators of inappropriate behaviour. The last three films especially centre on older men's obsessive desires for adolescent girls who are simultaneously in peril and indifferent to or in control of their predators. In *Exotica* and *Felicia's Journey*, it is not only the sexual independence of the girls that is in danger, but also their lives. In *Exotica*, for example, the sexually violated body of one girl is found abandoned in a field; another woman, a stripper in the Exotica nightclub, routinely and indifferently performs the adolescent in schoolgirl uniform for the father of the dead girl; while a third wilfully participates in another form of performance or deception, regularly "babysitting" the dead daughter for the obsessed father. In *The Sweet Hereafter*, we find perhaps the most chillingly complex of the representations of teenaged girls, and the one that bears the strongest resemblance to the character of Salome as rendered in Egoyan's production of the opera. Sexually abused by her own father in a scenario of performance and masquerade (they act out a fantasy of the girl as a famous rock star), Nicole is the epitome of sexual bipolarity—innocence and duplic-

ity, chastity and seduction, victimization and power. Bearing the marks of her psychic damage on her body, now in a wheelchair as a result of the bus crash that killed the other children in the vehicle, she, like Salome, defies her father through a calculated and wilful act of mendacity: she asserts her control of her own and her father's destiny by telling the lie that puts an end to the case. Played by Sarah Polley, only eighteen years old at the time and having grown up before our eyes in movies and television from the age of six, the poignancy of the incestuously defiled girl is as immense as her wilful determination and steely control are shocking. In these films, tropes of doubling, incongruity, and dissimulation, as well as of ingenuousness and chastity, inform the characterizations of the girls, surrounding them with ambivalence and contradiction.

In *Salome*, rather than a mixed-up teenaged girl in a socially and familially induced plight, I saw a young woman on the cusp of adulthood, sensually pampered, inquisitive, capable of briefly retreating into a flirtatious performance of childhood in one moment and commanding a sophisticated manipulation of adult social vectors in another. Primarily, I saw her as ravaged by desire—not only sexual desire for the alluring and powerful prisoner Jochanaan, but also desire for experience, freedom, and knowledge. Although the musical and dramatic texts remained somewhat opaque to me until recently (when I teamed up with a musicologist for the purposes of this article), the projections, the expressionistic lighting of the minimalist set, and the multi-layered images of the dance sequence provided another purely visual textual register that offered opportunities for multiple and complicated readings. The play on various formations of the image, the concatenation of visual media and meanings, were well known to me from earlier Egoyan works. Moreover, the emphasis in the verbal text on the gaze—especially looking and being looked at, the prohibition on looking and the refusal to look—is not only a staple of film theory, but recurs incessantly as a trope in Atom Egoyan's films. I was taken not by surprise but by wonder at the rich transformation of Egoyan's cinematic vision into the new field of opera.

Caryl Returning to the production after a hiatus of several years and joining with a cinema theorist to reflect further on the current culture of director-driven opera, which capitalizes on the ocular centrism of today's society and on the visual literacy of audiences bombarded by the media of television, film, computer graphics, and advertising, provides an opportunity to explore the interplay—the collaboration and collision—of the visual and the aural. That the action of *Salome* profoundly hinges on the seen and the heard—and on the unheard—provides dramatic justification for the interaction of film and music. Sophisticated video technology, film clips, live video projections, split screens, pseudo home movies, superimposed images, and a veiled shadow play exploiting lighting and distortion combine with character action,

costuming, scenery, makeup, and props to compound the impact of visual excess. Indeed, these techniques rival Wilde's symbolic metaphorical language in their overabundance and the aural excesses of Strauss's early-twentieth-century vocal and orchestral palette. Strauss's score is full of wayward chromaticism, exotic orientalist timbral, and crashing rhythmic effects, held in a precarious balance by aberrant non-functional harmonies and the potent manipulative power of many leitmotifs or leading motives. The multiplicity of images and interpretive potential of the opening film clips and the progressive narrative layering of memory and loss in the dance sequence rival the transformation, fragmentation, transposition, orchestration, and morphed uses and meanings of the aural snippets emanating from the orchestral pit. But having lost the capacity to be provoked or outraged by musical modernism in the wake of decades of experimentation in new music, we now experience sensory overload through visual saturation. To the traditional optics of the opera is added the forbidden look into the decadent offstage world of Herod's court—a luxurious home spa replete with massage tables, mud bath, pool, and lounging area.

Kay The presentation opens with a large overhanging screen that dominates the stage. On it is projected an image of a woman—Salome—in a full-body mud wrap. It is a split-screen multiple projection composed of fragments of that body, each part rendered in close-up detail, with the woman's body almost touching the edges of the frame. The constriction of the frame of the image around her almost corpse-like, unmoving body already resonates with the threat of violence. Eventually a hand moves across the torso in more than one of the fragments, in a splitting and fracturing that suggests the overlapping and contradictory forces to come. As the behind-the-scene spa episode proceeds, repeated serial extreme close-up images of a portion of the mud-covered face—white-rimmed eyes and mouth—reminded me of Warhol's serialized images of products of popular culture, perhaps a suggestion of the commodification, abstraction, and alienation with which Salome has been viewed by her family and the court. They are also reminiscent of traditional minstrel-show makeup—the blackness smeared over the face, receding only in the perfect white circles around the eyes and the mouth. With this reference, Salome appears as both a racialized and a performative figure. These serialized images then begin to cohere into an extremely large close-up of Salome's closed eyes, which open suddenly when she hears Jochanaan's voice. Eventually the split-screen images return—a luxurious modern architectural vista invaded briefly by Herod's lab-coated henchmen, a pool, a body diving and emerging—divided, fragmentary, overlapping.

Cut to a split-screen triptych, as a young woman exits a door on the right, moves into medium close-up in the middle while she turns briefly to

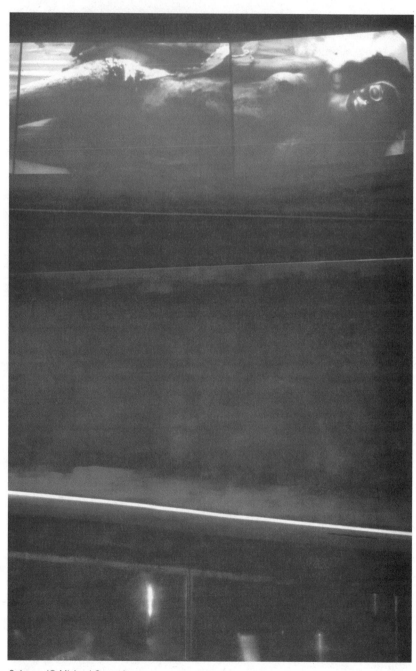

Salome. (© Michael Cooper)

look back, and then emerges into a garden on the left in full frame. It is night, and the garden is preternaturally lit with a large bright floodlight, perhaps another suggestion of the technologies of surveillance, which track her even as she tries to flee. This is all before Salome appears onstage. Before we see her, we already have a sense of her as a racialized figure, an object of infinite examination and surveillance, sensually pampered and luxuriously privileged yet longing for freedom. We also have a notion of the potential violence to the subject of the technologies of visual representation.

Caryl The menacing image of the mud-covered torso foreshadows Salome's dirty, defiled body. In the private, interior, off-stage moments, she is anything but the beautiful princess of legendary fame whom we view onstage. That her eyes open when her ears take in the cavernous disembodied voice of Jochanaan has the effect of carrying the final image of the visual triptych into the aural spaces, with the unseen voice of the prisoner penetrating from the subterranean cistern to the onstage terrace and carrying through to the spa party inside the palace. Salome may be an object of voyeuristic pleasure, but she also possesses an ability denied the others—an ability to hear a specialness in Jochanaan's voice. In the sound-drenched world of the operatic stage, characters are normally understood as hearing only the phenomenal or actualized song of others, something that is similar to diegetic sound in film. Salome hears Jochanaan's *voice* (but not necessarily its linguistic content) and is conscious of it from a great distance, signifying not only her relationship to Jochanaan—for she too is Herod's prisoner—but also her attraction to the oracular quality of his voice.

Strauss depicts this alluring voice through pure diatonic harmonies befitting a holy man whose voice is a conduit for biblical revelation. For instance, Jochanaan's first utterance upon ascending from the cistern— "Where is he whose cup of sin is now full?"—is bathed in pure triadic harmonies as befits he who precedes the Messiah. His statement is accompanied by not four, but six horns, as if to exaggerate the prophetic quality of his utterance. Diving into the pool, Salome performs a ritual cleansing of her mud-caked body—dirtiness being a marker of her Jewishness—before seeking out the source of the divine voice, predisposing her to the possibility of hearing the word.

A little digression is in order here. Strauss's ethnic slurs, already evident in Wilde's play, are difficult to ignore at several junctures. As a group, Jews had long been recognized as "others," stigmatized by marks of "difference" in religion, language, vocal intonation, bodily demeanour, and physicality— a racial profile evident in Strauss's depiction of the five quarrelsome nameless Jews in scene four. Identified as first, second, third, fourth, and fifth Jew in the libretto and score, four of them whine in a shrill feminized high tenor register while a fifth blunders along in imitation of a comic basso.

Their speech is completely unintelligible, their argumentation creating "a cacophony that is musically avant-garde but also indicative of the nature of Jews' discourse" (Gilman 1998, 172). Parodistic representation of bickering Jews speaking "Mauscheln," or Yiddish gibberish, was a popular topos in later-nineteenth-century humour, a marker Strauss could depend upon being recognized by his audience. Having the argumentative Jews morph into doctors whose medical lab coats are stuffed with drugs is a costuming choice that not only incriminates them as quacks or charlatans that pollute their profession by pushing pills, but also underlines their ethnicity. It is a further example of how the visual medium is exploited to capacity in this production. By focusing on the representation of the body and making explicit the musical and visual texts that animate that body, Egoyan is not so much reifying a racist ideology as adding an interpretive layer to a long history of Jewish representation revolving around race and discourse, making visually immanent the past positionality and societal constructedness of the marked Jew—an image that, as Sander Gilman has shown, was linked at the turn of the twentieth century to the perversion of Wilde's homosexuality (1988, 156–61). That the "doctors" who provide Herod with his fixes later "operate on" the young princess ought to be understood within the context of this long history of negative stereotyping and especially during the era of the opera's creation, when anti-Semitism was on the rise in Europe, challenging us never to forget the tragedy of the Holocaust and its legacy.

The authority of the "Jochanaan-voice," as separate from the embodied Jochanaan (who in human form possesses character flaws), is reinforced by a magnified real-time projection of the singer's mouth in the act of prophesying. The heraldic trumpeting call of the ventriloquist's voice as it travels from the bowels of the earth through the dark cylindrical tubing of the cistern reaches out to Salome, who, unable to "read his lips," is held captive by the mysterious musical quality of his voice. "Your voice is music to my ears," she tells him and, at an especially poignant moment in her final monologue after his death, she again references the "mysterious music" of Jochanaan's voice—a voice that can never be understood—while a leitmotif associated with him wells up in the orchestra. Contrast this with what the others hear: Herod is concerned with comprehension, pondering what Jochanaan's words mean, while Herodias hears only insults and screaming. The Jochanaan-voice possesses mythical powers like those of the musician Orpheus, whose famed powers of musical persuasion extended to restoring the dead to life again. The mythological singer's eventual downfall was a forbidden glance, leading to his expulsion from Hades and to his dismemberment and decapitation by the Bacchantes, leaving his severed head—vocal cords severed, tongue silenced—to float along the river, murmuring, blabbering.[1]

Kay As if to emphasize this Orphic presence, Jochanaan's mouth in Egoyan's production is a colossal visual presence. As he sings, an extremely tight close-up of his lips, teeth, and tongue is projected on a large screen on the rear wall of the set. Larger than the human figures that move in and out of the ambience of the image, the source of his voice dominates the visual field. It is almost as if the video camera, held in such close proximity to the mouth, replaces the microphone, amplifying the visual rather than the aural—indeed, dissolving the aural into the visual. Yet the characters within the scenario don't "see" the mouth: as Caryl states, Salome can't "read" Jochanaan's lips, because this visual image is privileged for the perceptions of the audience alone. A subtle detail in the set marks the privileged spectatorial relations between the image and the opera audience. The edges of the frame are painted over in uneven striations, producing an odd, rather messy "frame" for the image. The unevenness of the frame reminded me of the accidents that happened in pre-digital movie projection, such as hair in the gate or dirt on the print. These tiny globules of dust or strands of hair, when projected on a large cinema screen, would appear as enormous and monstrous interventions into the diegetic world, hijacking the viewer's vision as they moved slowly over the image or got horribly stuck in a corner. These were moments of unsettling spectatorial disjunction that cast the spectator's eyes from the image to the apparatus, returning the gaze back to the "scene" of cinema—back on the spectator his or herself. In the Canadian Opera Company's production of *Salome*, the self-reflexivity of the presentation of Jochanaan's mouth, through those markings that obscure the edges of the frame, underline the privileged and perhaps disturbing relation between the audience and image: this image is for *us*. The enormity of the image, with its markings of the apparatus, is a visual reminder of our presence as an audience, for whose pleasure (and horror?) these crimes are committed.

This trope contrasts significantly with another image of a mouth, also enormous, which Salome invokes herself. With the assistance of animation, Salome gestures into being—almost as if painting—a large pair of lips, uncannily reminiscent of Man Ray's famous floating lips: while these lips are also bright red, they are closed rather than open. They are not Jochanaan's. They are abstracted, idealized. They might even be Salome's lips, obsessing about the kiss. Again through a visual element we are offered a contradictory subtext that inverts and interrogates the aural and verbal text, complicating Salome's motives and suggesting her gradual empowerment and duplicity.

As she staggers around the stage during the second musical interlude, another large projection appears where Jochanaan's mouth had been. Here a woman's mud-smeared body lies askew in the frame: the head is toward the lower right of the screen, with the face not really legible; here legs angle

Salome. (© Michael Cooper)

off to the top left. This is not a reprise of the earlier spa scene, for she lies in a wide surround of thick lumpy mud, like the mud at the edges of the Dead Sea. A single image rather than composed of multiple fragments, it is paradoxically disturbing rather than ordinary in this context, for it effaces the earlier marks of the operations of visual technology, presenting itself as in a direct relation to "reality." On the stage, Salome acquiesces to the transcendent force of the image and adopts a similar posture. Desolate and menacing, it is an image of Salome's inner state, her abject acknowledgment of her own psychic filth.

As the music dies out, the mud flat rapidly dissolves into sparkling rippling water. A new musical motif begins and, as the body floats away, Herodias enters, observing both the image and Salome's body on the stage. The transformation of Salome is complete, and the inexorable movement toward the hideous finale has begun.

Caryl As Kay suggests, a seemingly lifeless Salome is anything but, for percolating in her psyche is the modus operandi for gaining the forbidden kiss. The musical theme with which Salome will eventually articulate her desire for the head of Jochanaan gurgles like a menacing undercurrent throughout the orchestra just prior to the entry of Herod and Herodias. The visual and aural spheres coalesce here in providing unspoken information.

The Dance of the Seven Veils

Caryl Upon seeing Wilde's play in Berlin for the first time in 1902, Strauss remarked that he was "already busy composing; ... the dance and especially the whole final scene is steeped in music [and] the play was simply calling for music" (Strauss 1953, 150). Where Wilde simply wrote "she danced," leaving no further instructions, the composer's imagination was fired by the potential of bringing the dance to life onstage. Strauss did not complete this task, however, until several weeks after he had finished composing the rest of the opera; finally, in August 1905, he sketched and orchestrated the dance during an intensive two-week period. The "Dance of the Seven Veils" constitutes the longest stretch of solely orchestral music in the entire work, and might even be understood as substituting for the opera's missing overture, conjuring up an exotic locale through an exuberant raw energy and bombastic rhythms that contrast with quiet, introspective, "orientalized" shadings. Composed last, like a typical overture, it is a prelude to the new power dynamic at Herod's court, one in which the balance of power shifts toward a victimized Salome. Only by undergoing ultimate degradation to appease her lustful stepfather is the heroine able to achieve her goals and satisfy her own bizarre desires.

What Strauss originally envisioned happening during the more than ten minutes it takes to perform the "Dance of the Seven Veils" is unclear and even shrouded in mystery. His score gives only two stage directions (apart from those for the onstage musicians, rendered superfluous in Egoyan's production), neither of which conveys much about the dance itself. Near the end Strauss indicates, "Salome seems to tire for a moment, then summons new strength," and a little later, "Salome remains for an instant in a visionary attitude near the cistern where Jochanaan is kept prisoner, before throwing herself at Herod's feet" (Puffett 1989, 55). Precisely how is Salome to dance, and how are Herod and the members of his court to respond? Choreographing this quintessentially unoperatic scene, in which the heroine quixotically loses her powerful vocality, poses many challenges. Is Salome's body language to be forthright and proud, meek and humble, or some combination thereof? And should her performance elicit hooting and catcalls from the onstage audience, or might some register their displeasure, disdain, shock, or horror? Some two decades after the opera's premiere, Strauss wrote a brief scenario for the dance in which he asked the young princess to adopt stylized poses and perform swaying movements, rapid turns, alluring motions, and menacing steps at various junctures in the music. Many of these directions, however, seem curiously out of step with the music. Indeed, the scenario is, on the whole, very unsatisfactory, causing me to question why, after such a long hiatus, Strauss decided to write out such a cryptic description—especially one that mentions the stripping of only five veils (Puffett

1989, 165–66). Was the fun-loving trickster perhaps up to another one of his ironizing jokes?

Kay Salome's dance has been pivotal not only in productions of the opera, performed and recorded in various visual media, but it has also been the subject of countless film interpretations from the earliest days of cinema. The first film version (1908), directed by J. Stuart Blackton and starring Florence Lawrence as Salome, was based on Wilde's play and produced only a few years after Strauss had written the opera. That film set in place a trend that was henceforth to mark all modes of representation of Salome's story: the emphasis on the dance of the seven veils. Another silent film was mysteriously titled *The Salome Dance Music* (1909), and many of the subsequent filmed versions (thirty-two motion pictures, five television movies, and three TV series) offer *The Dance of the Seven Veils* as an alternate title, while other titles invoke the dance, as in *Salome, Where She Danced* (1945) or *Salome's Last Dance* (1988). As a character, Salome has shown up, almost invariably dancing, in many more films, including most of the biblical epics from the silent period on.

For the film industry, the dance of the seven veils is a natural, as from the earliest days movies tested the limits of community standards. In the silent era, the orientalized epic debauch, notoriously directed by Cecil B. DeMille and D.W. Griffith, featured nudity, sex, and sexualized performance, especially in scenes in which women entertained by striptease dancing. Moreover, the dance is that element of the play and opera that centres vision—of both audience and characters—on the female body. The act of looking, as both surveillance and spectacle, usually connotes mastery or power, and has often been gendered masculine along with the textual and technical operations of film narrative itself. Mediated visuality, coded for strong visual and erotic impact, that is, may be read along the axes of power and asymmetry.

In films and filmed opera productions, the dance has been variously performed and constructed in relation to the gaze of the characters, the audience, and the camera. In a 1974 production directed by Gotz Friedrich and filmed for television, Teresa Stratas surprised the opera world with her daring and salacious dance as she shimmied and writhed around the stage, beckoning, flashing her eyes, and generally performing at a peak of orientalist eroticism. Other performances have used nudity more flagrantly, such as the 1995 Covent Garden production starring Catherine Malfitano, which sheds most of the conventional orientalist trappings of the dance. Dressed in a series of geometrical pieces of cloth that perform an almost architectural function in the piece, Malfitano's Salome also dances in an angular, more modernist choreographical style. Her sheer final garment—last of the seven layers—hides nothing of her naked body. Directed by Petr Weigl, who has

directed many film and television dramas, this production uses the camera and editing apparatuses to implicate not only the other characters, but also the film audience in the act of looking. Standing somewhat away from the dancer, the camera pitches and swoons as she moves, while the editing cuts between the looks of Herod and Herodias as well as of the onstage percussionists. This is the classic spectacle of the woman's body, not only fully revealed in its nakedness, but cinematically constructed in the form of *découpage classique* that theories of the cinematic apparatus saw as the principal suturing mechanism of cinema, binding the look of the audience into implicit mastery over the spectacle of the woman's body on display for our gaze.

As Linda and Michael Hutcheon point out, however, Salome the character and *Salome* the opera turn this widely accepted view upside down, as here, the looked-at accrues her power precisely in being object of the gaze: "This is a young woman who is not objectified by the gaze, but is instead empowered by it" (2000, 218–19). Only Jochanaan refuses to look at her, in Strauss's text, suggesting that he understands the power of the gazed-upon rather than of gazing, a power already central to Salome's sense of herself.

Somewhat surprisingly, in the cinematic versions of Salome's dance, it is Rita Hayworth's 1953 performance that is the most unequivocally chaste so far. Expected to showcase the star at her most voluptuous, capitalizing on her memorable performances in *Gilda* (1946) and *The Loves of Carmen* (1948), *Salome* (1953) was to be one of the great biblical epics of the 1950s, starring, along with Hayworth, Charles Laughton and Judith Anderson as Herod and Herodias, and handsome Stewart Granger as the Roman commander who is secretly being converted to Christianity by John the Baptist. Hayworth's performance, however, presents a character whose virtue, loyalty, and true love are so unambiguously genuine and whose dance is so guilelessly chaste that the outcome of the narrative had to be changed to accommodate the reversal. Rather than demanding the prisoner's head, Salome engineers his release to freedom, and the final scene offers the Roman soldier and his newly Christian bride a moment of prayer with the saintly John.

Yet in most productions, and in Strauss's libretto, Salome's dance bestows power on her as the audience and other characters gaze; that is, she alters the power and gender dynamics of the gaze itself. For the Hutcheons, "the person—of either sex—who gazes grants power to the one—of either sex—to be gazed upon" (2000, 219). They argue that Salome is in a position of mastery not so much of the gaze as of being gazed at, and that this is not only her real power but also her own knowledge of her visual power.

Egoyan's version of the famous exotic dance spins the relation of the gaze upon the woman's body in motion and the apparatuses of looking

(proscenium stage and cinema) into an unusual new realm. Rather than put
the spectacle of the diva's body on display, Egoyan turns the star, Helen
Field, virtually into a prop: while she is hoisted on a swing higher and higher
into the flies as the dance music begins, her dress unfolds magically to
become a giant scrim that fills most of the stage. Projected onto the screen,
a startling version of the dance ensues.

Caryl Musically, the dance is cast as a series of interlinking sections that
gradually increase in tempo, dynamic, and register. It opens with the onstage
musicians calling everyone to order with a "wild dance" marked "*molto
presto e furioso*," featuring an incessant *ostinato* of repeated offbeat *sforzan-
dos*. Salome commences dancing to an ominous waltz in A minor featuring
a serpentine melody for solo oboe, an instrument prized for its eerie nasal
quality and its associations with the exotic east. Modal inflections, created
by lowered second- and raised fourth-scale degrees, add to the musical exoti-
cism. A subtle trace of the leitmotif associated with Salome's youth and
innocence, first heard when she appeared onstage in scene two, makes a
brief appearance in the flute. Like a captured bird of prey, Salome dances as
if caught in a snare. Intermittent, broken triplets would seem to indicate
that her initial steps are tentative, but as the tempo quickens with the tran-
sient modal implication of A major (also the key of her entry in scene two),
a gentle, rocking melody ensues, one whose rhythms and triplet figures are
more assured. A melodic statement in luxurious thirds and sixths appears
briefly in the upper register before unravelling in a jagged cascade of descend-
ing staccato chords skittering across the soundscape like broken glass, fol-
lowed by a short threefold statement of the descending fourths associated
vaguely with the mysticism of Jochanaan. As Salome's plan gains in clarity
and assurance, her dance takes on an insouciant, light-hearted quality in a
faster-paced passage notable for its French-inspired soundscape. Luxuriant
washes of sound punctuated by snaps of castanets and hollow woodblock
bathe the listener's ears, culminating in *fortissimo glissandi* on harp and
celeste.

The scene continues with a sombre waltz for strings beginning in
C-sharp minor, the darker, menacing strains underscoring the odious nature
of the dance that is underway. As Salome's flesh is increasingly exposed, so
too is the sadistic nature of the striptease she is performing before her lust-
ful stepfather and his evil court. Vanquished is any semblance of fun and
games or innocent entertainment; the dance is now deadly serious, with
equally serious consequences. Chromatic inflections infuse the harmony
with a restless quality in spite of the regularity of the phrasing, and tonal
ambiguity denies any sense of closure. Everyone is now caught up, if not
implicated, in the dance, and there is no turning back. With the change to
C-sharp (enharmonically D-flat) major, marked by an increase in tempo, the

orchestral writing assumes a renewed warmth and spaciousness through the use of stratospheric strings, rendered all the more poignant by the pianissimo dynamic level. As the music gets swept up in an overly sentimentalized waltz worthy of Ravel, the level of ironic play becomes intoxicating; indeed, the more voluptuous the dance, the more sinister its intent for both performer and viewers. As this segment of the dance exhausts itself, another more hypnotic one, in A minor, ensues, this time with insistent castanet accompaniment. Chromatic lines weave snake-like throughout the musical texture, emphasizing the charm-like effect of Salome's movements. She appears to be dancing as if in a hypnotic trance. Following the entry of the tinkling celeste, Strauss indicates that "Salome seems to faint for a moment," and the dance is momentarily derailed, only to commence "with new strength" as the strings introduce a stinging staccato twitching figure in high register. Here the metre switches imperceptibly from triple to duple, as if to indicate that the dance has gone awry, and a rapid tempo ensues. Conflicting cross-rhythms between the upper and lower registers mirror the tangled emotions of the heroine and her frenzied wild display (Strauss even writes "wild" midway through this passage). The increasingly layered musical texture builds to a bombastic, pounding, thrusting conclusion, eventually exploding into a *molto presto* waltz fragment that unravels as the music rises precipitously to a stinging tremolo on high A (for first violin, celeste, clarinet in A, and piccolo). Dance and dancer linger in suspended animation as Salome adopts a "visionary attitude" by the cistern, and all is brought to a swift conclusion when, to rapidly falling helter-skelter octaves, Salome collapses at Herod's feet.

Kay The "dance" that we see on the large screen is akin to the other modes of visual representation that have been used throughout the piece in that it is fragmented, hallucinatory, gestural, and narrativizing. Indeed, it tells another story altogether, a story that further deepens the psychopathology of the central persona while at the same time delimiting the complexity of her contradictory character.

As the enormous scrim is unfolding, along with the orchestral echo of Salome's youth leitmotif, the first image that we see is home-movie-type footage of a young girl on a swing, facing the camera and smiling broadly. Eventually, a monochromatic image of a blindfolded young girl alone in the woods is projected. The elements of the shot—the blindfold, solitude, the forest—invoke an atavistic sense of peril reminiscent not only of ancient fairy tales, but also, because the image is in black and white, of a history of cinematic danger for women. As she begins walking, we see her suspended in space, for she is actually on a treadmill. From behind her, a forest landscape moves dreamily, eerily, independently of her as it is rear-projected onto the scrim of Salome's dress. Although technically rather simple—two images

projected at the same time—the effect is quite complicated, for the forest image is a tape loop that endlessly repeats the same tracking shot, as the image of the child on the treadmill continues to move, but not through the space of the proscenium or of the forest image. The effect paradoxically both fragments and connects the steps of her journey. In this fractured, liminal space, the menace of the initial impact of the image disappears. For a moment, the child is safe in a space in between, although on the other side of the scrim Herod follows her, piercing the stage with a flashlight, echoing the figure of a man on a catwalk in the flies who brought the production into illumination in the first moments of the show. The shaft of light is the essential, controlling element of cinema, and it conjures, as well as illumination and knowledge, suggestions of power and penetration. If he doesn't look directly upon Salome's body, Herod at least demonstrates that he has the luminous weapon that would allow him to do so. Nevertheless, as the image of the child dissolves to medium shot and then to large close-up, her blindfolded visage, now facing the camera, begins to rotate in space. She is, at least momentarily, floating free, though still without the benefit of vision—or is it *with* the protection of blindness?

But in this narrative of danger and the gaze, of safety and blindness, an unexpected concatenation of power and sight, visibility and visuality is produced when the child removes her blindfold to look with horror upon the adult Salome, who enters the stage space behind the scrim to begin her dance. The child "looks" from the safety of the projected image, while the dancer playing the adult Salome—present, embodied—steps into what will soon become a place of extreme danger.

It is at this crucial point that Salome's bodily movements actually become dance. But still, although the dancer appears to be naked, the audience is denied direct access to the spectacle of the diva's body in motion. The scene is removed from the spectators by the effect of backlighting, which transforms the figures onstage into silhouettes, mere shadows that flit in shallow two dimensions across the gauze-like screen. In contrast to the elaborate spectacle of the projected images (the device of the dress becoming screen, the triptych screen and looped forest effects, the multiple and precisely layered images of the child, the eye and its overlay), this is a low-tech but high-impact circuit of access or denial of access to vision, visibility, and mediation of visuality between the narrative spectators (Herod, Herodias, and their court) and the audience in the opera house.

Enter the vicious doctors, Herod's henchmen from earlier scenes. The powerful backlighting of this rear-screen space allows for wonderful iconic effects, as the shadow-figures can enlarge or diminish in size as they move closer to or farther from the light. As Salome dances, her movements becoming more frenzied; she is a tiny sharply focused silhouette in the foreground,

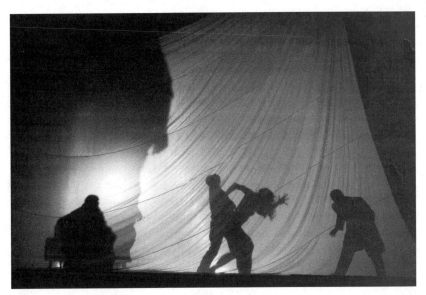

Salome. (© Michael Cooper)

while her pursuers, physically closer to the light, appear on the screen as huge, hulking, blurry figures. The sense of danger and the imbalance of numbers and power are crystallized when the doctors lift Salome up off the floor and carry her around above their shoulders as the music builds to a bombastic conclusion. Finally, in a ghastly penultimate scene, contrapuntally underscored by a waltz rhythm, the girl is gang-raped by Herod and his courtiers. There is no assignment of surveillance instruments as the source of the "scene": as Foucault asserts in his opposition of surveillance and spectacle, these are two separate regimes of power, in which different observers are implicated. In Egoyan's production, the "Dance of the Seven Veils," with its horrid conclusion, is a spectacle directed to the audience, albeit at one remove. As Jonathan Crary reminds us, vision and its effects are always inseparable from the possibilities of an observing subject (1990, 5). The scene of the rape, once and for all, is for the audience, and therefore doubly or triply defiling to all who participate, even if only by watching.

As with the other narratives told through the visual projections (the pampering spa, the suggestions of filth and decay), this is also a story from an off-stage space, filling in the psychopathology of the conflicted, hateful, dangerous, and desirous girl. Constantly under surveillance, incestuously brutalized, riven by the sudden mature desires of her adolescent body, confused and angry, she lives in a space of liminality, cut off from the imprisoned object of her desire but far too close to the dangers of those who profess their love for her. She seeks revenge and power.

Rather than the closing gestures of the dance that we have seen in earlier productions, in which Salome regularly postures in relation to the cistern in which Jochanaan ostensibly resides below, the projected image returns again to the essential question of the gaze, as it devolves to an extreme close-up of an eye that fills the entire screen. At the centre of the eye is the first image of the little girl, smiling broadly—triumphantly?—at the camera. As the final octaves of the piece tumble downward, the screen-dress collapses in a fade-to-black until Salome is revealed at Herod's feet.

The piece is a complex relay of gestures toward vision and toward denial of sight. The connection between innocence, safety, and lack of sight is offered and then retrieved, as the child Salome sees what she will become. But mastery, power, and vision are in a complex relation within the scenario, for the scene, the famous dance, is denied to the other personages of the story: it is offered to the audience alone. Yet the desire of the audience for the sight of Salome's body is thwarted by the use of silhouettes. The motifs of power, knowledge, vision, and light seem to implode here, cascading into a blackout as the apparatus of the image, the scrim, falls away.

Death: The Finale

Caryl To his credit, Egoyan respects the opera's extraordinarily powerful vocal moments. For instance, nothing intrudes on Salome's final monologue, one of the most static, tableau-like scenes in the opera, but one in which the power of the operatic diva is most manifest in the sheer strength, prowess, and presence of her voice. Salome's triumphal manipulation of the power of the gaze for her own discomforting purposes threatens to overshadow what was surely meant to be the most horrific visible display of all—the hideous sight of the bloody decapitated head and Salome's cannibalistic tasting of it (which Strauss's audience did not see). That we actually witness the gruesome act while she shields her own eyes with the much-fetishized blindfold (in anticipation of her own death perhaps?) in my view has the effect of wrenching our sympathies away from the gang-raped heroine presented to us in the dance, by bringing us into the realm of the grotesque. Repulsed by her actions, we turn away in disgust. Carefully, calculatingly, we are being prepared to hate her.

But I've leapt ahead. Let's return to the decapitation scene, which enacts a classic scene of mishearing. Here Salome mistakes the falling of Jochanaan's head for that of the executioner's sword. Crouched over the cistern, her ear cocked to its orifice, she is disturbed to hear no cries of fear or anguish, only a "terrible silence"; indeed, she believes Jochanaan is alive after he is already dead, and as the drama unfolds she continues to address him as if he could still hear (suggestive of his messianic powers perhaps?). As musicologist

Carolyn Abbate observes, this little melodrama of misinterpretation coaxes the listening ear into occupying a female position by erasing any sense of a male authorial voice (1993, 248–52).[2] Even the orchestra fails to offer any leitmotivic betrayal of her subconscious thoughts. The "silence" surrounding an anxious Salome is suggested by a low E-flat tremolo and rumbling bass drum punctuated by a series of repeated high B-flats played initially by the first double bassist, who is instructed (in the score) to pinch the string— ideally an animal-gut string, as would have been used in Strauss's day— between the thumb and index finger and to bow with "a very short stroke so that a tone is produced that resembles the suppressed groaning of a woman." Strauss knew only too well what an eerie and uncanny sound this would create. As he describes it in his memoirs, "the ominous passage proved so shocking during the rehearsal" that, "for fear of causing merriment... [I was] persuaded to tone the double bass down by a sustained B-flat on the English horns"—to his mind a failed experiment that he never employed again. Rather than representing "cries of pain uttered by the victim," the reiterated high B-flats represent, according to the composer, the "sighs of anguish from the heart of an impatiently expectant Salome" (1953, 151).

To produce this ugly strangled pitch, the player must hunch over the instrument, extend his or her left arm down the fingerboard, bend the wrist and contort the hand to pinch rather than press the string, and, with the right hand, draw the bow rapidly across the string in such a way as to create a sound envelope with an accented opening and a quick decay. It produces an irritating sound similar to that produced when a fingernail is scratched upon a blackboard—guaranteed to send shivers down the spine. Furthermore, the sight of an instrumentalist in the act of producing this horrid sound is anything but graceful. It is as if for a brief, breathtaking moment, player and instrument have been transformed into a new hulklike presence—invisible to the audience yet nevertheless lurking somewhere offstage. Looming within the orchestra pit is an unseen persona, a huge monstrous body of female shape with stifled vocal cords producing an otherworldly sound. This "newborn acoustic grotesquery," to borrow Abbate's term (1993, 248), grows in intensity as the other double-bass players successively join in, prodding us into perceiving Salome in the process of morphing from a beautiful young princess into a monstrous murderer. A new musical dimension is added to the operatic experience, creating a space for the instrumentalist to assume a more complex role than simple orchestral accompanist and for the auditor to revel in an expanded, if imagined, visualizing process.

Conclusion

Opera and film are both audiovisual media. As Sean Cubitt argues in a recent article in the *Journal of Visual Culture*, "we need to make another observation about the moving image: it is not visual but audiovisual":

> The image, if it is still, to the extent that it is still, is without time. The image remains the same if I look away and then look again. For this reason, it cannot be attached to music (the absurdity of Mussorgsky's *Pictures at an Exhibition*), which is a temporal art, or to sound which depends even more than music, because it is random, on the microchronology of vibrations. The image cannot vibrate, and so cannot occupy the temporality required for sound. It therefore is without noise, without music, and without words; and yet, the "moving" image is embedded in the sonorous. There is no necessity intrinsic on the image that demands another image; but here is something in sound that seeks visualization, and since it cannot associate with a still image, sound then requires the relations of image to image.... Sound implies time which demands movement which in turn seems to demand the visual. And yet the image is not sonic, by definition. And so we have an impasse again: the concepts of movement and image are not easily reconcilable. Something less simple than a presumption must accompany the transition to moving image. (2002, 360)

What Cubitt is getting at here is the temporal dimension of the visual and its centrality to human communication. How this potentiality might map onto a sung theatrical work, especially an opera like *Salome* that is so self-conscious in its demands as a visual work—requiring a female singer and dancer, one of the most demanding aural and visual couplings in all opera (Carmen too must dance and sing)—provokes further probing in Egoyan's *Salome*. That *Salome* is the ideal work on which to explore this interaction is surely one of the reasons Richard Bradshaw, general director of the Canadian Opera Company, after seeing the film *Exotica*, approached Egoyan to direct Strauss's opera, about another dysfunctional family. The link could not be more explicit: a film director obsessed with filming bizarre tales about innocent young women, exposing layer by layer their sordid pasts, tackles a related narrative from another narrative tradition—it's a natural fit. The clincher in Egoyan's staging is when the auteur portrays *not* the dancing Salome—understood either as the object of the infamous male gaze or as seizing the power dynamic by controlling the objectifying gaze and using it to her own devices—but rather a sympathetic young girl growing into a pathological teenager at the hands of child molesters. In this production, the lulling wash of orchestral sound during the "Dance of the Seven Veils" masks the actual cries of pain and pleasure emanating from the screened

stage. As Cubitt would have it, "the moving image is embedded in the sonorous," but in this case the music welling up from the orchestra overpowers—indeed, silences—the anguished cries and despairing calls of the young child-turning-pubescent teenager. Through the evolution of the ever more explicit images, in the interaction of sight and sound made manifest in the "Dance of the Seven Veils," the invisible and inaudible are actualized. And as if to make this unspeakable horror more palatable, the transgressors are "others" who perpetrate their shameful acts on an orientalized "other"—a distancing act that mimics the shadow imagery and screens the despicable action behind a veil of secrecy.

The visual is undeniably a powerful medium in opera, just as the voice and the orchestra are equally important to the operatic enterprise and are capable of assuming multiple roles within the narrative. Whether setting a scene, evoking an atmosphere, painting a poetic text, or delineating a character or character relationships, the role of music is not limited to dramatic underpinning or vocal accompaniment. The musical provocation to visualize within our imaginations is also a power to be reckoned with. The sight of sound, both seen and unseen, vies with the visual in this production of *Salome*, inviting us to revel in the synaesthetic pleasures of seeing and hearing.

Notes

1 For a recent interpretation of the operatic significance of the vocalizing Orpheus, see Carolyn Abbate (2001, 1–54).

2 As Abbate elaborates, Strauss "refuses to compose the unseen reality of what's happening in the cistern or in the hearts of the characters. In this, he in effect relinquishes male authority, frees the music from complicity in Herod's essentialism" (1993, 248).

Works Cited

Abbate, Carolyn. 1993. "Opera; or, the Envoicing of Women." In *Musicology and Difference: Gender and Sexuality in Music Scholarship*, ed. Ruth A. Solie, 225–58. Berkeley: University of California Press.

———. 2001. *In Search of Opera*. Princeton, NJ: Princeton University Press.

Crary, Jonathan. 1990. *Techniques of the Observer: On Vision and Modernity in the Nineteenth Century*. Cambridge, MA: MIT Press.

Cubitt, Sean. 2002. "Visual and Audiovisual: From Image to Moving Image." *Journal of Visual Culture* 1: 359–68.

Gerstel, Judy. 1996. "Atom Egoyan Puts Own Twist on *Salome*." *Toronto Star*, September 22.

Gilman, Sander. 1988. *Disease and Representation: Images of Illness from Madness to AIDS*, 155–81. Ithaca, NY: Cornell University Press.

Hutcheon, Linda, and Michael Hutcheon. 2000. "Staging the Female Body: Richard Strauss's *Salome*." In *Siren Songs*, ed. M.A. Smart, 204–21. Princeton, NJ: Princeton University Press.

Puffett, Derrick, ed. 1989. *Richard Strauss: "Salome."* Cambridge: Cambridge University Press.

Strauss, Richard. 1953. *Recollections and Reflections*. Edited by Willi Schuh. Translated by L. J. Lawrence. London: Boosey and Hawkes.

▶▶◀ **section 4**

Conversations

▶▶| 17

An Imaginary Armenian Canadian Homeland
Gariné Torossian's Dialogue with Egoyan

Adam Gilders and Hrag Vartanian

Like Atom Egoyan, Gariné Torossian is an Armenian Canadian who has found refuge in experimental styles of filmmaking, and her works, like his, revel in the complexity of identity and its role in the artistic imagination. These two Toronto-based filmmakers, moreover, have enjoyed a dialogue about their shared preoccupations, such as Arshile Gorky, technology, Armenia, diaspora, memory, and ephemera, as well as their shared aesthetic sensibilities. The interview that follows considers Torossian's creative praxis as a mode of commenting on and ultimately theorizing Egoyan's work as well as the themes and topics his work addresses.

Two of Torossian's short films reframe materials from Egoyan's features that grapple with aspects of his Armenianness. Her *Girl from Moush* (1994) uses photographic images from *Calendar* (1993), and *Garden in Khorkhom* (2003) integrates footage from *Ararat* (2002). Both shorts chart the parameters of Armenian diasporan identity while revealing the paradox of Canadian uniqueness, which, according to film theorist Scott MacKenzie, "can only be generated through the projection of an 'other' who is both dialogistic and antagonistic in nature."

Asked to design the poster for Egoyan's *Calendar*, Torossian had been given the images of Armenian medieval and classical monuments that, in the film, Egoyan's cinematic persona (he plays a figure based loosely on himself)

photographs for a commissioned calendar on Armenia. Using the pictures as both the inspiration and the raw material for her own work, Torossian put together a stunning piece that comments on and extends Egoyan's film's structure and themes. The resulting six-minute meditation on a homeland that she had yet to visit, *Girl from Moush*, transforms the iconic architectural stills into a river of images. With Super 8 and 16mm footage of these *photos trouvés*, Torossian collages the pictures with a dense weave of icons she viscerally associates with Armenia: photos of Armenian cultural figures, landscapes, and people, and video footage of herself. To underline the notion of being separated from true origins, Torossian uses images that are obviously culled from books, or blatant photocopies with stark forms robbed of detail.

Mike Hoolboom describes *Girl from Moush* as a "scrapbook [that] conjures a place found only in pictures, its documentary evidence strained by longing and nostalgia" (1997, 50). Torossian says the film imagines a liberating place. While Egoyan's *Calendar* visits the real Armenia and the director's cinematic character returns alienated, Torossian's place is a fictional concoction where she anticipates an exaggerated welcome. Torossian's film has a pronounced sense of longing, an emotion that prevails among exiles of all sorts.

In his essay "Imaginary Homelands," Salman Rushdie describes a process that he undergoes while looking at a photograph of his family's old Bombay home. He quotes the opening line of L.P. Hartley's novel *The Go-Between:* "The past is a foreign country, they do things differently there." For Rushdie, the past is a realm from which we have all emigrated, but the photo of his family's home shifts that perception: "It reminds me that it's my present that is foreign, and that the past is home, albeit a lost home in a lost city in the mists of lost time" (1991, 9). Rushdie articulates a sensibility akin to Torossian's, but unlike Rushdie, who once lived in the place he ascribes to his origins, both Torossian and Egoyan are generations removed from their homeland—and their cultural narratives depend as much on imagination as on memory.

Torossian's examination of her own diasporan identity continues in a film she made almost a decade later, which followed two short trips to Armenia. When Atom Egoyan saw Torossian's *Shadowy Encounters* (2002), which incorporates fragments from films by the Quay brothers, he offered her footage from *Ararat* depicting the Armenian American painter Arshile Gorky in his studio.

"I had told Atom that I was interested in making a film about Arshile Gorky and he said 'Why don't you take footage from *Ararat* for your film.' I liked the idea," Torossian explains. The resulting film, *Garden in Khorkhom* (2003), Torossian's first documentary-like narrative, integrates the recreated

scene in *Ararat* of Gorky in his studio. It is superimposed with a voice-over by Simon Abkarian, reading excerpts from Gorky's letters to his sister, particularly his recollections of Armenia, mixed with text culled or inspired by a landmark 2000 biography written by Nouritza Matossian, *Black Angel*—the first book to carefully reconstruct Gorky's Armenian memories and childhood. Gone is the hallucinatory utopianism of *Girl from Moush*, and what emerges is a story that retains Torossian's avant-garde aesthetic, mediated through her subject without veering into autobiography, which typically colours her work to this point.

The fourteen-minute film is an impressionistic tapestry that focuses on the relationship between the artist and his mother. That maternal attachment is the most tragic moment of Gorky's childhood—she dies in his arms from starvation after escaping the genocide in western Armenia—and one of the richest sources for his art. Paintings such as both versions of *The Artist and His Mother* (c. 1926–36 and c. 1926–42) and *How My Mother's Embroidered Apron Unfolds in My Life* (1944) demonstrate the psychological juggernaut his mother represented to him. Torossian's film reconstructs aspects of this formative relationship through his personal letters, art, and biography, and through Egoyan's footage. It is an arduous task, but *Garden in Khorkhom* captures some of the melancholy and complexity of their dynamic. Unlike Torossian's earlier work, this film unifies multiple narratives.

The new voice Torossian discovered in *Garden of Khorkhom* laid the foundation for her most ambitious project, which returns to Armenia and directly engages with Egoyan's *Calendar*. In early 2004, Torossian travelled to Beirut, Lebanon, where she was born, and in the summer she continued to Armenia. Beirut, for Torossian, represents a middle passage that mediates between her history and her present, as well as between Armenia and Canada. The trip represented her first extended stay in Beirut since her family fled the Lebanese civil war (1975–90).[1]

After months in Lebanon, Torossian travelled to Armenia and spent most of the summer of 2004 shooting her new, then untitled, film. She retraced the trip Egoyan depicts in *Calendar*, and even worked with two of that film's key actors, Arsinée Khanjian and Ashot Adamian. Unlike *Girl from Moush*, which builds on *Calendar*'s visuals, her new project tackles the narrative and identity issues that Egoyan's feature confronts, defines, but never seems to solve. *Calendar* is arguably the most successful at moments when the characters seem to fumble in the dark in an effort to connect to one another. Torossian revisits Egoyan's story but travels solo in an effort to connect with the country.

"At first, I was more like Arsinée's character in *Calendar*.... I was touching things, talking to people. But the strange thing was I wanted to be in the film but I couldn't, so I ended up behind the camera," she explains. The

film, she noticed, became one about extremes, driven by a strong need to search out some indecipherable thing that concerned her relationship with the place. Shot throughout Armenia, and integrating images of adjacent regions inhabited by Armenians (the Republic of Nagorno Karabakh and the Javakh province of Georgia), she credits the project for awarding her a new sense of freedom.

For Torossian, the film's curious side effect is that it unexpectedly made her feel more Canadian. "I feel like there is a lack of identity here, and the openness of Canadian identity allows you to explore. If I didn't make this film it would be hard to live here, which I've often felt before. I can appreciate it now. I don't dislike it anymore, I understand it," she explains.

Adam Gilders and Hrag Vartanian spoke to Torossian about a new stage in her long and continuing cinematic journey formed by a friendship with Egoyan and their common fascination with their shared Armenian Canadian identity. This interview has been compiled from conversations conducted during late August 2005 and early November 2005.

Adam Gilders/Hrag Vartanian You have just returned from your first major trip to Armenia, a place that you have described as the "imaginary homeland" and that connects you, as an Armenian Canadian filmmaker, with your friend and colleague Atom Egoyan. What were you doing there?

Gariné Torossian I was in Armenia for three different reasons. One was to show a couple of films—*Shadowy Encounters* (2002) and *Garden in Khorkhom* (2003)—at the Golden Apricot Film Festival in the beginning of July; the second was to make a film; and the third was to get away from Toronto and live for a short time in the place that has consumed my imagination since my childhood in Beirut. For as long as I can remember, this imagined Armenia has distracted me from my reality. I had formed the idea that the reality I was living was not as beautiful and profound as the imagined place—Armenia. So I had to go and really live there to understand these illusions, which were present for so long. The film I was making was also about these ideas.

AG/HV You commented in a previous conversation that you "thought about Atom Egoyan's *Calendar* a lot when you were in Armenia" and found yourself comparing your journey, as "an Armenian filmmaker coming to the land of [your] ancestors," with his. How does the character Atom plays in this film, the photographer, play into your thinking about *Calendar* and the journey it charts?

GT Initially this character irritated me. He doesn't allow himself to engage with his environment, with the landscape of his ancestors. He simplifies his experience by not fully engaging, partly because of the foreignness of

the people, of the language and culture. When he is in Armenia, the photographer is always behind the camera. He is the observer: rational, professional, and apart. I found this very frustrating—maybe because I'm not able to disengage in this way. But my understanding of this character changed when I was in Armenia: I realized why he simplified his experience as he did. The photographer finds a certain clarity by separating his professional from his emotional life, allowing him to respect both aspects. After shooting my new film, I found that my initial interpretation of *Calendar* and of Atom's character was more about me, about how I was relating to the character. At first, my idea for my new film was to engage completely, as a character and a director. Unlike the photographer, I wanted to be the director who was in the film; more like the photographer's wife, Arsinée, than the photographer. But when I did that, on my first day of shooting, it didn't work at all. When I watched the footage it was not at all what I imagined it would be. It didn't feel real. I realized in order for it to work it had to be fictionalized and performed. I found two actors to play the parts.

AG/HV How did your initial sense of your Armenian film—with a completely engaged character/director—not work? What was wrong with the footage?

GT When I sat down to watch the footage, I found that it didn't show the world I had imagined. I imagined a very particular rhythm, which did not come through when I was in front of the camera and engaged in dialogue with other characters. I decided I had to step out to get the right pictures and to see clearly. I had to separate the real from the imagined to give the film a chance to exist on its own, to have its own life. I realized that I had to respect the imagined world and not live in it or confuse it with reality. This separation was needed to allow the fiction to question and reflect on reality.

AG/HV Was it a matter of creating a greater separation between the roles of director and character? If so, did this bring you closer to the photographer's strategy—closer, rather, to Atom's strategy as a director, with his separation of his character's position and his own position as the director?

GT The photographer's strategy is a new one for me, which I think is necessary for a certain type of experience—an experience that is not exclusive to one person's imagination but is engaged with others and with the physical, external world. I think this is the first time I've seen my films in this way, with a real separation of the fictional world from my own world behind the camera and outside the fiction, so it's really the very first step. Something is changing. The films I've made have always been basically about my self in the film world, so there hasn't been the separation of me as director, directing other people and creating a fiction. For the first time in this new project,

I'm not playing the character, I'm not in my own world; I'm allowing others to be in my world.

AG/HV I want to return in a moment to these very suggestive issues of character and fiction, but I first want to ask you a more specific question about the place of Egoyan's *Calendar* in your new film. You have described *Calendar* as a uniquely personal film for Atom and Arsinée, a sort of oblique love letter, but it is also a personal film for you, both in your use of Atom's footage/stills in *Girl from Moush* (1993) and in your recent exploration of Armenia as a filmmaker, where you insert yourself into the fictions of Atom's film. Your use of *Calendar* in your new film is quite different from your use of Atom's images in *Girl from Moush*. How did your thinking about *Calendar* inform the transformations of your new film?

GT I made *Girl from Moush* about ten years ago. It was conceived at the same time as Atom conceived of his film *Calendar*. This summer I went to Armenia at about the same age that Atom went to make *Calendar*, at thirty-three. This makes me think that there are phases in our lives when we deal with certain issues. The more I thought about *Calendar* prior to shooting my film, the more I realized the issues were very similar—they have to do with being both Armenian and Canadian, and with the history and meaning of these cultures. There seems to be an urgent need to clarify these issues in order to move forward or to the next stage.

The most direct relation to *Calendar* in my new film comes through Ashot Adamian, the character who plays the driver/guide in Atom's film. Here again I am playing with fiction and reality by wanting a character from another film to enter into my film as though the character was a real person. Ashot's character was important for me because he was the true link to the past and to the "real" Armenia. In some ways this idea of the "real" Armenia refers back to the *Girl from Moush*, in which the narrator is overheard talking to an operator, trying to reach someone, anyone, in Armenia.

I wanted Ashot to be in my film because I see my film exploring the same issues of identity that I found in *Calendar*, so I called him when I was in Armenia. The character in my film sees Ashot by accident. She recognizes him from *Calendar* and wants to ask him about the film because she is going through similar things. They meet at a café and she tells him that she is going back to Toronto in a couple of weeks. She asks him if she can take his picture in front of a church. This church is right in the city, not at all the kinds of location Atom shot. It is obstructed by a Soviet-era building, built as part of an effort to get rid of the church. She takes him in front of the church to get a picture and then asks him questions about Atom's character in *Calendar*: Why did the photographer refuse to touch the churches or to engage with his environment? She's separating fact from fiction.

AG/HV Her interrogation of reality and fiction returns us elegantly to your earlier comment that you are allowing others—as characters—into your world, that you are taking a greater interest in the filmmaker's role as a maker of fictions. Do you see your films moving in a more narrative direction as you follow this interest in character?

GT I was interested in narrative from the start, but I moved towards collage because the form felt freer and fit with my instincts. It is a more directly emotional and personal form. I had the instinct to work with images and sound to explore the themes I was interested in at an almost subconscious level; it felt like words were in the way—blocking the immediacy of image and sound. I was interested in discovery and chance, not worrying about structure, order, and definition. I needed to go through this process to understand the territory that I am now looking to explore through narrative and fiction. But this type of narrative is definitely an extension of what I have been doing for the past ten years. The characters were hard to bring to life because I had to transfer the instinctual world of collage to a very different medium.

AG/HV How might this rethinking of character and direction affect your new film, and perhaps your filmmaking in general, at a technical or aesthetic level, with respect to your interest in techniques that have little to do with narrative, such as layering, fragmentation, and collage? We might frame this question by comparing your current project with earlier films that both make use of footage from films of Atom Egoyan—*Girl from Moush* and *Garden in Khorkhom*.

GT With *Garden in Khorkhom*, I took footage directly from *Ararat* and used it to construct my film. Shortly before I made that film, I had read about Arshile Gorky's life. I was deeply moved by his story—especially his relationship with his mother and with Armenia, his motherland. I felt a strong need to make a film inspired by his work. I talked with Atom about this and he suggested I use footage from *Ararat*. He had seen what I had done with *Shadowy Encounters*, which used footage from the brothers Quay films, and he was interested in seeing how I would interpret his images in my film. I reshot Atom's footage of Gorky in his studio on video in black and white, to give it an archival appearance. This studio footage was intercut with detail shots of Gorky's paintings and voice-over from his letters. In the voice-over, I also used the voice of Arsinée Khanjian's character in *Ararat* reading from a book she's written on Gorky. I see this film as a step towards a more narrative mode—less fragmented than *Shadowy Encounters*, for example. I was interested in clarity, which is a big part of the attraction to narrative. With the collage, I was dealing with a hidden world, a world that was mainly internal, and in this case I wanted to present the subject, something outside

Garden in Khorkhom. (© Torossian)

my direct experience. This material wasn't entirely controlled by instinct. I was dealing with language, and I wanted to let the actor define the emotion.

Girl from Moush (1993) presents a different situation, both in its use of collage and its relationship to Atom's material. Atom had asked me to design the poster for *Calendar* and gave me the church images for this purpose. At the same time, I was collecting images of Armenian art for my own film. Atom's photographs were similar to postcard images one can find in books. My film was about imagining a place based on images that I have seen and music I have heard, so the church pictures fit perfectly. Using my Super 8 camera, I shot images of Armenian art, still images from books, and pictures of the Armenian filmmaker Paradjanov; I superimposed and intercut self-portraits into images of the landscape and of churches, partly taken from Atom's calendar photographs. Through pasting and collaging, I was putting myself inside the landscapes, creating the illusion that I was walking into these places. The editing of this film did not have a predetermined structure or rhythm; Super 8 images were superimposed onto video footage; layers of 16mm film were cut and pasted, built in layers on top of one another, like a pile. [*Laughs*] The process sort of reminds me of falling rocks.

Originally, I was thinking about using footage from *Calendar* for my new film, but I'm not sure now. Either way, with the new film my relationship to Atom's work is based less on imagery and collage than on plot and fiction.

Girl from Moush. (© Torossian)

AG/HV First in *Girl From Moush*, then *Garden in Khorkhom*, and now in your new film, Egoyan's work looms large and the narratives he uses play a role in your narratives,.whether directly or indirectly. Do you see yourself as in a cinematic dialogue with Atom?

GT I never thought about the fact that there might be a cinematic dialogue between Atom's work and mine, but I think if there is any, it's a natural one

about being Armenian Canadian artists. We have been fascinated by similar aspects of Armenian culture, being art and music. As filmmakers, we have always shown interest in each other's work. I always like to show Atom my latest film. He encouraged me from the beginning when I had visited him for the first time to show him my photographs and drawings. When I showed him my first film, *Body and Soul*, in 1989, he was very moved by it.

Looking at it deeper now that this question is posed, I think maybe stylistically we have both chosen a very layered approach to telling our stories. There is no directness and order in the obvious way. There is a weaving in and out of scenes and images. Still, our cinematic dialogue is hard to identify because we are working in very different styles of film; I come from the experimental tradition and his main work is in dramatic features.

Egoyan represents to me an artist who is honest to his voice and the issues he needs to confront, question, and understand.

AG/HV As a Canadian how do you think that identity colours your perception of Armenia?

GT Canada allows me to investigate my Armenian identity because Canada celebrates its diversity. There is a lot of room in one's Canadian psyche to explore other identities. Canada is like a wise parent that gives its child freedom to decide for themselves who they are rather than telling. In the process of finding my Armenian identity, it was frustrating not to feel a Canadian identity, because it created a real desperate need to find something to feel connected to. Now that I have unveiled an understanding of my identity after many years of no clarity, I realize that Canada also offers an identity in itself. I think it is a new form of identity—a healthy one—because it doesn't impose itself, partly because of its short history. For me, Armenia is the poetry, the imagined, and Canada is the reality, the physical.

The thing I discovered was my feelings were true about Armenia, that it does have a special place in the imagination even though I know it now as a real place. I believe all those years I spent imagining [have] an identity of [their] own and will not really change. In a way, imagination is a culture of its own.

AG/HV What have you learned about Armenia from these cinematic projects? And has it contributed to your understanding of Canada at all?

GT Through these projects, I have answered the questions I have been concerned about since I moved to Canada. It was only through film that I could get to the core of these questions. I believe now that I have gotten a grasp of my Armenianness, or Armenia, I can understand or feel a deeper connection to Canada, but it is only the beginning.

Note

1 Egoyan's "reality" film entitled *Citadel* (2005) focuses on Beirut, documenting Beirut-born Khanjian's first trip back to Lebanon since she left during the civil war. While Torossian has yet to make a film about her Lebanese soujourn, her enthusiasm for the place does not preclude the possibility.

Works Cited

Hoolboom, Michael. 1997. *"Girl from Moush*: Gariné Torossian." *Cantrills Filmnoteṣ* 85/86 (June): 50–53.

MacKenzie, Scott. 1999. "National Identity, Canadian Cinema and Multiculturalism" *Æ: Canadian Journal of Aesthetics* 4 http://www.uqtr.uquebec.ca/AE/vol_4/scott(frame).htm.

Rushdie, Salman. 1991. *Imaginary Homelands: Essays and Criticism 1981–1991*. London: Granta.

▶▶❘ 18

Ripple Effects
Atom Egoyan Speaks with Monique Tschofen

Monique Tschofen Your parents were artists before they moved to Canada. Your sister is a concert pianist. And you have been fully immersed in the arts since you were in your teens. You were writing plays that were actually performed at theatre festivals when you were as young as thirteen. You've performed classical guitar. Then when you were an undergraduate student, you started making short films for the University of Toronto's Hart House, which led to the features and the work in television. You have since expanded your repertoire into the worlds of opera and installation art. In addition, you've always been very much involved with writing. Your credits as a screenwriter are astonishing, and you have now adapted three novels to the screen. We have seen you flex your journalistic muscles interviewing writers like Michael Ondaatje and Russell Banks, and your academic muscles with essays and introductions to a number of books on film and art. Do you consider any of these modes of expression to be your "mother tongue"?

Atom Egoyan I would say theatre is my mother tongue, because that's what I started out doing in school. I felt really drawn to the absurdists even before I knew who they were. An old teacher of mine just visited from Victoria. He reminded me of this early play that he had written I have a copy of, in which I was cast as a young boy playing myself. His name was Colin Skinner, and

the play was called *Robot*. He couldn't imagine what an influence this would have. In the play, my actual best friend played my imaginary best friend. To have a teacher who was involved in writing drama, directing it, but who enjoined me and my friends and to make this a collaborative work left a huge impression on me.[1] I began writing plays around this time just because I had this model; it was a very tangible thing for me to be able to do. I was also really drawn to the idea of how drama could deal with notions of dysfunctionality. If there were certain situations that I found untenable in my life, I was able to use drama as a way of dealing with some of the frustrations that arose. I loved the process—and maybe it's neurotically inspired—of making other people do things that they wouldn't do otherwise, and being able to organize people in a certain way that seemed to have some semblance of order.

The reason I made my first film is that I came to Toronto after having a wealth of plays produced at various schools in Victoria. I submitted a play to the Trinity College Dramatic Society, which was rejected. I was so outraged at this that I went to the Hart House Film Board and decided to make it as a short film, out of spite! Inadvertently, in making that film, I understood that the camera was a very powerful tool and could actually be another character, an active participant in the drama. That excited me.

At that time I also came to understand that all the drama I was writing was very derivative pastiches of Ionesco or Adamov, or Beckett, and later on Pinter. All these people had a huge influence on the plays I wrote, and I never really escaped from their shadow. Absurdist drama was something that informed the early films. I was fascinated by the harnessing of lunacy and despair, by the rituals that characters devised to deal with their pain or trauma. You see that absurdist influence in a film like *The Adjuster*—the use of repetition, role-playing, compulsive behaviour that touches on the violent and the grotesque. The absurdists believed that the assumptions of our civilization had been tested and were inadequate, and tried to find a way of expressing the senselessness of the human condition. Language and other modes of communication weren't reliable as mediums for real discovery and communication.

One of the things that I find so satisfying about returning to the theatre with *Salome* is that it offered me a chance to recover a brilliant piece of dramatic text by Oscar Wilde which probably doesn't work as well as a play as it does as a libretto. The psychodrama of that was—is—really compelling, and I'm really privileged to be able to go back to the theatre through opera because it was something that I originally aspired to do professionally.

MT I've been reading through those early plays in the archive. Filed alongside many of them are what seem to be the comments of your earliest critics. Some of their criticisms are harsh, but very interesting. They accuse

you of being too repetitious, or too abstract, or of cultivating too flat an affect. It seems to me that they are already noticing in your writing the core elements of what would later become your signature style. Along with thinking this is amazing, that a thirteen-year-old can have a signature style, I was wondering how you managed to survive the experience at that delicate age, and continued to write and put your work out there in your own voice.

AE That was the Victoria Drama Festival, and those were plays I wrote, directed, and acted in. The plays were adjudicated, and you weren't let off easily just because you were young and wrote a play. Those early critics and their harshness, and the fact that I wasn't going to be able to get away with putting on any old play, were all really important. I was taken seriously. I think it's important to be rejected early on because you have to define why you want to continue doing something. And you also have to be able to place yourself into a context, to figure out what the work is that's being accepted and understand how your own ideas relate to that. The most damaging thing might be to be immediately accepted and not to have anything to work against. You develop muscles with criticism. The early films also received some really negative critiques. I always understood that I wasn't making films that were supposed to appeal to everybody, and that was just part of the package.

MT In addition to returning to the theatre with *Salome* and your productions of the operas *Elsewhereless* and *Dr Ox's Experiment*, you've recently had the opportunity to direct Wagner's *Walküre*, from the Ring Cycle, for the Canadian Opera Company in Toronto. The themes of this opera, such as incest and power (which echo so many of the themes your work turns to), make it a wonderful fit. But I'm wondering whether Wagner's views about the possibilities of the operatic medium have any special resonances for you?

AE There are two ways of approaching the operatic projects. The first is purely sensual. I've always been excited by the fusion of music, drama, and spectacle, and Wagner certainly understood opera's extraordinary possibilities in this regard, with his idea of *Gesamkunstwerk*. But the second factor, and the one that draws me at a deeper level, is the underlying psychology of these works. *Salome* is a powerful study of abuse and its aftermaths, and *Walküre* is one of the most complex studies of a father–daughter relationship in the history of dramatic art. I was recently reading an essay by Germaine Greer which states that the third act of the opera contains the only love scene in non-pornographic literature between a father and a daughter that explores the erotic power of parental love. She explains that Wagner boldly re-enacts the conventional scene of childhood—Daddy putting his daughter to bed—but imbues it with grandeur, majesty, and sexual power. He presents these two archetypal figures as their rich musical themes lift them to

what she calls a "monumental intimacy." This is what excites me about opera.

MT Let me ask about your work in television. One senses throughout your work that there is a real tension between the way you represent the medium of television in your feature films—as vacuous, facile, and yet prescient and powerfully manipulative—and the fact that your own credits included several short and feature projects for the Canadian Broadcasting Corporation (CBC) and Britain's Channel 4, as well as directorial credits for some popular American series such as *Friday the 13th* and *Alfred Hitchcock Presents*. What has the medium of television offered you?

AE Television is about a communal event shared by millions of people yet watched alone, on in the intimacy of a familial setting. Maybe it's also about "monumental intimacy"! There's this tremendous fusion of the very public and the extremely private, and that's certainly at the dramatic core of a film like *Where the Truth Lies*—with the telethon—and even the cooking show in *Felicia's Journey*. What fascinated me about the telethon is the almost mythological way it presents celebrity—testing the very physical limits of popular entertainers—and then juxtaposing this with an extremely intimate moment exchanged between a celebrity at the height of his fame, Lanny Morris, and this little girl who believes that he saved her. This moment of their exchange is witnessed by millions, yet its true meaning is completely concealed until the end of the film.

There is something almost banal about the ease of television broadcasting and reception that belies the psychological complexity of transmission and projection. I've explored this in a number of earlier films as well, like *Speaking Parts* and *Gross Misconduct*. On the other hand, there's the intimate video diaries explored in films like *Family Viewing*, *Calendar*, and, most recently, *Citadel*. These contain images that are made for private consumption, but which are then discovered and reformatted in other ways, depending on the needs of the particular receiver.

MT Does the art of the theatre inform your other projects?

AE There's definitely a theatrical element to the installations. For example, in Montreal, the Musée d'Art Contemporain is a very theatrical space. It was able to do for *Hors d'usage* what I want any work to do, which is to create a sense of being able to enter into a space. This space could be a screen, or it could be physical if there's a degree of participation; either way, it plays with the curiosity of the viewer, and however much the viewer wants to invest in a piece, it can continue to unfold.

MT That's interesting, because entrances are never straightforward in your work. Part of the theatricality you refer to in *Hors d'usage* has to do with

the multitude of interstitial spaces one must pass through before reaching the main room of the installation. In installations such as *Close*, where the viewer's body is nearly pressed up against the screen, or *Hors d'usage*, where you tease the viewer with highly tactile images of people who are touching something your viewers are not allowed to touch, you seem to be physically prompting the viewer to assume certain intellectual and emotional positions vis-à-vis your work—in my experience, not only a position of curiosity, but also a position of doubt or uncertainty, and one that is never entrenched or static. So when you say you want your audience to "enter into" the space of your works and become participatory and invested as they would when entering the theatre, what do you mean? Is it safe to assume here you're talking about a more engaged kind of theatre, like the theatre of the absurd?

AE I don't believe that the theatre of the absurd is any more "engaged" than other theatrical traditions, but I do find that the process of theatrical engagement is highly charged and inspiring. I love the idea of entering a theatre and being immediately aware of the artifice. There's something improbable about the idea that a viewer can overcome the clumsy idea of watching something blatantly artificial and embracing it. And yet that's the power of the medium. If the alchemy works—if the performances and the direction find the right pitch and tone—the viewer overcomes this initial distance and an extraordinary communion occurs. It's a rare and almost sacred moment.

MT Yet as you say, being able to enter into a space is important. My own physical hesitations when I move through your installations—which I suppose aren't so dissimilar to the responses of viewers who have troubles with the narrative complexity or abstractions of your films—remind me of the scene in *Calendar* in which the photographer doesn't want to enter into the buildings he is photographing. Watching his awkward body, we have an acute sense of all the things he will lose because he hesitates to enter. And is this not a theme that recurs in your work, something bound up with a tension between seeing (the problem of images and screens, which in some ways remove us from embodied experience) and just being (in a body, time, and space)? Can you tell me about the relationship between the visual and the tactile in your work?

AE I think that issue has been raised in a lot of the films. *Exotica* makes it most explicit with the idea that you can look but can't touch. Certainly it is also in *Calendar*, in Arsinée's questioning "Don't you ever feel like touching?" I think that it's even in *The Adjuster*—these very tentative ways in which Maury Chaykin touches the adjuster at one point, trying to make contact, as opposed to Don McKellar's character physically violating Arsinée with his hand. This idea of contact is so loaded, and I've certainly tried to broach the issue.

I've always felt that entrance into a screen is a physical act. In *Speaking Parts*, there are these moments where I almost would like to think of the screen as an installation site that you are able to interact with, that in a way questions what you know about touch. Likewise, in the recent installations I've tried to create ways in which people can physically manoeuvre themselves into the private and communal memories that are being investigated. There is a physical sense that the person is activating or initiating a process with their very presence.

I think this is something that happens very often in terms of the family construct—in certain social constructs, someone's mere presence initiates a process of revolution or change. I was very influenced by this notion, in, say, a film like Pasolini's *Theorema*; Terence Stamp's physical presence into that family just begins to initiate a whole series of shocks and shifts which lead to a whole redefinition of not only that particular family but also the entire social class that it functions within. With *Ararat*, the fact that there is this button missing in the photograph of Arshile Gorky's mother, which initiates this physical gesture to cover it, which initiates a certain pose in that photograph, which then, of course, may lead to this painting. A simple gesture either symbolically or literally can have a profound ripple effect.

MT Yes. I see what you mean that it's not only a presence but often a particular gesture that sets up the real action of your films, unravelling the whole edifice of artifice. I can think of so many places in your films where somebody reaches out to touch somebody else, and that's often where the real action takes place, not in all the talking. Your work consistently turns to the motif of hands—reaching, touching, pulling back. Can you tell me more about this?

AE Of all the different parts of my anatomy, I've always been very aware of the hand. I think my interest in hands probably comes from being a classical guitarist, of actually being aware of hands having two completely separate functions, and being very aware of positioning. And that's funny, because my son is now working on violin; there's a real consideration of how a hand is positioned to produce sound, and the different types of tonal effects that are produced by the shifts in hands and fingers. Fingers also fascinate me. Extremities. There's that line in *Family Viewing* as Stan is staring at his fingers and says, "It's strange to think we still have fingernails." As a musician, you're very aware of how you get a tremolo, or of the different positionings—on the guitar or violin you can play a G there or here, the same sound but down different strings. The notion of placement becomes a crucial consideration in terms of the tonal consequence.

MT Moving out from there, you seem also to be fascinated by attendant notions like manipulation.

AE Again, classical guitar is very intricate that way. What the right hand is doing is so different from what the left hand is doing. And it's also interesting too with the violin, where what the bow hand is doing is quite subtle. I'm thinking of instruments where the functions of the two hands and the muscles of the two hands are quite different. There's a moment where when you're studying a new piece. Initially, you're aware of what's happening: you're aware of going thumb, index, middle, index, middle, index, ring, index, ring....You have to memorize these positions, and then you play them very rapidly until at a certain point you can't think about it. That is the point where it goes from a conscious manipulation to something that is completely intuitive.

MT I wonder whether a process much like this, which proceeds from repetition to intuition, explains some of your characters' manipulative behaviours, like Hilditch in *Felicia's Journey* or the lawyer in *The Sweet Hereafter*?

AE The passage of events and circumstances that lead to a ritualized activity, or a particular type of job or occupation, are fascinating. Certain professional pursuits—a litigation lawyer, a film censor, an insurance adjuster, a customs officer—allow an individual to indulge a neurosis that would otherwise not be socially acceptable, especially regarding how one can gain access to other people's lives.

MT One of the images I've retained from your installation *Out of Order/Hors d'usage* is the illusion that all of the tape being played on the reel-to-reels is linked. This vision of the interconnectedness of human experience— which seems to be an antidote to the equally powerful visions you produce about isolation, atomization, alienation—has a correlative on the level of the narratives you construct. You often pull together a number of storylines that seem disconnected, only to reveal that they are intimately connected. Many of your reviewers have a hard time with this complexity!

AE A film like *Ararat* certainly seems to convolute issues that some people want to see as black and white. I've gotten into huge arguments over this with critics who found the film irresponsible; they argued that we're living in black and white times, and these issues have to be represented unambiguously so that people understand what the nature of genocide is. This completely flies in the face of (a) the fact that the enduring legacy of this particular genocide is denial and (b) the fact that we do have a whole body of holocaust literature and films that don't need to be supplemented by another reworking of an obvious statement—which is that human beings are capable of great evil, that they're able to abstract one another, that they're able to dehumanize each other. What happens in this scenario is that you inevitably find yourself in the middle of a lot of narrative stereotypes. As an

artist, one is constantly trying to refine and purify one's own ideas and to distill what it is that one's trying to do. In my case, part of that distillation is an effort to generate a structural complexity, but to make that complexity as pristine as possible.

I had the experience right before *Ararat* of making *Krapp's Last Tape*, which was a very important text for me, and which I think in some ways the purest expression of what I do as a director working with one performance— working with a piece of text in one location. What astounded me were the shifts of time Beckett was able to deploy. We're working with three different periods of time: between Krapp as he is at the age of sixty-nine, reflecting on himself as he was twenty years before, which is also a reflection on who he was twenty years before that. So the idea of making the straight linear is something I came closest to with that project, and I allowed myself to do so because of the movements already there within that text.

MT Around the same time as you put together *Steenbeckett*, an installation that is all about analogue media that are disappearing, you produced all these DVDs. What are your thoughts on the relationship between analogue and digital culture?

AE The reason why I digitized all my films was a matter of convenience and accessibility: I want to make the work available to people. I think digital culture is enormously exciting. The tragedy is that most of the time it means watching something on a television screen, and no matter how progressive the landscape of digital culture is, it's sad to me that the conduit by which we watch it is very conventional. I think as that practice is challenged, we enter into something a lot more exciting.

The great virtue of digital culture is its democratization. It has made film making available to anyone. To shoot *Next of Kin* in 1984 on a shooting budget of $25,000 seemed miraculous until a few years ago, when that's actually quite a healthy budget to shoot something digitally, which can be edited on your computer and still presented at a really professional level. The issue for me is that digital culture makes filmmaking, or image-making, quite ubiquitous. The risk is that there is nothing particularly considered about the act of shooting digitally because it's so easy and inexpensive to do, and that notion of consideration is hugely important to me.

This idea of the considered image—as opposed to the casual or "easy" image—is something I certainly bring up in a film like *Citadel*, the digital diary shot in Lebanon with Arsinée, which was an "effortless" film to make. On the other hand, when I was shooting *Krapp's Last Tape*, we had to bring in this special magazine that could accommodate 2,000 feet of 35mm film, so that the final twenty-minute shot was all done in a single take. That was a hugely physical act, something that is becoming so rare now because you

can shoot so easily. With the tiny digital camera I used for *Citadel*, I could shoot an uninterrupted ninety-minute shot from the palm of my hand!

When you see the tape running through the whole space of *Out of Order/Hors d'usage*, which is also the idea behind *Steenbeckett* as well, I want you to have this idea of the physicality of the medium, so that there's a commensurate sort of relationship between the physical bulk and the amount of information that you're absorbing. We don't often get to experience that anymore. (That's even clear in *Hors d'usage*, because the sounds that you're actually hearing are not from the tape running through the players, but rather are stored digitally and are activated by a sensor.) What I find moving about the old technology is that it's at times supremely impractical, but that gives it a personality. But to state the obvious, the ancient idea that cinema or other recording technologies should only be defined by sheer physical bulk is a little ridiculous.

MT Are you saying the analogue requires a particular kind of commitment?

AT It requires commitment in a way that goes back to your issue about touching: you're aware that the physical properties of something define the relationship to its environment, or how that physical thing manoeuvres its way through the environment, either in purely practical ways or socially fraught ones.

MT It seems as though you're always been very much aware of the social and physical relationships of things to their environment, drawing our attention not only to the specificity of media, but also to the specificity of social and public spaces. For example, you've linked several pieces to Montreal—a city in a province that honours remembrance on licence plates. Are you hyperconscious of its particular socio-political legacy?

AE Yes, and I think that's why I've been so gratified by the success of *Ararat* in Montreal, because there was that whole other subtext in the film. In the film, the character of Celia is reluctant to use her native tongue—French—against Ani because she feels that ultimately this woman has the capability of intimidating her in her own native tongue. We get a glimpse of that tension in one conversation. I think that the Québécois ideas about how a collective memory is conveyed—it's fascinating that it's actually on the licence plate—connect to my own interests in these questions. Beyond this, my work has always found an audience there. The early films such as *Family Viewing* were really embraced in that city. And Montreal is also a hugely important city because most of my family lives there. Besides my parents, who went to BC when we moved to Canada, everyone else in my extended family settled in Montreal, so all my aunts and uncles and my cousins are

there. *En Passant* in a way deals with this idea that Montreal is a place that's full of ghosts. It was great to be able to incorporate my two uncles into *Out of Order/Hors d'usage*.

MT Ghosts are another theme that starts so early in your work. I came upon a grant proposal you did for your short film *Open House*, in which you talk about it as a ghost story—a haunted house.

AE I'm interested in the idea of the physical spaces we build to insulate ourselves from certain issues. Instead of distancing us, these spaces may actually achieve the opposite by concentrating, even exaggerating and pummelling us with their presence. The same thing can happen with rituals we set up to deal with grief or mourning—again, they may only serve to exaggerate these feelings. The psychological term for this is "faulty mourning." The places we dream would make us happy and our actual relationship to what it means to be in those places intrigue me as well.

For all the uncertainty in my early life, I always knew that when my parents were making things, when they were involved in the production of art, there was a refuge. So I have always had the sense that if people are involved in the process of making something together, there's something hopeful. So even in that film, *Open House*, the family is working together on this plan, and as the plan is being made, there is some joy in its creative aspect, even though it only defines their loneliness and their separation from the outside world. And that moment when the bell goes off and Frank goes to collect them, you know the glee, that sense of exhilaration that they're making something. And I think that process of making is infused throughout the work.

That's what *Ararat* questions: all these characters are trying to convey their past through these artifacts that they make, either Ani's book or Raffi's digital video or Rouben's screenplay or Edward's film—all with varying degrees of success. The film within the film may not be very good, and probably isn't—it's probably just going to disappear after that premiere. I think that's the difficult thing for people to understand. I'm not trying to be judgmental about it, but the fact is that there are things which disappear and there are things that endure. Gorky's painting has endured, but it's important to wonder about why it has endured and the degree to which people are prepared to investigate it. For years, it existed on the wall of the Whitney and the National Gallery of Art in Washington without people even knowing he was Armenian.

MT Is there some other determinism here? That Gorky's work survives because it's a painting as opposed to something more transient like a photograph, high art rather than low art?

AE That's interesting; I hadn't thought of it that way. I'm not so sure. I do think that I'm more drawn to the works that are more open to interpretation. I feel that you can invest more in them. There's much more interaction between that painting and the viewer than there is with Edward's film, which is very literal and doesn't really allow for a degree of interactivity. It bludgeons you, and I am suspicious of any sort of work that bludgeons you with an orthodoxy saying, "This is how this must be." What's interesting to me is how the customs agent is looking at a kid's diary and is trying to interpret the story behind what he's seeing literally. And Ani's book is an attempt to interpret an artist's life. In contrast, there's an arrogance to the Saroyan character, something almost self-satisfying and smug, in that he's finally getting a chance to tell this story. But I think that we can see in Rouben's character the sense that it's not telling the whole story. And certainly in Raffi's quest, he is trying to define authenticity: where, through the making of images, can you actually determine and find something that's authentic? I mean, that's such a fanciful idea, going to Turkey to get a 35mm image of Ararat. It's just ludicrous, but it's based on this emotional need to find authenticity. And for him it's not necessarily just in finding the artifact, in having the artifact there; it's being able to have it presented again in a physical way that allows for a degree of interactivity and which invites the viewer to participate.

MT There is another kind of interactivity and physicality your films treat that I'd like to ask you about: incestuous motifs and the pornographic images have been part of your work from the beginning. They both attract and disturb your audiences, and you have invited your audience to participate in them at the same time as you have frustrated this participation. Your short *Peep Show* first dramatizes this kind of interaction; *Exotica*—which I understand was marketed as a sex thriller in some areas—takes it up even more explicitly. Have audiences in different parts of the world responded differently? I would guess that the French, for example, because of the legacy of de Sade, might be more inclined to make connections between this sexual dynamic and social, political, or revolutionary dimensions of your films.

AE I would definitely say that the French have always been fascinated by the notion of perversity in my films. I found this most clearly in the early nineties, when I was in Paris for a retrospective of my work at the Jeu de Paume. It was very funny to be caught in the middle of an incredible discourse between Virilio and Baudrillard, the former saying the image is reality, the latter claiming that the image is a simulacrum of reality. But in France there is also the Sadeian notion—and I'm not just meaning to jump from one thing to the other!—but you are right in mentioning that there is also a tradition inherited from de Sade of the *staged* image, the Sadeian notion of the ritu-

alized "scene," the positioning of indulgence in sensual extreme. What I find compelling in de Sade is how an unacceptable ritual gains in sanctity—through the sheer power of description and staging—from representing what, under ordinary circumstances, would undoubtably be considered a transgression.

MT So are you working with the Sadean notion that a transgression in the form of sensual torment can express something that is socially or politically motivated?

AE Yes. But in my work a lot of the time many of those characters are not aware of what they're doing. I think that in the Sadeian universe, the torment is done with such a degree of complicity and understanding. There is a breathtaking degree of predetermination in terms of how things are laid out in his world.

MT Would you say these sets of themes about ritualistic sensual indulgence are put to the side in *Ararat*?

AE Yes, except we're dealing with perversity on such a huge scale. I mean, the whole thing is actually dealing with a fundamental perversity. So yes, there is the sense that the film lacks some of the tonal registers of my other films—the sort of the humour that comes from seeing people deal with or negotiate their lust, or determine between their lust and their other needs. And I'm not quite sure why, but there is something decidedly neutralized about the erotic encounters in the film. I think it's just given the nature of the bigger issue here. The exploration of things sexual was secondary because I think that everything is set within the context of this monstrous cataclysmic event and somehow that is the central perversity in the film.

There's also something else here in the film, and I think a lot of people are reacting to, which is that in the other films the characters are not very adept at communicating their feelings. With *Ararat*, we're dealing here for the first time with characters who, because of their responsibilities, are very articulate; an actor, an art historian, a screenwriter, a director. They are people who are able to talk, and I'm using language here in a different way. There's a didacticism because people feel that they have an opportunity to speak, and a tension because it may be snatched away from them at any given time. So there's this young man, who during a customs inspection, just begins to go into the most arcane details about the film that he has been working on, because he's given licence—he's given the opportunity. And he doesn't know when he'll be silenced. That does make the work tonally different than the other films. This gives it a sort of earnestness. People are used to something else from my work; they associate the work with kind of a degree of emotional reserve, which is present here in a different way.

MT Do you think the sex scenes in *Where the Truth Lies* that have generated so much controversy differ from this economy of ritualistic indulgences and perversity you have represented in earlier films?

AE I really do think we have to think of those sex scenes as just that: they are highly calculated *scenes*, set up by Lanny's voice-over narration. We spoke before of the Sadean notion of transgression and staging and predetermination, and how the sexual dynamics are constructed from the relation of power and politics. Lanny wants us to believe that he could have all the women he wanted, that the sex was vulgar, sleazy, compulsive, and impersonal. The more he can convince the viewer of this, the less implicated he is in Maureen's death. She was just another body, as opposed to someone who had some emotional consequence in his life. It's a masquerade. On the other hand, Vince's "sex scenes" feel exploitative because that's how he's choreographing the moment (the scene between "Alice" and Karen, for example). I was surprised that some people couldn't "read" these scenes for what they were. Perhaps it's because Lanny and Vince are such strong characters and that their personalities clashed too violently with my sensibilities as a director!

MT What about humour in your films?

AE The humour is often drawn at the expense of the viewer's comfort. It's about defining a sense of self-consciousness, and finding a droll humour in the sheer awkwardness of the execution. I'm not just speaking about the uncomfortable way the characters might have of going about things, but also my own discomfort in presenting events that are supposed to be monolithic in their meaning.

There are moments in *Ararat* that I think are funny, but they're often not understood that way—and some of them had to be cut. What is most darkly humorous about the piece is its use of kitsch, but I think that is something that people are uncomfortable negotiating. I certainly never wanted to make fun of the film within the film, but there are things which you can either look at from a distance or be implicated and very emotionally involved in. I just think it's difficult to be humorous about this particular event because it's a very sobering notion that something like this has not been addressed.

MT Your films always seem to tread on a delicate line. For me, the bananas in *Howard in Particular* are very funny, as was the trick ending of *Citadel*.

AE That's a good example of drawing the humour at the expense of the viewer's comfort. The event that concludes *Citadel* is partially staged. Defining the precise point at which the confabulation begins is extremely disturbing to the viewer who wants to believe that it must all be true. It creates a violent reaction. People don't know what to feel. I find this tension humor-

ous, but other people won't find it funny at all. It's a bit like David Cronenberg's *Crash*—a film I adore, and which other people just detest—which I find very, very funny at moments. Other people just will not respond to that.

MT You need to give yourself permission.

AE Exactly, and then that's the issue for me as a director: How do you give permission to people? It's not just laughter. In *Ararat*, I'm exploring, how do you allow people to question, and feel? It's all about trust. I think that what happened with this film is that, given the historic, political perceived need of the movie, people were not prepared to trust that I could question certain things which are considered orthodox. And that surprises me, because it's so much a part of everything I've done, but in this particular case there's something sacrosanct about the presentation of the issue which I agree with. The issue of genocide has deeply affected me and has certainly tormented members of my family. But I also think that the idea that a film is going to change everything is something I just can't take seriously. Though, that being said, this film has changed some things, because there is now a degree of public discussion. If you read the *Washington Post*, which has never used the word *genocide* before, you suddenly see five articles come out in November 2002 which use that term very freely. Most journalists accept it as a fact, which wouldn't have been the case the year before.

MT Since *Ararat*, you've produced two seemingly very different films. Your epistolary film *Citadel*, which as I understand was a private project—a kind of digital home movie you screened locally—seems to explicitly take up the question of politics and history again, investigating the devastating effects of the war in Lebanon, Arsinée's homeland, as well as the contemporary repression of Lebanese citizens. *Where the Truth Lies* appears to be much less political, through its forays into the entertainment business. Still, the two films are very much of a set through their obsession with the seductiveness of lying. What is your investment in this question of truth and lies that you keep returning to in your work?

AE I'm fascinated by storytelling, by the moral consequences of telling a story. In our culture, the bombardment of information has completely transformed the way in which we respond to a story and how we define the truth of a narrative. I think it was Walter Benjamin who spoke of a story needing to achieve an amplitude that sheer information lacks. So then the question becomes how much trust we give a storyteller, what a storyteller needs to do to achieve this trust. That path—the storyteller needing to prove himself worthy of trust—forms an entirely different narrative, and it's a risky one. I think that *Citadel* and *Where the Truth Lies* push those issues of trust. Who are the most reliable narrators of a story? Why should we believe them? At

the end of *Where the Truth Lies*, as Karen assembles the "truth"—which in this case is the absolute cliché of the butler having done it—there is no absolute proof of what she concludes, much as Christopher Plummer finds there is no reason to believe Raffi's story at the end of *Ararat*. Plummer finds himself in a dark room at Canada Customs. Karen finds herself on the empty backlot of Universal Studios. Thousands of stories—fantasies and industrial fabrications—have emanated from the later. The one that emerges from the dark room is absolutely unique. Is one story more valuable than the other? Why?

MT So what are your next plans?

AE I'll continue doing this for as long as I can, absolutely. One of the comforts of digital culture is that there is a way to continue to make this work in a more modest way. Like a lot of artists, I think that I work in a sort of garrison mentality: you just assume at all times that you are beleaguered and maybe that's the way it should be. This goes back to my earlier point about the critical comments about my work in theatre. You just assume that you're going to be met with resistance, and that defines your drive.

Note

1 Colin Skinner passed away shortly after this encounter.

▶▶| Filmography

Atom Egoyan's Oeuvre
Theatre, Film, Opera, Installation

Monique Tschofen and Angela Joosse

Theatre
Selected Plays Authored and/or Directed

A Fool's Dream 1973
The Doll 1974
Manx 1975
The Cell 1975
The School 1975
Blind Alley 1976
Profit by Proxy 1977
The End of Solomon Grundy 1977–78
Beach Heads 1980
Stumps 1981
Convention 1982
Open Arms 1984
Eh Joe 2006

Films
Short Films

(untitled) 1978 Canada
15 min. Super 8mm.
Director and screenplay: Atom Egoyan.

Lusts of a Eunuch 1978 Canada

17 min. Super 8mm.

Director and screenplay: Atom Egoyan. First screened Thursday, August 31, 1978, at the Art Gallery of Greater Victoria in an evening of experimental film, along with *Film* by Samuel Becket and *Un Chien andalou* by Luis Buñuel.

A pompous headmaster addresses an invisible audience.

Howard in Particular 1979 Canada

14 min. 16mm. B&W. English.

Director, screenplay, cinematography, and editor: Atom Egoyan. Music: Garth Lambert. Cast: Carmen Guild, Anthony Saunders, Arthur Bennett. Production company: Ego Film Arts, Hart House

First Prize, Dramatic Canadian National Exhibition Film Festival.

Beckett-inspired, this short film focuses on the absurdity of Howard's retirement from a mechanical assembly-line job at a company that makes fruit cocktail. Howard's boss, who claims to take an interest in him "in particular," addresses him from a audio recording with a litany of Howard's many failures. The boss then asks Howard to send the next retiree in, to repeat the dehumanizing process.

After Grad with Dad 1980 Canada

25 min. 16mm. Colour. English.

Director, screenplay, cinematography, and editor: Atom Egoyan. Sound: Michael Ruehl. Music: Garth Lambert. Cast: Lynda-Mary Greene, Anthony Saunders, Alan Toff. Production company: Ego Film Arts.

Finalist, Dramatic Short, Athens (USA) International Film Festival.

A tense film that depicts a young man who arrives at his girlfriend's house early and has to endure an abusive conversation with the girlfriend's father, who embarrasses him sexually.

Peep Show 1981 Canada

7 min. 16mm. B&W and colour. English.

Director, screenplay, cinematography, and editor: Atom Egoyan. Colour design: Anne McIllroy. Music and sound effects: Matthew Poulakakis and David Rokeby. Cast: John Ball, Clarke Letemendeia. Production company: Ego Film Arts.

First Prize, Experimental Canadian National Exhibition Film Festival.

This surreal short relies on a colourizing technique similar to Norman Maclaren's. Set somewhere between a pornographic pleasure dome and a shopping mall, the film literalizes the invitation of the peep show: "We add colour to your most subtle desires." A man enters a photo booth alone with the intention of responding to a personal ad that seeks "an ordinary man for mutually fulfilling relationship," but the photos that come out—perhaps projections of his fantasies—reverse the logic of the peep show by producing salacious images of him in increasingly compromising poses with a woman.

Ceremony & Allegory of the Medieval Hunt 1984 Canada
24 min. Video. English.
Director and producer: Atom Egoyan. Writer: Robin Healey. Production company:
Centre for Medieval Studies; Media Centre, University of Toronto.

This video explores the visual presentation of the hunt, practically and allegorically
in illuminated manuscripts, paintings, and tapestries of the thirteenth to fifteenth
centuries.

Men: A Passion Playground 1985 Canada
7 min. 16mm. Colour. English.
Director, concept, cinematography, sound, and editor: Atom Egoyan. Poetry and
performance: Gail Harris. Music: Matthew Poulakakis and Perry Domzella. Pro-
duction company: Ego Film Arts; Gail Warning.

Egoyan investigates the possibilities of poetry when combined with film, trying to
capture the "voice of this love-poem, dictionary-list, comic-history of the male
species" in Gail Harris's poem "Men" while allowing the silent, voiceless men their
own expression through visual images.

«En passant,» episode 4 of *Montréal vu par…* 1992 Canada
20 min. 35mm. Colour. English.
Director and screenplay: Atom Egoyan. Cinematography: Eric Cayla. Editor: Susan
Shipton. Music: Mychael Danna. Sound recording: Claude Hazanavicus. Sound
editing: Steve Munro. Sound mix: Peter Strobel. Cast: Maury Chaykin, Arsinée
Khanjian. Executive producers: Michel Houle, Peter Sussman. Producers: Denise
Robert, Doris Girard, Yves Rivard. Production company: Cinémaginaire Inc., Atlantis
Films Limited, National Film Board of Canada. Produced for the 350th anniver-
sary of Montreal.

In this contribution to the compilation *Montréal vu par… six variations sur un
thème*, Egoyan explores the tensions between words and images by following two
characters—a customs agent who sketches images of the people she lets into the
country, and one of her subjects, a man who is attending a conference on univer-
sal signs—as they each attempt to decipher the sensually charged city of Montreal
and the memories aroused by passing through its streets.

A Portrait of Arshile 1995 Canada/Britain
4 min. 35mm. Colour. English and Armenian.
Director and screenplay: Atom Egoyan. Photography: Atom Egoyan, Paul Sarossy.
Sound: Steve Munro. Music: Eve Egoyan. Voices: Atom Egoyan, Arsinée Khanjian.
Cast: Arshile Egoyan. Production company: Ego Film Arts for the BBC, Arts Coun-
cil of England.

An epistolary film in which Atom Egoyan and Arsinée Khanjian explain to their
newborn son, in English and Armenian respectively, the origins of his name through
an exegisis of the self-portrait of the Armenian painter Arshile Gorky and his
mother.

The Line 2000 Canada
4 min. 35mm. Colour. English.
Director and screenplay: Atom Egoyan. Cinematography: Paul Sarossy. Editor: David Wharnsby. Music: Mychael Danna. Sound: David Redfern, Steve Munro, Daniel Pellerin. Executive Producer: Niv Fichman. Producer: Jody Shapiro. Production company: Rhombus Media. Series: "Preludes."

The Line is one of ten short films created in celebration of the 25th anniversary of the Toronto International Film Festival; a short was screened before each feature film throughout the Festival.

Diaspora 2001 Canada
8 min. Colour.
Director, editor: Atom Egoyan. Music: Philip Glass. Commissioned by: Pomegranate Arts.

An abstract film collage made up of excerpts from Egoyan's film *Calendar* and other Armenian films, including Elia Kazan's *America, America*, intended as part of the series *Philip Glass: Shorts*.

Television

Open House 1982 Canada
25 min. 16mm. Colour. English.
Director, screenplay, and editor: Atom Egoyan. Cinematography: Peter Mettler. Music: David Rokeby. Sound: Michael Ruehl. Cast: Ross Fraser, Michael Marshall, Sharon Cavanaugh, Alberta Davidson, Housep Yeghoyan. Production company: Ego Film Arts with the assistance of the Ontario Arts Council. Aired on CBC as part of the *Canadian Perspectives* series.

A film, in Egoyan's words, about a kind of "haunted house" that follows "the dead spirits of a restless family" to expose a bizarre method of maintaining pride in a household drained of self-respect. A young couple is brought to an old house by a man posing as an estate agent in order to prompt the owners—his own catatonic father and depressed mother—to remember the better parts of their past.

In This Corner 1985 Canada
60 min. 16mm. Colour. English.
Director: Atom Egoyan. Screenplay: Paul Gross. Photography: Kenneth Gregg. Editor: Myrtle Virgo. Music: Eric Robertson. Cast: Robert Wisden, Patrick Tierney, Brenda Bazinet. Producers: Alan Burke, Sig Gerber. Production company: CBC. First broadcast February 2, 1986, on CBC.

A taut psychological film about "revolutionary romanticism," in which a Toronto boxer of Irish heritage is persuaded by the IRA to smuggle a terrorist back to Ireland with his fight crew. Through rhetorical obfuscation and aestheticization, male violence is shown to repeat inexorably. Nominated for a 1986 Gemini for Best Short Drama.

"Cupid's Quiver" 1987 Canada
30 min. Colour. English.
Director: Atom Egoyan. Screenplay: Stephen Katz. Producer: Jon Anderson. Production company: *Friday the 13th: The Series*. First broadcast: October 12, 1987.

A mysterious Cupid statue shoots arrows into its female victims, making them fall in love with whomever has possession of the statue. Once declarations of love are spoken, each owner is driven to kill his beloved.

"The Final Twist" 1987 Canada
30 min. 16mm. Colour. English.
Director: Atom Egoyan. Screenplay: Jim Beaver, from the story by William Bankier. Cast: Martin Landau, Robert Wisden, Ann-Marie MacDonald. Producers: John Slan, David Levinson, Barbara Laffey. Editor: Tom Joerin. Production company: *Alfred Hitchcock Presents*/Universal TV.

Three film-production-house employees who are mistreated by their unscrupulous boss use their special-effects skills to devise a murder plot.

"There Was a Lonely Girl" 1988 USA
30 min. 16mm. Colour. English.
Director: Atom Egoyan. Screenplay: Charles Grant Craig. Production: John Slan for *Alfred Hitchcock Presents*.

Parents decide it is time that their spoiled daughter moves out of their house.

"Looking for Nothing" 1988 Canada
30 min. 16mm. Colour. English.
Director and screenplay: Atom Egoyan. Editor: Bruce Griffin. Cinematography: Andrew Binnington. Sound: Robert Jones. Cast: Hrant Alianak, Damir Andrei, Aaron Ross Fraser, Arsinée Khanjian. Producers: Paul da Silva, Anne O'Brian. Production company: CBC's *Inside Stories* and *Toronto Talkies*, with participation of Telefilm Canada, Rogers Communications, in association with Multilingual Television and Don Haig Film Arts.

In anticipation of possible terrorist conspiracies against the premier at a gathering at an Armenian cultural centre, security officers are disguised in ethnic garb to represent diverse cultural groups. The premier's speech about multiculturalist policies, which erupts into mayhem, is priceless, but the episode also offers profound philosophical musings about the deceptive nature of appearances and the plenitude of "nothing." As a counterpoint to the clearly ineffective policies and politics is an authentic but abstract avant-garde theatrical performance.

"The Wall" 1989 USA
60 min. Colour. English.
Director: Atom Egoyan. Screenplay: J. Michael Straczynski. Production company: *The New Twilight Zone*.

A test pilot is sent through a gate into another dimension and discovers a utopian society. Unlike the previous volunteers, he chooses to do his duty and return to

Earth, but when he finds that the military are planning to destroy the utopia, he destroys the gate and returns there.

Gross Misconduct 1993 Canada
120 min. 16mm. Colour. English.
Director: Atom Egoyan. Screenplay: Paul Gross, based on the book by Marin O'Malley. Cinematography: Brian R.R. Hebb. Editor: Gordon McClellan. Music: Mychael Danna. Sound design: Steven Munro. Sound: Larry Kent. Cast: Linda Garanson, Charles W. Gray, Kevin Hicks, Dough Hughes, Daniel Kash, Kirsten Kieferle, Shannon Lawson, Peter MacNeil, Lenore Zann. Producer: Alan Burke. Production company: CBC.

Winner of the Grand Prix de la Compétition, Festival Cinema Tout Écran, Geneva, 1995; Golden Gate Award, San Francisco International Film Festival, 1993; nominated for four Gemini Awards, including Best Television Feature Film.

A highly stylized, neo-gothic-postmodern chronicle of Canadian hockey player Brian "Spinner" Spencer and his descent into drugs, infidelity, and murder.

"Bach Cello Suite #4: Sarabande" 1997 Canada
56 min. 16mm. Colour. English.
Director and screenplay: Atom Egoyan. Cinematography: Norayr Kasper. Editor: David Wharnsby. Sound recording: Ross Redfern. Sound editing: Steve Munro. Sound mix: Daniel Pellerin. Production designer: Phillip Barker. Music: J.S. Bach. Cast: Yo-Yo Ma, Lori Singer, Don McKellar, Arsinée Khanjian, Jan Rubes, George Sperdakos, David Hemblen, Tracy Wright. Producer: Niv Fichman. Production company: Rhombus Media, in association with Sony Classical Film and Video, TV Ontario, BBC, and Telefilm Canada. Series: *Inspired by Bach*.

Gemini Award for Best Short Dramatic Program, 1998; Golden Spire Award, San Francisco International Film Festival, 1998; Le Nombre d'Or, 4th International Widescreen Festival, Amsterdam 1998; international festival screenings include Berlin Film Festival, Chicago International Film Festival, Venice Film Festival, São Paulo International Film Festival, Valladolid, Oslo International Film Festival.

A baroque narrative about the responsibilities of the healing arts—medicine and music—woven together from a number of parallel stories about individuals who come into contact with cellist Yo-Yo Ma and Bach's Suite #4.

Krapp's Last Tape 2000 Canada/Ireland
65 min. 35mm. Colour. English.
Director and editor: Atom Egoyan. Play: Samuel Beckett. Cinematography: Paul Sarossy, Peter Mettler. Cast: John Hurt. Executive Producers: Joan Egan, Joe Mulholland, Rod Stoneman. Producers: Michael Colgan, Alan Moloney. Production company: RTE, Channel 4 Intl., Irish Film Board, Blue Angel Films, Gate Theatre, Parallel Films. First broadcast March 18–April 2, 2000, on RTE One (Irish Television).

Based on the play by Beckett and starring John Hurt, as part of the *Beckett on Film* project that commits all nineteen plays by Samuel Beckett to film.

Feature Films

Next of Kin 1984 Canada
72 min. 16mm. Colour. English.
Director, screenplay, and editor: Atom Egoyan. Cinematography: Peter Mettler. Music: Atom Eogyan, the Song and Dance Ensemble of Armenia. Sound recording: Clark McCarron. Sound editing: David Rokeby. Sound mix: Daniel Pellerin. Costumes: Delaine Prasek. Cast: Patrick Tierney, Berge Fazlian, Sirvat Fazlian, Arsinée Khanjian, Phil Rash, Paul Babiak, Margaret Loveys, Thomas Tierney. Production Managers: Camelia Frieberg, Jeremy Podeswa. Production company: Ego Film Arts, with the assistance of the Ontario Arts Council and the Canada Council.

Mannheim International Film Week, Gold Ducat Award, 1984; Genie nomination for Best Director; televised by the CBC, BBC, and ZDF; international festival screenings include: Sydney, Birmingham, Melbourne, Valladolid, Piccadilly, Cleveland.

Egoyan's first feature film explores various modalities of exile and belonging. In family therapy because he spends a lot of time "pretending," Peter discovers that there is enormous satisfaction in giving direction to people's lives. After watching the videotapes of the therapy sessions of an Armenian family whose problems stem from when they gave up their infant boy to foster care, Peter decides to insert himself into this other family's narrative, playing the role of their missing son.

Family Viewing 1987 Canada
86 min. 16mm. Colour. English.
Director and screenplay: Atom Egoyan. Cinematography: Robert MacDonald, Peter Mettler. Editors: Bruce McDonald, Atom Egoyan. Music: Mychael Danna. Costumes: Nancy Duggan. Art Director: Linda Del Rosario. Cast: David Hemblen, Aidan Tierney, Gabrielle Rose, Arsinée Khanjian, Selma Keklikian, Jeanne Sabourin, Rose Sarkisyan, Vasag Baghboudarian, David MacKay, Hrant Alianak, John Shafer, Garfield Andrews, Edwin Stephenson, Aino Pirskanen, Souren Chekijian, Johnnie Eisen, John Pellatt. Producers: Atom Egoyan, Camelia Frieberg. Production company: Ego Film Arts, the Ontario Film Development Corporation, the Canada Council, the Ontario Arts Council.

At the Montréal International Film Festival, Wim Wenders declined his prize for *Wings of Desire* and gave it to Egoyan instead, 1986; International Critics Award (FIPRESCI), Locarno, 1988; Best Feature Film, Uppsala, Sweden, 1988; Prix Alcan, Montréal Festival du Nouveau Cinéma, 1987; eight Genie nominations, including Best Film, Best Director, Best Screenplay, Male and Female Leads, Best Musical Score, Best Editing; international film festival screenings include Berlin, Hong Kong, Sydney, Locarno, Melbourne, Jerusalem, Figuera da Fox, London, Los Angeles, Miami, Turin, Cairo, Antwerp.

Tracing the destruction and rebirth of dislocated families, *Family Viewing* explores the impossibility of feeling connected when one's history and memories are unstable. Van leaves home after he finds his family's home movies have been recorded over with homemade pornography made by his father and featuring his stepmother (with whom Van may be having an affair) acting out the actions narrated by a phone-sex worker. The film hinges on a series of increasingly elaborate replacements,

from videos to grandmothers' bodies to experiences of mourning, designed, para-
doxically, to help Van reconnect to his past and the real.

Speaking Parts 1989 Canada
92 min. 35mm. Colour. English.
Director and screenplay: Atom Egoyan. Cinematography: Paul Sarossy. Editor:
Bruce McDonald. Music: Mychael Danna. Sound recording: John Megill. Sound
editing: Steve Munro. Sound mix: Daniel Pellerin. Art director: Linda Del Rosario.
Costumes: Maureen Del Degan. Cast: Gabrielle Rose, Michael McManus, Arsinée
Khanjian, David Hemblen, Patricia Collins, Tony Nardi, Gerard Parkes, Robert
Dodds, Jacqueline Samuda, Peter Krantz, Frank Tata, Patrick Tierney, Leszek Lis,
Sharon Corder, David MacKay. Producers: Camelia Frieberg, Atom Egoyan. Asso-
ciate producer: Donald Ranvaud. Production: Ego Film Arts with the participation
of Telefilm Canada, the Ontario Film Development Corporation, Academy Pictures
(Rome), and Film Four International (London).

Quinzine des Réalisateurs, International Film Festival, Cannes, 1989; Special Jury
Mention, Valladolid, 1989; Prize for Best Screenplay, Vancouver International Film
Festival, 1989; six Genie nominations, including Best Film, Best Director, Best
Screenplay, Best Male and Female Leads, Best Musical Score; International festi-
val screenings include Toronto, New York, Montreal, Jerusalem, Uppsala, Ghent,
Antwerp, Hong Kong, Sydney, Melbourne, Miami, Chicago, São Paulo.

In *Speaking Parts*, Egoyan explores two professions involved in the creation of illu-
sions: hotels and filmmaking. Lisa, a hotel chambermaid, falls in love with her col-
league Lance, who is also a bit actor, and obsessively watches videos of the movies
in which he has appeared. Clara, a screenwriter who is a guest at the hotel, obses-
sively watches videos of her dead brother in his mausoleum. Clara pursues Lance
in the hope of getting him a part in the movie she is writing about her brother,
whom he resembles. Behind the scenes, the Producer seeks to further blur the lines
between the real and the spectacular.

The Adjuster 1991 Canada
102 min. 35mm. Colour. English.
Director and screenplay: Atom Egoyan. Cinematography: Paul Sarossy. Editor:
Susan Shipton. Script editor: Allen Bell. Music: Mychael Danna. Sound design:
Steven Munro. Sound editing: Steven Munro. Sound mix: Daniel Pellerin, Peter
Kelly. Art directors: Linda Del Rosario, Richard Paris. Costumes: Maya Mani. Cast:
Elias Koteas, Arisnée Khanjian, Maury Chaykin, Jennifer Dale, Gabrielle Rose, Don
McKellar, Patricia Collins, David Hemblen, Rose Sarkisyan, Armen Kokorian, Jacque-
line Samuda, John Gilbert, Stephen Ouimette, Raoul Trujillo, Tony Nardi, Paul Bet-
tis, Frank Jefferson. Producers: Camelia Frieberg, Atom Egoyan, David Webb. Pro-
duction: Ego Film Arts with the participation of Telefilm Canada, the Ontario Film
Development Corporation, and Alliance Communications.

Special Prize of the Jury, Moscow Film Festival, 1991; Quinzaine des Réalisateurs,
International Film Festival, Cannes, 1991; Toronto CITY Award for Best Canadian
Film, Toronto Festival of Festivals, 1991; Golden Spike Award, Valladolid Film Fes-
tival, 1991; Best Canadian Film, Sudbury Filmfest, 1991; international festival

screenings include: New York, Toronto, Locarno, Edinburgh, Hoff, London, Montreal.

The Adjuster explores people who live virtual lives, floating through the placeless spaces of modern life—motels, suburbs, intimate and familial relationships. An insurance adjuster, Noah Render, seduces his clients, who are in a state of shock following unexpected tragedies. His wife, Hera, secretly videotapes pornographic films at the censor board where she works, to show her sister what she does at work. Meanwhile, a rich couple who pay huge sums to act out increasingly perverse sexual experiences are attracted to the empty house where Noah and Hera live and pose as a film crew to use the house as a set.

Calendar 1993 Canada/Armenia/Germany
75 min. 16mm. Colour. English/Armenian.
Director, screenplay, and editor: Atom Eogyan. Cinematography: Norayr Kaspar. Music: Djivan Gasparian, Eve Egoyan, Garo Tchaliguian, Hovhanness Tarpinian. Sound design: Steve Munro. Sound mixer: Daniel Pellerin. Cast: Arsinée Khanjian, Atom Egoyan, Ashot Adamian, Michelle Bellerose, Natalia Jasen, Susan Hamann, Sveta Kohli, Vica Tsvetnova, Roula Said, Annie Szamois, Anna Pappas, Amanda Martinez, Diane Kofri. Producers: Arsinée Khanjian, Simone Urdl. Production company: Ego Film Arts, ZDF German Television and the Armenian National Cinematheque.

Prix CICAE (International Confederation of Art Cinemas), Berlin International Film Festival, Forum of New Cinema, 1993; Jury Prize, Taormina Arte Cinema, 1993; Genie nominations for Direction and Screenplay; on many "Best 10 Films of 1994" lists in the United States; international film festival screenings include San Francisco, Antwerp, Riminicinema, Viennale, Rotterdam, Cinema Joce, Los Angeles, Valladolid, Jerusalem, São Paulo, New York.

A simple love triangle, made complicated by the interference of video recorders, cameras, answering machines, and letters that are never completed and never sent. Egoyan plays a photographer who returns to Armenia to take a series of shots of old churches for a calendar while he videotapes an oral history of the scenes that he photographs, narrated by their driver and translated by his wife. The photographer returns to Toronto while his wife stays behind with the guide. Over twelve calendar months, he attempts to "see," understand, and reconcile his loss by revisiting the documentary evidence of their dissolution.

Exotica 1994 Canada
104 min. 35mm. Colour. Dolby stereo. English.
Director and screenplay: Atom Egoyan. Cinematography: Paul Sarossy. Editor: Susan Shipton. Music: Mychael Danna, Leonard Cohen. Sound design: Steven Munro. Sound editing: Steve Munro. Sound mix: Daniel Pellerin, Peter Kely, Keith Elliott. Art directors: Linda Del Rosario, Richard Paris. Costumes: Linda Muir. Cast: Bruce Greenwood, Elias Koteas, Mia Kirshner, Don McKellar, Arsinée Khanjian, Sarah Polley, David Hemblen, Calvin Green, Peter Krantz, Damon D'Oliveira, Victor Graber, Jack Blum, Billy Merasty, Ken McDougall. Producers: Atom Egoyan, Camelia Frieberg. Associate producer: David Webb. Production: Ego Film Arts, with

the participation of Telefilm Canada and the Ontario Film Development Corporation.

Best Foreign Film, French Critics Association, 1994; Best Foreign Film, Belgium Critics Association, 1994; International Critics Prize, International Film Festival, Cannes (Competition), 1994; Toronto CITY Award for Best Canadian Film, Toronto International Film Festival, 1994; nominated for an Adult Video Award for Best Alternative Video; Silver Spike, Valladolid International Film Festival, 1994; nominated for thirteen Genies and winner of seven, including Best Director, Best Picture, Best Screenplay, Best Musical Score, Best Art Direction, Best Cinematography, Best Costume Design; international festival screenings include New York, Sundance, Viennale, Rotterdam, Locarno, London, Taipei, Cancun, Thessaloniki, Budapest.

Exotica interweaves three interrelated story lines about desire, loss, and exchange. Francis, a tax auditor who has lost his wife and daughter, repeatedly visits a strip club to be soothed by Christine, a stripper with a schoolgirl act who was once the friend and babysitter of Francis's murdered daughter. By day, he investigates the tax records of Thomas, a gay pet-store owner who has been betrayed and robbed by a lover. Eric, the stripper's ex-boyfriend, grows jealous of Francis and has him expelled from the club. Francis enlists the help of the pet-store owner to exact revenge.

The Sweet Hereafter 1997 Canada
110 min. 35mm. Colour. Dolby Digital. Cinemascope. English.
Director and screenplay: Atom Egoyan, based on the novel by Russell Banks. Editor: Susan Shipton. Cinematography: Paul Sarossy. Music: Mychael Danna. Sound editing: Steve Munro. Sound mix: Peter Kelly, Daniel Pellerin, Keith Eliott. Production designer: Phillip Barker. Art director: Kathleen Climie. Costumes: Beth Pasternak. Cast: Ian Holm, Tom McCamus, Sarah Polley, Bruce Greenwood, Gabrielle Rose, Alberta Watson, Arsinée Khanjian, Earl Pastko, Maury Chaykin, David Hemblen, Brooke Johnson, Stephanie Morgenstern, Peter Donaldson, Caerthan Banks, Kirsten Kierferle, Simon Barker, Sarah Rose Fruitman, Marc Donato, Devon Finn, Fides Krucker, Magdalena Sokoloski, James D. Watts, Allegra Denton, Russell Banks. Producers: Camelia Frieberg, Atom Egoyan, Robert Lantos, András Hámori, David Webb, Sandra Cunningham. Production company: Alliance Communications and Ego Film Arts.

Two Academy Award (Oscar) nominations, for Best Adapted Screenplay and Best Director, 1997; Eight Genies, including Best Picture, Best Director, Best Cinematography, Best Original Music, Best Actor (Ian Holm), Best Sound, Best Sound Editing, 1997; Grand Prize of the Jury, International Film Festival, Cannes (Official Competition), 1997; Independent Spirit Award for Best Foreign Film, 1997; National Board of Review Award for Best Ensemble Cast, 1998; Golden Spike Award, Valladolid, 1998; International Critics Prize, International Film Festival, Cannes, 1997; Ecumenical Award, International Film Festival, Cannes, 1997; Toronto CITY Award, Toronto International Film Festival, 1997; on over 250 top ten lists for 1997; international festival screenings include Toronto, Locarno, Taormina, Telluride, Aspen, New York, Boston, Valladolid.

Adapted from Russell Banks's novel, in which four different narrators tell the story of a school bus accident and its devastating effects on a community. Egoyan weaves a tale of manipulation and loss. Lawyer Mitchell Stephens is the focus of the narrative, as he approaches the members of the community, urging them to let him "represent their pain." His foil is Nicole, the haunting young singer who refuses exploitation by taking responsibility for the official story about the crash.

Felicia's Journey 1999 Canada/Britain
114 min. 35mm. Colour. Dolby digital. Cinemascope. English.
Director and screenplay: Atom Egoyan, based on the novel by William Trevor. Cinematography: Paul Sarossy. Editor: Susan Shipton. Music: Mychael Danna. Sound recording: Brian Simmons. Sound editing: Steven Munro. Production design: Jim Clay. Sound mix: Daniel Pellerin, Peter Kelly, Keith Elliott. Production designer: Phillip Barker. Art director: Kathleen Climie. Costumes: Beth Pasternak. Cast: Bob Hoskins, Elaine Cassidy, Arsinée Khanjian, Peter McDonald, Claire Benedict, Brid Brennan, Gerard McSorley, Sheila Reid, Nizwar Karanj, Ali Yassine, Kriss Dosanjh, Marie Stafford, Gavin Kelty, Mark Hadfield, Danny Turner, Susan Parry, Jean Marlow, Sidney Cole, Barry McGovern, Sandra Voe, Leila Hoffman, Bob Mason, Emma Powell. Producer: Bruce Davey. Executive producers: Paul Tucker, Ralph Kamp. Production company: Icon Productions.

Four Genies, for Best Adapted Screenplay, Best Cinematography, Best Original Music, and Best Actor (Bob Hoskins), 1999; Opening Night Gala, Toronto International Film Festival, 1999; Closing Night Gala, New York Film Festival, 1999; Best Cinematography, Valladolid, 1999; in official competition, Cannes Film Festival, 1999.

A subtle serial-killer film based on William Trevor's novel. Hilditch is a catering manager whose commitment to food prepared and served with love turns out to be the result of a complicated Oedipal relationship with his mother, a narcissistic TV cooking-show host. With the intention of releasing his own suffering, he picks up lost young women, gains their trust, videotapes their confessional conversations, and stores them away in an archive alongside videos of his mother's 1950s television shows before murdering them. His latest victim is an abandoned pregnant Irish girl. While he strives to impose a darker ending on her narrative, Felicia resists.

Ararat 2002 Canada/France
116 min. 35mm. Colour. English.
Director, producer, and screenplay: Atom Egoyan. Cinematography: Paul Sarossy. Editor: Susan Shipton. Music: Mychael Danna. Sound designer: Steve Munro. Art director: Kathleen Climie. Costumes: Beth Pasternak. Cast: David Alpay, Charles Aznavour, Eric Bogosian, Bruce Greenwood, Christopher Plummer, Marie-Josée Croze, Brent Carver, Raoul Bhaneja, Arsinée Khanjian, Simon Abkarian, Elias Koteas, Lousnak Abdalian, Arthur Hagopian, Christie MacFadyen, Vahan Ajamian, Sevaan Franks, Chris Gillet, Max Morrow, Haig Karkissian, Arshile Egoyan, Rose Sarkisyan, Setta Keshishian, Shant Srabian. Producers: Robert Lantos, Sandra Cunningham. Associate producers: Julia Rosenberg, Simone Urdl. Production company: Serendipity Point Films/Ego Film Arts.

Nominated for nine Genie awards and winner of five: Best Picture, Best Actress (Arsinée Khanjian), Best Supporting Actor (Elias Koteas), Best Original Score, and Best Costumes; National Board of Review Special Recognition of Films That Reflect the Freedom of Expression, 2002; Best Film on Human Rights, from the Political Film Society of Hollywood, 2002; Best Director for Atom Egoyan and Best Actress for Arsinée Khanjian, Durban International Film Festival, 2003; top prize, Golden Apricot Film Festival, Yerevan, 2004; official selection, 2002 Cannes International Film Festival; Opening Night, 2002 Toronto International Film Festival; international festival screenings include Atlantic Film Festival, Cinefest Sudbury, Calgary (opening night), Vancouver, Festival International Noveau Cinema in Montreal. Moscow, Karlovy Vary, Czech republic, Rio de Janeiro, São Paulo, Budapest (closing night), Valladolid, Pusan, Bangkok, Belgrade, Taipei, special presentation at Berlin, Gala Centerpiece Presentation for the AFI Fest, Los Angeles.

Ararat, Egoyan's most explicit film about the Armenian genocide, is a meditation on the spiritual role of art in the process of struggling for meaning and redemption in the aftermath of genocide. Following an ensemble cast of characters linked by circumstance, Egoyan shows how their present-day lives are shaped by the past but also by the distortions of memory and representation, especially painting and film.

Citadel 2004 Beirut/Canada
92 minutes. Mini DV.
Director, editor, and cinematographer: Atom Egoyan. Cast: Atom Egoyan, Arsinée Khanjian, Arshile Egoyan.

An epistolary film addressed to Egoyan's son, Arshile, ten years from now. The home movie recounts the family's journey to Lebanon—the first time Arsinée Khanjian had been back since her departure during the civil war, when she was seventeen years old. Meditations on memory and the commemoration of trauma lead to an analysis of the treacherously deceptive and seductive nature of the image. The Citadel's labyrinthine staircases, dead ends, and windows become a metaphor for film itself.

Where the Truth Lies 2005 Canada
Directory and screenplay: Atom Egoyan, based on Rupert Holmes's novel. Cinematography: Paul Sarossy. Editor: Susan Shipton. Art director: Craig Lathrop. Costumes: Beth Pasternak. Cast: Colin Firth, Kevin Bacon, Alison Lohman, David Hayman, Maury Chaykin, Sonja Bennett, Rachel Blanchard, Kristin Adams, Deborah Grover, Beau Starr, Arsinée Khanjian, Gabrielle Rose, Don McKellar, David Hemblen, John Moraitis, Michael Reynolds, Erika Rosenbaum, Rebecca Davis, Simon Sinn, Kathryn Winslow, Stuart Hughes, Shannon Lawson, Sean Cullen, Aliska Malish. Producer: Robert Lantos, Atom Egoyan, Chris Chrisafis, Sandra Cunningham. Production company: Serindipity Point and First Choice Films.

Adapted from Rupert Holmes's novel, the film tells the story of a pair of Las Vegas entertainers who get caught up in a web of deceit and murder when a girl is found dead in the duo's hotel room. When a young journalist is commissioned to write a book about the pair, she soon becomes obsessed with the intrigue surrounding the unsolved murder and, as a result, becomes part of the story she set out to write.

Installations

Return to the Flock 1996
Excerpts from *Calendar*, twelve Durotrans photographs, and twelve video monitors.
2-minute loop with sound.

Exhibitions
The Event Horizon, Irish Museum of Modern Art, Dublin, Ireland, November 2,
 1996–February 2, 1997.

America, America 1997
16mm film, projected on the wall in 10-minute loops, consisting of excerpts of Elia
Kazan's *America, America* and excerpts of 8mm films from Egoyan's personal
archive.

Exhibitions
La Biennale di Venezia, Armenian Pavillion, Venice, Italy, June 15–November 9,
 1997.

Early Development 1997
35mm film transfer from video of *Portrait of Arshile* fed through a projector, which
projects the image on a screen in 4-minute loops through a system of rollers that
pass it in front of the screen to become the projection surface of the image.

Exhibitions
Projections: Les transports de l'image, Le Fresnoy, Studio National des Arts Con-
 temporains, Tourcoing, France, November 1997–January 1998.
Something Is Missing, Museu Serralves, Porto, Portugal, January 25–March 17,
 2002.
Centre Culturel Canadien, Paris, France, September 3–28, 2002.

The American Lawn: Surface of Everyday Life 1998
Excerpts from *The Adjuster*.

Exhibitions
Canadian Centre for Architecture, Montreal, Canada, June 16–November 8, 1998.
Contemporary Arts Center, Cincinnati, Ohio, USA, April 4–June 7, 1999.
Museum of Art, Fort Lauderdale, Florida, USA, September 3, 1999–January 2, 2000.

Evidence 1999
Single-channel video consisting of excerpts from *Felicia's Journey* projected on a
monitor in 19-minute loops, with sound and a chair.

Exhibitions
Notorious: Alfred Hitchcock and Contemporary Art, Museum of Modern Art,
 Oxford, England, July 11–October 3, 1999.
Museum of Contemporary Art, Sydney, Australia, December 16, 1999–April 26,
 2000.
Art Gallery of Hamilton, Hamilton, Ontario, Canada, May 20–July 16, 2000.
Kunsthallen Brandts Klædefabrik, Odense, Denmark, August 25–November 12,
 2000.

Tokyo Opera City Art Gallery, Tokyo, Japan, April 3–June 7, 2001.
Hiroshima City Museum of Contemporary Art, Hiroshima, Japan, July 29–September 2, 2001.
Centre Cultural de la Fundació "La Caixa" de Lleida, Lleida, Spain, September 27–November 11, 2001.
Provinciaal Centrum voor Beeldende Kunsten–Begijnhof, Hasselt, Belgium, December 8, 2001–January 20, 2002.
Museu Serralves, Porto, Portugal, January 25–March 17, 2002.

The Origin of the Non-Descript 2001
Collaboration with Geoffrey James, inspired by *The Adjuster*. Photography and single-channel video in 30-second loop, with sound.
Exhibitions
Substitute City: Artists Infiltrate Toronto, The Power Plant, Toronto, Canada, March 24–May 27, 2001.

In Passing 2001
Single-channel video of *En Passant* on monitor, in 20-minute loop.
Exhibitions
After the Diagram, White Box, New York City, NY, USA, April 26–May 19, 2001.

Portrait of Arshile 2001
Single-channel colour video of *Portrait of Arshile* on monitor in colour in 4-minute loops, with sound.
Exhibitions
Armenie de Ontmoeting/Vier hedendaagse kunstenaars uit de diaspora, Stedelijk Museum de Lakenhal, Leiden, Netherlands, October 29, 2001–March 3, 2002.

Close 2001
Collaboration with Julião Sarmento. Colour video installation, rear projected, with sound.
Exhibitions
La Biennale di Venezia, Platea Dell'Umanita, Venice, Italy, June 10–November 4, 2001.
Something Is Missing, Museu Serralves, Porto, Portugal, January 25–March 17, 2002.
Museum De Paviljoens, Almere, Netherlands, March 23–June 23, 2002.

Steenbeckett 2002
Excerpts from *Krapp's Last Tape*, with film archive materials, 35mm film, Steenbeck editing table, produced by Artangel.
Exhibitions
Steenbeckett Atom Egoyan: An Installation, Museum of Mankind, London, England, February 15–March 17, 2002.

Hors d'usage 2002
Projection on floor, thirty-five reel-to-reel players, sound, and two videos projected on monitors.

Exhibitions
Atom Egoyan: Hors d'usage, Musée d'Art Contemporain de Montréal, Montreal, Quebec, Canada, August 29–October 20, 2002.
Hors d'usage: le récit de Marie-France Marsil, Centre Culturel Canadien, Paris, France, September 3–28, 2002.

Peep Show 28 2002
Video activated in dark booth with quarters or dollars.

Exhibitions
No Live Girls, The Lusty Lady, Seattle, Washington, USA, February 7–21 2002.
The Lusty Lady, San Francisco, California, USA, February 14–28, 2002.

Opera and Other Music

Salome 1996, 2002
Director: Atom Egoyan.

Performances
Canadian Opera Company, September 1996.
Vancouver Opera, November 1997.
Houston Grand Opera, January–February 1998.
Canadian Opera Company, remount, February 2002.

Nexus/Bolex 85–91 1996
Live music/film projection piece, collaboration with Nexus and Steve Reich, commissioned by Autumn Leaf Opera and Performance.

Performances
Walter Hall, Toronto, October 4, 1996.

Elsewhereless 1998
Director: Atom Egoyan. *Opera:* Rodney Sharman. *Libretto:* Atom Egoyan and Tapestry Music.

Performances
Buddies in Bad Times Theatre, Toronto, April 1998.
National Arts Centre, Ottawa, July 1998.
Vancouver Playhouse, Vancouver, May 1999.

Dr. Ox's Experiment 1998
Director: Atom Egoyan, based on Jules Verne's story. Opera: Gavin Bryars. Libretto: Blake Morrison.

Performances
English National Opera, London, England, June 1998.

Coke Machine Glow 2001
Gord Downie solo album. Collaboration and classical guitar on two songs.

Die Walküre 2004
Director: Atom Egoyan. Conductor: Richard Bradshaw. Design: Michael Levine. From Richard Wagner's *Ring Cycle*.

Performances
Canadian Opera Company, Toronto, April 2004.

Production

1995 *Curtis's Charm*. Director: John L'Ecuyer
1998 *Babyface*. Director: Jack Blum
1998 *Jack & Jill*. Director: John Kalangis
2002 *Luck*. Director: Peter Wellington
2003 *Foolproof*. Director: William Phillips
2003 *The Saddest Music in the World*. Director: Guy Maddin
2003 *Gambling Gods and LSD*. Director: Peter Mettler
2004 *Mouth to Mouth*. Director: Alison Murray
2005 *Coldwater*. Director: Ruba Nadda

Egoyan Onscreen

1985 *Knock! Knock!*
 62 min. Colour. English. Canada.
 Director: Bruce McDonald.

1988 *La Boite à soleil*
 73 min. B&W. French. Canada. Experimental film.
 Director: Jean-Pierre Lefebvre.

1994 *Camilla*
 95 min. Colour. English. Canada/USA.
 Director: Deepa Mehta. Atom Egoyan as a director.

1993 *Calendar*
 75 min. 16mm. Colour. English/Armenian. Canada/Armenia.
 Director: Atom Egoyan. Atom Egoyan as Photographer.

1995 *At Sundance*
 71 min. USA. Documentary.
 Directors: Michael Almereyda, Amy Hobby. Cinematography: Michael
 Almereyda. Atom Egoyan as himself.

1996 *The Stupids*
 94 min. Colour. English. UK/USA.
 Director: John Landis. Atom Egoyan as TV studio guard.

1999 *A Road to Elsewhere*
 54 min. Colour. Canada. Documentary.
 Directors: Robert Cohen, Shari Cohen. Atom Egoyan as himself.

1999 *Formulas for Seduction: The Cinema of Atom Egoyan*
52 min. UK. Documentary.
Directors: Eileen Anipare, Jason Wood. Atom Egoyan as himself.

2001 *Indie Sex: Taboos*
60 min. USA. TV.
Directors: Lisa Ades, Leslie Klainberg. Atom Egoyan as himself.

2002 *Escape from the Newsroom*
90 min. Colour. English. Canada. CBC Telefilm. First broadcast: October 28, 2002.
Writer and director: Ken Finkleman. Atom Egoyan as himself.

2003 *The Making of "Ararat"*
29 min. Colour. Canada. Documentary.
Director: Michele Francis. Atom Egoyan as himself.

2003 *Check the Gate: Putting Beckett on Film*
52 mins. Colour and B&W. Ireland/UK. Documentary.
Director: Pearse Lehane. Atom Egoyan as himself.

Other Awards

1995 Toronto Arts Award
1997 Knighted by the French government as *chevalier des arts et lettres*
1998 Outstanding Canadian Award, Armenian Community Centre
1999 Order of Canada
1999 Winner of the Armenian Centre of Columbia University's Anahid Literary Award
2003 Movses Khoranatsi, presidential medal from the Republic of Armenia
2003 Elected member of the Royal Canadian Academy of Arts

Honourary Doctorates: Trinity College at University of Toronto, Emily Carr Institute of Art and Design, University of Victoria, Brock University, Ontario College of Art, Queen's University, McGill University.

▶▶▎ Bibliography

Comprehensive Bibliography on Atom Egoyan

Angela Joosse

By Atom Egoyan

Ararat: The Shooting Script. New York: Newmarket Press, 2002.

"Arts: Memories Are Made of Hiss: Remember the Good Old Pre-digital Days? Atom Egoyan Does." *The Guardian*, February 7, 2002.

"Atom Egoyan: *A Portrait of Arshile*." *Ararat* 40, no. 160 (1999): 44.

"Atom's Oscar Diary." *Maclean's*, April 6, 1998, 61–64.

"*Calendar*." *Positif*, no. 406 (1994): 93–94.

"Director's Statement: Sarabande Suite #4: Yo-Yo Ma–The Films." *Sonyclassical.com*. http://www.sonyclassical.com/releases/63203/films/direct_4.html. (accessed June 25, 2003).

"Don't Let *Salome* Be Misunderstood." *National Post*, January 24, 2002.

"Meeting of the Minds." Interview of Gord Downie. *Ottawa Citizen*, June 22, 1997.

"Dr. Gonad." *Granta* 86 (2004): 251–54.

"An Essay on *Calendar*." In *The Event Horizon*, ed. Michael Tarantino, 70–74. Dublin: Irish Museum of Modern Art, 1997.

Exotica. Toronto: Coach House, 1995.

"Film, Video and Photography in Canada." Introduction to *Film, Video and Photography in Canada*. 1–2. Ottawa: Canadian Heritage, 1993.

Foreword to *Inside the Pleasure Dome: Fringe Film in Canada*, by Michael Hoolboom, 2nd ed., 1–2. Toronto: Coach House: 2001.

Foreword to *Weird Sex and Snowshoes: And Other Canadian Film Phenomena*, by Katherine Monk, 1–2. Vancouver: Raincoast, 2001.

"Holding On: Obsession." *Sight and Sound*, April (1994), 31.

"In Other Words: Poetic Licence and the Incarnation of History." *University of Toronto Quarterly* 73 (2004): 886–905.

"Janet Cardiff." Interview by Atom Egoyan. *Bomb Magazine* 79 (2002): 60–67. http://www.bombmagazine.com/cardiff/cardiff.html.

"Langage cinématographique et langage du rêve." *Positif*, no. 440 (1997): 15.

"Letter to Simone." In *Paris vu par: Le Centre Culturel Canadien de Paris célèbrates ses 30 ans*, 16. Paris: Centre Culturel Canadien à Paris, 2000.

"Pasolini's Théorème." In *Projections 4½: Film-makers on Film-making*, ed. John Boorman and Walter Donohue, 64–65. London: Faber and Faber, 1995.

"Place of a Lifetime: Armenia." *National Geographic Traveler*, November/December, 79–80.

"Recovery [Atom Egoyan on Incest, Fantasy and the Tragic Death of Children in *The Sweet Hereafter*]." *Sight and Sound*, October, 21–23.

"Sept. 11 Only the Beginning." *Toronto Star*, September 7, 2002.

Something Is Missing: Close, ed. Atom Egoyan, Julião Sarmento, and Michael Tarantino. Porto, Portugal: Fundação de Serralves, Edições ASA (Serralves Museum of Contemporary Art), 2002.

Speaking Parts. Toronto: Coach House, 1993.

Subtitles: On the Foreignness of Film. Ed. Atom Egoyan and Ian Balfour. Cambridge, MA: MIT, 2004.

"Le sourire d'Arshile." *Traffic* 10 (1994): 107–109.

The Sweet Hereafter: The Screenplay. Toronto: Ego Film Arts, 1997. *Fine Line Features: The Sweet Hereafter*. http://www.finelinefeatures.com/sweet/index.html. (accessed June 18, 2004).

"Tension en surface." *Positif*, no. 406 (1994): 88–90.

"'Théorème' de Pasolini." *Positif*, no. 400 (1994): 37.

"Le tombeau de Stanley Kubrick: 48 cinéastes répondent à *Positif*." *Positif*, no. 464 (1999): 45–62.

"*Turbulent*." Review of *Turbulent* by Shirin Neshat. *Filmmaker: The Magazine of Independent Film*, Fall, 18–20. http://filmmakermagazine.com/fa112001/reports/turbulent.html.

Interviews

Arroyo, José. "The Alienated Affections of Atom Egoyan." *Cinema Canada*, October 1987, 14–19.

Avakian, Florence. "Egoyan's New Film." *Ararat* 40, no. 106 (1999): 45–49.

Baber, Brendan. "Big Worlds in Small Packages." *Interview* December 1997, 84–85.

Baldassarre, Angela. "Atom Egoyan: *Felicia's Journey*." In *Reel Canadians: Interviews from the Canadian Film World*, 45–49. Toronto: Guernica, 2003.

Bear, Liza. "Atom Egoyan with Arsinée Khanjian." *Bomb Magazine* 30 (1990): 34–37.

———. "Look but Don't Touch: Liza Bear Interviews *Exotica*'s Atom Egoyan." *Filmmaker Magazine*, Spring 1995. http://www.filmmakermagazine.com/spring1995/dont_touch.php. (accessed February 25, 2005).

Béhar, Henri. "Egoyan, Banks, Greenwood, Lantos on *The Sweet Hereafter*." *Film Scouts* (1997). http://www.filmscouts.com/intervws/ato-ego.asp. (accessed May 16, 2000).

Brown, Laurie. "Atom Egoyan under the Spotlight." *CBC Infoculture*, November 15, 1999. http://www.infoculture.cbc.ca/archives/filmtv_09161999_egoyanin-terview.html. (accessed May 31, 2001).

Burnett, Ron. "Atom Egoyan: An Interview." *CineAction*, no. 16 (1989): 40–44.

Cancela, Lorena. "Everybody Knows, Nobody Talks: Atom Egoyan's *Ararat*." *Metro Magazine*, Winter, 88–91.

Castiel, Élie. "Atom Egoyan." *Séquences*, January, 26–27.

Chua, Lawrence. "Atom's Id: An Interview with Atom Egoyan." *Artforum*, March, 25–26.

Ciment, Michel. "Atom Egoyan: s'interroger sur la notion de représentation." *Positif*, no. 499 (2002): 9–13.

Ciment, Michel, and Philippe Rouyer. "'Cette expérience représente pour moi une ouverture': entretien avec Atom Egoyan." *Positif*, no. 440 (1997): 16–21.

———. "'Nous créons des rituels pour gérer nos névroses": entretien avec Atom Egoyan." *Positif*, no. 406 (1994): 79–83.

Ciment, Michel, and Yann Tobin. "Entretien avec Atom Egoyan: des personnages qui ritualisent leurs sentiments." *Positif*, no. 467 (2000): 17–22.

Comay, Rebecca. "Krapp and Other Matters: A Conversation between Atom Egoyan and Rebecca Comay." In *Lost in the Archives*, ed. Rebecca Comay, 342–71. Toronto: Alphabet City, 2002.

Cooper, Douglas. "Sundance Filmmaker Focus: Atom Egoyan." *Sundance Channel* http://www.sundancechannel.com/focus/egoyan/int1.html. (accessed June 25, 1998).

Coulombe, Michel, and Françoise Wera. "Entretien avec Atom Egoyan." *Ciné-Bulles* 7, no. 3 (1988): 6–11.

Cronenberg, David. "David Cronenberg Talks to Atom Egoyan about *M. Butterfly*, the Pitfalls of Preview Screenings, and the True Nature of 'Selling Out' to a Major U.S. Studio." *Take One*, Fall, 11–15.

Darke, Chris. "The Shape of Pain: Interview with Atom Egoyan." In *Light Readings: Film Criticism and Screen Arts*, 19–24. London: Wallflower, 2000.

Dwyer, Michael. "Egoyan's Journey." *Irish Times*, October 11, 1999. http://www.asbarez.com/archives/1999/991011md.htm.

Esch, Deborah. "Home Format: Atom Egoyan Talks with Deborah Esch." In *Semiotexte Architecture*, ed. Hrazten Zeitlian, n.p. New York: Autonomedia, 1992.

Ferks, Chris. "Interview with Atom Egoyan." *Made in Canada*, November 25, 2000. http://www.videofilcks.com/madeincanada/atomegoyaninterview.htm. (accessed November 11, 2000).

Frodon, Jean-Michel, and Thomas Sotinel. "Mémoires vives du génocide arménien." *Le Monde*, September 3, 2002. http://www.lemonde.fr.

Fuchs, Cynthia. "*Exotica*." *Maryland Institute for Technology in the Humanities*. http://www.inform.umd.edu/EdRes/Topic/WomensStudies/FilmReviews/exotica-fuchs. (accessed July 18, 2003).

———. "*Felicia's Journey*: Atom Egoyan Speaks about His Latest Film." *Nitrate Online*, November 19, 1999. http://www.nitrateonline.com/1999/ffelicia.html. (accessed October 29, 2000).

———. "Interview with Atom Egoyan: Director of *Ararat*: At the Mercy of Viewers." *PopMatters*. http://www.popmatters.com/film/interviews/egoyan-atom-021129.shtml. (accessed June 17, 2004).

———. "Interview with Atom Egoyan: Writer-Director of *Felicia's Journey*." *PopMatters*, November 11, 2001. www.popmatters.com/film/interviews/egoyan-atom .html. (accessed June 25, 2003).

———."Staying Open." *Philadelphia City Paper*, December 1997–January 1998. http://citypaper.net/articles/122597/movies.interview.shtml. (accessed July 23, 2004).

Glassman, Marc. "Emotional Logic: Marc Glassman Interviews Atom Egoyan." In *Speaking Parts*, by Atom Egoyan, 41–57. Toronto: Coach House, 1993.

Grugeau, Gérard. "Les élans du coeur." *24 Images*, no. 46 (1989): 6–9.

Harcourt, Peter. "A Conversation with Atom Egoyan." *Post Script: Essays in Film and the Humanities* 15, no. 1 (1995): 68–74. Reprinted in *Film Voices: Interviews from Post Script*, ed. Gerald Duchovnay, 215–24. Albany: SUNY Press, 2004.

Hayes, Matthew. "Fusing Art and Memory: Canada's Most Prominent Filmmaker, Atom Egoyan, on His New Art Installation." *Montreal Mirror*, August 29, 2002. http://www.montrealmirror.com/archives/2002/082902/cover.html.

"Interview with Atom Egoyan." Interview by Independent Feature Project. *IFC* (1998). http://www.ifctv.com/evenst/98isa/egoyan.html. (accessed May 16, 2000).

Johnson, Brian D. "Unearthly Sound." *Maclean's*, April 5, 2004, 45.

Johnson, David. "Writing and Directing *The Sweet Hereafter*." *Scenario* 3, no. 4 (1997): 38–43, 197.

Katz, Susan Bullington. "A Conversation with Atom Egoyan." In *Conversations with Screenwriters*, 93–103. Portsmouth, NH: Heinemann, 2000. First published in *Written By* 2, no. 2 (1998): 25–30.

Kauffman, Anthony. "An Interview with Atom Egoyan, Director of *The Sweet Hereafter*." *Indie Wire*, November 21, 24, 1997. http://www.indiewire.com/people/int _Egoyan_Atom_1_971121.html. (accessed February 25, 2005).

Kent, Sarah. "The Splice of Life: Sarah Kent Talks to Atom Egoyan about Editing, Memory, and *Krapp's Last Tape*." *Time Out* (London), February 27, 2002, 49.

Lageira, Jacinto, and Stephen White. "Relocating the Viewer: An Interview with Atom Egoyan." *Parachute*, no. 103 (2001): 51–71.

Maddocks, Fiona. "Interview: Atom Egoyan: 'The More I See of the US, the Better I Feel About Being Canadian." *The Observer*, June 14, 1998.

Maurer, Monika. "A Quick Chat with Atom Egoyan." *kamera.co.uk*, November 1998. http://www.kamera.co.uk/interviews/egoyan.html. (accessed May 16, 2000).

Naficy, Hamid. "The Accented Style of the Independent Transnational Cinema: A Conversation with Atom Egoyan." In *Cultural Producers in Perilous States: Editing Events, Documenting Change*, ed. George E. Marcus, 179–231. Chicago: University of Chicago Press, 1997.

Neff, Renfrew. "*Ararat*: Interview with Atom Egoyan." *Creative Screenwriting* 10, no. 1 (2003): 18–21.

———. "A Diplomatic Filmmaker: An Interview with Atom Egoyan." *Creative Screenwriting* 6, no. 6 (1999): 26–27.

Ondaatje, Michael, and Atom Egoyan. "Ondaatje and Egoyan: The Kitchen Table Talks." *Globe and Mail*, April 8, 2000.

Pevere, Geoff. "Difficult to Say." In *Exotica*, by Atom Egoyan, 43–67. Toronto: Coach House, 1995.

Porton, Richard. "Family Romances." *Cineaste*, December 1999, 8–15.

———. "The Politics of Denial: An Interview with Atom Egoyan." *Cineaste*, December 1999, 39–41.

Post, Pamela. "Atomic Energy: Atom Egoyan on Life as a Filmmaker, Father, Opera Director, and Voyeur." *Vancouver Opera*. http://www.vanopera.bc.ca/sal_ae.htm. (accessed June 13, 2000).

Racine, Claude. "Les affres de l'image." *24 Images*, no. 43 (1989): 10–11.

Rakoff, David. "Questions for Atom Egoyan: Northern Light." *New York Times*, November 12, 2000.

Rémy, Vincent. "Tous mes films sont les strip-teases." *Télérama*, November 30, 1994, 104–106.

Reschop, Julia. "Entretien avec Atom Egoyan." *24 Images*, no. 67 (1993): 62–66

Rothe, Marcus. "A propos de *Calendar*." *Jeune cinéma*, no. 231 (1995): 21–26.

Rourke, Kelley, and Jamie Driver. "Conversations with Atom Egoyan." *Opera America Newsline*, March 1999. http://www.operaam.org/egoyan.htm. (accessed May 29, 2000).

Rouyer, Philippe. "Jeux de miroirs." *Positif*, no. 370 (1991): 23–26.

Royer, Geneviève. "Atom Egoyan: l'alchimiste." *Séquences*, no. 189/190 (1997): 69–73.

Seibel, Alexandra. "The Ground Is Always Shifting." *Blimp*, no. 30 (1994): 32–35.

Sheehy, Ted. "Atom Egoyan Interview."*Film Ireland*, October–November 1999, 18–20.

Tobias, Scott. "Atom Egoyan." *The Onion A.V. Club*, November 18, 1999 http://avclub.theonion.com/feature/index.php?issue=3542&f=1. (accessed May 16, 2000).

Totaro, Donato, and Simon Galiero. "Egoyan's Journey: An Interview with Atom Egoyan." *Offscreen*, February 8, 2000. http://www.horschamp.qc.ca/new_offscreen/egoyan.html. (accessed November 28, 2000).

Wise, Wyndham. "Atom Egoyan: Face the Strange." *Take One* 13, no. 47 (September–November 2004): 63–94.

Scholarship on Atom Egoyan

Addonizio, Antonio, Atom Egoyan, and Arsinée Khanjian. *Il movente di un'immagine: conversazioni con Atom Egoyan: in appendice un'intervista a Arsinée Khanjian*. Palermo, Italy: della Battaglia, 2001.

Alemany-Galway, Mary. "*Family Viewing*." In *A Postmodern Cinema: The Voice of the Other in Canadian Film*, 165–90. Lanham, MD: Scarecrow, 2002.

"Atom Egoyan *Steenbeckett* 12:02–17.03.2002." In *Off Limits: 40 Artangel Projects*, ed. James Lingwood and Michael Morris, 58–59. London: Merrell, 2002.

Bailey, Cameron. "Scanning Egoyan." *CineAction*, no. 16 (1989): 45–51.

Beavis, Mary Ann. "*The Sweet Hereafter*: Law, Wisdom and Family Revisited." *Journal of Religion and Film* 5, no. 1 (2001). http://www.unomaha.edu/~wwwjrf/sweether.htm. (accessed July 25, 2002).

Brougher, Kerry, Michael Tarantino, and Astrid Bourron. *Notorious: Alfred Hitchcock and Contemporary Art*. Oxford: Museum of Modern Art, 1999.

Burnett, Ron. "Speaking of Parts: An Introduction to the Film." In *Speaking Parts*, by Atom Egoyan, 9–24. Toronto: Coach House, 1993.

Cardullo, Bert. "Blood, Snow, and Tears." *Hudson Review* 52, no. 1 (1999): 107–14.

Coates, Paul. "Protecting the Exotic: Atom Egoyan and Fantasy." *Canadian Journal of Film Studies* 6, no. 3 (1997): 21–33.

Dancyger, Ken. "The Influence of Psychoanalytic Ideas on Editing." In *Technique of Film and Video Editing: History, Theory, and Practice*, 3rd ed., 214–27. Boston: Focal Press, 2002.

De Bellis, Fabina. *Armenia-Canada… "Ararat": il cinema di Atom Egoyan*. Torino, Italy: Lindau, 2002.

de Benedictis, Maurizio, ed. *Identità e immagine nel cinema di Atom Egoyan*. Laureanda, Italy: Gabiana De Bellis, 1997–98.

del Río, Elena. "The Body as Foundation of the Screen: Allegories of Technology in Atom Egoyan's *Speaking Parts*." *Camera Obscura* 38 (1998): 92–115.

Desbarats, Carole, Daniele Rivière, Jacinto Lageira, and Paul Virilio. *Atom Egoyan*. Trans. Brian Holmes. Paris: Dis Voir, 1993.

Dillon, Steven. "Lyricism and Accident in *The Sweet Hereafter*." *Literature/Film Quarterly* 31 (2003): 227–30.

Dvorak, Marta. "Un cinéma de déviance 'écartelé entre deux extrémités': Cronenberg, Egoyan, Rozema et les autres." In *Cinéma/Canada*, ed. Marta Dvorak, 83–96. Rennes, France: Presses Universitaires de Rennes, 2000.

Gale Research Inc. "Atom Egoyan 1960–." *Contemporary Literary Criticism* 151 (2002): 121–77.

Gittings, Christopher E. *Canadian National Cinema: Ideology, Difference, and Representation*. New York: Routledge, 2002.

Gruben, Patricia. "Slipping off the Highway: Multiple Narratives in *The Sweet Hereafter*." *Creative Screenwriting* 8, no. 2 (2001): 68–72.

Harcourt, Peter. "Imaginary Images: An Examination of Atom Egoyan's Films." *Film Quarterly* 48, no. 3 (1995): 2–14.

Hennessy, Deborah. "Fragile Stuff: Video's Poetic Potential." *Skinny*, no. 9. www.arts.monash.edu.au/visarts/globe/issue9/dhtxt.html. (accessed July 25, 2001).

Hibon, Danièle, ed. *Atom Egoyan: café des images*. Paris: Jeu de Paume, 1993.

Hsiao, Juey-Fu. "Seeing Is (Dis)Believing: 'Trompe l'Oeil' in Atom Egoyan's Films." In *Canadian Culture and Literature and a Taiwan Perspective*, ed. Tötösy de Zepetnek, Steven Leung, and Yiu-nam Leung, 95–108. Taiwan: Research Institute for Comparative Literature, University of Alberta Department of Foreign Languages and Literature, National Tsing Hua University, 1998.

Hutcheon, Michael, and Linda Hutcheon. "Operatics: Arias, Anxieties and Epidemics." *Canadian Medical Association Journal* 157, no. 12 (1997): 1734–35.

Ismert, Louise, and Michael Tarantino. *Atom Egoyan: "Hors d'usage."* Montreal: Musée d'Art Contemporain de Montréal, 2002.

Jones, Kent. "Body and Soul: The Cinema of Atom Egoyan." *Film Comment* 34, no. 1 (1998): 32–37, 39.

Jost, François. "Proposition pour une typologie des documents audiovisuels." *Semiotica* 112 (1996): 123–40.

Kassabian, Anahid, and David Kazanjian. "From Somewhere Else: Egoyan's *Calendar*, Freud's Rat Man and Armenian Diasporic Nationalism." *Third Text* 19 (2005): 125–44.

Kleber, Pia, and Jorg Bochow. "Oedipus and the Riddle of the New Media: François Girard at the Canadian Opera Company." *University of Toronto Quarterly* 72 (2003): 817–26.

Knee, Adam. "Egoyan's *Exotica*: The Uneasy Borders of Desire." In *Moving Pictures, Migrating Identities*, ed. Eva Rueschmann, 159–79. Jackson: University Press of Mississippi, 2003.

Kraus, Matthias. *Bild—Erinnerung—Identität: Die Filme des Kanadiers Atom Egoyan.* Marburg, Germany: Schüren Verlag, 2000.

Kristensen, Stefan. "Memory and the Representation of Genocidal Violence: Reflections on Egoyan's *Ararat*." *Armenian Forum* 3, no. 2 (2003): 79–99.

Lane, Harry, Claire Hopkinson, and Wayne Strongman. "Life beyond the Premiere: Process and Purpose at Tapestry Music Theatre." *Canadian Theatre Review* 96 (1998): 50–55.

Latham, Rob. "Screening Desire: Posthuman Couplings in Atom Egoyan's *Speaking Parts* and David Cronenberg's *Videodrome*." In *Trajectories of the Fantastic: Selected Essays from the Fourteenth International Conference on the Fantastic in the Arts*, ed. Michael A. Morrison, 171–79. Westport, CT: Greenwood, 1997.

Leach, Jim. "Lost Bodies and Missing Persons: Canadian Cinema(s) in the Age of Multi-national Representations." *Post Script* 18, no. 2 (1999): 5–18.

Levin, David J. "Operatic School for Scandal." *Performing Arts Journal* 19, no. 1 (1997): 52–57.

Liu, Kate Chiwen. "Family in the Postmodern 'Non-Places' in the Films by Atom Egoyan and Ming-Liang Tsai." *Fu Jen Studies: Literature and Linguistics* 34 (2001): 1–27.

Longfellow, Brenda. "Globalization and National Identity in Canadian Film." *Canadian Journal of Film Studies* 5, no. 2 (1996): 3–16.

Lyons, Donald. "From the Northwest and Canada." In *Independent Visions: "A Critical Introduction to Recent Independent American Film*, 205–58. New York: Random House, 1994.

Masterson, Donald. "Family Romances: Memory, Obsession, Loss, and Redemption in the Films of Atom Egoyan." *University of Toronto Quarterly* 71 (2002): 881–91.

Marks, Laura U. "A Deleuzian Politics of Hybrid Cinema." *Screen* 35 (1994): 244–64.

———. *The Skin of the Film: Intercultural Cinema, Embodiment, and the Senses.* Durham, NC: Duke University Press, 2000.

May, Vivian M., and Beth A. Ferri. "'I'm a Wheelchair Girl Now': Abjection, Intersectionality, and Subjectivity in Atom Egoyan's *The Sweet Hereafter*." *Women's Studies Quarterly* 30 (2002): 131–50.

Mazierska-Kerr, Ewa. "Power, Freedom, and Gender in the Films of Atom Egoyan." In *Gender in Film and the Media: East-West Dialogues*, ed. Elżbieta H. Oleksy, Elżbieta Ostrowska, and Michael Stevenson, 27–38. Frankfurt: Peter Lang, 2000.

Miers, Paul. "Language and the Structure of Desire." *MLN* 114, no. 5 (1999): 1078–91.

Momo, Alberto, ed. *Atom Egoyan*. Rome: Dino Audino, 2000.

Monk, Katherine. "Probing the Negative: Moving Past the Film Plane and Understanding Empty Space." In *Weird Sex and Snowshoes: And Other Canadian Film Phenomena*, 89–118. Vancouver: Raincoast, 2001.

Mookerjea, Sourayan. "Allegory, Stereotype, and the Local Mode of Construction: *Calendar*'s Filmic Concept of Global Flows." *Space and Culture* 5, no. 2 (2002): 103–21.

———. "Montage in Spatial Ethnography: Crystalline Narration and Cultural Studies of Globalization." *Symploke* 9, nos. 1–2 (2001): 114–31.

Morgan, Jason. "'Do You Ever Get Tired of Being a Professional Faggot?': 'Perversion Chic,' Queer Nationalism, and English Canadian Cinema." Paper presented at Confluence, Athabasca University, 2000. http://confluence.athabascau.ca/content/vol1.1/nelprocpaper.html. (accessed June 18, 2003).

Mouren, Yannick. "Cinematic Fictions of the 'Videosphere.'" *International Review of Sociology* 1 (1994): 154–64.

Naficy, Hamid. *An Accented Cinema: Exilic and Diasporic Filmmaking*. Princeton, NJ: Princeton University Press, 2001.

Nelson, Tollof. "Passing Time in Intercultural Cinema: The Exilic Experience of the Time-Passer in Atom Egoyan's *Calendar* (1993)." *SubStance* 34, no. 1 (2005): 129–44.

O'Neill, Edward R. "Traumatic Postmodern Histories: *Velvet Goldmine*'s Phantasmatic Testimonies." *Camera Obscura* 19, no. 3 (2004): 156–85.

Païni, Dominique. "Catalogue: faut-il en finir avec la projection?" In *Projections, les transports de l'image*. Paris: Hazan/Le Fresnoy/AFAA, 1997.

———. "Should We Put and End to Projection?" Trans. Rosalind Krauss. *October* 110 (2004): 24–48.

Pevere, Geoff. "Middle of Nowhere: Ontario Movies after 1980." *Post Script* 15, no. 1 (1995): 9–22.

Pratley, Gerald. *Torn Sprockets: The Uncertain Projection of Canadian Film*. Newark: University of Delaware Press, 1987.

Romney, Jonathan. *Atom Egoyan*. World Director Series. London: British Film Institute, 2003.

———. "(Dis)continuous Performance." In *Off Limits: 40 Artangel Projects*, ed. James Lingwood and Michael Morris, 33–35. London: Merrell, 2002.

Rosenbaum, Jonathan. "Tribal Trouble: Atom Egoyan's *Calendar*." In *Movies as Politics*, 244–48. Berkeley: University of California Press, 1997. First published in *Chicago Reader*, August 19, 1994.

Russell, Catherine. "Role Playing and the White Male Imaginary in Atom Egoyan's *Exotica*." In *Canada's Best Features: Critical Essays on 15 Canadian Films*, ed. Eugene Walz, 321–46. Amsterdam: Rodopi, 2002.

Sandrini, Luca, and Alberto Scandola. *Solitudini troppo silenziose: il cinema di Atom Egoyan*. Verona, Italy: Cierre, 1999.

Schwartz, Nina. "Exotic Rituals and Family Values in *Exotica*." In *Perversion and the Social Relation*, ed. Molly Anne Rothberg, Dennis Foster, and Slavoj Žižek, 93–111. Durham, NC: Duke University Press, 2003.

Shary, Timothy. "Video as Accessible Artifact and Artificial Access: The Early Films of Atom Egoyan." *Film Criticism* 19, no. 3 (1995): 2–29.

Shapiro, Michael J. "Genres of the Public Interest: Technologies and Spaces of Being in Common." *International Review of Sociology* 8 (1998): 397–412.

Siraganian, Lisa. "Film and the Survivor in Atom Egoyan's *Family Viewing*." *729* 1, no. 1 (1995). http://wso.williams.edu/orgs/729/issue1/Lisa.html. (accessed June 25, 2003).

———. "'Is This My Mother's Grave?': Genocide and Diaspora in Atom Egoyan's *Family Viewing.*" *Diaspora* 6, no. 2 (1997): 127–54.

St. Peter, Christine. "Consuming Pleasures: *Felicia's Journey* in Fiction and Film." *Colby Quarterly* 38 (2002): 329–39.

Stolar, Batia Boe. "The 'Canadian Popular': Atom Egoyan, Michael Ondaatje, and Canadian Popular Culture." *Canadian Journal of Film Studies* 11, no. 2 (2002): 62–81.

Tarnay, L. "The Dialectics of the View: The Paradox of Narrative Minimalism in the Cinematographic Art of Atom Egoyan." *Degrés: revue de synthèse à orientation sémiologique*, no. 109–110 (2002): H1–H14.

Thomson, David. *The New Biographical Dictionary of Film.* New York: Knopf, 2002.

Tschofen, Monique. "Repetition, Compulsion, and Representation in Atom Egoyan's Films." In *North of Everything: English-Canadian Cinema, 1980 to 2000*, ed. William Beard and Jerry White, 166–83. Edmonton: University of Alberta Press, 2002.

Ty, Eleanor. "Spectacular Pleasures: Labyrinth Mirror in Atom Egoyan's *Exotica.*" In *Pop Can: Popular Culture in Canada*, ed. Lynne Van Luven, and Priscilla L. Walton, 4–12. Scarborough, ON: Prentice Hall Allyn and Bacon Canada, 1999.

Wall, Karen. "'Déjà vu/jamais vu': *The Adjuster* and the Hunt for the Image." *Canadian Journal of Film Studies* 2, nos. 2–3 (1993): 129–44.

Wilson, Emma. "The Female Adjuster: Arsinée Khanjian and the Films of Atom Egoyan." In *Cinema's Missing Children*, 28–40. London: Wallflower Press, 2003.

Weinrichter, Antonio. *Emociones formales: el cine de Atom Egoyan.* Valencia, Spain: Filmoteca Generalitat Valenciana, 1995.

Weese, Katherine. "Family Stories: Gender and Discourse in Atom Egoyan's *The Sweet Hereafter.*" *Narrative* 10, no. 1 (2002): 69–90.

Zlotnick-Woldenberg, Carrie. "*Felicia's Journey*: An Object-Relational Study of Psychopathy." *American Journal of Psychotherapy* 55, no. 1 (2001): 40–51.

Selected Reviews

"Adjusting to Success." Review of *The Adjuster*. *Maclean's*, June 3, 1991, 48.

Amile, Vincent. Review of *Bach Cello Suite 4: Sarabande*. *Positif*, no. 440 (1997): 21.

Ansen, David. "The Colors of Mourning." Review of *The Sweet Hereafter*. *Newsweek*, November 24, 1997, 73.

———. "A Holiday from the Hype." Review of *The Adjuster*. *Newsweek*, June 29, 1992, 64.

Anwar, Farrah. Review of *Calendar*. *Sight and Sound*, February 1994, 49.

Avakian, Florence. "Egoyan's New Film." Review of *Ararat*. *Ararat* 40, no. 160 (1999): 45–49.

Ayoub, Nina C. "Nota Bene." Review of *Subtitles: On the Foreignness of Film*. *Chronicle of Higher Education*, November 2004, 19.

Ayscough, Susan. "*Montréal vu par…* (Montreal Sextet)." *Variety*, November 18, 1991, 31.

Banning, Kass. "Lookin' in All the Wrong Places: The Pleasures and Dangers of *Exotica*." *Take One*, Fall 1994, 14–20.

Barker, Adam. *"Family Viewing."* *Monthly Film Bulletin*, October 1988, 299–300.

———. *"Speaking Parts."* *Monthly Film Bulletin*, September 1989, 283–84.

Barton, Ruth. "Film Ireland Reviews: *Felicia's Journey.*" *Film Ireland*, November–December 1999, 33–34.

Benjo, Caroline. "La traversée des apparences." Review of *Exotica*. *24 Images*, nos. 73–74 (1994): 48–49.

Bennett, Rad. Review of *The Sweet Hereafter*. *Audio* 82, no. 12 (1998): 88–89.

Berardinelli, James. Review of *Felicia's Journey*. *Reelviews: Current Reviews*, 1999. http://movie-reviews.colossus.net/movies/f/felicias.html. (accessed October 29, 2000).

———. Review of *The Sweet Hereafter*. *Reelviews: Current Reviews*, 1997. http://movie-reviews.colossus.net/movies/s/sweet_hereafter.html. (accessed June 25, 2003).

Bouquet, Stéphane. "Parents souceiux." Review of *The Sweet Hereafter*. *Cahiers du cinéma*, no. 517 (1997): 77.

Bourguignon, Thomas. *"Exotica*: L'homme-perroquet." *Positif*, no. 406 (1994): 78.

Bowman, James. "There's No Growing Up." Review of *The Sweet Hereafter*. *American Spectator* 31, no. 2 (December 1998): 76–77.

Castiel, Élie. *"The Adjuster/* L'Expert en sinistres." *Séquences*, no. 156 (1992): 56.

Chang, Chris. "Ruined." Review of *Calendar*. *Film Comment*, November/December 1993, 73.

Chatrian, Carlo. *"Ararat."* *Cineforum*, no. 416 (2002): 29.

Churchill, David. Review of *Open House*. *Cinema Canada* 98 (1983): 31.

Ciment, Michel. Review of *Felicia's Journey*. *Positif*, nos. 461–62 (1999): 114–15.

———. Review of *The Sweet Hereafter*. *Positif*, nos. 437–38 (1997): 106–107.

Coombes, Annie E. "Atom Egoyan's *Steenbeckett*: An Installation." *American Anthropologist* 105, no. 1 (2003): 161–63.

Corliss, Mary. "Ghosts." Review of *The Sweet Hereafter*. *Film Comment* 33, no. 4 (July–August 1997): 2–4, 8–11.

D'Addario, Darren. Review of *Where the Truth Lies*. *Time Out New York* 524 (October 13–19, 2005).

De Bruyn, Oliver. "Brûlantes solitudes." Review of *The Adjuster*. *Positif*, no. 370 (1991): 20–22.

———. "Le Voyage de Felicia." *Positif*, no. 467 (2000): 14–16.

Delaney, Marshall. "Ethnic Humour." Review of *Next of Kin*. *Saturday Night*, June 1985, 53, 55.

Delgado, Jérôme. *"Hors d'usage*, la nouvelle oeuvre d'Atom Egoyan, suscite de l'émotion. Des souvenirs en bobines." *Cyberpresse.ca*, http://www.cyberpresse.ca/reseau/arts/0208/art_102080131983.html.

Demers, Pierre. "Montréal vu par... Yvan Adam." *24 Images*, no. 59 (1992): 36.

Denby, David. Review of *Exotica*. *New York*, March 13, 1995, 63.

Deslandes, Jeanne. *"Close."* *Scope: An Online Journal of Film Studies* (August 2002). http://www.nottingham.ac.uk/film/journal/filmrev/films-august-02.htm. (accessed June 23, 2004).

Diamond, John. Review of *The Sweet Hereafter*. *New Statesman*, September 26, 1997, 56–57.

Dillon, Mark. "A Dramatic Quest." Review of *Felicia's Journey*. *American Cinematographer*, December 1999, 24–31.

———. "Envisioning Life in *The Sweet Hereafter*." *American Cinematographer*, December 1997, 18–20.

Dubeau, Alain. "*Exotica*: l'anti-catharsis canadienne." *Séquences*, no. 175 (1994): 33.

Dwyer, Victor. "Hockey's Hell-Raiser." Review of *Gross Misconduct. Maclean's*, March 1, 1993, 50–51.

Edelstein, David. "Discovering Atom: After Several Brilliant but Icy Films, Canadian Director Atom Egoyan Gets Warm, Erotic, and Commercial, with *Exotica*." *Vogue*, March 1995, 250.

Elia, Maurice. "*The Sweet Hereafter*: visages dans le brouillard." *Séquences*, no. 193 (1997): 39–41.

Elley, Derek. Review of *Calendar*. *Variety*, March 1, 1993, 58.

Enright, Robert. "Relying on the Kindness of Monsters." Review of *Felicia's Journey. Border Crossing* 19, no. 1 (2000): 10–11.

Erbal, Ayda. Review of *Ararat. American Historical Review* 108 (2003): 957–58.

Erickson, Steve. "Ill-Starred Trek." Review of *Felicia's Journey. Artforum* 38, no. 3 (November 1999): 59.

Evans, Gareth. "The Heart in the Machine: Atom Egoyan's New London Installation Examines Film and Memory." *Sight and Sound*, April 2002, 8.

"Exotic Taste." Review of *Exotica. Maclean's*, June 6, 1994, 84.

Fogel, Stan. Review of *Speaking Parts* [screenplay] by Atom Egoyan. *Books in Canada* 22, no. 5 (Summer 1995): 57.

Fourlanty, Éric. "Atom Egoyan: 'Au coeur du volcan.'" Review of *The Sweet Hereafter. Voir*, October 9, 1997.

———. "*Exotica*, les 1001 nuits." *Voir*, October 6, 1994.

———. Review of *Calendar. Voir*, May 6, 1993.

———. Review of *Exotica. Voir*, August, 25 1994.

———. Review of *Family Viewing. Séquences*, no. 133 (1998): 47.

Fraser, Hugh. "Much of Egoyan's *Salome* Is a Confused Mess." *Hamilton Spectator*, October 2, 1996.

Frazer, Bryant. Review of *Exotica*. http://www.deep-focus.com/flicker/exotica.html. (accessed June 15, 1998).

French, Philip. "The Brum's Rush: Cult Director Atom Egoyan Brings Bob Hoskins to Birmingham in His Homage to Hitchcock." Review of *Felicia's Journey. The Observer*, October 10, 1999.

Fuchs, Cynthia. "The Old Master: Atom Egoyan on Murder, Trauma and Videotape." *Philadelphia City Paper*, November 18–25, 1999. http://citypaper.net/articles/111899/ae.mov.atom.shtml. (accessed July 23, 2004).

———. Review of *Felicia's Journey. Nitrate Online*, November 19, 1999. http://www.nitrateonline.com/1999/rfelicia.html. (accessed October 29, 2005).

Fuller, Graham. "Shots in the Dark: How Two Movies about the '50s Make Us Shiver about Today." Review of *Where the Truth Lies* and *Good Luck and Good Night. Interview* 35, no. 10 (November 2005): 88.

Gerstel, Judy. "New Version of *Salome* Intended to Provoke and Astonish Audience." *Ottawa Citizen*, September 29, 1996.

Girard, Martin. "Rôles parlants." Review of *Speaking Parts. Séquences*, no. 144 (1990): 52–53.

Glassman, Marc. "Atomic Cinema: *The Sweet Hereafter.*" *Festival Cinemas Movie Guide*, February 27–April 23, 1998, 14.

———. Review of *The Sweet Hereafter. Take One*, Winter 1998, 42.

Gliatto, Tom. Review of *Exotica. People*, April 3, 1995, 17.

Golfman, Noreen. "Reach Out and (Don't) Touch Someone: *Exotica*, Written and Directed by Atom Egoyan." *Canadian Forum*, October 1995, 27.

———. "Surviving Ourselves: *The Sweet Hereafter.*" *Canadian Forum*, April 1998, 31–32.

Goudet, Stéphane. "Atom Egoyan: 'De beaux lendemains,' 'Out of the past.'" *Positif*, no. 440 (1997): 11–14.

Grande, John K. "Montréal: Atom Egoyan: Musée d'Art Contemporain de Montréal." Review of *Hors d'usage. Sculpture* 22, no. 5 (2003): 76–77.

Griffin, John. "*Calendar* Has a This-Is-Really-Happening Feel." Review of *Calendar. Montreal Gazette*, May 9, 1993.

Grugeau, Gérard. "Au-delà des images." Review of *Speaking Parts. 24 Images*, no. 46 (1989): 4–5.

———. "Le chant des sirènes: *Family Viewing.*" *24 Images*, no. 36 (1987–88): 24–25.

Gural-Migdal, Anna. "L'épreuve du mal: *My Own Private Idaho, Barton Fink, The Adjuster.*" *Vice Versa* 36 (1992): 9–10.

Harvey, Dennis. "*Tape* Measures Up for Beckett Project." Review of *Krapp's Last Tape. Variety*, October 2, 2000, 24.

Herbert, Martin. "Temporary Memory Loss." Review of *Steenbeckett. Art Review* 53 (2002): 82–83.

Hluchy, Patricia. "Starvation of the Soul." Review of *Felicia's Journey. Maclean's*, November 15, 1999, 148–49.

Hoberman, J. "Ghost Story." Review of *Exotica. Village Voice*, March 7, 1995, 49.

———. "Lost Horizons." Review of *The Sweet Hereafter. Village Voice*, November 25, 1997, 91.

Holden, Stephen. "To Dwell on a Historic Tragedy or Not: A Bitter Choice." Review of *Ararat. New York Times*, November 15, 2002.

Houle, Michel. "*Montréal vu par . . .* ou la grande bouffe des courts métrages." Review of *Bach Cello Suite #4: Sarabande. La revue de la cinématheque* 11 (1991): 9–10.

Huber, Cindy. "Atom Egoyan: *Steenbecket* at Artangel." *Lola* 12 (2002): 85.

Hunter, Steven. "*Felicia's Journey*: Soup to Nut." *Washington Post*, November 19, 1999.

———. "*The Sweet Hereafter*: A Cry of Hope." *Washington Post*, December 25, 1997.

Ivry, Bob. "Tough *Journey* for Bob Hoskins Film Required Actor to Play Two Roles in One." Review of *Felicia's Journey. Arizona Republic*, December 9, 1999.

James, Nick. "*Ararat.*" *Sight and Sound* 12, no. 7 (July 2002): 14.

Johnson, Brian D. "Bleak Beauty." Review of *The Adjuster. Maclean's*, September 30, 1991, 68.

———. "Bombed Out Atom." Review of *Where the Truth Lies. Maclean's*, October 17, 2005, 50–52.

———. "Crapshoot at Cannes." Review of *Where the Truth Lies. Maclean's*, May 30, 2005, 52–55.

———. "Lord of the Ring." Review of *Die Walküre. Maclean's*, April 5, 2004, 44–45.

————. "A Maze of Denial: With *Ararat* Atom Egoyan Bravely Attempts to Untangle His Armenian Roots." *Maclean's*, November 18, 2002, 116–17.

Johnston, Trevor. "Atomic Energy." Review of *Exotica*. *Time Out*, April 26, 1995, 71.

Jones, Jonathan. "Review: Art: *Steenbekett*: Former Museum of Mankind, London." *The Guardian*, February 16, 2002.

Jousse, Thierry. "De beaux lendemains." Review of *The Sweet Hereafter*. *Cahiers du cinéma*, no. 514 (1997): 26.

Joyard, Oliver. Review of *Felicia's Journey*. *Cahiers du cinéma*, no. 536 (1999): 57.

Kareda, Urjo. "In Review: Toronto." Review of *Salome*. *Opera News*, December 1996, 44.

Kauffmann, Stanley. "Peculiarities." Review of *Exotica*. *New Republic*, April 3, 1995, 28–29.

————. "Remembrances." Review of *Ararat*. *New Republic*, December 16, 2002, 26–27.

————. "A Stricken Town." Review of *The Sweet Hereafter*. *New Republic*, December 9, 1997, 30–31.

Klady, Leonard. Review of *Exotica*. *Variety*, May 16, 1994, 40.

Klawans, Stuart. "The Heat in the Kitchen." Review of *Felicia's Journey*. *The Nation*, December 6, 1999, 50–53.

————. Review of *The Sweet Hereafter*. In *Left in the Dark: Film Reviews and Essays, 1988–2001*. New York: Nation Books. First published in *The Nation*, December 8, 1997, 35–36.

Knowles, Richard Paul. "Drama." Review of *Speaking Parts* [screenplay], by Atom Egoyan. *University of Toronto Quarterly* 64 (1994): 84–106.

Koskinen, Maaret. "Hemlöshetens drematurgi." Review of *Family Viewing*. *Chaplin* 34, no. 2 (1992): 63–64.

Lamy, Régis. "*De beaux lendemains*." Review of *The Sweet Hereafter*. *Jeune cinéma*, no. 246 (1997): 40–42.

Lane, Anthony. "Worlds Apart: *Far from Heaven* and *Ararat*." *The New Yorker*, November 18, 2002, 104–105.

Lane, Harry. "*Salome*." *Theatre Journal* 54, no. 4 (2002): 651–53.

Larue, Johanne. "*Montréal vu par…*" *Séquences*, no. 156 (1992): 53–54.

Latimer, Joanne. "Egoyan Gets Reel." Review of *Out of Use*. *Globe and Mail*, August 29, 2002.

Lipman, Amanda. Review of *Exotica*. *Sight and Sound*, May 1995, 45.

Lizzie, Frank. "A Clear Light in Dark Corners." Review of *Exotica*. *The Guardian*, April 27, 1995.

Loiseau, Jean-Claude. "*Ararat*: le génocide arménien par Atom Egoyan: trop d'artifices." *Télérama*, September 7, 2002.

MacMillan, Laurel. "*Close*: A Film by Atom Egoyan and Julião Sarmento for the 49th Venice Biennale." *C Magazine*, no. 71 (2001): 44.

Malcolm, Derek. "Atom Egoyan Gets in a Muddle: *Ararat*: Cannes Film Festival 2/5." *The Guardian*, May 22, 2002.

Malloch, Bruce. Review of *Next of Kin*. *Cinema Canada* 113 (1984): 31.

Marsolais, Gilles. "Une vérité née du mensonge." Review of *The Sweet Hereafter*. *24 Images*, nos. 88–89 (1997): 34–35.

Masson, Alain. "*Ararat*: le ressort de l'oeil." *Positif*, no. 499 (2002): 4–8.

———. "*Exotica*: la monnaie vivante." *Positif*, no. 406 (1994): 75–77.

Matalon, Ronit, and Emanuel Berman. "Egoyan's *Exotica*: Where Does the Real Horror Reside?" *International Journal of Psychoanalysis* 81 (2000): 1015–19.

Matthews, Peter. "*Ararat*." *Sight and Sound*, May 2003, 38–39.

Mays, Marianne. "Space Matters: BeckettFest: *Krapp's Last Tape* on Film: Act without Words I." *The Manitoban*, January 25, 2001. http://www.umanitoba.ca/manitoban/archives/jan25_2001/arts5.html. (accessed May 13, 2003).

McCarthy, Todd. "*Ararat*." *Variety*. June 3, 2002, 26–27.

———. Review of *Where the Truth Lies*. *Variety*, May 23, 2005, 35–36.

McSorley, Tom. "Egoyan's *Speaking Parts*." *Take One*, Fall 1993, 48.

Melo, Alexandre. "Atom Egoyan/Julião Sarmento." Trans. Clifford Landers. Review of *Close* by Atom Egoyan and Julião Sarmento. *Artforum*, May 2002, 188.

Ménard, Guy. "Festival international du film de Cannes: pour des jours meilleurs." Review of *The Sweet Hereafter*. *Ciné-Bulles* 16, no. 2 (1997): 12–13.

Merkin, Daphne. "Not Just Child's Play: the Subversive Joy of *Bean*, and *The Sweet Hereafter*." *The New Yorker*, November 24, 1997, 137–38.

Murat, Pierre. "*Ararat*." *Télérama.fr*, May 20, 2002. http://www.telerama.fr/ami/imprimer.asp?art_airs=CAN1000065. (accessed July 9, 2002).

Nevers, Camille. Review of *The Adjuster*. *Cahiers du cinéma*, no. 450 (1991): 72–73.

O'Hehir, Andrew. Review of *Felicia's Journey*. *Salon*, November 19, 1999. http://www.salon.com/ent/movies/review/1999/11/19/felicia/print.html. (accessed October 28, 2000).

Ostria, Vincent. "Trompe-l'oeil." Review of *Exotica*. *Cahiers du cinéma*, no. 486 (December 1994): 58–59.

Paris, Barry. "Psycho Chef Serial Killer Cooks in Engrossing *Felicia's Journey*." *Pittsburgh Post Gazette*, February 4, 2000.

Pevere, Geoff. "Egoyan at His Provocative Best." *Toronto Star*, September 5, 2002.

———. "*The Sweet Hereafter*: Death, Canadian Style." *Take One*, Fall 1997, 6–11.

Pitman, Randy. Review of *Family Viewing*. *Library Journal* 116, no. 2 (February 1, 1991): 118–19.

———. Review of *Next of Kin*. *Library Journal* 116, no. 11 (June 15, 1991): 120.

Poole, Elissa. "African Triangle." Review of *Elsewhereless*. *Maclean's*, May 11, 1998, 59.

———. "Sharman, Egoyan Join Forces for Opera Project." Review of *Elsewhereless*. *Words and Music* 5, no. 4 (1998): 6.

———. "Songs of Obsession." Review of *Salome*. *Maclean's*, October 14, 1996, 93.

Porton, Richard. Review of *Felicia's Journey*. *Cineaste*, Winter 1999, 42–43.

Privet, Georges. "Le confort et l'indifférence." Review of 'The Adjuster.' *24 Images* 58 (1991): 58–59.

———. Review of *Calendar*. *Voir*, March 2, 1993.

Quart, Alissa. Review of *Exotica*. *Cineaste* 21, no. 3 (December 1995): 64.

Rakovsky, Antoine. "*The Adjuster*: It's Got to Be the Touching." *La revue du cinéma*, no. 477 (December 1991): 30–31.

Rayns, Tony. "Everybody Knows." Review of *Exotica*. *Sight and Sound*, May 1995, 9.

———. Review of *The Sweet Hereafter*. *Sight and Sound* 7, no. 10 (1997): 60–61.

Review of *Next of Kin*. *Variety*, October 25, 1989, 30.

Rich, Ruby. "Love for Sale." Review of *Exotica*. *The Advocate*, February 7, 1995, 63.

Romano, Hélène. Review of *Exotica*. *Jeune cinéma*, no. 230 (1995): 44–45.

Romney, Jonathan. "Exploitations." Review of *Exotica*. *Sight and Sound*, May 1995, 6–8.

———. "A Hitch in Time." Review of "Notorious: Alfred Hitchcock and Contemporary Art." *The New Statesman*, July 19, 1999, 35–36.

———. Review of *The Adjuster*. *Sight and Sound*, June 1992, 38.

———. "Strip Poker." Review of *Exotica*. *The Guardian*, April 27, 1995.

———. "This Green Unpleasant Land." Review of *Felicia's Journey*. *Sight and Sound*, October 1999, 34–35, 44.

Rouleau, Martine. "Communauté ephemère: *Hors d'usage*: Atom Egoyan." *Vie des arts*, no. 188 (2002): 85–86.

Rousseau, Yves. "Images d'une ville plurielle." Review of *Montréal vu par… 24 Images*, no. 59 (1992): 68–69.

Rouyer, Philippe. "*Calendar*: le point de vue du photographe." *Positif*, no. 406 (1994): 91–92.

———. Review of *Speaking Parts*. *Positif*, no. 341–42 (1989): 95–96.

Roy, André. "Couverture médiatique: *Family Viewing* d'Atom Egoyan." *Spirale*, no. 77 (1998): 14.

Russell, William. "Hoskins' Choice." Review of *Felicia's Journey*. *The Herald* (Glasgow), October 7, 1999.

Sandu, Sukhdev. "Text Messaging." Review of *Subtitles: On the Foreignness of Film*, edited by Atom Egoyan and Ian Balfour. *The New Statesman*, January 1, 2005, 89–90.

Schwartzberg, Shlomo. "*Gross Misconduct*: Atom Egoyan's New TV Movie on the Tragic Life of Hockey's Brian Spencer." *Performing Arts and Entertainment in Canada* 27, no. 3 (1992): 42–43.

———. Review of *Exotica*. *Performing Arts and Entertainment in Canada* 29, no. 1 (1994/95): 21.

Scott, A.O. "Pratfalls of Old Age Confronted by a Lost Self of Youth." Review of *Krapp's Last Tape*. *New York Times*, September 23, 2000.

Sharrett, Christopher. "The Family under Siege." Review of *The Sweet Hereafter*. *USA Today Magazine* 126, no. 2636 (May 1998): 53.

Sheehan, Declan. "Beckett on Film." *Film West*, no. 42 (2000): 14–18.

Simon, John. "Minus Four." Review of *The Sweet Hereafter*. *National Review*, February 9, 1998, 59–60.

"The Stax Report: Script Review of *Ararat*." *Armenian Genocide Poster Campaign*, http://armeniangenocideposters.org/html/ararat.html. (accessed May 22, 2002). First published in *IGN: Film Force*, May 1, 2002. http://filmforce.ign.com/articles/ 302109p1.html.

Stober, JoAnne. "Atom Egoyan." Review of *Hors d'usage*. *Border Crossings* 21, no. 4 (2002): 71–72.

Stratton, David. "*Sarabande*." *Variety*, September 22, 1997, 48.

Strauss, Frédéric. Review of *Family Viewing*. *Cahiers du cinéma*, no. 421 (1989): 51.

Strick, Philip. Review of *Family Viewing*. *Films and Filming*, no. 409 (1988): 34–35.

Taboulay, Camille. Review of *The Adjuster*. *Cahiers du cinéma*, no. 445 (1991): 46.

Taubin, Amy. "Burning Down the House." Review of *The Adjuster*. *Sight and Sound*, June 1992, 18–19.

———. "A Series of Serial Killers: The Loss of Innocence, Mobility, and Air." Review of *Felicia's Journey*. *Village Voice*, November 16, 1999, 136–44.

Testa, Bart. Review of *Best Canadian Screenplays*, by Douglas Bowie and Tom Shoebridge, and *Speaking Parts* [screenplay], by Atom Egoyan. *Canadian Journal of Film Studies* 3, no. 1 (1994): 86–90.

———. Review of *Speaking Parts* [screenplay] by Atom Egoyan. *University of Toronto Quarterly* 64 (1994): 238–41.

Thomas, Kevin. "Gripping *Felicia's Journey* Is a Triumph for Bob Hoskins." *Los Angeles Times*, November 19, 1999.

Tobin, Yann. Review of *Exotica*. *Positif*, nos. 401–412 (1994): 67.

Travers, Peter. "Digging Deeper." Review of *The Sweet Hereafter*. *Rolling Stone*, December 11, 1997, 85.

———. "Where the Truth Lies." Review of *Where the Truth Lies*. *Rolling Stone*, November 3, 2005, 106.

Tucker, Ken. "View to a Chill." Review of *Where the Truth Lies*. *New York*, October 17, 2005, 67–68.

Turan, Kenneth. "Egoyan's Clear Vision Guides Surreal Spin of *Adjuster*." *Los Angeles Times*, June 5, 1992.

———. "*Sweet Hereafter* Soars with Silence." *Los Angeles Times*, November 21, 1997.

Valot, Jacques. Review of *Family Viewing*. *Revue du cinéma*, no. 449 (1989): 27–28.

Wall, James M. "Films for Thought." Review of *The Sweet Hereafter*. *Christian Century*, February 18, 1998, 163.

———. "Personal Losses." Review of *Calendar*. *Christian Century*, March 3, 1993, 227–28.

Waring, Robert L. Review of *The Sweet Hereafter*. *Picturing Justice*, May 1998. http://www.usfca.edu/pj/articles/sweethearafter.htm. (accessed June 25, 2003).

Wilmington, Michael. "A World of Mixed-Up Media in Egoyan's *Speaking Parts*." *Los Angeles Times*, April 27, 1990.

Winston, Iris. "Does Atom Egoyan Dream of Being Elsewhere?" Review of *Elsewhereless*. *Performing Arts and Entertainment in Canada* 32, no. 1 (1998): 6–7.

Wise, Wyndham. "The True Meaning of *Exotica*." *Take One*, Fall 1995, 56.

Younis, Raymond. Review of *Exotica*. *Cinema Papers*, no. 107 (1995): 45.

Zacharek, Stephanie. "Missing Children." Review of *The Sweet Hereafter*. *Salon*, December 24, 1997. http://www.salon.com/ent/movies/1997/12/24sweet.html. (accessed October 28, 2000).

Selected Journalism

"A Sober Cannes 2002." *Daily Yomiuri* (Tokyo), May 30, 2002.

Abramowitz, Rachel. "Cannes Report: Serious Issues by the Sea; Israeli and Palestinian Films Make Political Issue at the Festival." *Los Angeles Times*, May 24, 2002.

Adams, James. "Egoyan's New Film *Ararat* to Open Toronto Festival." *Globe and Mail*, July 3, 2002.

Adilman, Sid. "Egoyan May Direct First Opera." *Toronto Star*, October 25, 1995.

———. "Egoyan Nabs Media Arts Award." *Toronto Star*, September 1, 1995.

———. "Egoyan Wins Final Cut of Hollywood Movie." *Toronto Star*, March 3, 1998.

———. "Quebec–Ontario Movie Deal Historic." *Toronto Star*, May 16, 1991.

———. "Time to Pick an Opening Gala Movie." *Toronto Star*, June 18, 2002.

Ambrose, Mary. "Atom Egoyan and the Moving Image: Inspired by Memory, Media, and a Beckett Play." *National Post*, March 16, 2002.

Anderson, John. "On Movies: Cannes They Ever Make Up Their Minds?" *Newsday* (Long Island, NY), May 26, 2002.

"Atom Egoyan ouvrira le festival du film de Toronto." Reuters, July 3, 2002.

"Atom Egoyan rebat les cartes du génocide arménien: Un témoignage à vocation universelle." *Le Monde*, May 22, 2002.

Barile, Alessandro, D. Perra, and L. Pignatti. "Note a margine sulla vertigine del vuoto." *D'Ars*, 37, no. 151 (1997): 29–31.

Beaucage, Paul. "Atom Egoyan: vidéo et voyeurism." *Séquences*, no. 200 (1999): 34–35.

"Beckett Goes to Hollywood." *The Observer*, November 2002. http://www.observer.co.uk/review/story/0,6903,399584,00.html. (accessed June 23, 2002).

Bernstein, Tamara. "We Have No Moral Obligations to 'Great' Art." *National Post*, January 25, 2002.

Birnie, Peter. "Sweet Smell of Success: Egoyan's Film, *The Sweet Hereafter*, Won the Jury Prize, the Critics' Prize and a Special Ecumenical Prize." *Vancouver Sun*, May 21, 1997.

Blumenfeld, Samuel. "Atom Egoyan, réalisateur, et Russell Banks, écrivain." *Le Monde*, October 9, 1997.

———. "Les contes de notre enface, version sanglante: *Le Voyage de Felicia*." *Le Monde*, May 19, 1999.

———. "Un mélodrame de l'absurde, sans émotion ni larmes." *Le Monde*, October 9, 1997.

Boddy, Trevor. "O Canada at O America." *Border Crossings* 18, no. 1 (1999): 65–68.

Braudeau, Michel. "Prises de vue en famille." *Le Monde*, June 8, 1989.

Brunette, Peter. "Atom Egoyan's Journey: The Canadian Director Gets More Accessible and More into His Characters with Each Film." *Boston Globe*, November 14, 1999.

Caldwell, Rebecca. "The Artist's life: Atom Egoyan: A Great Office Manager, Coltrane and a Starbucks Latte Help the Director Survive." *Globe and Mail*, January 19, 2002.

Calhoun, John. "New York Film Fun." *Entertainment Design*, January 1, 2000, 8–10.

"Canada Day at Cannes: Powerful Films from Cronenberg, Egoyan Show Importance of Festival in Exposing Non-Hollywood Works to the World." *Toronto Star*, May 20, 2002.

Chamberlain, Adrian. "Egoyan's Operatic Flight: Film Director Tackles Production of Wagner's Epic *Die Walküre*." *Toronto Star*, April 3, 2004.

Clark, Bill. "Canadian Culture Pollinates at 16th Singapore Festival." *Toronto Star*, April 25, 2003.

Clarke, Roger. "Film: When the Politics Gets Personal; French Class Warrior Robert Guediguian Has a New Battlefield. He Wants to Film in Armenia, the Land of His Ancestors." *The Independent*, October 26, 2001.

Clements, Andrew. "Save Our *Salome*." *The Guardian*, January 26, 2002.

Collazzo, Alexandra. "Musée d'Art Contemporain de Montreal: Wanted: Reel-to-Reel Recorders: Participate in Atom Egoyan's Creation!" Canada Newswire, November 2, 2001.

Conlogue, Ray. "Bracing for the Cinema's Judgement." *Globe and Mail*, May 15, 2000.

———. "Egoyan Film Sparks Turkish Backlash Threats of Legal Action and Boycotts Await the Premiere of *Ararat*, Ray Conlogue Writes, for Its Depiction of the Armenian Genocide." *Globe and Mail*, April 18, 2002.

———. "Private Fantasies, Public Space." *Globe and Mail*, May 29, 2002.

Crew, Robert. "Egoyan Defends Cannes Entry—New Movie about Armenian Killings Sparks Furor before Anyone Has Seen It." *Toronto Star*, April 25, 2002.

———. "Ride of Their Lives: Atom Egoyan and Michael Levine Put a Human Face on the COC's *Die Walküre*: Wagner's Four Opera Cycle a Monumental Undertaking." *Toronto Star*, April 1, 2004.

Darke, Chris. "Sibling Rivalry: Cinema and Video at War." *Sight and Sound* 3, no. 7 (July 1993): 26–28.

Davies, Tanya. "It's CanCon Time at Cannes." *Maclean's*, May 17, 1999.

———. "Two Paths, Same Peak." *Maclean's*, February 23, 1998, 60.

"Denial Comes First, Detail Comes Last at Press Scrums: Cronenberg Defends Jury Role; Egoyan Sidesteps Turk Controversy." *Toronto Star*, May 22, 2002.

Deziel, Shanda, Amy Cameron, and Brian D. Johnson. "No Cannes Duel." *Maclean's*, May 6, 2002, 6.

Doland, Angela. "Egoyan Addresses Armenian Genocide in His Latest Film at Cannes." Associated Press, May 20, 2002.

Dwyer, Michael. "Atomic Power." *Irish Times Weekend*, August 8, 1999.

———. "Cannes Plays Safe." *Irish Times*, May 29, 2002.

"Egoyan Film Makes Splash at Cannes." *Moncton Times and Transcript*, May 21, 2002.

Egoyan's *Ararat* to Open Toronto Film Festival." *Toronto Star*, July 2, 2002.

"Egoyan Shows Some Emotion in *Sweet Hereafter*." *Globe and Mail*, May 15, 1997.

Errett, Benjamin. "*Ararat* Beats Out *Spider* to Open Toronto Film Festival." *National Post*, July 3, 2002.

Esch, Deborah. "Egoyan on Location." *Canadian Art* 8, no. 3 (1991): 54–57.

Everett-Green, Robert. "Opera: The Look of Lust: Atom Egoyan Melds Strauss's Torrid Creation to Today's Voyeuristic Culture in This Stunning Production: *Salome*." *Globe and Mail*, January 21, 2002.

———. "Unsettling Scores." *Globe and Mail*, November 6, 2002.

"Exil exotique: biographie." *Ecran noir*. http://www.ecrannoir.fr/real/monde/egoyan.htm. (accessed July 25, 2001).

Frodon, Jean-Michel. "*Ararat*: Atom Egoyan rebat les cartes du génocide arménien." *Le Monde*, May 22, 2002.

Gerstel, Judy. "Atom Egoyan Puts Own Twist on *Salome*: Filmmaker Directs Opera with Provocative Verve That Marks His Screen Work." *Toronto Star*, September 22, 1996.

———. "Team Egoyan, Should We Be Cheering Our Film Industry or Are Atom's Oscar Nominations More His Nature than Its Nurture?" *Toronto Star*, March 14, 1998.

Gessell, Paul. "Bigger, Perhaps Better, but Less Canadian." *Montreal Gazette*, October 4, 1997.

Gill, Alexandra. "Gala Premiere a Homecoming, Egoyan Says." *Globe and Mail*, September 6, 2002.

Goddard, Peter. "Two New Movies Get Art and Artists Right: *Frida* and *Ararat* Are True to the Trade." *Toronto Star*, September 7, 2002.

Golfman, Noreen. "Double Happiness." *Canadian Forum*, October 1995, 25–26.

Gordon, Charles. "Why Cultural Canada Has Yet to Come of Age." *Maclean's*, May 11, 1998.

Griffin, John. "Atom Egoyan: Film-maker's On-and-Off-Screen Images Are Beginning to Merge." *Calgary Herald*, October 23, 1997.

Groen, Rick. "Two Kings, but Only One Ruler." *Globe and Mail*, September 3, 2005.

Gural-Migdal, Anna. "Mesonge et vérité du film: Soderberg, Egoyan…" *Vice Versa*, no. 28 (1991): 38–40.

Hamill, Morgan. "Atom Egoyan to Appear at Film-Exchange." Canada Newswire, January 22, 2002.

Harris, Lesley Ellen. "Atom Egoyan: Laughter in the Dark." *Canadian Forum*, December 1991, 15–17.

Hasted, Nick. "Film: The Tangled Roots of Atom Egoyan: Why Is the Cult Canadian Director so Fascinated by Buried Secrets? Nick Hasted Asked Him about His Own Life-Story, and Found Out." *The Independent*, September 26, 1999.

Hébert, Natasha. "Venise, plateau de l'humanité." *Esse*, no. 44 (2002): 30–37.

Hirst, Christopher. "The Weasel: Outside, Plato and Pals—Inside, I Was up an Artistic Trouser Leg." *The Independent*, March 3, 2002.

Hoberman, Jason. "Sex, Lies, and Videodrones." *Premiere*, April 1990, 51–52.

Hooper, Barrett. "*Ararat* Meant to Be Egoyan's *Schindler's List*." *National Post*, May 22, 2002.

———. "*Ararat* Stirs 'The Ghosts of History.'" *National Post*, May 21, 2002.

———. "Egoyan Covers Story from Only One Angle." *National Post*, September 5, 2002.

Hooper, Joseph. "Man at His Best: Uncovered." *Esquire*, April 1992, 34.

Howe, Desson. "Film Notes: After *The Sweet Hereafter*." *Washington Post*, November 19, 1999.

Howell, Peter. "Canada's Egoyan Goes for Gold at Cannes, *Sweet Hereafter* Palme d'Or Contender; Egoyan Just Happy to Be There." *Toronto Star*, May 16, 1997.

———. "Egoyan's *Ararat* to Open Film Fest." *Toronto Star*, July 3, 2002.

Hunter, Steven. "At Cannes, Underclass Warfare." *Washington Post*, May 26, 2002.

———. "Atom Egoyan as Enemy of the State of Denial: With *Ararat* Filmmaker Takes on Disputed Turkish Atrocities." *Washington Post*, November 24, 2002.

Inglis, Ken. "Sex, Lies, and Video." *The Herald* (Glasgow), October 7, 1999.

Ismert, Louis. "Atom Egoyan: Artist in Residence at the Musée." *Le Journal* (Musée d'Art Contemporain de Montréal) 13, no. 1 (2002): 8–9.

Januszczak, Waldemar. "The Best Canadian Art Stays with You for Ever. The Worst…" *Sunday Times*, March 10, 2002.

Jenish, D'Arcy. "Why Mel Made That Final Cut." *Maclean's*, February 15, 1999.

Johnson, Brian D. "Arsinée Unveiled." *Maclean's*, September 13, 1999, 59.

———. "Atom's Journey." *Maclean's*, September 13, 1999, 54–58.

———. "A Cannes-Do Event." *Maclean's*, May 31, 1999, 58–60.

———. "Champagne Dreams." *Maclean's*, May 26, 1997, 93–95.

———. "Exotic Atom." *Maclean's*, October 3, 1994, 44–47.

———. "Hollywood Stars and Canadian Style." *Maclean's*, September 20, 1999, 56–57.

———. "How Sweet It Is." *Maclean's*, September 8, 1997, 60–61.

———. "Riviera Rendezvous." *Maclean's*, June 3, 2002, 46–50.

———. "Suddenly Sarah." *Maclean's*, September 8, 1997, 56–59.

———. "Viewing Atom Egoyan." *Maclean's*, June 12, 1993, 48.

Kehr, Dave. "At the Movies." *New York Times*, June 7, 2002.

Kelly, Brendan. "Canada: *Ararat* Draws Ire." *Variety*, May 13, 2002, 14.

———. "A Rough Road for Two Fest Favorites." *Variety*, May 13, 2002, 36.

Kimergärd, Lars Bo. "Familie fremmedgrelse og elektronisk oplonsning." *Kosmorama*, no. 210 (1994): 27–32.

Kinzer, Stephen. "Movie on Armenians Rekindles Flame over Turkish Past." *New York Times*, January 20, 2004.

Kirkland, Bruce. "Egoyan's 'Dream Project': Director Thrilled to Make Beckett Film with John Hurt." *Canoe.ca*, August 2000. http://www.canoe.ca/JamMoviesArtistsE/egoyan.html. (accessed November 20, 2000). First published in *Toronto Sun*, August 24, 2000.

Knelman, Martin. "Egoyan and Cronenberg Face Off." *Toronto Star*, June 30, 2002.

Lacey, Liam. "Cannes Diary: Amid the Glitz, No Shortage of Vérité." *Globe and Mail*, May 21, 2002.

———. "Cannes Too Political for *Ararat*, says Egoyan." *Globe and Mail*, April 25, 2002.

———. "Welcome to My World: There's No Contradiction between Atom Egoyan's Amiable Presence and Dark Movies: Both Are about Generosity." *Globe and Mail*, November 12, 1999.

Lewis, Kevin. "The Journeys of Atom Egoyan." *MovieMaker* 36 (1999). http://www.moviemaker.com/issues/36/36_egoyan.html. (accessed June 25, 2003).

Littler, William. "Movies Work for Glass." *Toronto Star*, November 6, 2002.

———. "Opera Is Singing a Popular Tune These Days—A Once Mocked Highbrow Art Form Is Attracting Bigger and Younger Audiences." *Toronto Star*, April 20, 2002.

———. "Valkyries May Not Ride, but Trip Worthy of Wagner." *Toronto Star*, April 5, 2004.

Lovink, Geert, et al. "Atom Egoyan en de hedendaagse beeldcultuur: een rond tafel gesprek over de nieuwe media." *Skrien*, no. 173 (1990): 26–33.

Lubbock, Tom. "Arts: Why Clichés Are Important; Now That Avant-Garde Film Has Abandoned the Cinema for the Gallery, Artists Are Revealing the Medium's Surprising Dependence on the Familiar, says Tom Lubbock." *The Independent*, March 5, 2002.

MacDonald, Gayle. "*Ararat* Leads but Egoyan Left Out." *Globe and Mail* (Toronto), December 11, 2002.

———. "Egoyan Pulls Film from Competition." *Globe and Mail*, April 24, 2002.

———. "It Had to Be Made by Atom." *Globe and Mail*, June 16, 2001.

MacInnis, Craig. "Atom Egoyan." *Toronto Star*, April 2, 1993.

———. "Canada a Presence at Cannes." *Montreal Gazette*, May 7, 1997.

———. "Canadian Aims for Gold." *Calgary Herald*, May 5, 1997.

———. "*Exotica* Waves Flag at Cannes: Canadian Film in Competition for Fest's Top Prize." *Toronto Star*, May 15, 1994.

———. "A Canadian First: Torontonian Wins Runner-Up Prize for His Feature, *The Sweet Hereafter*." *Calgary Herald*, May 19, 1997.

———. "Egoyan's Movie Leads Genies." *Calgary Herald*, November 5, 1997.

———. "Egoyan's Premiere Earns Mild Applause." *Calgary Herald*, May 15, 1997.

Mack, Gerhard. "Metphern des Alltäglichen." *Kunstforum*, no. 156 (2001): 174–79.

Mackenzie, Suzie. "Life Is Sweet: Atom Egoyan's Films Are Set in a World of Grief and Neurosis." *The Guardian*, May 30, 1998.

MacKinnon, Mark. "Egoyan Film Moves Moscow Audience." *Globe and Mail*, July 1, 2002.

Macnab, Geoffrey. "Film: Light at the End of the Tunnel: Canada's Directors Are Famous for Their Dark, Cerebral Works, but the Government Wants to Encourage More Mainstream Fare: Geoffrey Macnab Asks, Is That Really a Smart Move?" *The Independent*, July 13, 2001, foreign edition.

Majendie, Paul. "Conflict Takes Centre Stage at Cannes Film Festival." Reuters, May 20, 2002.

———. "Director Calms Armenian–Turk Tension over Film." Reuters, May 20, 2002.

Major, Wade. "World Cinema; The Unusual Province of Canadian Films: The Country's Movies Focus on Unconventional Tales." *Los Angeles Times*, April 5, 2002.

Matossian, Nouritza. "Arts: When History Still Hurts." *The Independent*, May 20, 2002, foreign edition.

Mavrikakis, Nicolas. "La Biennale de Venise: art sans frontières." *Voir*, June 21, 2001.

McCort, Kristinha. "A Sense of Place." *Millimeter*, March 2002, 53–55.

McEwen, John. "Mixed Bag of Killjoys and Jokers Art." *Sunday Telegraph*, March 10, 2002.

McGinnis, Rick. "Masters of Illusion: An Exclusive Visit behind the Scenes of Atom Egoyan's New Film, *Ararat*." *National Post*, August 4, 2001.

McKay, John. "Atom Egoyan Isn't Entering His New Film *Ararat* in Cannes Festival Competition." Canadian Press, April 24, 2002.

———. "Cannes Is Great, but Egoyan Still Has to Finish Film." *Calgary Herald*, April 29, 1997.

———. "Egoyan a Major Contender at Genies: Director's Film Nominated in Eighteen Categories." *Calgary Herald*, December 12, 1997.

———. "Egoyan Excited to Open T.O.'s Festival." *Montreal Gazette*, September 3, 1997.

———. "Egoyan's *Ararat* to Open Toronto Film Fest; Cronenberg Film Also Has Gala." *Canadian Press*, July 3, 2002.

———. "Ian Holm Oscar Contender: British Actor Gets Top Marks in Atom Egoyan's Latest Work." *Calgary Herald*, October 9, 1997.

———. "Sweet Genies: Egoyan Dominates the Opposition with *The Sweet Hereafter*." *Calgary Herald*, December 15, 1997.

McKenna, Kristine. "This Director's Got a Brand Noir Bag." *Los Angeles Times*, March 12, 1995.

Mohan, Marc. "Early Egoyan." *The Oregonian*, August 3, 2001.

Monahan, Mark. "Tender Farewell to Reel Life." *Daily Telegraph*, February 16, 2002.

Monceau, Nicolas. "Atom Egoyan 'abasourdi' par le rejet *d'Ararat* dans la presse turque." *Le Monde*, May 25, 2002.

———. "La Turquie contre *Ararat*, le film qui raconte le génocide arménien." *Le Monde*, February 7, 2002.

Monk, Katherine. "Beating a Budget in Style." *Vancouver Sun*, May 29, 1993.

Morgan, Anna. "COC Faces Controversy over Opera *Salome*." *Canadian Jewish News*, February 14, 2002, 6.

Morrow, Martin. "Drama Is Quietly Devastating: Atom Egoyan Delivers a Chilling Tale That Is also Deeply Moving." *Calgary Herald*, October 24, 1997.

"Notorious: Alfred Hitchcock and Contemporary Art." *Tokyo Opera City* (2001). http://www.operacity.jp/en/ag/exh19.html. (accessed July 18, 2003).

O'Connell, Alex. "Geek Bares His Gifts." *The Times*, February 4, 2002.

Ogut, Erhan. "No Plans to Sue." *Globe and Mail*, April 24, 2002.

Onstad, Katrina, Ben Errett, and Sarah Murdoch. "Egoyan versus Cronenberg: Is One Really Darker and More Difficult Than the Other?" *National Post*, July 3, 2002.

Ouzounian, Richard. "Dealing with the Ghosts of Genocide: Egoyan and Khanjian Tell of Their Passion for Armenia." *Toronto Star*, September 5, 2002.

———. "Wagner's Ring Cycle Gets Canadian Premiere in Toronto." *Toronto Star*, August 1, 2002.

Perlmutter, Tom. "Trespassed Territory: Atom Egoyan and the Making of Images." *Cinema Canada*, no. 162 (1989): 12–13.

Pevere, Geoff. "Images of Men." *Canadian Forum*, February 1985, 24–28.

———. "It's All about Storytelling." *Toronto Star*, August 30, 2002.

———. "Letter from Canada." *Film Comment*, March 1992, 61, 63–65.

———. "An Outsider's Aesthetic: Contemporary Independent Film in Canada." *The Independent: Film and Video Monthly*, June 1987, 13–17.

———. "Surfacing: In Less Than a Decade Atom Egoyan Has Emerged as One of Canada's Most Formidable Talents." *Canadian Forum*, June 1993, 25–27.

Ramasse, François. "La Vidéo mode d'emploi." *Positif* 343 (1989): 13–15.

Reid, Michael D. "Canadian Filmmaker Explores Technology and Memory in Art Exhibit." CanWest News, March 12, 2004.

"Remembrance of Things Past: In This Digital World, It Was a Joy to Use Old Technology to Edit My Film of a Samuel Beckett Play, Writes Atom Egoyan." *Globe and Mail*, February 16, 2002.

Renaud, Nicolas. "Le cinéma d'Atom Egoyan." *Hors Champ*, August 1, 2002. http://horschamp.qc.ca/article.php3?id_article=58. (accessed August 1, 2002).

Richler, Noah. "Atom Egoyan's Latest Film Is Uncompromised Krapp." *National Post*, September 13, 2000.

Rollet, Sylvie. "Le cinéma d'Atom Egoyan: à la pointe extrême de la conscience." *Positif* 406 (1994): 84–87.

———. "Cinéma et mémoire, ou pourquoi nous sommes tous des héritiers du genocide arménien." *Positif* 515 (2004): 60–65.

———. "Le lien imaginaire." *Positif*, no. 435 (1997): 100–106.

Romney, Jonathan. "Arts: Cutting Edge Tales from Reel Life; Film-maker Atom Egoyan Has Made a Work of Art from Some Ageing Editing Machines: Jonathan Romney Asks Why." *The Independent*, February 17, 2002.

————. "Aural Sex: In Atom Egoyan's Movies, a Phone Is the Essential Sex Toy: Jonathan Romney Lends Him an Ear." *Time Out* (London), May 27, 1992, 18–19.

————. "Return of the Mighty Atom: Atom Egoyan Talks to Jonathan Romney about His Latest Film, Which Rediscovers Bob Hoskins and Makes Birmingham Almost Poetic." *The Guardian*, September 24, 1999.

Ruhe, Pierre. "The Go Guide: Classical Music: A Spring-Worthy Awakening, to Sounds of Glass." *Atlanta Journal-Constitution*, January 20, 2002.

Schmitt, Oliver. "Rêves et cauchemars africains d'Atom Egoyan, librettiste." *Le Monde*, May 5, 2002.

Scott, A.O. "Worldly Violence and Confusion Are Pervading the Realm of Celluloid." *New York Times*, May 21, 2002.

Scott, Graham. "Stars Come Out for Grad." *Varsity* (University of Toronto), June 25, 2003, 1.

Scott, Jay. "Elemental Atom." *Toronto Life*, September 1989, 34–37, 70.

Sherman, Paul. "Series Celebrates Egoyan's Early Work, and His Sweet Thereafter." *Boston Herald*, February 17, 2000.

Shopsowitz, Karen. "Atom and the Grants." *Saturday Night*, June 1985, 54–56.

Sotinel, Thomas. "*Ararat*: l'histoire prisonnière d'un labyrinthe intellectuel." *Le Monde*, September 3, 2002.

————. "Aznavour, l'arménien des arméniens." *Le Monde*, May 21, 2002.

Stone, Jay. "Happy Accidents Play an Important Part in Atom Egoyan's Winner *Exotica*." *Hamilton Spectator*, October 27, 1994.

Taubin, Amy. "Memories of Overdevelopment: Up and Atom." *Film Comment*, November–December 1989, 27–29.

Taylor, Timothy. "Atom's Journey: Atom Egoyan Is Successful and Acclaimed: Now, He's Aiming for Something More: A Film That Will Be to the Armenian Genocide What *Schindler's List* Is to the Holocaust." *National Post*, August 31, 2002.

Thomas, Kevin. "*Exotica* Offers a Metaphor for Contemporary Sexuality." *Los Angeles Times*, March 3, 1995.

Thorson, Bruce. "Egoyan Mounts an Ode to Analogue." *Globe and Mail*, February 16, 2002.

"Toronto's Opener Has 9/11 Insight." Associated Press, July 3, 2002.

Tracy, Tony. "Egoyan." *Film West*, no. 38 (1999): 14–17.

Trembley, Odile. "*Ararat*, d'Atom Egoyan, à Cannes—un génocidetiré de l'oubli." *Le Devoir*, May 21, 2002.

Trotter, Herman. "The Ring Arrives." *American Record Guide*, September/October, 24–25.

"Turkey Condemns Armenian Genocide Film at Cannes as 'Propaganda.'" Associated Press, May 22, 2002.

Turner, Craig. "The Great White (North) Hope." *Los Angeles Times*, November 23, 1997.

Turp, Richard. "Canadian Directors Making Waves in Opera." *Montreal Gazette*, January 4, 1997.

"Un témoignage à vocation universelle." *Le Monde*, May 22, 2002.

Vartanian, Hrag. "The Armenian Stars of the Canadian Cultural Universe: Atom Egoyan and Arsinée Khanjian: Canada's Premier Couple of the Arts." *AGBU News*, November 27, 2004. http://www.agbu.org/agbunews/display.asp?A_ID=39.

von Busack, Richard. "A Hitch in the Works: Atom Egoyan's *Felicia's Journey* Gives Us a Serial Killer in the Hitchcock Mode." *Metroactive*, November 1999. http://www.metroactive.com/papers/metro/11.18.99/feliciasjourney-9946.html. (accessed July 8, 2002).

Waal, Peter. "And the Winner Is ..." *Canadian Business*, October 1998, 25.

Walker, Susan. "Egoyan's Subjects Share Their Reel-to-Reel Lives." *Toronto Star*, September 7, 2002.

Wall, James M. "Personal Losses." *Christian Century*, March 3, 1993, 227–28.

Ward, Kevin. "Controversial Egoyan Film on Persecution of Armenians Makes Splash at Cannes." Canadian Press, May 20, 2002.

Waxman, Sharon. "Atom Egoyan's Particles of Faith: Director of *The Sweet Hereafter* Believes in Smart Audiences for His Complex Films." *Washington Post*, December 14, 1997.

Wherry, Aaron. "*Ararat*'s Canadian Debut Controversial." *National Post*, September 5, 2002.

Whyte, Murray. "Facing the Pain of a Past Long Hidden." *New York Times*, November 17, 2002.

Wickens, Barbara. "Triple-Win Canadian at Cannes." *Maclean's*, June 2, 1997, 14.

With BC-FILM-Cannes-Egoyan, Bgt." Canadian Press, April 24, 2002.

Yoruk, Murat Ahmet. "Embracing History." *Globe and Mail*, May 18, 2002.

Zach, Ondřej. "Video l[]i a sex ve filmach Atom Egoyana." *Film a Doba* 38, no. 4 (1992): 201–203.

Theses and Dissertations

Boyd, Melanie A. *Troubling Innocence: Convention and Transgression in Feminist Narratives of Incest.* PhD diss., University of Michigan, 2003.

Bozynski, Michelle Carole. *Music in Canadian Visual Narrative: Musical Collaborations in Five Films of Atom Egoyan and Patricia Rozema.* PhD diss., University of Toronto, 2004.

Chappell, Crissa-Jean M. *Subjectivity in Literature and Cinema: Alain Resnais's Collaborations with Three Modernist Novelists.* PhD diss., University of Miami, 2003.

del Río, Elena. *The Technological Imaginary in the Cinema of Antonioni, Godard and Atom Egoyan.* Ph.D. diss., University of California at Berkeley, 1996.

Hallquist, Pola L. *Intertextuality as Internal Adaptation in Ann-Marie MacDonald's "Goodnight Desdemona (Good Morning Juliet)," Robert Lepage's "Le confessionnal," and Atom Egoyan's "The Sweet Hereafter."* Master's thesis, Université de Sherbrooke, 1999.

Jaafar, Nisrine. *The Blue Flame and the Red Flame: Love and Eroticism.* Master's thesis, Concordia University, 2001.

Marks, Laura Underhill. *The Skin of the Film: Experimental Cinema and Intercultural Experience.* PhD diss., University of Rochester, 1996.

Miller, James Andrew. *Matters of Life and Death: Political Crisis and the Ghost Film.* PhD diss. University of Missouri–Columbia, 2005.

Morgan, Jason Jorgan Archibald. *Perversion and National Subjectivity in English Canadian Cinema.* Master's thesis, University of Calgary, 2000.

Pence, Jeffrey S. *Trying to Remember: Technology, Narrative, and Memory in Contemporary Culture*. PhD diss., Temple University, 1998.

Rockburn, Barbara. *Bonne Entente: Elliptical Elisions and Canadian Narrative Structure*. Master's thesis, Carleton University, 1997.

Sharman, Rodney William. *Phantom Screen*. (Original Composition; text by Atom Egoyan). PhD diss., State University of New York at Buffalo, 1991.

Tschofen, Monique. *Anagrams of the Body: Hybrid Texts and the Question of Postmodernism in the Literature and Film of Canada*. PhD diss., University of Alberta, 1999.

Zapf, Donna Doris Anne. *Singing History, Performing Race: An Analysis of Three Canadian Operas: "Beatrice Chancy," "Elsewhereless," and "Louis Riel."* PhD diss., University of Victoria (Canada), 2005.

Official Website

Ego Film Arts. http://www.egofilmarts.com.

Archives and Other Sources

Canadian Broadcasting Corporation.

The Atom Egoyan Archive. Toronto Film Reference Library, Toronto, Canada.

Archival Description: Extensive collection of moving images, textual records, and graphic materials, donated by Atom Egoyan, 1973–2001.

University of Victoria Library: Special Collections: Film Scripts.

Archival Description: Allen Bell Fonds 1985–1995; textual records containing typescript copies of five Egoyan screenplays (reworked by Bell), including *Family Viewing* (1987) in three drafts, *Speaking Parts* (1989) in five drafts, *The Adjuster* (1991) in one draft, *Exotica* (1995) in one draft (not reworked by Bell), and *The Sweet Hereafter* (1997) in three drafts; some additional holograph notes and a notebook regarding the scripts and correspondence from Atom Egoyan to Bell, 1985–1995, regarding the films.

▶▶| Notes on Contributors

Kay Armatage is an associate professor at the University of Toronto, cross-appointed to Cinema Studies, Innis College, and the Institute of Women's Studies. She is also a member of the Graduate Centre for the Study of Drama. She is author of *The Girl from God's Country: Nell Shipman and the Silent Cinema* (University of Toronto Press, 2003), co-editor of *Gendering the Nation: Canadian Women's Cinema* (University of Toronto Press, 1999), editor of *Equity and How to Get It* (Toronto: Inanna Press, 1999), and author of articles on women filmmakers, feminist theory, and Canadian cinema in books, film magazines, and refereed journals.

Marie-Aude Baronian is an assistant professor in the Department of Philosophy and Media Studies of the University of Amsterdam and a member of the Amsterdam School for Cultural Analysis (ASCA). She has written and lectured extensively on Atom Egoyan's cinema and on issues of representation, testimony, and memory, and is co-editor (together with Stephan Besser and Yolande Jansen) of the volume *Diaspora and Memory: Figures of Displacement in Contemporary Literature, Arts and Politics* (Rodopi, 2005). She has completed an interdisciplinary dissertation entitled *Image et témoignage: vers un esthétique de la catastrophe.*

William Beard is a professor of film/media studies at the University of Alberta, where he was for many years coordinator of the Film/Media Studies program. He is the author of *Persistence of Double Vision: Essays on Clint Eastwood* (University of Alberta Press, 2000) and *The Artist as Monster: The Cinema of David Cronenberg* (University of Toronto Press, 2001), and co-editor of *North of Everything: English-Canadian Cinema since 1980* (University of Alberta Press, 2002). He is currently working on a book about Guy Maddin.

Melanie Boyd received her PhD in English and Women's Studies from the University of Michigan and is now a postdoctoral fellow at Lawrence University, where she is affiliated with the Gender Studies Program. Her research focuses on contemporary U.S. and Canadian narratives of sexual violence, looking particularly at the rhetorics of innocence, damage, and healing that operate within these political texts; she is especially interested in their construction of narrative authority. Her current book project, *Refiguring Incest: Feminism, Narrative, and the Abandonment of Innocence,* looks at three decades of feminist accounts of paternal incest to highlight their shifting formulations of victimhood and to trace the implications of those shifts for feminist theorizations of subjectivity, agency, and violence.

Jennifer Burwell is an associate professor in the English Department at Ryerson University. She teaches media studies to Radio Television Arts students at Ryerson and to graduate students in the York/Ryerson Joint Graduate Programme in Communication and Cultural Studies. Her book, *Notes on Nowhere: Feminism, Utopian Logic, and Social Transformation* (University of Minnesota Press, 1997) examines utopian thought in relation to contemporary postmodern, critical Marxist, and feminist theory. Her current interests include the political economy of communications technology and the relationship between surveillance society and the public sphere.

Caryl Clark teaches musicology in the Faculty of Music, University of Toronto and in the Department of Visual and Performing Arts at UTSC (University of Toronto Scarborough Campus). Her publications reflect interests in the socio-cultural contexts of music-making, gender issues, performance studies, and the politics of musical reception. She is co-editor of two special interdisciplinary opera issues of the *University of Toronto Quarterly*—"Voices of Opera" (1998) and "Interdisciplinary Studies of Opera" (2003)—and is co-chair of the Humanities Initiative at the Munk Centre for International Studies. She is currently editing the *Cambridge Companion to Haydn.*

Elena del Río is an assistant professor of Film Studies at the University of Alberta. Her essays on the intersections of cinema and technology and of cinema and performance have appeared in *Camera Obscura, Discourse,* the *Quarterly Review of Film and Video, Science Fiction Studies,* and *Studies in French Cinema.*

Adam Gilders is a Toronto writer and academic. His fiction and articles have appeared in the *Paris Review*, *The Walrus*, and *J&L Illustrated*. He is the author, with photographer Jason Fulford, of *Sunbird*.

Patricia Gruben is an associate professor of Film and director of the Praxis Centre for Screenwriters at Simon Fraser University in Vancouver. She is also a filmmaker who has written and directed two dramatic features (*Low Visibility* and *Deep Sleep*), a feature-length documentary (*Ley Lines*) and several experimental narrative shorts including *Sifted Evidence* and *Before It Blows*. Recent publications include analyses of narrative structure in *The Sweet Hereafter* (*Creative Screenwriting*, March 2001) and Renny Bartlett's Eisenstein (*ScreenTalk*, January 2002).

Nellie Hogikyan is a sessional lecturer in Comparative Literature and psycholinguistics at l'Université de Montréal. She is in charge of the Postcolonial Studies Reading Group, which she co-founded in 2000 in the department of Comparative Literature at l'Université de Montréal, where she works on questions of subalternity in the context of Lebanese-Palestinian terrorism. She has published fiction and non-fiction in local newspapers and magazines. Her academic essays include "Silence et résistance: le langage du subalterne. Le cas des réfugié-e-s palestinien-ne-s au Liban" (in *Approches de l'outre-langue*, ed. Alexis Nouss, Presses Universitaires de Strasbourg, 2005), "De la mythation à la mutation: structures ouvertes de l'identité" (in *Poésie, terre d'exil*; Alexis Nouss Trait d'union, 2003), and "The Crisis in Reason: Feminism, Simone de Beauvoir and the Marquis de Sade" (*Revue de l'Institut Simone de Beauvoir Institute Review* 18/19, 2000).

Angela Joosse is a PhD candidate in the Joint Graduate Programme in Communication and Culture of Ryerson and York universities. She is the author of, "Dziga Vertov and Steve Mann: The Embodiment of the Master Metaphor of Vision," (*Intersections Conference Journal*, 2005). She is also a Toronto-based filmmaker. Her most recent films are *Shapes Eat Shapes* (2006), *City Window* (2005), *Ear after Ear* (2005), and *Avra*, which screened at the 2004 Montreal Festival des Films du Monde.

Katrin Kegel graduated from the University of Music and Performing Arts Mozarteum, Salzburg. After several years of theatre work, she took up studies of media communication and film at the University of Arts in Berlin and at Johann Wolfgang Goethe University in Frankfurt. She was as a staff member with the international film festivals of Toronto and Berlin and involved in a broad range of film-production work, with a special interest on international co-productions. She completed her masters in Film Studies with a thesis on ethnicity in the early films of Atom Egoyan (2002).

David L. Pike is an associate professor of literature at American University. He is author of *Passage through Hell: Modernist Descents, Medieval Underworlds* (1997), which won the Gustave O. Arlt Award and was a Choice Academic Book of the Year, and *Subterranean Cities: Subways, Cemeteries, Sewers, and the Culture of Paris and London* (2005). He is co-editor of the Longman *Anthology of World Literature* (2004) and has published widely on nineteenth- and twentieth-century urban literature, culture, and film. He is currently working on a history of Canadian cinema since 1980, to be published by Wallflower Press.

Lisa Siraganian is an assistant professor of English at Southern Methodist University in Dallas, Texas. She is currently working on a book about theories of the art object in twentieth-century American literature. She has previous published articles in *Diaspora* and *Modernism/Modernity*.

Batia Boe Stolar is an assistant professor in English at Lakehead University. She has recent or forthcoming publications in the *Canadian Journal of Film Studies*, *Studies in Canadian Literature*, and *Downtown Canada*. She is currently completing a manuscript on cultural constructions of the immigrant in Canadian and American literature and film, and researching visual representations of the immigrant in Canadian and American documentaries, photography, and film.

Gariné Torossian is a self-taught filmmaker and photographer. Mining a rich palette of colours and textures, superimpositions and dissolves, mixing formats of Super 8, 35mm, and video, Torossian creates films that bridge the gaps between visual, sound art, cinema, and music video. Sixteen of her films have shown internationally at festivals and universities. Retrospectives of her work have been held at New York's Museum of Modern Art, Stan Brakhage's First Person Cinema, Yerevan's Cinematheque, the Berlin Arsenal, and the Telluride Festival. She has been awarded prizes and mentions at the Berlin, Melbourne, and Houston film festivals.

Monique Tschofen is an associate professor in the Department of English at Ryerson University and a member of the Joint Graduate Programme in Communications and Culture of Ryerson and York universities. She is the editor of *Kristjana Gunnars: Essays on Her Work* (Guernica 2004) and has published articles on Canadian film, literature, and painting, intermediality and visuality, and violence in representation. She is currently working on a monograph on new-world torture narratives.

William Van Wert was the Laura Carnell Professor of English at Temple University, where he taught film and creative writing and was serving as the director of undergraduate English studies at the time of his death. He was the author of fifteen books, among them novels (*What's It All About, Stool*

Wives, Don Quixote), short story collections (*Tales for Expectant Fathers, Missing in Action, The Advancement of Ignorance*), poetry collections (*The Invention of Ice Skating, Proper Myth, Vital Signs*), and one book of essays (*Memory Links*), as well as extensive work in the area of film studies. His death is a profound loss to all who worked with him and read his work.

Hrag Vartanian is an Armenian Canadian writer and critic living in Brooklyn, New York. He is a staff writer for *AGBU News Magazine*, the *Brooklyn Rail* newspaper, and *Boldtype*, an online review journal. He also serves on the editorial board of the quarterly *Ararat*. His writing explores diversity and identity in a global context.

▶▶| Index

absurd, theatre of, 5, 7, 15, 118, 343–44, 347

Adjuster, The (Egoyan), 5–7, 12, 23–24, 53–77, 80–81, 84–85, 98n5, 108, 115–16, 118, 120n15, 147, 153n10, 164–67, 229, 234, 243, 248, 344, 347, 349

aesthetics, 2, 47, 120n17; diasporic, 195, 204; of distance, 208; and realism, 117

After Grad with Dad (Egoyan), 6

agency, 4, 15, 129, 223, 290; and incest, 278, 288; and innocence/culpability, 3, 222–26; and power, 3, 129, 191, 222, 226, 289; and victimization, 224, 226, 279

Alfred Hitchcock Presents, 120n16, 346

allegory, 84, 138

Ambassadors (Holbein), 300, 304n3

America, America (Kazan), 167

analogue, 12, 17n1, 114, 116; and digital, 102, 16, 350–51; and nostalgia, 108. *See also* digital

Angels in America: A Gay Fantasia on National Themes (Kushner), 179

Ararat (Egoyan), 5–6, 8, 12, 17n2, 79, 84, 98n4, 116, 126–27, 129, 133–54, 157, 160, 172, 175n10, 177, 181, 193, 195, 199–215, 272, 291n5, 331–33, 337, 348–57

Ararat, Mount: as icon or symbol, 136, 153n7; image of, 94, 151; as signifier, 127, 153n7, 202–203; and territory, 127

Ararat: The Shooting Script, 149

archetype, 24, 41, 83, 84, 262

archive, 5, 15, 16, 101, 106, 173, 344; vs. collection, 113, 114–18, 120n19

Armenia. *See* Armenia, Eastern; Armenia, Western; Armenian Secret Army for the Liberation of Armenia; belonging; Christianity; churches; community; diaspora; ethnicity; family; fetish; genocide; heritage; holocaust; homeland; identity; Justice Commandos for the Armenian Genocide; landscape; language; mediation; memory; narrative; stereotype; subjectivity; WASP

Armenia, Eastern, 201, 203, 215n3, 215n6

Armenia, Western, 153n14, 200, 201, 215n7, 333

Armenian Journey, An (Bogosian), 197

Armenian Secret Army for the Liberation of Armenia, 135

Artangel, 103, 105, 117